MUSEUM OF FINE ARTS, BOSTON
7 September–13 November 1983

THE CORCORAN GALLERY OF ART, WASHINGTON, D.C.
7 December 1983–12 February 1984

GRAND PALAIS, PARIS
16 March–11 June 1984

ORGANIZED BY THE MUSEUM OF FINE ARTS, BOSTON

Theodore E. Stebbins, Jr., Carol Troyen & Trevor J. Fairbrother

A NEW WORLD: *Masterpieces*

THE EXHIBITION AND CATALOGUE HAVE BEEN MADE POSSIBLE BY A GRANT FROM UNITED TECHNOLOGIES CORPORATION

with essays by Pierre Rosenberg & H. Barbara Weinberg

of *American Painting* 1760–1910

Catalogue edited by Janet G. Silver & designed by Derek Birdsall

Copyright © 1983 by
Museum of Fine Arts
Boston, Massachusetts
All rights reserved

Library of Congress
catalogue card no. *83-42955*
ISBN 0-87846-234-1 (paper)
ISBN 0-87846-236-8 (cloth)

Printed in Great Britain

CONTENTS

Lenders to the Exhibition

Addison Gallery of American Art, Phillips Academy, Andover, Massachusetts
Mr. and Mrs. Arthur G. Altschul
Amon Carter Museum, Fort Worth, Texas
The Art Institute of Chicago
The Brooklyn Museum, New York
The Butler Institute of American Art, Youngstown, Ohio
Sterling and Francine Clark Art Institute, Williamstown, Massachusetts
Cincinnati Art Museum
The Cleveland Museum of Art
The Corcoran Gallery of Art, Washington, D.C.
Dallas Museum of Fine Arts
The Detroit Institute of Arts
Mr. and Mrs. Stuart P. Feld
The Fine Arts Museums of San Francisco
Jo Ann and Julian Ganz, Jr.
The Armand Hammer Collection
Mr. and Mrs. George D. Hart
Harvard University, Cambridge, Massachusetts
The Historical Society of Pennsylvania, Philadelphia
Mr. and Mrs. Raymond J. Horowitz
Jefferson Medical College, Thomas Jefferson University, Philadelphia
Mrs. Alice M. Kaplan
Los Angeles County Museum of Art
The Manoogian Collection
The Metropolitan Museum of Art, New York
Musée du Louvre, Paris
Museum of Art, Carnegie Institute, Pittsburgh
Museum of Fine Arts, Boston
The Museums at Stony Brook, New York
National Academy of Design, New York
National Gallery of Art, Washington, D.C.
National Museum of American Art, Smithsonian Institution, Washington, D.C.
The National Portrait Gallery, Smithsonian Institution, Washington, D.C.
William Rockhill Nelson Gallery of Art and Atkins Museum of Fine Arts,
 Kansas City, Missouri
The New-York Historical Society
The New York Public Library
The Pennsylvania Academy of the Fine Arts, Philadelphia
Philadelphia Museum of Art
The Phillips Collection, Washington, D.C.
Reynolda House Museum of American Art, Winston-Salem, North Carolina
The St. Louis Art Museum
Smith College Museum of Art, Northampton, Massachusetts
The Tate Gallery, London
Terra Museum of American Art, Daniel J. Terra Collection, Evanston, Illinois
Timken Art Gallery, Putnam Foundation Collection, San Diego, California
The Toledo Museum of Art, Ohio
University of Pennsylvania School of Medicine, Philadelphia
Virginia Museum of Fine Arts, Richmond
Wadsworth Atheneum, Hartford, Connecticut
Whitney Museum of American Art, New York
Erving and Joyce Wolf
Mrs. Norman B. Woolworth
Worcester Art Museum, Massachusetts
Yale University Art Gallery, New Haven, Connecticut
Anonymous Private Collection, Courtesy of Jordon-Volpe Gallery, New York
Anonymous Private Collections

I am proud and pleased that United Technologies is a partner in this breathtaking exhibition of America's masterpiece paintings, and that these great paintings will be seen not only in our own country but also in Europe.

For Americans and Europeans alike, I believe, *A New World* will be a revelation and an art experience of surpassing excitement.

HARRY J. GRAY
Chairman and Chief Executive Officer
United Technologies Corporation

FOREWORD

Many nations have in past years organized and sent abroad great exhibitions of their country's art, willingly lending their treasures so they could be seen and enjoyed on other continents. Such exhibitions provide both pleasure and education for their viewers. We have come to realize that works of art transcend questions of nationality and that they demonstrate the very roots of the society which produced them. The people of the United States have frequently been the beneficiaries of major international expositions, and on numerous occasions the art has been French, the organizer the Louvre, and the lenders the people of France. Now the situation is reversed, as many great American paintings travel overseas to be shown in Paris, nearly all of them superbly generous loans from the major museums and private collections of the United States.

Modern American art, especially the work of the "New York School," became a compelling and widely appreciated force in the years after 1945, but it is only in the last decade that the quality and importance of American painting of the nineteenth century has been recognized internationally. Americans themselves have been far more familiar with Ingres and Manet, Turner and Constable, than they have with their own native painters. Moreover, the American painters who have become best known are expatriates such as Whistler and Cassatt, whose styles were truly international and whose major accomplishments occurred in Europe. The purpose of the present exhibition is to redress these imbalances. At the invitation of the Louvre, the Museum of Fine Arts, Boston, has organized an exhibition of American masterpieces, from John Singleton Copley's *Boy with a Squirrel* of 1765 to Winslow Homer's *Right and Left* of 1909. A few of these pictures were painted in Paris, and a number of others have been exhibited there previously, notably in the exhibition *Trois siècles d'art aux États-Unis* (1938), but this is the first time that the United States has sent to Europe an exhibition devoted to the best of early American painting. The only criterion for our selection has been artistic excellence; viewers will find here many of the most famous American artistic treasures—including *Paul Revere* by Copley, *Fur Traders Descending the Missouri* by Bingham, and *The Gross Clinic* by Eakins—along with others whose quality has only recently been recognized.

This exhibition offers to our audiences in the United States and Europe a unique opportunity to study the greatest of American paintings in one place, at one time. This opportunity exists only because of the immense generosity of lenders who have understood the importance of our exhibition. Forty-three American institutions across the nation and sixteen private collectors, together with the Tate Gallery in London and the Louvre, have lent their most cherished pictures, and we express our most profound gratitude to them. Our colleagues at the Metropolitan Museum of Art, New York, and the National Gallery of Art, Washington, D.C., have been especially kind in this regard.

The exhibition was organized by Theodore E. Stebbins, Jr., John Moors Cabot Curator of Paintings at the Museum of Fine Arts, Boston, together with John Walsh, Jr., formerly of the Museum of Fine Arts, now director of the J. Paul Getty Museum, Edward J. Nygren of the Corcoran Gallery of Art, William S. Talbot of the Cleveland Museum of Art, and, most importantly, Pierre Rosenberg of the Louvre, who first conceived of the exhibition and who has worked closely on every aspect of it with the American curators. They were aided by an advisory committee, listed on p. 4, consisting of many of the leading specialists in American painting, and chaired by two preeminent scholars, Lloyd Goodrich and Edgar P. Richardson. All of these distinguished professionals have aided the exhibition through their counsel.

We are especially indebted to Mabel H. Brandon, Senator and Mrs. H. John Heinz III, Jo Ann and Julian Ganz, Jr., William H. Gerdts, John Wilmerding of the National Gallery of Art, and John K. Howat of the Metropolitan Museum of Art for their early consultation and aid with the exhibition. Special thanks go to Richard Manoogian for granting permission for use of the cover illustration.

For the catalogue, we thank its authors, Theodore E. Stebbins, Jr., Carol Troyen, Trevor J. Fairbrother, Diana Strazdes, and Donald D. Keyes. Professor H. Barbara Weinberg of the City University of New York has summarized her extensive research in this field in an essay entitled "The Lure of Paris: Late-Nineteenth-Century American Painters and Their

French Training," and Pierre Rosenberg has written engagingly about his view of the show. We are particularly grateful to Derek Birdsall for his excellent design of the catalogue, and we thank Janet G. Silver for editing the manuscript. At the Museum of Fine Arts we acknowledge Harriet Rome Pemstein, coordinator of the project; Linn Hardenburgh and Galina Gorokhoff for their organizational assistance; Mary-Denise O'Connor-Kidney, who prepared the manuscript; John Caldwell for his assistance with the Winslow Homer entries (cat. nos. 62, 108, 110); Erica Hirshler for research; Linda Thomas, Registrar, and Lynn Herrmann, Assistant Registrar; Carl Zahn, Publications; Conservators Alain Goldrach and Frank Zuccari, the latter having undertaken thorough treatment of *Watson and the Shark* by Copley; designers Judith Downes and Tom Wong; Janice Sorkow; as well as James Barter, Patricia Loiko, Alexandra Murphy, Judith Neiswander, and Caroline C. Young.

At the Corcoran, we thank Dr. Peter Marzio, former director, for his enthusiastic support of the project; Edward J. Nygren, Curator of Collections; Judith Riley, Registrar; Adrianne Humphrey; and Barbara Moore. In Paris, the exhibition has been directed by Pierre Rosenberg assisted by Thierry Bajou, and Irène Bizot assisted by Ute Collinet, Claire Filhos-Petit, Marguerite Rebois, Claude Soalhat, and their able staffs.

On behalf of the catalogue authors, we also wish to thank the following for their kind assistance: Jeffrey Brown; Gerald L. Carr, Olana State Historic Site; Micheline Colin, Musées Royaux des Beaux-Arts de Belgique; William K. Crowley, Adirondack Museum; Katherine D. Finkelpearl, Wellesley College; Kathleen A. Foster, The Pennsylvania Academy of the Fine Arts; Barbara Krulik, National Academy of Design; Denise Leidy, Museum of Fine Arts, Boston; Rodney Mill, Library of Congress; Linda Muehlig, Smith College Museum of Art; Michael Quick, Los Angeles County Museum of Art; Mrs. Erwin Raisz for the use of her late husband's map; Donna Seldin, Coe Kerr Gallery; Barbara Stern Shapiro, Museum of Fine Arts, Boston; Nancy Rivard Shaw, The Detroit Institute of Arts; Natalie Spassky, The Metropolitan Museum of Art; William A. Vance, Boston University; David Weaver, cartographer; Joseph B. Zywicki, Chicago Historical Society; and in Paris, Ann Arikha

and Sebastièn Loste. The French edition of the catalogue has been translated by Claude de France.

Finally, and most significantly, we owe a great debt of gratitude to United Technologies Corporation, especially to Harry J. Gray, Chairman and Chief Executive Officer, for providing imaginative and most generous funding of this exhibition. We are also indebted to Raymond d'Argenio, Senior Vice-President, and to Gordon Bowman, Director of Corporate Creative Programs, for the enthusiasm and creativity they brought to this project. The exhibition would have been impossible without the support of United Technologies Corporation, which has proven to be a model sponsor in every respect.

JAN FONTEIN
Director
Museum of Fine Arts,
Boston

MICHAEL BOTWINICK
Director
The Corcoran Gallery of Art,
Washington, D.C.

HUBERT LANDAIS
Directeur des
Musées de France,
Paris

INTRODUCTION
Theodore E. Stebbins, Jr.

The fact that there is an American art has been largely overlooked both in Europe and in America. European observers mostly have viewed Americans as an industrious, practical people, with special gifts for the mechanical, the political, the economic, and the military. And Americans themselves have been inclined from the beginning to doubt the arts as impractical, frivolous luxuries. So the existence of an art that was, in the eighteenth and nineteenth centuries, both beautiful and moving, and the necessary conclusion that this art represents a major achievement of a society regarded chiefly for its accomplishments in other fields, may come as something of a surprise to the general public on both sides of the Atlantic.

The process leading to a new appreciation of American painting in Europe, and to a new understanding of our artistic past on the part of Americans, has been going on for some time, and many factors have contributed to it. For one thing, modern American painting in the form of Abstract Expressionism and then Pop Art came to international attention just as the United States reached its zenith of international power, following the Second World War. This naturally led to a curiosity about earlier American painting and to a search for American artistic roots; the result was the rediscovery of nineteenth-century painting by Lloyd Goodrich, E. P. Richardson, and others in the 1930s and '40s. Then, anomalously, as American power in the world declined somewhat in the 1960s and the 1970s and the nation became less intellectually and politically isolated from the rest of the world, American scholars became increasingly willing to consider American art in the international context. In the thirties and forties, American art was seen as somehow special, as isolated, idiosyncratic, and native, and as not open to comparison with the arts of Europe. In the writing of that time, one senses a fearful attitude, a worry that the apparent qualities of earlier American painting might crumble away if too closely compared with European art. In reaction to this defensive, "nativist" attitude, younger scholars (among them H. Barbara Weinberg, whose essay on American painters in Paris follows) have turned energetically to exploring the European background of early American painting, investigating especially our painters' travels and study in Europe. For the most part, this work has been useful, for it has led to a better understanding of the connection between our art and English history painting, German Romanticism, the art of Düsseldorf and Munich, English Pre-Raphaelitism, the École des Beaux-Arts, and Impressionism.

The question of national style, or, as it has been phrased, the search for what is American in American art, is a complex one indeed, and there is no period or style for which an answer comes easily. John Singleton Copley, the colonial painter whose work has often seemed to offer the very definition of American style, must be seen as a provincial English painter, and one whose work is comparable to that of other English artists working away from London. Church and Lane, the great native landscapists who were fully trained at home in the halcyon pre-Civil War years, must be understood in the light of very similar, equally native, equally indigenous work of Germans such as Caspar David Friedrich, Danes including Christian Eckersberg, and other northern Romantics. And after the Civil War, Homer and Eakins, no less than Sargent and Whistler, similarly demand consideration both as Americans and as part of the international art community: for in this period, painters all over Europe responded to Paris and to French style, and the question of nationality everywhere became more complicated.

As we demonstrate below, American painting—like the American nation—is made up of many things. It cannot be defined reductively as "linear" or "luminist," for our painters' styles are multifarious. It is possible, however, to single out certain attitudes which seem consistent from one generation to the next. From the beginning, American artists have been middle class, ambitious, idealizing, optimistic, uncritical, materialistic, courageous, literary minded, direct, self-conscious, highly serious, self-doubting, conscious of European models, proudly nationalistic, faithful to the picturesque, and deeply and essentially conservative. They are naive in several senses, most crucially in their belief in the importance of art and in the need for painting to be both beautiful and uplifting. And above all, the American painter is romantic: with a few notable exceptions, including Copley and Eakins, American artists have idealized and improved on what they saw, and they have diligently avoided the facts and problems and even the symbols of the real, the distasteful, or the ethical.

As American thinking about our art has changed, so have

French attitudes. The French chronicler Alexis de Tocqueville wrote in his book of 1835, *Democracy in America:* "It must be admitted that few of the civilized nations of our time have made less progress than the United States in the higher sciences or had so few great artists, distinguished poets, or celebrated writers." One and a half centuries later, Tocqueville's countrymen have asked to borrow the greatest American paintings for a showing in Paris. The roots of this invitation go back at least to 1972, when the Louvre began a systematic and highly successful investigation of nineteenth-century European painting. Beginning with an important exhibition of English Romantic painting, it has held major exhibitions of the Romantic art of Germany, Russia, and Italy; it recently devoted a show to The Hague School; a superb retrospective of the work of J. M. W. Turner opens in Paris in October 1983; and a nineteenth-century Danish show is being planned. The *New World* exhibition thus responds to the French wish to explore painting in the nineteenth century fully, with the special aim of introducing the French public to unfamiliar work that has merit and quality— hence the shows of Russian, Danish, and now American art.

Though the momentum for this special exhibition was built during the last decade, a positive French view of American art has long been forming. As early as 1867, the Exposition Universelle in Paris included 82 works by 41 American painters. Emphasis was on the Hudson River School, then at its height. Two paintings by Frederic Edwin Church were displayed, both of which are in our exhibition—*Niagara Falls* and *Rainy Season in the Tropics*—and he became the first American to win a French medal. In 1878, 127 American works were displayed. At the Exposition of 1889, 336 American paintings were seen, and Americans garnered a total of 110 awards, including 4 Gold Medals. In 1900, 352 American works, including drawings and cartoons, were included in the Exposition, with Homer and Eakins richly represented. In 1919 and 1923, large shows of contemporary American work were sent to Paris, and in 1938 the Museum of Modern Art organized the ambitious exhibition *Trois siècles d'art aux États-Unis*, a selection of 380 objects including painting and sculpture from 1670 to the 1930s, with sections devoted to prints, architecture, photography, folk art, and film. Homer was our best-represented painter, followed by Whistler,

Eakins, Ryder, and Charles Demuth. That exhibition included seven of the paintings in the current show: the two well-known pictures owned by France, Whistler's *Mother* and Homer's *Summer Night*, together with Homer's *Eight Bells*; Eakins's *Max Schmitt in a Single Scull*; Harnett's *Faithful Colt*; Washington Allston's *Elijah in the Desert*; and Raphaelle Peale's *After the Bath*. Only 18 of the 49 painters in the *New World* exhibition were also represented in the 1938 show, and the landscape school of Church, Cole, Lane, Heade, and others was totally absent there—all of which gives some indication of the changes of taste that have occurred over the past forty years.

The present exhibition thus marks the first time in two generations that a large number of the best American pictures of the late-eighteenth and nineteenth centuries have been sent to Paris. For Americans this is also a notable occasion: not since the Metropolitan Museum of Art's Centennial Exhibition of 1970 has a comparable group of our paintings been brought together. To do so is more difficult than it might seem, for there is only an extremely limited number of American paintings that show the artist at the peak of his or her talents and that are both of extraordinary quality and in excellent condition. Many of our painters made only a handful of truly fine works, together with many lesser ones; Bingham, Heade, Lane, Harnett, and Chase all provide examples of this. In many cases the painter's major work is simply unique: one thinks of C. W. Peale's *Staircase Group,* Raphaelle Peale's *After the Bath*, Copley's *Paul Revere*, Bingham's *Fur Traders Descending the Missouri*, Eakins's *Gross Clinic*, and Sargent's *Madame X*. It is difficult to conceive of a truly great show without these landmark pictures. Even our most prolific and consistent masters such as Copley or Homer produced only a dozen or two superb pictures. One explanation is that the structure of exhibitions and patronage was a fragile and often difficult one, and American taste tended toward the simplistic and undemanding. Some artists thus became discouraged, or they compromised, or on occasion they simply gave up their profession. An additional problem has been the general lack of appreciation for American painting over the years, which has meant that even our masterworks have been subjected to physical neglect or abuse, or they have been "conserved" at various times by well-meant but actually harmful treatment.

Even today, pictures are being ruined daily by restorers who misunderstand their technical subtlety and complexity. It is far less risky to clean a Monet, for example, with its thick impasto and extensive use of whites, than a Lane, with its thinly painted, delicately glazed, and very fragile surface. Indeed, a number of paintings which were once great, including some that are well-known, have been ruined. Though there is no such thing as "perfect" condition for an old painting, our aim in this exhibition has been to show works which the artist himself might have been pleased with, which look much as they did upon leaving the studio.

We originally planned to show just nine painters who are generally considered preeminent—Copley, Cole, Church, Heade, Lane, Bingham, Eakins, Homer, and Harnett—and indeed they remain the best-represented artists in the exhibition. It became clear, however, that a significant part of the story of American painting lies in its splendid variety of style and subject, and that to omit a group of masters arguably as accomplished, including Raphaelle Peale, Stuart, Mount, Bierstadt, Whistler, Sargent, and Ryder, would be to misrepresent the richness of our artistic tradition. At the same time, we felt no need to provide a survey or to represent every facet of our art: thus we have only twenty portraits, mostly by Copley or Eakins, despite the fact that portraiture accounts for close to half of all the paintings made in nineteenth-century America. Similarly, we lack history paintings by Emanuel Leutze and the like, as the requisite quality generally seems lacking. On the other hand, we have felt free to include genuine masterpieces by interesting but unquestionably minor painters such as Edward Ashton Goodes, John White Alexander, and George Hitchcock. We have attempted to examine each painting with fresh eyes, and to judge it strictly on the basis of its intrinsic merits.

Though lenders have been extraordinarily generous, this is not to say that we had carte blanche in borrowing paintings. Certain pictures simply could not be lent because of their fragile condition or other restrictions: these included Sargent's *Daughters of Edward Darley Boit* (Museum of Fine Arts, Boston), Cole's *Course of Empire* (New-York Historical Society), Harnett's *After the Hunt* (Fine Arts Museums of San Francisco), and Whistler's *White Girl* (National Gallery, Washington, D.C.). Some first-rank or nearly first-rank painters are not included here because the one or two most suitable choices were not available: portraitists Thomas Sully and J. W. Jarvis, and such late-nineteenth-century painters as Thomas W. Dewing and Abbott Thayer, for example. Certain other painters, such as Raphaelle Peale and John F. Peto, might well have been more richly represented. Finally, the question of including folk painting was considered at length by the Advisory Committee and the organizers and was narrowly rejected on the grounds that this wonderful material should properly be the subject of another exhibition.

The viewer will look in vain here for a survey of American life or history, for these were not the painters' subjects. We see here George Washington and Samuel Adams, but there is no painting of Jefferson or Lincoln, of Emerson or Whitman, or of other historical figures. And there are no depictions of major American battles or strikes, financial panics or political events. There is little indication of the importance of the Western frontier or industry and urbanization. We see only three black men and two black women; there are no cowboys and no Indians. There are just two religious pictures, two allegorical ones, and three with literary subjects. There is one nude, one rendition of the interior of the Louvre, and one medical operation. Our painters, like painters everywhere, referred more frequently to life in their work than to art.

Most of the paintings in this exhibition could never be used to illustrate a history book in the traditional way, but as a group they demonstrate an important but seldom-noted aspect of American history: the rise of an American art. The appearance of West, Copley, and C. W. Peale in the eighteenth-century colonies was remarkable enough; but the unsophisticated love affair between Americans and visual images which developed in the nineteenth century is astonishing, and it is worth recording. As a nation we may have been as pragmatic and money-minded as we have always thought, but we also became artistic. We developed a tender, idealizing, high-minded side which enabled us to produce major works of literature and painting. Though always self-doubting, always conscious of the primacy of Europe, Americans developed a collective memory which found expression in the arts. While we stripped and plundered the forests, we showed our underlying reverence for the land in our paintings. While we divided the nation on the basis of slavery and in a bloody Civil War, we loved paintings of community warmth and family. And while we became corrupt and vulgar during the Gilded Age, we produced painters of truth in Homer and Eakins. We take pride in these paintings as American, but we take greater pride in them as works of art. As Longfellow said: "Nationality is a good thing to a certain extent, but universality is better. All that is best in the great poets of all countries is not what is national in them, but what is universal. Their roots are in their native soil; but their branches wave in the unpatriotic air, that speaks the same language unto all men."

A French Point of View
Pierre Rosenberg

America has the capacity to do what it likes, and it now wants to be recognized as a force in the arts. America will try anything, even the acquisition of artistic genius, and it will get it, in its own way. It will accomplish in less than 100 years what Europe has taken fifteen centuries to achieve.

—Comte de Laborde, *De l'Union des arts et de l'industrie* (1856)

We in France speak of French or Italian painting, of the Spanish and Dutch schools, and even, quite justifiably, of Danish and Swiss art. Yet when we use the term "American painting," we think chiefly of art in the United States produced since the Second World War—and that immediately introduces an element of controversy. Whatever place we may assign to Mark Rothko or Jackson Pollock, to Barnett Newman, Franz Kline, or Ad Reinhardt, these and various other artists still active today have defined American painting for our public at large. The controversial discussions these artists aroused and the political interpretation given to them have dominated artistic debate since the 1950s.

Promoted by commercial interests and used as weapons to wage cultural war against Paris, American artists since the Second World War, however reluctantly, have come to be regarded symbolically, like the Statue of Liberty or the Vietnamese War. They have come to be considered by some as either consenting victims or independent architects of an American campaign of cultural expansion, or by others as visionary heralds of a new art movement, indeed a new civilization. Because of this, the true issues, in my opinion, have been obscured.

Now that the Abstract Expressionists have been granted their rightful place in the history of contemporary art, and the din of battle between New York and Paris has subsided, leaving both sides exhausted in the great confusion which contemporary painting seems to be experiencing, it is high time to look into the origins of American painting and to concentrate on its past. The strength of contemporary American art has been so irresistible, its impact so stunning, that Europeans have neglected to inquire into its beginnings and the steady development that led to its maturity. Since postwar art has now become more familiar—and the immense success of the Pollock exhibition at the Pompidou Center in 1982 testified to public enthusiasm—it is surely the opportune moment to investigate what came before, to discover what is original, new, and great in nineteenth-century American painting.

In 1938 Alfred Barr, who "discovered" Matisse, introduced the Jeu de Paume exhibition of *Trois siècles d'art aux États-Unis* with the following words: "To write about the art of the United

States for the French public is no easy task for an American." My own task, some forty-five years later—in the wake of events, and not only those arising from the Second World War, which distance us very much indeed from the Paris of 1938, of Picasso and Mondrian, Bonnard and Léger—is scarcely easier.

As regards the present exhibition, I am aware of a double obligation: first, to the Parisian art-loving public, which, in Barr's words, "is the most critical in the world" and will "form its own judgments," and second, to our American friends who may be wondering why the French wanted to have this exhibition at all.

Before attempting to respond to either, I must confess that I am in no sense a specialist in nineteenth-century American painting. (Such experts are, in any event, rare in Europe: it would be intriguing to seek the reasons why historians on this side of the Atlantic, for whom no civilization, century, or country holds any terrors, should have abandoned this field of research to the Americans alone.) I have, of course, during my travels around the U.S., devoted a good deal of time to visiting galleries and museums, large and small, in which American painters are naturally well represented. But my perusals of American art were, to be honest, purely for my own pleasure, not for the purpose of study. I looked, I admired, and sometimes I wondered why Americans give such unanimous acclaim to a particular picture (even now, if it had been left only to me, I would have hesitated to include Sargent's famous *Madame X* in our exhibition); and there were times, too, when I came to the conclusion that this or that picture by Bingham or Peto should have been given a place of honor. Nevertheless, my attitude was simply that of an amateur who wished to learn and be enlightened.

Imagine my embarrassment, then, when the plan for an exhibition of nineteenth-century American painting took shape, and my friend Ted Stebbins (if he will forgive my familiarity in so addressing him), who had the responsibility of putting it all together, asked me to help choose the works with him. He reasoned that American painting had for too long been abandoned to American art historians, and that he wanted to bring it out of its ghetto and give Europeans the chance to see it in its true colors. To do this he needed the viewpoint of a European—no matter how inexpert—to assist him. I applauded his bold approach and was delighted to realize that our thoughts on the exhibition were in accord.

What has occurred since the war, with regard to nineteenth-century painting in general, is a kind of cultural colonization in reverse. Joining those who were French more by reason of education, residence, and activity than by birth (like van Gogh), Friedrich and Turner, too, are now added to the list of the country's "giants." Paris has gradually come to appreciate and admire English painting of this period, as well as Russian painting, the *Macchiaoli*, the German Romantics, the Danes of the first half of the century (sometimes very close in their preoccupations with the effects of light to certain of their American contemporaries), and the anguished Scandinavians at the end of the century. It would be a great pity if the French were not given the opportunity to judge at firsthand the artistic achievements from across the Atlantic.

The selection of works presented in Boston, Washington, and Paris is therefore the result of cooperation and collaboration and reflects a compromise between what I liked and what the Americans thought we should have. Let me hasten to add that I was always prepared to defer to the opinion of the specialist.

The exhibition covers the period from Copley, who was born in 1738, to Eakins and Homer, who died in 1916 and 1910, respectively. (Sargent, incidentally, died in 1925 and Mary Cassatt in 1926.) It concentrates on the great figures of the age and their major works. Originally, I particularly hoped to include as many paintings as possible from the first half of the century, especially by Bingham and Church.

It seemed important to me to emphasize the continuity that exists between the solitude of the American wilderness, so well conveyed by Church and Cole, and that of the anonymous towns depicted so poetically by the great Edward Hopper (of whom four paintings were shown in Paris in 1938). But I was ultimately persuaded by the arguments given in favor of concluding the exhibition with the American "Impressionists" at the end of the century, although the term "Impressionism" seems inapt when applied to artists who so often received their training in the studios of some of the most academic Parisian painters of the day, such as Cabanel, Gérôme, Gleyre, and Couture. We will return later to this paradox, which has finally ceased being one today.

As it has finally developed, the exhibition could hardly be more beautiful and varied. All that is constant, as well as all that is contradictory, in American painting has its rightful place here; the lines of steady development and the sudden changes of direction are clearly traced. Here are the subjects closest to the artists' hearts—landscape, portraiture, trompe l'oeil, the leading art centers of Boston, Philadelphia, and New York—and the themes to which they constantly returned—solitude, tranquility, truth. But here, above all else, is the birth of American painting.

* * *

"Our day of dependence, our long apprenticeship to the learning of other lands, draws to a close." This famous quotation from Emerson's 1837 essay on "The American Scholar" succinctly expresses one side of the debate which divided American painters throughout the nineteenth century. The critic James Jackson Jarves summed up the opposing view when he protested against such isolationism in *The Art-Idea* of 1864: "If America elects to develop her art wholly out of herself, without reference to the accumulated experience of older civilizations," he wrote, "she will make a mistake and protract her improvement." (We owe these two quotations to the first version of H. Barbara Weinberg's excellent essay.)

The argument between these two sides, which, as we shall see, turned out to be irrelevant, actually summarizes the debate which split American painters in the nineteenth century into two camps. The question was whether artists should seek inspiration in Europe, serving an apprenticeship in London, Italy, Düsseldorf, Munich, or Paris, or whether they should reject all foreign influence so as not to lose their authenticity. This longstanding conflict between internationalism and isolationism has its parallel in American literature (e.g., Henry James versus Nathaniel Hawthorne) and also, of course, in American politics.

The painters decided the issue in their different ways. Some abandoned their homeland, either deliberately or unwillingly, finding contentment and success in varying measure (Benjamin West and John Singleton Copley, Mary Cassatt and John Singer Sargent). Some tried to absorb the best Europe had to offer; others, naively or cynically, turned their backs on Europe from the start and asserted their independence.

It is surprising that so little has been made of this rapport between America and Europe, and France in particular. French art historians, for example, have virtually ignored the letters and writings of American painters living in France under Louis XVI, during the Revolution, or in the days of the Empire. Included among these are some delightful and illuminating descriptions of our country (those of Copley, West, and Allston, for example; it is a pity that the thesis of Hélène Roux on this question remains unpublished). Nor in recent books on David is there any mention of the lively accounts (except for that of Trumbull, and even he is only partially quoted) of Vanderlyn or Rembrandt Peale, who visited the master's studio and had the honor of painting his portrait. Peale concluded his biography with the following revealing words: "It is my conviction . . . that the Arts, which have been travelling westward, are about to leave the old continent to flourish in the New."

Equally astonishing, on the other hand, is the evidently embarrassed attitude of American art historians toward those of their countrymen who, during their stays in Europe, seemed to concentrate exclusively on the most academic and "reactionary" elements of the art world abroad. How could great painters such as Eakins (who studied with Gérôme), William Morris Hunt, Eastman Johnson, and John La Farge (all with Couture), Sargent (with Carolus-Duran), Whistler (with Gleyre), and so many others possibly have received a sound training from such "mediocre" artists? That is a knotty question that deserves further reflection and an attempt at an answer.

Today, given hindsight, we can see that French academic artists are by no means as contemptible as was once alleged (American art historians have contributed much to their rehabilitation, as they have to that of the École des Beaux-Arts). Furthermore, we can now ask whether it is absolutely necessary, in order to be a great painter, to be avant-garde. Even if they were not major innovators like Degas, Cézanne, Ingres, or Seurat, the late-nineteenth-century American painters were no less impartial observers of a New World, seeing reality afresh, with new eyes. Some accused them of naiveté, like one French critic at the Exposition Universelle of 1867 who compared Church's *Niagara Falls*, which actually received a Second Class Medal of Honor, to a "gaudy billboard."

In any case, it is not really surprising that so many young Americans should choose to enter Gérôme's studio. The best of Gérôme's work is now in the U.S., and it is possible to discern certain affinities between his pictures and one particular current of American painting (just as it is between Millet and the Barbizon school and another no less important stream of American art). And indeed, there are similar affinities in the present century between Monet and Matisse, both extremely well represented in American museums, and contemporary American artists.

I have said that the dispute between isolationists and the devotees of the grand European tradition was really an illusory one, based on a false dilemma. E. Durand Gréville, in a famous article in the *Gazette des Beaux-Arts* of September 1887, already sensed this when he concluded his study of American painting with these words:

The number of fine works of art in the United States today is great enough that American artists can find models for their work at home. This trend in taste will not abate—on the contrary—and it is certain that the opportunity of seeing masterpieces of French art, together with the lessons that young American artists can learn from our school, will help to create a national school in America; and I say "national" deliberately; for a teacher's lessons, if they are good, have never obstructed a pupil's originality.

By 1887 the "national school" already existed. Durand Gréville was not alone in failing to recognize it clearly. What is more, it consisted of both those Americans who rejected Europe and those who admired it. (There is an analogy here with Hodler and Vallotton, artists who were the subject of recent exhibitions in Paris which received less attention here than they deserved. Although the former saw himself as Swiss and the latter did not, both form part of the Swiss School of painting.)

What makes the study of nineteenth-century American painting so fascinating, therefore, and what distinguishes it from the work of other schools, is not only, as Alfred Barr put it, the "three thousand miles" separating the U.S. from Europe; it is also that this painting represents the birth of a school.

This school is especially notable for its contrasts—realism-symbolism; moralism-aestheticism; romanticism-utilitarianism; quietude-pure painting—and also for its incessant questionings, its hesitations so readily comprehensible because so frankly and naturally aired. And finally it is notable for a certain naiveté. When Barr wrote, "To Allston's Poussin *manqué* Bingham may be said to have played the role of a Le Nain," he was forgetting, or perhaps was failing to take sufficient note of, how American painters continually and unflinchingly affirmed the exemplary grandeur of the New World and the regenerative powers of its virgin landscapes. When Colbert and Louis XIV sent young French artists to Rome, they aimed to give them the most thorough grounding by showing them the finest examples. When young American artists journeyed to Europe, when they received their training in its studios, and when, perhaps with stronger reason, they denied themselves such experiences, they rarely lost sight of what was unique to their own land, a country which, though its history was short, was so rich in promise.

* * *

American painting of the nineteenth century has tended to elude us. Because of its isolation—the isolation of its historians and of its collectors—from the larger international scene, its self-image has become distorted, alternating between an unwarranted sense of inferiority and one of superiority. This is a good occasion to introduce it into the context of the great process of reappraisal, which painting from Goya to Picasso, from David to Cézanne, has come through successfully.

THE LURE OF PARIS
Late-Nineteenth-Century American Painters & Their French Training
H. Barbara Weinberg

The search for European training in the second half of the nineteenth century radically altered American painting. Most late-nineteenth-century American painters sought extended and rigorous study abroad, unlike many of their Jacksonian counterparts, who had traveled chiefly to derive inspiration from works preserved in European galleries or from the friendly counsel of foreign contemporaries. Younger artists went to Europe—and especially to Paris—as students, early in their careers, rather than as mature painters seeking "finishing." They developed styles and techniques *ab initio* or, perhaps, added training at the source to training already gained under the tutelage of older artists who had themselves studied in Europe.

When young American artists returned from their studies abroad, they eagerly paraded their new skills, inviting audiences to appreciate their inventiveness in choosing unusual subjects, their ability to manipulate form, light, and pigment, and, especially, their assimilation of contemporary European artistic ideals. The purely local and "American" in figure painting gave way to more international and "artistic" subjects: the nude, religion and myth, European and American history, fashionable urbanites, peasants, picturesque craftsmen or black workers, and exotic types ranging from *bashi-bazouks* to Blackfoot Indians. An analogous shift occurred in landscape painting, where heroic subjects yielded to more generalized and meditative images. In still-life painting, accumulations of objets d'art, often of European origin, and evocative flowers replaced bountiful arrangements of succulent edibles celebrating in microcosm the bounty and beauty of the American land. Attitudes toward technique also attested to an increasing concern with art-making as a self-conscious enterprise. Many painters experimented with new media—watercolor, pastel, etching—and proudly displayed their technical dexterity in oils.

Yet although differences between pre- and post-Civil War American paintings are striking, a constraint in paint handling and a tendency toward classical organization is common to both. This is explained in part by the fact that the European academies did not encourage a simple rejection of the classical and linear modes employed by antebellum artists. Painters in Europe after the war were trained in these familiar modes and at the same time learned to accommodate them to the expectations of newly prosperous, sophisticated patrons. Their academic training emphasized careful study and meticulous rendering of forms, most often human figures, and especially in Paris, the nude. European teachers stressed artistic invention based on a creatively eclectic approach to Old Master and contemporary works, and encouraged attention to subjects other than landscape and images of everyday life. Thus in addition to extensive study of drawing, which had also been a mainstay of earlier American academic training, the European academies required technical finesse in finishing a painting, diligent investigation of anatomy, settings, and props, and ample acquaintance with past and present art. Such ideals provided a rigorous test of an artist's competence, seriousness, and sincerity; eager to prove themselves, the overwhelming majority of late-nineteenth-century Americans studying abroad therefore pursued academic training instead of or before experimenting with more avant-garde tendencies.

The American turn to Europe for study and inspiration has often been attributed to a loss of confidence in the American dream following the Civil War.[1] However, as it coincided with the emergence of the United States as a confident and vital international power, with the decades of proud displays of American goods at European fairs, and with a period of immense growth in transportation and communication, America's new-found artistic cosmopolitanism invites another interpretation.[2] It seems more likely to have been the product of an optimistic belief in Americans' ability to compete fully in the world cultural arena by unabashedly gleaning the necessary techniques from European sources. As a result of the Civil War, the United States had become economically and politically more powerful, contributing immeasurably to international prosperity and participating in worldwide advances on all practical fronts—industrial, technological, scientific, and financial. Internationalism on creative fronts was inevitable. As James Jackson Jarves urgently remarked in 1864, "We have not time to invent and study everything anew. The fast-flying nineteenth century would laugh us to scorn should we attempt it. No one dreams of it in science, ethics, or physics. Why then propose it in art?"[3] In assimilating contemporary European styles and applying them to a range of international subjects, artists of the period after the

Civil War redefined their Americanness in terms of their ability to absorb, and surpass, the best that the world had to offer.

Historians of American art have been slow to explore the extent and profundity of European influence, especially that of the French, upon late-nineteenth-century American painters. The effect of nativist and, ultimately, isolationist thinking between the First and Second World Wars is partly to blame. Defensively searching to define a characteristic American style, most commentators understandably concentrated on antebellum painting, which not only celebrated the most laudable aspects of American life but was also less obviously imitative of European works than was late-nineteenth-century art. Even American colonial portraits, despite their obvious sources in the English Baroque portrait tradition, received sympathetic consideration because of their reference to the heroic, formative era of the United States.

Committed to seeking what was reassuring in the American past and what was American in American art, nativist commentators were uneasy with late-nineteenth-century American art. Reinforced by concurrent modernist disdain for European academicism, they lauded those late-nineteenth-century American painters who had seemed least susceptible to European influences, ignored the most avid of the cosmopolites, and denied the cosmopolitanism of others by minimizing the importance of their academic training and emphasizing their "native" inclinations in such things as subject matter. Winslow Homer, for example, who had sought no foreign training despite visits to France and England, was paired with Walt Whitman as a great American *isolatio*. Frederick Bridgman, an expatriate with a durable commitment to the style and subject preferences of his Parisian teacher, Jean-Léon Gérôme, was lost to American art history, despite the fact that contemporary American critics had often likened the quality of his work to that of Homer. And Thomas Eakins, another student of Gérôme's, was viewed entirely in relation to antebellum impulses. The classical quietude of his Philadelphia river paintings, their ordered compositions, meticulous detail, and emanating light, were typically linked to the tradition of George Caleb Bingham and Fitz Hugh Lane rather than to his European teacher, for whom he maintained a personal and professional respect, and whose

works he studied and admired. Critics rejoiced in Eakins's advice to young art students in 1914 that they should "remain in America to peer deeper into the heart of American life," without acknowledging what Eakins himself perceived—that American facilities for art study, so "meagre" when he had gone to Paris for instruction in 1866, had so improved under the influence of French models that foreign training was almost unnecessary.[4]

To reexamine the notion of Homer's complete insusceptibility to foreign influence is not to deny him his unquestionable strength as an artist, but rather to invite consideration of the universal pictorial qualities that generated a reputation despite deviation from prevailing taste and sustained it for a century. To rehabilitate Bridgman is not to suggest that he deserves approbation equal to that accorded him in the 1870s, but to understand that period's pride in his cosmopolitanism, fascination with the exotic locales he recorded, and taste for his technical finesse. And to restore Eakins to a cosmopolitan context is not to demean his accomplishments, but rather to appreciate his sensitivity and creativity in conjoining French academic ideals with American thematic resources.

The reinterpretation of certain late-nineteenth-century American artists in light of the cosmopolitan spirit of the period, and the rehabilitation of others, are still in an early stage. Ultimately, as scholars undertake analogous studies of other late-nineteenth-century national schools also deeply affected by training in Paris, it may be possible to analyze particular national characteristics without chauvinistic prejudice. For example, the German, Swedish, Australian, or American tendencies to absorb, imitate, or domesticate the ideals of the Paris École des Beaux-Arts or the French Impressionists will offer provocative areas for comparative study.

* * *

The pattern of American painters' attraction to different European art centers has always reflected prevailing cultural attitudes, so it is not surprising that the artistic imagination in the American colonies was first captured by England. London provided the criteria of taste in portraiture and picturesque landscape and the models for technical emulation until after the second war for independence, the War of 1812. Thus Benjamin West, lacking instruction and stimulation at home, sought in London a sympathetic milieu in which to develop artistic maturity. Very well established in London and president of the Royal Academy after the death of Sir Joshua Reynolds in 1792, West availed himself, during the Peace of Amiens in 1802, of the opportunity to examine contemporary French art and the artistic spoils of Napoleon's campaigns. Susceptible, too, to the appeal of continental approbation, West sent the sketch for *Death on the Pale Horse* (cat.no. 16) to the Paris Salon of that year. There it offended conservative taste, which would have preferred his precocious neoclassical works of the 1760s, but aroused the interest of Napoleon, who also supported the analogous painterly Romanticism of Baron Gros.[5]

West constituted, in effect, the first American art academy in London. He assisted and instructed his compatriots, helping to transform John Singleton Copley from a colonial "original" into a rival of the English portraitists, to make Gilbert Stuart's style so similar to that of Raeburn or Gainsborough as to have it mistaken for theirs, and to provide John Trumbull with a formula for the dramatic portrayal of historical scenes.

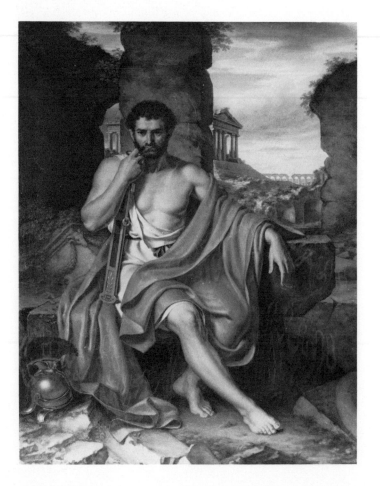

Although West attracted a number of American painters in search of professional guidance, he functioned only informally as a teacher, offering advice and a chance for apprenticeship rather than a prescribed curriculum of study. Few American painters pursued such curricula during this period or, indeed, sought any formal training abroad until the middle of the nineteenth century. London, Paris, and Rome, the major European art centers, were considered stops on Grand Tours, during which American painters learned of their contemporaries' attitudes from friendly conversations and sought inspiration from the works of the Old Masters. Such tours occasionally prompted ambitious souvenir paintings, such as Samuel F. B. Morse's *Gallery of the Louvre* (cat.no. 22), which imaginatively rehangs the Salon Carré with Old Master paintings, typifying American artists' taste of the 1830s, especially their indifference to the contemporary French paintings recently put on display in that gallery.[6] During the 1840s, some American artists, such as John Frederick Kensett and Thomas Pritchard Rossiter, established themselves in Paris for periods of extended residence, but their "instruction" consisted chiefly of independent inspection and rigorous copying of the Old Masters.

Not all artists turned to London, of course, and a handful did study in Paris; but those American artists who undertook formal French training prior to 1850 were often motivated by links to French heritage or other coincidental circumstances. A notable example is John Vanderlyn, the first American painter to enroll in the atelier of an academic teacher affiliated with the École des Beaux-Arts. Vanderlyn was apparently moved to seek training in Paris rather than in London—the usual choice for an artist of his generation—by the republican political sympathies of his patron, Aaron Burr. As he remarked in a letter to his father in March 1798, a year and a half after his arrival in Paris, "I am very happy for my part that it pleased my patron to send me here, for to acquire the knowledge of the Arts there is but one Paris in the Universe. I am certain, though, some of my countrymen have preferred London very foolishly, and to their own regret perhaps, had they known more of Paris."[7]

Vanderlyn, a student of François-André Vincent, who was a rival of Jacques-Louis David, clearly manifests neoclassical tendencies in his mature works. His *Caius Marius amid the Ruins of Carthage* of 1807 (fig. 1; 1832 version), which was awarded a medal by Napoleon in the Salon of 1808, is reminiscent in its brooding stoical content of David's *Lictors Returning to Brutus the Bodies of His Sons* (1789; fig. 2). And his *Ariadne Asleep on the Island of Naxos* (cat.no. 19), which he showed in the Salons of 1810 and 1812, similarly attests to Vanderlyn's absorption of neoclassical lessons.

The American public lacked the French taste for neoclassicism, and it remained indifferent to Vanderlyn's classical histories and mythologies, as well as to the ambitious American historical scenes of John Trumbull. Thus these and other figure painters turned their efforts to portraiture, which was in high demand. Others chose landscape painting because of its appeal to Americans' pantheistic reverence for the manifestations of God's works in the New World.

The Hudson River landscape painters and their mid-century counterparts in American genre and still-life painting were not immune to foreign influence, however, and they freely adopted as compositional armatures prototypes from French classical

landscape, Dutch seventeenth-century landscape, genre, and still-life paintings, eighteenth-century Venetian *venduta* scenes, and more recent English Romantic works. But while American painters were well acquainted by this time with contemporary European standards, especially with Ruskinian attitudes toward truth in art, they continued for the most part to eschew extensive formal study abroad.

Some American painters, mostly of German heritage, such as Albert Bierstadt, did seek instruction in the academy at Düsseldorf.[8] However, this did little to alter the essential aspect of American landscape and genre painting and, like the dicta of John Ruskin, merely reinforced a well-entrenched taste for lucid composition and scrupulous recording of natural forms. Formal study in Paris gradually became more appealing to mid-century American painters. But art students abroad in the late 1840s and 1850s, such as Edwin D. White and Eastman Johnson, tended to be quite peripatetic, combining study in Paris with instruction in Düsseldorf, Florence, and Rome. These journeys differed from the customary Grand Tour of the preceding decades only by including periods of formal training in the cities visited.

Figure 1.
John Vanderlyn
Caius Marius amid the Ruins of Carthage, 1832
Collection Albany Institute of History and Art

Figure 2.
Jacques-Louis David
Lictors Returning to Brutus the Bodies of His Sons, 1789
Musée du Louvre, Paris

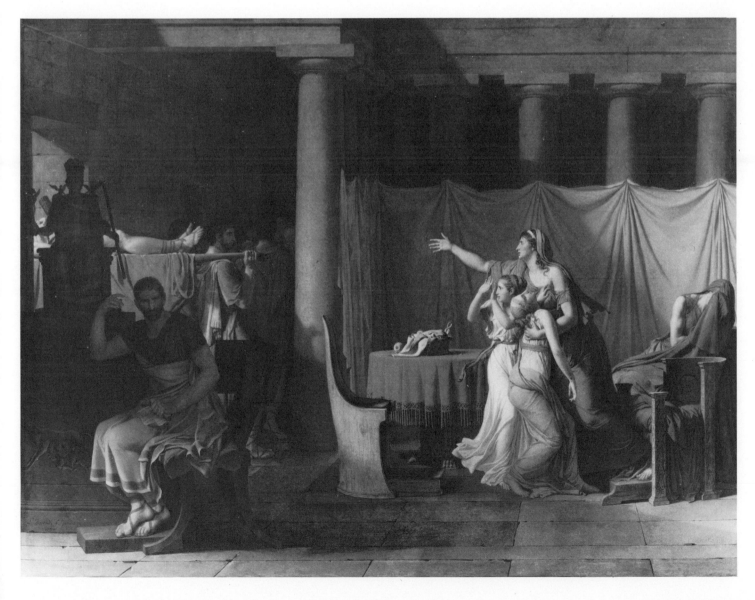

Those American students who did decide to study in Paris could choose from among several teachers according to their artistic preferences. Only a few chose to study with the elderly François-Édouard Picot, a strict advocate of neoclassical ideals whose course of study was too rigorous for American students lacking adequate prior training either at home or abroad. Marc-Gabriel-Charles Gleyre was a no less orthodox technician than Picot, tracing his artistic heritage through Louis Hersent to Jean-Baptiste Regnault, but his detachment from the Paris Institut and the École des Beaux-Arts, and his unusual sympathy for the straightened circumstances of young artists, increased his appeal to young Americans already attracted to the gentle humanism exhibited in his paintings of classical and exotic subjects.

The first American student to enroll in Gleyre's studio, and the most important, was James McNeill Whistler, who arrived in June 1856, already a skilled draughtsman as a result of his training at West Point. Whistler had resisted academic ideals and during the early 1860s emulated the manner of his friends among the Realists, especially Courbet. However, his subsequent experiments with an antinaturalistic landscape style in the mid-1860s constitute a revision of the principles of Gleyre, who taught that the artist should distill his experience of the visible world rather than simply record it, and select from nature rather than remain a slave to it. Whistler finally resolved the challenges that he had set for himself in his experiments with abstract pictorial organization in a series of single-figure *Arrangements* in the 1870s, of which the *Grey and Black: Portrait of the Painter's Mother* (cat.no.77) is the best known. It has been reasonably suggested that the profile pose of this sitter and of Thomas Carlyle, Whistler's second subject in this series (1872–73; fig. 3),

the reflective, melancholy mood, and the somber monochromatic palette derive from the same characteristics in Gleyre's best-known painting, *Le Soir* (or *Lost Illusions*, 1843; fig. 4), as if some fifteen years after his association with Gleyre's studio, Whistler finally acceded to his teacher's influence.[9]

As a result of their desire either to rid themselves of orthodox stylistic constraints learned elsewhere, usually in Düsseldorf, or to acquire a fluent style despite inadequate prior training, the greatest number of mid-century American art students in Paris chose Thomas Couture as their master.[10] Couture, who was unusually sympathetic to American pupils, had opened an atelier for instruction the year before the success of his *Romans of the Decadence* (fig. 5) in the Salon of 1847. He was committed to a style in which the generative stages of his paintings conditioned and enlivened the final surfaces. His technique, derived from a profound appreciation of the painterly traditions of the Venetian High Renaissance, was simple, rapid, and expressive in comparison with standard academic practice. Eastman Johnson, who had spent two years learning the rigorous procedures of Düsseldorf, studied with Couture only briefly in 1855, but his later works betray the influence of Couture's handling of tone and mass. Johnson's *Sugaring Off* series (fig.6) relies on an unabashed exploitation of the *ébauche*, the initial laying in of broad tonal masses advocated by Couture, and eschews the meticulous finishing process by which more orthodox academic practitioners—French and German—would have scraped down and "buried" the *ébauche* under more refined modulations.

Unlike Johnson, John La Farge had had no formal artistic training before undertaking study with Couture in 1856. La Farge's exposure to Couture in Paris was also brief, but he sought additional training in Couture's manner from William Morris Hunt in Newport, Rhode Island. Hunt had been Couture's first American pupil and, like Johnson, had found in him an antidote to the academicism of Düsseldorf. La Farge's assimilation of the French master's techniques is evident in the grainy, scumbled surfaces of such evocative still lifes as *Agathon to Erosanthe, A Love Wreath* of 1861 (cat.no.66), the subject of which was also of interest to Couture. However, Couture's technical divergence from the academic mainstream had provided a liaison to Barbizon painting for Hunt and several other of his American pupils, and La Farge discovered that his American teacher had apparently shifted his devotion from Couture, with whom he had studied from 1846 to 1852, to Jean-François Millet, in whose company he spent three years in Barbizon before his return home. Although Hunt's techniques and principles of instruction continued to reflect Couture's attitudes, his figure subjects, such as farm girls with animals, and his landscapes were often conditioned by the preferences of the Barbizon School. Hunt was also instrumental in promoting a taste for the work of Millet and his colleagues among Boston collectors and in opening the floodgate of appreciation for Barbizon art that affected much late-nineteenth-century American painting.[11]

Couture's influence can also be seen in the work of Albert Pinkham Ryder. Ryder has been championed by nativist interpreters of late-nineteenth-century American painting for his lack of European study and his apparent immunity to contemporary foreign influence. While he admitted to an early effort to imitate the masters of the past and spoke admiringly of Corot and of the contemporary Dutch realist painter Matthew

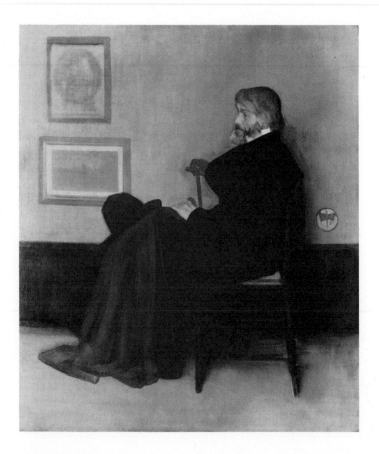

Maris, Ryder renounced such influences in favor of intuitive responses to nature. His mature works, such as *Siegfried and the Rhine Maidens* of 1888–91 (cat.no.87) and *Constance* of 1896 (cat.no.88) are unique in the history of American art and are similar in spirit to French Symbolist painting, which Ryder most likely would not have known. Yet despite attestations to Ryder's entirely independent development, certain convincing connections have been suggested between him and Couture. The French master's painterly techniques, especially his exploitation of broadly defined forms and heavily scumbled surfaces, could well have been introduced to Ryder through his friendly relationships with two artists trained by Couture, William Marshall and Robert Loftin Newman.[12]

Winslow Homer has been particularly susceptible to reconsiderations of his position in respect to late-nineteenth-century cosmopolitanism. In addition to remarking on the connections between his works and those of Jules Breton and the Barbizon School, scholars have recently evaluated the relation of his paintings to other foreign influences: his images of man's struggle against the sea of the 1880s, such as *The Fog Warning* (1885; cat.no.104) can be compared to contemporary English works of the Tyne School; Japanese design principles are found in his late abstractions, such as *Sunlight on the Coast* (1890; cat.no.107); and his *Prisoners from the Front* (1866; fig.7) is analyzed for its French academic prototypes.[13] Whether or not it intentionally emulated familiar academic motifs, *Prisoners* met with approval when it was shown in the display of American paintings at the Paris Exposition Universelle in 1867. Paul Mantz, the critic for the prestigious *Gazette des Beaux-Arts*, proffered the compliment: "This is firm, precise painting, in the

Figure 3.
James McNeill Whistler
Arrangement in Grey and Black, No. 2:
 Portrait of Thomas Carlyle, 1872–73
Glasgow Art Gallery & Museum

Figure 4.
Marc-Gabriel-Charles Gleyre
Le Soir (or *Lost Illusions*), 1843
Musée du Louvre, Paris

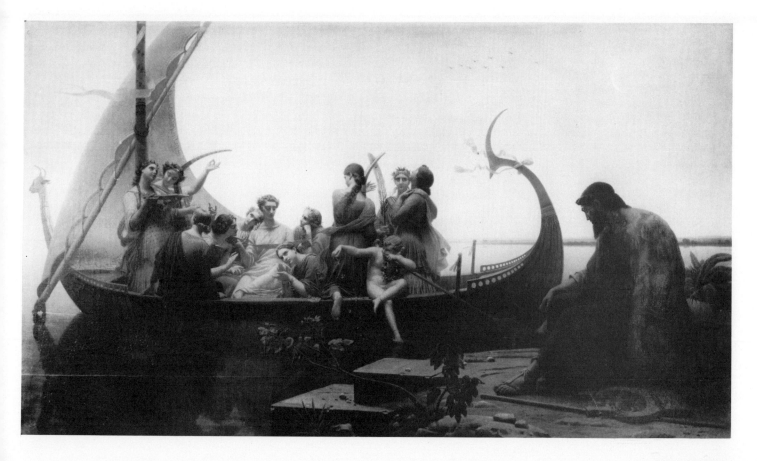

manner of Gérôme, but with less dryness."[14] Homer's visit to Paris at the time of the Exposition Universelle has been especially provocative to scholars in light of the similarities between his subject interests and those of Claude Monet in the mid-1860s, especially their mutual concern with ladies at leisure. The temporary lightening of Homer's palette upon his return home has also provoked curiosity about his possible contact with incipient Impressionism while in Paris.

The American display at the Paris fair of 1867 marked a turning point in the development of American art. At the first Exposition Universelle in 1855, which had replaced the Salon of that year, the United States had been represented by only eleven artists who had chosen to submit their works independently. By contrast, the display of 1867 was the first concerted effort to mount a large and comprehensive survey of American painting abroad. A committee of artists and collectors organized the exhibition in New York and selected high-quality representative works. Inevitably, the painters of the Hudson River School predominated. Seventy-five paintings drawn mainly from New York collections were shown, the works of forty painters including Asher B. Durand, John Frederick Kensett, Sanford Gifford, and Albert Bierstadt. Frederic Edwin Church, represented by *Niagara Falls* (1857; cat.no.38) and the more recent *Rainy Season in the Tropics* (1866; cat.no.46), received a Second Class Medal for the earlier painting, the only award accorded an American painter.

The desire to display the fruits of American artistic enterprise at the Exposition of 1867 was motivated in part by a wish to assert national unity and cultural accomplishment in the wake of the tragically divisive Civil War. Gérôme, observing Church's *Niagara Falls*, commented: "Ça commence là bas"—"So it's beginning over there." Benjamin Champney, the American painter who recorded the remark at the turn of the century, interpreted it as "intimating that the artists over here were beginning to do well in their own way."[15] Ironically, though, what *was* just beginning—although not apparent in the Church painting—was certainly not work "in their own way" but rather a rejection of purely native impulses by American artists and an avid pursuit of European training.

After the Civil War, newly wealthy American art patrons had become increasingly interested in acquiring foreign works, especially French, which encouraged American artists' desire to compete with their European rivals. As Henry Tuckerman noted in his *Book of the Artists*, published in 1867, government support of American artists was almost entirely lacking in the United States. In addition, he wrote,

private encouragement . . . inclines chiefly to foreign products; portraits alone are in constant demand from native studios; men of wealth, observation, and travel, who aim at a collection of fine pictures, are usually devotees of the "old masters," or admirers of the modern schools of England, Germany, and France; and the most patriotic critic must admit that they have ample reason for the preference, both as a matter of taste and as a judicious investment.[16]

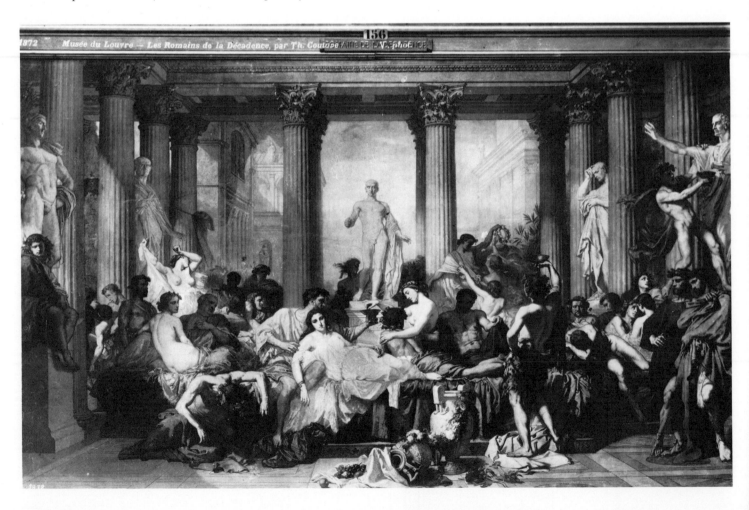

In the ensuing decades, the "'old masters'" were increasingly rivaled by the products of European studios. Of the "modern schools," the French now for the first time assumed a position of primacy in the eyes of American patrons, many of them industrialists and financiers who may have also appreciated France's support of the northern cause during the Civil War. Assisted since the mid-1840s by European dealers, who had established American branches or who had arranged touring exhibitions and sales of modern French paintings, and by American dealers using French-trained American painters as agents, American collectors acquired tremendous numbers of academic, Barbizon, and, later, Impressionist works. Boston became the center of taste for Barbizon painting, largely under the influence of William Morris Hunt. New York's enthusiasm for academic art was served by a branch of the French firm Goupil, Vibert & Company, opened in 1846, and by Samuel P. Avery, who had redirected his efforts from the promotion of American works, which he had helped to assemble for the 1867 Exposition Universelle, to the paintings of the French academic masters. Xenophobic protest against infection of native art by "lascivious" French tendencies that had marked American art criticism of the 1840s and '50s—largely in response to American collectors' increasing access to French works and the fear of competition for American painters and their supporters—fell away rapidly. Boston found in Barbizon landscape sentiment a resonance of the city's long transcendentalist tradition of nature worship and found its suggestive painterliness consistent with the manner of the much-appreciated Washington Allston. Academic painting, which had moved from the didactic and historically specific to a more fluid, anecdotal, and genre-oriented approach, appealed elsewhere, especially in New York, to the vigorous common sense of moneyed patrons impressed by displays of technical finesse uncomplicated by abstruse

Figure 5.
Thomas Couture
The Romans of the Decadence, 1847
Musée du Louvre, Paris

Figure 6.
Eastman Johnson
Sugaring Off, c. 1861–66
Museum of Art, Rhode Island School of Design, Providence
Jesse H. Metcalf Fund

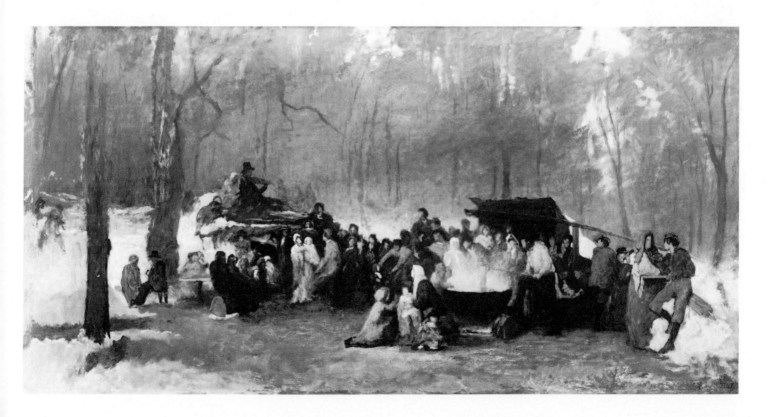

narratives. By 1886, a French art critic touring American collections could report for the *Gazette des Beaux-Arts* that U.S. holdings of French paintings were astonishing: "It is not by the hundreds but by the thousands that one must count them."[17]

In addition to the obvious desire to equip themselves to compete with French painters for American patronage, American painters also yielded to the multifaceted lure of Paris as an art center, finding there a unique art spirit as well as ample and varied opportunities for study. In contrast to the concentration on the art of the past that permeated other cities, Paris took a lively interest in contemporary painting, which prompted American artists to prefer it to any other European center. American students' letters home crackle with the excitement of visits to the Louvre, submissions to the Salons, reflections on their contemporaries' works, and enthusiasm for study and travel. "I feel that my coming over here has been the most fortunate thing that could possibly have happened to me," Julian Alden Weir told his brother in January 1874. "My eyes have been opened to see many things that otherwise I know I would not have discovered for years had I continued in the manner I studied when at home."[18] And the painter Phebe Natt reported from Paris in 1881 to readers of a popular American journal that ". . . a vast art-world surrounds the student, into the midst of which he is plunged, wondering, enjoying, benefiting by it all, but often in ways he had least expected. In Italy he will live among the treasures of bygone ages; here, though surrounded by representative work of all time, he is at the centre of the most active, earnest effort of the present."[19] Although some American

Figure 7.
Winslow Homer
Prisoners from the Front, 1866
The Metropolitan Museum of Art, New York
Gift of Mrs. Frank B. Porter, 1922

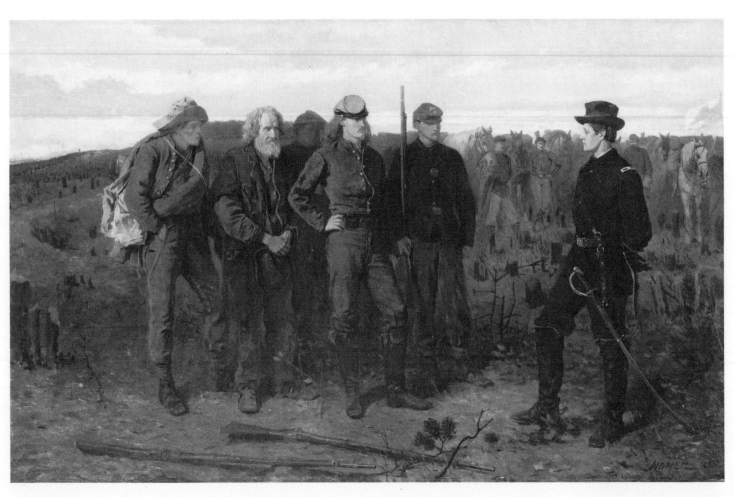

art students—especially those of German heritage—had chosen to study in Munich in the 1870s, many of them subsequently renovated their style in light of French developments.[20] Government-sponsored exhibitions in France, attended by the most eminent political and intellectual figures, generated official and private purchases and commissions, as well as a prestigious system of honors, and stimulated lively critical debate. French art students' camaraderie in Paris later provided the model for organizations of American compatriots, including the American Art Association of Paris, founded in May 1890 to accommodate the astonishing number of American students, about fifteen hundred, then reported to be working there, and the American Girls' Art Club, founded in September 1893.[21] Such organizations were prototypes for societies that these artists established in America after their return. Similarly, the art colonies to which American artists flocked during summers in France—Pont-Aven, Grez, Écouen, Barbizon, Étaples—found their later equivalents in such locales as Old Lyme, Connecticut; Cragsmoor, New York; and Cornish, New Hampshire.

An important factor in persuading American students to pursue French training was the curriculum reform of the École des Beaux-Arts in 1863, an event as crucial to the history of conservative standards in the late nineteenth century as the Salon des Refusés of that year was to the growth of modernism.[22] In the period before 1863, a matriculant's training in the École had been limited to daily two-hour sessions of instruction in drawing from antique casts and from the living model, supervised by a rotating faculty of twelve artists. The artist sought all other practical instruction in techniques of composition and painting in the atelier of a private teacher, who might or might not have been attached to the École's faculty. The reform of 1863 created a curriculum that was more technically and theoretically comprehensive and more fully professional, and it remained essentially unchanged for two decades following. Drawing instruction, always basic, was given by a single teacher, Adolphe Yvon, and the range of lecture courses in such subjects as anatomy, history and archaeology, and aesthetics and art history, was expanded and enriched. Most important, three ateliers for practical instruction in painting were established within the physical and administrative domain of the École, allowing matriculants a single center for instruction in all aspects of their craft and permitting an affiliation with the École even for those who chose not to enter, or failed to succeed in the semi-annual *concours des places* for matriculation.

Of the three ateliers for painting at the École des Beaux-Arts, that of Gérôme was by far the most popular among American students, who, like other foreigners, were admitted to the École and its studios tuition-free, on an equal footing with their French counterparts. Instruction in the École at this time varied little from studio to studio, emphasizing technical procedures consistent with the tradition of David; the individual personality of the *chef d'atelier* and his approach to subject were therefore crucial in determining a student's choice. Gérôme was considered an especially attractive and generous teacher, sympathetic to the natural endowments of individual pupils, many of whom recorded their encomiums in letters home and later in commemorative publications.[23] By the 1860s, Gérôme had established a substantial reputation as an interpreter of vignettes drawn either from ancient and modern history or from the everyday life of classical antiquity or exotic contemporary locales, usually Near Eastern. Gérôme's varied and fluid approach to subject made him an attractive and valuable resource for American artists. Whatever their theme or subject, his paintings emphasize an appreciation of human form and a concern for human sentiment. His works are relatively small in scale and display a distinctive commitment to investigative observation, diligent description, archaeological accuracy, and a detailed, glossy finish (see fig. 8).

The literalism of Gérôme's work, so antithetical to the Realism then being developed by modernists such as Manet and the Impressionists, depended upon close analysis of *what* he saw rather than of *how* he saw; that is, it was conceptual rather than perceptual. This conceptual realism was entirely consistent with the empirical tenor of the late nineteenth century. As the American critic Eugene Benson observed in 1866,

> *Gérôme . . . is closest to the moral spirit and best shows the intellectual traits of his time. . . . He investigates like an antiquarian; he is severe like the classicists; he is daring like the romanticists; he is more realistic than any painter of his time, and he carries the elaboration of surfaces and the science of design further than any of his contemporaries. Like the modern mind, he travels, he explores, he investigates, and he tries to exhaust his theme. He labors to leave nothing unsaid, to cover the whole of his subject.*[24]

By comparison with Gérôme, other *chefs d'atelier* at the École attracted far fewer American pupils.[25] Those who had the most limited subject interests, such as Isadore Pils and Henri Lehmann, received very few applications. Gérôme's most substantial rival was Alexandre Cabanel, who directed an atelier during the quarter-century from 1864 to his death in 1889, and who attracted thirty-five American pupils, compared to Gérôme's ninety during the same period. Cabanel's subject repertoire—historical and religious themes, mannered portraits, and subjectless images of semi-clad females—was more limited than that of Gérôme's. Lacking Gérôme's concern with contemporary, albeit exotic, themes, Cabanel was less appealing to American artists. Indeed, the works of a number of Cabanel's American pupils are closer in spirit to Gérôme, particularly in the choice of a humanized, rather than a bombastically dramatic, approach to history painting.[26]

Thomas Hovenden, for example, who enrolled in Cabanel's studio in 1874, balanced historical episodes with a concern for human psychology and the details of quotidian life in a manner reminiscent of Gérôme. When Hovenden returned home after six years of study and work in France, he applied to American historical episodes his interest in humanized, literally "journalistic" Breton history, typified by his *In Hoc Signo Vinces* of 1880 (cat. no. 80). His tendency to conjoin accounts of historical events with genre detail permitted an easy transition to genre painting, and his later images of picturesque American types are equally carefully composed and lovingly rendered.

Gérôme was also a figure of considerable durability, in contrast to other late-nineteenth-century *chefs d'atelier*, and his students enjoyed a unique continuity during his forty-year tenure at the École. Those who had studied under Gérôme in the 1860s and '70s encouraged younger artists to follow the same course during the '80s and '90s. Gérôme's general approach to

subject, rather than his specific choice of subject, and his technical traits constitute common denominators in the works of many of his American pupils. Some, like Frederick Bridgman and Edwin Lord Weeks, pursued their careers abroad and closely emulated the specific interests of their teacher. They exploited archaeological discoveries and various locales in North Africa and the Indian subcontinent, and their works, like those of Gérôme, have a certain value as scientific and ethnographic record. These artists were so international in their styles and activities that it might seem difficult to build a case for their Americanness on any basis other than the accident of their place of birth. Yet contemporary American critics, sympathetic to the pervasive American aspiration to cosmopolitanism, proudly claimed them as their own and commended their complete assimilation of European ideals. Reporting on the Salon of 1877, the Paris-based *American Register* crowed: "Gérôme himself might have signed Mr. Bridgman's 'Funeral of a Mummy' [fig. 9]—such was the verdict of the severe critic of the Paris Figaro, M. Albert Wolff."[27]

Another pupil of Gérôme's, George de Forest Brush, had observed that the master's "strong love of character [was] . . . the key to his choice of subjects, which are most frequently of semi-barbaric people, in whom individuality is more strongly pronounced than among the civilized."[28] Brush found his own "semi-barbaric" subjects in American Indian tribes with whom he lived in the early 1880s. Like the North African types that Gérôme had examined, the Indian tribes were considered exotic and allowed for dramatic compositions based upon carefully studied, semi-nude forms and ethnographically correct settings and props (see fig. 10). Gérôme's approach to subject and style

also served as a common resource for painters as varied as Douglas Volk, whose vignettes of American colonial life were a domestication of French academic history painting, and Kenyon Cox, who responded to late-nineteenth-century America's perception of itself as a Renaissance society reincarnate with appropriate classical allegories.[29]

The American displays at the Paris Expositions of 1878 and 1889 testified to the increasing assimilation of French ideals by American painters: of the 190 American artists exhibiting at the 1889 Exposition, three-quarters had been trained in France, three times as many as in 1867. Increasing numbers of American artists exhibiting in the annual Paris Salons in this period also had French training, and the awards accorded them reflected the general change in attitude. Although Church's works had gained him a medal at the Exposition of 1867, and although Bierstadt's first Salon submission, *Storm in the Rocky Mountains—Mt. Rosalie* (Brooklyn Museum, N.Y.), coincided with his receipt of the Legion of Honor in 1869, subsequent Salon and Exposition juries, both French and American, increasingly favored French-trained American painters. In 1889, when the Düsseldorf-trained Bierstadt's *Last of the Buffalo* (1888; Corcoran Gallery of Art, Washington, D.C.) was rejected by the American selection jury for display at the Exposition Universelle, four Paris-trained painters—all expatriates—were named Chevaliers of the Legion of Honor: John Singer Sargent, a pupil of Émile-August Carolus-Duran; William T. Dannat, a pupil of Carolus-Duran and Mihály Munkácsy; Thomas Alexander Harrison, a pupil of Gérôme and Jules Bastien-Lepage; and Daniel Ridgway Knight, a pupil of Gleyre and Ernest Meissonier. Of course, the greatly increased number of participants in the Salons and special

exhibitions reflected the general increase in American art production in the late nineteenth century, which is evident as well in the development of domestic exhibition facilities and teaching institutions and in the greater sophistication of professional American art criticism.

The distinctly French orientation of the American display at the 1889 Exposition Universelle evoked some concern that "American" art had disappeared entirely, had become essentially French. American art critics of the 1890s defensively protested American independence of mind despite the painters' extensive French training. While still praising those who had absorbed the principles of the École des Beaux-Arts and rival Parisian institutions, writers such as George William Sheldon attempted to delineate their specifically American traits, and, in a sense, became forerunners of twentieth-century nativist critics.

Of the hundreds of American painters who had assimilated French academic ideals in the late nineteenth century, Thomas Eakins was especially hailed by twentieth-century nativist critics, not only because of his particularly American subject matter but also for his strength as an artist. Like other American students who had worked with Gérôme, Eakins effected a substantial transformation of his teacher's subject preferences in his own work, applying Gérôme's principles to the mundane thematic resources of his American milieu, and simultaneously reconciling meticulous academic surface finish with more painterly tendencies.[30] Eakins's ambitious sculling pictures of the early 1870s, for example, especially *Max Schmitt in a Single Scull* (cat.no.57) and *The Biglin Brothers Turning the Stake* (cat.no.58), may be considered domestications of Gérôme's exotic river scenes, and they retain some of the basic characteristics of Gérôme's works: careful arrangements of forms and their interrelationships, meticulously observed and recorded

Figure 8.
Jean-Léon Gérôme
Excursion of the Harem, 1869
Chrysler Museum, Norfolk, Virginia
Gift of Walter P. Chrysler, Jr.

Figure 9.
Frederick Bridgman
The Burial of a Mummy (now lost), Salon 1877,
reproduced in *Art Journal* 4 (August 1878): 228

anatomical and costume detail, overall focus, and glowing light emanating from the horizon. Eakins's academic heritage is also evident in a work such as *The Swimming Hole* (1883–85; fig. 11), a classical composition which depends upon a stable pyramid, reminiscent of a temple pediment, to organize the informal revelries of a series of static bathers—actually individual academic studies—into a formal sequence of motion. Gérôme's exotic North Africans find parallels in Eakins's cowboys of the primitive Dakota badlands, and his gladiators are updated in the American's late boxing and wrestling images. Eakins's rare excursions into historical subject matter also suggest a residual influence from his teacher. His arcadian images of the early 1880s recall the idyllic vignettes of classical life that were the benchmarks of Gérôme's neo-Grec vision, and his unfinished *Phidias Studying for the Frieze of the Parthenon* (c. 1890; Private Collection) is evidence of his commitment to study from nature. His William Rush series, a testimonial to study from nature similar to the *Phidias*, also constitutes an American—and ultimately autobiographical—equivalent of the numerous historical images of artists in their studios that were produced throughout the nineteenth century by French painters of various stylistic affiliations, including Gérôme. The Rush series also indicates Eakins's own interest in sculpture: in fact, he worked as a sculptor himself and recommended that his students do so in order to gain an understanding of volume that could be applied to painted images. This as well as his tendency to use wax maquettes and photographs for study purposes also followed Gérôme's principles and practice.

What is striking in Eakins, and perhaps unique among Gérôme's American students, is his consistent transmutation of French academic picturesqueness into an entirely genuine, literally native or natural, mode. Eakins always confronts his subject, be it Philadelphia scullers, cowboys in the badlands, or his pupils at a swimming hole, as an equal. (Indeed, he appears among those pupils, swimming back to shore, in the last image.) He is never simply a voyeur, and as a consequence viewers of his paintings share the same relationship to his subjects that he had. They seem familiar and accessible, not distanced by time or geography or by artistic self-consciousness and precious theatricality.

During 1869, his last year of study in Paris, Eakins entered the studio of Léon Bonnat, a portraitist extremely popular with American patrons and a friend of Gérôme's, whose own earlier interest in portraiture had waned. Eakins's contact with Bonnat not only assisted his development as a portraitist—an important concern to an artist anticipating a return to the United States—but generated his profound sympathy for seventeenth-century Spanish painting. The surfaces of many of his paintings betray the influence of Bonnat, and of Bonnat's ultimate sources, Velázquez and Ribera. Like Bonnat, Eakins conjoined academic technique with Spanish painterliness.

Carolus-Duran was another important Parisian resource for American art students seeking exposure to a style derived from Spanish Baroque art. An advocate of direct painting, rather than cautious draughtsmanship, to develop forms, Carolus-Duran had agreed to offer studio criticism to young painters, most of them

Americans, in 1872. John Singer Sargent, who enrolled in 1874, is his best-known American pupil, and the one who most amply reflects his teacher's painterly virtuosity.[31] Sargent's assimilation of Spanish fluency is fully evident in such works as *Dr. Pozzi at Home* (1881; cat.no.81), a portrait in which the condensation of pictorial space, the anatomical flattening, and the expanse of assertive strokes of vivid red are a testament to Sargent's complete adoption of the tradition of Velázquez.

Sargent became acquainted with Claude Monet in 1878, while he was still studying with Carolus-Duran, and produced several brilliant, small-scale plein air studies in that year; however, he did not thoroughly investigate Impressionist techniques until the late 1880s. In 1886, two years after the scandal attending the exhibition of his portrait of Mme Gautreau (cat.no.82) in the Salon of 1884, Sargent moved from Paris to London in search of patronage for portraits. With fewer commissions than anticipated forthcoming in the years immediately following, he sought diversion in Impressionist experiments. Sargent's Impressionist works are distinct from orthodox Impressionism as defined by Monet. (To be sure, when measured against the core of Monet's Impressionist works—the landscapes painted between 1873 and 1880—even other French Impressionists seem cautious.) In Sargent's Impressionist paintings, forms such

Figure 10.
George de Forest Brush
The Moose Chase, 1888
National Museum of American Art
Smithsonian Institution, Washington, D.C.
Gift of William T. Evans

Figure 11.
Thomas Eakins
The Swimming Hole, 1883–85
Fort Worth Art Museum, Texas

as trees, boats, and figures are often "made" according to a preconception of their identity, rather than rapidly "matched," and close-up vantage points often generate portraitlike accounts of individual figures. Impressionist facture is often combined with more conventional brushstroke, and heightened chromaticism modified by tonal shadows. Moreover, like most other American Impressionists, Sargent was selective in his use of that style, applying it episodically only when the task at hand—a landscape or other outdoor scene, for example—invited it, but eschewing it for indoor scenes or portraits.

Another American painter who turned to Impressionism, Mary Cassatt, avidly converted to the style upon making the acquaintance of Edgar Degas, a leader of the group, in 1877. She rapidly adopted the concern with everyday subjects, the chromatic palette, and the fluent paint handling typical of Impressionism. The evident restraint of her style is best explained by her having been affiliated with Degas and Renoir, rather than with the more radical Monet. Cassatt was instrumental in promoting Degas and the Impressionists among New York and Philadelphia collectors. She was also unique among American painters in her personal involvement with the Impressionists during their exciting period of innovation and group exhibition, and the only American to commit herself to showing with them.

With the exception of Cassatt, who had both independence of mind and independence of financial means, the American Impressionists came to the movement quite late, catching up with it in the late 1880s, just when it was finding an American market. By this time, the movement had lost its experimental impetus and radical associations: thus, American Impressionism coincides with French Impressionism's later, more conceptual phase. Indeed, American Impressionist paintings often appear more structured and patterned than do Impressionist works—interiors by Childe Hassam, for example, resembling those by Bonnard, and his landscapes those by van Gogh; the controlled and decorative tonal patterns of John Twatchtman recalling the sinuous landscape distillations of Gauguin or Maurice Denis. But the American Impressionists had developed what resembles a Post-Impressionist style by going around Impressionism, rather than through it.

A conservative and selective adoption of Impressionism characterizes the oeuvre of William Merritt Chase, for example. In Chase's mature paintings, the deep tonalities and bravura brushwork that were fundamental to his training in the Munich circle of Wilhelm Leibl in the 1870s—and which are exemplified by his compatriot Frank Duveneck's *Turkish Page* of 1876 (cat. no. 79)—alternate often according to the seasons with the more brilliant palette and delicate stroke evident in *The Fairy Tale* (1892; cat. no. 92).

Unlike Sargent and Chase, whose early education as artists had involved instruction in more painterly techniques, most of the American Impressionists, such as Childe Hassam, Julian Alden Weir, and Theodore Robinson, experienced lengthy training in the academic tradition, and this was an essential factor in conditioning the caution with which they turned to Impressionism. Academic ideals were so ingrained that wholehearted divestiture of them would have been nearly impossible. The conceptual bias of academic painting also inhibited Americans from adopting a fully perceptual mode, as it did,

indeed, some of the French Impressionists, including Renoir. In most cases, the American Impressionists had begun their art studies in American institutions which, by the 1870s, had begun to emulate the instructional procedures of the École des Beaux-Arts. Frederic Crowninshield, a pupil of Cabanel, at the School of the Museum of Fine Arts, Boston; Eakins and his successor Hovenden at the Pennsylvania Academy of the Fine Arts; and Lemuel Wilmarth, the only American student to have preceded Eakins in enrolling in Gérôme's atelier, at the National Academy of Design, New York—all imparted conservative French standards to their pupils who, in most cases, pursued additional academic instruction in Paris before finally turning to Impressionism.

In order to accommodate the tremendous influx of foreign art students to Paris in the late nineteenth century—including the many women who were precluded from enrolling at the École until 1897—numerous private academies were founded. The most influential and successful of these private art schools was the Académie Julian. The impact of Julian's upon American Impressionism may be gauged from the fact that eight members of "The Ten American Painters," the most visible and distinctive group of American Impressionists at the turn of the century, had been trained there. Constituting a reasonably competitive alternative to the École in terms of technical, if not theoretical, instruction, Julian's flourished partly as a result of the more rigorous, and intentionally exclusionary, entrance examination at the École, instituted in connection with new curriculum reforms in 1883.[32]

Julian's employed as critics a number of artists who were appointed to the École during the period after the expansion of its curriculum in 1883 and who served there while continuing to teach at Julian's: these included Gustave-Clarence-Rodolphe Boulanger, Jules-Joseph Lefebvre, William-Adolphe Bouguereau, and Tony Robert-Fleury. Their appointment was a result of a reform which instituted "simultaneous instruction" in the three arts of painting, sculpture, and architecture, taught by drawing instructor Adolphe Yvon along with a sculptor and architect.[33] In keeping with this change, the *concours des places* for matriculation was expanded to require a demonstration of analogous breadth of competence. A new evening course in drawing, staffed by Boulanger and his colleagues, was established to fill the gap Yvon had left.[34] Even before their appointment to the École, these critics at Julian's had endorsed their students' matriculation, and a number of American Impressionists, including Edward Simmons, Philip Leslie Hale, and Edward Redfield, pursued dual institutional affiliations with the independent and government schools.

Theodore Robinson's extensive exposure to academic principles—including two years of instruction under Wilmarth at the National Academy of Design and two years of matriculation in the École des Beaux-Arts with concurrent instruction under Gérôme—was typical of the American Impressionists. His years in Paris coincided with the emergence of Impressionism in public exhibitions, but he and many of his compatriots had gone abroad to gain grounding in traditional techniques, and they were either initially indifferent to—or even outraged by—the Impressionists. An unusually vivid reaction was recorded by Weir, Robinson's colleague in Gérôme's atelier, who told his parents in a letter of April 1877 that he had visited the third

exhibition of

a new school which calls themselves 'Impressionalists.' I never in my life saw more horrible things. . . . They do not observe drawing nor form but give you an impression of what they call nature. It was worse than the Chamber of Horrors. I was there about a quarter of an hour and left with a head ache. . . . I was mad for two or three days, not only having paid the money but for the demoralizing effect it must have on many. . . .[35]

Despite Weir's initial horror, both he and Robinson were to become American Impressionists in the following decade. Robinson, coming to Impressionism after considerable exposure to academic ideals and techniques, maintained a characteristic adherence to volumetric form and careful compositional organization, as well as an avoidance of chromatic license. His use of photographs for study purposes and his insistence on studio finishing mark his paintings as more the product of "impressionizing" than of Impressionism.

Robinson's *World's Columbian Exposition* (cat. no. 95) exemplifies these stylistic and thematic reconciliations and also documents the event of 1893 that demonstrated the pervasive French influence on late-nineteenth-century American architects, painters, and sculptors. The fair's setting derived in conception and detail from Beaux-Arts architectural standards, the result of collaborative planning under the leadership of Richard Morris Hunt, William's brother and the first American architect to have been trained in the Parisian École. American painters exhibited almost twenty-four hundred paintings, prints, and drawings, the overwhelming majority of which were grounded in French academic, Barbizon, and more contemporary principles. Twenty-five American artists working in the Impressionist mode showed 141 works, a significant debut for a style that was to gain numerous adherents in the years following and to enjoy substantial and enthusiastic patronage. American Impressionist paintings were at once descriptive enough to enjoy broad appeal, fresh enough to reassure modernist taste, and decorative enough to invite middle-class patronage. The applicability of the Impressionist mode to a great variety of American subjects, scenic as well as figural, accounts in large measure for its success, its durability, and its academic institutionalization well into the twentieth century.

Among the American Impressionists, there were several who provided mural decorations for the entrance pavilions of the Chicago fair's Manufactures and Liberal Arts Building. Cassatt executed an allegory of *Modern Woman*, similar in spirit to her *Young Women Picking Fruit* (1891; cat. no. 93) for the Women's Building. The interest in mural painting generated by the fair stimulated numerous similar commissions in the late 1890s and early twentieth century. French-trained American muralists, including some who had experienced the "three arts" course at the École, enjoyed unprecedented opportunities to collaborate with architects and sculptors in the unified decoration of Beaux-Arts libraries, courthouses, and state capitols, as well as domestic interiors.

Other trends in American art life that had begun to appear in the 1880s climaxed in the last decade of the century, denoting and encouraging a growth of status and professionalism among American painters. They now operated in an enlarged and distinctive art world such as the United States had never known.

Collectors had emerged who were dedicated to acquiring contemporary American works, not as a patriotic duty, but as pleasing additions to their collections and as good investments. Dealers had appeared who were willing to display and promote American art, facilities for art instruction and exhibition had expanded, studio accommodations had improved, and prizes had been established to acknowledge merit. Art critics, stimulated by the potential for interpretation of sophisticated, cosmopolitan subjects and styles of contemporary European and American art, served a substantial audience in popular and specialized journals. Having optimistically set out after the Civil War to experience and assimilate European, especially French, stylistic and institutional models, American painters had finally begun to enjoy the rewards of emulating them.

NOTES

1. See, e.g., Van Wyck Brooks, *New England: Indian Summer* (New York, 1940), and *The Confident Years, 1885–1915* (New York, 1952); Lewis Mumford, *The Golden Day: A Study of American Literature and Culture* (New York, 1926); and Malcolm Cowley, ed., *After the Genteel Tradition: American Writers, 1910–1930* (New York, 1937).

2. An important effort to correct the image of late-nineteenth-century American cosmopolitanism as the product of insecurity or loss of patriotism is Michael Quick, *American Expatriate Painters of the Late Nineteenth Century* (Dayton Art Institute, Ohio, 1976).

3. Jarves, *The Art-Idea: Part Second of Confessions of an Inquirer* (1864; Cambridge, Mass., 1960), p. 166.

4. Eakins, interview in *The Philadelphia Press*, 22 February 1914, quoted in Lloyd Goodrich, *Thomas Eakins, His Life and Work* (New York, 1933), p. 139.

5. Allen Staley ("West's *Death on the Pale Horse,*" Detroit Institute of Arts Bulletin 58 [1980]: 137–49) identifies the Detroit picture as the version shown in Paris in 1802, on the basis of an obituary of West written by William Carey in 1820. Donald D. Keyes ("Benjamin West's *Death on the Pale Horse:* A Tradition's End," *The Arts* 7 [September 1973]: 3–6) discusses the Paris reaction but identifies a smaller version in the Philadelphia Museum (whose attribution to West Staley doubts) as the work shown in the 1802 Salon.

6. David Tatham ("Samuel F. B. Morse's *Gallery of the Louvre:* The Figures in the Foreground," *American Art Journal* 13 [Autumn 1981]: 38–48) notes the "rehanging" of the works in the painting but does not discuss its significance.

7. Vanderlyn to Peter Vanderlyn, Paris, 10 March 1798, quoted in Louise Hunt Averill, "John Vanderlyn, American Painter" (Ph.D. diss., Yale University, 1948), p. 20.

8. See the essays by Wend von Kalnein and Donelson F. Hoopes in *The Düsseldorf Academy and the Americans* (The High Museum of Art, Atlanta, 1972).

9. The impact of Gleyre upon his pupils, including those of extremely liberal tendencies such as Whistler, is convincingly discussed in Albert Boime, "The Instruction of Charles Gleyre and the Evolution of Painting in the Nineteenth Century," in *Charles Gleyre, ou Les Illusions perdues* (Winterthur Kunstmuseum, 1974), pp. 102–24.

10. See Boime, *Thomas Couture and the Eclectic Vision* (New Haven, Conn., 1980), chap. 15, which provides a comprehensive account of Couture's influence upon his many American pupils.

11. See Peter Bermingham, *American Art in the Barbizon Mood* (National Collection of Fine Arts, Washington, D.C., 1975).

12. These relationships are discussed in Boime, "Newman, Ryder, Couture and Hero-Worship in Art History," *American Art Journal* 3 (Fall 1971): 5–22.

13. See, e.g., John Wilmerding, *Winslow Homer* (New York, 1972) and William H. Gerdts, "Winslow Homer in Cullercoats," *Yale University Art Gallery Bulletin* 36 (Spring 1977): 18–35.

14. Mantz, quoted in Lloyd Goodrich, *Winslow Homer* (New York, 1944), p. 39.

15. Champney, *Sixty Years' Memories of Art and Artists* (Woburn, Mass., 1900), p. 142.

16. Tuckerman, *Book of the Artists: American Artist Life* (New York, 1867), pp. 35–36.

17. E. Durand-Gréville, quoted in Alexandra R. Murphy, "French Paintings in Boston: 1800–1900," in *Corot to Braque: French Paintings from the Museum of Fine Arts, Boston* (Boston, 1979), p. xvii. Murphy provides an excellent account of art collecting in Boston in the nineteenth century. See also Lois Marie Fink, "French Art in the United States, 1850–1870: Three Dealers and Collectors," *Gazette des Beaux-Arts*, series 6, 92 (September 1978): 87–100.

18. Weir to John Ferguson Weir, 11 January 1874, quoted in Dorothy Weir Young, *The Life and Letters of J. Alden Weir* (New Haven, Conn., 1960), p. 27.

19. Natt, "Paris Art-Schools," *Lippincott's Magazine* 27 (March 1881): 269.

20. See the essays by Michael Quick and Eberhard Ruhmer in *Munich and American Realism in the 19th Century* (E. B. Crocker Art Gallery, Sacramento, Calif., 1978).

21. Whitelaw Reid noted fifteen hundred American art students in Paris in his speech at the inaugural meeting, reported in E. H. Wuerpel, "American Artists' Association of Paris," *Cosmopolitan* 20 (February 1896): 403. See also Emily Meredyth Aylward, "The American Girls' Art Club in Paris," *Scribner's Magazine* 16 (November 1894): 598–605.

22. A useful account of the 1863 curriculum reform of the École des Beaux-Arts and its subsequent structure appears in Boime, "The Teaching Reforms of 1863 and the Origins of Modernism in France," *Art Quarterly*, n.s. 1 (1977): 1–39. Material concerning changing regulations at the École during the nineteenth century appears in the Archives de L'École Nationale Supérieure des Beaux-Arts (Archives Nationales, Paris): see *Recueil de règlements de L'École, 1819–1893*, esp. *Règlements* of 1819, 1839, 1846, 1864, and 1883. See also C. H. Stranahan, *A History of French Painting* (New York, 1888).

23. See, e.g., "Open Letters: American Artists on Gérôme," *Century Magazine* 37 (February 1889): 634–36, and obituary observations by Weir, Douglas Volk, and William deLeftwich Dodge in the *New York Herald Magazine*, 31 January 1904, p. 8.

24. Benson, "Jean-Léon Gérôme," *The Galaxy* 1 (August 1866): 582.

25. See my "Nineteenth-Century American Painters at the École des Beaux-Arts," *American Art Journal* 13 (Autumn 1981): 66–84, which lists teachers at the École, the American pupils in their ateliers, and matriculants in the École proper.

26. American collectors were also more attracted to Gérôme than they had been to Cabanel. While many of them sought out the latter's services as a portraitist (in part, perhaps, because Gérôme avoided portrait painting), they acquired Gérôme's works so avidly that by 1882 he was represented in almost every major collection outside of New England, where the taste for Barbizon painting prevailed. See Earl Shinn [Edward Strahan], *The Art Treasures of America*, 3 vols. (Philadelphia, 1879–82), which lists numerous collections and testifies to the extent of American collectors' interest in Gérôme and Cabanel.

27. The *Register*'s remarks were almost immediately recirculated in a major reference work, Clara Erskine Clement and Laurence Hutton's *Artists of the Nineteenth Century and Their Works* (Boston and New York, 1879), p. 94.

28. Brush, in "Open Letters," *Century Magazine* 37, p. 635.

29. See the essay by Richard N. Murray in *The American Renaissance, 1876–1917* (Brooklyn Museum, N.Y., 1979).

30. The seminal study of Eakins in relation to influences absorbed in Paris is Gerald M. Ackerman, "Thomas Eakins and His Parisian Masters Gérôme and Bonnat," *Gazette des Beaux-Arts*, series 6, 73 (April 1969): 235–56.

31. For Sargent's relationship to his Parisian teacher, see Charles Merrill Mount, "Carolus-Duran and the Development of Sargent," *Art Quarterly* 26 (1963): 385–417.

32. Lucy H. Hooper ("Art Schools of Paris," *Cosmopolitan* 14 [November 1892]: 59–60) notes that "for some years past," the entrance examinations for matriculation in the École had been made more rigorous, to "form a barrier to the ever-increasing army of foreign students, and especially of those from the United States," and she records the consequent increase in popularity of the independent academies.

33. The course in simultaneous instruction expanded the Cours supérieur de l'art décoratif begun in 1873.

34. See Paul Dupré and Gustave Ollendorf, *Traité de l'administration des Beaux-Arts*, 2 vols. (Paris, 1885), which describes the new structure and curriculum of the École.

35. Weir to "Father and Mother," 15 April 1877, quoted in Young, *Life and Letters*, p. 123.

I. *Colonial Genius & the New Nation* Theodore E. Stebbins, Jr.

A World primal again, vistas of glory incessant and branching,
A new race dominating previous ones and grander far,
 with new contests,
New politics, new literatures and religions, new inventions and arts.

—Walt Whitman, *Starting from Paumanok*

The process by which the American nation was established as an independent political entity is by now well known. As long and complex as this process was, three dates stand out as crucial turning points: 1776, when representatives of the thirteen colonies gathered at the Second Continental Congress in Philadelphia on 4 July to ratify the Declaration of Independence and thus "dissolve the political bonds" connecting them with Great Britain; 1783, when the Treaty of Paris ended the Revolutionary War and brought independence to the colonies; and 1787, when the states formally ratified the Constitution of the United States of America.

The steps through which America became culturally and artistically independent are less clearly understood. There is no consensus on when and how *this* independence came about, or even whether it ever occurred. The American mind from the beginning has devoted itself to the "practical," and matters of art and style have remained secondary. Thus like generations of civic leaders to come, John Adams, second president of the United States, viewed art as an impractical luxury. On his visit to Paris and Versailles in 1778, he wrote that "the richness, the magnificence and splendor are beyond all description," but went on to decry these "bagatelles," saying "I cannot help suspecting that the more elegance, the less virtue, in all times and countries."[1] In a letter of 1780 Adams concluded, "It is not indeed the fine arts which our country requires: the useful, the mechanic arts are those which we have occasion for. . . ."[2] There were many, like Adams, who believed the arts *should* never be encouraged in a new nation founded on the theory of equality; in addition, many respectable eighteenth-century thinkers were convinced that the arts *could* never prosper in such a place. Many believed that "Africa, Asia, and America yield their treasures for the benefit of Europeans who alone practice the civilized arts of music, painting, sculpture, and architecture."[3] The influential French naturalist Georges-Louis-Leclerc Buffon formulated a theory which was widely supported in Europe over the following century, that the heat, humidity, "stagnant water, the extent of the forests and the raw state of nature" in America were the reasons "why such large reptiles, huge insects, small quadrupeds and frigid men are found in the New World."[4] In the face of such opinion, it would be no surprise to find that the American colonists thought first of physical and then of political survival in their arduous new environment.

But despite all this, the wilderness sheltered occasional creative spirits. Even in the 1670s, a century before the American nation was born, a recognizable American art could be discerned. At this time a population of one hundred thousand was strung out along the Eastern coast in settlements from Charleston, South Carolina, to Falmouth and Portsmouth north of Boston, and up the Hudson River to Albany. These coastal towns supported a variety of skilled artisans, craftsmen, and a handful of true artists, who worked in styles closely following those of England and Holland. We can look to the 1670s as the time of the first American painters, for in this decade about a half-dozen portraitists were working in the Boston area making elegant life portraits of wealthy merchants and ministers and their families. They worked in a late-Elizabethan style which had been fashionable in London two generations earlier, yet the best of the paintings made by the "Freake Limner" and his contemporaries were elegant, finely wrought, and sensitive likenesses. Still, painting surely lagged in comparison with silver and furniture-making: the demand for stylish portraiture was apparently relatively slight, and that was the only kind of painting the society wanted at all; moreover, communication of the painter's style and technique from abroad was inevitably slower and more difficult than in the case of the decorative arts. For the crafts, style could be transmitted by a single well-trained individual coming from abroad, and up-to-date fashion might be learned from an easily transportable silver beaker or an oak chest, from a book or an engraving, or even by word of mouth. Painting is different: it cannot exist in isolation, and it demands a complex cultural substructure, including systems for training, patronage, exhibition, and criticism. The wonder, in 1670, is not that so *little* painting was going on, and of such provinciality, but that so *much* was, that it was relatively so sophisticated, and that one could see in it the beginnings of an American art.

Cultural foundations were being laid nearly from the time of the first settlements by these craftsmen, and also by a small number of believers in the need for art in America. In the early 1720s, Bishop Berkeley, before setting sail for the New World, wrote his poem "On the Prospect of Planting Arts and Learning in America," which concluded with the famous line: "Westward the course of empire takes its way."

One of the earliest pieces of American art criticism was also in poetic verse and was directed toward Berkeley's friend "Mr. Smibert, on the sight of his pictures." The author was Mather Byles, writing for the Boston *Gazette* about 1730, the year after Smibert's arrival: he compared the wilderness state of 1630 ("No laureled Art o'er the wide Region smiled, / Nor blest Religion dawned amidst the wild . . .") with the promise heralded one hundred years later by the coming of this sophisticated painter from London: "'Tis yours, great master, in just lines to trace / The rising prospect, or the lovely face."

John Smibert (1684–1751), the subject of these glowing words, was a well-trained English painter who settled in Boston in 1729 and at once became the outstanding painter of the colonies. Smibert had had the advantage of three years of study in the great artistic centers of Italy, and then from 1720 to 1728 he painted in London, where he won a reputation as an able if not inspired portraitist. His ability alone would have made him

preeminent here, but his influence and position were aided by his having brought with him "an important collection of copies of old-master paintings, plaster casts of ancient sculpture, and prints," along with his books on art.[5] Thus Smibert's studio and the adjacent shop where he sold colors, canvas, and other painters' supplies became, quite literally, the center of the infant American art world. The fact that one city in the colonies, Boston, had been the home of the best American painting of the seventeenth century, and that it could draw a painter of Smibert's stature into permanent residence and then support him with adequate patronage for his portraits (and apparently a few landscapes as well) until his death in 1751, all gave some small hope that an American art might one day exist.

<center>* * *</center>

By 1760 an American art had been born, several years before the colonies finally set their course toward independence, and some three decades before the new nation was established. It was an art with very little underpinning, and it was fragile indeed, for it could be found only in one American city—Boston—and there in the hands of just one painter—John Singleton Copley, then a youth of twenty two but nonetheless already an experienced, stylish painter. Copley was the first great American artist, a genius who painted far better than his society had any right to expect.

Though John Smibert died in 1751, shortly before the young Copley began to paint, the example of his work and the copies, prints, and materials which he left behind all must have helped form the younger painter's ideals. In addition, Copley had the advantage of living for several formative years in the Boston household of Smibert's friend Peter Pelham (c. 1695–1751), who had married Copley's widowed mother in 1748 and who was himself a painter, printmaker, and artistic jack-of-all-trades.

Copley began to paint about 1753, at fourteen, copying complex rococo engravings after mythological scenes, studying facial expression and anatomy from other European print sources, and learning how to make an acceptable likeness in oil paints. He learned from and quickly came to equal the English-born Joseph Blackburn, his only serious rival in Boston, and by 1757 he was beginning to rely less on Baroque formula and more on his own clear and direct powers of observation. His portraits of 1758–60, for example, those of the Thaddeus Burrs (St. Louis Art Museum), combine an elegance of pose and gesture in a three-quarter length format and exquisite rendering of the sitters' finery—a silk waistcoat, a lace and velvet gown—with a seeming sternness of demeanor. These paintings have about them a weightiness, a sobriety, a sense that sitters and painter alike viewed their roles with the utmost seriousness.

Working almost wholly on his own, never having traveled outside his native Boston, Copley developed a style that was a close variant of the prevailing English manner. Despite his isolation, he taught himself to paint as well as the ablest of contemporary provincial English painters.[6] But he had no standard against which he might judge his own abilities, for he had never seen a painting by Sir Joshua Reynolds or Thomas Gainsborough or the other leading English and Continental painters about whom he had heard so much. His instinct from the start was to strive not merely for colonial success but for international preeminence, and he viewed the achievements of the leading English artists with the naiveté and awe of the provincial—he had no idea that he was, in his own way, already their equal. Instead, he dreamed of the glories of European art, and of himself trying to scale "the summit of that Mighty Mountain where the Everlasting Laurels grow," as he put it.[7] He was mortified that his clients only wanted portraits, that he was ranked as a craftsman on the level of a carpenter or tailor, and that Bostonians failed to see that painting was "one of the most noble Arts in the World."[8] In 1765 he painted *Boy with a Squirrel* (cat. no. 1) for a London exhibition, hoping for comments from Reynolds and Benjamin West to give him a measure of his abilities. Their response was favorable and must have been enormously gratifying: though the picture was criticized for "coldness" and "an over-minuteness," Reynolds concluded that it was "a wonderful Picture to be sent by a Young Man who was never out of New England, and had only some bad Copies to study."[9]

In the portraits that followed, Copley showed increasing confidence and dexterity. He had long been skilled at depicting fabrics and costume, and it has been said that he portrayed goods and status rather than personality. But quite the opposite seems to be the case: Copley painted fine costume because convention dictated it, but his real concern was with character—which he now dealt with more and more convincingly. He painted his subjects according to his own standards, and was apparently little affected by their political views or their power, rank, or wealth. Thus, John Hancock is portrayed as languid and unthinking, even though he was possibly the wealthiest man in the colonies; yet the portrait of Hancock's wife, Dorothy Quincy Hancock (both Museum of Fine Arts, Boston), done seven years later, sympathetically conveys her fragility and her thoughtful mood.

Copley's elegant pictures of *Nicholas Boylston* (cat. no. 2) and his sister *Rebecca Boylston* (cat. no. 3) reflect the international rococo style. Nicholas Boylston is the merchant at ease, dressed in silks, looking out on the world with total assurance, and his sister is the picture of feminine delicacy. Yet Copley's portraits are also restrained and conservative; as with the cabinetmakers of Boston and Philadelphia, his work stopped well short of a true rococo style, held in check by the native culture itself. Such restraint, in fact, became the hallmark of American style. As the speed of cultural transmission increased, America did not so much lag behind stylistically as simply reject the decorative extremes of each successive European style. Copley's style surely has its decorative, fictional aspects: for example, his sitters, unlike those of a Duplessis or a Fragonard in France, often did not own the elegant clothing they wore—their costumes were either borrowed from fashionable neighbors or simply invented by the artist following mezzotint prototypes. Henry Pelham, the son of an artisan, is dressed like a young prince in *Boy with a Squirrel*. And Copley's women often appear uncomfortable and out of place in their finery; they are dressed and painted according to the demands of the fashionable portrait, demands which reflect their aspirations rather than their real lives. Yet at the same time Copley is more the realist in his effort—very often successful—to portray not only physical "likeness" but psychological and moral truth as well. He would put his sitters through fifteen or more sittings of six hours each,

as he probed beyond mere appearance. He simply could not paint a true rococo portrait: though he used its apparatus, he never mastered its regal atmosphere, its sense of genuine ease and luxury.[10]

In the late 1760s, Copley rejected the rococo format and began to portray his sitters in plainer surroundings, with ever-increasing attention to their moods and their abilities. His *Paul Revere* (cat.no.4) is really two pictures: the brilliantly painted white shirt and silver teapot show off Copley's mastery of technique, in a sense reflecting Revere's own abilities as a skilled craftsman; but Copley surely neither loved nor admired Revere as a man, and he made this clear in his rendering of the patriot's stolid head and bland expression. That Copley's bias against Revere was personal and not political is demonstrated by his extraordinarily powerful portrait of Revere's friend and political ally, the radical *Samuel Adams* (cat.no.5). Adams's face and hands look strong and taut, unlike Revere's, his eyes are intense and his expression intelligent and reasoning.

Copley left the colonies for good in 1774, traveling to Rome and then settling in London, where he arrived to fulfill his lifelong dream of working with the greatest painters of the English-speaking world. He left on the eve of the Revolution, at a time when Boston was on the threshold of a marked decline in prosperity, power, and artistic production. For the fifty years following, Philadelphia ranked as the most powerful American city. It served as the capital of the new nation, and it was there that the first American Congresses sat, the Constitution was written, and George Washington reigned after he was elected the first president of the United States in 1788.

During these years Philadelphia also became the leading art center in the new American republic, thanks in large part to the remarkable Peale family of painters. Head of this clan and its teacher, founder of the first American art academies and museums, organizer of our earliest exhibits, was Charles Willson Peale. At the beginning of his career he worked briefly with Copley in Boston, and then went to London in 1766 to study with Benjamin West. By the early 1770s, as one sees in his *Cadwalader Family* (cat.no.7), he had mastered the rococo tradition: his family grouping here is sophisticated and elegant while showing little of Copley's interest in psychological truth. Unlike Copley, Peale practiced two distinct styles, one for his fashion-conscious patrons in Philadelphia and the South, and quite another in the informal, personal pictures he made for himself and his family. Thus, the superb *Staircase Group* of 1795 (cat.no.10) owes its inventive freshness and charm to the fact that Peale was painting two of his sons (Raphaelle and Titian Peale) with only himself to please.

Peale's influence was great. The arts were his life, and he worked throughout his career to build institutions which would train and support the American painter and would exhibit his work. He organized the Columbianum—America's first academy—in Philadelphia in 1794, as well as its first and only exhibition, and later established museums of art and natural history in several cities. He set an important example in his own work, branching out from portraiture to still life, landscape, genre, and figurative painting. Most important, he taught his children to be painters and museum proprietors, and many of their sons and daughters carried on this remarkable tradition into a third generation.

Peale's eldest son, Raphaelle, had a difficult life marred by illness and drink, and he won practically no reputation in his lifetime: his speciality was small neoclassical still lifes, for which there was almost no market (see cat.no.12). Raphaelle's *Venus Rising from the Sea, a Deception* of 1823 (cat.no.13), until recently simply called *After the Bath*, is testimony both to his superb skill and to the lack of patronage for anything but portraits in America. This masterpiece is unique in his oeuvre, presumably because it was unsalable and thus there was no call on him to make another like it. Nonetheless, Raphaelle is now recognized as the founder of still-life painting in America, and perhaps the most genuinely talented of all the Peales.

Raphaelle's younger brothers, Titian and Rubens, turned largely to museum administration, while his elder brother, Rembrandt, gained a major reputation for grandiose history paintings such as the *Court of Death* (1820; Detroit Institute of Arts) and for his many portraits. Like his father, he painted George Washington from life several times, and his "porthole" portrait of the president and its replicas were in considerable demand. Rembrandt painted portraits of several other prominent figures of his time, including one of Thomas Jefferson in 1805 (New-York Historical Society), which is perhaps the finest portrait of the third American president. In the same year, Rembrandt helped found the Pennsylvania Academy of the Fine Arts in Philadelphia, and shortly thereafter visited Paris twice both to study and to paint portraits for his father's museum. As with his father, some of his best work is found not among his formal portraits and history paintings but rather in less conventional pictures he did of family and friends. His masterpiece of informal portraiture is *Rubens Peale with a Geranium* of 1801 (cat.no.11). Here he portrays his younger brother warmly and sympathetically, while giving almost equal attention to a large geranium (thought to be the first of its species brought to America), thus demonstrating the character and artistry of his family as well as its wide-ranging interest in science and in the arts in America.

However much the Peales aimed to serve as official portraitists to the new republic, their images of American leaders never took on the popular or iconic status won by the paintings of Gilbert Stuart. For one thing, Stuart was better trained than they, having worked for twelve years in London where he totally mastered the simplified, classic style of Gainsborough and Romney. Rejecting Copley's deliberate approach, Stuart used only a sitting or two to capture an immediate likeness of his subject. Stuart's special gift lay in his ability to capture the essence of his sitter, the very look of the eyes, mouth, and expression, while at the same time conveying a sense of calm nobility. His paintings of the early presidents and other leaders became part of the national iconography, and none is better known than his superb portrait of *George Washington* (cat.no.9), painted in Philadelphia in 1796, and deliberately left unfinished in order to emphasize both its spontaneity and its identity as the original from which stemmed many replicas, by himself and others. Unlike Copley, Stuart had no wish to probe character; rather, his portraits resonate with dignity and strength, showing men and women completely comfortable in their trappings and their power. Working rapidly in a modern style brought from England, Stuart gave us a new race of American heroes, the equal of any Roman, preserved forever.

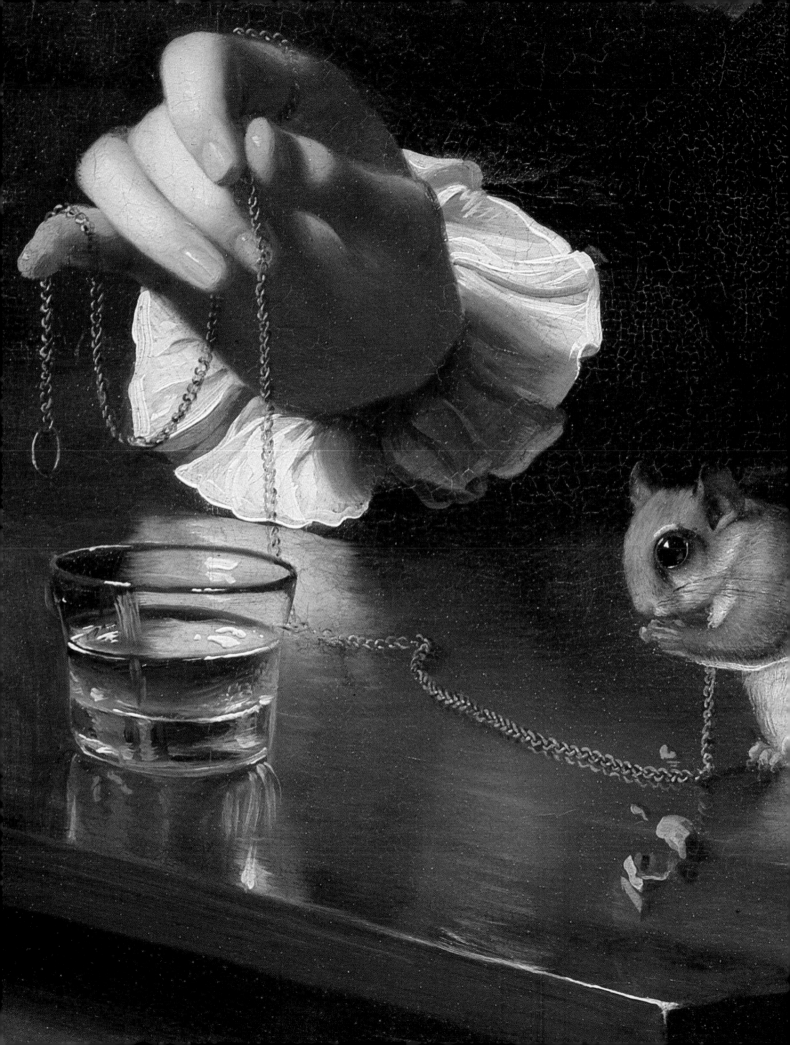

All details shown are actual size

JOHN SINGLETON COPLEY (1738–1815)
Boy with a Squirrel, 1765
Oil on canvas, 30¼ × 25 in. (76.8 × 63.5 cm.)
Museum of Fine Arts, Boston, Anonymous Gift

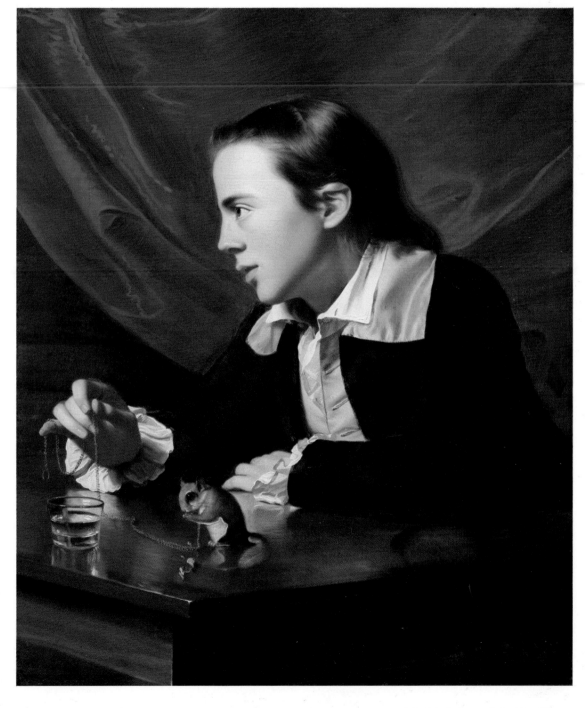

2
JOHN SINGLETON COPLEY (1738–1815)
Nicholas Boylston, 1767
Oil on canvas, 49 × 40 in. (124.5 × 101.6 cm.)
Harvard University, Cambridge, Massachusetts, Bequest of Ward Nicholas Boylston, 1828

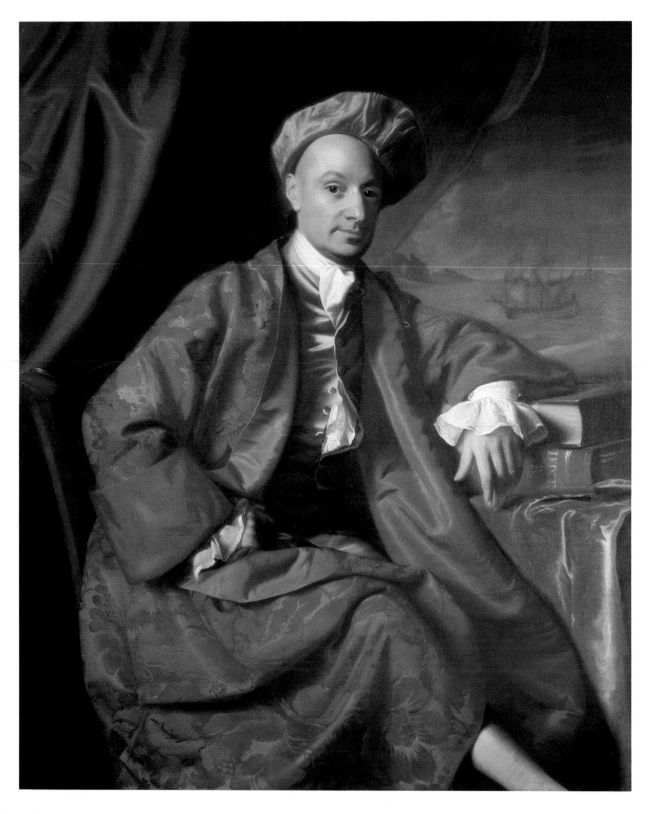

3
JOHN SINGLETON COPLEY (1738–1815)
Rebecca Boylston, 1767
Oil on canvas, 50 × 40 in. (127 × 101.6 cm.)
Museum of Fine Arts, Boston, Bequest of Barbara Boylston Bean

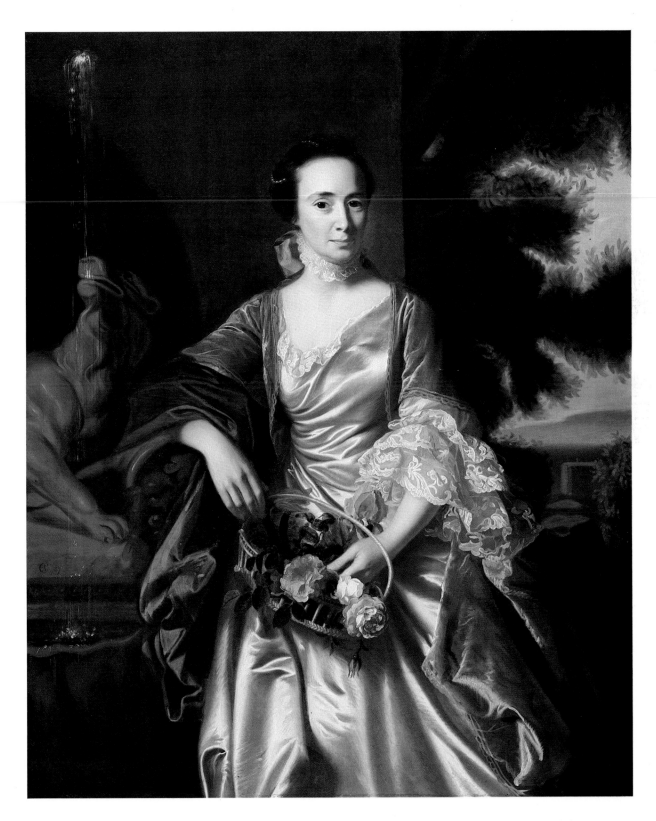

4
JOHN SINGLETON COPLEY (1738–1815)
Paul Revere, c. 1768–70
Oil on canvas, 35 × 28½ in. (88.9 × 72.4 cm.)
Museum of Fine Arts, Boston, Gift of Joseph W., William B., and Edward H. R. Revere

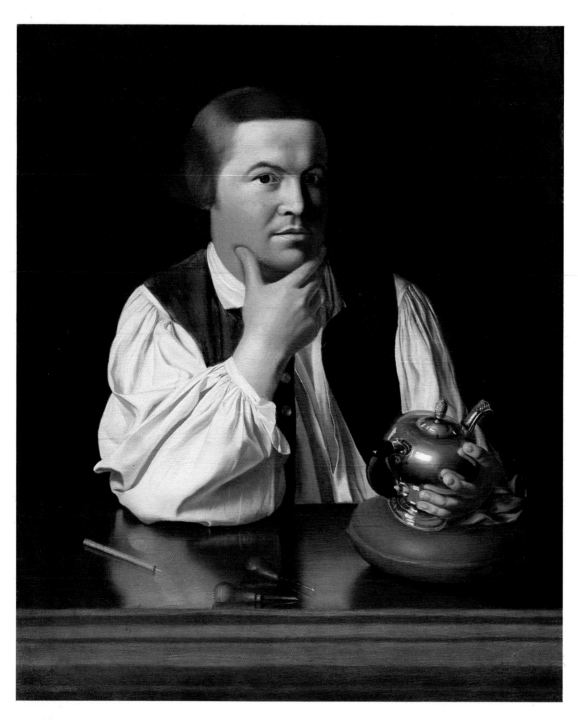

5
JOHN SINGLETON COPLEY (1738–1815)
Samuel Adams, c. 1772
Oil on canvas, 50 × 40¼ in. (127 × 102.2 cm.)
Museum of Fine Arts, Boston, Deposited by the City of Boston

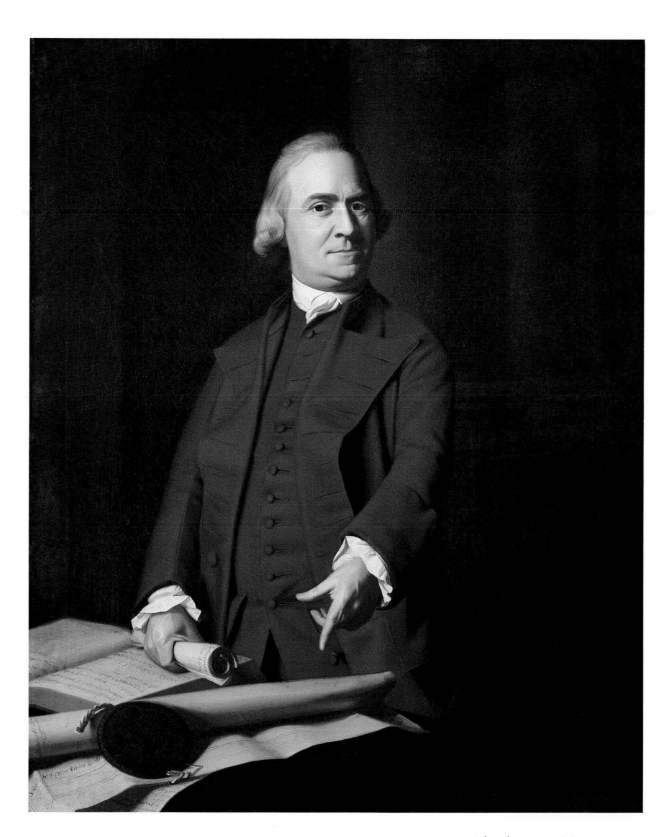

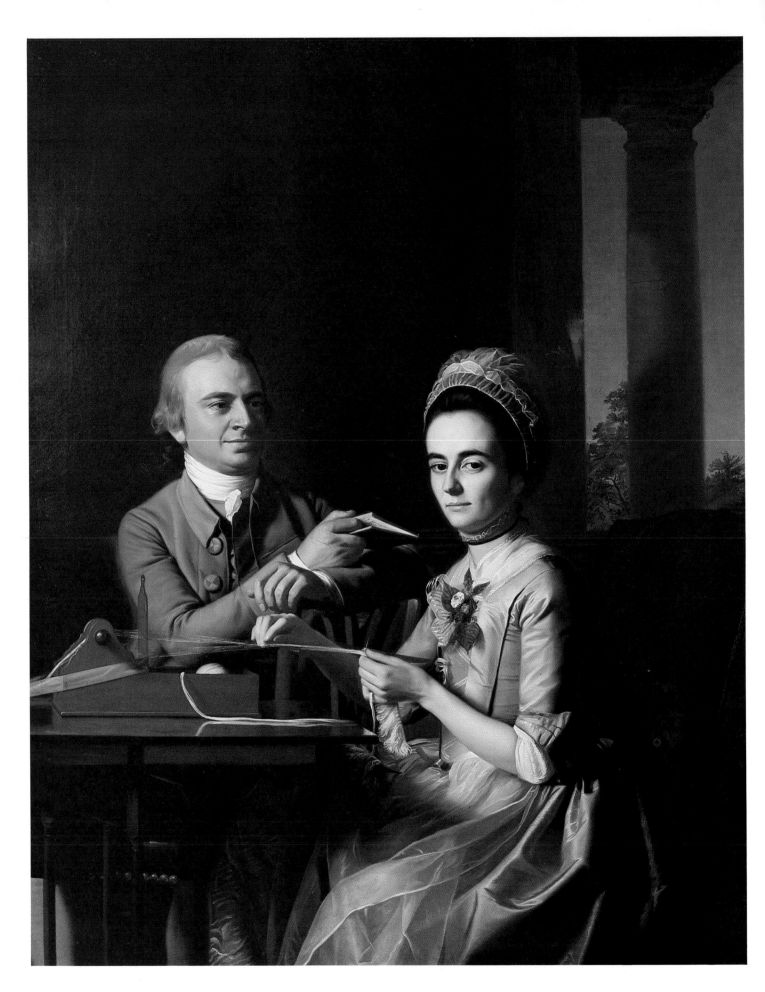

6
JOHN SINGLETON COPLEY (1738–1815)
Mr. and Mrs. Thomas Mifflin, 1773
Oil on canvas, 61½ × 48 in. (156.2 × 121.9 cm.)
The Historical Society of Pennsylvania, Philadelphia

7
CHARLES WILLSON PEALE (1741–1827)
The John Cadwalader Family, 1772
Oil on canvas, 51½ × 41¼ in. (130.8 × 104.8 cm.)
Private Collection

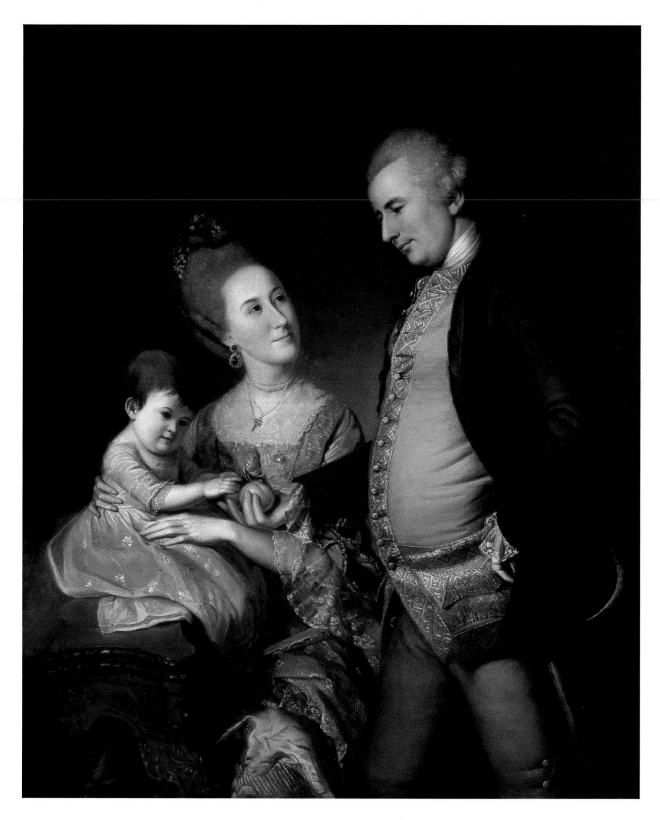

8
GILBERT STUART (1755–1828)
Martha Washington, 1796
Oil on canvas, 48 × 37 in. (121.9 × 94 cm.)
Museum of Fine Arts, Boston, and The National Portrait Gallery,
 Smithsonian Institution, Washington, D.C.

9
GILBERT STUART (1755–1828)
George Washington, 1796
Oil on canvas, 48 × 37 in. (121.9 × 94 cm.)
Museum of Fine Arts, Boston, and The National Portrait Gallery,
 Smithsonian Institution, Washington, D.C.

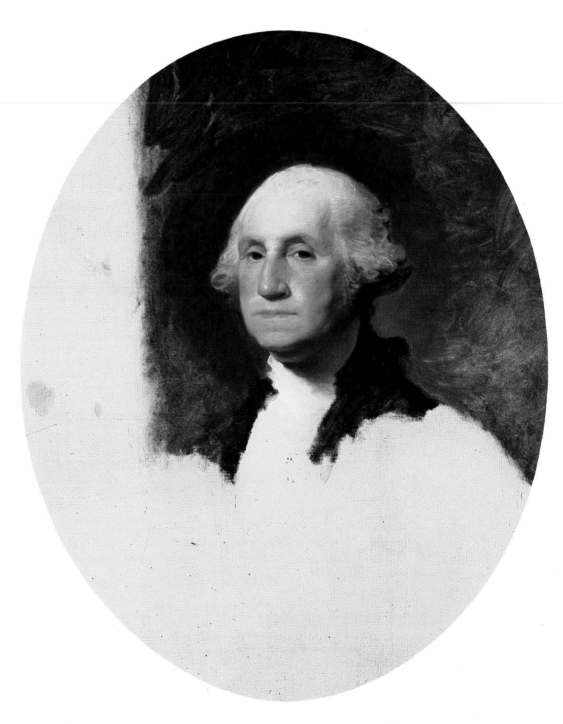

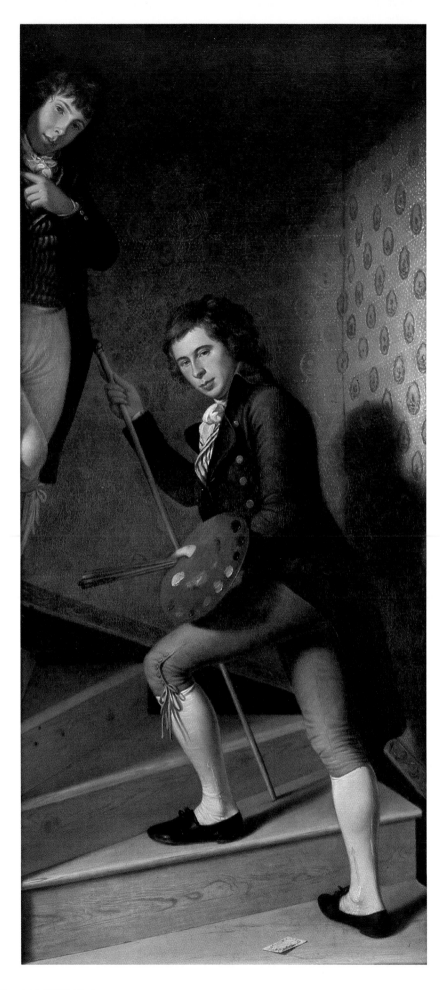

10
CHARLES WILLSON PEALE (1741–1827)
Staircase Group, 1795
Oil on canvas, $89\frac{5}{8} \times 39\frac{1}{2}$ in. (227.7 × 100.3 cm.)
Philadelphia Museum of Art,
 The George W. Elkins Collection

11
REMBRANDT PEALE (1778–1860)
Rubens Peale with a Geranium, 1801
Oil on canvas, 28 × 24 in. (71.1 × 61 cm.)
Mrs. Norman B. Woolworth

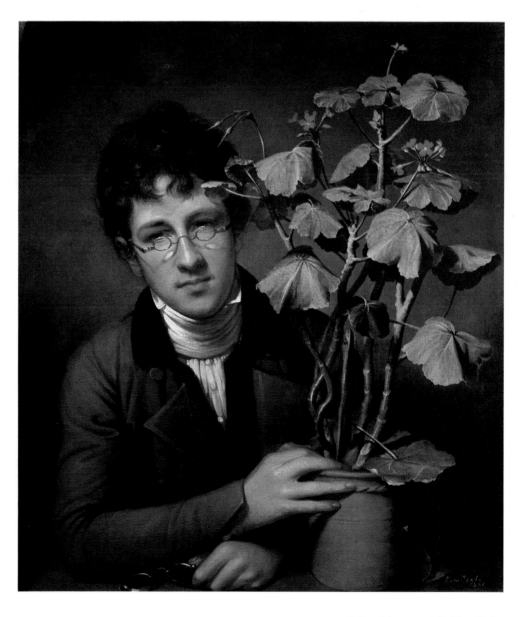

12
RAPHAELLE PEALE (1774–1825)
A Dessert, 1814
Oil on wood, 13⅜ × 19 in. (34 × 48.3 cm.)
Jo Ann and Julian Ganz, Jr.

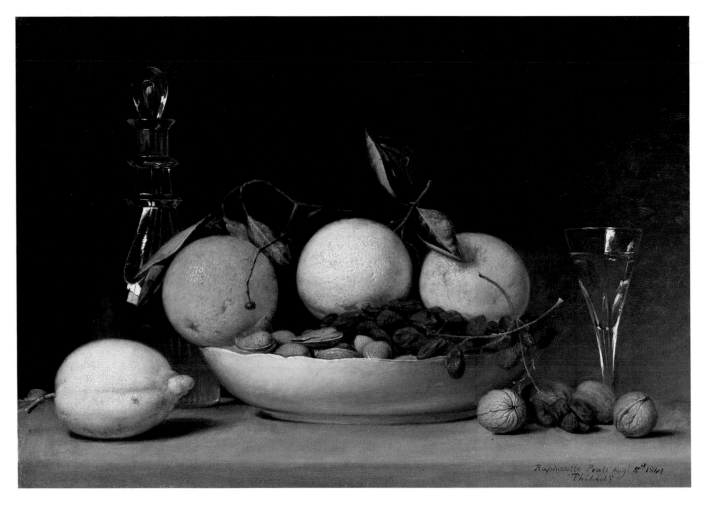

13

RAPHAELLE PEALE (1774–1825)
Venus Rising from the Sea—A Deception [*After the Bath*], 1823
Oil on canvas, 29 × 24 in. (73.7 × 61 cm.)
William Rockhill Nelson Gallery of Art and Atkins Museum of Fine Arts, Kansas City,
 Missouri, Nelson Fund

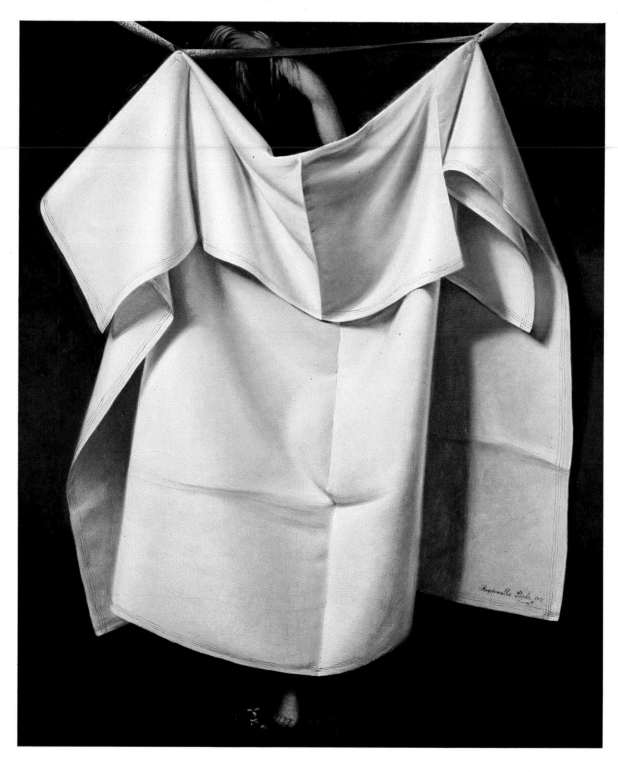

II. *The Grand Manner*

As remarkable as Copley's development of a probing portrait style in Boston, and even more significant for the future of the arts in America, was Benjamin West's rise to international prominence. For West was also a young American—born in 1738, like Copley—who determined early on to become a great painter. Growing up in Philadelphia, gleaning what he could from local painters, West learned to make portraits in the Baroque manner which may have been acceptable likenesses but which showed few of the natural gifts of his contemporary in Boston. Reading of the artistic glories of London and Rome, he formed the same high ambition as Copley—to travel abroad in order to become a history painter. Good fortune then shone on West, as it would throughout his life, and the support of a group of patrons enabled him to travel to Europe at the age of twenty-two. Arriving in Rome in July 1760, he became the first of many American painters to undertake the Grand Tour. He went on to succeed beyond his wildest dreams, becoming during his career official painter to the British sovereign George III, president of the Royal Academy in London, and teacher and exemplar for three generations of aspiring American artists.

In 1765, West's first American student, the Philadelphian Matthew Pratt, painted a small group portrait which he entitled "The American School" (Metropolitan Museum of Art, New York): it was remarkable in showing a group of young American painters gathered around West for instruction in his London studio, and its prescient title suggests that West's studio had already become, *de facto*, the first American art academy. West and his students in London faced few of the limitations of environment and culture about which Copley complained so eloquently. While they considered the noblest form of art to lie in emulating Renaissance masters in the practice of "history painting"—the depiction of moralizing scenes from classical or contemporary literature, from the Bible, or from recent military or political history—they also painted and exhibited landscapes and seascapes, "genre" pictures, architectural views, sporting scenes, and of course the great staple, portraits. Thus when Charles Willson Peale returned home from London in 1769 he understood not only the painter's technique but also his aspirations; from West's example, he knew how to exhibit and sell paintings, how to establish academies, and how to teach others these skills.

West's painting *Agrippina Landing at Brundisium with the Ashes of Germanicus* of 1768 (Yale University Art Gallery, New Haven,

Conn.), heralds the new neoclassical style which celebrated antique virtue as a model for modern conduct, and which was carried to its heights by Jacques-Louis David in France two decades later. West's superb *Death of Wolfe* of 1771 (National Gallery of Canada, Ottawa) established the period's image of war as the death of a modern, Christ-like hero. And his paintings of the mid-seventies point toward the new Romantic style, which he fully developed in his series of drawings and paintings from 1783 to 1817 dealing with the "fury, horror, and despair"[1] of an apocalyptic subject taken from the Book of Revelation, *Death on the Pale Horse* (see cat. no. 16). Moreover, West was, when the spirit moved him, a superb portraitist, and many of his best pictures are those of visiting Americans, from an early one of *Charles Willson Peale* (New-York Historical Society) to the intense *Robert Fulton* of 1806 (New York Historical Association, Cooperstown).

When Copley arrived in London in July 1774, he naturally sought out the well-established West, who received him with his characteristic kindness and generosity. However, the long-awaited experience of seeing the works of the Old Masters for the first time proved disappointing for Copley: he wrote that "the works of the great Masters are but Pictures"[2]; apparently he had expected the Titians and Raphaels to be perfect and magical, something more than paint on canvas. Absorbing a panoply of European styles as he traveled to Paris and then through Italy to Rome, he shucked off the restrictions of his colonial culture, reporting excitedly "there is a kind of luxury in seeing."[3] In Rome in 1775 he painted *Mr. and Mrs. Ralph Izard* (Museum of Fine Arts, Boston) in a new manner, decoratively and superficially: it seems somehow tragic that he never came to realize what he had accomplished "in his own little way" in Boston, but rather was so anxious to join the international mainstream that he gave up his unique American manner.

Copley aimed to succeed on the highest level—as a painter of large-scale narrative or history paintings. He began this effort in 1778 with the remarkable *Watson and the Shark* (cat. no. 14) which won praise in London for its exotic subject and superbly balanced neoclassical composition. His *Death of the Earl of Chatham* (1779–81; Tate Gallery, London), a scene from recent English history, brought him greater success, and his next great work, the *Death of Major Peirson* of 1782–84 (Tate Gallery, London), fully established his reputation. At that time, quite remarkably, two of the preeminent British masters—West and Copley—

were Americans. Both men maintained an allegiance to their native country, its artists and institutions, but neither ever returned home.

West's flexibility as a teacher and his own changing interests over the years are demonstrated by the variety of styles and specialties of his students. C. W. Peale took home a rococo portrait style, while Gilbert Stuart, who was in London in the following decade, developed a far simpler, more classical style. Quite another course was followed by John Trumbull, a graduate of Harvard College in 1773 and the first American painter to stem from the educated upper class. His earliest work, like Stuart's, was influenced by Copley's American style. Later, he spent the years from 1784 to 1789 in London, and under the guidance of West he set about the great project of his career, the depiction of the major events of the Revolutionary War. Beginning in 1785 with his *Battle of Bunker's Hill* (Yale University Art Gallery, New Haven, Conn.), which was based on the West prototype *The Death of Wolfe* though painted more fluidly, Trumbull set out to create a grand series of fourteen pictures. At the same time, he aimed to establish his reputation as a history painter in England through his depiction of the British victory in holding Gibraltar against French and Spanish troops (see cat.no. 15). He longed to return to America in triumph, with the Revolution series profitably engraved, and commissions coming to him for large, public versions of his compositions.

But neither private citizens nor governmental bodies in America were yet ready to support painters of Trumbull's ambition and interests. It was not until 1817 that the U.S. Congress finally commissioned Trumbull to paint four pictures for the Capitol Rotunda, and by then he was discouraged and embittered, having spent many years painting largely undistinguished portraits for an undiscerning clientele. Like so many American painters throughout the nineteenth century, his best work was achieved early in his career; lacking the nourishment of a sympathetic public, his art withered and declined in the long years at home.

If Trumbull may be said to have failed in the largest sense, then a later student of West's, Washington Allston, must be deemed a success. Allston spent most of the period from 1801 to 1818 abroad, studying with West, becoming familiar with the galleries of the Grand Tour—especially those of Rome—and then becoming an esteemed landscape, portrait, and religious history painter back in London. His style combined classical subjects with a Romantic approach, and his technique was essentially Venetian, with rich glazing and subtle coloration. Allston's interests lay in the irrational and the mysterious, in moments of supernatural intervention and intense human emotion. Despite his concern with these subjects, so far from the American preference for "likenesses," Allston's work, his ambitions, and his personality all attracted popular attention when he returned to Boston in 1818. He was genuinely learned and totally devoted to his art; his sincerity and passion were manifest. The English poet Coleridge regarded him as "a man of genius," as did a generation of Americans. His work was collected, particularly in Boston, and patrons gathered to support him over the years that he was working on the never-completed *Belshazzar's Feast* (Detroit Institute of Arts). Allston's *Elijah in the Desert* of 1818 (cat.no. 18)—after the biblical tale in which the prophet Elijah, wandering in the desert, is

miraculously rewarded for his faith when ravens bring him food—looks at once backward and toward the future. It reflects the artist's learning, and especially his recent exposure in Paris to the work of Titian and Salvator Rosa. Painted in England, it was brought by Allston to the artistic desert of America in the hope that he too would be rewarded with miraculous nourishment and support in the New World. And his faith was rewarded: unlike every one of his predecessors in America, he never had to resort to portraiture in order to make a living. Rather, his idealized works, based on European art, helped establish the art of painting in America.

Of the Americans aspiring to the Grand Manner, only John Vanderlyn studied extensively in Paris rather than with West in London. He was there in the years 1797 to 1801, learning the French neoclassical style, and during 1803–4 he returned to Paris with his friend Allston; Vanderlyn's *Murder of Jane McCrea* (Wadsworth Atheneum, Hartford, Conn.) and Allston's *Landscape—A Wild Place* (unlocated) were exhibited at the Salon of 1804, the first American works to be shown there.[4]

In the following year, both Vanderlyn and Allston painted extraordinary portraits in the modern style. These works had little to do with the American mainstream, which generally followed Stuart's model, but they showed what the gifted American abroad could accomplish. Vanderlyn's portrait of *Sampson Vryling Stoddard Wilder* (cat.no. 20) demonstrates his mastery of French style in its crisp execution and the direct, haughty gaze of the sitter, while Allston's *Self-Portrait* (cat.no. 17) is quite different in mood, being restrained, introspective, and ultimately enigmatic. Later, Vanderlyn's *Marius amid the Ruins of Carthage* (1807; M. H. de Young Memorial Museum, San Francisco) was awarded a gold medal on the order of Emperor Napoleon. His superb nude, *Ariadne Asleep on the Isle of Naxos* of 1814 (cat.no. 19), equally attests to the artist's ambition and sophistication. Like so much of the best work by Americans of the period, it was executed outside the United States, where there would have been neither critical acclaim, popular understanding, nor patronage for it. As with Trumbull, Vanderlyn's late career at home was marked by personal frustration and stylistic decline.

Allston's friend and student Samuel F. B. Morse, who later gained fame as the inventor of the telegraph, traveled to London in 1811. He was captivated by West (proclaiming "he has just completed a picture . . . which has never been excelled. In his private character he is unimpeachable. . . ."[5]) and by the idea of becoming a history painter in the Grand Manner. Morse shared the ambitions of his generation in stating that he could never be satisfied "unless I am pursuing the intellectual branch of the art. Portraits have none of it; landscape has some of it, but history has it wholly."[6] As late as 1832–33, Morse was making his noblest effort to raise American taste to European levels. Seeking to demonstrate both his own proficiency and to introduce many of the greatest sixteenth- and seventeenth-century Old Master paintings of the Louvre—all at once—to an uneducated American public, he painted his celebrated *Gallery of the Louvre* (cat.no. 22). In this totally romantic conception, executed with exceptional grace and proficiency, Morse imaginatively "rehung" the Salon Carré and rescaled its pictures for his own greater end: the transplanting of European taste and style to American shores.

14

JOHN SINGLETON COPLEY (1738–1815)
Watson and the Shark, 1778
Oil on canvas, 72 × 90¼ in. (182.9 × 229.2 cm.)
Museum of Fine Arts, Boston, Gift of Mrs. George von Lengerke Meyer

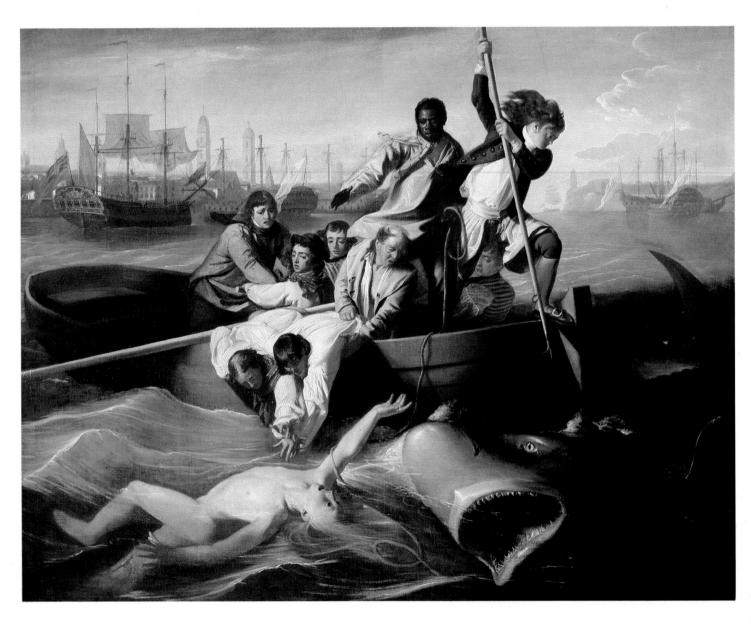

15
JOHN TRUMBULL (1756–1843)
The Sortie Made by the Garrison of Gibraltar, 1788
Oil on canvas, 20 × 30 in. (50.8 × 76.2 cm.)
Cincinnati Art Museum, Ohio, John J. Emery Endowment

16
BENJAMIN WEST (1738–1820)
Death on the Pale Horse, 1796
Oil on canvas, 23½ × 50½ in. (59.7 × 128.3 cm.)
The Detroit Institute of Arts, Founders Society Purchase,
 Robert H. Tannahill Foundation Fund

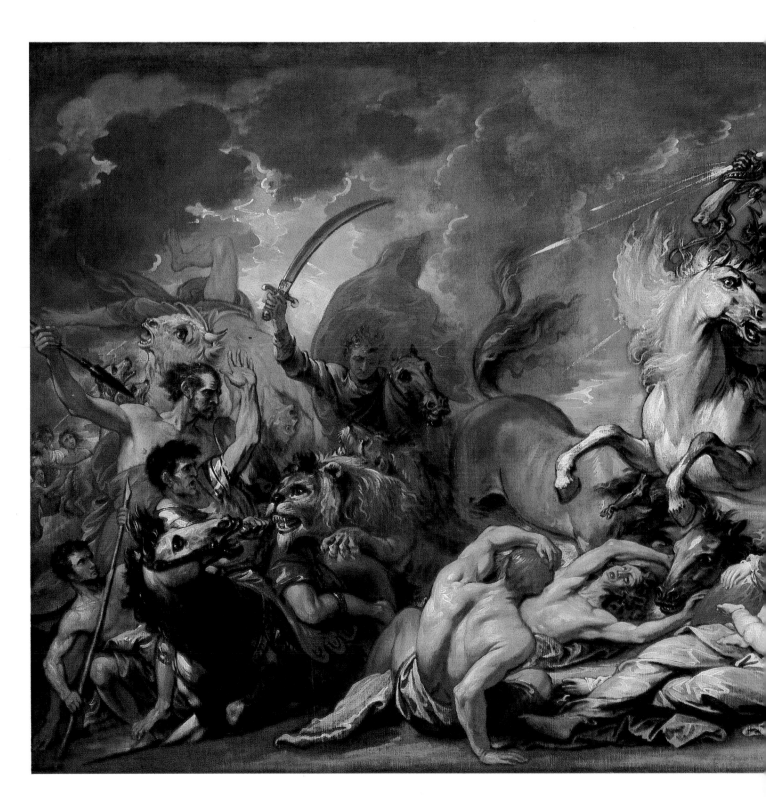

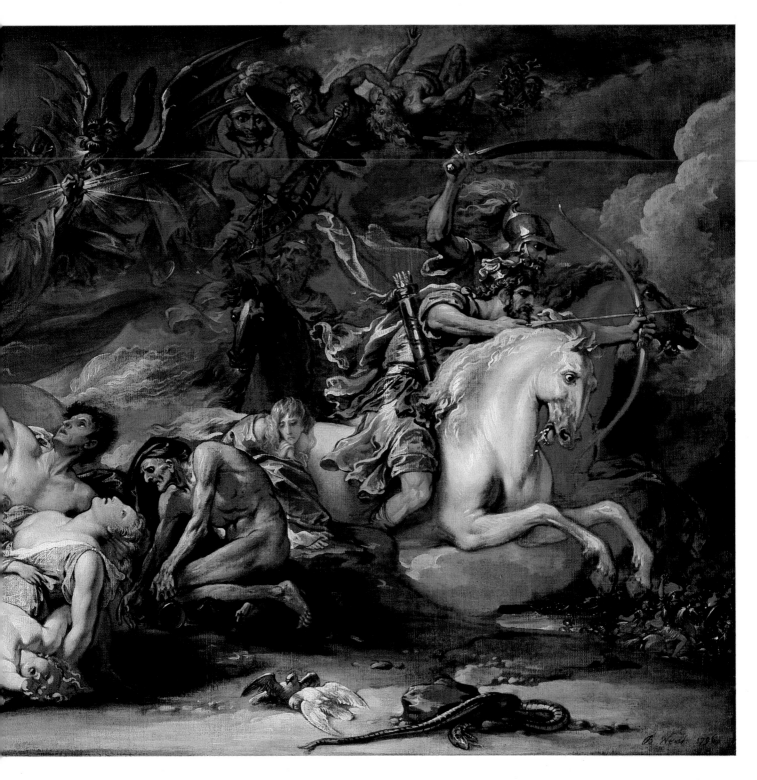

17
WASHINGTON ALLSTON (1779–1843)
Self-Portrait, 1805
Oil on canvas, $31\frac{1}{2} \times 26\frac{1}{2}$ in. (80 × 67.3 cm.)
Museum of Fine Arts, Boston, Bequest of Miss Alice Hooper

18
WASHINGTON ALLSTON (1779–1843)
Elijah in the Desert, 1818
Oil on canvas, $48\frac{3}{4} \times 72\frac{1}{2}$ in. (123.8 × 184.2 cm.)
Museum of Fine Arts, Boston, Gift of Mrs. Samuel Hooper and Miss Alice Hooper

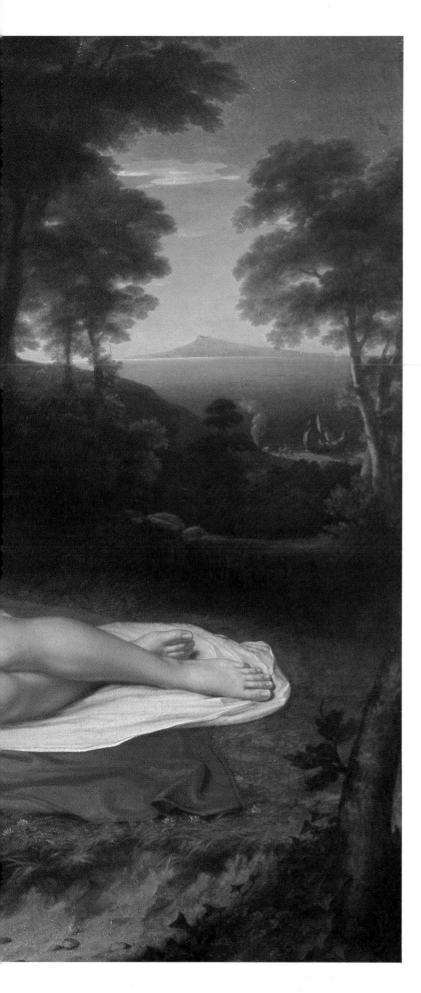

19

JOHN VANDERLYN (1775–1852)
Ariadne Asleep on the Island of Naxos, 1814
Oil on canvas, 68 × 87 in. (172.7 × 221 cm.)
The Pennsylvania Academy of the Fine Arts, Philadelphia,
 Presented by Mrs. Joseph Harrison, Jr.

20

JOHN VANDERLYN (1775–1852)
Sampson Vryling Stoddard Wilder, 1805/1808–12
Oil on canvas, $36\frac{1}{4} \times 28\frac{7}{8}$ in. (92.1 × 73.4 cm.)
Worcester Art Museum, Massachusetts,
 Gift of Lawrence Alan Haines in memory of his father,
 Wilder Haydn Haines

21

JOHN NEAGLE (1796–1865)
Dr. William Potts Dewees, 1833
Oil on canvas, $56\frac{3}{4} \times 44\frac{3}{4}$ in. (144.1 × 113.7 cm.)
University of Pennsylvania School of Medicine, Philadelphia

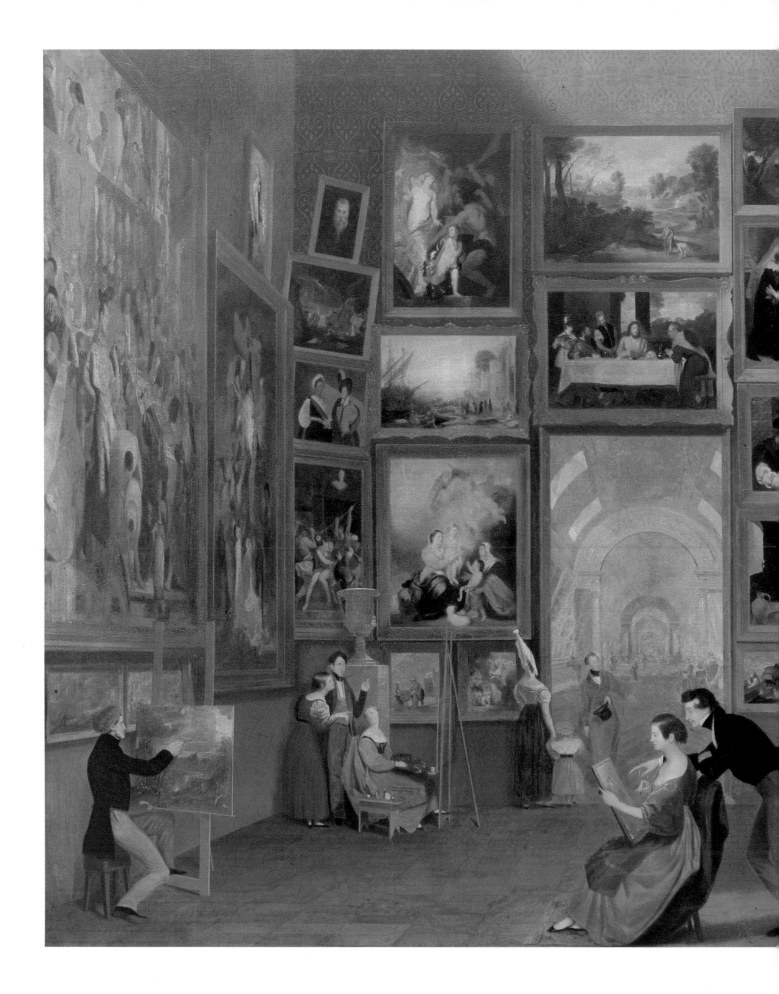

22
SAMUEL F. B. MORSE (1791–1872)
Gallery of the Louvre, 1833
Oil on canvas, $73\frac{3}{4} \times 108$ in.
 (187.3 × 274.4 cm.)
Terra Museum of American Art,
 Evanston, Illinois,
 Daniel J. Terra Collection

III. *Painter & Poet in the Land*

During the first third of the nineteenth century, solid roots for the growth of an American culture were finally set. The eighteenth century had witnessed isolated achievements by remarkable men of the Enlightenment—Franklin and Jefferson in statecraft and learning, Copley and the elder Peale in the arts—but it was only with America's final military victory over Britain in the War of 1812 that the true work of cultural independence began.

American artists returning from study abroad during these early years of the nineteenth century were greeted by a barren artistic environment. As E. P. Richardson has said, "There was no Emperor to distribute honors, no Louvre to lend prestige to painting, no Salon to attract the attention of society"[1]; neither were there art schools, regular exhibitions, nor more than a handful of patrons. Art, if it meant anything at all to Americans, meant simply a portrait likeness painted quickly and bought cheaply.

But there were signs of change and growth. In New York in 1802 a group of merchants established the American Academy of the Fine Arts, the first lasting institution of its kind in the New World. For years its only function was to house a set of plaster casts after the antique from which aspiring artists could study, but in 1816 it began holding annual exhibitions of contemporary painting. In Philadelphia, on 13 June 1805, Charles Willson Peale wrote Thomas Jefferson about his city's plans for an institution to display casts of statues and paintings and to teach young artists; later that year the Pennsylvania Academy of the Fine Arts was founded, "to improve artists, to correct public taste, to call forth talents from obscurity, . . . to prevent the emigration of young artists to foreign countries," and most importantly, "to give a character to the fine arts in America."[2] And in Boston, by this time ranked third among America's art centers, an Athenaeum was founded in 1807. Though its primary function was as a library, it also began holding annual exhibitions in 1826 and soon began to build a fine art collection.

The establishment of these institutions led to the founding in New York in 1826 of the National Academy of Design, which quickly gained a position of national preeminence which it held for nearly a century. Its founders included Samuel F. B. Morse, who became president, Rembrandt Peale, John Vanderlyn, William Dunlap—the first historian of American art, whose landmark book *History of the Rise and Progress of the Arts of Design in the United States* appeared in 1834—and most important for the future, the landscapists Thomas Cole and Asher B. Durand.

Progress in the arts and in artistic institutions was paralleled in these years by the rise of poetry and fiction. Three authors in particular contributed to the formation of a national literature. One was Washington Irving (1783–1859), whose *Sketch Book* became a best-seller both in England and the U.S., making him the first American writer to win an international reputation. Many of his sketches dealt with travel in England, but the most memorable ones, particularly "Rip van Winkle" and "The Legend of Sleepy Hollow," were based on American experience and quickly became part of American folklore. Irving's contemporary, James Fenimore Cooper (1789–1851), also began in a conventional English mode, but his second novel, *The Spy*, is the first of its genre, a democratic historical novel. In *The Pioneers* (1823) and *The Last of the Mohicans* (1826), Cooper wrote of the American wilderness and its highly principled Indians and backwoodsmen, and took a major step toward creating an American literature. Finally, William Cullen Bryant (1794–1878) became America's leading nature poet. "Thanatopsis"—one of his earliest and best poems—was published in *The North American Review* in 1817, two years after that important magazine was founded. The poem expresses the love and warmth which Bryant, following Wordsworth, felt for nature, which he regarded as holy: "To him who in the love of Nature holds / Communion with her visible forms, she speaks / A various language."

By identifying American art with the American land, these poets and novelists, within one short generation, found in their works a sense of nationality that had eluded contemporary painters. Though none of these authors ever quite achieved true greatness, together they made a substantial contribution to American culture, and they also helped set the stage for the rise of Thomas Cole and the landscape school.

Landscapes had been painted occasionally in America at least since the time of John Smibert in the 1730s. The untrained Winthrop Chandler made landscapes in the Connecticut River Valley before the Revolution, as did John Trumbull, Ralph Earl, and others shortly after. At the turn of the century, English painters including Francis Guy and William Groombridge brought new landscape techniques to these shores, and by 1820 at least two men, Alvan Fisher in Boston and Thomas Doughty in Philadelphia, made their living as full-time painters of landscape views. Nonetheless, all this was prologue to Thomas

Cole's arrival in New York in 1825, for it was Cole who accomplished in painting what Cooper had in writing, creating a new, powerful form which responded to national needs.

Cole had his own strong links with the Old World, having been born in an English industrial town and apprenticed there to an engraver. He painted portraits as an itinerant and studied briefly at the Pennsylvania Academy before his fortuitous move in 1825 to New York—a city just then becoming the economic and cultural hub of the U.S. When the aging Trumbull saw Cole's early landscapes, he quickly recognized their strength, and Cole became an immediate success. Bryant noted that "from that time he had a fixed reputation," and Henry Tuckerman, the leading mid-century historian of American art, felt the same way: "To him may be traced directly the primal success of landscape painting as a national art in the new world."[3]

Cole was quite simply the ablest landscape painter of his time. He viewed nature passionately, as a living, holy place full of meaning and symbol, and he surely agreed with Emerson's statement that "every natural fact is a symbol of some spiritual fact. . . . The whole of nature is a metaphor of the human mind."[4] Cole in many ways was the first full-fledged American Romantic. He exulted in nature's variety, and identified with her changing moods. He was a poet, a gifted essayist, prolific letter-writer, theorist, and traveler; he drew constantly and well, and he was not afraid to use his paints quickly and exuberantly. He was also much more than a landscape painter; he was a teacher and in a sense also a history painter in his every work. As such, he was too sophisticated for his patrons, and he engaged in a constant struggle to combat and modify their taste for simple and recognizable American views.

Cole was anything but the simple materialist. As he wrote his friend Durand, "I never succeed in painting scenes, however beautiful, immediately on returning from them. I must wait for time to draw a veil over the common details, the unessential parts which shall leave the great features, whether the beautiful or the sublime, dominant in the mind."[5] Parallel to Cole's sentiment is Emerson's statement that "Transcendentalism . . . is Idealism," and crucial to it, he said, was "the tendency to respect the intuitions and to give them . . . all authority over our experience."[6]

Like every painter since Benjamin West, Cole dreamed of making the Grand Tour of Europe to see the Old Masters. When he planned to set sail in June 1829, however, his friends and patrons, rather than encouraging him, warned of the risks to his art. Their resistance indicated a new attitude toward American culture, now thought to be strong enough to sustain an artist of great ability like Cole, but still too weak to withstand the lure and the luxury of European style. The poet Bryant wrote a sonnet to Cole warning that "Fair scenes shall greet thee where thou goest, fair / But different . . ." and admonishing him to "Gaze on them, till the tears shall dim thy sight, / But keep that earlier, wilder image bright."[7]

Following Allston's advice, Cole spent most of his time abroad traveling in England (he concluded, "I cannot but think I have done more than any of the English painters"), then went briefly to Paris, where like Morse he was disappointed to find the Old Masters preempted by modern painters ("I was disgusted . . . with their subjects. Battle, murder, and death, Venuses and Psyches, the bloody and the voluptuous . . .").[8] However, the

European experience added greatly to Cole's vocabulary and enriched his imagination: his experience with the light and scenery of Italy and with the towers and castles of England and the Rhine matured his vision and enabled him to become a full-fledged Romantic. On his return he could speak to his nation as artist and as moralizer, as Copley had done before him, as Church and Homer and Eakins would do later. Cole's ethic expands beyond that of the native sublime ("the wilderness," he wrote, "is yet a fitting place in which to speak of God")[9] to a vision of truth for his nation and for mankind. In *The Titan's Goblet* (cat.no.24) he refers to mighty races from legendary times. He goes on to speak allegorically yet directly to the future of America and to the sins of pride and lust in his *Course of Empire* (1836; New-York Historical Society), which Cooper called "the work of the highest genius this country has ever produced."[10] At the height of his powers, he executed a similar allegory, *Past and Present* (1838; Amherst College, Mass.) before concluding with a four-painting series, *The Voyage of Life* (cat.nos.25–28), which deals not with vanity and power but with the ultimate human question, Whither goest thou?

Cole's patron Luman Reed urged him to paint simple American views rather than trying to force his history scenes on the public and collectors, and Cole frequently obliged—both because "fancy pictures seldom sell, and they generally take more time than views,"[11] as he put it, but also because he saw *every* picture as a speaking of man and God, as containing an allegorical message. Thus, his famous *Oxbow* (1836; Metropolitan Museum of Art, New York) tells of calm following a storm, of cultivated farmland contrasted to wilderness, of the role of the artist, and of the Lord as supreme painter making marks on his canvas. *Schroon Mountain, Adirondacks* (cat.no.30) is equally idealized: the Adirondack forest and a modest peak of four thousand feet become symbols for America's wilderness purity and for her national aspiration, while autumn colors represent the special quality of our land. The *View of Florence from San Miniato* (cat.no.29) represents the other side of the world, and the other side of man: here Cole revels not in the sublime but in the beautiful, the gentle, the civilized, in all that is best about man's accomplishment on earth.

When Cole died in 1848 in Catskill, New York, on the banks of the Hudson River, the nation lost its most popular painter. His work had become well known through countless reproductions, engravings, and copies, and many imitators had followed his lead in painting views of the Catskills and the White Mountains, of the Maine coast, Niagara Falls, and other picturesque sights. They followed his methods as well, traveling through the countryside making drawings and oil sketches from nature, before returning to their city studios to work up the finished paintings.

After the death of Cole, his friend Durand became the landscape school's leading teacher and theorist. His "Letters on Landscape Painting," published in the new American art magazine *The Crayon* in 1855, codified the school's approach to landscape. Durand's own meticulous, delicate style is seen at its best in his *Kindred Spirits* (cat.no.31), painted in memory of Cole a year after his death and commemorating his friendship with Bryant. Here painter and poet together enjoy God's perfect landscape, the American wilderness.

23
JOHN QUIDOR (1801–1881)
Money Diggers, 1832
Oil on canvas, $16\frac{5}{8} \times 21\frac{1}{2}$ in. (42.2 × 54.6 cm.)
The Brooklyn Museum, Gift of Mr. and Mrs. Alastair Bradley Martin

24
THOMAS COLE (1801–1848)
The Titan's Goblet, 1833
Oil on canvas, $19\frac{3}{8} \times 16\frac{1}{8}$ in. (49.3×41 cm.)
The Metropolitan Museum of Art, New York, Gift of Samuel P. Avery, Jr., 1904

25
THOMAS COLE (1801–1848)
The Voyage of Life: Childhood, 1842
Oil on canvas, $52\frac{7}{8} \times 76\frac{7}{8}$ in. (134.3 × 195.3 cm.)
National Gallery of Art, Washington, D.C., Ailsa Mellon Bruce Fund, 1971

26
THOMAS COLE (1801–1848)
The Voyage of Life: Youth, 1842
Oil on canvas, $52\frac{7}{8} \times 76\frac{3}{4}$ in. (134.3 × 194.9 cm.)
National Gallery of Art, Washington, D.C., Ailsa Mellon Bruce Fund, 1971

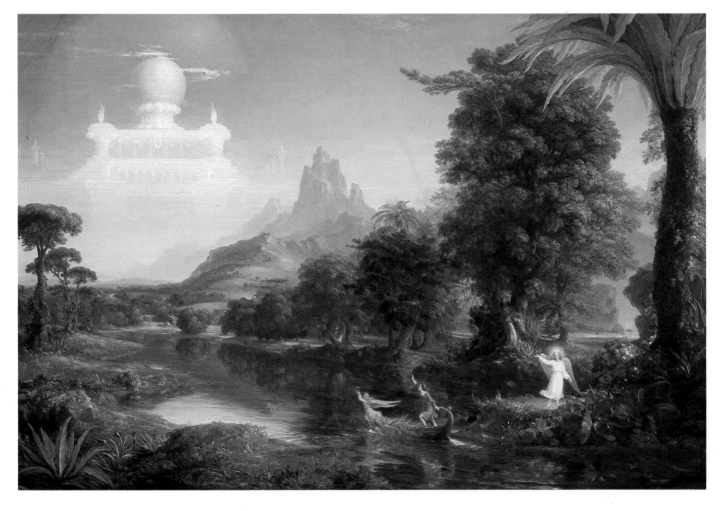

27
THOMAS COLE (1801–1848)
The Voyage of Life: Manhood, 1842
Oil on canvas, $52\frac{7}{8} \times 79\frac{3}{4}$ in. (134.3×202.6 cm.)
National Gallery of Art, Washington, D.C., Ailsa Mellon Bruce Fund, 1971
[Detail on pages 70–71]

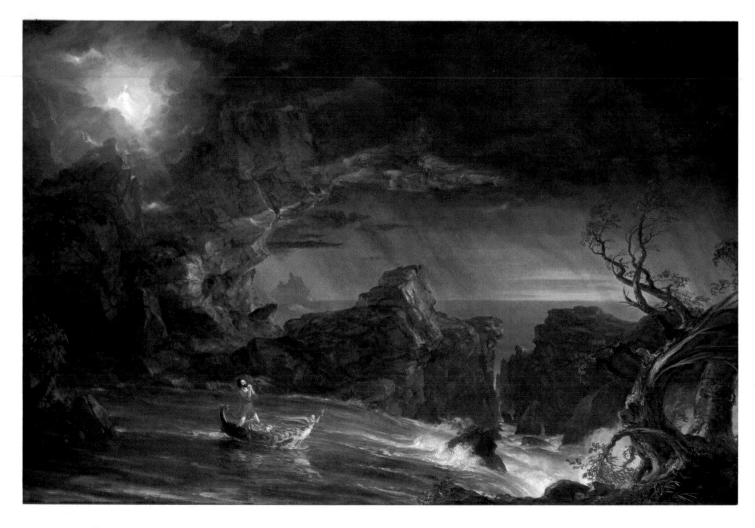

29 [pages 74–75]
THOMAS COLE (1801–1848)
View of Florence from San Miniato, 1837
Oil on canvas, 39 × 63⅛ in. (99.1 × 160.3 cm.)
The Cleveland Museum of Art, Purchase, Mr. and Mrs. William H. Marlatt Fund

28
THOMAS COLE (1801–1848)
The Voyage of Life: Old Age, 1842
Oil on canvas, 52½ × 77¼ in. (133.4 × 196.2 cm.)
National Gallery of Art, Washington, D.C., Ailsa Mellon Bruce Fund, 1971

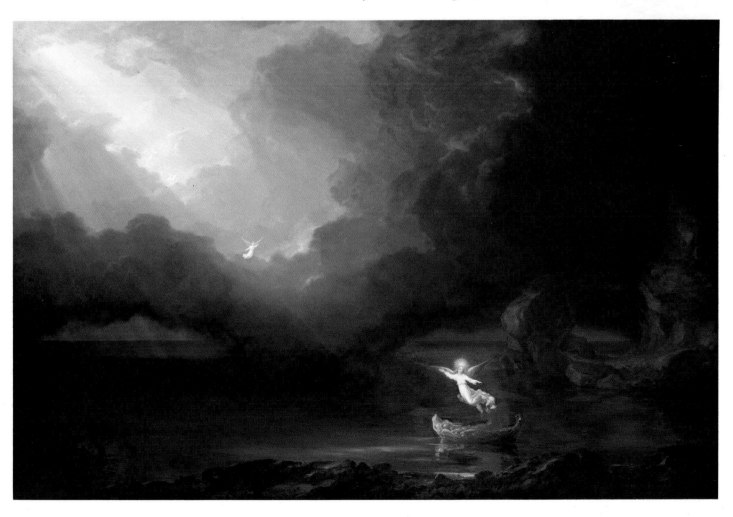

30
THOMAS COLE (1801–1848)
Schroon Mountain, Adirondacks, 1838
Oil on canvas, 39⅜ × 63 in. (100 × 160 cm.)
The Cleveland Museum of Art, The Hinman B. Hurlbut Collection

31
ASHER B. DURAND (1796–1886)
Kindred Spirits, 1849
Oil on canvas, $44\frac{1}{8} \times 36\frac{1}{16}$ in. (112.1×91.6 cm.)
The New York Public Library, Astor, Lenox and Tilden Foundations

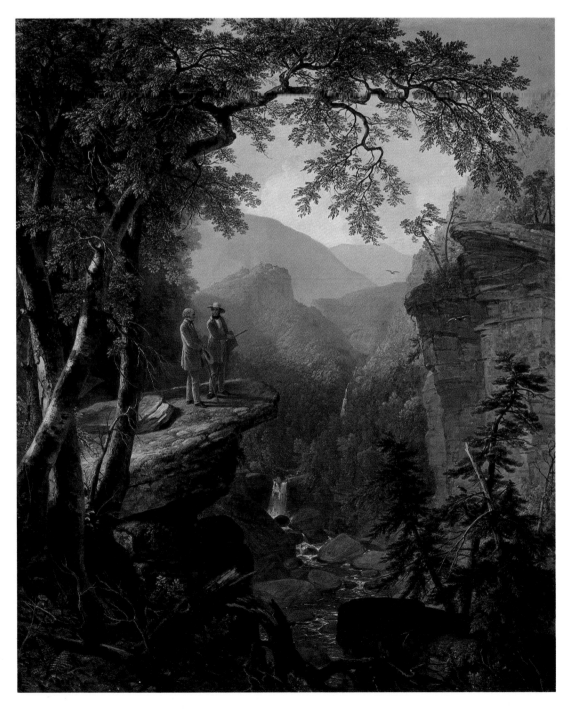

IV. The Ideal Landscape

The arts in America prospered during the 1830s. Art academies grew stronger, and newly wealthy merchants in the larger cities began to form fine collections of contemporary American painting. Following the examples of Stuart, Allston, and Cole, painters began to work in every city and many of the smaller towns across the nation. A land that had been feared inevitably barren for the arts now became supportive of them, to the extent that one foreign visitor wrote in 1837: "While in America I was struck by the manner in which the imaginative talent of the people had thrown itself forth into painting; the country seemed to swarm with painters."[1] Portraiture was still in highest demand, as it would be throughout the century, but now the pyramid of artistic talent was much broader: at the top were a few able painters in the major metropolitan centers (such as Jarvis and Waldo in New York, Sully and Neagle in Philadelphia), while secondary talents in major cities and in small towns produced large quantities of work for eager patrons. The new demand also supported many practitioners of other genres, including historical and literary illustration, "comick" scenes of daily life, still life, and especially landscape, which was beginning to play an increasingly important role as the new national art.

Ralph Waldo Emerson optimistically reported on the state of American letters to his Harvard audience in 1837, proclaiming that "our day of dependence, our long apprenticeship to the learning of other lands, draws to a close."[2] In terms of literature, Emerson was certainly justified, for his own work had already reached maturity, and that of his contemporaries was not far behind. This unequaled moment of ripeness in our national literature has been called the "American Renaissance": it is marked by Hawthorne's *Scarlet Letter* (1850) and *House of the Seven Gables* (1851), by Melville's *Moby Dick* (1851), Thoreau's *Walden* (1854), Whitman's *Leaves of Grass* (1855), and by Emerson's own work, beginning with *Nature* (1836).[3] There is no doubt that a wide-reaching, multifarious, heroic American voice is found here; the question is whether the contemporary generation of painters reached the same level of independence, or the same heights of creativity.

Thomas Cole affirmed the special, American quality of our wilderness—"We are still in Eden"[4]—and the unique opportunity it provided for the development of a truly national school, and Durand instructed the young landscapist to avoid Europe, saying: "Go not abroad then in search of material for the exercise of your pencil, while the virgin charms of our native land have claims on your deepest affections."[5] In the years following Cole's death in 1848, two painters, Frederic Edwin Church and Fitz Hugh Lane, painted the American Eden in a new way. In their hands, the "day of dependence" on Europe did end, for

both men were fully trained in America: for them, the idea of travel and study in Paris or London seemed both unnecessary and unwise. Instead, they followed Durand's dictates, studying America's "virgin charms" in detail, drawing trees and rocks, observing changes of light and atmosphere, while portraying the holiness of nature. They painted ideal landscapes whose details were based on experience but whose overall effect was grounded in faith. Realism for these painters was a preliminary necessity, "an inferior . . . disciplinary stage of Idealism," as Durand said; but the proper landscape surpassed reality: "that picture is ideal whose component parts are representative of the utmost perfection of Nature."[6] Or as Emerson himself put it: "In landscape, the painter should give the suggestion of a fairer creation than we know."[7]

Church had become Cole's student in 1844 and was quickly recognized as his successor as leader of the American landscape school. Cole had painted romantic landscape, combining in his imagination selections from observed nature, literature, and allegory; he had portrayed nature's dichotomies, depicting good and evil, past and present, dream and reality. Church and his generation, on the other hand, painted the ideal landscape of which Durand had written: for Church only natural history spoke of creation and signified the special, holy destiny of the New World.

Church's *Mt. Ktaadn* of 1853 (cat.no. 36) portrays the greatest peak of the Maine wilderness under a twilight sky and in a perfect, windless calm. Church studied the mountain from every angle, under varying conditions of light and weather, and carefully recorded his observations in pencil and oil sketches. Later in his New York studio he idealized the scene, making the peak higher and more symmetrical, and adding a lake and a mill, figures and cattle, to make the harsh wilderness landscape suitably picturesque. In doing so, he followed standard practice of the period. As Edgar Allan Poe had said, "In the most enchanting of natural landscapes, there will always be found a defect or an excess," concluding that "the arrangement of these parts will always be susceptible of improvement" by the artist.[8]

In the following decade—the period of his greatest creativity—Church went on to win wide popular recognition, financial reward, and critical acclaim for his views of the New World. In *Niagara Falls* of 1857 (cat.no. 38), he portrayed America's unrivaled natural wonder. Combining closely painted detail with a sweeping, panoramic composition, he expressed the power of nature and the optimism and strength of the nation itself. *Twilight in the Wilderness* (cat.no. 39), the most dramatic of his North American paintings, represents a hushed and fragile moment, one of intense silence and tension, one of awe. Here was the pure wilderness as God had made it, before man.

Church's art depended on the constant challenge and renewal of ever grander subjects. He was drawn especially to the immense peaks and wondrous vegetation of the Andes Mountains of Colombia and Ecuador, and much of his best work resulted from his trips of 1853 and 1857 to that distant region. His masterwork of 1862, *Cotopaxi* (cat.no.45) represents a tropical Eden on earth, at once rational in its detailed description yet incomprehensible in its exotic grandeur: this is ideal landscape literally at a moment of Creation, with smoke pouring from the massive volcano and nearly obliterating the sinking sun. Like Melville with *Moby Dick* and *Typee*, Church voyaged ever further to escape the realities of his own place and time while seeking moral lessons in the exotic and the magnificent. With his voyage to the Arctic and the resulting *Icebergs* of 1861 (cat.no.44), his art becomes increasingly theatrical, and a purer, dreamlike romanticism dominates his picture-making.

Church's great contemporary, Fitz Hugh Lane, stemmed from a very different background and had a different kind of career. Where Church became a national figure, Lane remained always a middle-class painter who was known and admired only locally in his native town of Gloucester, Massachusetts. If Church recalls Melville in his escapism and his heroic scale, Lane is closer to Thoreau, who ventured only a few miles from home to Walden Pond in order to discover universal truths. Church's art was, to use Barbara Novak's terms, one of "Grand Opera," while Lane's was that of "the still small voice."[9]

Marine painting as such hardly existed in America before Lane came to maturity around 1850, and his major predecessors, such as Robert Salmon (1775–c.1845), were most often immigrants who had been fully trained abroad. In view of the reliance of all the Eastern states—and especially those of New England—on shipping and commercial fishing, the late development of the genre may seem surprising; but it is no more so than the lack of eighteenth-century wilderness scenes. For the Romantic painter bases his art on reminiscence, on the recognition of loss and the concurrent need to record memory. Thus the forests weren't painted until they were threatened by sawmills and settlements, and the sea became a proper subject only when painters intuited that the picturesque age of sail was giving way to a different, modern age of steamships. Significantly, Lane's harbor scenes become more idealized as he goes along: the crowded, bustling commercial harbors of the early 1850s (see cat.no.32)—corresponding to Church's *Mt. Ktaadn* in their vision of the world—are replaced in the following years by nearly empty views of harbors in the Maine wilderness, where single ships ride at anchor awaiting their end, a poignant reminder of earlier, better times.

Emerson had written that "thanks to the nervous, rocky west . . . we shall yet have an American genius."[10] In one sense he may have been correct, for the existence of the ever moving westward frontier and the fact of a seemingly limitless area for national expansion crucially influenced the American mind and thus our artistic imagination. In a more literal sense, however, the West seems to have had little affected our art, for in fact neither the mountains and plains nor the cowboys and Indians of the frontier were often used as subjects by our major painters. Most of the highly regarded landscape painters did take at least one extensive trip to the Rocky Mountains and beyond, but few

paintings of note resulted: the subject was somehow too big, too empty, too difficult to convey. However, Western scenery did become the specialty of Albert Bierstadt, whose work won great popularity during the 1860s and '70s. The brilliant oil sketches he made on his first trip West in 1859 and thereafter became the basis for a number of climactic pictures of the Western mountains. His *Sierra Nevada in California* of 1868 (cat.no.47) shows the artist, and the "Grand Opera" style, at their best: this painting demonstrated to an astounded Eastern public the almost unbelievable magnificence and the crystalline purity of the last American wilderness.

The chief landscape painters, with the exception of Lane, worked in or near New York, and a number of them had studios in the same building on Tenth Street. They have been known collectively as the "Hudson River School," a lasting though literally inaccurate appellation, for the Hudson was only one of the many subjects which they frequently portrayed. During the summers, the artists would venture out on sketching trips, Church on his long voyages, Bierstadt to the West, and others to Lake George and the Adirondack Mountains, the White Mountains, the coast of Maine, Newport, the Catskills, Niagara Falls, and numerous other picturesque sites. Their compositions were likely to be one of four regular types: the mountain-and-lake scene, such as *Mt. Ktaadn*; the broad wilderness panorama favored by Church and his followers; the interior woodland scene made popular by Durand (see cat.no.31); and the shore scene, often with breaking waves, which Cole and Church (see cat.no.43) both painted, and which became a specialty of another popular member of the school, John F. Kensett (see cat.no.42). All of the better landscapists of mid-century practiced a detailed "Ruskinian" style in the depiction of natural elements such as rocks, trees, and water, and all were concerned with light—some following Church in his concern with the evanescent colors of dawn and sunset, others like Kensett and Bierstadt painting the dramatic, clear light of midday, while yet others such as Sanford Gifford investigated the warm haze of Indian summer afternoons (see cat.no.41).

An exceptional figure in the school was Martin Johnson Heade, who followed his own way and never won significant popularity or patronage. Apparently influenced by both Church and Lane, Heade nonetheless developed a style which was not concerned with naturalistic detail, with brilliant light, or with the popular sites favored by his contemporaries. Instead, he painted places without topographical or picturesque distinction—the shoreline of Narragansett Bay, the coastal salt marshes of Massachusetts and Rhode Island—and his major concern was with fleeting atmospheric effects. His pictures have a sense of quiet drama; they seem somehow pessimistic in comparison to the confident, sparkling paintings of Kensett or Bierstadt. His *Stranded Boat* (cat.no.48) simply depicts fog and loneliness, while *Salt Marsh Hay* (cat.no.49), one in a long series, examines sunlight breaking through a stormy sky as a rainshower passes. Heade's masterpiece, *Thunderstorm over Narragansett Bay* of 1868 (cat.no.50) seems at once both carefully observed and keenly romantic: in its hushed mood and high drama, it shows the American painter beginning to move away from creating ideal landscape and toward exploring the mind of the painter.

32

FITZ HUGH LANE (1804–1865)
Boston Harbor, Sunset, 1850–55
Oil on canvas, 24 × 39¼ in. (61 × 99.7 cm.)
Jo Ann and Julian Ganz, Jr.

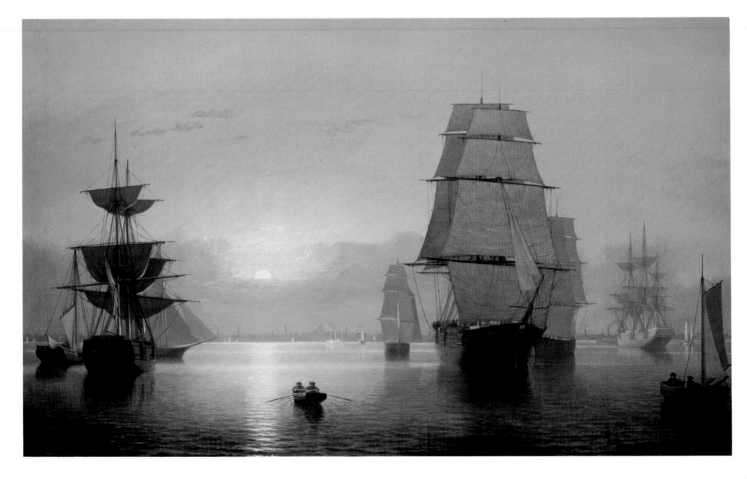

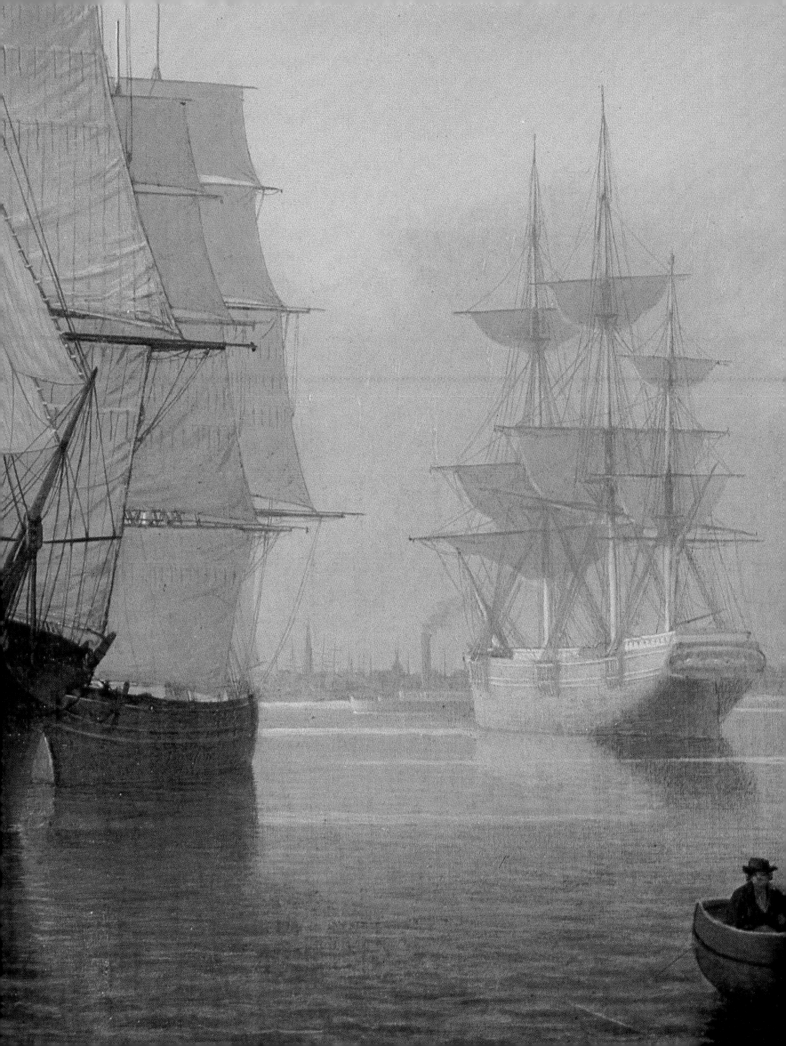

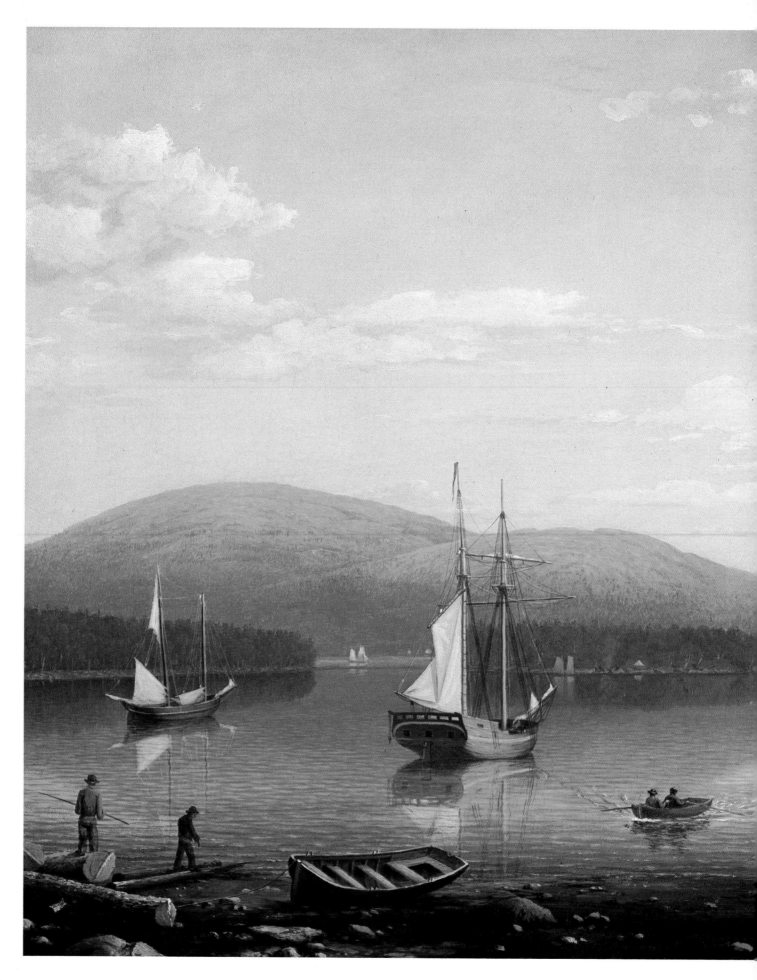

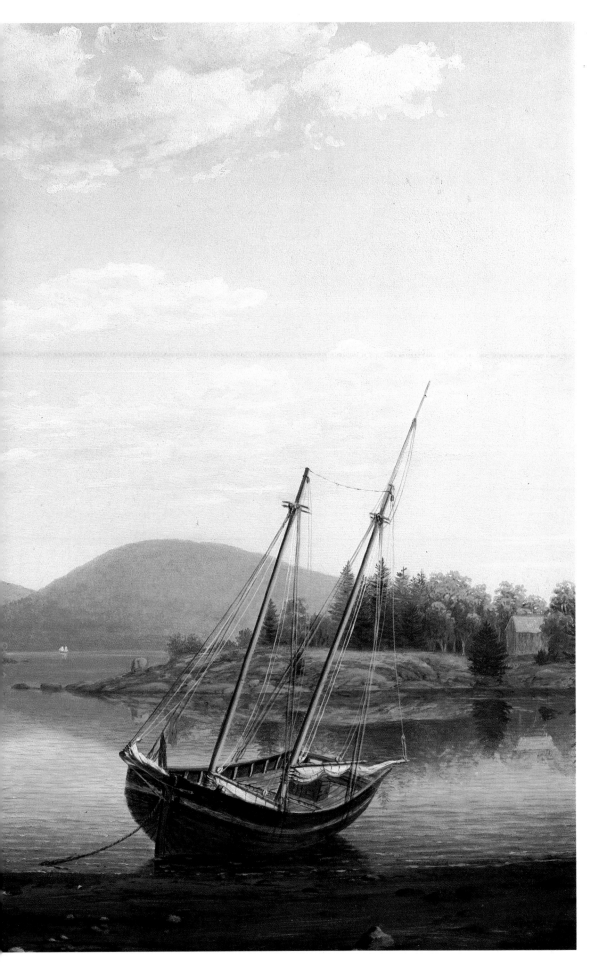

FITZ HUGH LANE (1804–1865)
Somes Harbor, Maine, c. 1850
Oil on canvas, $20\frac{1}{8} \times 30\frac{1}{8}$ in.
(51.1×76.5 cm.)
Erving and Joyce Wolf

34
FITZ HUGH LANE (1804–1865)
Lumber Schooners at Evening on Penobscot Bay, 1860
Oil on canvas, $24\frac{5}{8} \times 38\frac{1}{8}$ in. (62.6 × 96.8 cm.)
National Gallery of Art, Washington, D.C., Andrew W. Mellon Fund,
 and Gift of Mr. and Mrs. Francis W. Hatch, 1980

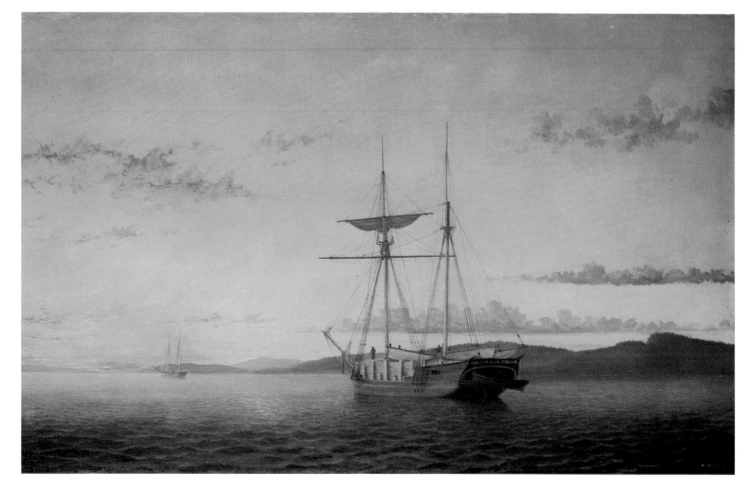

FITZ HUGH LANE (1804–1865)
Owl's Head, Penobscot Bay, Maine, 1862
Oil on canvas, 16 × 26 in. (40.6 × 66 cm.)
Museum of Fine Arts, Boston, M. and M. Karolik Collection

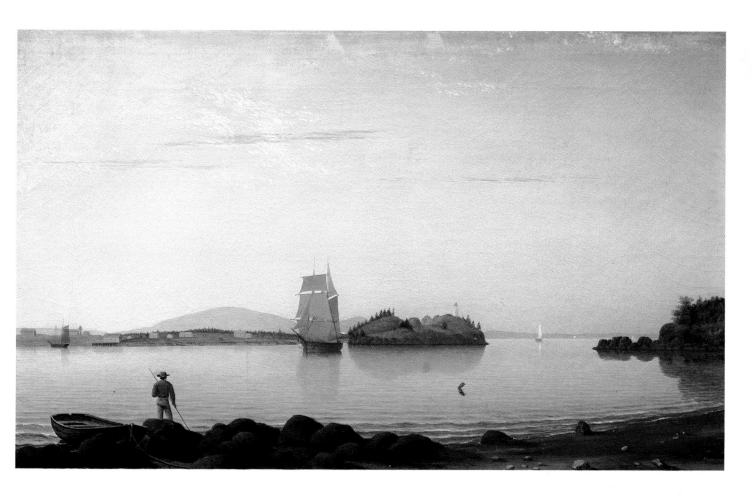

36
FREDERIC EDWIN CHURCH (1826–1900)
Mt. Ktaadn, 1853
Oil on canvas, $36\frac{1}{4} \times 55\frac{1}{4}$ in. (92.1 × 140.3 cm.)
Yale University Art Gallery, New Haven, Connecticut, Stanley B. Resor, B.A. 1901, Fund

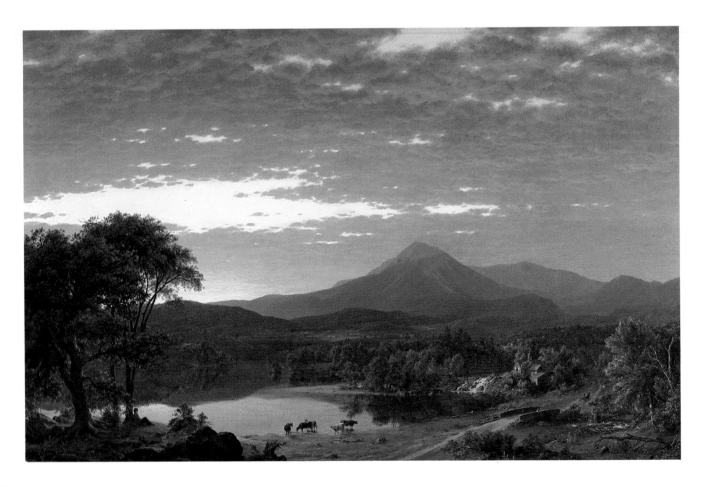

37
FREDERIC EDWIN CHURCH (1826–1900)
The Andes of Ecuador, 1855
Oil on canvas, 48 × 75 in. (121.9 × 190.5 cm.)
Reynolda House Museum of American Art, Winston-Salem, North Carolina,
 Gift of Z. Smith Reynolds Foundation

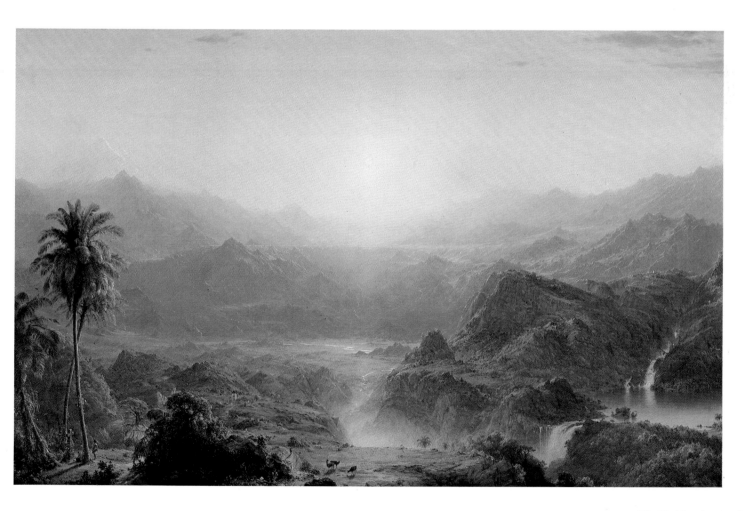

38
FREDERIC EDWIN CHURCH (1826–1900)
Niagara Falls, 1857
Oil on canvas, $42\frac{1}{2} \times 90\frac{1}{2}$ in. (108×229.9 cm.)
The Corcoran Gallery of Art, Washington, D.C., Gallery Fund Purchase, 1876

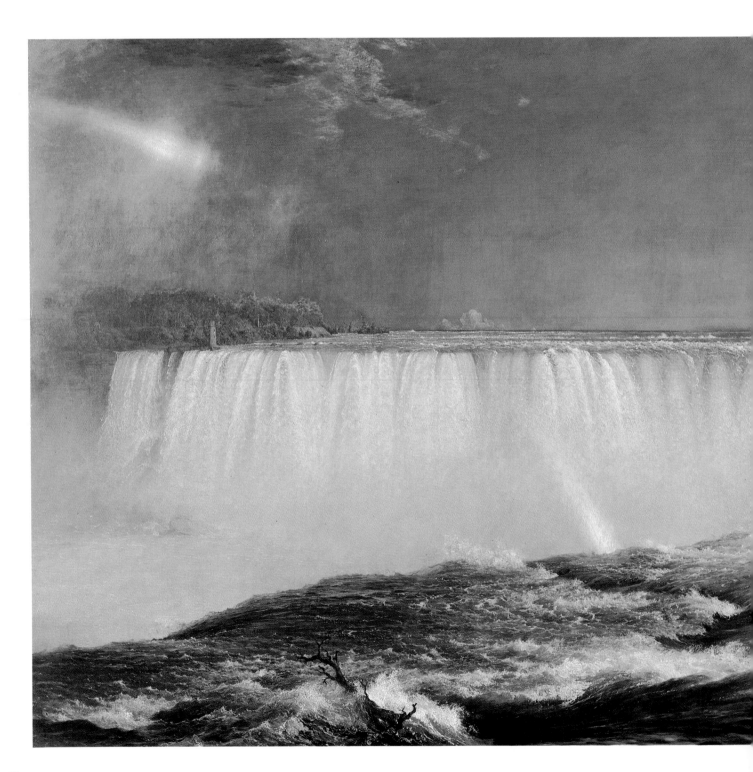

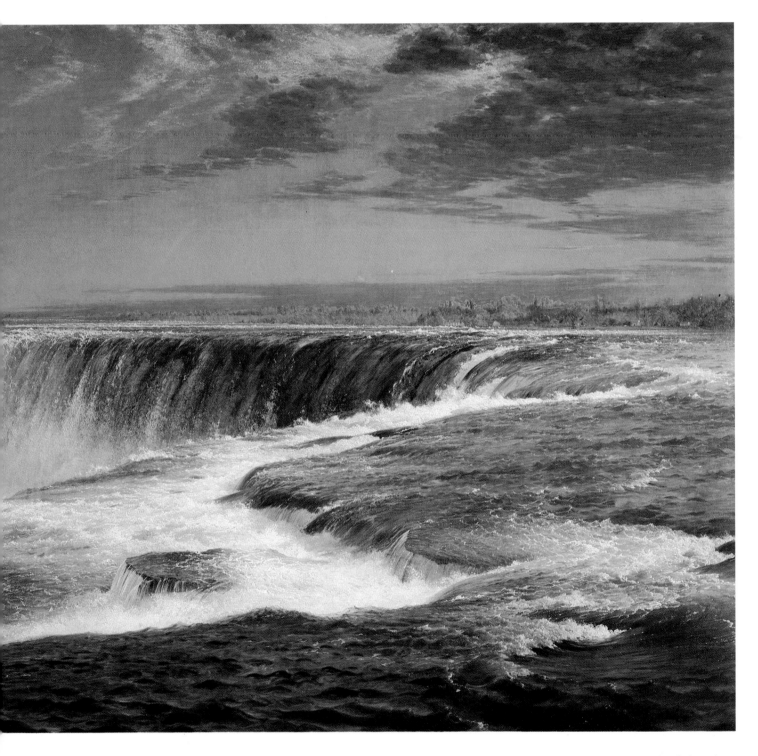

39
FREDERIC EDWIN CHURCH (1826–1900)
Twilight in the Wilderness, 1860
Oil on canvas, 40 × 64 in. (101.6 × 162.6 cm.)
The Cleveland Museum of Art, Purchase, Mr. and Mrs. William H. Marlatt Fund

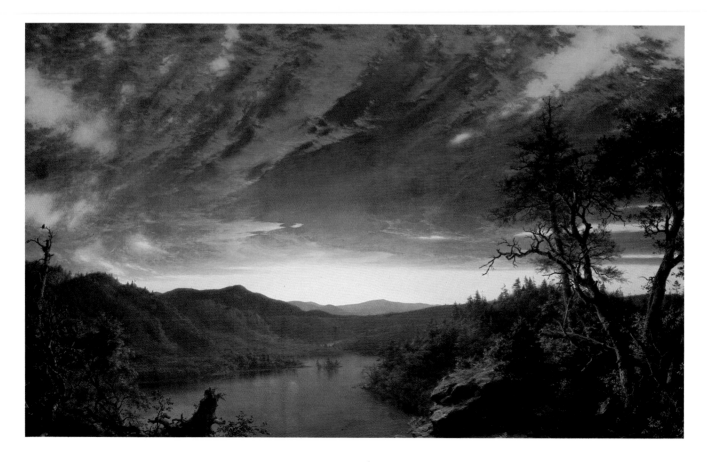

40
WORTHINGTON WHITTREDGE (1820–1910)
Twilight on the Shawangunk, 1865
Oil on canvas, 45 × 68 in. (114.3 × 172.7 cm.)
The Manoogian Collection

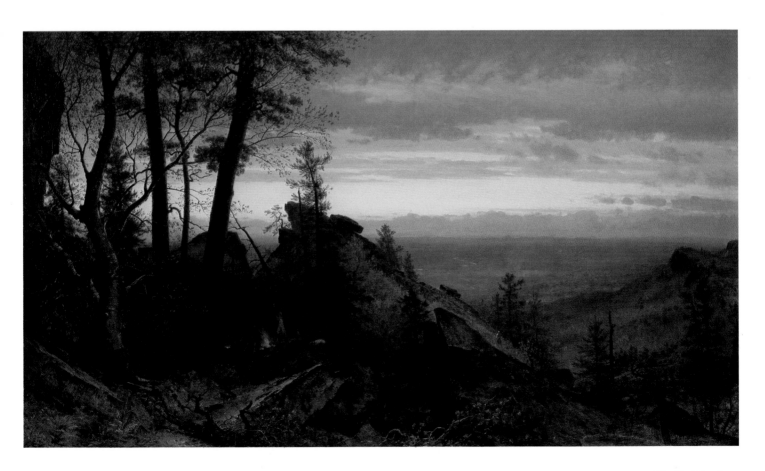

41
SANFORD ROBINSON GIFFORD (1823–1880)
Sunset on the Hudson, 1879
Oil on canvas, $18\frac{1}{8} \times 34\frac{1}{8}$ in. (46×86.7 cm.)
Private Collection

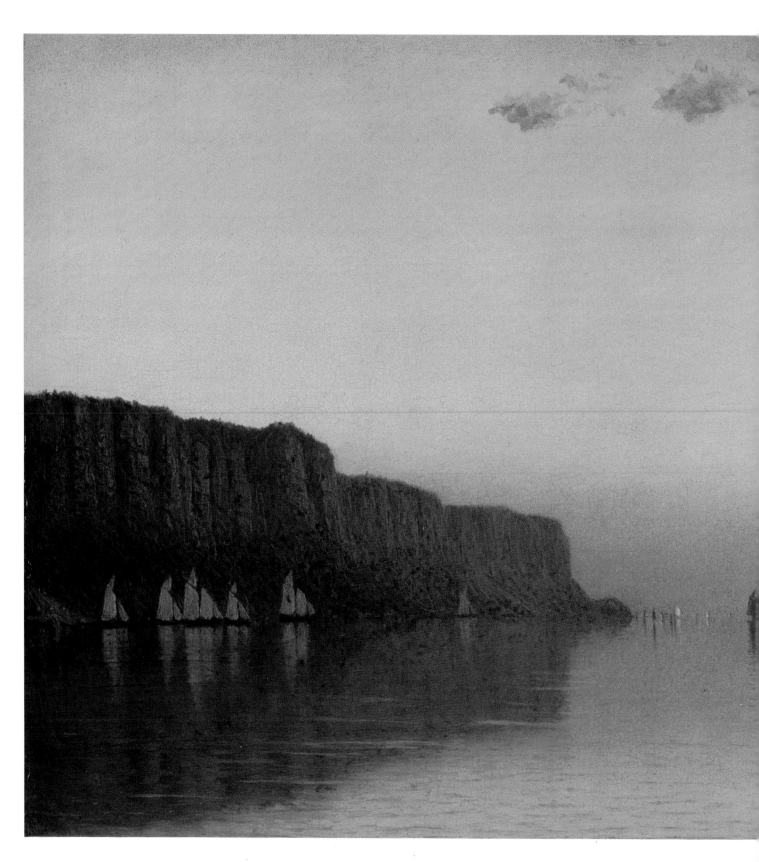

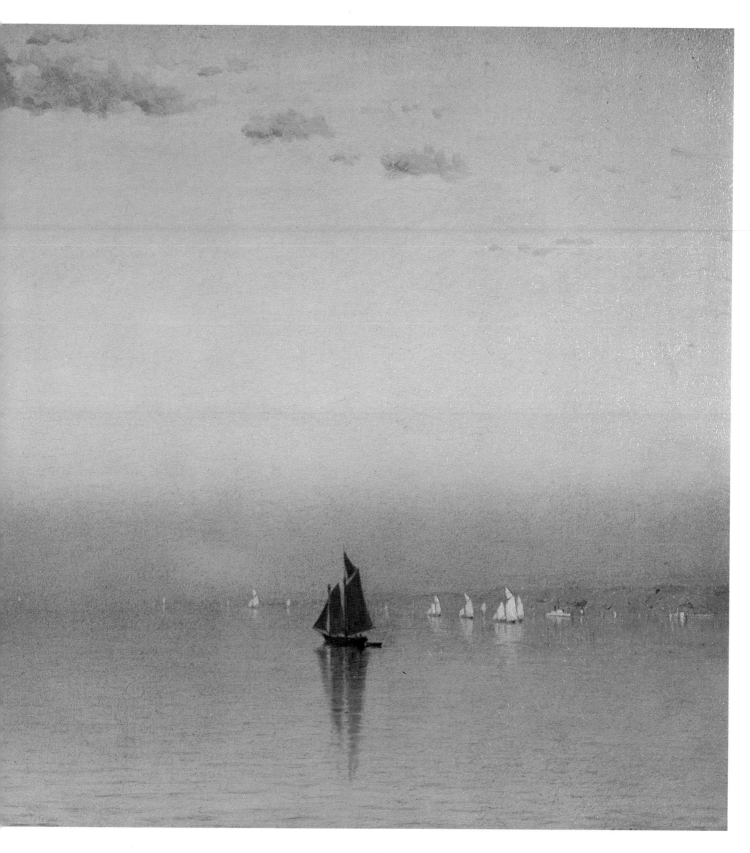

42
JOHN FREDERICK KENSETT (1816–1872)
Narragansett Bay, 1861
Oil on canvas, 14 × 24 in. (35.6 × 61 cm.)
Mr. and Mrs. George D. Hart

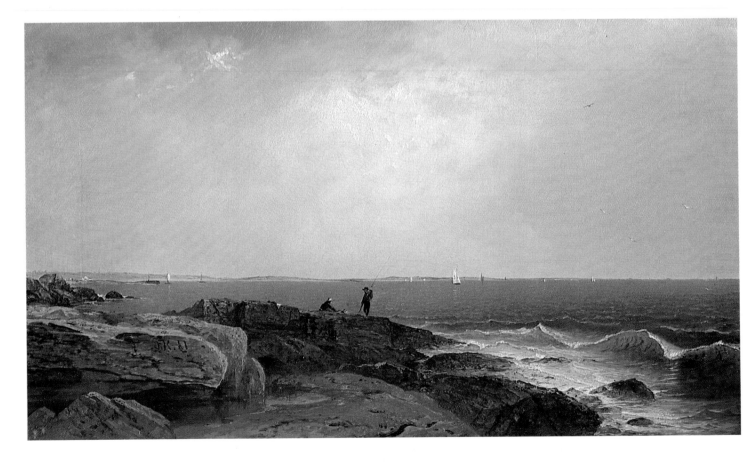

43
FREDERIC EDWIN CHURCH (1826–1900)
Sunrise off the Maine Coast, 1863
Oil on canvas, $36\frac{1}{8} \times 48$ in. (91.8 × 121.9 cm.)
Wadsworth Atheneum, Hartford, Connecticut, Bequest of Mrs. Clara Hinton Gould

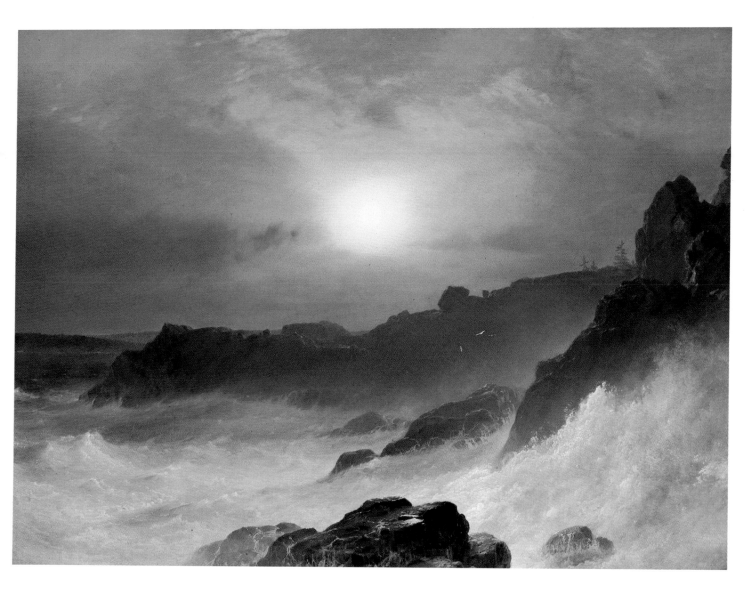

44
FREDERIC EDWIN CHURCH (1826–1900) Oil on canvas, 64½ × 112½ in. (163.8 × 285.8 cm.)
The Icebergs, 1861 Dallas Museum of Fine Arts, Anonymous Gift

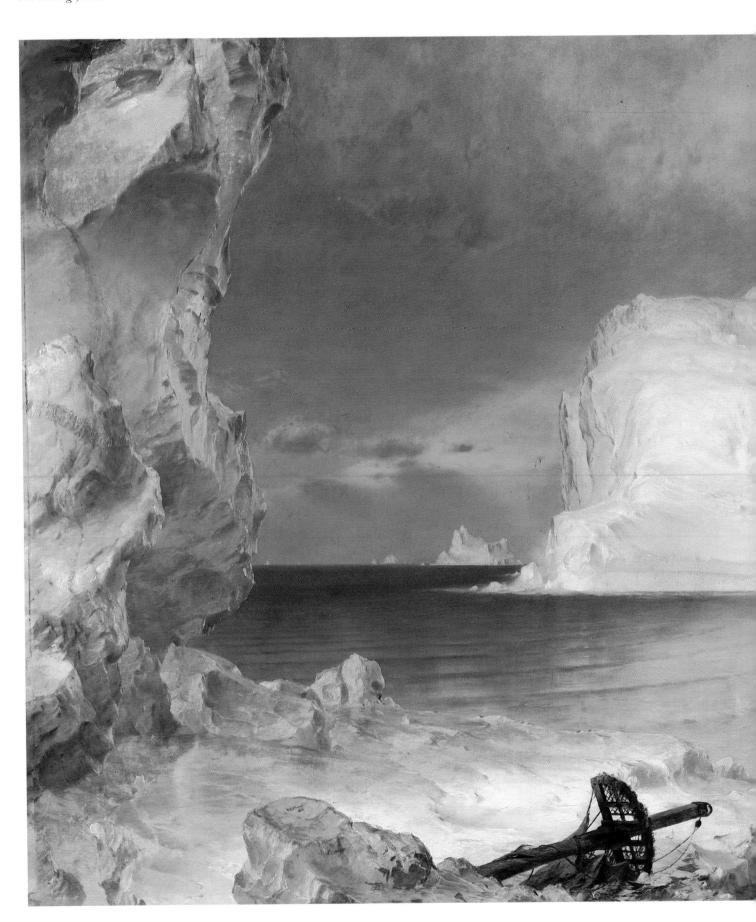

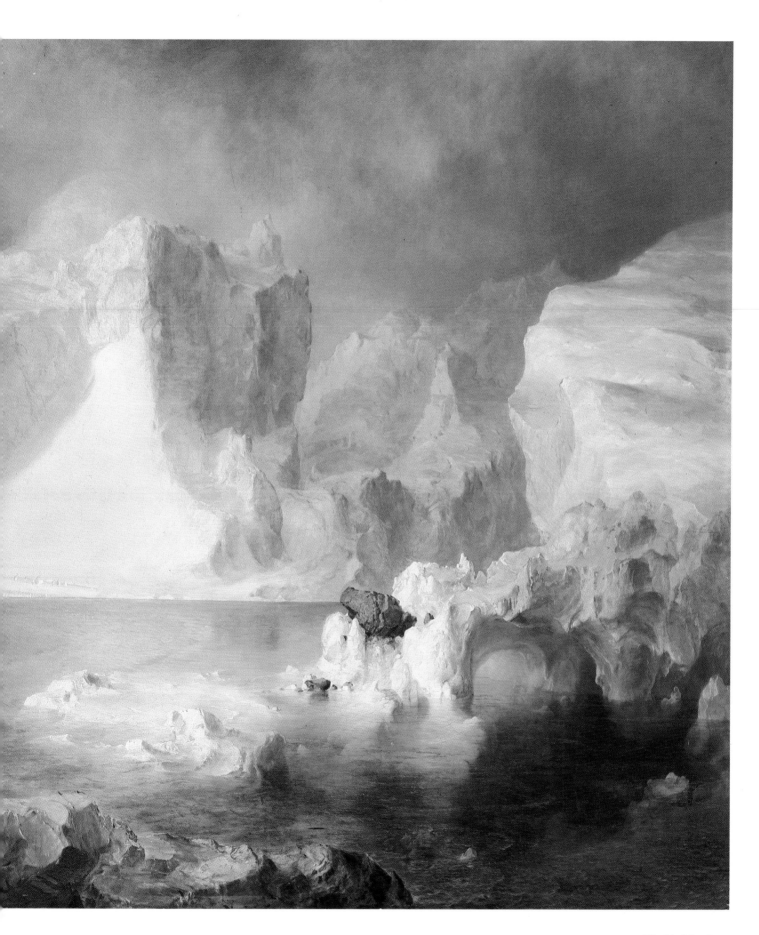

45
FREDERIC EDWIN CHURCH (1826–1900)
Cotopaxi, 1862
Oil on canvas, 48 × 85 in. (121.9 × 216 cm.)
The Detroit Institute of Arts, Founders Society Purchase, Robert H. Tannahill
 Foundation Fund, Gibbs-Williams Fund, Dexter M. Ferry, Jr., Fund,
 Merrill Fund, Beatrice W. Rogers Fund, and Richard A. Manoogian Fund

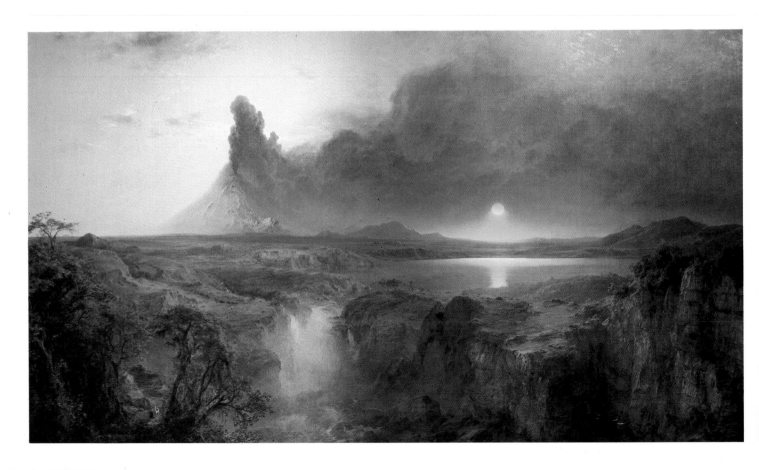

47 [pages 100–101]
ALBERT BIERSTADT (1830–1902)
The Sierra Nevada in California, 1868
Oil on canvas, 72 × 120 in. (182.9 × 304.8 cm.)
National Museum of American Art, Smithsonian Institution, Washington, D.C.,
 Bequest of Helen Huntington Hull

46
FREDERIC EDWIN CHURCH (1826–1900)
Rainy Season in the Tropics, 1866
Oil on canvas, $56\frac{1}{4} \times 84\frac{3}{16}$ in. (142.9 × 213.8 cm.)
The Fine Arts Museums of San Francisco, Museum Purchase,
 H. K. S. Williams Fund for Mildred Anna Williams Collection

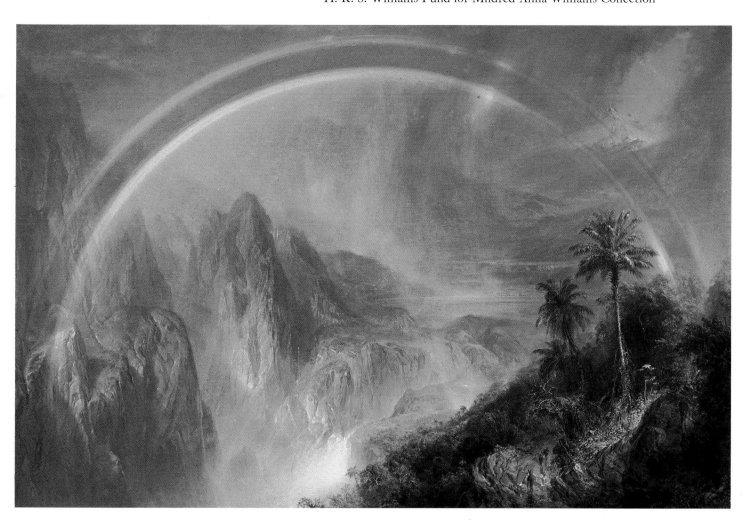

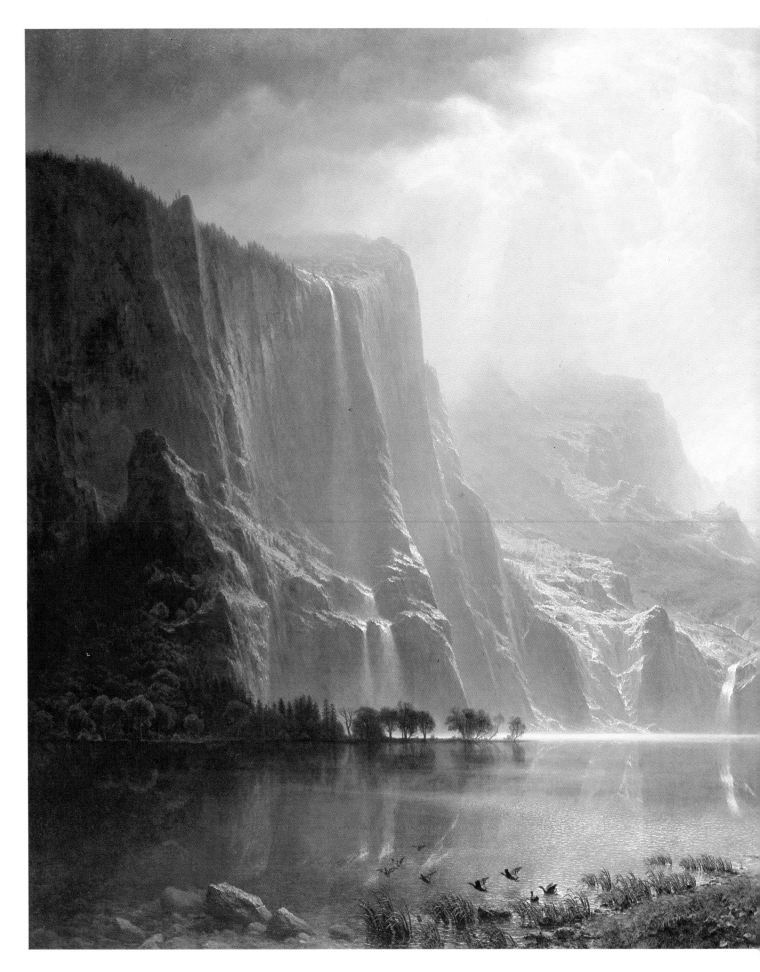

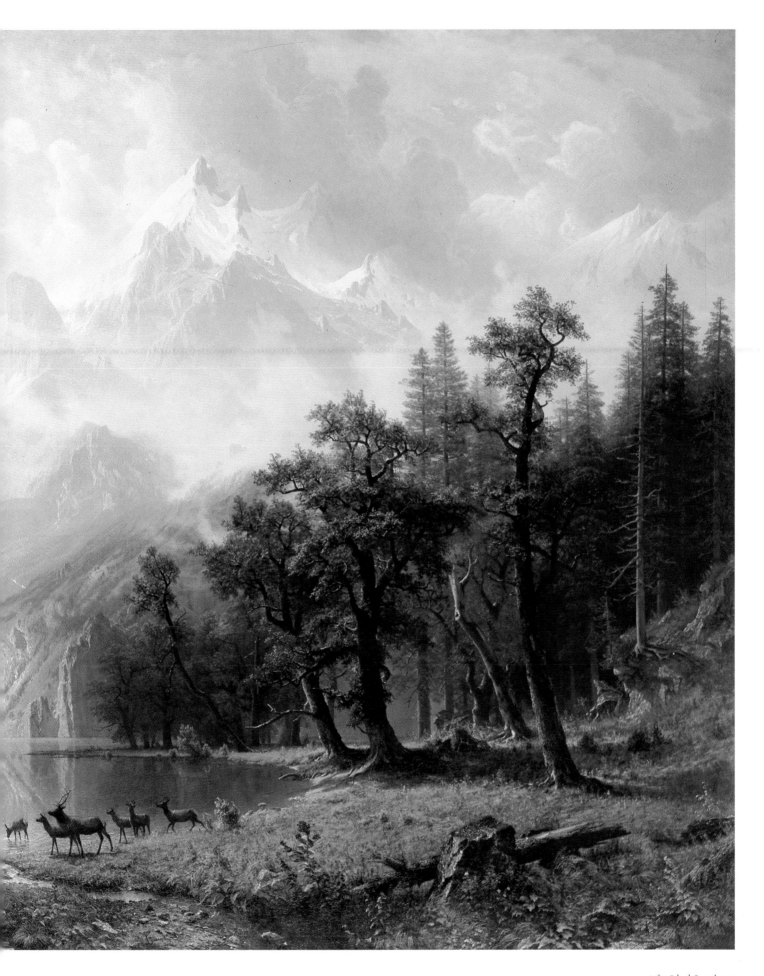

48
MARTIN JOHNSON HEADE (1819–1904)
The Stranded Boat, 1863
Oil on canvas, $22\frac{3}{4} \times 36\frac{1}{2}$ in. (57.8×92.7 cm.)
Museum of Fine Arts, Boston, M. and M. Karolik Collection

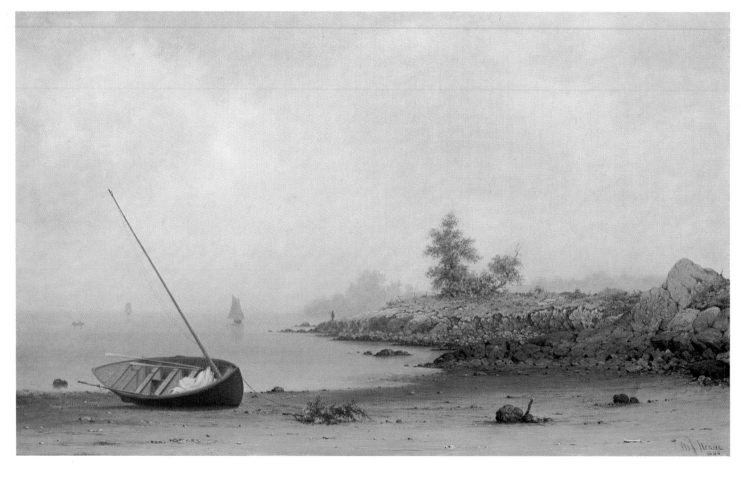

50 *[pages 104–105]*
MARTIN JOHNSON HEADE (1819–1904)
Thunderstorm over Narragansett Bay, 1868
Oil on canvas, $32\frac{1}{8} \times 54\frac{1}{2}$ in. (81.6 × 138.4 cm.)
Amon Carter Museum, Fort Worth, Texas

49
MARTIN JOHNSON HEADE (1819–1904)
Salt Marsh Hay, c. 1870
Oil on canvas, 13 × 26 in. (33 × 66 cm.)
The Butler Institute of American Art, Youngstown, Ohio

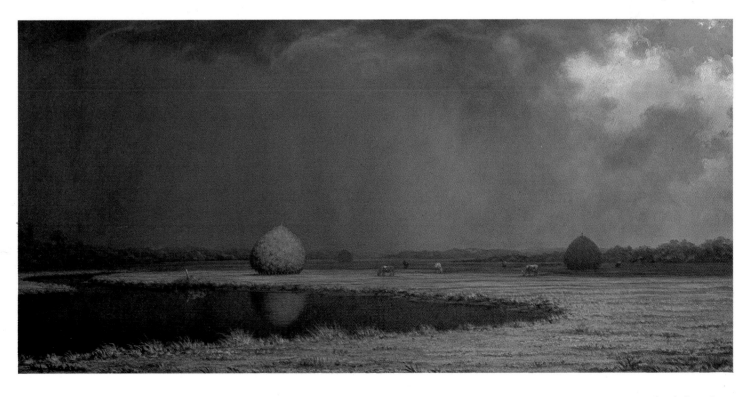

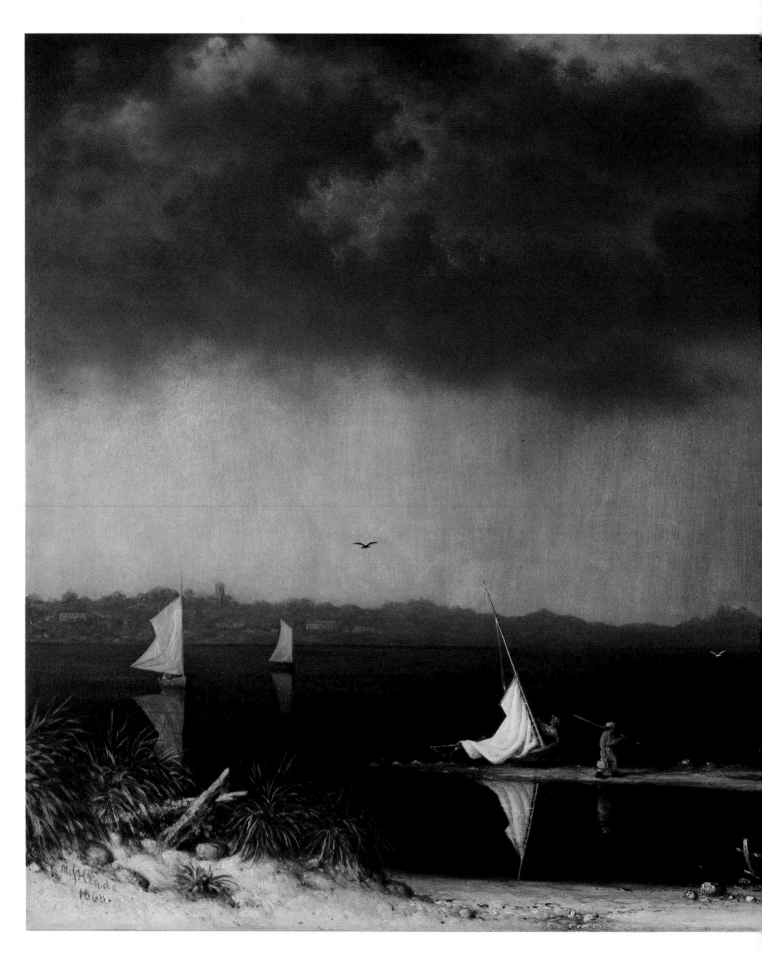

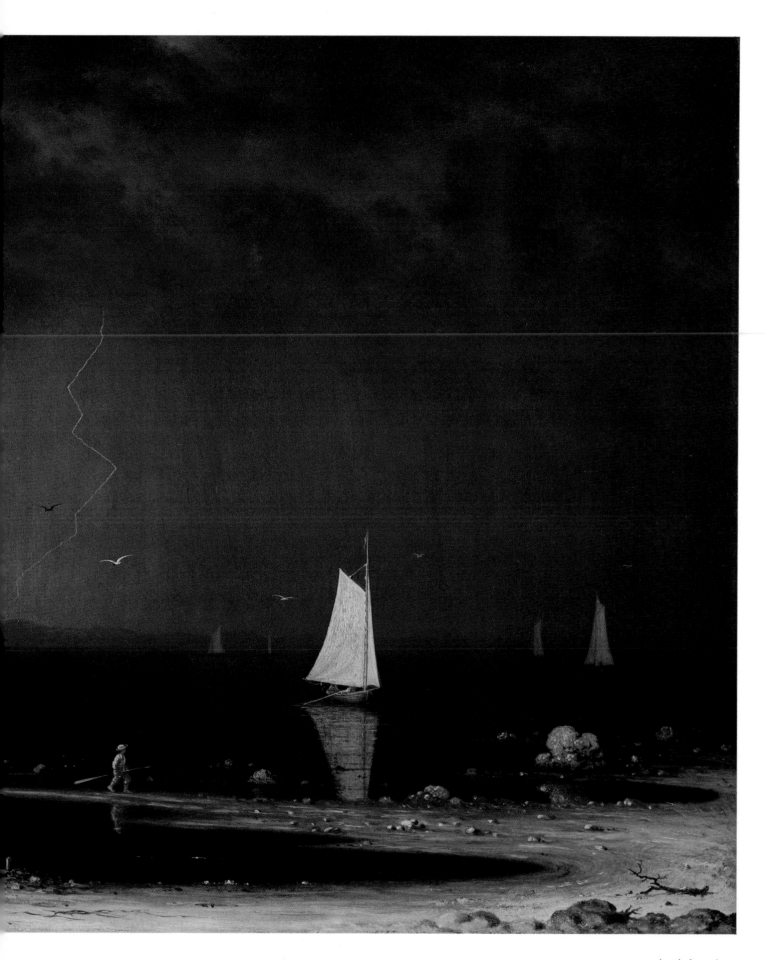

V. *Americans Outdoors*

The three decades following 1830 may be seen as a Golden Age of American painting. It was a rare time, when the best painters were recognized as such and were honored and patronized by their society. Interest in the arts grew, exhibitions multiplied, teaching improved, and chauvinistic collectors competed to support their favorite artists. Moreover, a taste for the arts spread down from the wealthy to the middle classes: through illustrated books and the inexpensive prints of such firms as Currier & Ives, images of fine paintings became popular throughout the nation. Beginning in 1839, the American Art-Union aided in this process. This organization prospered by establishing a lottery for the distribution of original paintings. By 1849 it boasted nineteen thousand members, each of whom had paid five dollars annual dues, receiving in return an engraving of one of the most prized pictures and a chance to win one of 460 paintings. The Art-Union produced a monthly *Bulletin*, which became in effect the first American art magazine. It helped broaden the audience for the fine arts, and it functioned as an important corporate patron as well, for it purchased from the artists hundreds of paintings which had to meet its general criteria of having an easily understood American subject.

Genre painting—generally defined as the realistic depiction of everyday life—was the last of the principal modes of painting to develop in America, coming to fruition only in the 1830s. However, it quickly won popularity, as genre pictures became favorites of the Art-Union and of collectors and the public. A key role here was played by William Sidney Mount, whose career is a tribute to the newfound strength and independence of the arts in America. He was the first painter of national reputation who believed travel and training abroad to be unnecessary: "... a visit to Europe would be gratifying to me," he wrote, "but I have had a desire to do something in art worthy of being remembered before leaving for fear I might be induced by the splendor of European art to tarry too long, and thus lose my nationality."[1] Instead, Mount studied in 1826–27 at the recently founded National Academy of Design in New York. For the next two years he painted awkward biblical history paintings inspired by West, but in 1830 he established his future course with the *Rustic Dance after a Sleigh Ride* (Museum of Fine Arts, Boston). In this work, Mount already signals his concern for rural life and manners, a comic sense which never becomes satirical or patronizing, a love of music, dance, and gesture, a fascination with human types, and a compositional ability which led him to frame his figures within strong architectural or natural elements. His talents, moreover, were promptly recognized. The eminent Allston saw his work in Boston in 1834 and, recommending that he further study the Dutch seventeenth-century prototypes,

such as Ostade and Jan Steen, predicted that he would become "a great artist in the line he has chosen."[2]

Allston himself had made a handful of genre scenes, such as the satirical, literary *Poor Author and Rich Bookseller* of 1811 (Museum of Fine Arts, Boston), and subsequently other Boston painters, including Henry Sargent (1770–1845) and Alvan Fisher (1792–1863), worked in this vein. A closer precedent for Mount's work was that of John Lewis Krimmel (1787–1821), a young German-trained painter who worked briefly in Philadelphia. But just as Thomas Cole was the first landscapist to make real contact with the American landscape, so Mount was the first to use simple-looking scenes of daily life in the country to probe for the roots of American character. Painting what appears to be the incidental, he sought the universal—and in this he became the first of a distinguished line of seekers which included Homer and Eakins a generation later, and Edward Hopper in the twentieth century.

Mount painted an ideal America, rural, sunny, comfortable, a place without divisions of class, race, or region, without meanness or poverty. The land seems so bountiful that labor is hardly necessary: no one strains, no one works, and it seems to be Sunday always. Still, the knowing viewer can find in Mount's work evidence of the major issues of the period: there are hints, if one will read them, of the limited role of women in the society, of the isolation of the black man, of drunkenness and gambling, of the struggle between rural morality and the harsh new rules of urban life.

Our second great genre painter, George Caleb Bingham, came from Missouri, then on the far-western frontier, and so lacked Mount's proximity to New York with its exhibitions and schools. Beginning in the early 1830s, he worked for a decade as a journeyman portraitist before bursting onto the scene in 1845 with four paintings exhibited at the American Art-Union, including *Fur Traders Descending the Missouri* (cat. no. 54). In the following year his *Jolly Flatboatmen* (Pell Collection, Washington, D.C.) was engraved and distributed by the Art-Union and made him nationally known. But his mature career was short: after a series of superbly composed group scenes that have elements of both genre and history painting, including *The County Election* (1851–52; St. Louis Art Museum), his work declined rapidly. Bingham's reputation disappeared as well; the critic Henry Tuckerman in his definitive *Book of the Artists* of 1867 granted him one sentence only, commenting—astonishingly—that his work boasted "no special grasp or refinement in execution."[3]

Since Bingham's rediscovery in the 1930s, he has been regarded as an archetypal American painter. Unlike Mount, he paints neither individual character, gesture, nor incident.

Rather, his subject is very simply life on the great American river. His figures are the traders, settlers, and raftsmen, who are interesting not as individuals but as self-reliant American types. Whitman described the same scenes in his *Song of the Broad-Axe* (1856): "strong shapes and attributes of strong shapes, masculine trades, sights and sounds . . ."

> *The beauty of all adventurous and daring persons,*
> *The beauty of wood-boys and wood-men with their clear untrimm'd faces,*
> *The beauty of independence, departure, actions that rely on themselves.*

In painting the heady, masculine flavor of the frontier, in depicting these rugged Westerners relaxing, dancing, and celebrating America in clean, bare feet and unsoiled clothing, Bingham paints the nation's mythic view of itself. If the artist could be believed, this *was* a golden land, one of beautiful, hazy summer days when men could simply drift with the current, where labor and hardship and hate were unknown. Bingham himself was a politician, and of course he knew better; or as Mark Twain's Jim said to Huck Finn, "It's too good to be true, Honey. It's too good to be true."

The tradition of American genre—of carefully selected and composed scenes painted as if they were simple vignettes of everyday life—continued with astonishingly little modification nearly to the end of the century. Only a handful of genre painters sought reality in their work, daring to paint the seamy side of American life, the repressed part of the national psyche: most notable of these was David G. Blythe (1815–1865) of Pittsburgh, a self-taught master of satire who remained unknown to his contemporaries. Rather, as the nation became urbanized, sporting and Western views became increasingly popular, for they gave citizens in the East a chance to participate in the raw excitement of the frontier. The most popular master of sporting scenes was the prolific Arthur F. Tait, many of whose works were reproduced as Currier & Ives lithographs. Tait was an animal specialist, who painted everything from barnyard chickens to wild game, and he had an illustrator's flair for the dramatic moment, as seen in his masterpiece, *A Tight Fix* (cat.no.63).

Even more highly regarded by critics and collectors of the time was Eastman Johnson, who was well trained and technically able, having studied at Düsseldorf, The Hague, and Paris, and his style reflected French art, the small interiors suggesting the work of Pierre Edouard Frère (1819–1886), and the outdoor scenes at times coming close to those of Jules Breton (1827–1906).[4] Johnson's *Old Kentucky Home* of 1859 (New-York Historical Society), a view of contented slave life in the South, won him an enthusiastic audience, and his sentimental Civil War vignettes—the wounded soldier talking with a nurse, the little boy at home trying on his father's military cap—provided an acceptable, genteel vision of the war. After the war he made a number of effective, charming scenes of domestic interiors, and then turned increasingly outdoors again, concentrating on two series of works, one of maple-sugaring camps in Maine, the other of cranberry pickers on Nantucket Island, which are as sophisticated as any American pictures of the time. Here he avoids storytelling and instead suggests something of the beauty and rhythm of people working together outdoors at traditional pursuits. These scenes are filled with light, and in the many oil studies for *The Cranberry Harvest* (cat.no.60) one sees the painter at his best.

Had the careers of Winslow Homer and Thomas Eakins both ended in 1880, we would remember each one of them today as an able genre painter who failed to win a large reputation during his own time. Taste of the period favored the nostalgic, the easily read story, and both Homer and Eakins were somehow too tough-minded and too objective to rival an Eastman Johnson or a J. G. Brown. Homer was the more highly regarded of the two, having won respect for his *Prisoners from the Front* (1866; Metropolitan Museum of Art, New York) at the Exposition Universelle of 1867, and during the seventies he was considered an able but not preeminent painter. To modern eyes, Homer's work seems noteworthy for its strength of drawing and composition, and particularly for its lack of sentimentality. Post-Civil War genre painters including Homer made a dramatic shift in subject, moving from the optimistic, masculine visions of Bingham and Mount to a world that seems largely populated by women and children. The more successful artists painted children as unpleasant little adults, mischievous, cute, and cunning, while Homer saw them quite differently: like Twain in *Huckleberry Finn*, he viewed the child as having a special sensibility, with qualities of grace and thoughtfulness that set him apart from the corrupt and imperfect adult world. In *Snap the Whip* (cat.no.61), much of Mount's style and world view is preserved; the protagonists have simply become smaller.

Homer glorified women above all. Heroic women provide the great continuous strand in his art, from *The Morning Bell* of the late 1860s (Yale University Art Gallery, New Haven, Conn.), to the very late paintings of women by the shore (see cat.no.106). Homer was in tune with the other major figurative painters of his time, as women simply became the dominant artistic subject during this period. For most of our artists, however, woman is ever more genteel: she reads, sips tea, or plays the piano; or she is seen as virgin, mother, or angel. Homer, uniquely in America, identified women with nature, with the outdoors, with learning (in his pictures of the schoolmistress), with courage, and with labor. He portrays the lower-class woman, even the black woman, and sees her—for example, in *The Cotton Pickers* (cat.no.62)—as powerful and intelligent.

Thomas Eakins, like Homer, spent the first part of his career largely as a genre painter, but his subjects are unlike Homer's in being urban and masculine. Eakins had had a thorough grounding in European art through his travels and training (1868–70), but his subjects come from popular American imagery, and his style is quite uniquely his own. Like Whitman, he portrays male comradeship, strength, and balance; he favors those whose brains, muscles, and courage function together. He paints city men seeking health and pleasure outdoors. Eakins was an accurate, precise painter, who admired precision and strength in others. He spent his whole life working with the most difficult tools—the brush, the chisel—in order to make sense out of the complexities of middle-class urban life in America. He is the rarest of American painters, a true realist. His work relates back to Bingham's, but it portrays individuals rather than types, and seeks not a universal American dream but a momentary, individual approach to truth.

51
WILLIAM SIDNEY MOUNT (1807–1868)
Farmers Nooning, 1836
Oil on canvas, $20\frac{1}{8} \times 24\frac{3}{16}$ in. (51.1×61.4 cm.)
The Museums at Stony Brook, New York, Gift of Frederick Sturges, Jr., 1954

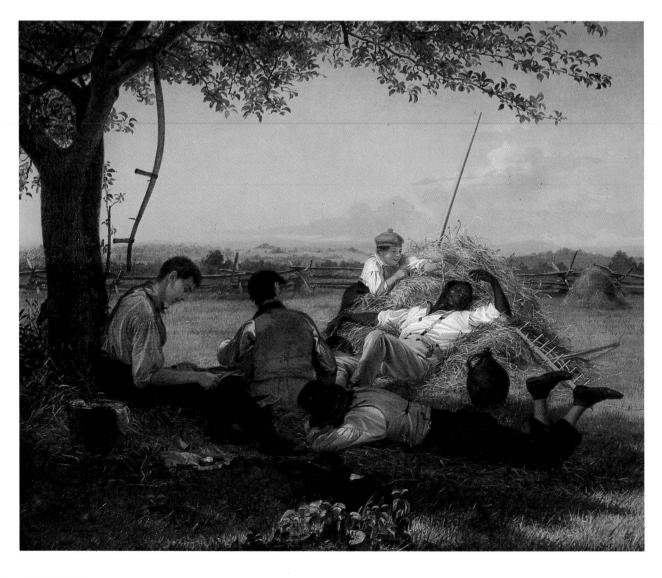

52
WILLIAM SIDNEY MOUNT (1807–1868)
Bargaining for a Horse, 1835
Oil on canvas, 24 × 30 in. (61 × 76.2 cm.)
The New-York Historical Society

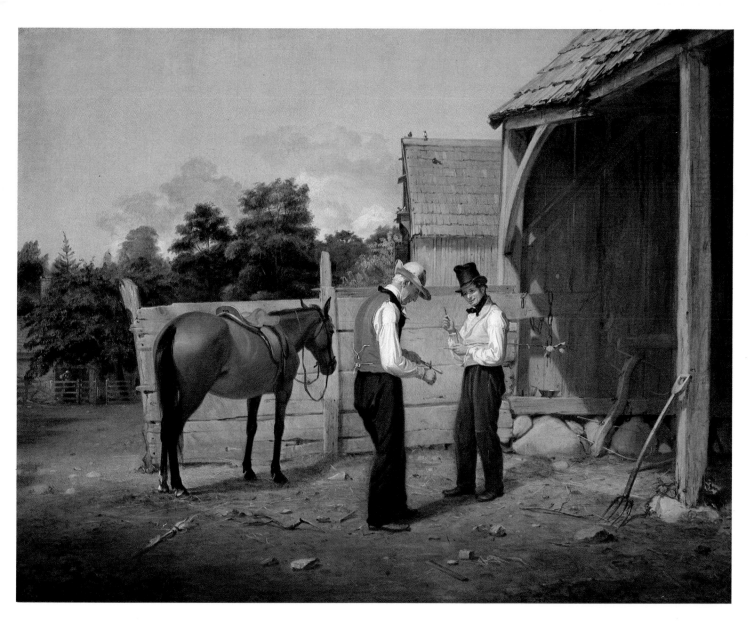

53
RICHARD CATON WOODVILLE (1825–1855)
War News from Mexico, 1848
Oil on canvas, 27 × 25 in. (68.6 × 63.5 cm.)
National Academy of Design, New York

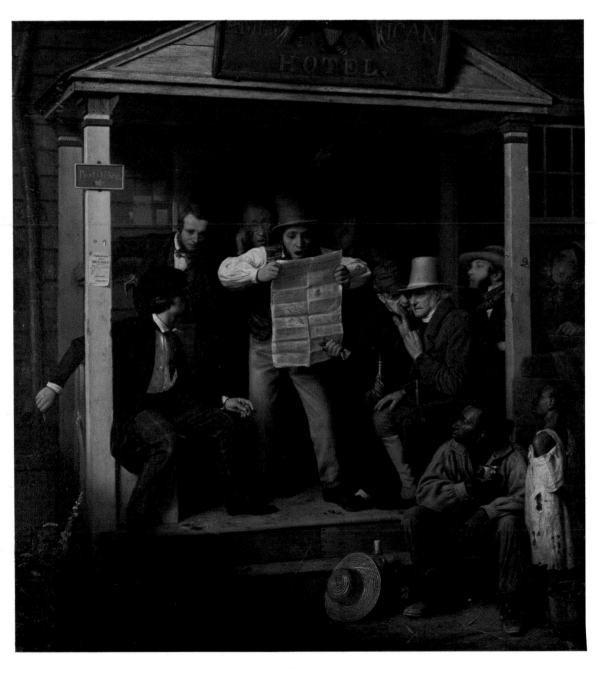

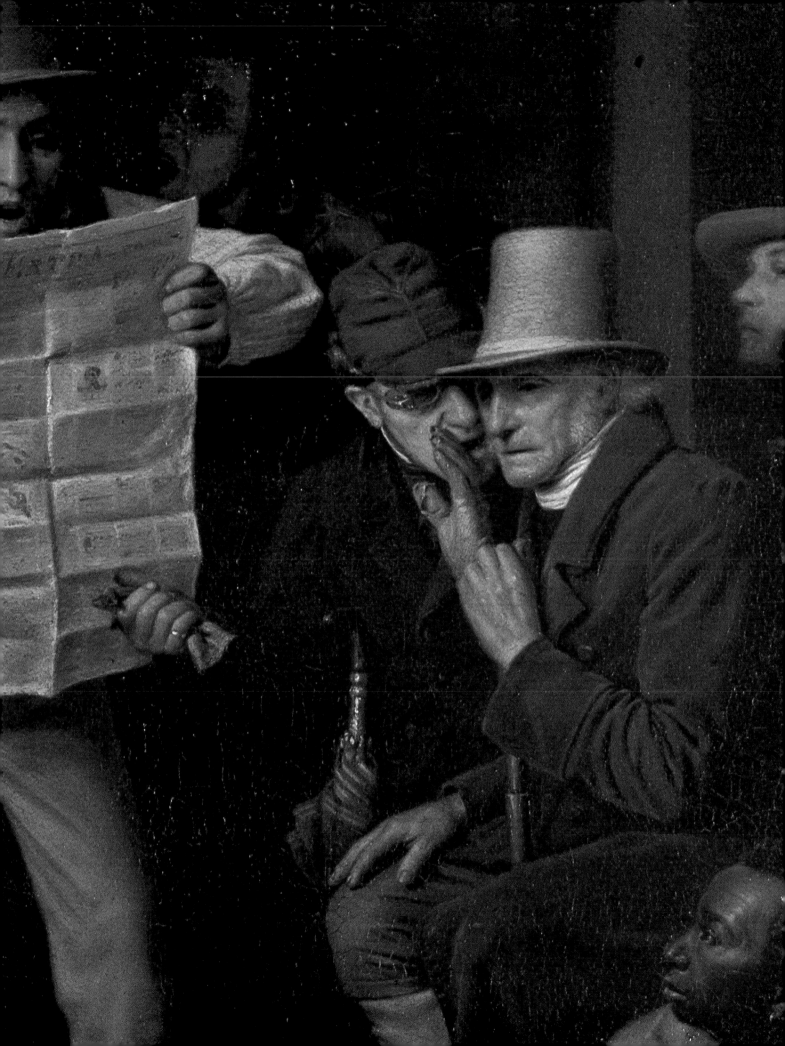

54
GEORGE CALEB BINGHAM (1811–1879)
Fur Traders Descending the Missouri, 1845
Oil on canvas, 29 × 36½ in. (73.7 × 92.7 cm.)
The Metropolitan Museum of Art, New York, Morris K. Jesup Fund, 1933

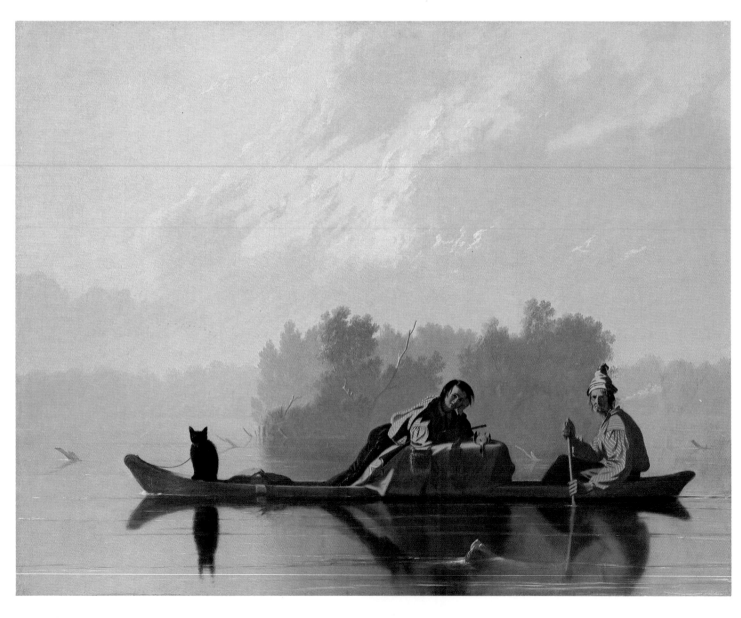

55
GEORGE CALEB BINGHAM (1811–1879)
Boatmen on the Missouri, 1846
Oil on canvas, $25\frac{1}{8} \times 30\frac{3}{8}$ in. (63.8 × 77.2 cm.)
The Fine Arts Museums of San Francisco, Gift of Mr. and Mrs. John D. Rockefeller 3rd

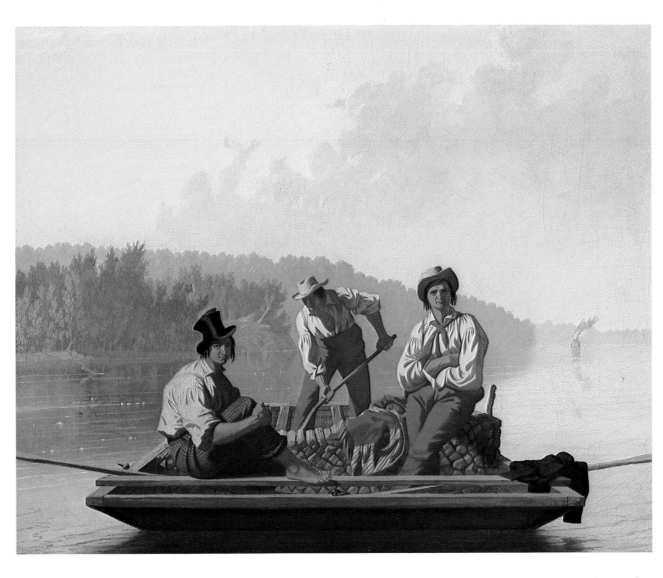

56
GEORGE CALEB BINGHAM (1811–1879)
Raftsmen Playing Cards, 1847
Oil on canvas, 28 × 38 in. (71.1 × 96.5 cm.)
The St. Louis Art Museum, Purchase, Ezra H. Linley Fund

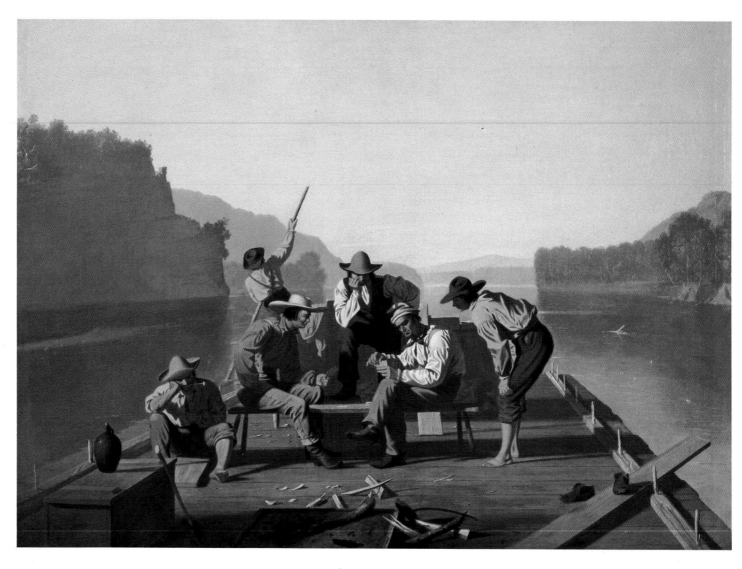

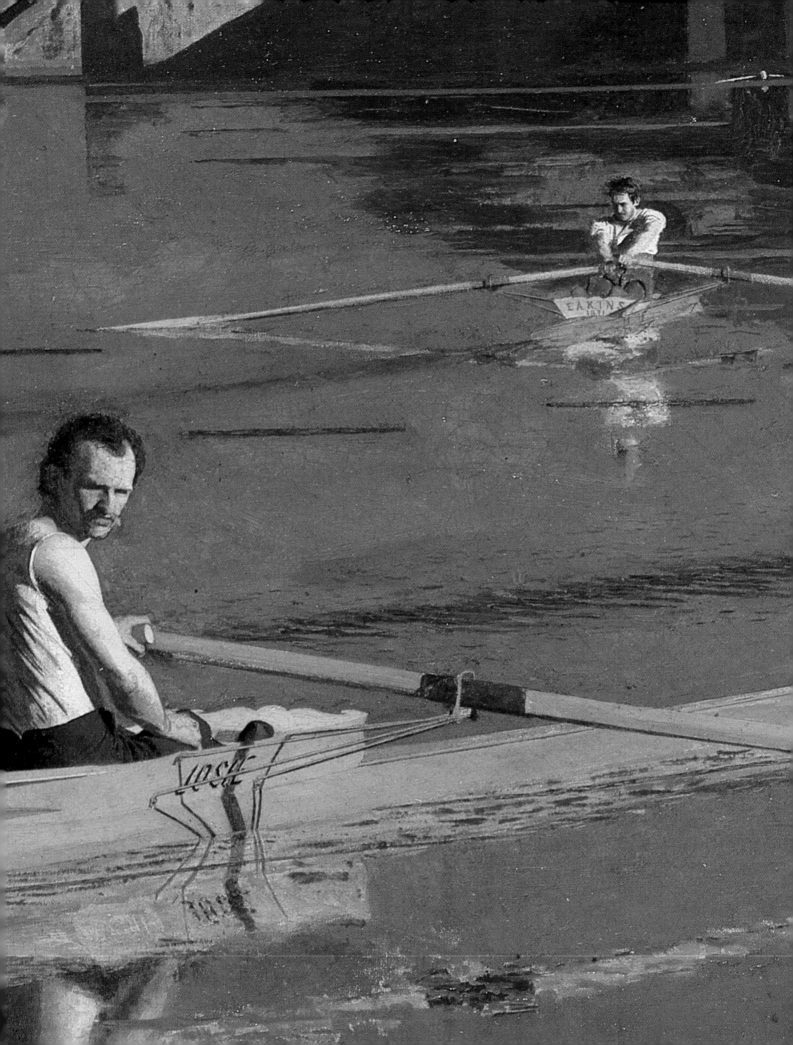

57
THOMAS EAKINS (1844–1916)
Max Schmitt in a Single Scull, 1871
Oil on canvas, $32\frac{1}{4} \times 46\frac{1}{4}$ in. (81.9 × 117.5 cm.)
The Metropolitan Museum of Art, New York, Alfred N. Punnett Fund and Gift of George D. Pratt

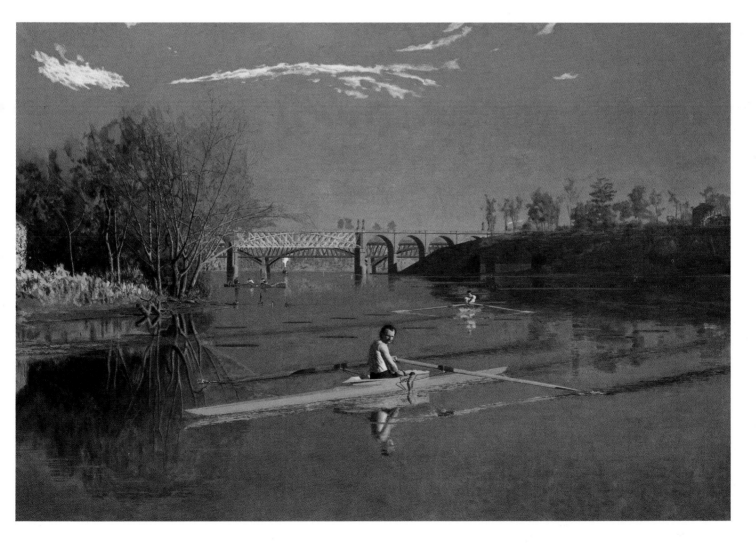

58
THOMAS EAKINS (1844–1916)
The Biglin Brothers Turning the Stake, 1873
Oil on canvas, $40\frac{1}{4} \times 60\frac{1}{4}$ in. (102.2 × 153 cm.)
The Cleveland Museum of Art, The Hinman B. Hurlbut Collection

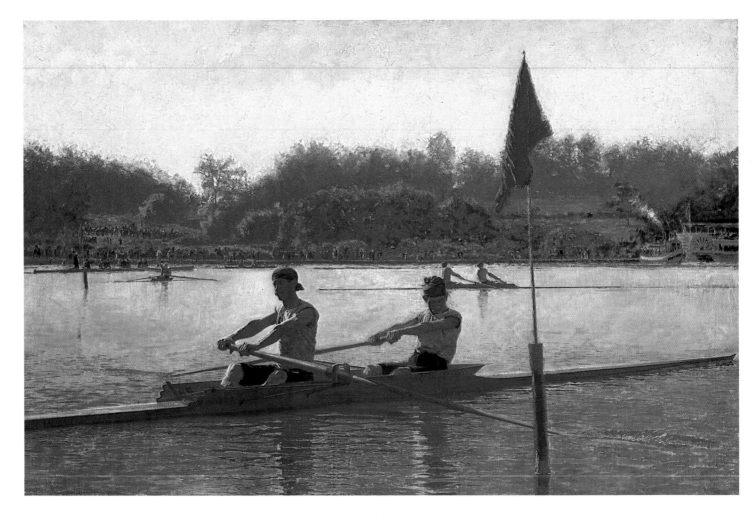

59
THOMAS EAKINS (1844–1916)
Will Schuster and Blackman Going Shooting for Rail, 1876
Oil on canvas, $22\frac{1}{8} \times 30\frac{1}{4}$ in. (56.2 × 76.8 cm.)
Yale University Art Gallery, New Haven, Connecticut, Bequest of Stephen Carlton Clark, B.A. 1903

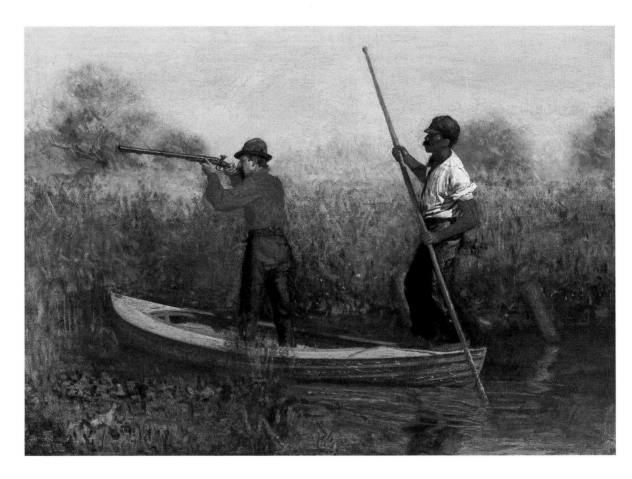

60
EASTMAN JOHNSON (1824–1906)
The Cranberry Harvest, Nantucket Island, 1880
Oil on canvas, $27\frac{3}{8} \times 54\frac{5}{8}$ in. (69.5 × 138.8 cm.)
Timken Art Gallery, Putnam Foundation Collection, San Diego, California

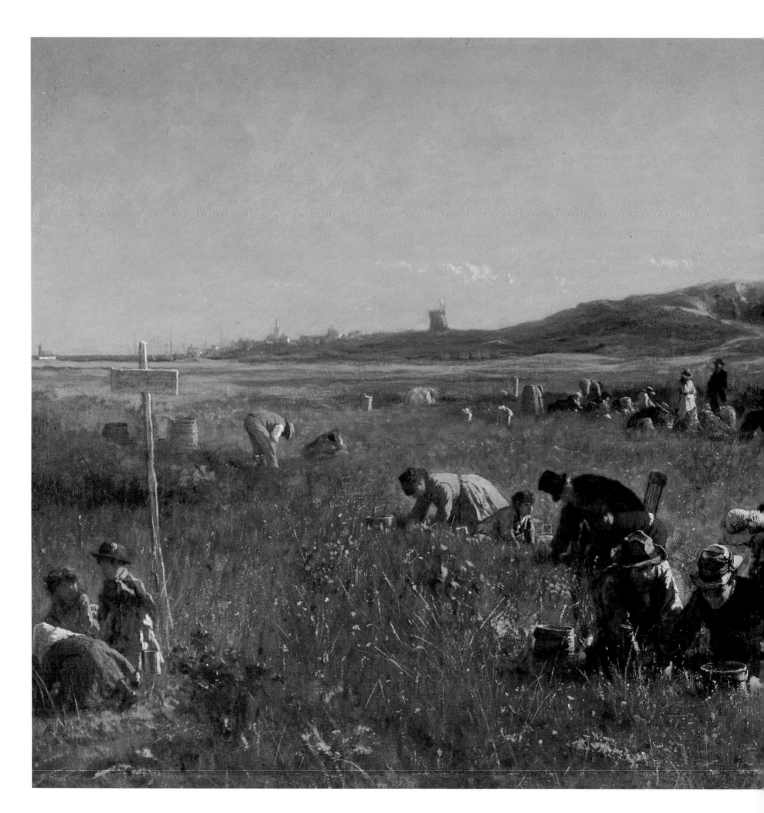

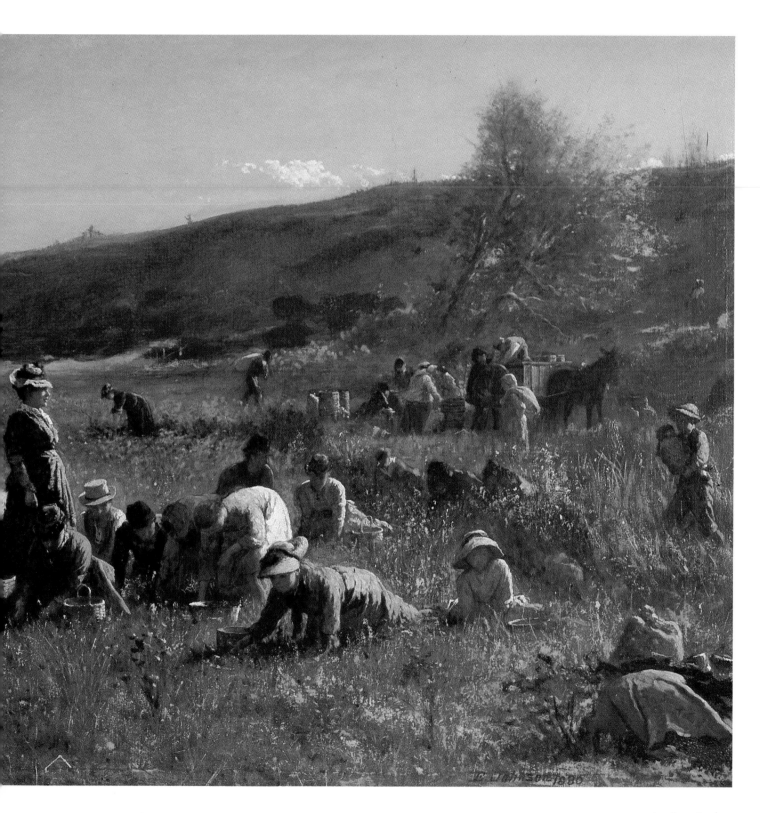

61
WINSLOW HOMER (1836–1910)
Snap the Whip, 1872
Oil on canvas, 22 × 36 in. (55.9 × 91.4 cm.)
The Butler Institute of American Art, Youngstown, Ohio

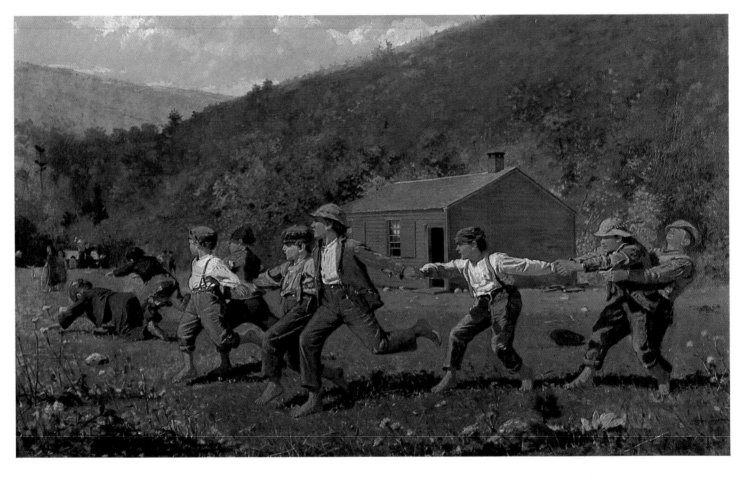

WINSLOW HOMER (1836–1910)
Snap the Whip, 1872

62
WINSLOW HOMER (1836–1910)
The Cotton Pickers, 1876
Oil on canvas, $24\frac{1}{16} \times 38\frac{1}{8}$ in. (61.1 × 96.8 cm.)
Los Angeles County Museum of Art, Acquisition made possible through Museum Trustees:
 Robert O. Anderson, R. Stanton Avery, B. Gerald Cantor, Edward W. Carter, Justin Dart,
 Charles E. Ducommun, Mrs. F. Daniel Frost, Julian Ganz, Jr., Dr. Armand Hammer,
 Harry Lenart, Dr. Franklin D. Murphy, Mrs. Joan Palevsky, Richard E. Sherwood,
 Maynard J. Toll, and Hal B. Wallis

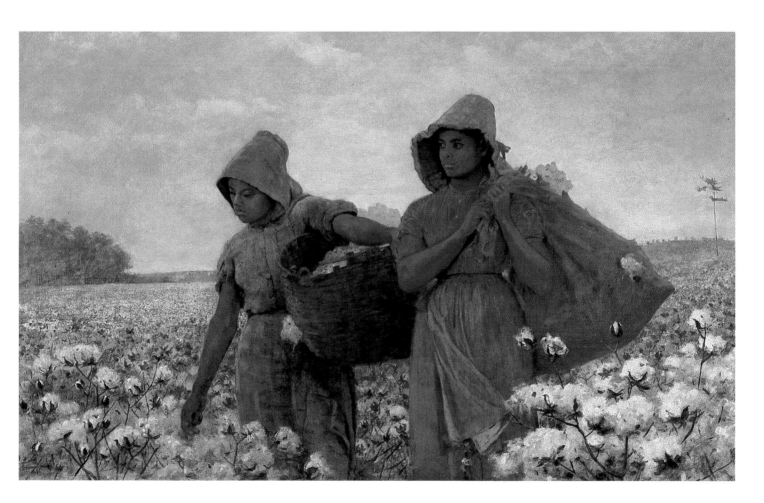

63
ARTHUR FITZWILLIAM TAIT (1819–1905)
A Tight Fix, 1856
Oil on canvas, 40 × 60 in. (101.6 × 152.4 cm.)
The Manoogian Collection

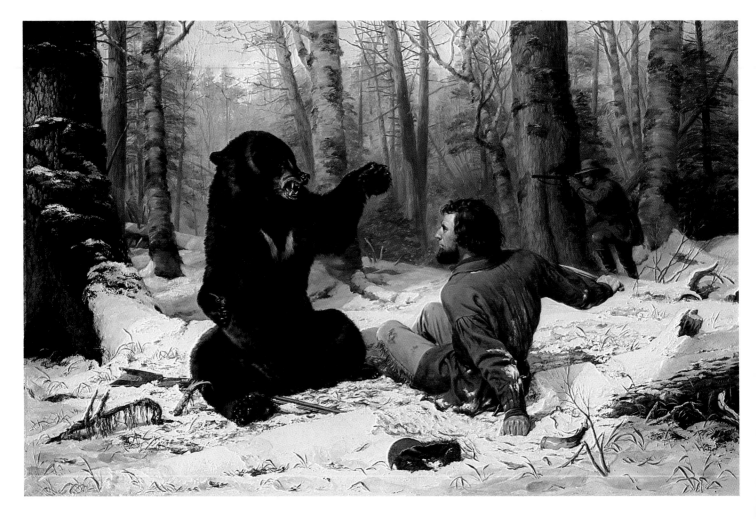

ARTHUR FITZWILLIAM TAIT (1819–1905)
A Tight Fix, 1856

64
FREDERIC REMINGTON (1861–1909)
Evening on a Canadian Lake, 1905
Oil on canvas, $27\frac{1}{4} \times 40$ in. (69.2 × 101.6 cm.)
The Manoogian Collection

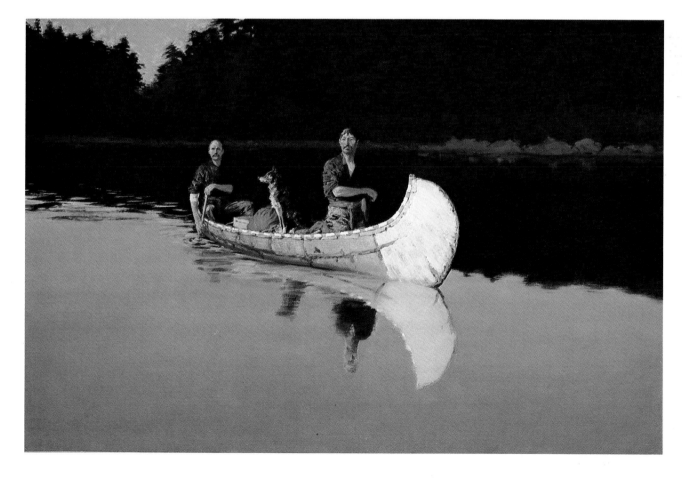

VI. *The Flowering of Still Life*

Still-life painting played a minor role in American art during the first half of the nineteenth century. This is not surprising, for the genre had been held in low regard by the English painters and writers who so much influenced the artists of the young nation. There were only a handful of still lifes painted in America in the eighteenth century, and hardly more in the following decades. When they *were* made, the artist was likely to be experimenting or joking or simply testing his own dexterity. The first to make this mode anything like a specialty was Raphaelle Peale of Philadelphia (see cat. nos. 12 and 13), and he seems to have taken it up as a last resort, his drunkenness and irresolute personality apparently having made him unfit for "higher" occupations. However, Raphaelle influenced other members of his family to try this unprofitable genre: his uncle James Peale (1749–1831) painted a number during the last decade of his life, and various nieces and cousins—including Margaretta Angelica Peale (1795–1882), probably the ablest of the group—carried on in his style until the Civil War.

A few fine still lifes were made during this time by artists other than the Peales, but these are isolated examples indeed. One can point to the unique neoclassic composition of peaches and grapes dated 1810 (St. Louis Art Museum) by the Boston portraitist John Johnston (1753–1818) and to the handful of still lifes by the Washington, D.C., portrait painter Charles Bird King (1785–1862). King had worked in the London studio of Benjamin West, and on his return in 1812 he successfully portrayed a variety of distinguished figures including many Indian leaders who visited the nation's capital. He painted several tabletop compositions of fruit in baskets, and in addition made two very different "vanitas" pictures including *The Vanity of the Artist's Dream* (1830; Fogg Art Museum, Cambridge, Mass.). This extraordinary work pictures an artist's cupboard filled with cast-off relics, art books, paints, and a notebook page whose text gives ironic summary to the plight of the arts in America, reading, "The exhibition of a Catskin in Philadelphia produced Twelve Hundred dollars, totally eclipsing its rival, the splendid portrait of West by Sir T. Lawrence, the latter we regret did not produce enough to pay its expenses."

More still life began to be painted around 1850, though this mode did not play a significant role in the general painting boom of mid-century, which was marked particularly by the high quality and popularity of landscape and genre painting. Only a few still lifes were distributed by the American Art-Union, including fourteen pictures between 1841–48 by the Philadelphian Joseph B. Ord (1805–1865), a follower of the Peales, and eleven in the years 1848–52 by Severin Roesen (c. 1815–1871). The latter, a German porcelain painter who arrived in New York in 1848, made a large number of fruit and flower compositions in a detailed, artificial style based ultimately on late-seventeenth- and early-eighteenth-century Dutch style as practiced by such masters as Wilhelm van Aelst and Jan van Huysum. Roesen's Victorian style is carried to an extreme of detailed observation and multileveled symbolism in the work of the little-known E. A. Goodes, a generally mundane painter who executed just one truly extraordinary picture (see cat. no. 65).

By the time of the Civil War, still life had gained considerable popularity through the work of a number of artists including John F. Francis (1808–1886), a specialist in robust luncheon pieces full of fruits, cakes, porcelain, and silver, and George C. Lambdin (1830–1896), a flower specialist whose roses were highly regarded. The work of these two Philadelphians and of the New York painter of fruit George Henry Hall (1825–1913) was realistic and cheerful, though generally lacking either stylistic originality or iconographic subtlety. These are middle-class paintings with a simple message of abundance. In their domestic scale and subject matter, they recall the strong still-life tradition of another middle-class, mercantile society, that of seventeenth-century Holland. And, as in Holland, still-life painting—though well patronized—was little recognized by contemporary critics, nor was it practiced by the ablest artists of the time: Mount made a few small floral compositions, but artists of the calibre of Copley or Church, Bingham or Homer, by and large eschewed this genre and left it to specialists.

Two exceptions to this rule—who are also two of the handful of still-life painters mentioned in Tuckerman's survey of 1867—are John La Farge and Martin Johnson Heade. La Farge was associated with William Morris Hunt (1824–1879): both studied with Couture in Paris, and both played a role in bringing to America a taste for the "modern" French style of Millet and the Barbizon School. La Farge's early still lifes, made between 1859 and 1862, are entirely out of the mainstream of American Victorian still life as represented by Roesen and Hall. His *Agathon to Erosanthe, A Love Wreath* (cat. no. 66) has no American parallel in its subtle coloration, its rich handling, and its gentle, elegiac mood; rather, it looks back toward Europe, and ahead to the moody still lifes of John F. Peto and the figurative works of

Abbott Thayer and Thomas Dewing. Heade, on the other hand, was very much part of his time, and his landscapes relate to both Church and Lane. He was, uniquely, equally able and productive in still life. During the 1860s he made a series of elegant small pictures of vases of flowers, executed in the detailed Victorian style. In the following decade, however, he broke away from convention, combining exotic jungle orchids and colorful hummingbirds in steamy, tropical landscape settings (see cat.no.67). These paintings have been mistaken for the studies of a naturalist, in the tradition of the great American ornithologist and watercolorist John James Audubon (1785–1851), but they are far from it: they were executed long after the painter returned from his South American travels, and, like his landscapes, they speak more of his Romantic intuition, of the electric connection that a willing spirit can make with nature, than they do of the naturalist's observations. Heade went on in the mid-eighties to make yet another, very different kind of still life, now painting Cherokee roses, orange blossoms, and especially large white magnolias on red and blue velvet (see cat.no.68). If the tropical paintings seem frenzied and passionate, the later flowers equally suggest sensuality, but now the mood is languorous, indulgent, and satisfied.

Increasing numbers of still lifes were made during the last quarter of the century, and they can be divided into three discrete groups, each employing its own distinct style, and each appealing to a different audience. By far the most highly regarded still lifes of the period were paintings by the leading masters of academic style such as William Merritt Chase and Julian Alden Weir (1852–1919). Second, there are the "trompe l'oeil" works of William Harnett and his school, which today seem so especially American but which in their own time were hardly acknowledged as serious art. Finally, one has the large number of "hard-edged" fruit paintings by Joseph Decker, Levi W. Prentice, and others, which were made for a vast middle-class audience.

Chase and Weir were painters with major reputations and positions of leadership in the art world. Both specialized in conservative portraiture and Impressionist landscapes, and for them still life represented a lesser interest. The still lifes of both artists are dark and richly painted, affected by their experience with the painterly Munich style of their own time. Similar but lighter-toned and more obviously influenced by the work of the eighteenth-century French master Chardin are the elegant still lifes of Emil Carlsen (1853–1932), perhaps the ablest of "painterly" still-life practitioners of the time.

During the last two decades of the century, American painters led by Harnett made trompe l'oeil painting into a high art form.[1] This kind of illusionistic, literally reproductive painting, designed to fool the eye of the viewer, was used by mosaic artists in Roman villas at Pompeii, and appeared regularly thereafter as an incidental genre in western art. It was prankish, meant to provide a humorous, momentary deception and to show off the accurate hand of the artist. Occasional precedents for Harnett's style can be found in seventeenth- and eighteenth-century Holland, France, and England, and in the work of the Peales in early nineteenth-century America, but in fact no major painter had ever made a specialty of such a style, or carried it to such artistic heights. In Harnett's hands, in fact, trompe l'oeil became a popular national art of remarkable originality.

Harnett was successful and well patronized in his lifetime, and his work was popularly known through chromolithographs after his famous *Old Violin* (1886; Private Collection, Cincinnati) and from many copies and imitations. But the serious and sophisticated collectors and critics, on the whole, rejected his work: his illusionism was admired as craft but dismissed as "mere trickery," as lacking the qualities of true art, and his audience came largely from the unsophisticated middle class. At the time, his work must have seemed old-fashioned, its literal detail relating back to the aesthetic of Lane and Church rather than to the freshly brushed, light-toned look of a La Farge or a Chase. It is only in recent years—since the rise of Cubism and the modern aesthetic—that Harnett has been truly appreciated, for his paintings now seem as intelligently constructed, as carefully and subtly balanced, as the work of a Picasso or a Mondrian.

Harnett's followers in the trompe l'oeil style generally failed to win much patronage or popularity in their lifetimes: their art was far from the mainstream, and in its linearity, its simplicity, and its popularity with unsophisticated viewers it constituted a folk art of sorts. De Scott Evans (or "S. S. David," 1847–1898), became a master of tiny, flat compositions of peanuts behind glass while he earned his living painting academic pictures of fashionable women. John Haberle worked in a scientific museum at Yale University, in his spare time making extraordinary trompe l'oeil paintings (see cat.no.74) as well as traditional, loosely painted fruit and flower still lifes. The best-known artist of this group, John F. Peto, a Philadelphian who studied at the Pennsylvania Academy while Eakins was teaching there, took on much of Harnett's palette and subject matter while rejecting the fanatical attention to detail that marks the true trompe l'oeil painter: his paintings instead make use of heavier brushwork and cropped images to deal with questions of mood and tone more consistent with contemporary academic painting (see cat.no.75).

A third, intermediate style of still life was widely practiced in the late years of the century: its compositions employ fruit and vegetables on tabletops, recalling the Peales, but the objects at their best are finely wrought and hard edged. Like the trompe l'oeil masters, these artists worked for a popular audience outside the academic mainstream, and generally apart from the most sophisticated urban centers. In Prentice's *Apples in a Tin Pail* (1892; Museum of Fine Arts, Boston) or Decker's *Pears* (cat.no.69), one may find the influence of Harnett and of photography, but one sees above all an extraordinary, focused vision that again looks forward to the twentieth century.

Still life painting was, to a remarkable degree, the result of local tradition, with its creative roots and ongoing strength centered in the city of Philadelphia. This had been the home of the Peales, as well as of Ord, Lambdin, and Francis; Roesen had worked in Williamsport, a smaller city also in Pennsylvania. Heade grew up near Philadelphia, Harnett lived in the city, and Peto was trained there. Nonetheless, still life became a nationally popular art form. It appears to have been practiced in America more widely and perhaps with more originality than in any of the other northern nations, such as Germany, Britain, or Denmark, whose art is closest to our own—again a phenomenon which cannot yet fully be explained.

65
EDWARD ASHTON GOODES (1832–1910)
Fishbowl Fantasy, 1867
Oil on canvas, 30 × 25⅛ in. (76.2 × 63.8 cm.)
Mr. and Mrs. Stuart P. Feld

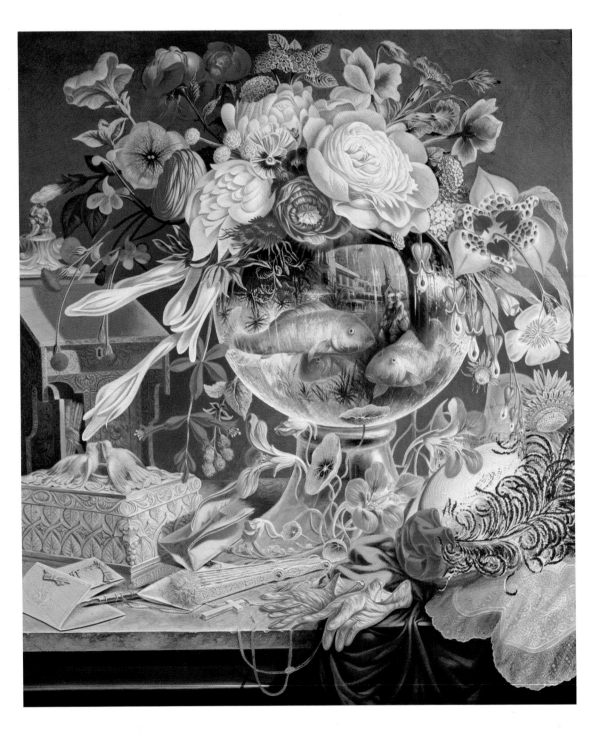

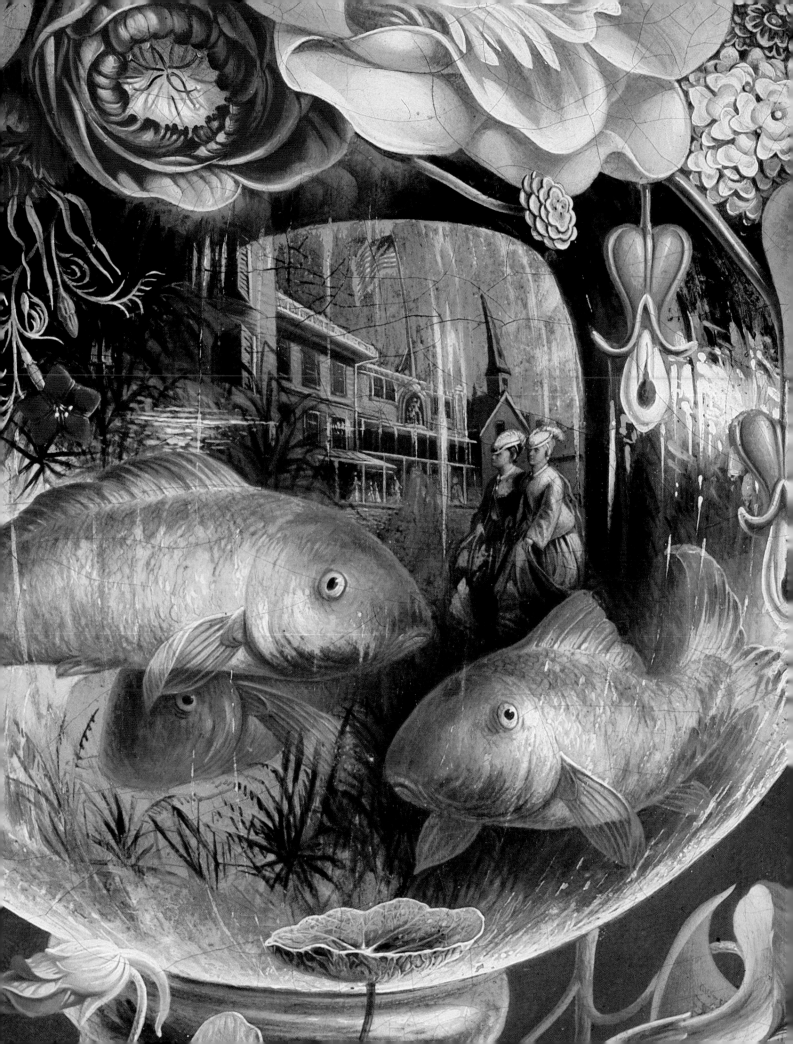

66
JOHN LA FARGE (1835–1910)
Agathon to Erosanthe, A Love Wreath, 1861
Oil on canvas, 22 × 12½ in. (55.9 × 31.8 cm.)
Private Collection

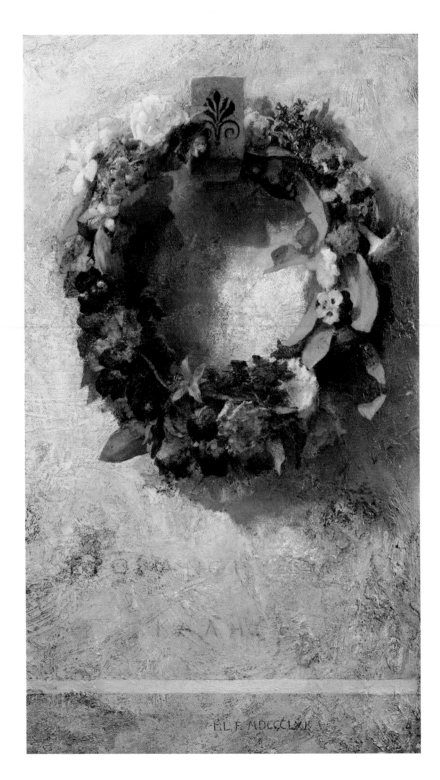

67
MARTIN JOHNSON HEADE (1819–1904)
Two Fighting Hummingbirds with Two Orchids, 1875
Oil on canvas, $17\frac{1}{2} \times 27\frac{3}{4}$ in. (44.5 × 70.5 cm.)
Whitney Museum of American Art, New York,
 Gift of Henry Schnakenberg in memory of Juliana Force, 1967

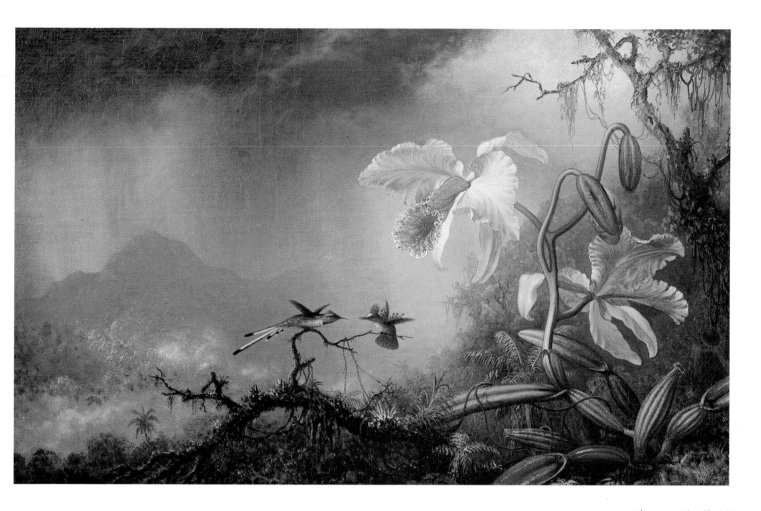

68
MARTIN JOHNSON HEADE (1819–1904)
Giant Magnolias on a Blue Velvet Cloth, c. 1890
Oil on canvas, 15 × 24 in. (38.1 × 61 cm.)
Private Collection

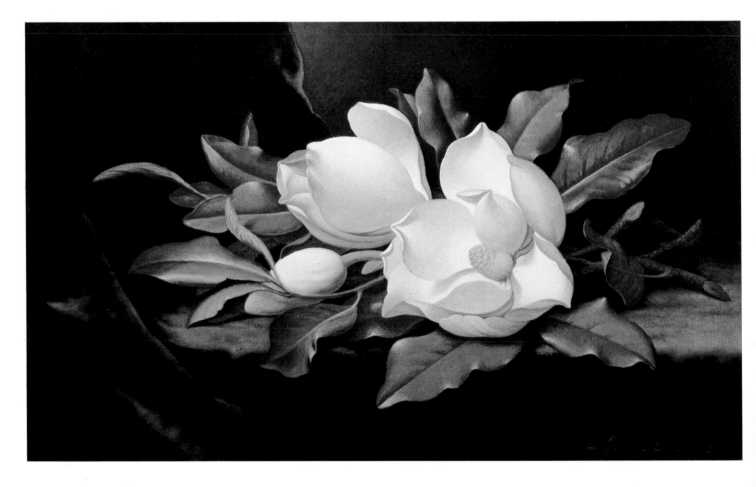

MARTIN JOHNSON HEADE (1819–1904)
Giant Magnolias on a Blue Velvet Cloth, c. 1890

69
JOSEPH DECKER (1853–1924)
Pears, c. 1885
Oil on canvas, $23\frac{1}{2} \times 11\frac{9}{16}$ in. (59.7 × 29.4 cm.)
Private Collection

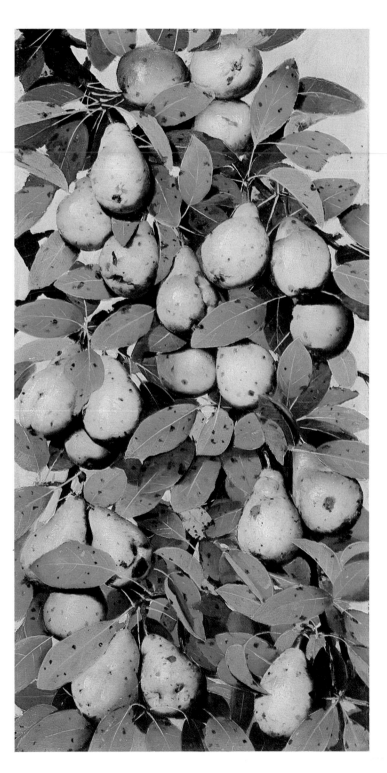

70
WILLIAM MICHAEL HARNETT (1848–1892)
Trophy of the Hunt, 1885
Oil on canvas, 42½ × 22 in. (108 × 55.9 cm.)
Museum of Art, Carnegie Institute, Pittsburgh, Purchase, 1941

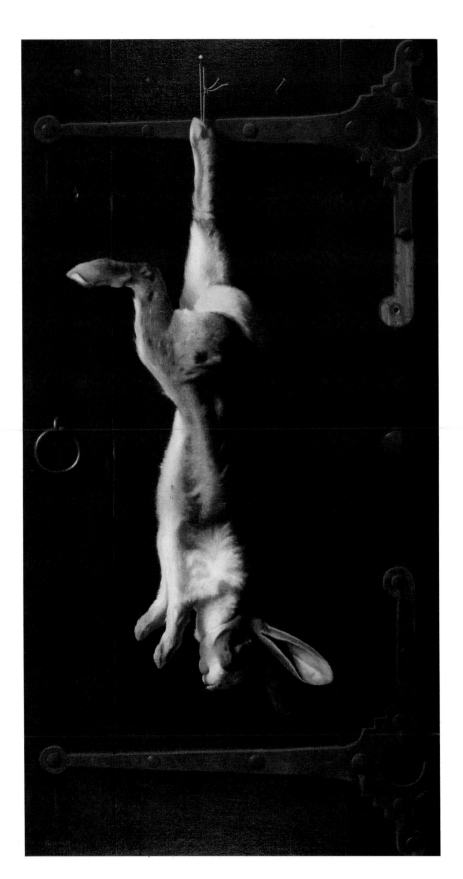

WILLIAM MICHAEL HARNETT (1848–1892)
The Faithful Colt, 1890
Oil on canvas, $22\frac{1}{2} \times 18\frac{1}{2}$ in. (57.2 × 47 cm.)
Wadsworth Atheneum, Hartford, Connecticut,
 The Ella Gallup Sumner and Mary Catlin Sumner Collection

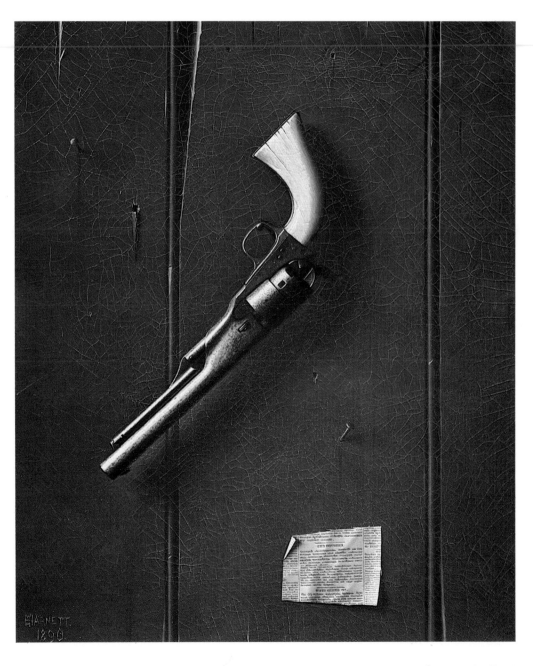

72
WILLIAM MICHAEL HARNETT (1848–1892)
Mr. Hulings' Rack Picture, 1888
Oil on canvas, 30 × 25 in. (76.2 × 63.5 cm.)
Mrs. Alice M. Kaplan

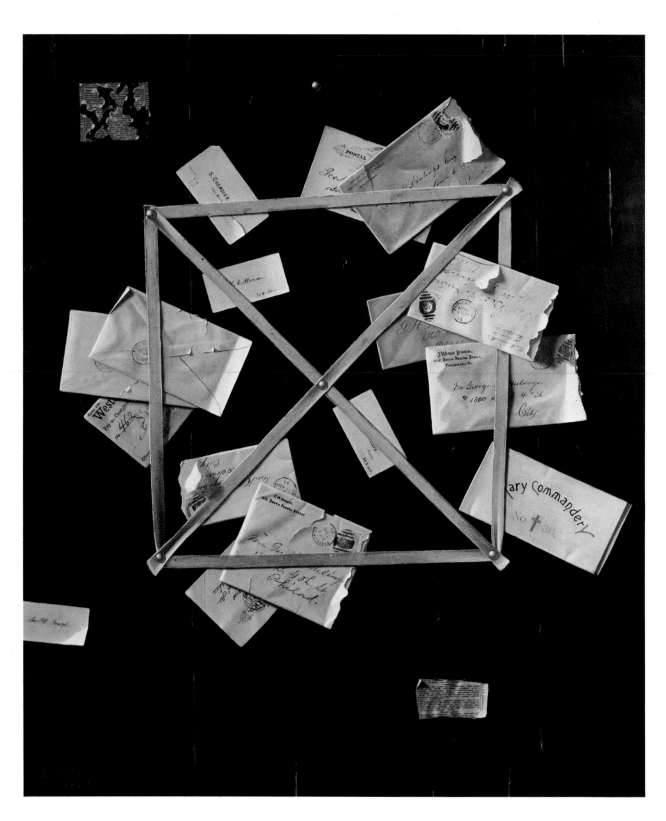

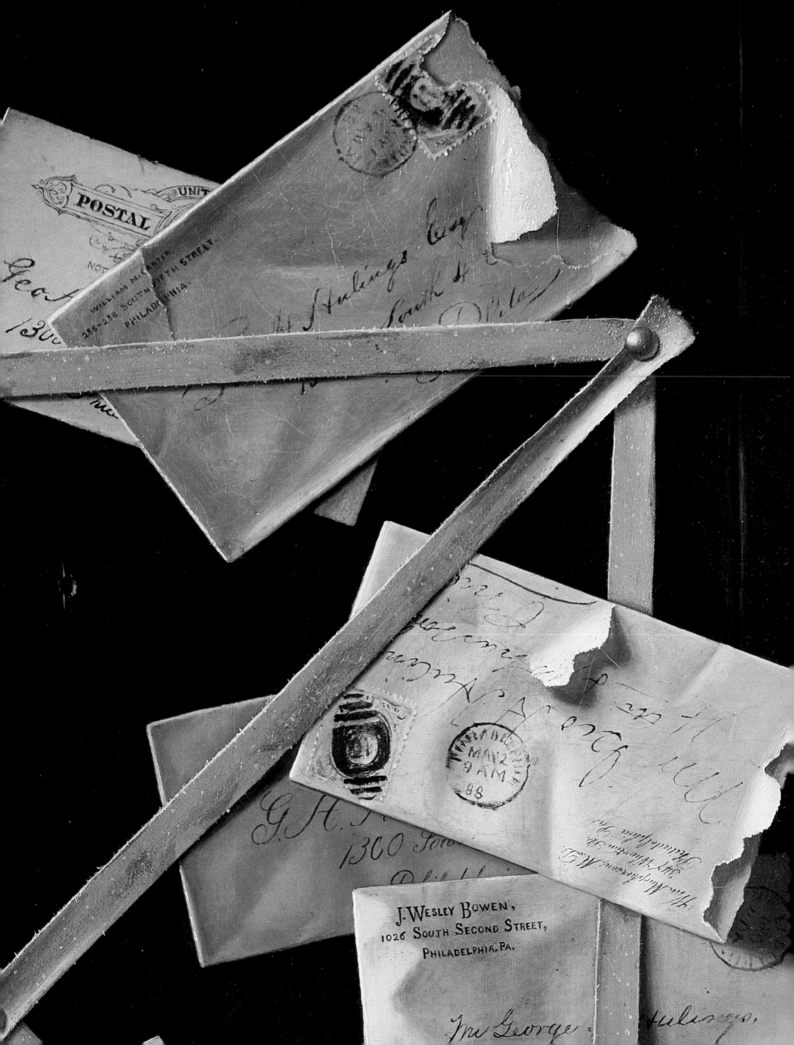

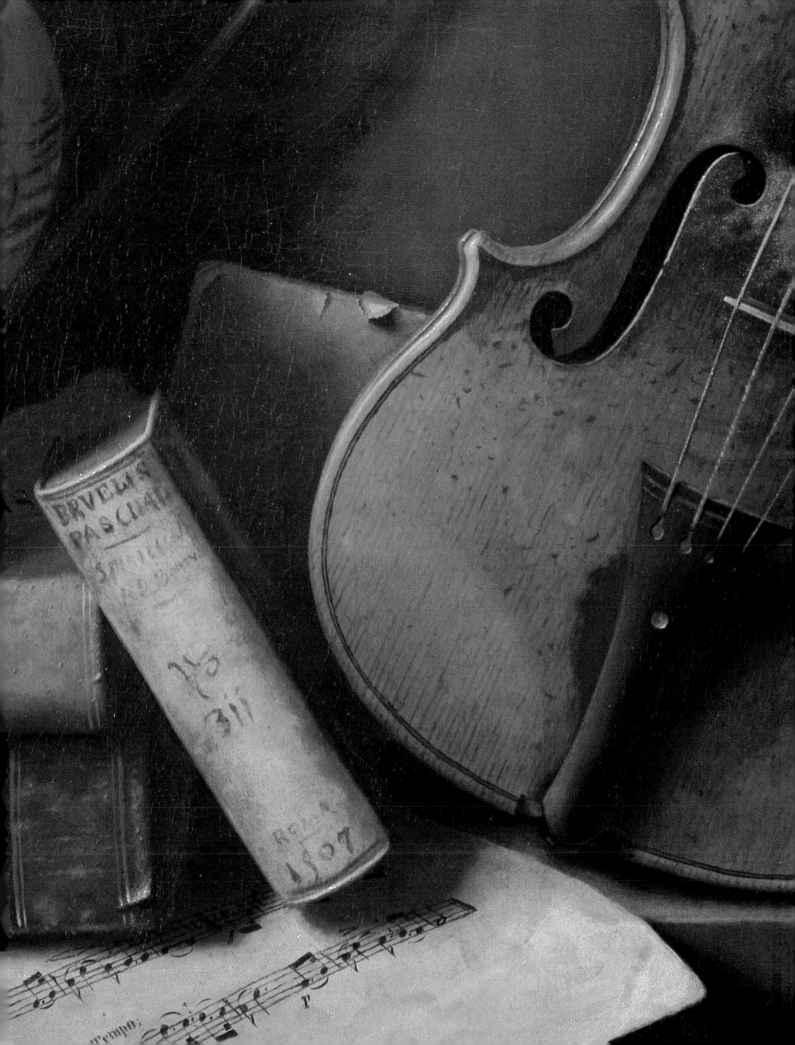

73
WILLIAM MICHAEL HARNETT (1848–1892)
Old Models, 1892
Oil on canvas, 54 × 28 in. (137.2 × 71.1 cm.)
Museum of Fine Arts, Boston,
 Charles Henry Hayden Fund

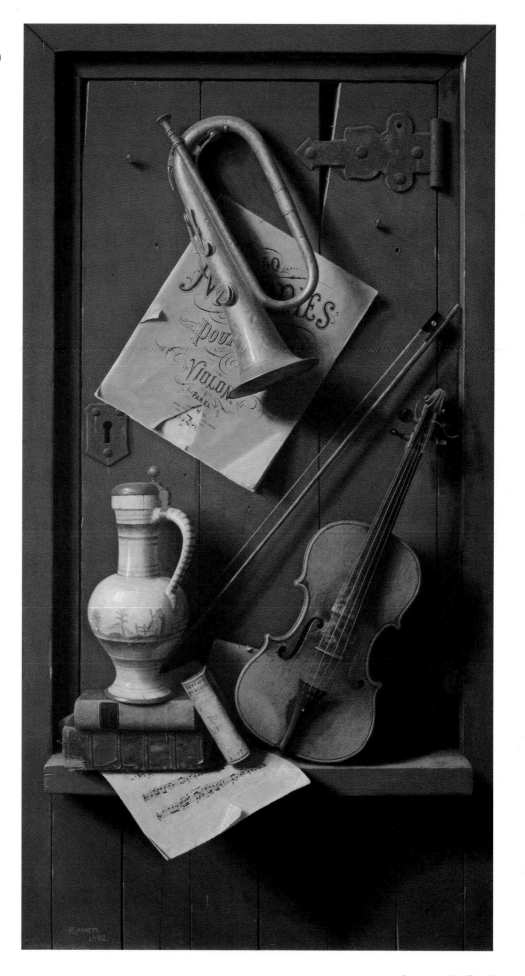

74
JOHN HABERLE (1856–1933)
A Bachelor's Drawer, 1890–94
Oil on canvas, 20 × 36 in. (50.8 × 91.4 cm.)
The Metropolitan Museum of Art, New York, Purchase, Henry R. Luce Gift, 1970

75
JOHN F. PETO (1854–1907)
Old Companions, 1904
Oil on canvas, 22 × 30 in. (55.9 × 76.2 cm.)
Jo Ann and Julian Ganz, Jr.

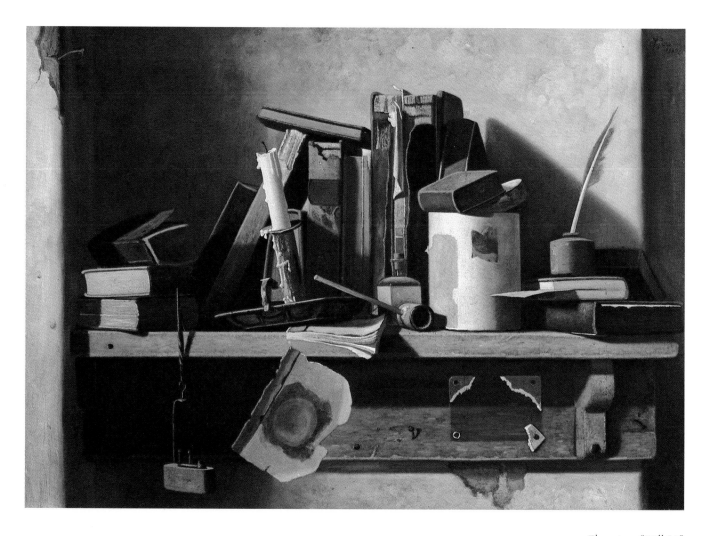

VII. *International Styles*

During the confident years before the Civil War, when the nation believed in its Manifest Destiny, American painters had taken pride in the special, national character of their genre and landscape subjects, and critics applauded the fact that many of our major painters—including Mount, Bingham, and Church—had found no need for European training. All this changed rapidly after the war, and the American art world seemed overnight to become cosmopolitan in outlook and eclectic in style. Now every ambitious young painter felt the need for training abroad, and the lure of Munich and especially of Paris became irresistible. Paintings in the Hudson River School style suddenly seemed outdated, and the older artists decried the "baleful foreign influences" they found all around them. Their style, more literal and more national, now appeared naive and unsuited to the modern age.

The same "internationalization" of painting was also occurring in other countries, in Germany, Denmark, and Russia, among others, and so to understand this phenomenon one has to look beyond America's devastating Civil War—and the spiritual and moral loss of confidence that followed—to other, more widespread factors. Of crucial importance was the vast improvement in speed and ease of international communication. Travel to Europe on the new steamships became faster and more reliable: the trip abroad could become an annual event rather than a once in a lifetime adventure.[1] Moreover, more and better art books and periodicals were published on both sides of the Atlantic, and beginning in the 1870s they were graced with accurate photographic and lithographic reproductions. Cultural transmission could occur in a matter of weeks, rather than taking decades as in the eighteenth century.

The American-born artist James Abbott McNeill Whistler moved to Paris in 1855, when he was twenty-one, and he went on to win international attention and to influence many American painters. He became one of our archetypal expatriates, never returning home; though American by virtue of his birth, whether he was truly an American painter is debatable.

Like many expatriates who followed, Whistler rejected the American environment for purely artistic rather than for political reasons. The materialism of an artist like Church and the folklore of a Mount meant nothing to him: in his actions, Whistler echoed Nathaniel Hawthorne's statement that "the Present, the Immediate, the Actual, has proved too potent for me," and he would have sympathized with Hawthorne's comment on the difficulty of creating art in a place like America with "no shadow, no antiquity, no mystery, no picturesque and gloomy wrong."[2]

Unlike other Americans abroad, both earlier and later, Whistler immediately sought out the avant-garde in Paris, he came to know Manet and Baudelaire, and he absorbed a wide variety of influences including those of the controversial Realist Gustave Courbet, Velázquez, and the delicate, patterned prints of Japan. In 1859 he moved to London, which became his permanent home, and here again he quickly came to know the leading painters—in this case the Pre-Raphaelites and particularly Dante Gabriel Rossetti. Whistler synthesized all of these disparate modes from France, England, and elsewhere, and through his special genius he found a style distinctly his own. Both his reputation as a painter of great originality and his penchant for *causes célèbres* were established in 1863 when his extraordinarily bold, sensual *Symphony in White No. 1: The White Girl* (1862; National Gallery of Art, Washington, D.C.) was rejected by the Paris Salon and then—along with Manet's *Déjeuner sur l'herbe* (Musée du Louvre, Paris)—caused a sensation at the Salon des Refusés. Whistler frequently gave both his figurative and landscape paintings musical titles—"Symphony," "Arrangement," "Harmony"; he believed that "as music is the poetry of sound, so is painting the poetry of sight, and the subject-matter has nothing to do with harmony of sound or of colour."[3] The famous portrait of his mother (cat. no. 77) he called *Arrangement in Grey and Black*, and he painted her accordingly, with attention to dark tones and flat composition. Here he totally rejected both the detailed, storytelling approach of the English and the colorful, painterly style of the French in developing his own unique manner which emphasized subtle tonal relationships and abstract structure. His landscapes are equally bold: *Nocturne: Blue and Gold—Old Battersea Bridge* (cat. no. 78) is a study not of place but of mood. Whistler was not concerned with "the Present . . . the Actual"; instead he painted the evanescent, the vaporous, and the eternal.

Whistler is often paired with John Singer Sargent, another American expatriate who rose to international prominence. Both were stylists, but in very different ways, for Whistler drew on the most advanced currents of his time to become the first American avant-garde painter, while Sargent made use of the art of the past to become a latter-day Van Dyck, the most fashionable portrait painter of his era. Both Whistler and Sargent were influential, but in different ways, the one affecting modern style into the twentieth century, the other providing a lasting image for the English-speaking world of how the powerful and wealthy should be painted. Born in Florence of American parents, Sargent studied with Carolus-Duran in Paris in the mid-1870s. In 1882, at the age of twenty-six, he produced two of his masterpieces, *El Jaleo* (Isabella Stewart Gardner Museum, Boston), an exotic study of Spanish dance, and *The Daughters of Edward Darley Boit* (Museum of Fine Arts, Boston), a spare, evocative interior portrait of four young girls. Two years later he caused a sensation with his Paris Salon picture, *Madame X* (cat. no. 82): the painting was ridiculed, and its poor reception

was one reason that, later in the year, Sargent moved to London, where he became close to such other American painters there as Edwin Austin Abbey (1852–1911) and Frank D. Millet (1846–1912). Sargent regarded *Madame X* as his best work, but never again to this extent did he sacrifice the demands of portraiture for a flattering likeness to the demands of art for pure form. England was a natural place for Sargent for there he reigned supreme, painting the aristocracy of Britain and America (where he traveled ten times) in high style. If his contemporaries misjudged him, overrating his brilliance, so too have his modern detractors, for his pictures at their best can be sensitive, insightful portraits which capture the spirit of their time. As with Whistler, the question of the painter's nationality was raised, and Sargent's friend Henry James asked: "But *is* a painter an American . . . after he has become an R.A. [a member of Britain's Royal Academy of Arts]; especially a painter born, like Mr. Sargent, beside the Arno and with forty years of Europe on his conscience?"[4]

Late-nineteenth-century artists were also drawn to other European centers besides Paris and London. Most important in the 1870s was Munich, where painters such as Wilhelm Liebl taught a painterly, dark style that seemed totally modern. His star American pupil was Frank Duveneck, whose works were considered "the very essence of Munich . . . with their rich, bituminous backgrounds, their unctuous brush work, and their resemblance to darkened, time-stained old masters."[5] This style of "slap-dash bravura" was employed by Duveneck in such works as the much-admired *Turkish Page* of 1876 (cat. no. 79). Other Americans in Munich included William Merritt Chase, John Twachtman (1853–1902)—both later Impressionists—and the figurative painter John W. Alexander who later, in Paris, produced his single masterpiece, *Isabella and the Pot of Basil* (cat. no. 84), in a style relating both to Symbolism and to Art Nouveau. As Henry James had said, "In the Palace of Art there are many mansions."

Americans both in Europe and back home produced many works which can be considered decorative or historical genre pictures. Duveneck's *Turkish Page* was one: the painter's demonstration of style was all-important, and the mildly pathetic subject tells no story, echoes no folktale or legend, refers to no American trait—the subject merely evokes curiosity and sentimentality. The same approach with the painter demonstrating technical skill and historical knowledge occurs in the English work of Millet and Abbey and in the work of many of Gérôme's students, including the Orientalists Frederick A. Bridgman and Edwin Lord Weeks. Much the same can be said of the colony of Americans working at Pont-Aven in Brittany, though the work of Robert Wylie and then of Thomas Hovenden (who was in France from 1874 to 1880) displays a more old-fashioned creation of character and moralism. Hovenden's *In Hoc Signo Vinces* (cat. no. 80) is itself old-fashioned, relating back to the French Revolution and telling of individual courage and fealty to King; it is the same kind of subject Hovenden painted afterward, in a slightly drier manner, in his best American pictures including *In the Hands of the Enemy* (1889; Stoeckel Trust, Yale University, New Haven, Conn.). Thus with only a few exceptions, including Hovenden, and Eakins and Homer more importantly, American genre painters both at home and abroad turned away from the portrayal of American character and local

folklore to generalized, exotic themes. Their subjects were likely to be sentimental and foreign—the Turkish page, the Armenian woman, the Parisian beggar, the Egyptian black—or mysterious and literary. Allusions to sexuality and death, to vaguely known terrors and horrible anxieties, become frequent. Death is imminent in Vedder's *Cup of Death* (cat. no. 83), it has already occurred in Alexander's mournful *Isabella*, and both paintings associate death with a languid female form. Thus, even in this international period, when American painters were in such close touch with Europe, they tended to work less realistically than their foreign contemporaries. This fact was noted by the historian Samuel Isham in 1905. He writes that in France, England, and Germany one finds many paintings that "give the wage and body of the time," while in America there is "hardly anything of the sort." Isham concludes that Americans had an aversion to pictures of daily life which led, as he put it, to a "lack of realistic painting" here.[6]

Albert Pinkham Ryder's *Siegfried and the Rhine Maidens* (cat. no. 87), inspired by a Wagnerian opera and painted in a frenzy, tells the story of a heroic, individual struggle against the fates. *Constance* (cat. no. 88), very calm by contrast, represents a tale from Chaucer in which a despairing mother and her child are miraculously kept alive through faith. Nature's awesome force is revealed in both paintings, but the subject of each is the power of the human being to think and to love.[7] Ryder's style was sophisticated yet highly individualistic, the result both of four trips to Europe (including one to Paris in 1882) and of his own way of seeing. He was known and admired in his time, and with La Farge, Vedder, Inness, and Duveneck was among the first members of the progressive Society of American Artists, an important European-oriented group which broke away from the National Academy of Design in 1877.

George Inness's work provides a good example of the way in which the attitude of painters changed in a half-century. He began in the late 1840s with a detailed, Hudson River School style modeled on that of Durand, and in 1855—already having made two trips to France and Italy—he still could paint the realistic, luminous *Lackawanna Valley* (1855; National Gallery of Art, Washington, D.C.). After that his work increasingly made use of Corot and the Barbizon School, though he never became an imitator. *Lake Albano* (cat. no. 85) represents the Romantic painter's view of Italy, carefree, colorful, and artistic. Through frequent trips abroad, Inness continually developed his own modern synthesis. His final style is subjective, richly painterly, and nearly monochromatic: *Home at Montclair* (cat. no. 86) represents not place but poetry, mood, and feeling.[8]

It has been traditional to think of our best painters of this era as necessarily withdrawing from life in America—either by moving abroad or "escaping" into their own imaginary worlds—and to consider this escapism as essentially mystical and pessimistic. The world view of Church and Mount was surely very different from that of Ryder or of Inness, but to consider the latter painters simply pessimists is overly simplistic: the paintings of the Jacksonian era reflect a general confidence in God and in the future of the nation, but the paintings of the postwar period are more involved with the significance, the responsibility, and the psyche of the individual human being.

76
WILLIAM RIMMER (1816–1879)
Flight and Pursuit, 1872
Oil on canvas, 18 × 26¼ in. (45.7 × 66.7 cm.)
Museum of Fine Arts, Boston, Bequest of Miss Edith Nichols

77
JAMES ABBOTT McNEILL WHISTLER (1834–1903)
Arrangement in Grey and Black: Portrait of the Painter's Mother, 1871
Oil on canvas, 56¾ × 64 in. (144.1 × 162.6 cm.)
Musée du Louvre, Paris

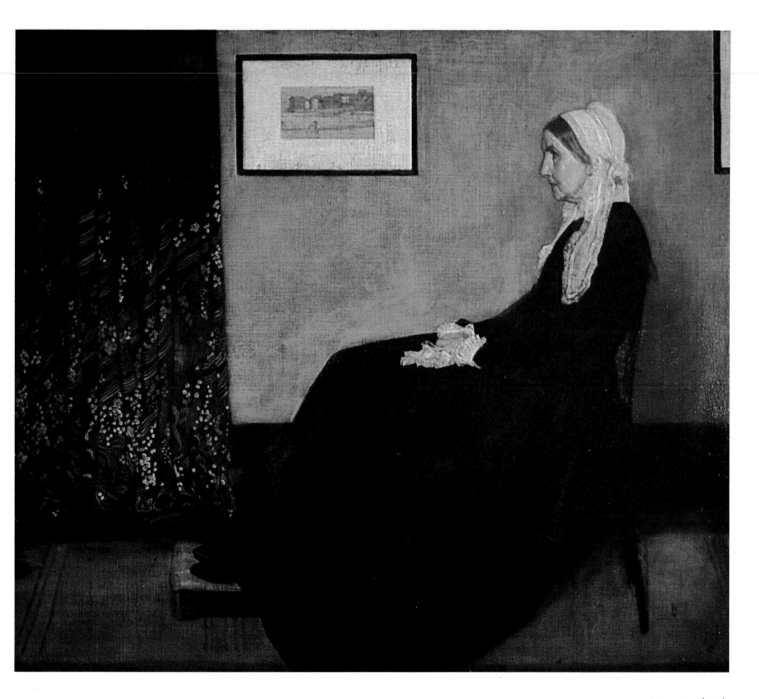

78
JAMES ABBOTT MCNEILL WHISTLER (1834–1903)
Nocturne: Blue and Gold—Old Battersea Bridge, 1872–75
Oil on canvas, $26\frac{1}{4} \times 19\frac{3}{4}$ in. (66.7 × 50.2 cm.)
The Tate Gallery, London

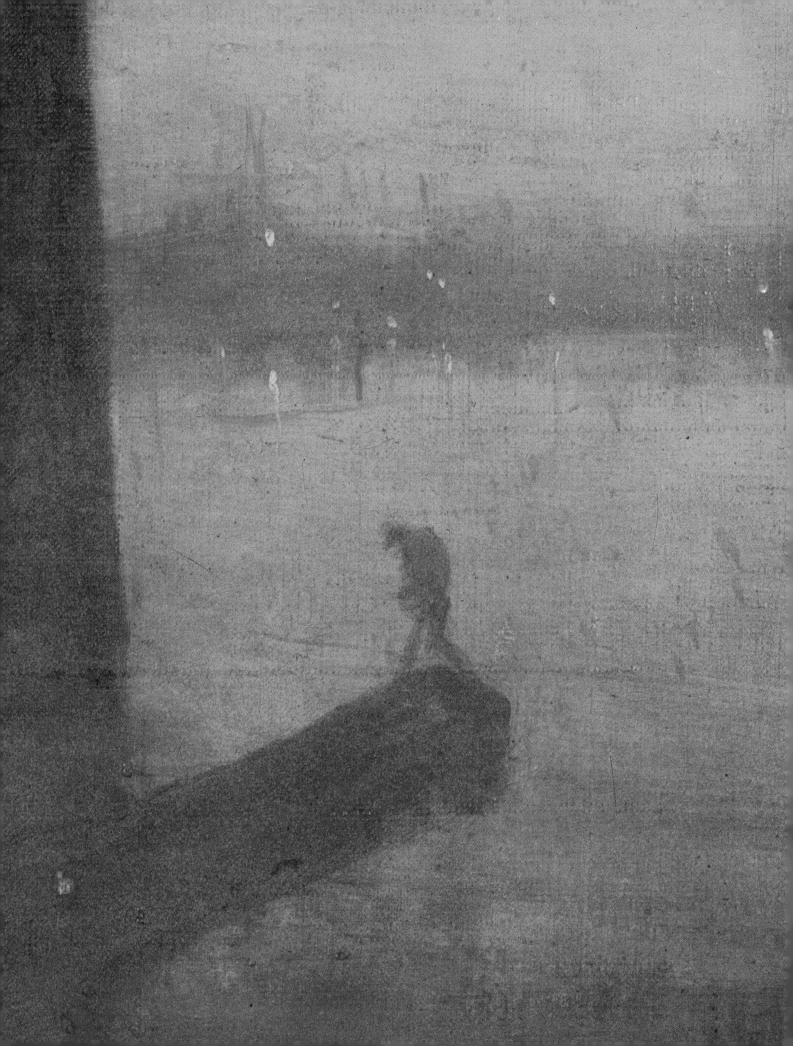

79
FRANK DUVENECK (1848–1919)
The Turkish Page, 1876
Oil on canvas, 42 × 56 in. (106.7 × 142.2 cm.)
The Pennsylvania Academy of the Fine Arts, Philadelphia, Temple Fund Purchase

80
THOMAS HOVENDEN (1840–1895)
In Hoc Signo Vinces, 1880
Oil on canvas, 39 × 54 in. (99.1 × 137.2 cm.)
The Detroit Institute of Arts, Gift of Mr. and Mrs. Harold O. Love

JOHN SINGER SARGENT (1856–1925)
Dr. Pozzi at Home, 1881
Oil on canvas, $80\frac{1}{2} \times 43\frac{7}{8}$ in. (204.5 × 111.5 cm.)
The Armand Hammer Collection

82
JOHN SINGER SARGENT (1856–1925)
Madame X (Madame Pierre Gautreau), 1884
Oil on canvas, $82\frac{1}{8} \times 43\frac{1}{4}$ in.
 (208.6 × 109.9 cm.)
The Metropolitan Museum of Art,
 New York,
 Arthur Hoppock Hearn Fund, 1916

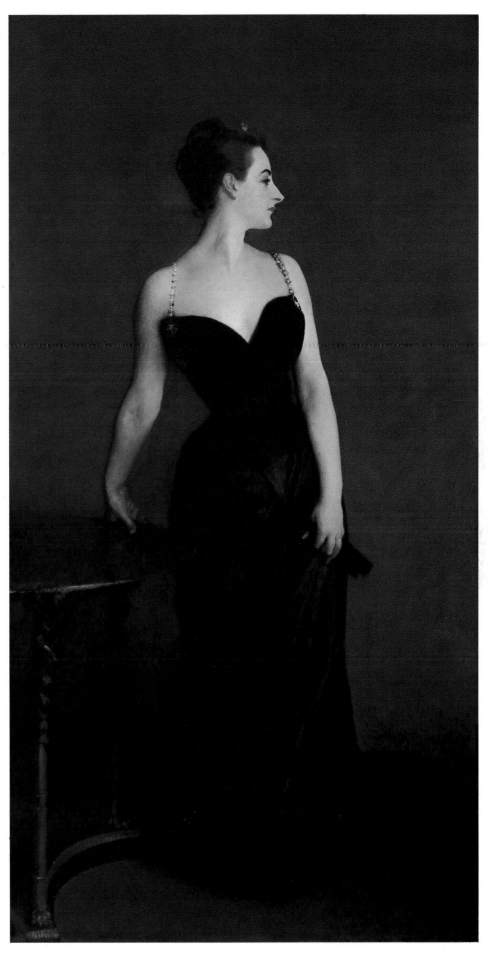

83
ELIHU VEDDER (1836–1923)
The Cup of Death, 1885
Oil on canvas, $44\frac{3}{8} \times 20\frac{3}{4}$ in. (112.7×52.7 cm.)
Virginia Museum of Fine Arts, Richmond

84
JOHN WHITE ALEXANDER (1856–1915)
Isabella and the Pot of Basil, 1897
Oil on canvas, $75\frac{1}{2} \times 35\frac{3}{4}$ in. (191.8 × 90.8 cm.)
Museum of Fine Arts, Boston,
 Gift of Ernest Wadsworth Longfellow

85
GEORGE INNESS (1825–1894)
Lake Albano, c. 1873–75
Oil on canvas, $30\frac{3}{8} \times 45\frac{3}{8}$ in. (77.2 × 115.3 cm.)
The Phillips Collection, Washington, D.C.

86
GEORGE INNESS (1825–1894)
Home at Montclair, 1892
Oil on canvas, $30\frac{1}{8} \times 45$ in. (76.5 × 114.3 cm.)
Sterling and Francine Clark Art Institute, Williamstown, Massachusetts

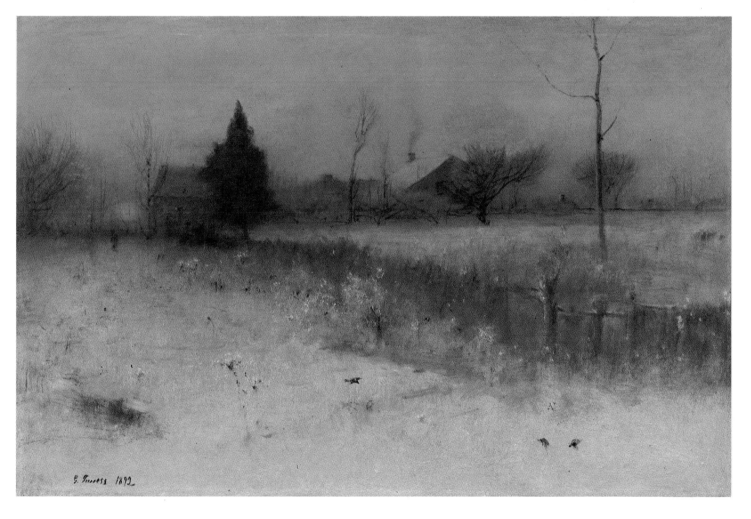

87
ALBERT PINKHAM RYDER (1847–1917)
Siegfried and the Rhine Maidens, 1888–91
Oil on canvas, $19\frac{7}{8} \times 20\frac{1}{2}$ in. (50.5 × 52.1 cm.)
National Gallery of Art, Washington, D.C., Andrew W. Mellon Collection, 1946

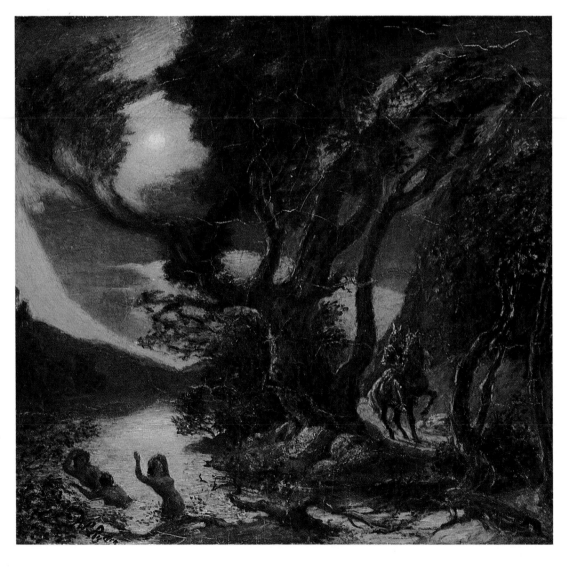

88
ALBERT PINKHAM RYDER (1847–1917)
Constance, 1896
Oil on canvas, $28\frac{1}{4}$ × 36 in. (71.7 × 91.4 cm.)
Museum of Fine Arts, Boston, Abraham Shuman Fund

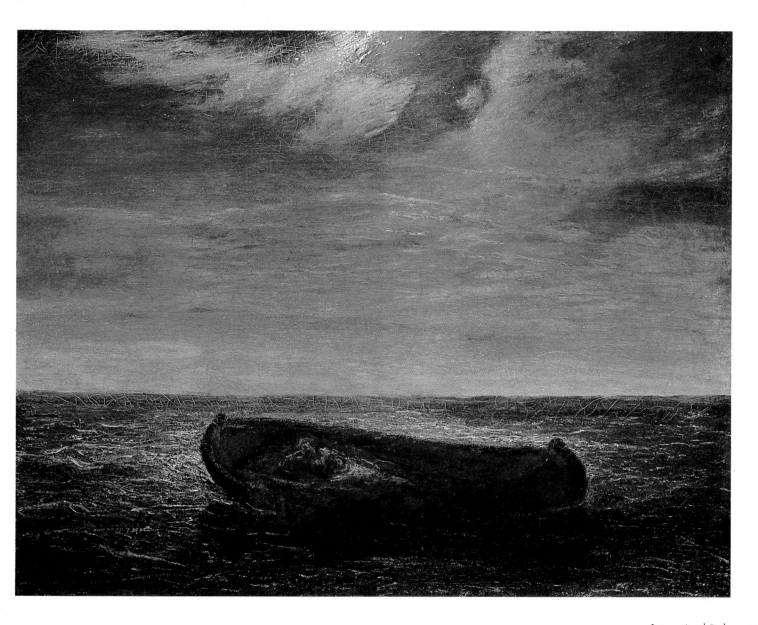

VIII. *Painters of Light*

In 1905 the historian Samuel Isham recognized perhaps the single most important factor contributing to American style: "American painting," he pointed out, "has always been sensitive to the general development of art in Europe, taking what it could assimilate and adapting it to its use."[1] American painters have received their energy, their stylistic innovations, and their teaching from Europe—from London, Düsseldorf, Munich, Rome, and Paris. They have learned from Europe what painting might be, and they have adapted these lessons to the special qualities of the American land, as well as to our character, taste, and patronage. European art has seemed to the painter to be almost literally divine, while America has beset him with a continual, inherent set of mundane limitations. Each generation of American painters has had to learn painting again, and normally each has turned toward Europe rather than to earlier American artists for these lessons. Thus Copley's influence on his successors was, considering his preeminence, remarkably slight; and the same can be said of Allston, Church, Homer, and many of our best painters. Innovation has come from Europe: from Americans working there such as West, Sargent, and Whistler; from Americans returning home, such as Stuart or Hunt or Duveneck; from European masters abroad who influenced Americans through their books and prints or their teaching; and from lesser European painters who came to America in every generation after 1670, bringing knowledge of fashionable new styles.

Thus each succeeding generation of American painters rejected the one before with disdain and finality: Church's *Twilight in the Wilderness* may have influenced his contemporaries, but for the younger men, for a Duveneck or a Chase, it wasn't even art. Similarly, with so much energy coming from foreign travel and inspiration, it is no surprise that the painters' most inspired works—beginning with John Smibert's *Bermuda Group* (Yale University Art Gallery, New Haven, Conn.) in 1729— were often made early in their careers. The self-generating painter who could keep growing on his own, a Copley or a Homer, was a rarity.

In addition, American painters and their patrons remained deeply conservative. The aesthetic of the picturesque remained in force here well into the twentieth century. Our painters believed that paintings were meant to be beautiful and pleasing, representing truth and nature, and they steadfastly refused to allow other social, political, or symbolic ends to interfere. Even the moral didacticism of West's kind of history painting was too much for most Americans: and the best American neoclassic paintings, by Trumbull, Vanderlyn, and others, were painted abroad. Extremes were avoided at all costs. The social criticism of a Daumier, the luxuriance of a Delacroix, the emotional coloration of a Turner, were simply impossible on these shores. The new speed of communication did remarkably little to change this, for the caution in American art was deep-rooted, reflecting a continuing fear of full-bodied emotional expression that John Adams would have understood, and no new technology could change it. America has always been a land which hungered for art, while fearing it.

For reasons which are still unclear, Americans turned away from England and toward France after the Civil War. Then for many years the dominant influence on our art was the Barbizon style of Rousseau, Corot, and Millet, stripped of its social aims and made purely picturesque: one finds Ryder, Inness, J. Francis Murphy, Henry Ward Ranger, and in fact most of our landscapists referring back to this French style of the 1840s in the creation of the moody, Tonalist pictures that became so popular here in the 1870s and '80s. Many Americans were studying in France in these two decades, but even those later considered to be most "progressive" were working at the Académie Julian and with Gérôme, Carolus-Duran, and other conservative masters. Monet, Degas, Pissarro, Renoir, and others had first exhibited together in 1874 in Paris, at which time the term "Impressionism" was coined, and the Americans knew of them but rejected their work. Inness denied that his own painting had anything to do with Impressionism and called that style "the sloth enrapt in its own eternal dullness."[2] Julian Alden Weir visited the third Impressionist show in 1877 and found the works lacking drawing and form: he reported the show "worse than a Chamber of Horrors."[3] These reactions were typical of American response to the new—one thinks of Cole in London in 1829 or Morse in Paris at the same time—and Impressionism was especially hard to grasp as it seemed so radically bright, so flamboyant in handling, and so lacking in spirituality and mood.

One American painter played a fairly central role in the Impressionist movement in France: this was Mary Cassatt, a wealthy young woman from Philadelphia who became a friend and outspoken admirer of Degas. At his invitation she joined the Impressionist group, and she exhibited with them from 1879 to 1886. Cassat lived in Paris and was unquestionably a French painter, though she considered herself an American, retaining both her citizenship and close personal ties. Moreover, she sent several paintings to exhibits in the U.S., showing both at the National Academy (in 1874 and 1878) and at the new Society of American Artists beginning in 1879; these were perhaps the first works in the new French style to be seen by a wide American audience. They seemed idiosyncratic and strange to conservative American eyes, and they had little effect here. By this time, however, Cassatt had begun to advise the American collectors Louisine and Horace Havemeyer on their purchases of Degas, Manet, and others whom she admired. Cassatt's own work had also matured: her *Blue Room* of 1878 (National Gallery of Art, Washington, D.C.) is richly painted and boldly composed, and the elegant *Woman and Child Driving* of 1879 (Philadelphia Museum of Art) recalls Degas in its contrast of light figures against a dark background and its close-up, cropped composition. However, Cassatt's most striking work comes a decade later, impelled by a new familiarity with Japanese prints and increasing independence from her French mentors: in works of the early nineties including *Young Women Picking Fruit* (cat. no. 93) and *The Bath* (cat. no. 94), there is a new, decorative linearity, a flattening of form, and a tightening of composition. These paintings are superb works by a mature painter who has gone beyond the Impressionist mode to her own Post-Impressionist style.

Americans began to embrace French Impressionism in the

years 1886–87. Most important in introducing the style to the U.S. were the activities of the Parisian art dealer Paul Durand-Ruel, who, backed by Cassatt, brought to New York in 1886 a large exhibition of Manet, Monet, Renoir, and the other French painters. The show was a success, and some sales were made to American collectors who took to the new style quickly. Durand-Ruel later reported, "Without America, I was lost, ruined, through having bought so many Monets and Renoirs. Two exhibitions there, in 1886–1887, saved me. The American public does not laugh, it buys—moderately, it is true; . . . since then, as everyone knows, the French public has followed suit."[4]

American painters began to take up modified versions of the style at exactly this time, beginning in the mid-eighties, and within a few years—by the time of the Chicago Exposition of 1893—it was widely practiced and highly popular in the U.S. One of the first was the expatriate John Singer Sargent, who traveled to Venice in 1880 and 1882 and there made a series of broadly brushed, dramatic interior views and street scenes whose overall darkness is broken by superb touches of sunlight (see cat.no.90). After moving to England following the *Madame X* uproar, he painted at Broadway in the Cotswolds during the summers of 1885 and '86, and came closer to the Impressionist spirit with the great *Carnation, Lily, Lily, Rose* (Tate Gallery, London), an evocation of the movement and light of early evening. In the following year he came to know Monet; they exhibited together in 1889, but afterward Sargent's art moved in other directions.

In many ways Sargent was the model American Impressionist: the product of strict Academic training, he adapted the new, light palette, and quick, plein air brushwork of Impressionism to his own occasional uses, but it was only one of the many arrows to his bow. He made his living painting portraits in a dark, dashing style; and like so many of his contemporaries, including Cassatt, Vedder, Weir, Abbey, Dewing, and Blum, among others, he also made decorative murals, an art whose requirements were at odds with those of Impressionism.[5] And his best and most consistent Impressionist work—marvelous light-filled Venetian watercolors and a series of small oil paintings—was done during the first two decades of the twentieth century, when the French movement was long since dead.

Sargent's young friend Dennis Bunker (1861–1890) similarly was a "holiday" Impressionist while a professional, academic portraitist. And able as he was, he was also conservative, or limited: in his work there is never "the total dissolution of form as in Monet's painting," nor "the full prismatic range."[6] This pattern was followed in Boston especially: E. C. Tarbell (1862–1938), the leader of the Boston school, combined Monet's technique with Renoir's in his own explorations of sunlight, as in *Three Sisters* (1890; Milwaukee Art Center), while continuing to paint elegant, dark portraits, and with his colleague Frank Benson (1862–1951) he carried on this dual approach until his death in 1938.

William Merritt Chase, a preeminent teacher and one of the most gifted painters of his time, had painted in the Munich style after returning from study there in the seventies, then was influenced by Whistler, before beginning his own involvement with Impressionism about 1887. At his best, Chase is a superb stylist, and his carefully crafted pictures rank among the best of American Impressionist works. They would never be confused with those of French Impressionism, any more than Church would be confused with Friedrich, or Stuart Davis with Léger, and there is no reason to expect otherwise. Style seldom developed organically in this country: our artists received it late, after it had been discovered and worked out abroad, and they used it synthetically to meet the different needs of their own time and place. Chase's *Open Air Breakfast* (cat.no.91) is superbly composed and drawn, the artist's touch quick but completely controlled, and the mood provocative, cool, with elements of symbolism. His *Fairy Tale* (cat.no.92) of the early nineties, however, comes closer to the Impressionists in France in its freshness of tone, its feeling of domestic warmth, and its genuine concern with sunlight and color.

Childe Hassam took up Impressionism during the same time. A trip abroad in 1883 enabled him to develop a fine urban style in the manner of Caillebotte, demonstrated in his masterful *Rainy Day in Boston* of 1885 (cat.no.89). He stayed in Paris for nearly three years, and his work became lighter in tone and freer in color mixing, as in *Grand Prix Day* (1887; Museum of Fine Arts, Boston). On his return to the U.S., Hassam painted some of the most brightly colored and well-handled of American Impressionist pictures, both in oil and watercolor. His normal subjects were flowers, gardens, and the sea; *The Room of Flowers* of 1894 (cat.no.97)—an atypical interior—is perhaps the most sophisticated of his works in its complex composition, spatial perspective, and coloring. The slashing brushwork is typical of Hassam's mature style, and the overall effect is closer to Bonnard and the Nabis than to the French Impressionists. Hassam's work varies widely in quality, as with most of his contemporaries. It tends toward increasing decorativeness and patterning in the first two decades of the twentieth century, but he returned to a truer Impressionism in a series of street scenes with flags executed between 1910 and 1918.

American painters traveled frequently to Paris in the last two decades of the century, and even in the U.S. they could see up-to-date examples by the French painters. Durand-Ruel opened a gallery in New York in 1888, and showed Monet, Sisley, and Pissarro in New York and Boston in 1890, Monet alone in New York in 1891, and so on. Moreover, a number of the Americans came to work with the French masters: Sargent knew Monet, and Theodore Robinson (see cat.no.95) came to know both Monet and Pissarro, and was especially affected by the quieter approach of the latter.

The American Impressionists in 1898 formed a group which came to be called "The Ten American Painters," and they exhibited together until the season of 1918–19. Included were Chase and Hassam, the Bostonians Tarbell and Benson, as well as Weir and Twachtman. Weir was especially noted for his figures which have a debt to Manet. Twachtman's evocative, empty landscapes with little perceptible brushwork owe much to Whistler's quiet, tonal style. The Impressionist style had a vastly different life in America than in France, for here it was adopted a full decade after it had so energetically come to maturity. It was a radical style here only briefly, if at all; instead, it quickly came to replace Tonalism as the accepted mainstream, academic mode for landscapes and outdoor genre scenes, and as such it was practiced well into the 1930s and beyond.

89
CHILDE HASSAM (1859–1935)
Rainy Day in Boston, 1885
Oil on canvas, $26\frac{1}{8} \times 48$ in. (66.4 × 121.9 cm.)
The Toledo Museum of Art, Ohio, Gift of Florence Scott Libbey

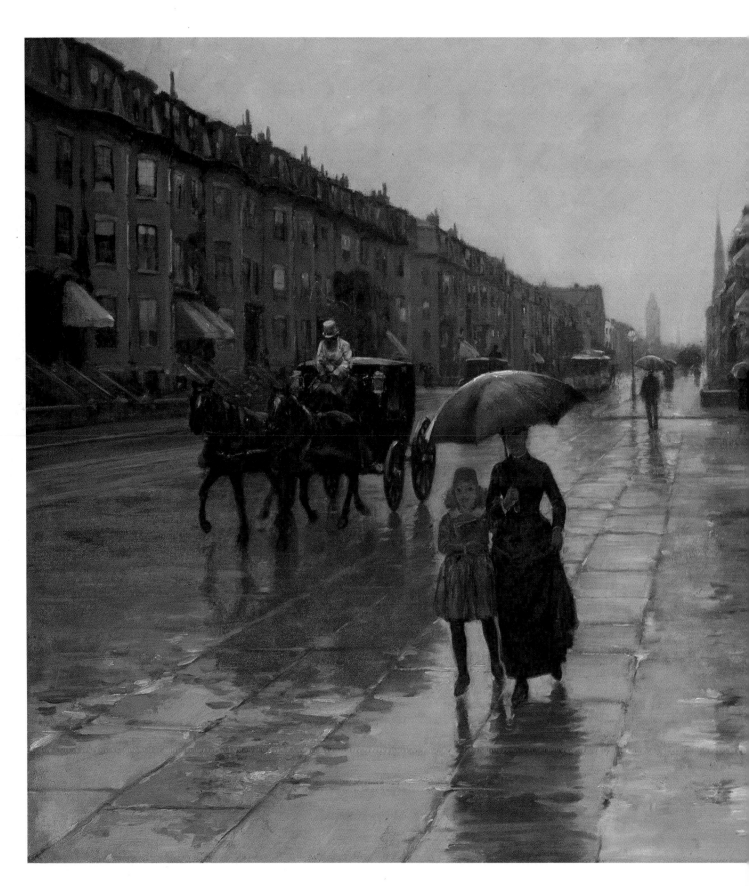

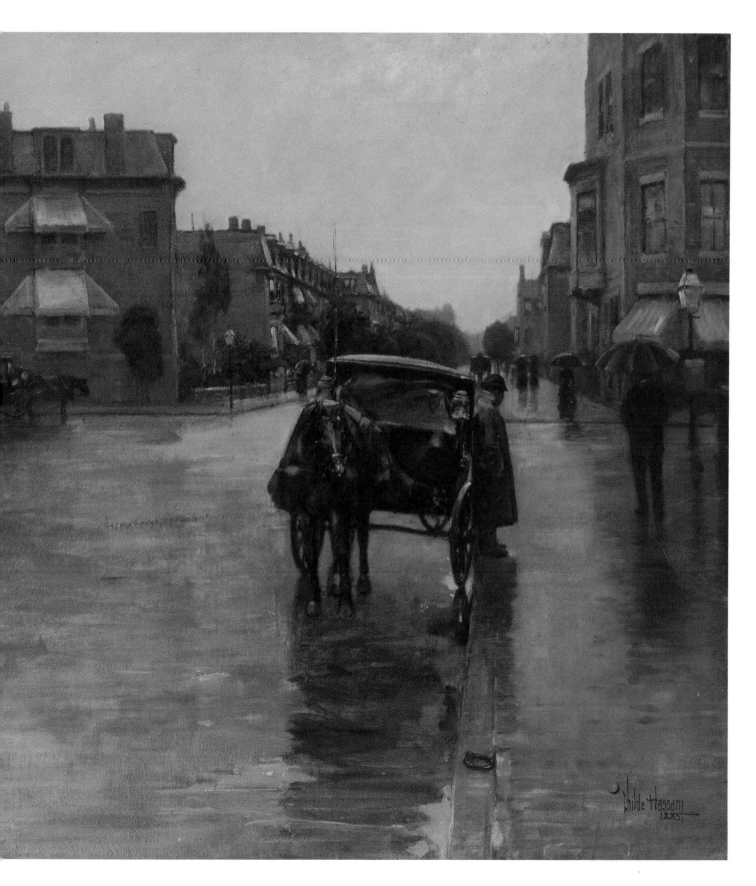

90
JOHN SINGER SARGENT (1856–1925)
Venetian Interior, c. 1882
Oil on canvas, 27 × 34 in. (68.6 × 86.4 cm.)
Museum of Art, Carnegie Institute, Pittsburgh, Purchase, 1920

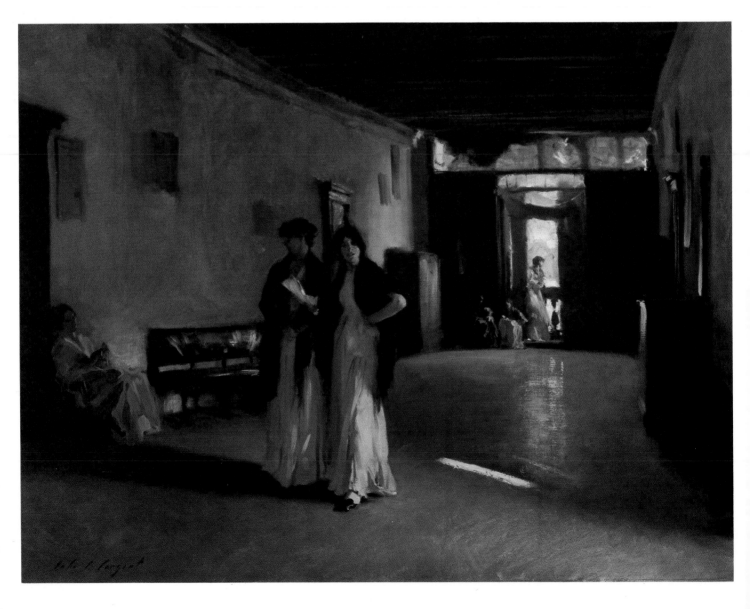

91
WILLIAM MERRITT CHASE (1849–1916)
The Open Air Breakfast, c. 1888
Oil on canvas, $37\frac{7}{16} \times 56\frac{3}{4}$ in. (95.1 × 144.1 cm.)
The Toledo Museum of Art, Ohio, Gift of Florence Scott Libbey

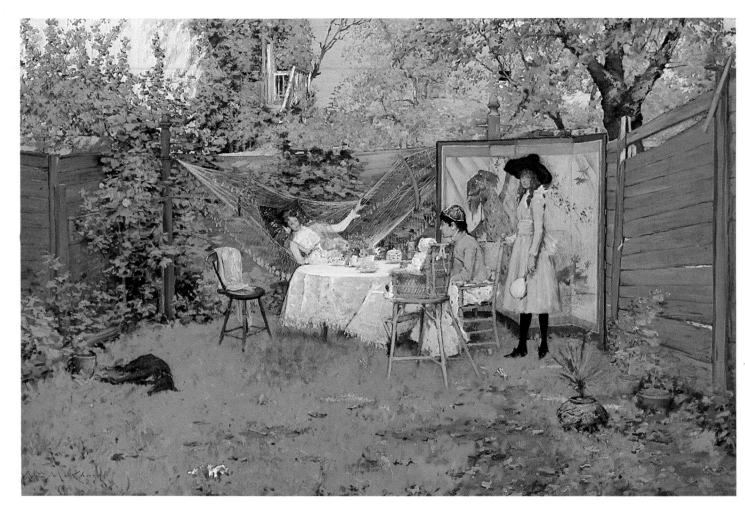

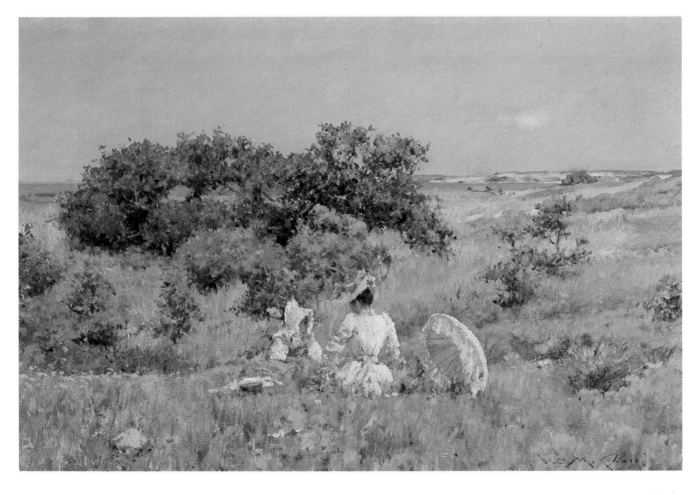

93
MARY CASSATT (1844–1926)
Young Women Picking Fruit, 1891
Oil on canvas, $51\frac{3}{8} \times 35\frac{3}{4}$ in. (130.5 × 90.8 cm.)
Museum of Art, Carnegie Institute, Pittsburgh, Patrons Art Fund, 1922

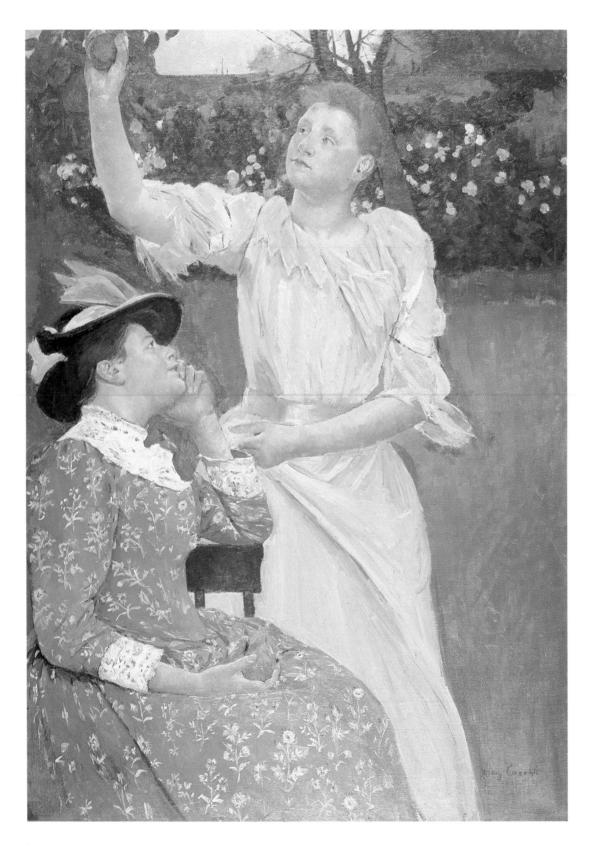

94
MARY CASSATT (1844–1926)
The Bath, 1891–92
Oil on canvas, $39\frac{1}{2} \times 26$ in. (100.3 × 66 cm.)
The Art Institute of Chicago, The Robert A. Waller Fund

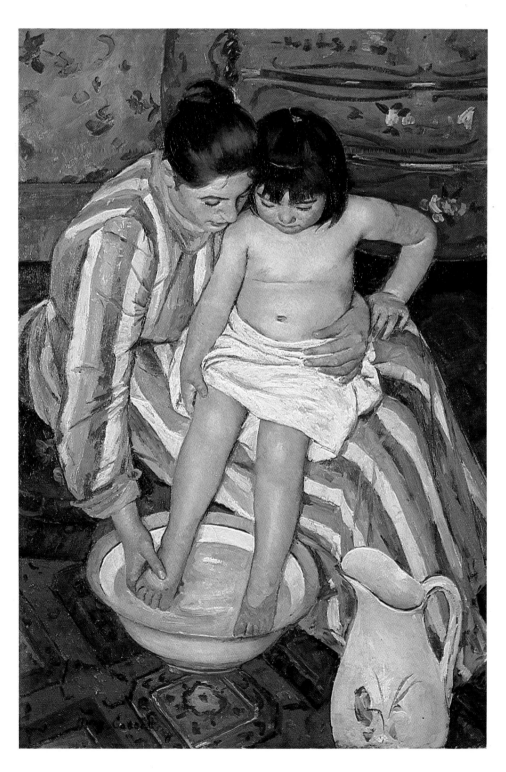

95
THEODORE ROBINSON (1852–1896)
World's Columbian Exposition, 1894
Oil on canvas, 25 × 30 in. (63.5 × 76.2 cm.)
The Manoogian Collection

96
GEORGE HITCHCOCK (1850–1913)
The Bride, c. 1900
Oil on canvas, 30 × 24 in. (76.2 × 61 cm.)
Private Collection, Courtesy of Jordan-Volpe Gallery, New York

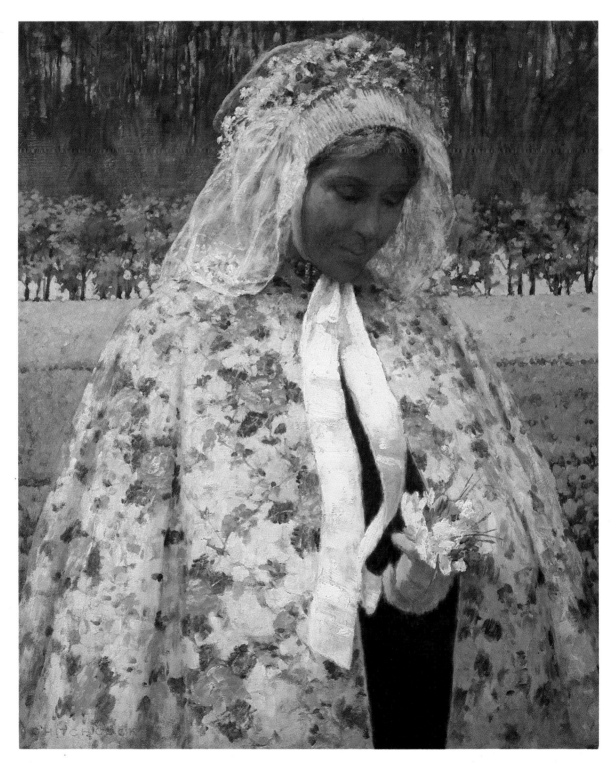

97
CHILDE HASSAM (1859–1935)
The Room of Flowers, 1894
Oil on canvas, 34 × 34 in. (86.5 × 86.5 cm.)
Mr. and Mrs. Arthur G. Altschul

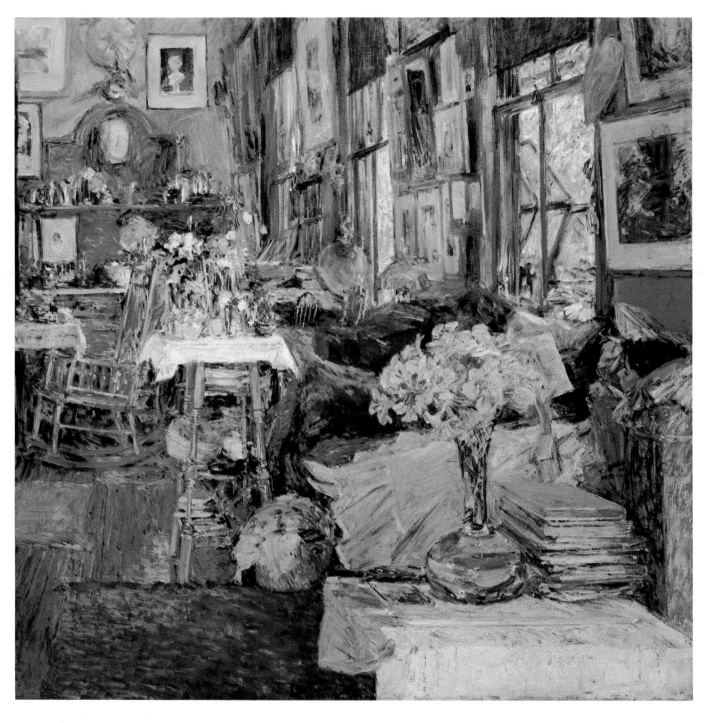

IX. *Homer & Eakins*

"It sounds like a paradox, but it is a very simple truth, that when today we look for 'American art' we find it mainly in Paris. When we find it out of Paris, we at least find a great deal of Paris in it."[1] When Henry James wrote these words in 1893, he was probably thinking of the most highly regarded American painters of the day, of Frederick Bridgman, Edwin Lord Weeks, John White Alexander, Walter Gay, Charles Sprague Pearce, William Picknell, and perhaps Mary Cassatt, who was less well known than the others but like them lived in France. Or he might have been referring to Whistler and Sargent in London, each of whom undeniably had much of Paris in him, or to still powerful Barbizon followers such as J. Francis Murphy or Charles H. Davis, or to any number of recently returned Impressionists including Robinson, Hassam, or Chase. American painting then owed more to French influence than at any other time in our history. Every aspiring American artist who could afford it studied for years in France. As Barbara Weinberg demonstrates, this was a great many; and numbers of these followed up their study with extensive stays in Paris or in Brittany or Normandy. Even the most nationalistic critics recognized that much of the best American painting was being done in France; and the fact that the work being done in America seemed *nearly* as "French" hardly offered solace. Samuel Isham, writing in 1905, acknowledged that at the 1889 Paris Exposition Universelle, the best American pictures by far had been those by artists working in France, but he took encouragement from the 1900 Exposition where the "native" American section seemed to him relatively stronger.

Like critics before and after him, Isham eagerly sought evidence of a typical and powerful American art, but strangely neither the work of Thomas Eakins nor even that of Winslow Homer fully satisfied him or the taste of his time. Regarding Eakins, he said that "the lack of painter-like training told terribly," leading to "no facile method" and a "neglect of the beauties and graces of painting." Dismissing Eakins, Isham concluded that "the eye longs for beauty of surface, richness of impasto, or transparent depths of shadow. . . ."[2] The critic devoted more time to Homer, finding his pictures "from the first firmly constructed, well drawn, and with an amazing power to strike the mind." He admired Homer's "veracity" and "his exact feeling for weight and force," but found the paintings to lack both "tone, . . . a pervading color note which draws the whole picture into harmony," and the decorative qualities of Inness or Whistler.[3] Though he would hardly have admitted it, Isham's complaint against both painters was, in essence, that neither was French enough.

Only one critic of that time coupled Homer and Eakins, seeing a unity of purpose in their work despite their obvious differences of style and subject: this was Sadakichi Hartmann, who observed that only Homer and Eakins "are masters in the art of painting, and at the same time have strong, frank, decided ways of expressing something American."[4] Even Hartmann apologized for Homer's technique—for "his awkward linear beauty, his neglect of values, his crude key of colors"—while praising his power and individuality. The same merits were found in Eakins—a strength and occasional brutality that seemed a proper antidote to the effeminacy Hartmann found generally in our art. Praising its brushwork and robust realism, he judged Eakins's work "nearer to great art than almost anything we can see in America."[5]

Hartmann's prescient judgment has been echoed by critics up to our own day, and these two painters have become the most admired of our nineteenth-century artists.[6] Though apparently they met only late in life, their work shares a common strength. Each was knowledgeable, and each surely had some of Paris in him, but neither would submit to the self-consciously stylish, sophisticated mode of their time. Most important, each was that rarity among American painters and writers, an individualist whose first concern was ethical. Walt Whitman, the great poet who functioned as both conscience and champion to America, found our society to be "canker'd, crude, superstitious and rotten," lacking the most important "verteber to State or man," as he put it, the element of "moral conscience."[7] Like Whitman, Homer and Eakins both dealt with the moral questions their contemporaries assiduously avoided: the matters of mortality and sexuality, of fear and cruelty, of the individual in society and in nature. It is no wonder that the work of these painters made both public and critics uneasy.

Homer and Eakins both had a natural instinct for drawing; in fact, Homer was initially trained as an illustrator. Each began to paint during the Civil War, and each traveled to Paris in 1866. Here their paths diverged, for Homer joined no atelier and stayed only ten months. He apparently saw the work of progressive landscapists such as Boudin, for on his return his own palette became lighter and his touch freer. Eakins, on the other hand, immersed himself in three years of academic study under Gérôme, with short periods of work with Léon Bonnat and the sculptor A. A. Dumont, followed by a six-month stay in Spain where he especially admired the work of Velázquez. Both Homer and Eakins made genre pictures on their return to America, but Homer became a painter of an idyllic, rural world of the past, of mothers and sons, to which he longed to retreat, while Eakins

was concerned with the real world, painting ritualistic portraits of urban men—athletes, craftsmen, and men of science—the figures he identified with and emulated. The work of both men suggests a great yearning: on Homer's part, to belong to another age, another place, and on Eakins's, to be another person, great and respected, a champion.

Like Charles Willson Peale, his predecessor in Philadelphia, Eakins was immensely curious about how things worked: he was an assiduous student of the complexities of human and animal anatomy, of light refraction and perspective, of medicine and science. He made drawings of all kinds, particularly of the nude, took photographs, made sculptural studies—and became a dedicated and revered teacher. Yet his genius was little recognized. His first masterpiece, *Max Schmidt in a Single Scull* of 1871 (cat.no.57), found no buyer until it was bought by the Metropolitan Museum of Art, New York, in 1934. And the work which may be his greatest, *The Gross Clinic* of 1875 (cat.no.98), was rejected for the Philadelphia Centennial Exposition of 1876 and was finally sold in 1878 for only $200. Eakins includes himself in both of these paintings—rowing in one, as a medical student in the other—and in a way he portrays himself, his hopes, his values, his moral judgments, in almost all his paintings. Eakins painted Dr. Gross because he idolized him, and most of Eakins's portraits are similarly uncommissioned depictions of men and women whom he liked and admired. Those who commissioned portraits from him were rarely satisfied, because instead of flattering his subjects, Eakins sought out their weaknesses. The painter Edwin Austin Abbey, queried as to why he didn't ask Eakins to paint his portrait, responded: "For the reason that he would bring out all those traits of my character I have been trying to conceal from the public for years."[8] (Walt Whitman wrote of the "terrible doubt of appearances," saying that things he observed "might prove nought of what they appear.") Eakins portrayed his friend Whitman as aged and flabby. The businessman A. W. Lee appears rigid and incapable of feeling. The singer of *The Pathetic Song* (cat.no.99) looks fragile and contemplative. Amelia C. van Buren (cat.no.101) slumps, lost in thought, seemingly trapped and very mortal. Eakins portrayed his wife Susan as the bearer of great pain: her head is tilted, and she looks out directly with a kind of wonder. Edith Mahon (cat.no.103), another of the musicians whom Eakins admired, carries the same kind of pain, but seems less damaged by it. Eakins's brother-in-law Louis N. Kenton is portrayed as *The Thinker* (cat.no.102): in his humble, introspective pose he represents the values of humanity and inquiry which Eakins revered. Morality was the determining factor in Eakins's portraits, and it must have seemed to the painter that nearly every force in society conspired against the simple, creative individual who stood apart from the mainstream. In his own *Self-Portrait* of 1902—painted the year he was at long last elected to the National Academy of Design, at the age of fifty-seven—he movingly suggests the toll of many defeats.[9]

Eakins was a dedicated realist, one of the few in American art. His concern was the human personality and the soul, and his work is contemporaneous with the pioneering researches of William James in religion and psychology.[10] There was Paris in his art, but mostly in the preparations—the drawings, oil sketches, and choice of subject—rather than in the finished painting itself. His work of the seventies could be considered stylistically "advanced," but on the whole he went his own conservative way, ignoring the fashionable academic, Tonalist, and Impressionist modes. His art seems revolutionary and ultimately modern, however, in its insistent probing for psychological truth.

Winslow Homer's essential interests were similar to Eakins's, though his technique and subject matter were considerably different.[11] Homer was nominally a landscape painter, in a sense carrying on Hudson River School attitudes, and even less of a modernist than Eakins. His style was more fluent and his real concerns more disguised than were those of Eakins, and so he won more public and critical approval in his lifetime. He painted metaphor, skirting the edges of issues rather than confronting them head-on as Eakins had. Even more than with Eakins, however, one senses in Homer an artist in pain. Enormous amounts of frustration and anger flow out through his incredibly fluid brush; clearly, paint is the only thing Homer can touch confidently and lovingly.

As Eakins's aspirations are apparent in his work, Homer's fears are apparent in his. Only children and black families communicate shared knowledge and warmth in his art; adults of his own class stare past one another and cannot make contact. Homer identified himself with the children he painted, longing for a strong, warm mother like the fisherwomen he painted in England in 1881–82, then retreating to his lonely cabin by the sea in 1883, like a boy to his treehouse. His reaction to civilization was something like that of Huck Finn: "When I couldn't stand it no more I lit out." Once in Maine, safe from the intrusions of civilization—from its incessant demand that he grow up and learn to communicate—Homer lived a boy's life, sleeping on the floor, painting alone, hunting and fishing with his brother. His pursuits were safely and exclusively masculine: he sailed out to the Grand Banks with the fishing fleet so he could capture the look and feel of the strong oarsmen and rolling waves (see cat.no.104). As Eakins had painted the profundity of old age, so Homer painted the sea again and again, searching there for nature's female rhythms. A single rising wave creates the outline of a woman in *West Point, Prout's Neck* (cat.no.109), identifying the two as Ibsen had in his play *Woman from the Sea* (1888). Women on the shore, their skirts billowing like sails, their arms and breasts and thighs strong, resemble the sea in their power to engulf a man. In *A Summer Night* (cat.no.106), which recalls the work of Edvard Munch, women by the sea dance mysteriously to a tune only they can hear. Here and elsewhere Homer explores sexuality, as Eakins had in a different way. He confronts also the question of mortality: in *The Gulfstream* (1899; Metropolitan Museum of Art, New York), he paints the final loneliness of man and his inevitable death. In *The Fox Hunt* (cat.no.108), he returns to the more graceful metaphors of nature: the fox, normally the predator, is trapped in deep snow, and a line of birds flock from the sea for the kill. In *Right and Left* (cat.no.110), painted in 1909, the year before Homer died, the moment of death is seen as instantaneous yet prolonged, as surprising rather than shocking, as awkward rather than painful. The artist, dying more slowly but just as surely as the ducks he paints, presented a vision of grace and beauty, suggesting the possibility of finding truth even in the final moments of life.

98
THOMAS EAKINS (1844–1916) Oil on canvas, 96 × 78½ in. (243.8 × 199.4 cm.)
The Gross Clinic, 1875 Jefferson Medical College, Thomas Jefferson University, Philadelphia

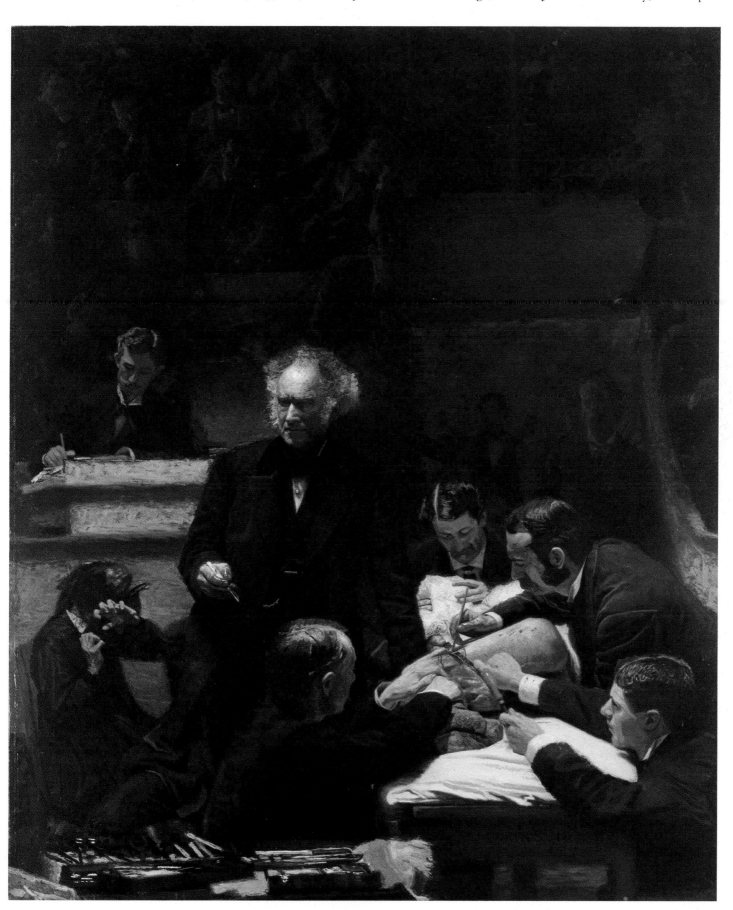

99
THOMAS EAKINS (1844–1916)
The Pathetic Song, 1881
Oil on canvas, 45 × 32½ in. (114.3 × 82.6 cm.)
The Corcoran Gallery of Art, Washington, D.C., Gallery Fund Purchase, 1919

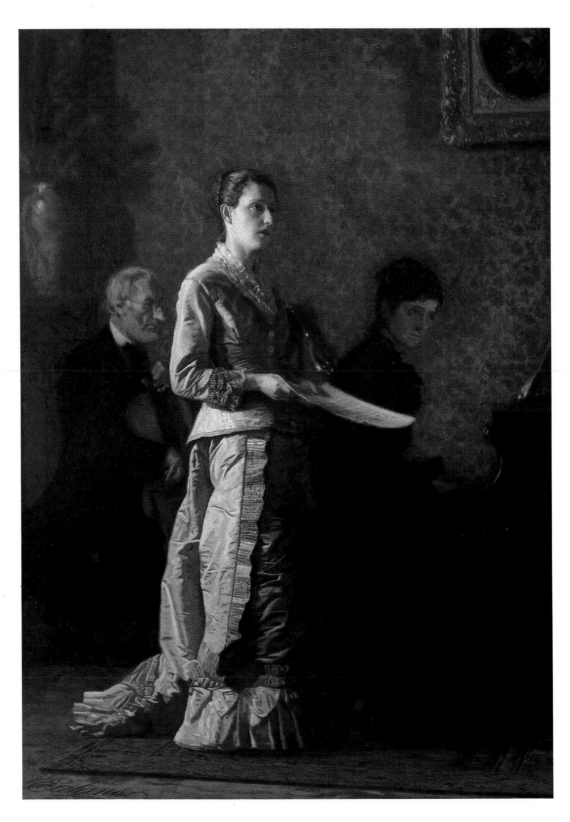

100
THOMAS EAKINS (1844–1916)
Home Ranch, 1892
Oil on canvas, 24 × 20⅛ in. (61 × 50.8 cm.)
Philadelphia Museum of Art,
 Gift of Mrs. Thomas Eakins and Miss Mary Adeline Williams

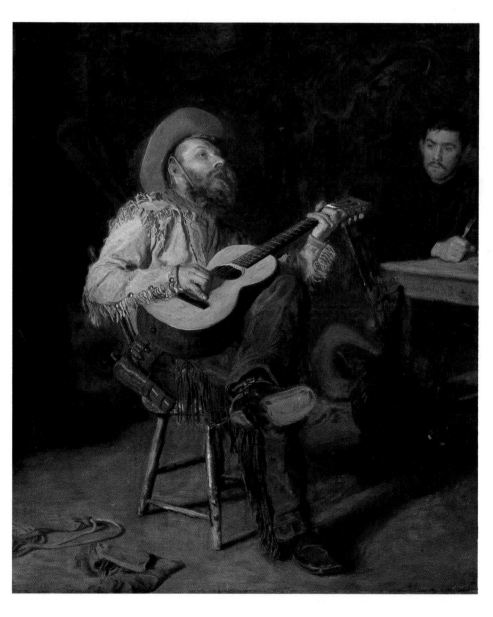

101
THOMAS EAKINS (1844–1916)
Amelia C. van Buren, c. 1890
Oil on canvas, 45 × 32 in. (114.3 × 81.3 cm.)
The Phillips Collection, Washington, D.C.

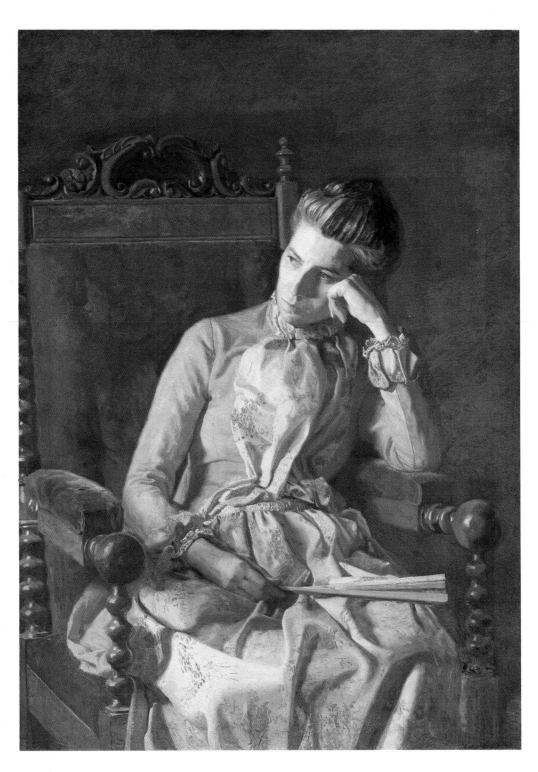

102
THOMAS EAKINS (1844–1916)
The Thinker: Portrait of Louis N. Kenton, 1900
Oil on canvas, 82 × 42 in. (208.3 × 106.7 cm.)
The Metropolitan Museum of Art,
 New York, Kennedy Fund, 1917

103
Thomas Eakins (1844–1916)
Mrs. Edith Mahon, 1904
Oil on canvas, 20 × 16 in. (50.8 × 40.6 cm.)
Smith College Museum of Art, Northampton, Massachusetts,
 Purchase, 1931

104
WINSLOW HOMER (1836–1910)
The Fog Warning, 1885
Oil on canvas, 30 × 48 in. (76.2 × 121.9 cm.)
Museum of Fine Arts, Boston, Otis Norcross Fund

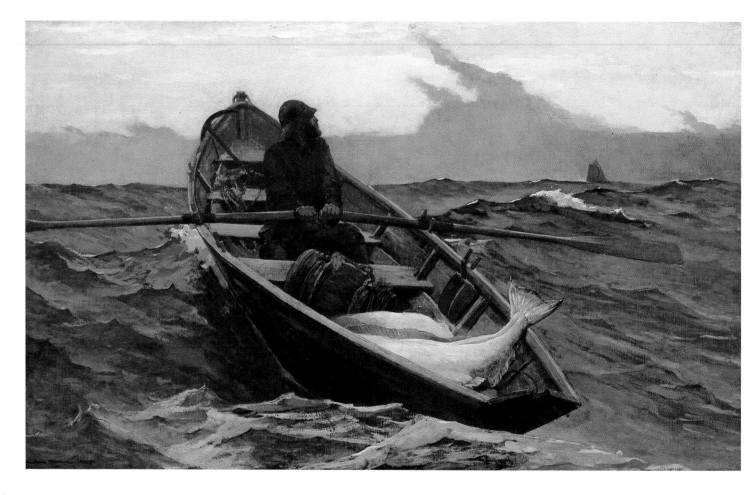

105
WINSLOW HOMER (1836–1910)
Eight Bells, 1886
Oil on canvas, $25\frac{3}{16} \times 30\frac{1}{8}$ in. (64 × 76.5 cm.)
Addison Gallery of American Art, Phillips Academy, Andover, Massachusetts

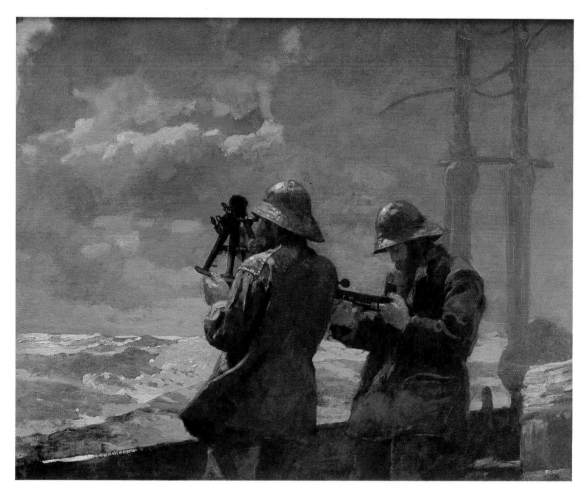

106
WINSLOW HOMER (1836–1910)
A Summer Night, 1890
Oil on canvas, $30\frac{3}{16} \times 40\frac{1}{8}$ in. (76.7 × 101.9 cm.)
Musée du Louvre, Paris

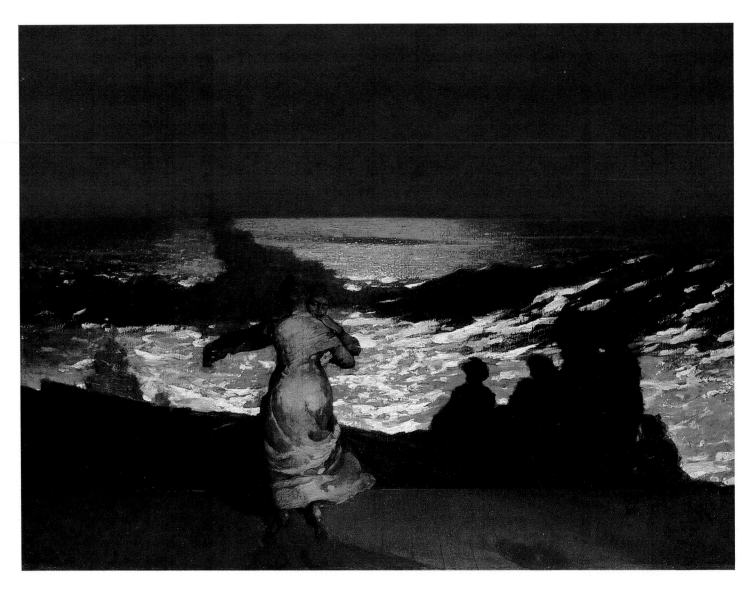

107
WINSLOW HOMER (1836–1910)
Sunlight on the Coast, 1890
Oil on canvas, $30\frac{1}{4} \times 48\frac{1}{2}$ in. (76.8 × 123.2 cm.)
The Toledo Museum of Art, Ohio, Gift of Mr. and Mrs. Edward Drummond Libbey

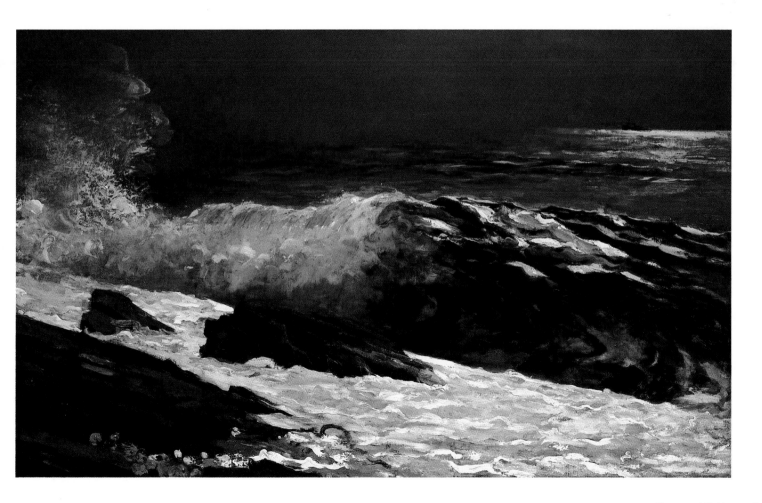

108
WINSLOW HOMER (1836–1910)
The Fox Hunt, 1893
Oil on canvas, 38 × 68½ in. (96.5 × 174 cm.)
The Pennsylvania Academy of the Fine Arts, Philadelphia, Temple Fund Purchase

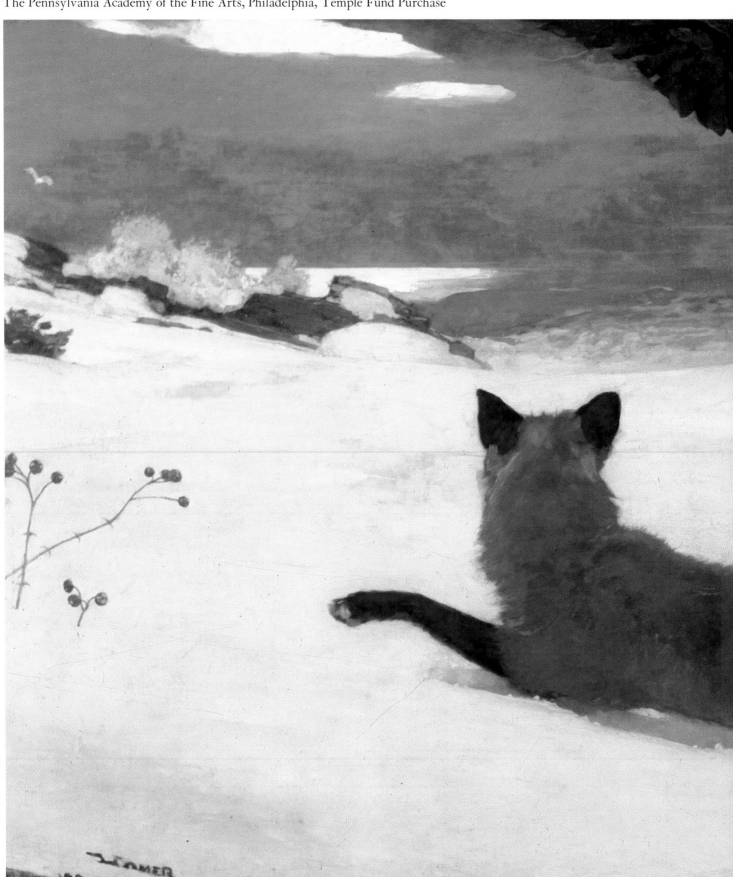

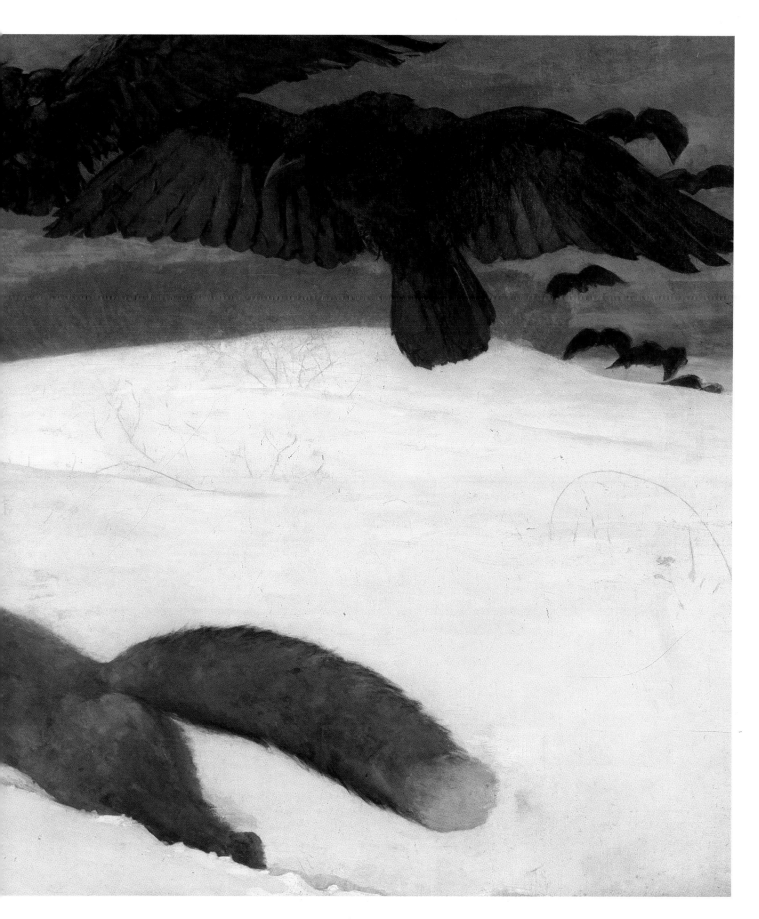

109
WINSLOW HOMER (1836–1910)
West Point, Prout's Neck, 1900
Oil on canvas, $30\frac{1}{16} \times 48\frac{1}{8}$ in. (76.4 × 122.2 cm.)
Sterling and Francine Clark Art Institute, Williamstown, Massachusetts

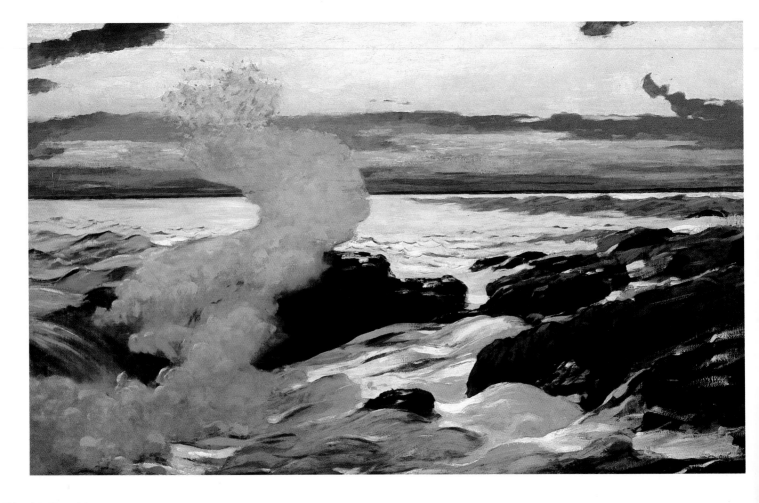

WINSLOW HOMER (1836–1910)
Right and Left, 1909
Oil on canvas, $28\frac{1}{4} \times 48\frac{3}{8}$ in. (71.8 × 122.9 cm.)
National Gallery of Art, Washington, D.C., Gift of the Avalon Foundation, 1951

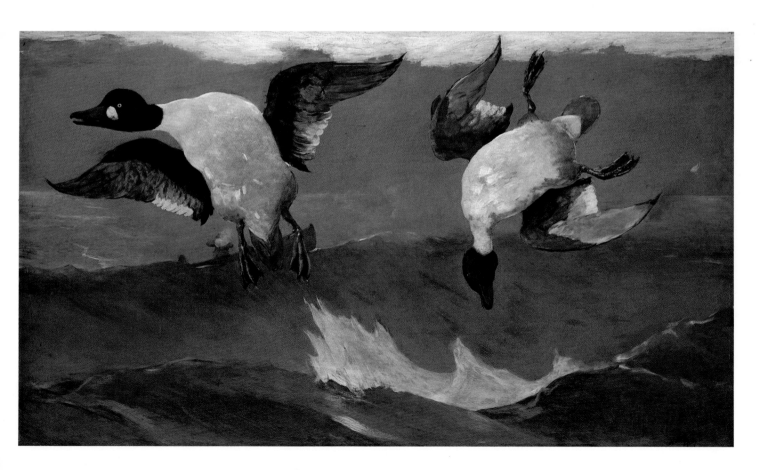

Notes to Chapters I–IX

I. *Colonial Genius and the New Nation* (*pages 33–35*)
1. Adams to Abigail Adams, Paris, 12 April 1778, *Familiar Letters of John Adams and His Wife Abigail Adams, During the Revolution*, ed. Charles Francis Adams (New York, 1876), p. 329.
2. Adams to Abigail Adams, 1780, ibid., p. 381.
3. Hugh Honour, *The New Golden Land: European Images of America from the Discoveries to the Present Time* (New York, 1975), p. 113.
4. Buffon, quoted in Honour, *The New Golden Land*, p. 151.
5. Jules D. Prown, *John Singleton Copley*, 2 vols. (Cambridge, Mass., 1966): 1:10.
6. See, e.g., the work of the well-trained Joseph Wright of Derby (1734–1797), whose fine portraits of *Rev. John Carter* and *Miss Carter* of 1760 are neither more sophisticated nor more advanced than Copley's *Burrs*. Both paintings are formerly Athorpe Collection; see Benedict Nicolson, *Joseph Wright of Derby*, 2 vols. (London, 1968), 2: plates 27 and 28, cat. nos. 31 and 32.
7. Copley, quoted in Prown, 1:51.
8. Ibid., p. 17.
9. Ibid., p. 48.
10. Cf. Duplessis's *Portrait de Mme. Freret-Éricour* (1769; Nelson Gallery–Atkins Museum, Kansas City, Mo.); color plate 12 in Pierre Rosenberg, *The Age of Louis XV: French Painting 1710–1774* (Toledo Museum of Art, Ohio, 1975).

II. *The Grand Manner* (*pages 50–51*)
1. Washington Allston, quoted in Jared B. Flagg, *The Life and Letters of Washington Allston* (New York, 1969), p. 44.
2. Copley, quoted in Jules D. Prown, *John Singleton Copley*, 2 vols. (Cambridge, Mass., 1966), 2:245.
3. Ibid., p. 253.
4. See William H. Gerdts and Theodore E. Stebbins, Jr., "*A Man of Genius": The Art of Washington Allston* (Boston, 1979), p. 34.
5. Morse to his father, 25 March 1812, *Samuel F.B. Morse: Letters and Journals*, ed. Edward Lind Morse, 2 vols. (Boston, 1914), 1:68.
6. Ibid., p. 132.

III. *Painter and Poet in the Land* (*pages 64–65*)
1. Richardson, *Painting in America* (New York, 1965), p. 90.
2. Peale, quoted in Frank H. Goodyear, Jr., "A History of the Pennsylvania Academy of the Fine Arts, 1805–1976," *In This Academy* (Pennsylvania Academy of the Fine Arts, Philadelphia, 1976), p. 16.
3. Bryant, "A Funeral Oration Occasioned by the Death of Thomas Cole" (New York, 1848), p. 14; Tuckerman, *Book of the Artists* (1867; New York, 1966), p. 225.
4. Emerson, quoted in Larzer Ziff, *Literary Democracy: The Declaration of Cultural Independence in America* (New York, 1981), p. 31.
5. Cole, quoted in Louis L. Noble, *The Life and Works of Thomas Cole*, ed. E. S. Vessell (1853; Cambridge, Mass., 1964), p. xix.
6. Emerson, "The Transcendentalist," in *Selected Writings* (New York, 1964), p. 93.

7. Bryant, quoted in Noble, *Life and Works of Cole*, p. 100.
8. Cole, quoted in Noble, ibid., pp. 78, 89.
9. Cole, "Lecture on American Landscape Delivered before the Catskill Lyceum," *Northern Light* 1 (1841): 25–26.
10. Cooper, quoted in Noble, *Life and Works of Cole*, p. 167.
11. Cole, quoted in Noble, ibid., p. 159.

IV. *The Ideal Landscape* (*pages 78–79*)
1. Mrs. Anna Jameson, quoted in Edgar P. Richardson, *American Romantic Painting* (New York, 1945), p. 6.
2. Emerson, "The American Scholar" (1837), *The Selected Writings of Ralph Waldo Emerson*, ed. Brooks Atkinson (New York, 1964), p. 45.
3. See F. O. Matthiessen, *American Renaissance* (New York, 1941).
4. Cole, "Essay on American Scenery," quoted in John McCoubrey, *American Art, 1700–1960: Sources and Documents* (Englewood Cliffs, N.J., 1965), p. 109.
5. Durand, "Letter on Landscape Painting, II," *The Crayon* 1 (1855): 34.
6. Durand, "Letter on Landscape Painting, VIII," *The Crayon* 1 (1855), p. 354.
7. Emerson, "Art," *Selected Writings*, p. 305.
8. Poe, "The Domain of Arnheim," quoted in Larzer Ziff, *Literary Democracy: The Declaration of Cultural Independence in America* (New York, 1981), p. 68.
9. Novak, *Nature and Culture: American Landscape and Painting, 1825–1875* (New York, 1980), p. 18.
10. Emerson, "The Young American," quoted in Ziff, *Literary Democracy*, p. 33.

V. *Americans Outdoors* (*pages 106–107*)
1. Mount, draft letter, undated (Museums at Stony Brook, N.Y.), quoted in Barbara Novak, *American Painting of the Nineteenth Century* (New York, 1969), p. 144.
2. Allston, letter of August 1834, quoted in William Dunlap, *A History of the Rise and Progress of the Arts of Design in the United States*, ed. Alexander Wyckoff, 3 vols. (1834; New York, 1965): 2:425.
3. Tuckerman, *Book of the Artists* (1867; New York, 1966), p. 494.
4. See ibid., p. 467.

VI. *The Flowering of Still Life* (*pages 126–127*)
1. The remarkable story of Harnett's rediscovery, and the separation of his work from that of Peto and others, is told in Alfred Frankenstein, "*After the Hunt" and After: William Michael Harnett and Other American Still Life Painters, 1870–1900* (Berkeley and Los Angeles, 1953).

VII. *International Styles* (*pages 144–145*)
1. See Michael Quick, *American Expatriate Painters of the Late Nineteenth Century* (Dayton Art Institute, 1977).
2. Hawthorne, preface to *The Marble Faun*, in *The Complete Novels and Selected Tales of Nathaniel Hawthorne*, ed. Norman Holmes Pearson (New York, 1937).

3. Whistler, *The Gentle Art of Making Enemies* (1890; New York, 1967), p. 127.
4. James, *The Painter's Eye* (Cambridge, Mass., 1956), p. 254.
5. Samuel Isham, *The History of American Painting* (New York, 1905), p. 381.
6. Ibid, pp. 499–500.
7. See Elizabeth Johns, "Albert Pinkham Ryder: Some Thought on His Subject Matter," *Arts Magazine* (Nov. 1979): 164–71.
8. Inness's late style has been called "Tonalism." For a study of other American painters working in a similar mode, see William H. Gerdts et al., *Tonalism: An American Experience* (Phoenix Art Museum, Ariz., 1982).

VIII. *Painters of Light* (*pages 160–161*)
1. Isham, *The History of American Painting* (New York, 1905), p. 363.
2. Inness, quoted in William H. Gerdts's excellent study *American Impressionism* (Seattle, 1980), p. 21.
3. Weir, quoted in Gerdts, *American Impressionism*, p. 72.
4. Durand-Ruel, quoted in Maria and Godfrey Blunden, *Impressionists and Impressionism* (New York, 1972), p. 173.
5. See H. Barbara Weinberg, "American Impressionism in Cosmopolitan Context," *Arts* 55 (November 1980): 160–65.
6. Gerdts, *American Impressionism*, p. 41.

IX. *Homer and Eakins* (*pages 174–175*)
1. James, *The Painter's Eye*, ed. John L. Sweeney (Cambridge, Mass., 1956), p. 216.
2. Isham, *The History of American Painting* (New York, 1905), pp. 525–26.
3. Ibid., pp. 352–55.
4. Hartmann, *A History of American Art*, 2 vols. (New York, 1902), 1:193.
5. Ibid., p. 204.
6. Homer, more admired than Eakins in his lifetime, was the subject of an adulatory biography by William H. Downes in 1911, while Eakins received his first full-scale treatment in Lloyd Goodrich's study of 1933; Goodrich followed this with a still definitive book on Homer in 1944.
7. Whitman, "Democratic Vistas," in *Complete Poetry and Selected Prose*, ed. James E. Miller, Jr. (Boston, 1959), p. 461.
8. Abbey, quoted in Lloyd Goodrich, *Thomas Eakins* (Cambridge, Mass., 1982), p. 77.
9. *Walt Whitman* is owned by the Pennsylvania Academy of the Fine Arts, Philadelphia; *A. W. Lee* is in the collection of Reynolda House, Winston-Salem, N.C.; *Susan Eakins* is in the Hirshhorn Museum, Washington, D.C.; and the *Self-Portrait* is at the National Academy of Design, New York.
10. See William James, *The Principles of Psychology* (1890) and *Varieties of Religious Experience* (1902).
11. See the superb discussion of Eakins as realist and Homer as romantic with naturalistic impulses in Lloyd Goodrich, "Realism and Romanticism in Homer, Eakins, and Ryder," *Art Quarterly* 12 (Winter 1949): 17–29.

Authors of Catalogue Entries

Trevor J. Fairbrother	*T.J.F.*
Donald D. Keyes	*D.D.K.*
Theodore E. Stebbins, Jr.	*T.E.S.*
Diana Strazdes	*D.S.*
Carol Troyen	*C.T.*

JOHN SINGLETON COPLEY

(1738, probably Boston—1815, London)

The son of humble Irish immigrants to Boston, Copley was essentially self-taught. When he was ten, his mother married the London-trained mezzotint engraver Peter Pelham (1697–1751), from whose collection of European engravings Copley learned the conventions of eighteenth-century British portraiture. Copley's portraits from the late 1750s show the influence of the itinerant American artist Robert Feke (c. 1705–1751) and more importantly the British drapery painter Joseph Blackburn, who was active as a portraitist in America from 1754 to 1763. By the early 1760s Copley was the most accomplished and prestigious artist in America, generously patronized by the mercantile elite around Boston. He sent the first of a series of portraits to London for exhibition in 1765. In 1769 he married a prominent Boston merchant's daughter, Susanna Clarke, and soon began to build a grand house on Boston's Beacon Hill. He had a profitable season painting portraits in New York in 1771. After repeated encouragement from artists in London, he finally made a tour of England, Italy, Germany, and Holland in 1774–75, ardently studying the works of the Old Masters. At the outbreak of the Revolutionary War in 1775, his wife and family came from Boston to settle permanently with him in London.

Copley's career prospered in England, where he turned his attention from portraiture to history painting and, to a lesser extent, religious art. Among his most grand history pictures is The Death of the Earl of Chatham *(1779–81; Tate Gallery, London), which re-created a recent tragic event and incorporated the life portraits of over fifty of those present at the House of Lords when the well-known American sympathizer suffered a stroke. Copley was elected to full membership in the Royal Academy in 1779. He favored heroic modern history pieces but continued as a portraitist, serving a grander clientele than America offered: for example, he painted the three youngest daughters of King George III in 1785 (H.M. Queen Elizabeth II). He worked to the end of his life, although he painted no more great, innovative works after 1800.*

Throughout the nineteenth century, Copley's fame depended mostly upon the fact that he was an American-born artist who had won a significant reputation in England. His closely detailed, penetrating American portraits were not widely valued until this century. Now they are celebrated for their direct vision and independence from the more idealizing presentation and mannered execution of the European mainstream.

The principal monograph, Jules D. Prown's John Singleton Copley *(Cambridge, Mass., 1966), divides his American and English works in two separate volumes, allowing each part of his career to be judged in context.*

I

JOHN SINGLETON COPLEY
Boy with a Squirrel, 1765
Painted in Boston
Oil on canvas, 30¼ × 25 in. (76.8 × 63.5 cm.)
Museum of Fine Arts, Boston,
 Anonymous Gift

Painted when the artist was twenty-seven years old, this picture was Copley's means of introducing himself to the artists and connoisseurs of England. In the previous ten years he had won local prestige painting portraits and had begun to consider moving to Europe, where the best artists commanded international fame and great wealth. He wrote frustratedly to a friend that in Boston ". . . pictures are confined to sitting rooms, and regarded only for the resemblance they bear to their originals."[1] *Boy with a Squirrel* is not strictly a portrait but an exhibition piece for the cosmopolitan London audience, destined to be judged against the latest works by British artists. Copley hoped that the reception of this picture would decide the question of whether to stay in Boston or follow his ambition. It appeared in an exhibition of the Society of Artists of Great Britain held in London in 1766, and much to the artist's relief and satisfaction it drew praise from Joshua Reynolds and Benjamin West. Reynolds insisted that Copley's "Genius" should not be wasted in America:

> *. . . with the advantages of the Example and Instruction which you could have in Europe, You would be a valuable Acquisition to the Art, and one of the first Painters in the World, provided you could receive these Aids before it was too late in Life, and before your Manner and Taste were corrupted or fixed by working in your little way at Boston.*[2]

As an exhibition piece, *Boy with a Squirrel* was made to demonstrate everything Copley had learned. It is justly famous for its brilliantly painted passages that capture the material essence of things, such as the sparkling translucence of the glass, the reflective sheen of the polished tabletop, and the freshness of the white ruffled cuffs. The rich tones of the velvet drape and mahogany table dominate the canvas and bring the colorfully dressed youth into strong relief. His tender flesh receives direct illumination, as if he were gazing through a window, and its warmth is further enhanced by the pink satin collar. In the 1830s an English critic cited *Boy with a Squirrel* as one of Copley's finest experiments in color: ". . . of all that he ever painted, nothing surpasses [it] for fine depth and beauty of colour; and this was done, I presume, before he had heard the name of Titian pronounced."[3]

Using his stepbrother Henry Pelham (1749–1806) as a model, Copley composed this work differently from his commissioned portraits, making it unusually intimate. The viewer is drawn directly into the boy's realm by the illusion of the projecting tabletop corner, unlike Copley's more frontally arranged portraits, in which the subject is set

much further back from the picture plane. Most important, however, is the profiled head: the innocent, daydreaming expression with big upward-gazing eyes and sensuous parted lips. The effect of this face is not unlike the transfixed reverie associated with European devotional pictures of saints and Madonnas, even though the setting is a decidedly secular and materialistic evocation of the private world of a seemingly aristocratic youth. The closest precedents for *Boy with a Squirrel* are the slightly earlier genre pieces by Jean Siméon Chardin which show an elegant boy in profile before a table, idling time with playing cards or a spinning top; Copley may have been aware of these through engravings.[4]

It is doubtful that Copley's stepbrother looked so young and unblemished in his sixteenth year, when *Boy with a Squirrel* was painted. Copley seems to have based the likeness on his earlier oil sketch showing Pelham in profile, reading by candlelight (c. 1759; Private Collection), made when the boy was about ten. As an exhibition piece, *Boy with a Squirrel* is idealized to suit the artist's aesthetic intentions. Pelham may not in reality have worn quite such pretty clothes or had an expensive gold chain for his pet squirrel, yet these details are crucial visual components, since the picture is not simply a portrait of a beautiful youth but a poem about the innocence and sheltered luxury of an ideal childhood.[5]

Boy with a Squirrel provided an unforgettable debut for Copley in London. The following year he tried to repeat the achievement with another interior scene of a child and pets—*Portrait of a Young Lady with a Bird and Dog* [Mary Warner] (1766–67; Toledo Museum of Art, Ohio)—which was included in the 1767 Society of Artists exhibition. Thinking to please his London peers, Copley made this a full-length picture, larger and more complicated, with a less handsome model; but ironically it disappointed Reynolds and West. Both paintings remained in London: *Boy with a Squirrel* was exhibited there a second time in September 1768, and Copley wrote to a friend that he was willing to sell both pictures.[6] He sent new works to the Society of Artists exhibitions in 1768, 1771, and 1772, but did not resolve to visit Europe until 1774. The British acclaim which greeted *Boy with a Squirrel* in 1766 seems to have encouraged and sustained Copley during the intervening years in Boston. None of his American portraits has its special charm and tenderness, but its focus on the contemplative individual may have inspired several fine portraits of women seated at tables, for example *Mrs. Humphrey Devereux* (1770–71; on loan at the National Art Gallery, Wellington, New Zealand) and *Mrs. Richard Skinner* (1772; Museum of Fine Arts, Boston). *T.J.F.*

NOTES

1. Copley to Captain R. G. Bruce (1767?), quoted in Allan Cunningham, *The Lives of the Most Eminent British Painters, Sculptors, and Architects*, 2d ed., 6 vols. (London, 1830–39), 5:165.

2. Reynolds' remarks reported by R. G. Bruce in a letter to Copley (4 August 1766), quoted in *Letters and Papers of John Singleton Copley and Henry Pelham, 1739–1776* (1914; New York, 1970), p. 41. In his letter to Copley of the same date (ibid., p. 44), Benjamin West wrote that Reynolds at first assumed *Boy with a Squirrel* had been painted by Joseph Wright of Derby, another young artist from the provinces who had only recently started to exhibit in London.

3. Cunningham, *Lives of British Painters*, 5:185.

4. Three years before Copley painted *Boy with a Squirrel*, an engraving by François-Bernard Lépicié after Chardin's *House of Cards* (1741; National Gallery, London) was distributed free of charge to those who purchased the January 1762 issue of the *British Magazine*; there is no documentary evidence that Copley owned or saw prints after Chardin. See the entry on *House of Cards* (no. 71) and other related genre paintings in Pierre Rosenberg, *Chardin, 1699–1779* (Cleveland Museum of Art, 1979).

5. Two other 1765 portraits by Copley which include pet squirrels represent five-year-old *John Bee Holmes* (Private Collection) and twenty-year-old *Mrs. Theodore Atkinson* (Lenox Collection, New York Public Library). A French engraving after Jacques Courtin's *Jeune fille à l'écureuil* shows a young girl in profile with a pet squirrel: the similarity between the engraving and Copley's *Boy with a Squirrel* is noted in a letter from Alfred Neumeyer, *Gazette des Beaux-Arts* (Supplement) 69 (May–June 1967): 22.

6. Cunningham (*Lives of British Painters*, p. 167), quotes a letter from Copley to Captain Bruce in which he offers to sell "Both my brother's portrait and the little girl's." Bruce wrote Copley (25 June 1767): "Your Brother's Portrait I have removed from Mr. Reynolds's to Mr. West's, where I think it had better remain as a Specimen till you arrive yourself to dispose of it" (*Copley–Pelham Letters*, p. 59).

PROVENANCE

The artist; his son, the Rt. Hon. Lord Lyndhurst; purchased by James Sullivan Amory of Boston from the Lyndhurst Sale, Christie's, London, 5 March 1864; by descent in the Amory and Hunnewell families of Boston; to present owner 1978.

EXHIBITION HISTORY

Society of Artists, London, *Seventh Exhibition*, 1766, cat. no. 24.

Society of Artists, London, *Special Exhibition in Honor of the King of Denmark*, 1768, cat. no. 19.

International Exhibition, London, 1862 (Fine Art Department, British Division), cat. no. 120.

Boston Athenaeum, *Annual Exhibition*, 1864, cat. no. 302.

Boston Athenaeum, *Annual Exhibition*, 1871, cat. no. 247.

Boston Athenaeum, *Exhibition of Paintings for the Benefit of the French*, 1871, cat. no. 144 (as *Young Pelham, son of Peter Pelham*).

Copley Society, Boston, *Loan Collection of Pictures of Fair Children*, 1901, cat. no. 29.

Museum of Fine Arts, Boston, *Loan Exhibition of One Hundred Colonial Portraits*, 1930, cat. no. 38 (ill.; as *Henry Pelham*).

Metropolitan Museum of Art, New York, *Paintings of John Singleton Copley*, 1936–37, cat. no. 11 (ill.).

Museum of Fine Arts, Boston, *John Singleton Copley*, 1938, cat. no. 58.

Tate Gallery, London, *American Painting from the 18th Century to the Present Day*, 1946, cat. no. 43.

Jewett Arts Center, Wellesley College, Mass., *Four Boston Masters*, cat. by John McAndrew et al., 1959.

National Gallery of Art, Washington, D.C., *John Singleton Copley*, cat. by Jules D. Prown, 1965–66 (traveling exhibition), no. 26 (ill.).

Museum of Fine Arts, Boston, *Copley, Stuart, West in America and England*, cat. by Jonathan L. Fairbanks et al., 1976, no. 10 (ill.).

2

JOHN SINGLETON COPLEY
Nicholas Boylston, 1767
Painted in Boston
Signed and dated lower left:
 JSC 1767 [initials in monogram]
Oil on canvas, 49 × 40 in. (124.5 × 101.6 cm.)
Harvard University, Cambridge,
 Massachusetts,
 Bequest of Ward Nicholas Boylston, 1828

Nicholas Boylston (1716–1771) was a Boston merchant renowned for his extravagantly stylish taste. In 1766, the year before Copley painted Boylston's portrait, John Adams, the future president, described an evening at the merchant's house:

> An elegant Dinner indeed! Went over the House to view the Furniture, which alone cost a thousand Pounds sterling. A Seat it is for a noble Man, a Prince. The Turkey Carpets, the painted Hangings, the Marble Tables, the rich Beds with crimson Damask Curtains and Counterpins, the beautiful Chimny Clock, the Spacious Garden, are the most magnificent of any Thing I have ever seen.[1]

Though *Nicholas Boylston* embodies fashionable suavity and distinction, Copley also shows the arrogant confidence of the self-made man, especially in the firm smile and sharp eyes. Boylston's father had been a saddler and shopkeeper: apparently the fabulous financial success evident in Copley's portrait stemmed from the sitter's own mercantile efforts.[2]

Nicholas and his sister Rebecca (cat. no. 3) seem completely familiar to wealth and privilege, but in Copley's 1766 portrait of their aged, widowed mother (*Mrs. Thomas Boylston*, 1766; Harvard University, Cambridge, Mass.) one senses that the rather worn old woman has had a life of toil, not spent in the finery she now wears. Presumably Nicholas Boylston commissioned the portraits of his mother, his sister, and himself for the grand house described by John Adams. In that sumptuous setting, the colorful intensity of his and Rebecca's portraits would not seem unusual, although they look ostentatious in comparison with Copley's more typical Boston portraits. That Boylston is a merchant is indicated by the two hefty business ledgers by his side and the landscape view behind him, in which a ship sails past a lighthouse toward a port. Generally the merchants and businessmen painted by Copley appear in public dress: conservative, dark-colored suits. What is unusual about *Nicholas Boylston* is the subject's debonair attitude and his very showy informal costume. He wears a loose blue-green damask dressing gown with a blue lining, beige silk waistcoat and breeches, and white stockings. In place of a wig his shaved head is covered with a large, dark pink velvet turban.

Boylston appears at the same time aggressive and elegantly relaxed. The hand at the waist is fistlike, while that resting on the ledgers is graceful and loose. The subject sits in a nervous, angular pose, but the dominant lines of the composition are the big, leisurely curves made by the folds of his dressing gown and the drape behind him. The bold lines of these sumptuous fabrics herald the man's importance like swags and brackets on a building facade. Copley's treatment of the dressing gown is spectacular: his earnest rendering of its subtle color and pattern denotes respect for the value and beauty of the imported European fabric and an innate understanding of its sensuousness.[3] Copley's detailed attention to the marvelous clothes was not at the expense of characterization: Boylston's bold patrician features and his shrewd, self-possessed personality inevitably dominate the viewer's impressions.

The colorful and decorative accoutrements of *Nicholas Boylston* have an air of extravagance suggesting European fashions and their aristocratic arbiters. But compared with the work of European court portraitists, this Copley remains disarmingly direct, free from gestures and mannerisms, and ultimately sober, despite its sense of luxury.

T.J.F.

NOTES
 1. *Diary and Autobiography of John Adams*, ed. L. H. Butterfield, 2 vols. (Cambridge, Mass., 1961), 1:294.
 2. Little is known of Boylston's life. He died a bachelor, leaving a large part of his fortune to his nephew, Ward Hallowell, whom he had adopted as Ward Nicholas Boylston in 1770. Nicholas Boylston is remembered today as the founder of the Boylston Professorship of Rhetoric and Oratory at Harvard University, a bequest made in his will.
 3. Copley wears an identical blue-green dressing gown and an elaborately embroidered waistcoat in his magnificent and distinguished pastel self-portrait (1769; Henry Francis du Pont Winterthur Museum, Wilmington, Del.).

PROVENANCE
Nicholas Boylston; Ward Nicholas Boylston, 1771; to present owner, 1828.

EXHIBITION HISTORY
National Gallery of Art, Washington, D.C., *John Singleton Copley*, cat. by Jules D. Prown, 1965–66 (traveling exhibition), no. 29 (ill.).
Fogg Art Museum, Cambridge, Mass., *American Art at Harvard*, 1972, cat. no. 8 (ill.).

3

JOHN SINGLETON COPLEY
Rebecca Boylston, 1767
Painted in Boston
Signed and dated lower left:
 JSC 1767 [initials in monogram]
Oil on canvas, 50 × 40 in. (127 × 101.6 cm.)
Museum of Fine Arts, Boston,
 Bequest of Barbara Boylston Bean

Copley comes closest to the rococo style in this lively, colorful portrait. The beautiful Rebecca Boylston (1727–1798) was a forty-year-old unmarried woman, sister of the enormously wealthy Boston merchant Nicholas Boylston, whom Copley painted in the same year (cat.no.2). The conspicuous prosperity, refinement, and social sophistication of both subjects allowed the artist to portray them *en négligé:* they wear showy, fashionable clothes that would be inappropriate for a formal public occasion. The self-assurance of these prominent members of the colonial aristocracy is heightened by their decision to be portrayed with such apparent informality. The figure of Rebecca dazzles the viewer with its array of brilliant clothes and accessories: a loose, asymmetrically wrapped dress of shiny white silk or satin; billowing white lace sleeve ruffles and a frilled lace neckband tied at the back with a lavender ribbon; a crimson velvet overrobe edged with gold embroidery; a purplish-red silk drapery over one arm; and a single string of pearls woven into her coiffure.[1]

Considering prevailing custom, it is surprising that a wealthy Bostonian like Rebecca Boylston remained unmarried into her forties, especially if she was the alluring woman Copley's portrait suggests. The artist highlighted her physical attractiveness with her quick-witted glance, the fluid, twisting stance

of her slender figure, and a loose, revealing neckline. Both physically and mentally she differs considerably from most of the middle-aged women painted by Copley, especially the plump, formally attired, contented matriarchs who sit passively upon upholstered chairs in dim rooms. Nonetheless, the artist does not hide the signs of Rebecca's age, which is perhaps most apparent in her eyes. In 1773 Rebecca became the second wife of wealthy landowner Moses Gill (later lieutenant governor of Massachusetts), and Copley painted a second portrait of her at about this time (*Rebecca Boylston Gill*; Museum of Art, Rhode Island School of Design, Providence). In the second portrait, her age is immediately apparent, and she has a reserved and stately bearing which is emphasized by the severe, rather classical lines of her dress and a towering coiffure woven with pearls and silk.

The outdoor setting of *Rebecca Boylston* evokes the special grace and refinement of the subject's station and complements her confident, open spirit. The lush, warm-toned vista, massive leafy tree, ornate fountain, and basket filled with summer blossoms collectively evoke an untroubled existence. The Boylston house on School Street in Boston had a splendid garden which John Adams described in 1773 as "... large, beautifull and agreable ... with a great variety of excellent fruit, Plumbs, Pears, Peaches, Grapes, Currants ... and a figg Tree"[2] In both Copley portraits of Rebecca, she appears with flowers in a hilly, wooded landscape; in the second one she stands beside a potted lily plant with a profusion of large white blooms. Thus it seems likely that she was interested in horticulture and helped with her family's garden in Boston. In addition to their pictorial and biographical roles, the carefully nurtured and treasured flowers denote the subject's privileged background. The play of the fountain in *Rebecca Boylston* echoes the woman's lively mentality, and the jet of water adds to the overall shimmering quality of the costume and foliage. The fountain is a sculpted garden ornament with a lion and cornucopia set before a niche, and the animal spouts water into a shell-like basin. Copley probably borrowed this image from a print source, but given the exceptional wealth of the Boylstons, it might represent one they had imported for their large garden.[3]

T.J.F.

NOTES

1. Miss Boylston's clothes are fashioned in a modern European style and, given her wealth, she may have owned them. It is possible that her dressmaker was inspired by a European print or, alternatively, that Copley was. The crimson overrobe that she wears is the same as that in Copley's *Mrs. Jerathmael Bowers*, recently reidentified as *Mrs. Joseph Sherburne* (1767–70; Metropolitan Museum of Art, New York), a portrait for which the artist copied the entire costume from James McArdell's mezzotint (c. 1759) after Joshua Reynolds' *Lady Caroline Russell*.
 I am grateful to Joanna Hill, Conservation Assistant, Department of Textiles and Costumes, Museum of Fine Arts, Boston, for discussing *Rebecca Boylston* with me.

2. *Diary and Autobiography of John Adams*, ed. L. H. Butterfield, 2 vols. (Cambridge, Mass., 1961), 2:85. Adams mentions the Boylston garden again in 1773; see entry for Copley's *Nicholas Boylston* (cat.no.2).

3. For his slightly earlier portrait, *Mrs. John Murray* (1763; Worcester Art Museum, Mass.), in which the subject is somewhat similarly flanked by a late-seventeenth-century Baroque classical urn and a landscape vista, Copley took the urn from a mezzotint after Kneller's *Duke of Gloucester*; see Trevor J. Fairbrother, "John Singleton Copley's Use of British Mezzotints: A Reappraisal Prompted by New Discoveries," *Arts Magazine* 55 (March 1981): 122–30.

PROVENANCE
By descent in the Boylston family; to present owner, 1976.

EXHIBITION HISTORY
Possibly Boston Athenaeum, *47th Exhibition of Paintings*, 1871, cat.no.256.
Museum of Fine Arts, Boston, *John Singleton Copley*, 1938, cat.no.10.

4

JOHN SINGLETON COPLEY
Paul Revere, c. 1768–70
Painted in Boston
Oil on canvas, 35 × 28½ in. (88.9 × 72.4 cm.)
Museum of Fine Arts, Boston,
 Gift of Joseph W., William B., and
 Edward H. R. Revere

This portrait predates the now legendary nighttime ride in April 1775, when Paul Revere (1735–1818) forewarned the American forces at Concord and Lexington, Massachusetts, that the British army was marching north from Boston. Nonetheless, by the time he sat for Copley, the Boston silversmith and engraver was already well known in the colonies as a devoted patriot. He was active in political organizations such as the Sons of Liberty, was critical of British policy in his engravings, and assumed a crucial role as mediator between the intellectual leaders of the revolution and the much larger group of workers that supported them. His bold political stance might be inferred from the confrontational immediacy of Copley's composition.

Paul Revere is typical of Copley's male portraits in showing the attributes of the subject's profession. In a half-length portrait of another Boston silversmith, *Nathaniel Hurd* (c. 1765; Cleveland Museum of Art), the craftsman sits at a table with a book he must have consulted frequently (its spine is inscribed "Display of Heraldry/I Guillim"). But Hurd is elegantly attired in an informal dressing gown and turban, details which make the portrait a statement on the material rewards of his career and on his relaxed, gentlemanly self-image. In contrast, Revere is painted in a white undershirt, a heavier white shirt, and a blue-green waistcoat, with no jacket. His teapot and engraving tools remind

us of his daily work.[1] The portrait is related to the European practice of portraying artists, sculptors, and architects with the tools and products of their professional pursuits. Louis-Michel Van Loo's portrait of Diderot (1767; Musée du Louvre, Paris) is a particularly vivid example of a contemporary French attempt to personify creative genius in the arrested image of an artistic individual transfixed by a sudden inspiration. Van Loo shows the great writer informally dressed, seated at a table with a silver inkwell and a pile of manuscripts; Diderot looks up with one hand holding his pen, the other poised in the air, symbolizing the thought process. In Boston Copley did not enjoy the same freedom to paint the momentary gesture and unconventional facial expression, but he was clearly aware of this tradition of informal artists' portraits (probably from engravings) when he conceived *Paul Revere.*

In no other portrait does Copley show a man holding his head in such an evocative manner: this musing pose recalls Rembrandt's half-length *Titus* (1660; Baltimore Museum of Art), although no direct connection can be established.[2] An equally striking effect derives from the teapot held in Revere's other hand; the overall formality of the portrait seems to imbue this beautiful object with a special presence, like the skulls held by philosophers in "*vanitas*" portraits. In fact, the silver teapot vies with the subject's face for our attention, and its material existence promises to bear Revere's fame after his death. The portrait is thus a noble monument to its subject's status as an artist-craftsman, and not merely a casual shirt-sleeves vignette. The highly polished wood surface with an elaborate front molding is obviously not Revere's regular workbench; it serves as a handsome classical compositional device that gives distance and authority to the figure. The shiny wood gives the painter an opportunity to show his skill at rendering reflections, and the engraving tools not only indicate how Revere will add the final embellishment to the teapot, but also help establish the illusion of frontal space. Though Revere wears a workshirt, it is perfectly clean for the occasion. Copley's rendering of the voluminous shirt sleeves is perhaps the most aesthetically memorable passage of the picture. The whiteness of the linen and the bold illumination of the folds and gathers are exactly detailed. The passage recalls Zurbarán's startling representations of white clothes and draperies; it is doubtful that Copley knew the work of the seventeenth-century Spanish painter, but nonetheless the parallel certainly reflects the taste for meticulous realism in both cultures.

Copley devotes great labor to the distinct surface qualities of silver, linen, and wood, and these elegant passages seem to transcend

Revere's rather burly presence. A sense of his unsophisticated, brawny personality is unavoidable, and the tension between the blunt vigor of his face and the quiet monumental beauty of the setting sustains the picture's enigmatic appeal.

T.J.F.

NOTES
 1. The rococo silver teapot held by Revere might have been made by him as early as 1760 or as late as 1773; see Kathryn C. Buhler, *American Silver, 1655–1825, in the Museum of Fine Arts, Boston,* 2 vols. (Greenwich, Conn., 1972), 2: nos. 346 and 359. Prown dates this picture to 1768–70, choosing a late date on the stylistic grounds of strong value contrasts and a more restrained palette, and assuming that it predates 29 March 1770, when Copley's stepbrother Henry Pelham angrily accused Revere of pirating his engraving of the Boston Massacre.
 2. The Baltimore Museum of Art has no record of a print after the Rembrandt (letter from Jay M. Fisher, Associate Curator, Prints, Drawings, and Photographs, 14 June 1982). *Titus* was in the Duke of Rutland's collection by 1836. In Britain it may have inspired the hand-at-chin pose of John Runciman's *Self-Portrait* (c. 1768; Scottish National Portrait Gallery, Edinburgh, on loan from the Society of Antiquaries of Scotland).

PROVENANCE
By descent in the Revere family; to present owner, 1930.

EXHIBITION HISTORY
Museum of Fine Arts, Boston, *John Singleton Copley,* 1938, cat.no.64.
Wildenstein & Co., New York, *The American Vision,* 1957, cat.no.3 (ill.).
Jewett Arts Center, Wellesley College, Mass., *Four Boston Masters,* cat by John McAndrew et al., 1959, no.7.
National Gallery of Art, Washington, D.C., *John Singleton Copley,* cat. by Jules D. Prown, 1965–66 (traveling exhibition), no.45 (ill.).
Milwaukee Art Center, *The Inner Circle,* 1966, cat.no.23 (ill.).
National Portrait Gallery, Washington, D.C., *This New Man,* cat. by Oscar Handlin et al., 1968, p.112 (ill.).
Museum of Fine Arts, Boston, *Paul Revere's Boston, 1735–1818,* cat. by Jonathan L. Fairbanks, 1975, no.5 (ill.).
Philadelphia Museum of Art, *Copley from Boston,* 1980, pamphlet without checklist (ill.).

5

JOHN SINGLETON COPLEY
Samuel Adams, c. 1772
Painted in Boston
Oil on canvas, $50 \times 40\frac{1}{4}$ in. (127 × 102.2 cm.)
Museum of Fine Arts, Boston,
 Deposited by the City of Boston

Samuel Adams is Copley's only American work to present a political figure engaged in his political role. Adams (1722–1803) served in the Massachusetts House of Representatives from 1765, and Copley translated the firmness and righteousness of his personality into this extraordinarily dramatic painting. In a symbolic sense, we see Adams in the role of adversary through the eyes of Thomas Hutchinson, Royal Governor of Massachusetts: Adams confronts Hutchinson as spokesman for the town of Boston in its effort to expel British troops after the Boston Massacre (5 March 1770).[1] With a rigid, puffed-up stance and a grim look of defiance, he points to the charter and seal granted by King William and Queen Mary to the colony; in his other hand he clenches the statement prepared by the outraged citizens of Boston. Copley heightens the impression of forcefulness with chiaroscuro. Adams's hands and head stand out in bold relief, while his brown suit recedes into a somber background with a suitably classical, austere perspective of columns. The artist seems particularly mindful of the advice Benjamin West sent him from London, to make the head and hands the most consequential parts of a portrait:

> . . . one may Observe in the great works of Van dyke, who is the Prince of Portrait Painter[s], how he has mannaged by light and shedow and the Couler of Dreperys . . . [to make] the face and hands apear allmost a Disception.[2]

Adams's clothes are plain and conservative, and the buttoned shirt collar with almost no cravat exposed suggests both his constrained temperament and his middle-class background. The pose and costume suggest that Adams is an earnest, domineering person, although there is no sense of caricature in Copley's observations.

In a recent study, historian Pauline Maier writes of Adams: "He was hated by enemies who saw in him all the evils of the Revolution, but was admired in equal measure by others, who used him as a standard to identify the most active friends of the colonial cause."[3] Furthermore, Maier corrects the negative interpretation of Adams's political career that has prevailed in history textbooks since the nineteenth century. Instead of a duplicitous, professional agitator, she presents a peculiarly New England personality, emotionally and intellectually enmeshed in an awareness of his Puritan heritage: Adams was a classic revolutionary, a man ". . . of intense discipline for whom the public cause purged mundane considerations of self."[4] Amazingly, Copley's portrait does not pass final judgment on Adams, who elicited such strongly contrasting reactions from contemporaries. Visually the painting is an austere tribute to the strength (and perhaps narrowness) of Adams's convictions, and the antithesis of the relaxed and colorful painting of the aristocratic Tory Nicholas Boylston (cat. no. 2).

Apparently Boston merchant John Hancock commissioned the portrait of Adams for his own use, probably shortly after May 1772, when he and Adams resolved a brief political quarrel.[5] Hancock had been painted by Copley in 1765 (Museum of Fine Arts, Boston), but that conventional work with the standard attributes of a wealthy merchant lacked the fervor of *Samuel Adams*. By the 1770s both Hancock and Adams were leaders in the resistance to British policy. In 1774 Paul Revere copied the heads of these two men from their Copley portraits for engraved frontispieces to *The Royal American Magazine*. This journal published patriotic pieces as well as the usual essays, stories, and poems, and for both frontispieces the engraved heads were flanked by allegorical figures of Liberty. In 1775 the entire image of Copley's *Samuel Adams* was engraved in mezzotint by Samuel Okey and published in Newport, Rhode Island.[6] Both Hancock and Adams served as governors of Massachusetts after the Revolution.

T.J.F.

NOTES

1. This now traditional interpretation of the picture first appeared in William V. Wells, *The Life and Public Services of Samuel Adams*, 3 vols. (Boston, 1865), 1:476–77.

2. West to Copley, 20 June 1767, *Copley-Pelham Letters*, p.57.

3. Pauline Maier, *The Old Revolutionaries, Political Life in the Age of Samuel Adams* (New York, 1980), p. 3.

4. Ibid., p. 48. Here Maier also quotes William Lecky's insightful assessment of Adams's personality, written in 1898: "Poor, simple, ostentatiously austere and indomitably courageous, the blended influence of Calvinistic theology and of republican principles had permeated and indurated his whole character, and he carried into politics all the fervor of an apostle and all the narrowness of a sectarian."

5. See Wells, *Life of Adams*, p. 475. Jules Prown feels that the picture might have been painted soon after the Boston Massacre, and dates it 1770–72; see Prown, *Copley*, p. 83.

6. See Clarence S. Brigham, *Paul Revere's Engravings*, rev. ed. (New York, 1969). Okey's mezzotint was copied from a painting by J. Mitchell (unlocated) which was based on the Copley original.

PROVENANCE

John Hancock, Boston; gift to the City of Boston by Hancock's heirs, 1836; deposited at the Museum of Fine Arts, Boston, 1876.

EXHIBITION HISTORY

Boston Athenaeum, *First Exhibition of Paintings*, 1827, cat.no. 246 (lent by S. A. Wells).

Museum of Fine Arts, Boston, *Contemporary Art*, 1879, cat.no.79.

Museum of Fine Arts, Boston, *Loan Exhibition of One Hundred Colonial Portraits*, 1930, cat.no. 2 (ill.).

Harvard University, Cambridge, Mass., *Tercentenary Exhibition*, 1936, cat.no. 3 (ill.).

Corcoran Gallery of Art, Washington, D.C., *Signers of the Declaration of Independence*, 1937–38, cat.no.22.

Colonial Williamsburg, Va., *They Gave Us Freedom*, 1951, cat.no. 10 (ill.).

Art Gallery of Toronto, *Comparisons*, 1957, cat.no.59.

National Gallery of Art, Washington, D.C., *John Singleton Copley*, cat. by Jules D. Prown, 1965–66 (traveling exhibition), no.48 (ill.).

National Portrait Gallery, Washington, D.C., *This New Man*, cat. by Oscar Handlin et al., 1968, p.73 (ill.).

National Portrait Gallery, Washington, D.C., *In the Minds and Hearts of the People*, 1974, cat.p.137 (ill.).

Amon Carter Museum, Fort Worth, Tex., *The Face of Liberty: Founders of the United States*, cat. by James T. Flexner, 1975–76.

Museum of Fine Arts, Boston, *The Patriot Painters*, 1978.

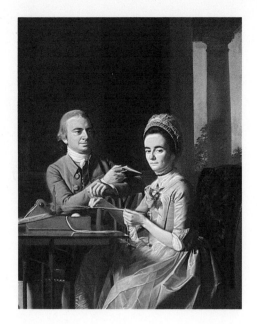

6

John Singleton Copley
Mr. and Mrs. Thomas Mifflin, 1773
Painted in Boston
Signed and dated upper right:
 J. Singleton Copley Pinx. / 1773. Boston
Oil on canvas, $61\frac{1}{2} \times 48$ in. (156.2 × 121.9 cm.)
The Historical Society of Pennsylvania,
 Philadelphia

Thomas Mifflin (1744–1800) was a wealthy young Philadelphia merchant of Quaker birth. He and his wife Sarah Morris Mifflin (c. 1747–1790) were painted during a visit to Boston in the summer of 1773. Like Samuel Adams, Thomas Mifflin was a radical Whig; he was soon to become aide-de-camp to General Washington, and later a quartermaster general of the Revolutionary Army and governor of Pennsylvania.

In his portrait of Adams (cat. no. 5), Copley had immortalized his subject as a forceful orator and statesman. For the portrait of the Mifflins, however, he omitted political allusions and concentrated on the overriding harmony and stability of the couple's marriage. In fact he made a completely new statement in American family portraiture by focusing on the importance of the woman and casting the man in the role of companion and admirer. (The traditional sex roles are exemplified in Charles Willson Peale's 1772 *John Cadwalader Family*, cat. no. 7.)

Only three group portraits are known from Copley's mature American period: *Mary and Elizabeth Royall* (c. 1758; Museum of Fine Arts, Boston), the 1773 Mifflin portrait, and *Mr. and Mrs. Isaac Winslow* (1774; Museum of Fine Arts, Boston). The latter two are amongst the few late works executed in Boston before Copley's departure for Europe on the eve of

the Revolution; moreover, *Mr. and Mrs. Thomas Mifflin* is the most psychologically intricate and visually involved of all his American works. The Mifflins may have chosen a double portrait rather than two separate canvases to economize on time or money during their visit from Philadelphia; alternatively, the artist might have suggested the idea when he recognized the rare and challenging opportunity to paint a two-figure composition.

Copley ingeniously juxtaposed his subjects in a narrow space without spoiling the mood of domesticity that emerges from their activities: Mrs. Mifflin looks up from the fringe she is making on a small loom to face the viewer, while Mr. Mifflin interrupts his reading and twists around over his chair-back in order to gaze admiringly at his wife. These are wealthy, refined, and handsome people, whose social prominence is symbolized by the architectural column and parklike landscape behind them. Nonetheless, there is a sober inflection to Copley's portrayal of the Mifflins which readily distinguishes them from more blatantly aristocratic subjects like Nicholas and Rebecca Boylston (cat. nos. 2 and 3). It is Mrs. Mifflin who dominates the picture: she occupies the frontal plane and commands both the viewer's and her husband's attention. She is performing her task with evident dignity and pride, and she later recalled posing twenty times for the hands which work the loom with such ease and grace.[1] The closeness of the Mifflins' personal relationship is indicated pictorially by the visual proximity of their hands, and their concern with self-improvement is suggested by the book and the loom which occupy them even during their leisure together. Thus their portrait embodies the earnest moral and intellectual values of the Enlightenment, values that would be held so highly by the first president of the United States.[2]

Copley's late American portraits attain a profoundly individual expression based on detailed clarity of vision, frank definition of space, and sober tonalities; their celebration of truthfulness and simplicity seems to anticipate the neoclassical style. Thus *Mr. and Mrs. Thomas Mifflin* readily recalls the slightly later portraits by Jacques-Louis David, especially his *Antoine Lavoisier and His Wife* (1788; Rockefeller University, New York). Copley developed this subtle and insightful style independently, without firsthand knowledge of Europe's classical and Renaissance heritage. Seeing Raphael's *Transfiguration* for the first time in Rome in 1775 and wishing to describe the style of "the greatest of The Modern Painters" to his stepbrother Henry Pelham, Copley made an analogy with the style of his portrait of the Mifflins:

Raphael has studied the life very carefully. his Transfiguration, after he had got the composition of it on the Canvis, he has painted with the same attention that I painted Mr. Mifflins portrait and his Ladys. in that determined manner he has painted all the heads, hands, feet, Draperys, and background, with a plain simple body of Colours and great precision in his outline, and all parts of it from nature.[3]

He was not boasting with this comparison, but simply reminding Pelham of one of his own works that had certain characteristics he was now gratified to find in Raphael's masterpiece.

 T.J.F.

NOTES
1. See Rembrandt Peale, "Reminiscences. Exhibitions and Academies," *The Crayon* (May 1855): 290: "Mrs. Governor Mifflin . . . told me she sat twenty times for the hands. This tediousness of operation deterred many from sitting to Copley."
2. Lois Dinnerstein has pointed out that the image of Mrs. Mifflin working at her loom involves "contemporary notions of piety, patriotism, and industry." When the portrait was painted, there was a strong movement in America to boycott British imports such as textiles; although we now tend to see her activity as a genteel reflection of Enlightenment morality and industriousness, it may have connoted American patriotic values to the subjects and their Whig friends. See Dinnerstein, "The Industrious Housewife: Some Images of Labor in American Art," *Arts Magazine* 55 (April 1981): 109–11.
3. Copley to Henry Pelham, 14 March 1775, *Copley-Pelham Letters*, p. 301.

PROVENANCE
Bequeathed by Thomas Mifflin to his sister Susannah Morris; her great-nephew, Dr. Mifflin Morris; by descent in the Wistar family; to present owner, 1900.

EXHIBITION HISTORY
Pennsylvania Academy of the Fine Arts, Philadelphia, *Sixth Annual Exhibition*, 1818, cat. no. 68.
Metropolitan Museum of Art, New York, *Paintings by John Singleton Copley*, 1936–37, cat. no. 33 (ill.).
Metropolitan Museum of Art, New York, *Life in America*, 1939, cat. no. 28 (ill.).
Philadelphia Museum of Art, *Diamond Jubilee Exhibition*, 1951, cat. no. 61 (ill.).
Detroit Institute of Arts, *Painting in America: The Story of 450 Years*, cat. by Lloyd Goodrich, 1957, no. 31.
National Gallery of Art, Washington, D.C., *John Singleton Copley*, cat. by Jules D. Prown, 1965–66 (traveling exhibition), no. 55 (ill.).
Whitney Museum of American Art, New York, *Art of the United States: 1670–1966*, cat. by Goodrich, 1966, no. 55 (ill.).
National Portrait Gallery, Washington, D.C., *In the Minds and Hearts of the People*, 1974 (ill.).

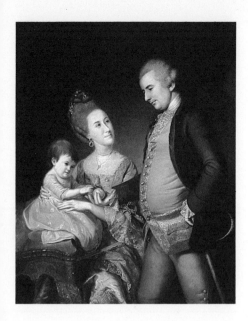

7

CHARLES WILLSON PEALE
The John Cadwalader Family, 1772
Painted in Annapolis, Maryland
Signed and dated lower left:
 CW Peale/pinx^t 1771.
Oil on canvas, 51½ × 41¼ in. (130.8 × 104.8 cm.)
Private Collection

John Cadwalader (1742–1786) was a merchant-planter and one of the wealthiest men in pre-Revolutionary Philadelphia. During the Revolution he was brigadier general of the Pennsylvania militia and afterward became a leader of Philadelphia's business community. He was also one of the city's major art patrons and one of Peale's most loyal supporters.

In 1770 Cadwalader met Peale and urged him to become the city's resident portrait painter.[1] To prove those good intentions, Cadwalader, his cousin John Dickinson, and his friend John Beale Bordley became Peale's first Philadelphia patrons, commissioning from him a variety of portraits, landscapes, and miniatures.

Peale began the portrait of the Cadwalader family at his Annapolis studio in September 1770. He continued to work on it in 1771 and dated it that year, although he did not deliver it to his patron until 1772. About that time Cadwalader moved into and furnished a large row house in downtown Philadelphia. This portrait was among the home's fashionable new appointments.[2]

The picture shows John Cadwalader, well fed and powerful, striking a pose of the man-of-affairs at ease. Beside him, Mrs. Cadwalader glances at her husband while holding their daughter, who accepts a peach from her father. Part of the portrait's purpose was to indicate the family's prosperity, which is evident in their elaborate clothing and the locally made card table (one of the most elegant examples of the form in America). These trappings, along with the predominant silvery color in the painting, were intended to suggest the cosmopolitan refinements of rococo taste. Yet the portrait conveys an equally important message about family bonds. On one level that message speaks through symbolic conventions that artists of the 1700s had inherited from the previous two centuries. John Cadwalader's hat, the fruit he holds out to his daughter, his wife's pearls and closed fan conveyed, respectively, a husband's link to the outside world, the promise of fecundity, earthly love, and the ties of marriage. On another level is a much more immediate message about the sovereignty of informal intimacies in domestic life.

While Peale strove to attain an easy, relaxed elegance in this portrait, he still betrayed the traces of primitiveness and awkwardness which ran through all his work. He could never completely accept the delicacy and lightness of the rococo, particularly when it stood at odds with the precision of solid, round forms which he associated with good craftsmanship.

Nevertheless, his portrait's attempt at studied informality, which recalls the portrait styles of Copley and painters that Peale had recently seen in England, was something new for Philadelphia. The off-center composition, showing sitters preoccupied with their activity rather than oriented toward the viewer, began to appear in British portraits in the 1760s. In addition, there is a certain casualness in the way the baby daughter is propped up on the card table, itself a piece of furniture used for informal entertainment.

This painting was one of Peale's Philadelphia trial balloons: he intended to exhibit it and some other portraits in the city and thereby measure public interest in his work. His venture showed promise: even before he finished this canvas, he received orders for other portraits, and by 1772 he reported to John Bordley that although he had postponed moving to Philadelphia, "it is not for want of business. I have my hands full."[3] However, the position that Peale was able to attain as the city's primary portrait painter, despite his technical shortcomings, suggests that in the 1770s and 1780s, when it was the most prosperous city in the American colonies and boasted the country's most sophisticated craftsmen in architecture and the decorative arts, Philadelphia remained somewhat of a backwater for painting.

D.S.

NOTES

1. See Charles Coleman Sellers, *Charles Willson Peale* (New York, 1969), p. 83.
2. See Nicholas B. Wainwright, *Colonial Grandeur in Philadelphia: The House and Furniture of General John Cadwalader* (Philadelphia, 1964), p. 45.
3. Peale to Bordley, November 1772 (Peale-Sellers Papers, American Philosophical Society, Philadelphia). Peale followed this portrait with similar half-length family groups: *The Edward Lloyd Family,* begun in 1771, *The Johnson Family,* painted in 1772, and *The Peale Family Group,* begun in 1773.

PROVENANCE
Descended in the Cadwalader family to Capt. John Cadwalader, U.S.N.R. (Ret.).

EXHIBITION HISTORY
Pennsylvania Academy of the Fine Arts, Philadelphia, *Philadelphia Painting and Printing to 1776,* cat. by Edgar P. Richardson et al., 1971, no. 22.
Philadelphia Museum of Art, *Philadelphia: Three Centuries of American Art,* cat. by Darrel Sewell et al., 1976, no. 92.
Metropolitan Museum of Art, New York, *Charles Willson Peale and His World,* cat. by Richardson et al., 1982 (traveling exhibition), no. 14.

GILBERT STUART

(1755, North Kingston, Rhode Island
—1828, Boston)

Gilbert Stuart was raised in Newport, Rhode Island, where his father worked in the tobacco business. As a boy he took art lessons from Cosmo Alexander, a Scottish painter then working in Newport. In 1772 Stuart followed Alexander to Edinburgh, where his teacher died unexpectedly. Unable to find work, Stuart returned home within a year. In 1775 he went abroad again, this time to London, where he studied with Benjamin West (q.v.) for four years. He set up his own portrait business in 1782 and successfully competed with London's premier portraitists, Joshua Reynolds and George Romney. Despite his success, debts mounted, and by 1787 he was forced to move to Dublin in order to escape them. In 1792 he returned to the United States for the same reason. There he worked in New York, Philadelphia and its environs, and Washington, D.C., before moving in 1805 to Boston, where he resided until the end of his life.

Stuart was the most sophisticated and highly regarded American portrait painter of his generation. His technique developed out of the fashionable style of late-eighteenth-century British portraiture as practiced by Gainsborough and Romney. Accordingly, the style Stuart brought to America was a "painterly" one. With rapid brushwork and a keen appreciation for the optical blending of colors, he created a soft and atmospheric effect in his paintings. His American works were highly successful, and by the end of his life he was recognized as his country's foremost portrait painter. Yet Stuart never saw himself as the founder of a national style. Nor did he become an advocate of academies as did other American artists of his generation. But he freely dispensed advice on painting, and his continuing advocacy of truth to nature and avoidance of artifice won him many followers.

No recent comprehensive study of Stuart's art exists. The principal catalogue of his paintings is Lawrence Park, Gilbert Stuart: An Illustrated Descriptive List of His Work *(New York, 1926). A greater number of biographies of the artist have been written; among them are those by James T. Flexner (New York, 1955), and Charles Merrill Mount (New York, 1964).*

8

GILBERT STUART
Martha Washington, 1796
Painted in Germantown, Pennsylvania
Oil on canvas, 48 × 37 in. (121.9 × 94 cm.)
Museum of Fine Arts, Boston, and
 The National Portrait Gallery,
 Smithsonian Institution, Washington, D.C.
Exhibited in Boston and Paris only

It was Martha Washington (1731–1802) who commissioned Stuart to paint portraits of herself and her husband (cat.no.9) the year before the president retired from public life. Like its companion, the portrait of Martha Washington is unfinished. Only her face is fully painted: her hair, bonnet, and the background around her head—which might have shown a curtain—have only been blocked in. Still, what is visible tempts us to reconstruct her character. She was generally remembered as organized, even-tempered, and congenial.

Martha Washington (née Martha Dandridge) was married at age eighteen to wealthy Virginia landowner Daniel Parke Custis. Custis's death in 1757 left her the custodian of a large estate and four young children. Two years later she was courted by, and soon married, George Washington, then commander of Virginia's forces in the French and Indian War, and himself a prosperous plantation owner. They settled at his home, Mount Vernon, in Virginia. During the Revolutionary War, she joined Washington at military headquarters in Massachusetts and later at Valley Forge, Pennsylvania. After five tranquil years at Mount Vernon following the close of the war, she assumed duties as the nation's First Lady, first in New York City, and then in Philadelphia, as her husband served two terms as president of the United States (1789–97). She was sixty-five years old, one year older than Washington, when Stuart painted them in 1796.

As was Stuart's practice in his portraits of older women, he did not disguise her rather plain features with elaborate costume or sweetened expression. Martha Washington's gaze is passive, if kindly, her headdress a modest lace cap which reflects her preference for quiet domestic life rather than the grand affairs of state. Her face has a softness and silvery transparency quite different from the mottled ruddiness of her husband. She reportedly was pleased with the effect of her portrait, but disliked her husband's.[1] Ironically, this did not agree with the public's eventual assessment of their relative merits. Even though her portrait was sometimes exhibited independently and not simply as a companion piece, it never became the object of special veneration that Washington's image became.

This unfinished portrait illuminates Stuart's working method. He painted directly onto the buff ground of his canvas without benefit of underdrawing. He worked outward from the face, defining body and background as he progressed. Stuart advocated drawing with the brush and a painterly technique, and was fascinated by the way the eye blends colors and shapes. "Look at my hand," he once said, "see how the colors are mottled and mingled, yet all is clear as silver."[2] Stuart was known for his refusal to follow any past school: as he claimed, "I wish to find out what nature is for myself, and see her with my own eyes."[3]

D.S.

NOTES
1. See E. P. Richardson, *Gilbert Stuart, Portraitist of the Young Republic* (Museum of Art, Rhode Island School of Design, Providence, 1967), p. 28.
2. Quoted in William Dunlap, *The Rise and Progress of the Arts of Design in the United States,* 3 vols. (1834; Boston, 1918), 1:215.
3. Ibid., p. 216.

PROVENANCE
Purchased by the Washington Association and 22 subscribers; from the artist's estate for $1,500 to the Boston Athenaeum, 1831; deposited by the Boston Athenaeum at the Museum of Fine Arts, Boston, 1876–1979; to present owners, 1980.

EXHIBITION HISTORY
Boston Athenaeum, *Gilbert Stuart Memorial Exhibition,* 1828, cat.no. 121.
Boston Athenaeum, *Annual Exhibition,* 1832, cat.no. 153; 1840, cat.no. 148; 1846, cat.no. 24; 1848, cat.no. 139; 1850–63, various cat.nos.; 1864–69, cat.no.48; 1870–74, various cat.nos.
Museum of Fine Arts, Boston, *Contemporary Art,* 1879, cat.no. 102.
Museum of Fine Arts, Boston, *Gilbert Stuart,* 1880, cat.no.202.
Museum of Fine Arts, Boston, *Gilbert Stuart,* 1928, cat.no.79.
Amon Carter Museum, Fort Worth, Tex., *The Face of Liberty: Founders of the United States,* cat. by James T. Flexner, 1975–76, no.98.

9

GILBERT STUART
George Washington, 1796
Painted in Germantown, Pennsylvania
Oil on canvas, 48 × 37 in. (121.9 × 94 cm.)
Museum of Fine Arts, Boston, and
 The National Portrait Gallery,
 Smithsonian Institution, Washington, D.C.
Exhibited in Boston and Paris only.

With studios in both capitals of the republic, Philadelphia and Washington, D.C., Stuart became during the 1790s and early 1800s the unofficial portrait painter to the nation's new ruling class. His sitters included the country's wealthiest citizens as well as its leading political figures, including such illustrious men as John Adams, James Madison, James Monroe, and most importantly, the first president, George Washington (1732–1799). When Washington sat for Stuart, he was nearing the end of his second term of office and of his presidency, to which he had been elected in 1789. Since his early twenties, he had had a long career as a state official for Virginia, serving as commander of the Virginia forces in a frontier dispute with the French in the 1750s, and of course he led the American forces to victory in the Revolutionary War from 1775 to 1783. One of Washington's great strategic victories—the seizure of Dorchester Heights overlooking Boston Harbor in the spring of 1776—was commemorated by Stuart in a full-length portrayal of the general in military costume (1806; Museum of Fine Arts, Boston). Washington's military career was combined with that of gentleman farmer of the family estate, Mount Vernon, in Fairfax County, Virginia.

Stuart began three portraits of Washington in 1795–96: the first was a small bust-length (the "Vaughan" portrait; National Gallery of Art, Washington, D.C.); the second was an elaborate full-length commissioned by a group of Philadelphia patrons, intended to show

Washington as head of state (Pennsylvania Academy of the Fine Arts, Philadelphia). The third was this painting, requested by Mrs. Washington along with a companion portrait of herself (cat. no. 8) to be hung in their home. The artist intended to present Washington in a rectangular image, showing his body to the elbows. He sketched in parts of a black coat, a white stock, and a dark-brown setting. Enough of the portrait is finished to show how restrained the characterization would be. In contrast to Copley's concern with elaborately detailed settings and accessories, Stuart saw facial likeness, glance, and expression as the only crucial elements of portraiture. In addition to these portraits of George and Martha Washington, several other important works, including *Mrs. Perez Morton* (c. 1802; Worcester Art Museum, Mass.), have completed faces but sketchy, unfinished settings. This demonstrates the extent to which he valued the real work of capturing a lifelike impression of a face over the more routine elaboration of clothes and props.

Stuart never did deliver these portraits of George and Martha Washington: he kept them in his studio instead and used the unfinished bust of the president as a model for the numerous portraits of the president ordered from him in later years. The demand was considerable: Stuart produced at least 114 portraits of Washington, over sixty of which were replicas of this unfinished work.[1] After Stuart's death, this portrait and the one of Martha Washington were purchased by public subscription for the Boston Athenaeum. The "Athenaeum head" as it was called, became by far the most famous portrait of Washington. William Dunlap, in his 1834 *Rise and Progress of the Arts of Design in the United States,* judged it Stuart's finest work. At the Boston Athenaeum it received the kind of attention reserved for works of Old Masters, particularly among would-be artists: the Athenaeum records confirm that numerous individuals were given permission to copy it. Virtually no other work of American art has been as widely known and as consistently admired between the time it was made and our own day, and it has become in a sense the nation's "official" portrait of our first president. Perhaps this is due to the portrait's ability to capture Washington's best-remembered character traits, as described by the Enlightenment philosopher the Marquis de Chastellux, who served in the American Revolution, and who called Washington "brave without temerity, laborious without ambition, generous without prodigality, noble without pride, virtuous without severity."[2]

D.S.

NOTES
 1. See Cuthbert Lee, *Early American Portrait Painters* (New Haven, Conn., 1929), p. 19.
 2. Francois-Jean Marquis de Chastellux, *Voyages . . . dans l'Amerique septentrionale* (1786), quoted in Alan Kors, chap. 1, *Abroad in America: Visitors to the New Nation 1776–1914,* ed. Marc Pachter (National Portrait Gallery, Smithsonian Institution, Washington, D.C., 1976), p. 10.

PROVENANCE
Purchased by the Washington Association and 22 subscribers from the artist's estate for $1,500 for the Boston Athenaeum, 1831; deposited by the Boston Athenaeum at the Boston Museum of Fine Arts, 1876–1979; purchased jointly by present owners, 1980.

EXHIBITION HISTORY
Boston Athenaeum, *Gilbert Stuart Memorial Exhibition,* 1828, cat. no. 120
Boston Athenaeum, *Annual Exhibition,* 1832, cat. no. 154; 1840, cat. no. 153; 1846, cat. no. 41; 1848, cat. no. 138; 1850–63, various cat. nos.; 1864–69, cat. no. 49; 1870–74, various cat. nos.
Museum of Fine Arts, Boston, *Contemporary Art,* 1879, cat. no. 191 (?).
Museum of Fine Arts, Boston, *Gilbert Stuart,* 1880, cat. no. 201.
Museum of Fine Arts, Boston, *Gilbert Stuart,* 1928, cat. no. 76.
Amon Carter Museum, Fort Worth, Tex., *The Face of Liberty Founders of the United States,* cat. by James T. Flexner, 1975–76, no. 97.

CHARLES WILLSON PEALE

(1741, Queen Anne's County, Maryland
—1827, Philadelphia)

Few American artists had as many varied interests as Charles Willson Peale. His first profession was as a saddler, but during the early 1760s he received a few lessons in painting and in 1767 went to study art in London, where he became an early pupil of Benjamin West's. In 1769 he returned to America, plying his portrait trade in Annapolis, Baltimore, and Philadelphia. Peale served in the Continental Army for three years; then in 1778 he settled in Philadelphia, where for the next dozen years he was the city's principal portrait painter. His vocation as portrait and miniature painter, however, gradually gave way to other pursuits. He became involved in organizing art exhibitions, grew deeply interested in natural history, was active in the American Philosophical Society, and dabbled in mechanical inventions, paleontology, and taxidermy. In 1786 he established his own museum of art and natural history and operated it until late in life.

Peale would have considered his chief contributions to have been as a museum proprietor and art proselytizer. Moreover, he encouraged eight of his children, together with his brother, a nephew, four nieces, and three grandchildren, to become practicing artists. Because other painters periodically made incursions into his portrait business, however, and his plans for art organizations met with various degrees of opposition, Peale never felt he achieved complete success. However, he is remembered today along with Thomas Eakins as Philadelphia's premier painter and one of the most important early talents in American art.

Charles Coleman Sellers's biography of Peale (New York, 1969) and checklist, Portraits and Miniatures by Charles Willson Peale (Philadelphia, 1952), form the primary body of information on Peale and his art. In 1982 the Metropolitan Museum of Art and the National Portrait Gallery organized a major exhibition of the artist's work, Charles Willson Peale and His World (cat. by Edgar P. Richardson et al. [New York, 1983]).

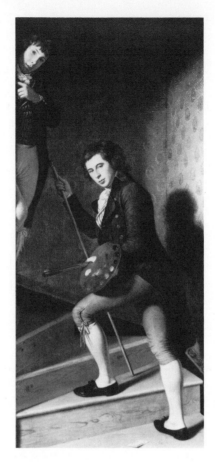

IO

CHARLES WILLSON PEALE
Staircase Group, 1795
Painted in Philadelphia
Once signed lower right, on calling card;
 signature now obliterated
Oil on canvas, $89\frac{5}{8} \times 39\frac{1}{2}$ in.
 (227.7 × 100.3 cm.)
Philadelphia Museum of Art,
 The George W. Elkins Collection
Exhibited in Paris only

Peale painted the *Staircase Group* for the first and only exhibition of the Columbianum, or American Academy of Fine Arts, a short-lived institution which Peale helped to found in Philadelphia. The academy was to have a permanent art gallery, offer annual exhibitions, and operate an art school, where the Peale children were to study.[1] Peale, his brother James, and sons Raphaelle and Rembrandt all contributed work to the exhibition, which was held in the Senate Chamber of Philadelphia's State House.

This painting was to be the showpiece of the exhibition, a display of Peale's virtuosity in pictorial invention and painting skill. The nearly life-sized work depicts two of Peale's sons, Raphaelle and his younger brother Titian, who look out at the viewer from the foot of a stairway. The most distinctive feature of the painting—particularly on so

large a scale—is its trompe l'oeil character. Peale heightened the startling effect of its illusionism by exhibiting it in an existing door frame with a step built out below it. Peale took considerable pride in the picture's inventiveness and displayed it in his museum. According to an often-repeated anecdote, George Washington was once taken in by the illusion and saluted the young men in the painting.[2]

Although some American painters before Peale had been intrigued by trompe l'oeil illusionism, Peale's choice of full-length human figures in a domestic setting was then unique in American art. His devices were, however, similar to trompe l'oeil practices in seventeenth-century European art. Peale may well have known of a painting displayed in the Castel Sant'Angelo in Rome that showed a cavalier similarly climbing a staircase; alternatively, the life-sized illusions of rooms and people that were used to decorate seventeenth-century Dutch and English homes may have been his model.[3]

Peale frequently used members of his family as subjects for his paintings, an indication of the great pride he took in his family's artistic proclivities. This work is only one of several "portraits" of family members that are among Peale's most interesting images. Their inventiveness may be related to the fact that for these paintings the artist was not constrained by the normal requirements of commissioned portraiture.

Peale seems to have had a special purpose in mind in choosing Raphaelle and Titian as his subject. In 1794, the year he was laying plans for the Columbianum and its exhibition, he announced that he intended to retire from painting in favor of his sons. His desire to see the Peale painting business pass to a new generation may have motivated him to portray his sons in a large painting to be exhibited. The picture may have been meant to advertise the professional talents of his eldest son Raphaelle. Trained under his father, Raphaelle had just recently begun to strike out on his own as a painter, and in the *Staircase Group* he is shown confidently turning toward the viewer with palette and maulstick in hand.[4]

The *Staircase Group* states Peale's artistic legacy to his sons in another way as well. In his desire to demonstrate his virtuosity and genius to the Philadelphia public, Peale revealed a belief that convincing illusionism was the measure of an artist's power. This belief was evidence that Peale held considerably more old-fashioned artistic values than those of his teacher, Benjamin West. But his values were taken to heart by his son Raphaelle, by several of his painter-relatives, and by such later Philadelphians, as William Harnett (q.v.). *D.S.*

NOTES

1. See Louise Lippincott, "Charles Willson Peale and His Family of Painters," *In This Academy* (Pennsylvania Academy of the Fine Arts, Philadelphia, 1976), p. 82.

2. See *The Crayon* 3 (April 1856): 100.

3. See M. L. d'Otrange Mastai, *Illusion in Art, Trompe l'Oeil* (New York, 1975), pp. 165, 185, 190, 264.

4. See Charles Coleman Sellers, *Charles Willson Peale* (New York, 1969), p. 262.

PROVENANCE

Peale family; purchased by Lewis H. Newbold or Joseph Harrison, Philadelphia, 1854; estate of Mrs. Joseph Harrison to Sabin W. Colton, Jr., Bryn Mawr, Pa., by sale, 1910; to his son, Dr. Harold S. Colton, 1933; on loan to Philadelphia Museum of Art, 1933–45; to present owner, 1945.

EXHIBITION HISTORY

Senate Chamber, State House, Philadelphia, *The Columbianum or American Academy of the Fine Arts*, 1795, cat.no.61.

Peale Museum, Philadelphia, *Historical Catalogue of the Paintings in the Philadelphia Museum*, 1813, cat.no.209.

Independence Hall, Cincinnati, *National Portrait and History Gallery*, 1852, cat.no.100.

Pennsylvania Academy of the Fine Arts, Philadelphia, *Portraits by Charles Willson Peale, James Peale and Rembrandt Peale*, 1923, cat.no.255.

M. H. de Young Memorial Museum, San Francisco, *American Painting*, 1935, cat.no.15.

Baltimore Museum of Art, *200 Years of American Painting*, 1938, cat.no.4.

Metropolitan Museum of Art, New York, *Life in America*, 1939, cat.no.55.

Carnegie Institute, Pittsburgh, *Survey of American Painting*, 1940, cat.no.75.

Philadelphia Museum of Art, *Life in Philadelphia*, 1940, cat.no.53.

McClees Gallery, Philadelphia, *Paintings and Watercolors by the Peale Family*, 1944, cat.no.4.

Tate Gallery, London, *American Painting*, 1946, cat.no.162.

Art Institute of Chicago, *From Colony to Nation*, 1949, cat.no.88.

Century Association, New York, *Paintings by Members of the Peale Family*, 1953, cat.no.32.

Pennsylvania Academy of the Fine Arts, Philadelphia, *150th Anniversary Exhibition*, 1955, cat.no.8.

Minneapolis Institute of Art, *Four Centuries of American Art*, 1963, cat.no.23.

City Art Museum, St. Louis, *200 Years of American Painting*, 1964, cat.no.7.

Museum of Fine Arts, St. Petersburg, Fla., *Inaugural Exhibition*, 1965, cat.no.2.

Detroit Institute of Arts, *The Peale Family*, cat. by Charles H. Elam et al., 1967, no. 10.

Philadelphia Museum of Art, *Philadelphia: Three Centuries of American Art*, cat. by Darrel Sewell et al., 1976 no. 137.

Metropolitan Museum of Art, New York, *Charles Willson Peale and His World*, cat. by Edgar P. Richardson et al., 1982 (traveling exhibition), no. 55.

REMBRANDT PEALE

(1778, Bucks County, Pennsylvania —1860, Philadelphia)

Charles Willson Peale's second surviving son Rembrandt was his favorite pupil and the most diligent artist of the second generation of Peales. He received his artistic education from his father, who, in 1794, announced in the Philadelphia press his retirement from portraiture in order that his sons Rembrandt and Raphaelle (q.v.) might establish their own professional careers. Rembrandt and his father both painted President Washington from life in 1795, and Rembrandt used his original likeness to make sixty-five replicas over the years. Portraiture was the mainstay of his career, and he contributed many paintings of "distinguished men" to his father's museum. In 1802 he traveled to England with his brother Rubens to exhibit one of the mastodon skeletons which they had helped their father exhume in upper New York State the previous year. He remained in London to study with Benjamin West and then returned to Europe (1808 and 1809–10) to make more portraits of military, political, and artistic celebrities for the Peale Museum. The artists he painted on this and later visits included Bertel Thorwaldsen, Jean-Antoine Houdon, Jacques-Louis David, and Vicenzo Camuccini. Influenced by personal contact with West, David, and Pascal Gérard, he attempted to support himself as a history painter in the 1810s. One very large picture, The Court of Death *(1820; Detroit Institute of Arts) toured several American cities producing income from admissions. But since the venture was not an outstanding financial success, the artist was forced to accept portraiture as the most reliable artistic profession. He painted portraits in New York, Philadelphia, and Boston in the 1820s.*

Rembrandt Peale established his own museum in Baltimore (1814) and was a founding member of both the Pennsylvania Academy of the Fine Arts (1805) and the National Academy of Design (1826). After two more trips to Europe (1828–30 and 1832–33), he settled permanently in Philadelphia. He wrote of his travels and of art in Notes on Italy *(1831) and late in life contributed a long series of essays, entitled* Reminiscences, *for the American art journal* The Crayon.

There is no monograph on this artist. An outline of his career can be gained from The Peale Family: Three Generations of American Artists *(Detroit Institute of Arts and Munson-Williams-Proctor Institute, Utica, N.Y., 1967), and James A. Mahey, "The Studio of Rembrandt Peale," American Art Journal 1 (Fall 1969): 20–40.*

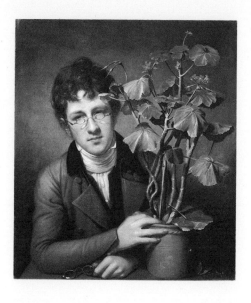

I I

REMBRANDT PEALE
Rubens Peale with a Geranium, 1801
Painted in Philadelphia
Signed and dated lower right: *Rem. Peale / 1801*
Oil on canvas, 28 × 24 in. (71.1 × 61 cm.)
Mrs. Norman B. Woolworth

Rembrandt Peale was twenty-three when he made this tender, frank portrait of his younger brother Rubens (1784–1865). Rubens had poor eyesight and is seen wearing one pair of spectacles and holding another in his hand. The artist depicts on his brother's cheeks the shadows and beams of light from the spectacles, and the handsome youth's eyes look directly at the viewer over the metal rims. Contrary to the standards of the twentieth century, the pragmatic, science-oriented Peale family would have found it dishonest *not* to be portrayed in spectacles if indeed one wore them constantly. A similar mixture of directness, curiosity, and respect for the truth no doubt inspired Rembrandt Peale to paint the geranium (according to family tradition, the first grown in America) as accurately as his brother's features. He allows each "subject" one-half of the canvas and paints both with unidealizing love and attention.

Rubens Peale with a Geranium can be constructively compared with Copley's *Boy with a Squirrel* (cat.no.1). Both exert a similar impact as highly detailed realistic pictures. But whereas the Copley celebrates poetic mood and sensuous paint textures and colors, the Peale seems plain, simple, and very direct. The Copley is ultimately rococo, and the sobriety of the Peale is neoclassical. Peale handles his paint more straightforwardly than Copley, with fewer elegant touches of impasto and no subtle glazing effects. Of course *Rubens Peale with a Geranium* has its own visual beauty:

a palette of earthy browns, reds, and quiet green foliage; and a compositional tension between the youth and the plant in which the white V-shape of the shirt and cravat is a strong visual element.

Pictorially the geranium is as important as Rubens Peale, and it is significant that the plant is not treated as a mere attribute in the eighteenth-century manner.[1] However, the compositional importance bestowed on the plant did not institute a new trend; it is unique in early American portraiture. The most useful context in which to consider the work is the special type of relaxed Peale family picture, where the normal conventions of portraiture did not need to be followed. Rembrandt's father, Charles, built this tradition with his cheerful and witty *Family Group* (1773; New-York Historical Society) and his 1795 *Staircase Group* (cat.no.10). Thus although the geranium symbolizes and documents the intellectual and scientific endeavors of the Peales, it also gives the portrait the unexpected note of informality that elevates it to that small group of the family's most innovative works.[2]

T.J.F.

NOTES

1. In *Painters of the Humble Truth: Masterpieces of American Still Life, 1801–1939* (Columbia, Mo., 1981), p. 63, William H. Gerdts draws a comparison with the portrait of the eighteenth-century scientist John Bartram (attributed to John Wollaston, c. 1758; National Portrait Gallery, Smithsonian Institution, Washington, D.C.): Bartram points to one of the pears he grew in Philadelphia from English seeds. This symbolic specimen of fruit is placed in the bottom left corner of the composition, whereas Rubens Peale's geranium could not be more prominent. As Gerdts points out, Rembrandt Peale has empathetically endowed the plant with something of the tenderness he feels for the subject of the portrait.

2. Later works of this sort include Charles Willson Peale's *Raphaelle Peale* (c. 1817–18; Private Collection), in which the artist's son poses with his palette and easel before one of his still-life paintings of apples, and his *James Peale* (1822; Detroit Institute of Arts), in which the artist's brother is examining by lamplight a portrait miniature he has painted.

PROVENANCE

Mrs. Sabin W. Colton, Jr., Bryn Mawr, Pa., 1923; Mrs. Robert P. Esty, Ardmore, Pa.; Lawrence A. Fleischman, Detroit; to present owner.

EXHIBITION HISTORY

Pennsylvania Academy of the Fine Arts, Philadelphia, *Exhibition of Portraits by Charles Willson Peale, James Peale and Rembrandt Peale*, 1923, cat.no.73.

Pennsylvania State University, University Park, *Pennsylvania Painters*, 1955, cat.no.11.

Metropolitan Museum of Art, New York, *American Art from American Collections*, cat. by James Biddle, 1963, no. 185.

The Peale Museum, *The Peale Family and Peale's Baltimore Museum, 1814–1830*, cat. by Wilbur Harvey Hunter, 1965, no. 16.

The Detroit Institute of Arts, and Munson-Williams-Proctor Institute, Utica, N.Y., *The Peale Family: Three Generations of American Artists*, 1967, cat.no.139 (ill.).

Metropolitan Museum of Art, New York, *19th-Century America: Paintings and Sculpture*, cat. by John K. Howat and Natalie Spassky, 1970, no. 2 (ill.).

Coe Kerr Gallery, New York, *The American Painting Collection of Mrs. Norman B. Woolworth*, cat. by William H. Gerdts, 1970, no. 87 (ill.).

Philbrook Art Center, Tulsa, Okla., *Painters of the Humble Truth: Masterpieces of American Still Life 1801–1939*, cat. by Gerdts, 1981 (traveling exhibition) (ill.).

RAPHAELLE PEALE

(1774, Annapolis, Maryland
—1825, Philadelphia)

Raphaelle, the oldest surviving son of Charles Willson Peale, had the least conventional yet most intriguing career of all the Peale family artists. His early involvements with the family museum included a 1792 trip to South America to collect specimens. Raphaelle and his brother Rembrandt (q.v.) traveled to Charleston and Baltimore together painting portraits (1795–97) and also worked in Philadelphia. Raphaelle focused on miniatures in the late 1790s, while Rembrandt continued with life-sized canvases. In the early 1800s Raphaelle concentrated on silhouettes traced with a recently invented copying device called the physiognotrace. Professionally he was outstripped by his younger brother Rembrandt, who prepared to succeed their father as head of the family's artistic empire. Furthermore, Raphaelle made an unfortunate marriage against his father's advice. By 1809 he was being treated for alcoholism, and often suffered from severe attacks of gout; his livelihood as a portraitist may have been jeopardized by these illnesses.

In Philadelphia in the 1810s, Raphaelle devoted his attention to small still lifes, which he exhibited at the newly instituted annual exhibitions of the Pennsylvania Academy of the Fine Arts, winning popular and critical acclaim. These works of subtlety and fineness form a marked contrast with his sad, dissipated life (he died impoverished in 1825). It bothered his father that he did not apply "such talents of exact imitation" to making a successful career out of portraiture. Nonetheless, Raphaelle has come to be regarded as the most important Peale of his generation, largely because he was the country's first professional still-life artist and thus the founder of the American, and in particular the Philadelphian, tradition of still-life painting.

The only study of this artist is the short exhibition catalogue Raphaelle Peale, 1774–1825: Still Lifes and Portraits, *with an essay by Charles Coleman Sellers (Milwaukee Art Center and M. Knoedler & Co., New York, 1959). More information can be found in the extensive Peale family literature centered on Charles Willson Peale (q.v.), particularly* The Peale Family: Three Generations of American Artists (Detroit Institute of Arts and the Munson-Williams-Proctor Institute, Utica, N.Y., 1967).

12

RAPHAELLE PEALE
A Dessert, 1814
Painted in Philadelphia
Signed and dated lower right: *Raphaelle Peale*
 Aug.ᵗ 5th 1814 / Philadᵃ
Oil on wood, 13⅜ × 19 in. (34 × 48.3 cm.)
Jo Ann and Julian Ganz, Jr.

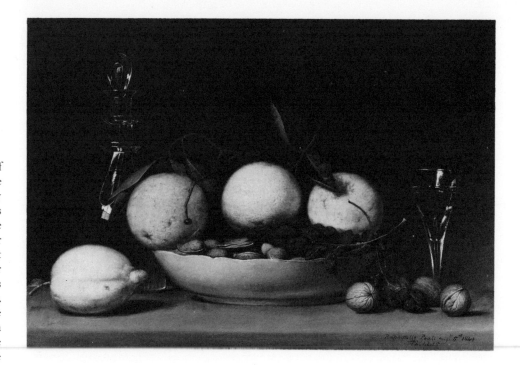

Raphaelle Peale exhibited a diverse group of eight still-life and trompe l'oeil pictures at the State House in Philadelphia as part of the 1795 Columbianum exhibition organized by his father.[1] He also showed five portraits, and the catalogue referred to him as a portrait painter at the Peale Museum. Apparently he did not establish his profession as a still-life painter until the 1810s, and all of his surviving works in this genre date from the period 1812 to 1824 when he exhibited many still lifes at the annual exhibitions of the Pennsylvania Academy of the Fine Arts. *A Dessert* cannot be positively identified as one of the works he exhibited in Philadelphia, although its subject matter is typical, as the following sampling of titles from the exhibition catalogues suggests: *Fruit Piece* (1813), *Lemons* (1814), *Still Life—Wine and Cake* (1817), *Still Life—Orange, Apple, Prunes, Etc.* (1819), *Still Life—Lemons, Flowers, Etc.* (*China sugar bowl*) (1823).

A Dessert presents a lemon, oranges, almonds, walnuts, and two products of the vine: raisins and wine. The fruits and nuts—greater delicacies in Peale's day than in ours—are casually grouped in a pleasing mound that gives a sense of abundance. Two elegant pieces of glass stand behind this inviting array, a decanter at the left and a wine glass at the right, each containing a sweet wine (probably sherry or madeira). Both vessels are almost full, adding to the sense of a bountiful feast for the appetite and the eyes. There are various plays of spherical forms and curved surfaces: the outward swell of the soft-paste china dish, the contrasting inward curve of the walnuts in the lower right, and the curves of the decanter and glass (gleaming silhouettes against the rich dark-brown setting). Even the stems holding the raisins make an elegant visual dialogue of curve and reverse-curve. Peale gives a remarkable sense of surface textures as well as the differently reflective qualities of glass, ceramic glaze, and waxy orange rind.

Like all great still-life painters, Raphaelle Peale imbues the objects he paints with a striking and transcendent physical presence. They are grouped in relationships that cause the viewer to pause and reflect, and presented in soft but direct light that is quite different from the muted, pearly atmosphere in the eighteenth-century European tradition of Chardin. Peale's light searches out and scrutinizes the outlines and sharpest highlights on all that he paints. The contrast of the objects with the dark background emphasizes intimacy and nearness and heightens the sense of momentary beauty. By suggesting the short natural life of fruits and foodstuffs, Peale hints at man's brief life; but first and foremost he creates delectations for the eye.

Peale's still-life arrangements are usually more closely grouped at the center of the canvas; *A Dessert* is thus unusual in its horizontal attenuation. The foodstuffs form an elegant serpentine which appears to be stretched out by the pieces of glass at either end. This composition has recently been linked to American neoclassicism, particularly in architecture: visual simplicity, classical harmonies of pure forms, and intellectual sobriety are indeed the hallmarks of Peale's best still lifes.[2]

T.J.F.

NOTES

1. The eight pictures were: 76. *A Shad*; 77. *Herrings*; 78. *Small Fish*; 79. *A Covered Painting*; 80. *Still Life*; 81. *Still Life*; 82. *A Bill*; 83. *A Deception*.

2. See John Wilmerding, "The American Object: Still-Life Paintings," in Wilmerding et al., *An American Perspective: Nineteenth-Century Art from the Collection of Jo Ann and Julian Ganz, Jr.* (National Gallery of Art, Washington, D.C., 1981), pp. 88–90.

PROVENANCE

James Fullerton, Boston, by 1828; Oswald J. Arnold, Chicago and Minneapolis; Charlotte Arnold, Minneapolis; Charlotte Arnold's descendents, San Diego, Calif.; to present owners through Terry DeLapp, Los Angeles.

EXHIBITION HISTORY

Boston Athenaeum, *Annual Exhibition*, 1828, cat. no. 151.

National Gallery of Art, Washington, D.C., *An American Perspective: Nineteenth-Century Art from the Collection of Jo Ann and Julian Ganz, Jr.*, cat. by John Wilmerding et al., 1981 (traveling exhibition) (ill.).

13

RAPHAELLE PEALE
*Venus Rising from the Sea—A Deception
[After the Bath]*, 1823
Painted in Philadelphia
Signed and dated lower right: *Raphaelle Peale
1823 / Pinxt*
Oil on canvas, 29 × 24 in. (73.7 × 61 cm.)
William Rockhill Nelson Gallery of Art and
Atkins Museum of Fine Arts, Kansas City,
Missouri, Nelson Fund

This striking study of white tones dramatically contrasted against a dark background has a stark grandeur and excellence unique in Peale's oeuvre. Its meticulous realism readily brings to mind similarly impressive details in Old Master paintings, particularly Dutch still lifes. Besides the peerless technical qualities, there is a delightful visual pun involved: it is a painting of a painting largely covered over by a cloth, suspended from a woven tape by two silvery pins. The artist must have been aware of the European domestic practice of covering paintings in a similar way, and perhaps knew the minor tradition in Dutch trompe l'oeil art of including part of such a cover or curtain in one corner of the painted image.[1] The viewer readily infers that Peale's hidden painting is of a female nude from the reference to Venus in the title as well as the bare foot and arm that the cloth suggestively fails to hide. A work by the English neoclassical artist James Barry entitled *Venus Rising from the Sea* (1772; Municipal Gallery of Modern Art, Dublin; reproduced in two English engravings, 1772 and 1778) was the source for Peale's nude: in Barry's original composition, the goddess is shown completely nude, but the most memorable affectation of the work is her shiny tresses held so gracefully above her head. Any contemporary art connoisseur would have recognized this detail in Peale's trompe l'oeil.[2]

"Deceptions" are rare in Raphaelle Peale's oeuvre: a few pictures listed in contemporary exhibition catalogues (but now missing) were certainly of this type, and an 1802 trompe l'oeil watercolor of a card rack has survived.[3] The philosophic humor of *Venus* lies in the fact that man is by nature curious and will always be fascinated by the desire to remove the cloth. A more specific joke may also have been intended, concerning taste and art patronage in Philadelphia. Remembering when Adolph Ulric Wertmüller exhibited his libidinous nude *Danäe* (1787; Nationalmuseum, Stockholm) in Philadelphia, Raphaelle's brother Rembrandt wrote: "[It] was admired by the few persons in Philadelphia that *talked* about painting; but nobody thought of purchasing it, partly repelled by the subject, which was abhorrent to their Quaker sentiments, and by the high price put upon it, as his masterpiece."[4] Raphaelle's *Venus* seems to comment ironically that the best nude for Philadelphia is a covered one; but the message is delivered cheerfully, and the work succeeds in being slightly titillating while pretending to be chaste.

Since its rediscovery in 1931, this picture has been appealingly but inaccurately known as *After the Bath*, a title created by New York dealer Edith Halpert. It quickly became one of the most celebrated American paintings, as its extensive exhibition history suggests. The detailed finish and sharp lighting must have registered strongly with the hard-edged modern painting style of the early 1930s (as practiced by Charles Sheeler, for example). Furthermore, the invented title brought it popular appeal as an early spoof on American prudery.[5] However, the title *After the Bath* implied that the image was a bather hiding behind a bath towel, when in fact the painting is a life-sized illusion of a cloth or napkin hung by small straight pins in front of a painting of Venus. Regardless of the subject, twentieth-century sensibility appreciates the quasi-photographic rendition of the cloth, as well as the abstract compositional sense of its curves, creases, and shadows. In fact, Peale's intentions were analogous to photography and abstract art in the desire to craft the perfect illusion and create a graceful design.

T.J.F.

NOTES

1. See, e.g., Emanuel de Witte's 1653 *Interior of the Nieuwe Kerk in Delft with the Tomb of William the Silent* (Coll. Mr. and Mrs. Edward Carter, Los Angeles).
In several reviews of Philadelphia exhibitions in the 1810s the small, highly finished works of the Dutch and Flemish schools were suggested as models for artists seeking the patronage of the growing American merchant and affluent classes.

2. The connection between cat. no. 13 and a painting of the same title which Peale exhibited and offered for sale at the Pennsylvania Academy in 1822 has been conclusively demonstrated by Dorinda Evans, particularly in her recent essay "Raphaelle Peale's *Venus Rising from the Sea*: Further Support for a Change in Interpretation," *The American Art Journal* 14 (Summer 1982): 62–72. Since the work is dated 1823 (Evans questions the legibility), it is not likely to be the 1822 picture exhibited in Philadelphia, and probably purchased by William Gilmor (Evans, pp. 69–72). The issue of originals and replicas is unresolved, but the subject is unquestionably a "deception" involving Barry's *Venus*.

3. Three works exhibited at the 1795 *Columbianum* exhibition (see cat. no. 12, note 1) are relevant: *A Covered Painting*, *A Deception*, and *A Bill* (which was probably a trompe l'oeil of a paper document or currency). The watercolor, *A Deception* (1802; Private Collection) is illustrated in Evans, "Peale's *Venus*," fig. 7.

4. Rembrandt Peale, "Reminiscences. Adolph Ulric Wertmüller," *The Crayon* 2 (October 1855): 207.

5. The Peale family tradition, first reported in print in 1947, is that the artist made the work to tease his shrewish wife; supposedly, when she first saw it she imagined that Raphaelle, having painted a sensuous female nude, had tried to hide it from her by pinning a napkin in front of it, and she was thus ridiculed when she found that the napkin could not be removed. Evans, "Peale's *Venus*," p. 65, cautions that this tale could have been embroidered over the years.

PROVENANCE
Unidentified Connecticut collection; William A. Gough, Bridgeport, Conn., 1931; with Edith Halpert, The Downtown Gallery, New York, 1931; William Rockhill Nelson Trust, Kansas City, 1933; to present owner, 1934.

EXHIBITION HISTORY
Downtown Gallery, New York, *American Ancestors*, 1931.
Wadsworth Atheneum, Hartford, Conn., *Three Centuries of American Painting and Sculpture*, 1935, cat. no. 29.
Smith College, Northampton, Mass., 1936.
Wadsworth Atheneum, Hartford, Conn., *The Painters of Still Life*, 1938, cat. no. 86.
Musée du Jeu de Paume, Paris, *Trois siècles d'art aux États-Unis*, cat. by Alfred H. Barr, Jr., 1938, no. 130 (ill.).
Carnegie Institute, Pittsburgh, *Survey of American Painting*, 1940, cat. no. 67.
Santa Barbara Museum of Art, Calif., *Painting Today and Yesterday in the U.S.*, 1941, cat. no. 91 (ill.).

Museum of Modern Art, New York, *Realism and Magic: Realism in American Painting*, 1943.

Downtown Gallery, New York, *Opening Exhibition of New Gallery*, 1946.

Denver Art Museum, *American Heritage*, 1948, cat. no. 19.

Saginaw Museum, Mich., *An Exhibition of American Painting from Colonial Times until Today*, 1948, cat. no. 44.

Wildenstein & Co., New York, *Landmarks in American Art*, cat. by John I. H. Baur, 1953, no. 11.

Cincinnati Art Museum, *Paintings by the Peale Family*, 1954, cat. no. 63.

Pennsylvania State University, University Park, *Centennial Exhibition: Pennsylvania Painters*, 1955, cat. no. 10.

Detroit Institute of Arts, *Painting in America: The Story of 450 Years*, cat. by Edgar P. Richardson, 1957 (traveling exhibition), no. 60.

American Federation of Arts, New York, *The American Vision*, 1957.

Atlanta Art Association Galleries, *Still Life Paintings from the XVI Century to the Present*, 1958.

Dallas Museum of Fine Arts, *50th Anniversary Exhibition*, 1958.

Milwaukee Art Center, *Raphaelle Peale*, cat. by Charles Coleman Sellers, 1959 (traveling exhibition), no. 10 (ill.).

Corcoran Gallery of Art, Washington D.C., *The American Muse*, 1959, cat. no. 2.

City Art Museum, St. Louis, *200 Years of American Paintings*, 1964.

Corcoran Gallery of Art, Washington D.C., *Past and Present*, 1966.

Whitney Museum of American Art, New York, *Art of the United States 1670–1966*, cat. by Lloyd Goodrich, 1966, no. 213.

Detroit Institute of Arts, *The Peale Family: Three Generations of American Artists*, cat. by Edward H. Dwight et al., 1967 (traveling exhibition), no. 124 (ill.).

University of North Carolina, Chapel Hill, *The Age of Dunlap: The Arts of the Young Republic*, cat. by Harold Dickson, 1968.

Metropolitan Museum of Art, New York, *19th-Century America: Painting and Sculpture*, cat. by John K. Howat and Natalie Spassky, 1970, no. 23 (ill.).

Philadelphia Museum of Art, *Philadelphia: Three Centuries of American Art*, cat. by Darrel Sewell et al., 1976, no. 214 (ill.).

Nelson Gallery-Atkins Museum, Kansas City, Mo., *Kaleidoscope of American Painting, 18th and 19th Centuries*, 1978, cat. no. 80 (ill.).

Philbrook Art Center, Tulsa, Okla., *Painters of the Humble Truth: Masterpieces of American Still Life 1801–1939*, cat. by William H. Gerdts, 1981 (traveling exhibition) (ill.).

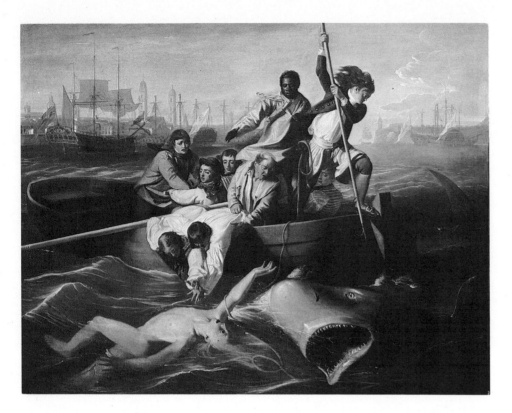

14

JOHN SINGLETON COPLEY
Watson and the Shark, 1778
Painted in London
Signed and dated inside the boat:
 J. S. Copley P. 1778.
Oil on canvas, $72 \times 90\frac{1}{4}$ in. (182.9×229.2 cm.)
Museum of Fine Arts, Boston, Gift of Mrs.
 George von Lengerke Meyer

This heroic representation of a shark's assault on a swimmer was Copley's first "history painting" in the grand manner, and it marks a dramatic change in his style, brought about by a tour of Europe in 1774–75 and his subsequent decision to settle in London. There he became primarily a history painter, and portraiture assumed a lesser role. *Watson and the Shark* called for a broad range of human emotional expressions, an ability to paint a nude figure partially submerged in water, and the power to suggest the sultry atmosphere of Havannah. Copley responded to these new challenges with great confidence, and maintained his overall sense of close realistic detailing while loosening his brushwork for such passages as the rushing currents of water and the heavy folds of some of the clothing.

When first exhibited in 1778 at the Royal Academy, London, the following explanatory title was used: *A boy attacked by a shark, and rescued by some seamen in a boat; founded on a fact which happened in the harbour of the Havannah.* In the tradition of Renaissance and Baroque painters of religious and mythological

narrative, Copley chose to paint the moment of greatest imminence, namely the climax of the shark's attack. Having already lost a foot and some flesh from the calf, the agonized youth is transfixed in the face of death; a rope has been thrown but not grasped; a sailor is about to stab at the lunging monster with a boathook; terrified oarsmen work to get the boat alongside the victim. Only the original title confirmed that the rescue was successful, although the boy lost one leg. The Englishman Brook Watson (1735–1807) was the victim of this shark attack, which occurred in Havannah in 1749; when Copley completed his painting in 1778, Watson was a merchant residing in London, with transatlantic connections. It is unclear when and where Watson and Copley became acquainted, and there is no contemporary evidence to support the later assumption that Watson commissioned the picture.

Watson and the Shark was the first important picture in which Copley displayed his scholarly appreciation for the portrayal of sublime events in painting.[1] Recent writers have observed his reference to Raphael's *Miraculous Draught of Fishes* (1515; H.M. Queen Elizabeth II, on loan to the Victoria and Albert Museum, London).[2] It might be added that the windswept profile of the warriorlike sailor standing at the right is particularly Raphaelesque. There is also a debt to Rubens in the overall visual turbulence and the diagonally articulated dynamism of the grouped figures.[3] A variety of visual

precedents has been proposed for the naked figure of the swimmer: the most intriguing and insightful is the deranged child in Raphael's *Transfiguration* (1518–20; Vatican City); the other suggestions are two famous antique sculptures, *Borghese Gladiator* (Musée du Louvre, Paris) and the *Laocoön* (Vatican City), the drowning man in the left foreground of Titian's woodcut *Submersion of Pharoah's Army in the Red Sea*, and the figure of Liberty (as a dying Indian brave) in a 1765 political cartoon attributed to Copley.[4] Thus recent scholarship demonstrates that *Watson and the Shark* embodies the English theoretical approach to history painting as expounded by Joshua Reynolds and practiced by Benjamin West (q.v.).

The picture has an aura of New World associations of which Copley must have been conscious in seeking attention as a new American artist working in London. The event had transpired in Central America, and he presented it with an uninhibited directness and in engaging proportions that distinguish it from the English artistic mainstream.[5] In a pencil study of the rescue group (Detroit Institute of Arts), the figure throwing the rope is a white man with long hair, yet for the painting Copley adopted the magnificent head of a black man, which in the context significantly enhanced the exotic American flavor.

There are two virtually identical versions of *Watson and the Shark*, both signed and dated 1778 (the other is at the National Gallery of Art, Washington, D.C.). It is not certain which was exhibited at the Royal Academy in London in 1778; nonetheless, the picture drew excited reactions from the English critics and established Copley's reputation as an important modern history painter.[6]

T.J.F.

NOTES

1. The first "sublime" picture was *The Ascension* (Museum of Fine Arts, Boston), a small work painted in Rome in 1775. Copley admitted that his inspiration came directly from Raphael, and he hoped in vain that this canvas would attract a commission from a church to paint the scene life-sized for an altarpiece: see *Copley-Pelham Letters*, pp. 300–301.

2. See Roger B. Stein, "Copley's *Watson and the Shark* and Aesthetics in the 1770s," *Discoveries and Considerations: Essays on Early American Literature and Aesthetics Presented to Harold Jantz* (Albany, 1976), pp. 85–129, and Irma B. Jaffe, "John Singleton Copley's *Watson and the Shark*," *American Art Journal* 9 (May 1977): 15–25.

3. See Jules D. Prown, *John Singleton Copley*, 2 vols. (Cambridge, Mass., 1966), 2:273, where the relationship with Rubens's images of lion hunts is stressed.

4. On Raphael's *Transfiguration*, see Stein, "Copley's *Watson*," pp. 110–11; on the *Gladiator*, see Prown, *Copley*, 2:273; on the *Laocoön*, see Jaffe, "Copley's *Watson*," p. 19; on Titian, see Martin Kemp, Letter to the *Art Bulletin* 62 (December 1980): 647; on Liberty in the cartoon *The Deplorable State of America*, see Ann Uhry Adams, "Politics, Prints, and John Singleton Copley's *Watson and the Shark*," *Art Bulletin* 61 (June 1979): 270–71.

5. John McCoubrey has noted that the later vertical version of *Watson and the Shark* (1782; Detroit Institute of Arts) has a more unified composition that brings it closer to the English mainstream: see *The American Tradition in Painting* (New York, 1963), pp. 19–20.

6. Watson's name is not mentioned at all in the catalogue to the 1778 Royal Academy exhibition. In 1779 Valentine Green produced a mezzotint engraving said in the inscription beneath the image to be taken from the painting owned by Watson. However, comparing specific details (including strong highlights) shows that the mezzotint reproduces the canvas kept by Copley (i.e., cat. no. 14). If one accepts that Copley would have had the superior (probably original) version reproduced in mezzotint, it might be expected that he would have sent the same version to the Royal Academy. Thus it should no longer be assumed that the Washington picture is the original because it was purchased by Watson. In fact it seems just as likely that the idea for this important exhibition piece came from Copley and that Watson received the replica.

PROVENANCE

The artist; his son, Lord Lyndhurst; gift of Lyndhurst "to a near relative [unidentified] in Boston" (according to Martha Babcock Amory, the artist's granddaughter, in *The Domestic and Artistic Life of John Singleton Copley, R.A.* [Boston, 1882], p. 74); Charles Hook Appleton (by 1873); his daughter, Mrs. George von Lengerke Meyer; to present owner, 1889.

EXHIBITION HISTORY

Possibly at the Royal Academy, London, *Tenth Exhibition*, 1778, cat. no. 65.
Possibly British Institution, London, 1807, cat. no. 110.
Museum of Fine Arts, Boston, *John Singleton Copley*, 1938, cat. no. 80.
Carnegie Institute, Pittsburgh, *Survey of American Painting*, 1940, cat. no. 51.
Museum of Modern Art, New York, *Romantic Painting in America*, cat. by James Thrall Soby and Dorothy C. Miller, 1943, no. 57 (ill.).
Jewett Arts Center, Wellesley College, Mass., *Four Boston Masters*, cat. by John McAndrew et al., 1959, no. 16 (ill.).
National Gallery of Art, Washington, D.C., *John Singleton Copley*, cat. by Jules D. Prown, 1965–66 (traveling exhibition), no. 68b (ill.).

JOHN TRUMBULL

(1756, Lebanon, Connecticut
—1843, New York City)

John Trumbull is best remembered for his depictions of the Revolutionary War. Now virtual icons of American nationalism, they are also emblematic of his lifelong political and artistic identity. Born into a well-to-do and politically prominent Connecticut family, Trumbull was raised to pursue one of the learned professions. He consequently took up Latin and Greek in school, and attended Harvard College, graduating in 1773. The outbreak of the Revolution roused him to enlist in the Continental Army. Before he resigned in 1777, he had attained the rank of colonel and served as Washington's aide-de-camp.

Since leaving college, Trumbull had occasionally painted portraits of family members and scenes from ancient history. In 1780 he decided to study painting formally and so went to London to become a pupil of Benjamin West's (q.v.). Trumbull thus became the first professional American artist to have had a college education, and he readily became an advocate of painting's noble and intellectual aspects. His arrest and deportation for treason interrupted his art education, but after the war he was in London again; between 1784 and 1789 he studied at the Royal Academy, then in Paris, and painted his first major works. His ambition to create a heroic record of key events in the American Revolution took him back to the States with preparatory studies in anticipation of a major governmental commission.

From 1794 to 1804, Trumbull worked in England in a diplomatic capacity. He subsequently settled in New York City, was elected a director of its new American Academy of Fine Arts, served as its president from 1816 to 1835, and generally assumed the position of the city's ranking artist.

Trumbull painted religious and allegorical subjects, as well as portraits and landscapes, but he considered his crowning achievement to have been the 1817 commission that placed five of his history paintings in the rotunda of the U.S. Capitol. In 1831 he sold most of the works he possessed to Yale College, which established a gallery for them there. The sale did not prevent him from serious financial worries in the last decades of his life, however. Irritated by the lack of appreciation for his artistic contributions, the elderly painter took a frosty attitude toward younger artists, which kept him from stepping into the mentor's role he so greatly desired.

The basic sources of information on Trumbull's art are: The Autobiography of Colonel John Trumbull, *edited by Theodore Sizer (New Haven, Conn., 1953); a checklist, also by Sizer,* The Works of Colonel John Trumbull, Artist of the American Revolution *(New Haven, Conn., 1967); a monograph by Irma Jaffe (Boston, 1975); and the catalogue of a major retrospective, edited by Helen A. Cooper,* John Trumbull: The Hand and Spirit of a Painter *(Yale University Art Gallery, New Haven, Conn., 1982).*

15

JOHN TRUMBULL
The Sortie Made by the Garrison of Gibraltar, 1788
Painted in London
Oil on canvas, 20 × 30 in. (50.8 × 76.2 cm.)
Cincinnati Art Museum, Ohio, John J. Emery Endowment

When Trumbull worked in Benjamin West's studio, he was particularly inspired by West's paintings of contemporary historical events, and he made oil sketches for several of his own compositions to show that he too could be an innovator in this category of history painting. He began his *Sortie Made by the Garrison of Gibraltar* in 1787, with the intention of establishing his reputation in London as a history painter.

The subject, suggested to him by a publisher of engravings, was the successful attack against the Spanish made in November 1781 by British troops stationed at Gibraltar.[1] The British sortie there had recently been used as a theme for paintings by other artists in England, most notably John Singleton Copley in 1782 and Sir Joshua Reynolds in 1787. The theme appealed to Trumbull because it offered pathos as well as the requisite measure of heroism and nobility. It was the final episode of the battle that intrigued the artist and his publisher: the Spanish abandoned the fortress, with the exception of their commander, who then made a last charge, alone, against the oncoming British troops. Wounded, the vanquished Spaniard died refusing the help of the British officers who approached him. This warrior's insistence upon a noble death created, to Trumbull's mind, "a scene of deep interest to the feelings," especially in contrast to "the darkness of night, with the illumination of an extensive conflagration, great splendor of effect and color."[2]

In 1787 the artist made a small, quickly painted oil sketch of the subject (Corcoran Gallery of Art, Washington, D.C.). This second oil sketch, painted in the following year, is slightly larger and more highly finished. Trumbull improved the accuracy of the uniforms, created a clearer distinction between the British officers and the dying Spaniard, and made the picture's overall appearance calmer. He further developed the theme of the painting by modeling the pose of the dying Spaniard on a celebrated antique statue, *The Dying Gladiator*.

Trumbull declined a generous offer to sell this sketch, preferring to adapt it to a monumental format. He completed his large canvas (Metropolitan Museum of Art, New York) in 1789 and placed it on public exhibition. The artist correctly anticipated its appeal to British patriotism.[3] Yet the same

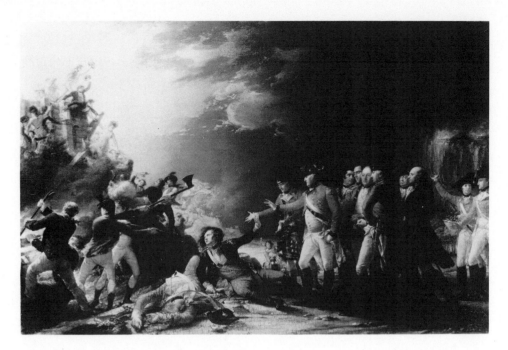

work was equally popular in the United States, where it was purchased in 1828 by the Boston Athenaeum and frequently exhibited there.

The model that inspired Trumbull's composition was West's *Death of General Wolfe* (1770; National Gallery of Canada, Ottawa), in which soldiers in accurate, contemporary dress still appear as ideal, timeless heroes. Trumbull's innovation on West's formula was to use atmospheric effects to intensify the emotional impact of the scene. In this painting, the foreground swells up where the dying Spaniard sprawls. The background dips precipitously at the same place, so that the fallen officer's body is silhouetted against the horizon. Dark clouds to the right and rocket flames to the left help separate the bystanders from the officer so that he dies uncompromisingly alone.

One can also see here Trumbull's inclination to compose figures in serpentine curves, and his predilection for reflected light and softened contours. These were essentially pictorial innovations of rococo art, which in some quarters—Paris, for example—was rapidly becoming outmoded. Although Trumbull was well aware of the newer neoclassical standards, he chose to build his history paintings around the older, more optical style, and continued to do so through the 1790s.

<div align="right">D.S.</div>

NOTES

1. See Helen A. Cooper, ed., *John Trumbull: The Hand and Spirit of a Painter* (Yale University Art Gallery, New Haven, Conn., 1982), pp. 56–62.
2. Quoted in *The Autobiography of Colonel John Trumbull*, ed. Theodore Sizer, rpt. ed. (New York, 1970), p. 148.
3. See letter of Trumbull to his brother, 27 February 1789, quoted in *Autobiography of Trumbull*, p. 149n.

PROVENANCE
Sold by the artist to Sir Francis Baring, London 1803 or 1804; Lady Ashburton, London; Mr. McPherson, Rome; John A. Burnham, Boston; Frank Bulkey Smith; with M. Knoedler & Co., New York; to present owner, 1922.

EXHIBITION HISTORY
American Academy of Fine Arts, New York, *Annual Exhibition*, 1828, cat. no. 45.
Apollo Association, New York, *Annual Exhibition*, 1841, cat. no. 65.
Detroit Institute of Arts, *Painting in America: The Story of 450 Years*, cat. by Edgar P. Richardson, 1956, no. 38.
Whitney Museum of American Art, New York, *Art of the United States 1670–1966*, cat. by Lloyd Goodrich, 1966, no. 278.
Yale University Art Gallery, New Haven, Conn., *John Trumbull: The Hand and Spirit of a Painter*, cat. ed. Helen A. Cooper, 1982, no. 11.

BENJAMIN WEST

(1738, Springfield, Pennsylvania —1820, London)

Benjamin West was one of the most cosmopolitan of American artists and the first native American to have gained an international artistic reputation. Yet a long-held national myth—exemplified in William Dunlap's Rise and Progress of the Arts of Design in the United States *of 1834—cast him as a self-trained genius who spent his boyhood among Indians and whose native ingenuity was his most valuable artistic asset. West's beginnings were indeed provincial. Born an innkeeper's son in the farming community of Chester County, Pennsylvania, he produced his first paintings at age fourteen and was working professionally by age eighteen. He received instruction books and some advice from William Williams (1727–1791), a mariner and painter in Philadelphia, but was also encouraged to get formal training.*

When a Philadelphia merchant provided him with funds to travel in 1759, West became the first American-born artist to study abroad. He spent three years in Rome studying ancient and modern art in order to become a history painter. Then in 1763 he settled in London, soon earned a reputation for heroic paintings in ancient settings, quickly attracted students, and became a founding member of the Royal Academy of Arts. In 1771 West's sensational Death of General Wolfe (*National Gallery of Canada, Ottawa*) *established a new genre, the contemporary history painting, and in 1772 the artist was appointed history painter to King George III. In 1792 he was elected to succeed Sir Joshua Reynolds as president of the Royal Academy.*

Although West never returned to America, he played a major role in the development of American art. His London studio became, in effect, the first "school" for American painters, a number of whom traveled to London in order to work with him, and he generously helped further the careers of his numerous protégés. Also influential was the example that West set as a history painter. He and his work remained the noble model for American artists to the middle of the nineteenth century.

John Galt and William Dunlap wrote the chief contemporary accounts of the artist's life and work. The most recent biography is Robert C. Alberts's Benjamin West (*Boston, 1978*), *and the most recent monograph on his art is John Dillenberger's* Benjamin West: The Context of His Life's Work with Particular Attention to Paintings with Religious Subject Matter (*San Antonio, Tex., 1977*).

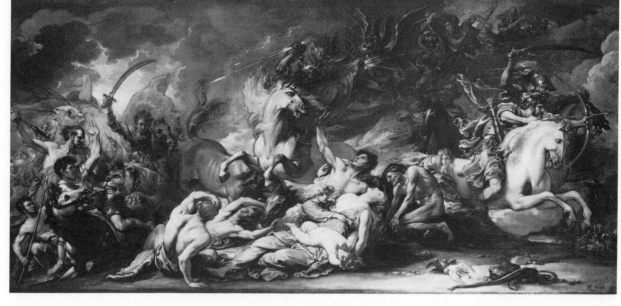

16

Benjamin West
Death on the Pale Horse, 1796
Painted in London
Signed and dated lower right: *B. West. 1796*
Oil on canvas, $23\frac{1}{2} \times 50\frac{1}{2}$ in. (59.7 × 128.3 cm.)
The Detroit Institute of Arts,
 Founders Society Purchase,
 Robert H. Tannahill Foundation Fund

The sublime biblical composition became a characteristic of British history painting in the last two decades of the eighteenth century and the first two decades of the nineteenth; its high priest was Benjamin West. By bringing divine power and mystery to history painting, he offered viewers an emotional experience that classical subjects could not provide.

The embodiment of West's ambitions for biblical painting was *Death on the Pale Horse*. He began planning the work in 1783; it was initially conceived as part of a cycle for George III's Chapel of Revealed Religion at Windsor Castle but was eventually withdrawn from that project. However, West remained interested in the composition: he kept the drawings for it and in 1796 produced this large oil sketch.[1] It in turn became the basis for an enormous final version (Pennsylvania Academy of the Fine Arts, Philadelphia) which was completed in 1817 and exhibited in its own gallery in London. It also toured the United States during the 1830s and became one of the most highly acclaimed paintings of its time.

West's students from 1796 onward had the opportunity to see his project; they had great admiration for it and took its sublime power as their personal artistic goal.[2] Typical were the comments of his pupil Washington Allston (q.v.): "No fancy could have better conceived and no pencil more happily embodied the visions of sublimity than he has in his inimitable picture from Revelation," Allston said. "A more sublime and awful picture I never beheld . . . and I am certain no painter has exceeded Mr. West in the fury, horror and despair which he has represented."[3] In 1802 West exhibited his canvas at the Paris Salon. It immediately attracted the attention of the French, who were unaccustomed to such violence, active brushwork, and turbulent colors in a contemporary work.

West's subject depicted Saint John's symbolic vision of the end of the world as related at the beginning of the sixth chapter of the Book of Revelation, one of the most mysterious and violent episodes in the Bible. In a graphic and literal manner, West showed the horseman Death emerging from Hell, trampling his victims, while others starve and still others are attacked by lions and mounted soldiers. West treated his subject in a way that invited association with works of the Old Masters: the tumult of men and beasts relates to the work of Rubens, and the stormy night setting recalls Michelangelo's *Last Judgment*, for example.

But West also drew upon newer aesthetic ideas to give power to his painting. His major acknowledgment of current thought appears in his application of Edmund Burke's notion of the sublime. Burke, who wrote his influential *Philosophical Enquiry into the Origin of Our Ideas of the Sublime and Beautiful* in 1756, held that the most profound human emotions arise from terror, darkness, obscurity, vastness, and confrontation with the supernatural. All these requirements for sublimity can be found in West's picture.[4]

Even though he rejected the clear forms and restraint of the classical tradition, West made emphatic references to classical antiquity in the composition. His human characters recall the heroic nudes of antique art; so do the sharply incised profiles West used for the horses, for the dying mother and child, and for the warriors. The most interesting classical reference appears in the figure of Death emerging from the darkness with thunderbolts in his fists. This came not from the Bible story but from Greek myth: the pagan deity Zeus hurled thunderbolts to show his power over the earth. It is clear that the painting's emotional power comes from the elements not mentioned in the biblical text, and when West painted the final version of his great work, the editorial liberties that he conceived here became more dominant still.

D.S.

NOTES

1. For a chronology of the various versions of the composition, see Allen Staley, "West's *Death on the Pale Horse*," *Bulletin of the Detroit Institute of Arts* 58 (1980): 137–49.

2. See Dorinda Evans, *Benjamin West and His American Students* (National Portrait Gallery, Smithsonian Institution, Washington, D.C., 1981), p. 134.

3. Quoted in Jared B. Flagg, *The Life and Letters of Washington Allston* (1892; New York, 1969), p. 44.

4. See Grose Evans, *Benjamin West and the Taste of His Times* (Carbondale, Ill., 1959), pp. 60–61.

PROVENANCE
Collection of Lord Egremont, 1819; to present owner, 1979.

EXHIBITION HISTORY
Royal Academy, London, *Annual Exhibition*, 1796, cat.no.247 (as *The opening of the four seals [vide Revelation]; a sketch, for His Majesty's Chapel, Windsor*).
Paris, *Salon*, 1802, cat.no.756.
National Portrait Gallery, Smithsonian Institution, Washington, D.C., *Benjamin West and His American Students*, cat. by Dorinda Evans, 1980 (traveling exhibition), no. 101.

WASHINGTON ALLSTON

(1799, Wacamaw, South Carolina
—1843, Cambridgeport, Massachusetts)

Washington Allston would have described himself as a poet, an art theorist, and a painter in the tradition of the European Old Masters. Today he is generally considered America's first major Romantic painter.

Born near Charleston, South Carolina, Allston attended school in Newport, Rhode Island, and graduated from Harvard College in 1800. In 1801 he went to London, where he enrolled at the Royal Academy and, like many young American artists before him, became a protégé of Benjamin West's (q.v.). From 1803 to 1808 he toured the Continent, spending eleven months in Paris and slightly over three years in Rome. He was again in Europe, primarily England, between 1811 and 1818, exhibiting actively and concentrating chiefly on large-scale biblical and literary compositions. He returned to America in 1818 and spent the rest of his career around Boston.

Allston achieved some recognition while in Europe, but his lasting reputation came in his native country. In America he represented a high standard of European sophistication and idealism, which set him apart from his contemporaries. He was admired not only for his history paintings but for his portraits and imaginary, mood-filled landscapes as well. Allston's work was particularly influential in Boston, where for fifty years, from the 1820s to the 1870s, local intellectuals and literary figures held him in the highest esteem.

Allston's own writings included a novel, Monaldi (1841), as well as a series of lectures on art and several dozen poems, published posthumously in 1850.

Although William Dunlap treated Allston extensively in his Rise and Progress of the Arts of Design in the United States in 1834, Allston's chief biographer was Jared B. Flagg, whose Life and Art of Washington Allston was published in 1892. Edgar P. Richardson, whose monograph appeared in 1948, is generally credited with reviving Allston's reputation, which had declined during the first decades of the twentieth century. Scholarly interest in Allston has greatly increased in the last two decades: in 1979 he was the subject of a major retrospective exhibition, "A Man of Genius": The Art of Washington Allston (1779–1843), at the Museum of Fine Arts, Boston.

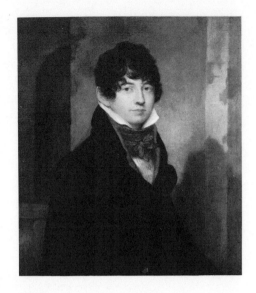

17

WASHINGTON ALLSTON
Self-Portrait, 1805
Painted in Rome
Signed and dated left center:
 W. ALLSTON / ROMAE. 1805.
Oil on canvas, $31\frac{1}{2} \times 26\frac{1}{2}$ in. (80×67.3 cm.)
Museum of Fine Arts, Boston,
 Bequest of Miss Alice Hooper

When Allston left London's Royal Academy School for the Continent in 1803, accompanied by John Vanderlyn, his intention was not only to see the most important works of art there but also to begin working as a full-fledged, independent painter. In Paris, his first stop, his studies were varied—copying Rubens's coloring technique, drawing after antique sculpture, painting landscapes—and they showed a desire to sample a wide variety of artistic expression. By the time Allston reached Rome in the first months of 1805, he had determined to forge a style of his own. His great desire in Rome was to be recognized by his peers, particularly the younger, foreign-born artists working there. With that purpose in mind, he painted two works soon after his arrival: a large ideal mountain landscape, *Diana and Her Nymphs in the Chase* (1805; Fogg Art Museum, Cambridge, Mass.), and this self-portrait.

Both these paintings were strikingly different from Allston's earlier work in their classical calm and in the cool clarity of their coloring, a result of his experience in Paris. There he had felt the effects of the Greek-inspired primitivism that pervaded the Salon and the ateliers.[1] Specifically it emanated from Jacques-Louis David and, to an even greater extent, his younger pupils like the "Barbus" and Ingres, who were practicing a style of extreme simplicity, based on spare, flattened forms, crisp contours, and limited colors. The uncomplicated frontal pose of Allston's self-portrait, its harmony of black and grays, and the blank background show a similar sensibility. With these very limited technical means, Allston achieved in this painting a certain evocative stillness.

The art of the Italian Renaissance provided a model for this new simpler, classical ideal.[2] Indeed, the coloring and the stone wall background lend Allston's image the flavor of Renaissance portraits that he had seen at the Louvre, particularly Raphael's *Self-Portrait* and Titian's *Man with a Glove.*

Allston's self-portrait also reveals a great deal about his self-image as an artist.[3] His formal dress and Phi Beta Kappa key are indications that he saw himself as a gentleman-intellectual. Although his clothing is rendered in detail, the setting is not, conveying only an indeterminate classical past. Allston does not hold the conventional pencil or palette of artists' portraits, but in a way he does display the tools of his trade, for his pensive attitude suggests that the painter's mind is his chief asset. Such a focus upon the invisible thoughts and feelings of the subject, and an attempt to involve the viewer in them, became a central characteristic of Allston's Romanticism.

D.S.

NOTES

1. See Diana Strazdes, "Washington Allston's Early Career: 1796–1811" (Ph.D. diss., Yale University, 1982), pp. 129–33.

2. See George Levetine, *The Dawn of Bohemianism: The Barbu Rebellion and Primitivism in Neoclassical France* (University Park, Pa., 1978), pp. 94–102.

3. This aspect of Allston's portrait is examined further in Carol Troyen, *The Boston Tradition* (New York, 1980), pp. 82–84.

PROVENANCE

Gift of the artist to Mrs. Nathaniel Amory, Boston, by 1839; her sister, Mrs. Wormely, 1865; John T. Johnston sale, New York, 1876, no. 140; to Miss Alice Hooper, Boston, 1875; to present owner, 1884.

EXHIBITION HISTORY

Harding's Gallery, Boston, *Allston*, 1839, cat. no. 23.

Museum of Fine Arts, Boston, *Exhibition of the Works of Washington Allston*, 1881, cat. no. 229.

M. H. de Young Memorial Museum, San Francisco, and California Palace of the Legion of Honor, *American Painting*, 1935, cat. no. 49.

Harvard University, Cambridge, Mass., *Tercentenary Exhibition*, 1936, cat. no. 4.

Virginia Museum of Fine Arts, Richmond, *American Painting—Inaugural Exhibition*, 1936, cat. no. 16.

Detroit Institute of Arts, and Museum of Fine Arts, Boston, *Washington Allston: A Loan Exhibition of Paintings, Drawings and Memorabilia*, 1947, cat. no. 1.

Museum of Fine Arts, Boston, *Great Americans*, 1954, cat. no. 25.

Brooklyn Museum, N.Y., *The Face of America*, 1957–58 (traveling exhibition), cat. no. 36.

Corcoran Gallery of Art, Washington, D.C., *American Painters of the South*, 1960, cat. no. 57.

Museum of Fine Arts, Boston, *"A Man of Genius": The Art of Washington Allston (1779–1843)*, cat. by William H. Gerdts and Theodore E. Stebbins, Jr., 1979–80 (traveling exhibition), no. 15.

American Federation of Arts, New York, *The Boston Tradition: American Paintings from the Museum of Fine Arts, Boston*, cat. by Carol Troyen, 1980 (traveling exhibition), no. 20.

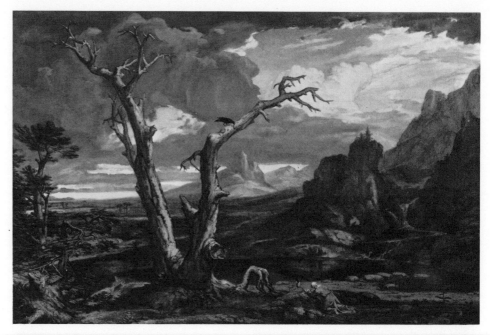

18

WASHINGTON ALLSTON
Elijah in the Desert, 1818
Painted in London
Signed twice on back:
 W. Allston 1818; W. Allston A.R.A.
Oil on canvas, $48\frac{3}{4} \times 72\frac{1}{2}$ in. (123.8×184.2 cm.)
Museum of Fine Arts, Boston,
 Gift of Mrs. Samuel Hooper and
 Miss Alice Hooper

Two distinct traits characterize Allston's history painting. First, although he firmly believed that such works should always instill a feeling of awe and grandeur in the viewer, he never followed a rigid formula, and he felt free to borrow from other genres to achieve desired effects. Second, Allston was not averse to taking ideas from the Old Masters, and he considered the practice consistent with his tenet that the history painter should be experimental and innovative.

Allston worked most actively as a history painter during his second stay in England (1811–18). Like many of his fellow artists there, including Benjamin West and Benjamin Robert Haydon, Allston chose biblical themes. His decision to embrace the Episcopal Church in 1815, following the lead of his friend Samuel Taylor Coleridge, no doubt affected his choice of subject as well. He exhibited his biblical works, including *Elijah in the Desert*, at the Royal Academy and the British Institution. He included it among the works he brought with him to America, where he hoped they would achieve as much critical success as they had in England.

This picture takes its theme from 1 Kings 17:1–7. God ordered the prophet Elijah into the desert where ravens miraculously kept

him alive by bringing him bread and meat. Allston chose to convey the prophet's religious experience primarily through the vast and disturbingly barren landscape around him. Allston used landscape to create mood in his paintings throughout his career, from early works like *Diana and Her Nymphs in the Chase* of 1805 (Fogg Art Museum, Cambridge, Mass.) to late canvases like the *Spanish Girl in Reverie* of 1831 (Metropolitan Museum of Art, New York). Such use of landscape accorded with older aesthetics of the sublime as interpreted by the Englishman Edmund Burke.[1]

In *Elijah in the Desert*, Allston referred to two of the Old Masters who had a continuing influence upon his art: Titian and Salvator Rosa. On a trip to the Louvre in 1817, the artist was particularly impressed by the paintings of Titian.[2] Among that master's works there was *St. Jerome in the Wilderness*, which shows a similar kneeling figure in a sonorously colored landscape; Titian's canvas may have given Allston the idea for his own. In creating his version, Allston greatly reduced the figure's size and added a gnarled tree and turbulent clouds suggestive of the works of Salvator Rosa. He also used his own coloring method, building up layers of underpainting and glazing, applied in a skim milk vehicle which allowed him to work quickly and which gave the work its unusual dry, roughened texture.[3]

The later history of *Elijah in the Desert* is typical of Allston's vacillating reputation. During the 1820s it was bought by an Englishman who, by the 1830s, consigned it to an attic.[4] In 1870, however, it was purchased for the princely sum of $4,000 for the newly founded Museum of Fine Arts in Boston. It was the first accessioned work in a collection whose other early acquisitions consisted of antiquities and Old Master paintings.[5] *D.S.*

NOTES

1. See Elizabeth Johns, "Washington Allston's Library," *American Art Journal* 7 (November 1975): 34.

2. See Jared B. Flagg, *The Life and Letters of Washington Allston* (New York, 1892), pp. 126–27.

3. See E. P. Richardson, "Allston and the Development of Romantic Color," *Art Quarterly* 7 (1944): 33.

4. See *The Letters and Journals of James Fenimore Cooper*, ed. James F. Beard, 2 vols. (Cambridge, Mass., 1960), p. 397: Cooper was interested in buying the painting.

5. See Walter Muir Whitehill, *Museum of Fine Arts Boston, A Centennial History*, 2 vols. (Cambridge, Mass., 1970), pp. 17–22.

PROVENANCE

Isaac P. Davis, Boston, after 1819; Henry Labouchère (later Lord Taunton), London, before 1828; Mrs. Samuel Hooper and Miss Alice Hooper, Boston, 1870; to present owner, 1870.

EXHIBITION HISTORY

British Institution, London, *Exhibition of Paintings*, 1818, cat.no.242.

Royal Academy, London, *Annual Exhibition*, 1870, cat.no.129.

Boston Athenaeum, *Special Exhibition of Paintings for the Benefit of the French*, 1871, cat.no.151.

Boston Athenaeum, *Annual Exhibition*, 1871, cat.no.225; 1871–72, cat.no.226.

Museum of Fine Arts, Boston, *Contemporary Art*, 1879, cat.no.55.

Museum of Fine Arts, Boston, *Exhibition of the Works of Washington Allston*, 1881, cat.no.234.

Whitney Museum of American Art, New York, *A Century of American Landscape Painting*, cat. by Lloyd Goodrich, 1938, no.6.

Musée du Jeu de Paume, Paris, *Trois Siècles d'Art aux États-Unis*, cat. by Alfred H. Barr, Jr., 1938, no.3.

Lyman Allyn Museum, New London, *Trumbull and his Contemporaries*, 1944, cat.no.39.

Detroit Institute of Arts, *The World of the Romantic Artist*, cat. by E. P. Richardson, 1944–45, no.35.

Detroit Institute of Arts and Museum of Fine Arts, Boston, *Washington Allston: A Loan Exhibition of Paintings, Drawings and Memorabilia*, 1947, cat.no.20.

Gallery of the Fine Arts, Columbus, Ohio, *Romantic America*, 1948, cat.no.1.

American Federation of Arts, New York, *Nineteenth-Century American Art*, 1953–54 (traveling exhibition), cat.no.47.

Corcoran Gallery of Art, Washington, D.C., *The American Muse*, 1959, cat.no.60.

Munson-Williams-Proctor Institute, Utica, N.Y., *19th Century American Painting*, 1960, cat.no.1.

Metropolitan Museum of Art, New York, *19th-Century America: Paintings and Sculpture*, cat. by John K. Howat and Natalie Spassky, 1970, no.6.

Jewett Art Center, Wellesley College, Mass., *Salvator Rosa in America*, 1979, cat.no.75.

Museum of Fine Arts, Boston, *"A Man of Genius": The Art of Washington Allston (1779–1843)*, cat. by William H. Gerdts and Theodore E. Stebbins, Jr., 1979–80 (traveling exhibition), no.49.

JOHN VANDERLYN

(1775, Kingston, New York
—1852, Kingston)

In the generation of Americans who reached artistic maturity in Europe and who became adherents of history painting's lofty ideals, John Vanderlyn holds the distinction of being the first to master the style of French neoclassicism. After his education in a Kingston academy, he went to New York where he attended a drawing school conducted by the Englishman Archibald Robertson (1765–1835) and worked for Thomas Barrow, a print dealer. He became acquainted with Gilbert Stuart, followed him to Philadelphia, and studied under him for eight or nine months. In 1796 Aaron Burr, then a U.S. Senator residing in Philadelphia and a client of Stuart's, financed Vanderlyn's passage to France. He studied in Paris under the academician François-André Vincent (1746–1816) until 1801, and then returned to New York.

In 1803 Vanderlyn left again for Europe and remained there nearly twelve years. Two of those (1805–07) he devoted to a trip to Rome; the rest of the time he resided in Paris. There he enjoyed a degree of recognition from the French that no previous American artist had known: he exhibited several times at the Salon, where his crowning achievement was a Gold Medal awarded in 1808 for his Caius Marius amid the Ruins of Carthage *(M. H. de Young Memorial Museum, San Francisco). He is considered to have produced his best work at this stage of his career.*

Vanderlyn returned to New York in 1815, expecting his career to progress in the manner it had in Paris. But he was disappointed. Struggling to make his production acceptable to an American audience unfamiliar with high art, he resorted to portrait painting and exhibited huge panoramas of Niagara Falls and Versailles. In 1837 he secured his most profitable and coveted commission, the Landing of Columbus *for the Capitol Rotunda in Washington. Unfortunately, most of Vanderlyn's American projects met with public indifference. As time passed he found his ideas increasingly out of step with popular taste, and he ended his life a poor and embittered man.*

The major sources for information about Vanderlyn's career are a manuscript biography by his contemporary, Robert Gosman (New-York Historical Society), and Marius Schoonmaker's John Vanderlyn, Artist, 1775–1852 *(Kingston, N.Y., 1950). He was the subject of unpublished doctoral dissertations by Louise Hunt Averill (Yale University, 1949) and William Oedel (University of Delaware, 1981), and a retrospective exhibition held in 1970 at the University Art Gallery, State University of New York at Binghamton (catalogue by Kenneth C. Lindsay).*

JOHN VANDERLYN
Ariadne Asleep on the Island of Naxos, 1814
Painted in Paris
Signed and dated lower left: *J. Vanderlyn fect Parisiis 1814*
The Pennsylvania Academy of the Fine Arts, Philadelphia,
Presented by Mrs. Joseph Harrison, Jr.

Ariadne Asleep on the Island of Naxos is not only Vanderlyn's masterpiece, it was also the embodiment of his hopes for his artistic future in the United States. He began the work in Paris in 1809, essentially completed it in the following two years, but did not sign and date it until 1814.[1] He exhibited it at the Salon twice, in 1810 and 1812, then brought it with him to New York in 1815. He intended it to introduce large-scale history painting in the Salon manner to the American public, hoping thereby to gain both fame and financial reward.

In both subject and execution the work is true to the conventions of early-nineteenth-century Salon painting. It relates an episode in the myth of Ariadne, daughter of Minos, King of Crete, who fell in love with the Greek hero Theseus and helped him escape from Minos's labyrinth. Theseus took the princess with him to Crete but, having seduced her, abandoned her on Naxos where she—according to one variant of the legend—died in childbirth. Vanderlyn showed Ariadne reclining in a shaded grove, undressed and deep in the inevitable slumber that follows seduction, with Theseus setting sail in the distance. The artist added a subtle note of pathos to his depiction by allowing the viewer to know what Ariadne herself is unaware of, that she is pregnant and about to be abandoned.

The interplay of two references to past art give Vanderlyn's work its meaning. For the pose of Ariadne, the artist looked to the highly acclaimed Roman copy of a Hellenistic sculpture then known as "the abandoned Ariadne."[2] Long at the Vatican, it had been taken to Paris where it was displayed at the Musée Central des Arts between 1800 and 1815.[3] The context into which this Ariadne was placed brings to mind works by the Venetian Renaissance painters Titian and Giorgione depicting the sleeping Venus. In slumber she surrenders herself to the senses and so provides an appropriate metaphor for Vanderlyn's theme of seduction, which is enhanced by the lush landscape's suggestions of a sensual realm.

At the same time Vanderlyn set himself somewhat apart from earlier artistic approaches. His colors are cooler; his contours are more Parisian than Venetian. His emphasis on strong draftsmanship and solid modeling

removes the softness and charm of his antique and Renaissance models, giving his image a detached appearance, a self-conscious rigor that is more philosophical than sensual.

From the time he conceived the painting in Paris, Vanderlyn intended to use *Ariadne* for public exhibition in America. He anticipated with pleasure the controversy that awaited paintings of female nudes in his own country, and in 1809 wrote, "The subject may not be chaste enough . . . at least to be displayed in the house of any private individual. . . . but on that account it may attract a great crowd if exhibited publickly."[4] Nonetheless, Vanderlyn was careful to clothe his image in a moralistic pathos that would be acceptable to Americans, who generally found female nudes objectionable. Thus, pity for Ariadne's plight provided the viewer with a justification for lingering over the image.

In 1819 *Ariadne* was placed in the vestibule of the New York Rotunda, an exhibition hall Vanderlyn built in City Hall Park to house his panorama, the *Palace and Gardens of Versailles* (1816–19; Metropolitan Museum of Art, New York). In 1822 Vanderlyn exhibited *Ariadne* in Charleston, South Carolina, then brought it back to New York. The painting's reception was mixed. While intellectuals and connoisseurs admired it, the large number of less educated viewers were irritated by Ariadne's nudity. Still, it did not impassion either group sufficiently to make it the *succès de scandale* the artist hoped it would become.[5] Even though most contemporary viewers seem to have missed the implications of *Ariadne's* iconography, the painting continued to serve as a representative of the European classical tradition. Asher B. Durand produced a major engraving of it in 1835, and in 1878 it was installed, amid much fanfare, at the Pennsylvania Academy of the Fine Arts.[6]

D.S.

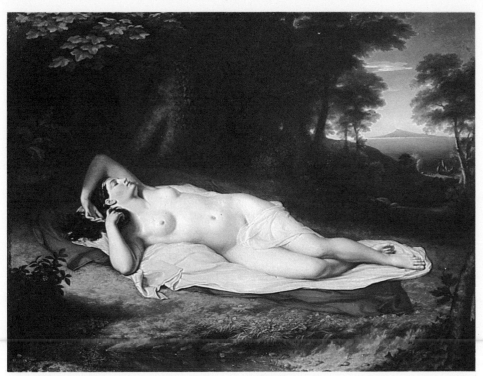

NOTES

1. See Louise Hunt Averill, *John Vanderlyn, American Painter* (Ph.D. diss., Yale University, 1949), cat.no.5.

2. Traditionally considered to be Cleopatra, the sculpture was renamed *Ariadne* by Ennio Quirino Visconti, *Museo Pio-Clementino*, 3 vols. (Rome, 1782), 2: plate xliv.

3. See Francis Haskell and Nicholas Penny, *Taste and the Antique* (New Haven, Conn., 1981), pp. 186–87.

4. John Vanderlyn to John R. Murray, Paris, 3 July 1809 (Archives of American Art, Washington, D.C.).

5. See the review in the *National Advocate*, 21 April 1818, quoted in Neil Harris, *The Artist in American Society: The Formative Years, 1790–1860* (New York, 1966), pp. 81–82.

6. See Frank H. Goodyear, Jr., et al., *In This Academy* (Pennsylvania Academy of the Fine Arts, Philadelphia, 1976), p. 33.

PROVENANCE

Purchased from the artist by Asher B. Durand, 1831; purchased at auction by Joseph Harrison, Philadelphia; to present owner, 1878.

EXHIBITION HISTORY

Paris, *Salon*, 1810, cat.no.808.

Paris, *Salon*, 1812, cat.no.922.

Periodically exhibited at Vanderlyn's New York Rotunda, 1819–29.

Logan Square, Philadelphia, *Great Central Fair*, 1864.

Cincinnati, *Seventh Industrial Exposition*, 1879.

Baltimore Museum of Art, *The Greek Tradition in the Arts*, cat. by George Boas et al., 1939.

Addison Gallery of American Art, Andover, Mass., *William Dunlap, Painter and Critic: Reflections on American Painting of a Century Ago*, 1939, cat.no.33.

Carnegie Institute, Pittsburgh, *Survey of American Painting*, 1940, cat.no.99.

Municipal Museum, Baltimore, *Rendezvous for Taste: Peale's Museum, 1814–1830*, 1956, cat.no.132.

Cleveland Museum of Art, *The Venetian Tradition*, 1956, cat.no.58.

Detroit Institute of Arts, *Painting in America: The Story of 450 Years*, cat. by Edgar P. Richardson, 1957, no. 35.

Wildenstein & Co., New York, *The American Vision*, 1957, cat.no.6.

Cleveland Museum of Art, *Neoclassicism: Style and Motif*, 1964.

San Francisco Museum of Art, *Man, Glory, Jest, and Riddle*, 1964, cat.no.225.

Metropolitan Museum of Art, New York, *19th-Century America: Paintings and Sculpture*, cat. by John K. Howat and Natalie Spassky, 1970, no. 10.

University Art Gallery, State University of New York, Binghamton, *The Works of John Vanderlyn: From Tammany to the Capitol*, cat. by Kenneth C. Lindsay, 1970, no. 57.

Pennsylvania Academy of the Fine Arts, Philadelphia, *In This Academy*, cat. by Frank H. Goodyear, Jr., et al., 1976, no. 85.

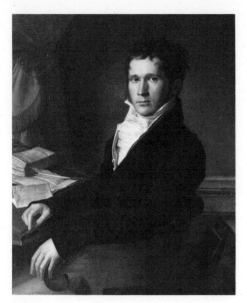

20

JOHN VANDERLYN
Sampson Vryling Stoddard Wilder, 1805/1808–12
Painted in Paris
Oil on canvas, 36¼ × 28⅞ in. (92.1 × 73.4 cm.)
Worcester Art Museum, Massachusetts,
 Gift of Lawrence Alan Haines in memory of
 his father, Wilder Haydn Haines

The degree to which Paris left its mark on Vanderlyn is apparent in his portrait of Sampson Vryling Stoddard Wilder (1780–1865). The sitter, a purchasing agent from Boston and only a few years younger than the artist, had gone to Paris, like Vanderlyn, in pursuit of professional opportunity. In this portrait, Vanderlyn worked in a manner restrained nearly to the point of austerity, making this one of his most stylish and successful portraits.

Wilder is shown turning toward the viewer from a writing desk on which are collected letters from clients and a book on mercantile law. To surround the sitter with the paraphernalia of his profession was an extremely traditional way of constructing a portrait, as was the inclusion of objects that indicated the sitter's taste and status. Such is the function of the Greek Revival chair and Wilder's suit of clothes, both shown in meticulous detail.

Vanderlyn's choice of colors, forms, and manner of painting reinforce the precisely honed sharpness of the image. Colors are intentionally limited, with muted grays and browns predominating. Forms too are chosen judiciously and arranged so as to make a stabilizing grid within the shallow pictorial space. Every shape has a strong, clear contour and high finish, suggestive of the style of Vanderlyn's academic training, but more specifically akin to the stylistic refinements then practiced by young French painters such as Gerard, Girodet-Trioson, and Ingres.

The work's exact date is not known. Family tradition dates it to 1805, just before Vanderlyn's departure for Italy. It has been argued of late that the artist painted the work between 1808, when he returned to Paris, and 1812, when Wilder departed.[1] Both before and after his trip to Italy, Vanderlyn thought of himself not as a portraitist, but as a history painter. Even when short of funds, he preferred making replicas of Old Master works to painting portraits, since replicas commanded higher prices for the time expended on them.[2] It was therefore an unusual circumstance when a portrait became the focus of Vanderlyn's creative energy while he was in Europe. Correspondingly, Vanderlyn projected qualities in this image—its elevated, rarefied composure in particular—which had become equally essential to his history paintings.

D.S.

NOTES
 1. See Susan E. Strickler, "A Paris Connection: John Vanderlyn's Portrait of Sampson V. S. Wilder," *Worcester Art Museum Journal* 5 (1981–82): 38–39. This conclusion was based on an analysis of the Lyon postmark on one letter, the verification of Wilder's address on another, and the assumption that Wilder was not well enough established in 1805 to have considered such a portrait commission.
 2. See Kenneth C. Lindsay, *The Works of John Vanderlyn: From Tammany to the Capitol* (University Art Gallery, State University of New York at Binghamton, 1970), pp. 24–25.

PROVENANCE
Sampson V. S. Wilder, to 1865; his wife, Electa Barrell Wilder, to 1878; her daughter, Francina Eglée Wilder Haines, to 1886; her son, Edward Wilder Haines, to 1911; his son, Wilder Haydn Haines, to 1980; to Lawrence Alan Haines; to present owner, 1981.

EXHIBITION HISTORY
Paris, *Salon*, 1805.
On loan to the Cleveland Museum of Art, 1916–27.
Brooklyn Museum, N.Y., *Early American Paintings*, 1917, cat.no. 123.
On loan to the Cleveland Museum of Art, 1920s.
On loan to the Museum of Fine Arts, Boston, 1927–33.
Vose Galleries, Boston, *Exhibition of Colonial Artists*, 1935.
Senate House Museum, Kingston, N.Y., *Exhibition of the Work of John Vanderlyn, 1776–1852*, 1938, cat.no. 11.
On loan to the Fogg Art Museum, Cambridge, Mass., 1939; 1953–81.
On loan to the Fogg Art Museum, Cambridge, Mass., 1960s.
University Art Gallery, State University of New York at Binghamton, *The Works of John Vanderlyn: From Tammany to the Capitol*, cat. by Kenneth C. Lindsay, 1970, no. 25.
Wildenstein & Co., New York, *Paris–New York: A Continuing Romance*, 1972, cat.no. 19.

JOHN NEAGLE

(1796, Boston—1865, Philadelphia)

John Neagle received his first professional instruction at a Philadelphia drawing school run by Pietro Ancora. In 1810 he entered a five-year apprenticeship with Thomas Wilson, a carriage and ornamental painter. His artistic talents brought him to the attention of the leading Philadelphia artists: Charles Willson Peale (q.v.), Thomas Sully (1783–1873), John Lewis Krimmell (1787–1821), and Bass Otis (1784–1861). Neagle studied portraiture with Otis, and in 1817 he was listed for the first time in the Philadelphia city directory as a portrait painter. Except for an apparently unsuccessful excursion to Lexington, Kentucky, and New Orleans (1818), he spent his entire professional career in Philadelphia. From 1821 to 1862 he exhibited portraits at the Pennsylvania Academy of the Fine Arts there almost every year. His subjects included famous actors of the day (Kean, Booth, and Forrest), the local Greek Revival architect William Strickland, politician Henry Clay, and, above all, Philadelphia's clergy, university professors, and members of the upper class.

In 1825 Neagle visited Gilbert Stuart (q.v.) in Boston to study his technique at firsthand and paint his portrait (Museum of Fine Arts, Boston). The painterly styles of Stuart and Sully were the major influences on Neagle's work. Stuart had worked in the Philadelphia-Germantown area from 1794 to 1803, and Neagle would have known his portraits from those years. In 1826 Neagle married Sully's daughter. Between 1827 and 1830 he won great acclaim at Philadelphia, New York, and Boston exhibitions with a full-length portrait of Philadelphia blacksmith Patrick Lyon (1826–27; Museum of Fine Arts, Boston; replica 1829; Pennsylvania Academy of the Fine Arts). It was very favorably reviewed by the New York artist and critic William Dunlap, and further praised in his famous book of 1834, The Rise and Progress of the Arts of Design in the United States. Neagle was elected an Academician at the Pennsylvania Academy of the Fine Arts in 1824, and served there as director in 1830 and 1831. For the rest of his career he seems to have had a steady business as a portraitist; apparently he had no serious professional interests in history painting, landscape, or still life.

There is no recent monograph on Neagle. Many of his works are illustrated in the 1925 exhibition catalogue Portraits by John Neagle *(Pennsylvania Academy of the Fine Arts). Basic biographical information is found in Marguerite Lynch's "John Neagle's Diary,"* Art in America *37 (April 1949): 79–99.*

21

JOHN NEAGLE
Dr. William Potts Dewees, 1833
Painted in Philadelphia
Oil on canvas, 56¾ × 44¾ in. (144.1 × 113.7 cm.)
University of Pennsylvania School of
Medicine, Philadelphia

When he sat for Neagle in 1833, William Potts Dewees (1768–1841) was an adjunct professor of obstetrics at the University of Pennsylvania and author of an important medical text, *A Compendious System of Midwifery* (1824). Apparently he had been derided early in his career for his scholarly devotion to an aspect of medicine which was then performed by women and deemed unmanly. However, Neagle's noble presentation of him suggests nothing of this: posed like a classical orator facing an audience, the doctor's figure rises dramatically from shadow, and his authoritative bearing is echoed upward in the massive column behind. The towering stature that this portrayal achieves is related to Samuel F. B. Morse's iconic full-length portrait of the Marquis de Lafayette (1825–26; Art Commission of the City of New York).[1]

Neagle's *Dr. Dewees* typifies the essentially Romantic attitude that portraits of the great should communicate distinction, grandeur, and intellectual power while preserving a likeness for posterity. Neagle used props to help achieve this effect: the large text by the famous French obstetrician Jean-Louis Baudelocque (1745–1810) alludes to Dewees's profession, and the writing set on top of it (decorated with what is probably a bust of Shakespeare) suggests Dewees's own important scholarly contributions to the field. In addition, the document held at his side indicates he is about to deliver a lecture. The paintings in the background imply Dewees's aesthetic and moral refinement. The two nearest examples seem to allude to the doctor's sense of charity and his profession: the upper one depicts The Good Samaritan, and that behind the pen shows a woman and child with two attendant figures (perhaps The Holy Family or The Finding of Moses). However, the boldly sculpted head is the commanding feature of the picture, as it is the intellectual and spiritual center of the individual. The expressive face is confident, kind, and poignant, and the hair's ruffled stylishness might denote creative genius. Given such a sympathetic, knowing characterization, it is not surprising to learn that he was the artist's doctor. In fact, the portrait was done in exchange for an outstanding medical bill of $139 plus one year's free medical services to the Neagle family.[2]

The handling of *Dr. Dewees* shows the predominant influence of Thomas Sully, whose broad-brushed, soft-edged execution paralleled that practiced in Edinburgh by Henry Raeburn and in London by Thomas Lawrence (with whom Sully had studied in 1809–10). It is a significant reflection on the growth of the American art world in the early nineteenth century that Neagle became a sophisticated exponent of this elegant style without ever going to Europe. Neagle's rise to fame in the 1820s coincides with an increasing abundance of European art of all ages and schools on view at the new exhibition organizations in America. Neagle collected European paintings, and he may have owned those that hang behind Dr. Dewees.[3]

Neagle painted at least three other three-quarter-length portraits of the faculty of the University of Pennsylvania: Samuel Brown Wylie, Professor of Greek and Latin languages (1847); William E. Hornor, Professor of Anatomy (1853); and William Gibson, Professor of Surgery (1855)—all, like *Dr. Dewees*, owned by the University.

T.J.F.

NOTES

1. William H. Gerdts discusses Morse's portrait in relation to Neagle's in his essay "Natural Aristocrats in a Democracy, 1810–1870," in Michael Quick et al., *American Portraiture in the Grand Manner, 1720–1920* (Los Angeles County Museum of Art, 1981), p. 37.

2. Neagle often exchanged his professional services for those of others. The exchange between Neagle and Dewees, which, as the artist noted, did not include a frame for the portrait, is discussed by Marguerite Lynch in "John Neagle's Diary," *Art in America* 37 (April 1949): 93.

3. During his lifetime Neagle lent sixteen works of art to exhibitions at the Pennsylvania Academy. Most of them were portraits, but of relevance to the paintings depicted in the Dewees portrait is *Christ Appearing to His Disciples at the Sea of Tiberias*. See Anna Wells Rutledge, *Cumulative Record of Exhibition Catalogues: The Pennsylvania Academy of the Fine Arts, 1807–1870* (Philadelphia, 1955), p. 340.

PROVENANCE
Presumably a gift of Dewees or his descendents.

EXHIBITION HISTORY
Pennsylvania Academy of the Fine Arts, Philadelphia, *Annual Exhibition*, 1834, cat. no. 21.
National Academy of Design, New York, *Annual Exhibition*, 1835, cat. no. 20.
Pennsylvania Academy of the Fine Arts, Philadelphia, *Special Exhibition*, 1836, 1837, 1838, and 1840, cat. no. 154 for all.
Pennsylvania Academy of the Fine Arts, Philadelphia, *Exhibition of Portraits by John Neagle*, cat. by Mantle Fielding, 1925, no. 94 (ill.).
Pennsylvania Academy of the Fine Arts, Philadelphia, *150th Anniversary Exhibition*, 1955, cat. no. 44 (ill.).
Philadelphia Museum of Art, *The Art of Philadelphia Medicine*, cat. by Whitfield J. Bell, Jr., 1965.
Penn Mutual Tower, Philadelphia, *Area Universities Bicentennial Exhibition*, 1976.
Birmingham Museum of Art, Ala., *The Art of Healing*, cat. by William H. Gerdts, 1981 (ill.).

SAMUEL F. B. MORSE

(1791, Charlestown, Massachusetts
—1872, New York City)

Son of a minister and noted geographer, Morse was raised in Charlestown, Massachusetts, and educated at Yale College. In the year Morse graduated, 1810, he met Washington Allston (q.v.) and made plans to follow him to Europe. From 1811 to 1815 Morse studied painting in London under Allston, with whom he enjoyed a close friendship, and also studied with Benjamin West (q.v.). Morse returned to the United States in 1815 and traveled for a few years in search of portrait commissions in New Hampshire, Vermont, Connecticut, and North Carolina. In 1823 he settled in New York City and became the principal founder and first president of the National Academy of Design.

Like his mentors Allston and West, Morse's style was eclectic. He sought to combine the noble forms of ancient and Renaissance classicism with the sensuous immediacy of Venetian colorism. In his subject matter, Morse aspired to be a history painter but found it difficult to reconcile his lofty ambitions with the tastes of the large yet unsophisticated American art public. Morse's search for subjects that would satisfy both himself and his audience led to experiments with idealized landscape and various "elevated" genre themes. Nevertheless, the tensions and disappointments that other intellectual, European-trained artists faced when working in America continued to beset Morse, and he painted far more portraits than he did any other subject. After he returned in 1833 from a second European trip, he gradually abandoned painting in favor of telegraphy, various mechanical inventions, and political interests.

The standard biography of Morse is Carleton Mabee's The American Leonardo: A Life of Samuel F. B. Morse *(1943; New York, 1969). A briefer biography for the layman is Oliver W. Larkin's* Samuel F. B. Morse and American Democratic Art *(Boston, 1954). Morse's numerous letters and journals were edited and published by his son, Edward Lind Morse (1914; New York, 1973). Paul Staiti's Ph.D. dissertation* Samuel F. B. Morse and the Search for the Grand Style *(University of Pennsylvania, 1979) is a comprehensive study of Morse's art. In 1959, the National Academy of Design mounted a major exhibition of Morse's painting, and more recently New York University organized another exhibition of his work (Grey Art Gallery and Study Center, 1982).*

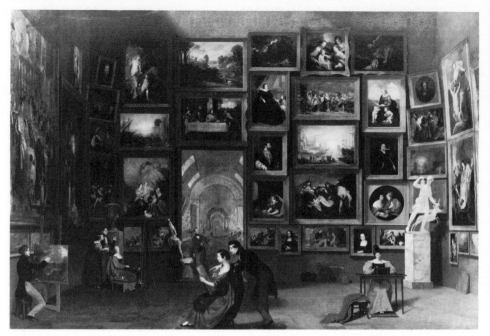

22

SAMUEL F. B. MORSE
Gallery of the Louvre, 1833
Painted in Paris
Oil on canvas, $73\frac{3}{4} \times 108$ in. (187.3×274.4 cm.)
Terra Museum of American Art, Evanston,
 Illinois, Daniel J. Terra Collection

The *Gallery of the Louvre* was the chief product of Morse's European tour of 1829–33. In 1830 the painter took up residence in Paris and, encouraged by his friend the novelist James Fenimore Cooper, conceived the idea of representing an imaginative view of the Louvre's most famous gallery, the Salon Carré, lined from floor to ceiling with masterpieces of sixteenth- and seventeenth-century European painting which the artist would select. Morse worked on his canvas during the spring and summer of 1832. He erected an elaborate moveable scaffold in order to execute miniature copies of his thirty-seven chosen paintings.

Morse intended his painting to tour the United States. He hoped that it would attract two types of audience who would pay an admission fee to see it. First, Morse anticipated curiosity-seekers, those who flocked to large-scale panoramas and dioramas of fantastical sights. To these people, the Salon Carré and the Grande Galerie beyond it—the latter the longest room then in existence—represented a distant wonder of the world that most of them would never see. Second were the connoisseurs who would be interested in the virtuosity of Morse's composition and the technical qualities of his work.

Morse deliberately patterned his *Gallery of the Louvre* after the vast *capricci* of art galleries painted by Teniers, Pannini, Zoffany, and

others in the seventeenth and eighteenth centuries. He had seen such paintings in Europe and correctly predicted a renewed popularity for these works in America. In 1834 four large canvases by Pannini, the eighteenth-century painter whose name became synonymous with the specialized genre of gallery interiors, toured Boston and New York, with special exhibitions at the Boston Athenaeum and the American Academy of the Fine Arts. Two of the paintings represented galleries containing paintings and sculptures having to do with ancient and modern Rome. At the Boston Athenaeum, these two picture galleries were acclaimed as "magnificent" and "ingenious."[1] Likewise the New York press applauded Pannini's gallery of ancient Rome as "a masterpiece, an unrivalled masterpiece."[2]

However, Morse did not aim to present himself as a modern rival to painters such as Pannini; the *Gallery of the Louvre* was intended as a statement of his own artistic values. The works he imaginatively assembled in the Salon Carré (and meticulously identified in an elaborate key that accompanied the painting) were by the artists he admired most. Titian, Veronese, Raphael, Carracci, Claude, Rembrandt, Teniers, Van Dyck, all contributed to Morse's own eclectic style. The human figures in the gallery, moreover, are not the usual collectors and patrons of eighteenth-century proto-types; instead, they are artists and students, all copying from the Old Masters. These figures were possibly added after the painting was exhibited, and all but the mother and child appear to be foreigners.[3] Morse portrayed himself at the center of the room, advising a student. In *Gallery of the Louvre*, then, Morse created a tribute to the Old Master tradition and presented himself as its inheritor.

When Morse exhibited his painting in New York and New Haven, Connecticut, art critics gave it a warm reception. William Dunlap wrote an admiring advance notice of the work in the New York *Mirror* on 2 November 1833. Nevertheless, Morse found public attendance low and his proceeds disappointingly slim. After speculating that the Boston Athenaeum might buy the work, Morse finally sold it to a Syracuse, New York, friend of Fenimore Cooper's. Shortly afterward, searching for a financially successful venture, he began his experiments with the telegraph and found that in science, as in art, he could combine observation with abstract principles for a noble purpose.

D.S.

NOTES
1. Robert F. Perkins, Jr., and William J. Gavin III, eds., *The Boston Athenaeum Art Exhibition Index, 1827–1874* (Boston, 1980), pp. 308–309.
2. *American Monthly Magazine* 3 (1834): 429.
3. See David Tatham, "Samuel F. B. Morse's *Gallery of the Louvre:* The Figures in the Foreground," *American Art Journal* 13 (Autumn 1981): 38–48.

PROVENANCE
The artist to George Hyde Clark, Cooperstown, N.Y.; John Townsend, Albany, N.Y.; his daughter, Julia Townsend Monroe, Syracuse, N.Y.; on extended loan to Syracuse University, 1884–92; by purchase to Syracuse University, 1892; to present owner, 1982.

EXHIBITION HISTORY
Metropolitan Museum of Art, New York, *Samuel F. B. Morse, American Painter*, 1932, cat. no. 56.
Addison Gallery of American Art, Andover, Mass., *William Dunlap, Painter and Critic*, 1939.
Wadsworth Atheneum, Hartford, Conn., *Pictures within Pictures*, 1949.
Detroit Institute of Arts, *Painting in America: The Story of 450 Years*, cat. by Edgar P. Richardson, 1957, no. 74.
Carnegie Institute, Pittsburgh, *American Classics of the 19th Century*, 1957.
Virginia Museum of Fine Arts, Richmond, 1958.
Vassar College, Poughkeepsie, N.Y., *Samuel F. B. Morse*, 1961.
Minneapolis Institute of Art, *Four Centuries of American Art*, 1963.
Musée des Beaux-Arts, Montreal, *The Painter and the New World*, 1967, cat. no. 1195 (ill.).
Metropolitan Museum of Art, New York, *19th-Century America: Paintings and Sculpture*, cat. by John K. Howat and Natalie Spassky, 1970, no. 30.
Indianapolis Museum of Art, *American Self-Portraits*, cat. by Ann C. Van Devanter and Alfred Frankenstein, 1974, no. 20 (ill.).
Grey Art Gallery and Study Center, New York University, *Samuel F. B. Morse*, cat. by Paul Staiti, 1982, no. 44.

JOHN QUIDOR

(1801, New York City
—1881, Jersey City, New Jersey)

Quidor was apprenticed to the portrait painter John Wesley Jarvis in New York in 1818. His four years with Jarvis, spent for the most part copying old engravings, probably constituted his only formal training. After spending several years speculating in land in Illinois, Quidor returned to New York in 1827 and attempted to establish himself there. During this period he painted processional banners, signs, fire engine panels, portraits, and literary subjects. This last genre formed part of a small but significant group of works by well-known artists such as Henry Inman and Asher B. Durand which had been inspired by the stories by Washington Irving and James Fenimore Cooper, the most popular American writers of the 1820s and '30s. Today Quidor is best known for his paintings of these literary subjects, particularly of Irving's "Rip van Winkle" and Knickerbocker's History of New York, *and of Cooper's Natty Bumpo; however, in his own lifetime Quidor's works were not generally well received. His increasingly quarrelsome temperament may well have driven away potential patrons, and he seems to have had to rely on sign painting (no example of which is presently known) for his major source of income.*

Quidor was an exception in mid-nineteenth-century American painting, which was dominated by romantic realists. His uneven craftsmanship and baroque imagery, stamped with his singularly eccentric personality, isolated him from his contemporaries, even though to our eyes his paintings are wonderfully amusing, well drawn, and carefully composed, capturing the essential spirit of his literary source.

Quidor returned to Illinois in 1837. In the mid- to late forties, he did a series of religious paintings, probably hoping to recover some of the money he had lost in land speculations. He moved back to New York in 1851 and unsuccessfully attempted to resurrect his career by repeating many of his earlier literary subjects. Quidor's entire life was disappointing, both financially and artistically, and he died without receiving public recognition.

Quidor was only rediscovered in 1942 with John I. H. Baur's exhibition and catalogue for the Brooklyn Museum. Baur updated this work for the Munson-Williams-Proctor Institute exhibition (1965–66). An exhibition, mostly of the rather uneven late works, was held at the Wichita Art Museum, Kansas, in 1973, with a catalogue essay by David M. Sokol, who has also written elsewhere on Quidor.

23

JOHN QUIDOR
Money Diggers, 1832
Painted in New York City
Signed and dated right center: *J. Quidor Pinx / N. York June, 1832.*
Oil on canvas, $16\frac{5}{8} \times 21\frac{1}{2}$ in. (42.2 × 54.6 cm.)
The Brooklyn Museum, Gift of Mr. and Mrs. Alastair Bradley Martin

Like his contemporaries Thomas Cole and Charles R. Leslie, Quidor based many of his paintings on literary sources.[1] However, unlike those artists, who stress order and balance in their depictions of fictional episodes, Quidor inventively expands upon his sources, presenting raucous, extreme characterizations.

Money Diggers is based on Washington Irving's "Wolfert Webber, or Golden Dreams," from *Tales of a Traveller,* first published in 1824. Wolfert Webber is a Dutch farmer who dreams of discovering buried treasure. With the aid of a black man named Mud Sam and a Dr. Knipperhauser, who brings along a divining rod, drugs, herbs, and a book on witchcraft, he hunts for treasure buried by a buccaneer near Long Island Sound. But at the moment the booty is unearthed, the pirate's ghost appears, claiming his treasure and terrifying the farmer and his superstitious cohorts:

> *At length the spade of the old fisherman struck upon something that sounded hollow; the sound vibrated to Wolfert's heart. He struck his spade again.*
>
> *"'Tis a chest," said Sam.*
>
> *"Full of gold, I warrant it!" cried Wolfert, clasping his hands with rapture.*
>
> *Scarcely had he uttered the words when a sound from overhead caught his ear. He cast up his eyes and lo! by the expiring light of the fire he beheld, just over the disk of the rock, what appeared to be the grim visage of the drowned buccaneer, grinning hideously down upon him.*

Wolfert gave a loud cry and let fall the lantern. His panic communicated itself to his companions. The negro leaped out of the hole; the doctor dropped his book and basket, and began to pray in German. All was horror and confusion.

Despite the popularity of Irving's tale and the widespread vogue for gothic horror stories, the irrationality and grotesque distortion of Quidor's rendition offended contemporary genteel sensibilities, and it was almost completely neglected.

While many of Quidor's paintings seem to be chaotic and carelessly composed, they do have closely integrated compositions. In this painting, the writhing tree at the left and the rock formation and digging implements on the right edge frame the pit and the three figures, even to the point of echoing the gestures of the treasure hunters. Unlike many of Quidor's other paintings, which are pale in tone, the colors here are bright and bold, made more intense by the contrast between the firelight and the darkness of the surrounding space. In Quidor's rendition of Irving's tale, fear is the most important element. The extreme, grotesque gestures are probably derived from well-known caricatures, such as the work of the Englishmen James Gilray, Thomas Rowlandson, and George Cruikshank,[2] while the gnarled trees and twisted roots resemble similar forms in the Romantic landscapes of Thomas Cole (q.v.).

Quidor painted a replica of *Money Diggers* in 1856 (Coll. Mimi D. Bloch, New York). Like all of his late pictures, the replica lacks the bright color, crisp drawing, and vital energy of the original version done more than twenty years before.[3]

D.D.K.

NOTES

1. Quidor's first known painting, *Dorothea* (1823; Brooklyn Museum, N.Y.), was taken from Cervantes's *Don Quixote*. Almost all of his subsequent works come from stories by Washington Irving and James Fenimore Cooper. See John I. H. Baur, *John Quidor* (Munson-Williams-Proctor Institute, Utica, N.Y., 1965), pp. 8–15; and David M. Sokol, "John Quidor, Literary Painter," *American Art Journal* 2 (Spring 1970): 60–73.

2. See Christopher Kent Wilson, "Engraved Sources for Quidor's Early Work," *American Art Journal* 8 (November 1976): 22–23, where Joseph Wright of Derby's *The Earthstoppers on the Banks of the Derwent* of 1773 is cited as a source for this painting, even though there is no evidence that Quidor saw the picture nor is there any known print after Derby's painting.

3. See David M. Sokol, *John Quidor, Painter of American Legend* (Wichita Art Museum, Kan., 1973), cat.no.11.

PROVENANCE
Joseph Harrison, Jr., Philadelphia, by 1870; Harry Stone, 1912; Bernard Cone; Mrs. Sheldon Keck, Brooklyn, N.Y., by 1942; Mr. and Mrs. Alastair Bradley Martin, to 1948; to present owner, 1948.

EXHIBITION HISTORY
American Academy of the Fine Arts, New York, *Fifteenth Annual Exhibition*, 1833, cat.no.30.
The Newhouse Galleries, New York, *Second Annual Exhibition of American Genre Paintings Depicting the Pioneer Period*, 1933, cat.no.47.
The Corcoran Gallery of Art, Washington, D.C., *De Gustibus: An Exhibition of American Paintings Illustrating a Century of Taste and Criticism*, 1949, cat.no.1.
Brooklyn Museum, N.Y., *John Quidor*, cat. by John I. H. Baur, 1942, no.6.
Museum of Modern Art, New York, *Romantic Painting in America*, cat. by James Thrall Soby and Dorothy C. Miller, 1943, no.173 (ill.).
American Federation of Arts, New York, *American Painting of the 19th Century*, 1952 (traveling exhibition), cat.no.75.
Whitney Museum of American Art, New York, *American Painting in the 19th Century*, 1954, cat.no.49.
Newark Museum, N.J., *Classical America*, cat. by Berry B. Tracy and William H. Gerdts, 1963, cat.no.280.
Munson-Williams-Proctor Institute, Utica, N.Y., *John Quidor*, cat. by Baur, 1966 (traveling exhibition), no.6 (ill.).
Metropolitan Museum of Art, New York, *19th-Century America: Paintings and Sculpture*, cat. by John K. Howat and Natalie Spassky, 1970, no.41 (ill.).
Los Angeles County Museum of Art, *American Narrative Painting*, cat. by Nancy Wall Moure, 1974, no.16 (ill.).
Davis and Long Co., New York, *Masterpieces of American Painting from the Brooklyn Museum*, 1976 (traveling exhibition), cat.no.8 (ill.).

THOMAS COLE

(1801, Bolton-le-Moor, Lancashire, England —1848, Catskill, New York)

The artist who frequently has been called the father of American landscape painting emigrated from England with his parents at the age of eighteen. His artistic education was piecemeal. In Nottinghamshire he served an apprenticeship to a designer of calico prints, and he drew patterns for his father's paperhanging business in Steubenville, Ohio. There a portrait painter named Stein gave him some painting lessons, and Cole began working as an itinerant artist. When his family moved to Pittsburgh, he again assisted in his father's business, making landscape sketches in his free time. He subsequently moved to Philadelphia where for two years he supported himself and studied part-time at the Pennsylvania Academy.

In 1825 Cole arrived in New York City where he began painting landscapes exclusively. He quickly attracted the attention of New York artists and patrons with his direct and powerful representations of the Hudson River area. From 1829 to 1832 Cole traveled through England, France, and Italy, hoping that exposure to the Old Masters, contemporary artists, and European scenery would enrich his art. On his return to America, he settled in the town of Catskill, New York, and soon established himself as a leading figure in the New York art scene.

During the decade that followed, Cole focused his efforts upon his two most ambitious projects: The Course of Empire *(New-York Historical Society) and* The Voyage of Life *(cat. nos. 25–28). A second visit to Europe from 1841 to 1842 seems only to have reinforced Cole's desire to ennoble landscape painting by making it a vehicle for religious and allegorical messages. Cole's premature death was universally mourned in New York's artistic and literary circles. As poet and writer as well as painter, a founding member of the National Academy of Design, a friend and mentor to William Cullen Bryant, Asher B. Durand, and Frederic Edwin Church, Cole helped establish New York as the center for innovation in American landscape painting.*

The only biography of Cole is Louis Legrand Noble's Life and Works of Thomas Cole *(1853; Cambridge, Mass., 1964) published shortly after the artist's death. Major retrospective exhibitions of his work were mounted as a memorial to him in 1848 (American Art-Union, New York), on the centenary of his death in 1948 (Wadsworth Atheneum, Hartford, Conn.), and in 1969 (Memorial Art Gallery, University of Rochester, N.Y.). Matthew Baigell has published a brief monograph on the artist (New York, 1981). In the past two decades, however, the most extensive inquiries into Cole's art have appeared as scholarly articles and within studies of American landscape painting.*

mountains, plains, and various civilizations.[2] The details of the painting, however, are not consistent with the Norse emblem: Cole's vessel appears to be stone, not bark, and the buildings suggest classical, not Nordic, antiquity. Still, the idea that this represents earth as a ring of land around a circular sea is worth considering. It was the world much as classical antiquity had imagined it, and was probably the emblem Cole intended as he filled the goblet with temples and ships.

In part then, this picture has to do with cycles of death and life, with the relics of lost ages gradually being transformed by the accretions of time and nature. Indeed, ruin and renewal on a cosmic scale occupied Cole increasingly in the years that followed this work.[3] Equally important is the idea that civilizations have no awareness of the powerful process of regeneration they are part of, nor of the vastness of other worlds that lie beyond them.

D.S.

NOTES

1. See Ellwood C. Parry III, "*The Titan's Goblet*: A Reinterpretation," *Metropolitan Museum of Art Journal* 41 (1971): 123, 128–29.

2. See John M. Falconer, *The Titan's Goblet* (1886), cited in Howard S. Merritt, *Thomas Cole* (Memorial Art Gallery, University of Rochester, N.Y., 1969), pp. 29–30.

3. He developed such ideas to their fullest in landscape cycles of the mid and late 1830s, particularly his monumental *Course of Empire* (New-York Historical Society).

PROVENANCE

Luman Reed, 1833, returned to the artist; James J. Mapes, by 1834; John M. Falconer, Brooklyn, N.Y., by 1863; sold at Anderson Art Galleries, New York, 28 April 1904, no.407; purchased by Samuel P. Avery, Jr.; to present owner, 1904.

EXHIBITION HISTORY

National Academy of Design, New York, *Annual Exhibition*, 1834, cat.no.41.

Stuyvesant Institute, New York, *Exhibition of Select Paintings by Modern Artists*, 1838, cat.no.37.

Artists' Fund Society, New York, *Fourth Annual Exhibition*, 1863, cat.no.160.

Brooklyn Art Association, N.Y., *Chronological Exhibition of American Art*, 1872, cat.no.34.

Metropolitan Museum of Art and National Academy of Design, New York, *Loan Exhibition of Paintings*, 1880.

Museum of Modern Art, New York, *Fantastic Art, Dada, Surrealism*, cat. ed. Alfred H. Barr, Jr., 1936, no.70.

Wadsworth Atheneum, Hartford, Conn., and Whitney Museum of American Art, New York, *Thomas Cole, 100 Years Later*, cat. by Esther Seaver, 1948, no.23.

Corcoran Gallery of Art, Washington, D.C., *The American Muse*, 1959, cat.no.62.

Memorial Art Gallery, University of Rochester, N.Y., *Thomas Cole*, cat. by Howard S. Merritt, 1969 (traveling exhibition), no.27.

24

THOMAS COLE
The Titan's Goblet, 1833
Painted in New York City
Signed and dated lower right: *T. Cole 1833*
Oil on canvas, $19\frac{3}{8} \times 16\frac{1}{8}$ in. (49.3 × 41 cm.)
The Metropolitan Museum of Art, New York,
 Gift of Samuel P. Avery, Jr., 1904

During Cole's lifetime, his *Titan's Goblet* was consigned to the relative obscurity reserved for small and quickly painted pictures. The artist left no record that he had any preoccupation with it or ambitions for it, nor did critics lavish much attention upon the work when it was exhibited. Nevertheless, it has survived as Cole's most unusual and enigmatic landscape.

Cole painted the work after he returned from Italy. Accordingly, the scene reveals a vaguely Italian, placid, almost melancholy landscape which appears in the half-lit haze of dawn or dusk. From a high, distant point of view, the observer looks down upon a vista punctuated by mountains and cliffs. Inlets of water wind from background to foreground, reflecting the sunlight. A huge stone form resembling a goblet or fountain stands upon a cliff in the middle ground, dominating the scene. The goblet is simultaneously an alien object and very much at one with its surroundings. Dense foliage has encrusted its base and rim, and water has filled its bowl. Miniscule ancient cities have arisen around

the rim, and tiny boats sail offshore. Below, their counterparts sail the larger waterways, where similarly ancient buildings nestle along the shore.

This imagined terrain has both intrigued and puzzled critics. While an *American Monthly Magazine* reviewer dismissed the painting in 1834 as "merely and gratuitously fantastical," those same qualities earned it a place in a major exhibition of Surrealist painting at the Museum of Modern Art, New York, in 1936. The goblet's disturbing, mute presence suggests allegory, and indeed its intended meaning provoked speculation in Cole's century and afterward.

The interpretation now generally accepted reads the goblet as a relic from the age of the Titans of Greek legend, twelve giants who lived long before gods and men. The artist may have been inspired by the idea of giants inhabiting the landscape of J. M. W. Turner's *Ulysses Deriding Polyphemus*[1] which he saw while in Europe. Unlike Turner, however, Cole suggests a time after the giants' disappearance, when a lone artifact of this purportedly omnipotent race is being overrun by vegetation and gradually succumbing to time. Thus Cole used the myth to inject into the landscape a melancholy note on the passing of former ages and civilizations.

A different explanation of the painting's imagery was current in the later nineteenth century. The goblet was then thought to be Yggdrasil, the Norse tree of life, whose branches held a disclike ocean surrounded by

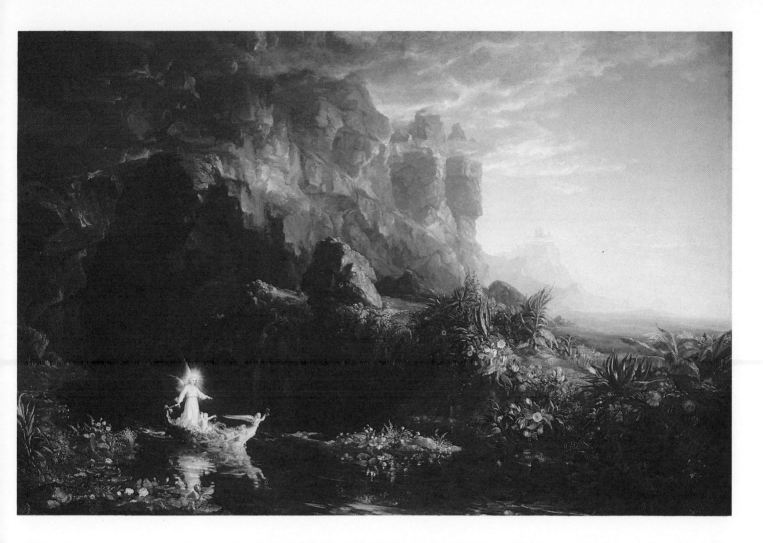

25

Thomas Cole
The Voyage of Life: Childhood, 1842
Painted in Rome
Signed and dated lower left: *1842/T. Cole/Rome*
Oil on canvas, $52\frac{7}{8} \times 76\frac{7}{8}$ in. (134.3 × 195.3 cm.)
National Gallery of Art, Washington, D.C.,
 Ailsa Mellon Bruce Fund, 1971

In many ways *The Voyage of Life* represented the culmination of Thomas Cole's quest to be a painter of heroic, monumental landscape. In Cole's time, it was his most acclaimed work and one of the best-known productions of any American artist.[1] It was the second epic landscape cycle the artist attempted, the first being the five-part *Course of Empire* which he exhibited in 1836. That same year he began planning *The Voyage of Life*. However, not until 1839 did Cole find a commissioner, the New York banker and collector Samuel Ward, who wanted a series from Cole in the style of the *Course of Empire* for a "meditation room" in his home.

The original *Voyage of Life* (Munson-Williams-Proctor Institute, Utica, N.Y.) was finished late in 1840 and exhibited in New York the same year. The brisk sale of engravings from it attested to the popularity of the series, so much so that Cole was encouraged to paint a replica of it. He produced his second version of the work while in Rome between November 1841 and April 1842. He had long felt that the size and strongly moralizing tone of such a series suited it best for public exhibition. Consequently, as soon as his second set was complete, Cole showed it in Rome at the Piazza del Popolo. After his return to the United States, it toured Boston and Philadelphia, and so it was through this second set that audiences outside New York were introduced to *The Voyage of Life*.

Cole's series moralizes on the four ages of man, using throughout the metaphor of a voyager on the river of life. In this first scene representing childhood, a small boat emerges from a womblike cave into a bright, softly lit and indistinct landscape. Between the boat's masthead of personified Hours and the Guardian Spirit at its rudder, an infant is nestled in a bed of flowers. In the other canvases of the series, boat and passenger become the leitmotif in a story told essentially by the metamorphosis of the colors and contours of the surrounding landscape. *D.S.*

NOTES

1. When Cole died, the series was exhibited in New York, where upward of 100,000 people went to see it. See Rev. Gordon D. Abbott, *Cole's Voyage of Life: A Series of Allegorical Pictures* (New York, 1860), p. 3.

PROVENANCE
Sold by the artist to George K. Shoenberger, Cincinnati, December 1844 or early 1845; to the estate of George K. Shoenberger, 1892; by sale to Ernst H. Huenefeld, Cincinnati, 1908; by gift to the Bethesda Hospital and Deaconess Association (Bethesda Home for the Aged), Cincinnati, 1908; to present owner, 1971.

EXHIBITION HISTORY
Piazza del Popolo, Rome, *Annual Exhibition*, 1842.
Harding's Gallery, Boston, *Boston Artists' Association Exhibition*, 1843.
Clinton Hall, New York, *National Academy of Design Annual Exhibition*, 1843–44.
Pennsylvania Academy of the Fine Arts, Philadelphia, 1844, cat.nos. 1–4.

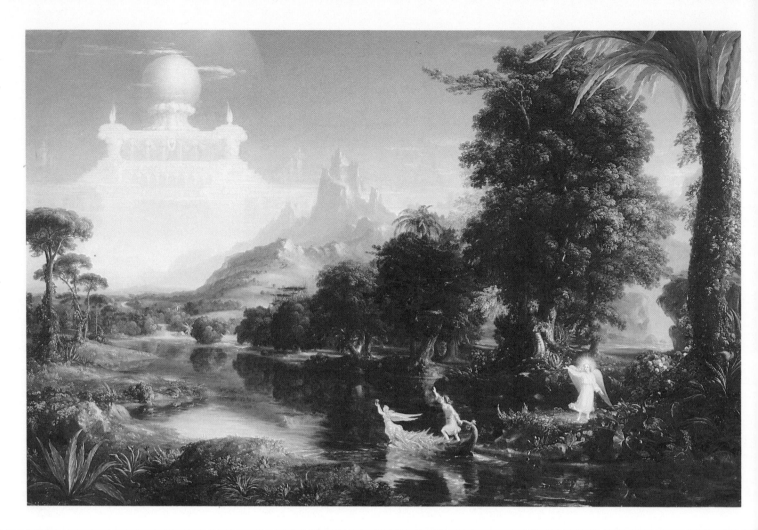

26

THOMAS COLE
The Voyage of Life: Youth, 1842
Painted in Rome
Signed and dated lower left: *Rome/1842/T. Cole*
Oil on canvas, $52\frac{7}{8} \times 76\frac{3}{4}$ in.
 (134.3×194.9 cm.)
National Gallery of Art, Washington, D.C.,
 Ailsa Mellon Bruce Fund, 1971

Voyage of Life: Youth became the best-known single image in Cole's series because tens of thousands of steel engravings of it were distributed in 1848 when the American Art-Union raffled off the first series from Samuel Ward's estate.[1] The picture shows that the infant of the first scene has become a young boy, who now takes hold of the boat's rudder himself. As his Guardian Spirit bids him farewell from the shore, the youth heads downstream, where he sees a clear sky, blue mountain peaks, and the faint apparition of a Moorish-style castle in the sky. All are brightly colored in accord with the goal that the youth so optimistically anticipates.

This particular scene is laden with images that Cole had already developed into a personal landscape symbolism. He previously used the architecture of past ages as an emblem for human ambition and wide calm rivers for idyllic perfection in his *Architect's Dream* (1840; Toledo Museum of Art, Ohio) and *The Course of Empire* (1836; New-York Historical Society). In the public exhibitions of *The Voyage of Life*, audiences were given a written guide to the interpretation of those symbols, but as this scene makes apparent, the allusions are akin to popular parables that need no special exegesis. *D.S.*

NOTES
 1. See Jay Cantor, "Prints and the American Art-Union," *Prints In and Of America to 1850*, Winterthur Conference Report 1970 (Charlottesville, Va., 1970), pp. 311–13.

Provenance and exhibition history: see cat. no. 25.

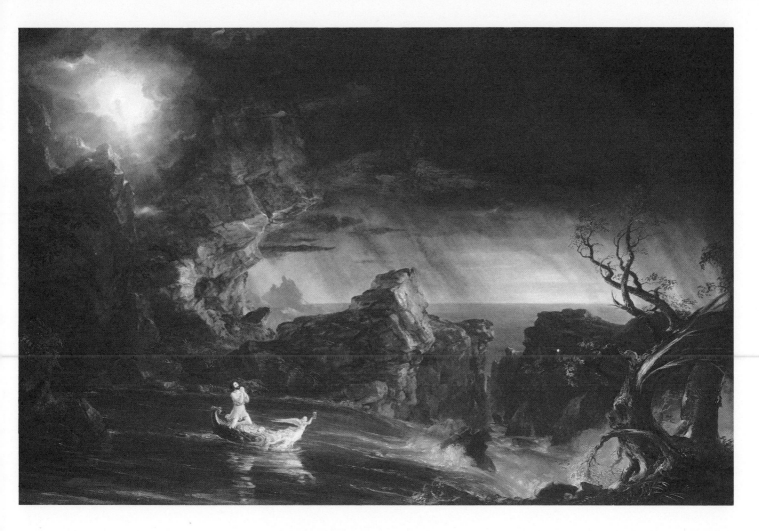

27

THOMAS COLE
The Voyage of Life: Manhood, 1842
Painted in Rome
Oil on canvas, $52\frac{7}{8} \times 79\frac{3}{4}$ in.
　(134.3×202.6 cm.)
National Gallery of Art, Washington, D.C.,
　Ailsa Mellon Bruce Fund, 1971

This third part of Cole's cycle shows a storm-blackened landscape and a rudderless boat leading its apprehensive passenger toward a cataract. The explanatory text that Cole prepared to accompany the painting emphasized the anguish characteristic of adulthood:

> *The swollen stream rushes furiously down a dark ravine, whirling and foaming in its wild career, and speeding toward the Ocean, which is dimly seen through the mist and falling rain. The boat is there, plunging amid the turbulent waters. The Voyager is now a man of middle age: the helm of the boat is gone, and he looks imploringly toward heaven, as if heaven's aid alone could save him from the perils that surround him. The Guardian Spirit calmly sits in the clouds, watching with an air of solicitude the affrighted Voyager. Demon forms are hovering in the air.*[1]

Only faith, Cole suggested, could save man from this metaphorical sea of troubles.

　The scene is suggestive of *The Deluge* in Poussin's epic landscape cycle of religious themes, *The Seasons* (1660–64; Musée du Louvre, Paris). Cole probably did not expect his American audience to see any parallel, but it may have been important to his self-esteem and his sense of artistic heritage to associate his creative progress with that of the undisputed master of heroic landscape painting.

　　　　　　　　　　　　　　　　D.S.

NOTES
　1. Quoted in Louis Legrand Noble, *The Life and Works of Thomas Cole*, ed. Elliott S. Vessell (1853; Cambridge, Mass., 1964), p. 216.

Provenance and exhibition history: see cat. no. 25.

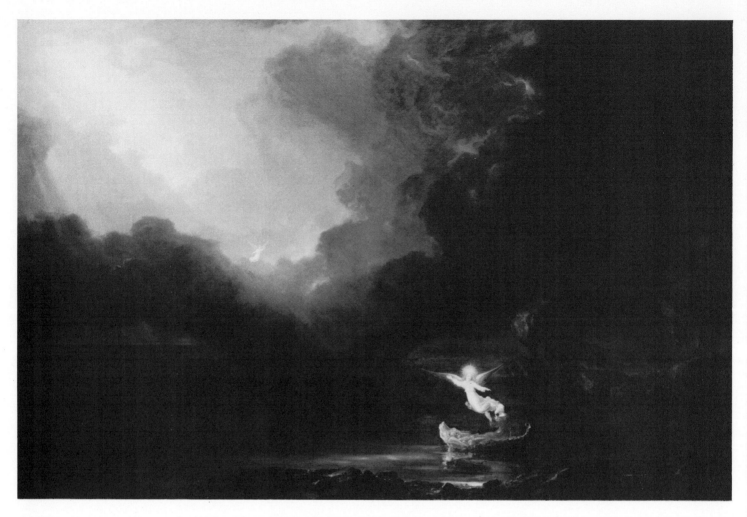

28

THOMAS COLE
The Voyage of Life: Old Age, 1842
Painted in Rome
Signed and dated bottom edge, left of center:
 T. Cole/1842; and right of center: *Rome*
Oil on canvas, $52\frac{1}{2} \times 77\frac{1}{4}$ in.
 (133.4 × 196.2 cm.)
National Gallery of Art, Washington, D.C.,
 Ailsa Mellon Bruce Fund, 1971

In the final scene in this series, the sky is still
dark, but the waters have calmed and the
voyager has reached the mouth of the river.
Although the masthead of Hours has long
broken off his boat, his Guardian Spirit has
returned to him, beckoning the voyager
toward his epiphany: a break in the clouds
where sunlight pours in from beyond. Cole
sprinkled throughout the series these and
other religious references that were well
known to his Protestant audience.[1] He
enhanced their legibility by combining them
with widely understood nature symbols.[2]

The key to the series' success was, in fact,
that it was so legible and that it satisfied many
artistic appetites at once. It was at the same
time a landscape, a religious painting, and
popular panorama, which could be "read" for
its story line but could also appeal directly to
the emotions. Cole understood that American
art audiences of the mid-nineteenth century
desired the trappings of high culture that
history paintings offered, but he also knew
that they did not necessarily want to be
reminded of their ignorance and lack of
historical tradition. What better way to
bridge this gap than with a lofty and
moralizing theme that could be understood
without an extensive literary background.

Although *The Voyage of Life* seems to have
been custom-made for an American audience,
it also struck a responsive note in Rome.
When the artist was putting the finishing
touches on this last painting of the series,
Bertel Thorvaldsen, Rome's preeminent
sculptor, visited his studio. Cole was highly
gratified with his older colleague's reaction to
the paintings:

> *He seized the allegory at once, and understood
> the whole intention of the artist. He said my
> work was entirely new and original in its
> conception, and executed in a masterly manner.
> He commended much the harmony of colour, and
> the adaptation of scenery and detail to the
> expression of the subject.*[3]

Works similar to Cole's series were enjoying
great popularity in other countries. In Britain,
for example, there existed the same public
demand for large, dramatic works constructed
around landscapes. Englishmen like John
Martin and Samuel Coleman were, around
1840, creating their own variants of *The Voyage
of Life* that likewise conveyed the power of
natural forces and the mystery of unknown
ages.

 D.S.

NOTES
 1. See Alan Wallach, "*The Voyage of Life* as
Popular Art," *Art Bulletin* 59 (June 1977).
 2. See Barbara Novak, *Nature and Culture:
American Landscape and Painting, 1825–1875* (New
York, 1980), p. 110.
 3. Journal entry, 20 March 1842, quoted in
Noble, *Life and Works of Cole,* p. 239.

Provenance and exhibition history: see cat.no.25.

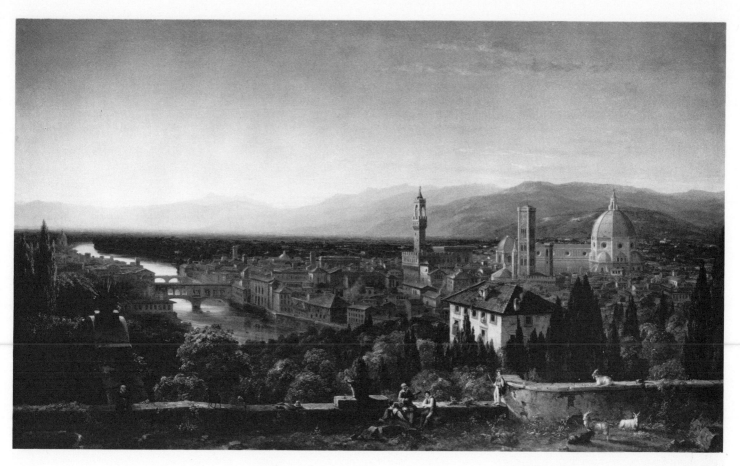

29

Thomas Cole
View of Florence from San Miniato, 1837
Painted in New York City
Signed lower right: *T C*
Oil on canvas, 39 × 63⅛ in. (99.1 × 160.3 cm.)
The Cleveland Museum of Art, Purchase,
 Mr. and Mrs. William H. Marlatt Fund
Exhibited in Boston and Washington only

Of all the cities on the Continent, Florence was the one Cole knew best. He lived there almost continually from the summer of 1831 to the early fall of 1832. He painted several oil sketches of the scenery around Florence's Arno River, and before he left Italy he made a detailed drawing (Detroit Institute of Arts) of the vista from San Miniato al Monte, a small church located outside the walls of Florence, whose promontory overlooking the city and reputation as Dante's church made it a favorite with tourists. Five years later in New York, Cole finally made this picture from his sketch. He apparently painted it on speculation, perhaps thinking that the popularity in America of Italian landscape and topographical views would assure him of a sale.

Cole gave his work some touches that transported it from merely a topographical view into a more ideal realm. In the foreground he placed figures associated with the pastoral tradition in landscape: to the left a monk, on the right a goatherd gazing at the river beyond, and in the center two ladies and a man listening to a minstrel. These figures were emblematic of meditation, a life lived in harmony with nature, and lyric poetry, respectively. Combined with the calm river and the late-afternoon sky, they encourage the viewer to see the painting as the poetic memory that this spot had become for Cole by 1837.

In his travels through Italy, Cole recorded

the distinctive features of the local landscape that differentiated it from the Hudson River area at home. He was especially attracted to the low Italian hills and wide valleys which created broad, uninterrupted vistas, the poplar trees that dotted the landscape, and the haze that extended along the Italian horizon. He was equally attracted to the arched, white masonry buildings of Italy, and the half-ruined walks and walls which gave the country's landscape the mark of continuous civilization. Italy was already the idealized realm *par excellence* for numerous generations of painters, and Cole's *View of Florence from San Miniato* is virtually a catalogue of its characteristic features.

The contrast between the Italian and North American landscapes intrigued Cole, and in the later 1830s he tended to alternate examples of each. For instance, the year before Cole painted this view of Florence he produced *The Oxbow* (Metropolitan Museum of Art, New York), a view of the Connecticut River seen from an adjacent hill. His views of the two continents could not have been more distinct. The American site is surrounded by rugged hills; the land shows no regular progression from foreground to background; colors are cool; forms are jagged and cast sporadically into shadow. The landscape around the Arno, on the other hand, is ordered in parallel planes; its colors are warm; its forms are softly lit, clear, and regular.

The simpler and more serene mood Cole projected here might seem at first to be at variance with the larger and more operatic cycles of allegorical landscape that had then become his preoccupation. Yet all these works convey the quiet reverie of an ideal realm essential to the vocabulary of feelings that Cole wanted landscape to speak.

<div align="right">D.S.</div>

PROVENANCE
Purchased from the artist by Mr. Hunt, Boston, 1839; Jonathan Mason, Boston, 1839; Edward James, New York, by 1848; Thomas P. Cushing, Boston, 1850; to present owner, 1961.

EXHIBITION HISTORY
National Academy of Design, New York, *Annual Exhibition*, April 1837, cat.no.39.
Boston Athenaeum, *Annual Exhibition*, 1839 (as *View on the Arno Near Florence*), cat.no.123.
American Art-Union, New York, *Exhibition of the Paintings of the Late Thomas Cole*, 1848, cat.no.33.
Boston Athenaeum, *Annual Exhibition*, 1850, cat.no.137.
Baltimore Museum of Art, *Thomas Cole, Painting by an American Romanticist*, 1965, cat.no.14.
Memorial Art Gallery, University of Rochester, N.Y., *Thomas Cole*, cat. by Howard S. Merritt, 1969 (traveling exhibition), no.32.
University of Kansas Museum of Art, Lawrence, *The Arcadian Landscape*, cat. by Charles Eldredge, 1972, no.12.

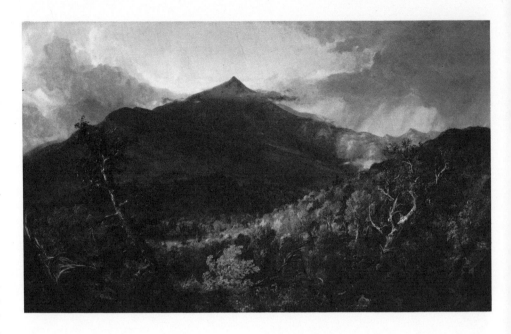

30

THOMAS COLE
Schroon Mountain, Adirondacks, 1838
Painted in Catskill, New York
Signed and dated lower left:
 T. Cole Catskill 1838
Oil on canvas, $39\frac{3}{8} \times 63$ in. (100×160 cm.)
The Cleveland Museum of Art,
 The Hinman B. Hurlbut Collection
Exhibited in Boston and Washington only

Despite Cole's forays into idealized, classical landscape during the 1830s, he never abandoned naturalistic depictions of local vistas, for his New York buyers continued to demand them. This painting was one such work. There is little evidence that the canvas was thought to be exceptional in any way in Cole's own time. Today, however, it is generally considered to be his most majestic depiction of the American wilderness, and to represent Cole at the height of his powers. The innovations that first characterized his Hudson River views—a comprehensive fidelity to natural phenomena and an ability to lend grandeur to native wilderness scenery—appear here in mature form.

The site Cole selected, Schroon Lake, was not near the town of Catskill, where he normally selected views for his landscapes, but farther north, in the Adirondack Mountains, near the source of the Hudson River. The area's terrain is the most mountainous in the state: the elevation ranges from 3500 to 5000 feet. Cole made two sketching trips to Schroon Lake, the first in October, 1835. He reported of this excursion:

> *The lake I found to be a beautiful sheet of water, shadowed by sloping hills clothed with heavy forests. . . . Two summits in particular attracted my attention: one of a serrated nature, and the other like a lofty pyramid. At the time I saw them, they stood in the midst of the wilderness like peaks of sapphire.*[1]

He visited Schroon Lake again in late June, 1837, accompanied by Asher B. Durand (q.v.). During that trip he commented,

> *The scenery . . . has a wild sort of beauty that approaches it: quietness—solitude—the world untamed . . . an aspect which the scene has worn*

thousands of years. . . . I do not remember to have seen in Italy a composition of mountains so beautiful or pictorial as this.[2]

The convincing realism of the work that resulted from his sketching trips attests to Cole's close observations of the scenery. But the work is also a re-creation of a distant memory: the red foliage is derived not from his more recent summer trip, but from his first sight of the place in the autumn two years earlier. The action of Cole's memory seems to have intensified the spiritual quality of this scene. Indeed, he intended a metaphorical meaning for *Schroon Mountain, Adirondacks*. The blasted tree in the foreground was a device, borrowed from Salvator Rosa, that Cole often used to suggest the inevitable destruction of living things. The autumn foliage adds to the effect: "The woods are glowing with strange beauty," he said in 1835, "but it is the hectic flush, that sure precursor of death."[3] He observed the eternal remoteness of the pyramid-shaped mountain, in contrast to the forest below, and may well have seen the peak as a metaphor for the incorruptible soul, victoriously rising through the clouds.

Cole's fondness for images from memory linked him to British theorists of the eighteenth century who developed the notion of the picturesque. Like those earlier proponents of landscape art, Cole believed in the analogy between landscape painting and poetry, and sought poetic inspiration in the local scenery. He also believed that an artist should present a general impression of nature and thus create a composition superior to any actually seen.[4]

Yet Cole's Romantic naturalism deviated considerably from older compositional precepts. The theorists of the previous century emphasized pleasant views, ordered by formulaic divisions into light and dark areas and made "accessible" to the viewer by roads and paths leading from foreground to background. Most previous views of American scenery tended to follow this formula. In contrast, Cole's American views emphasized meteorological effects and often obscured the legibility of the topography with deep and unexpected shadows or large trees looming in the foreground. In *Schroon Mountain, Adirondacks*, Cole emphasized the remoteness of the scene, and his high point of view impairs the audience's imagined access to it. For the viewer, the result is a more powerful confrontation with nature's forces than any previous American painter had provided.

D.S.

NOTES

1. Quoted in Louis Legrand Noble, *The Life and Works of Thomas Cole*, ed. Elliott S. Vessell (Cambridge, Mass., 1964), p. 151.

2. Ibid., p. 177.

3. Ibid., p. 151.

4. See Alan Wallach, "Thomas Cole's British Esthetics and American Scenery," *Artforum* 7 (October 1969): 47.

PROVENANCE

Dr. George Ackerly, New York, 1838; for sale, 1839, by Emma Ackerly; J. S. Chapman, New York, by 1849; purchased by Nicholas M. Matthews, Baltimore, from the American Art Association, 1914; with Holland Galleries, New York, 1917; to present owner, 1917.

EXHIBITION HISTORY

National Academy of Design, New York, *Annual Exhibition*, 1838, cat. no. 20 (as *Schroon Mountain, Essex County New York, After a Storm*).

Stuyvesant Institute, New York, 1838, cat. no. 38.

Apollo Association, *January Exhibition*, 1839, cat. no. 263.

American Art-Union, New York, *Exhibition of the Paintings of the Late Thomas Cole*, 1848, cat. no. 75.

The Picture Gallery, Maryland Historical Society, Baltimore, *Second Annual Exhibition*, 1849, cat. no. 199.

Whitney Museum of American Art, New York, *A Century of American Landscape Painting, 1800–1900*, cat. by Lloyd Goodrich, 1938, no. 20.

Carnegie Institute, Pittsburgh, *A Century of American Landscape Painting*, cat. by Goodrich, 1939, no. 59.

Albany Institute of History and Art, N.Y., *The Works of Thomas Cole, 1801–1848*, 1941.

Art Institute of Chicago, *The Hudson River School and the Early American Landscape Tradition*, cat. by Frederick A. Sweet, 1945 (traveling exhibition), no. 48.

Wadsworth Atheneum, Hartford, Conn., and Whitney Museum of American Art, New York, *Thomas Cole, 1801–1848: One Hundred Years Later*, cat. by Esther Seaver, 1948, no. 22.

Memorial Art Gallery, University of Rochester, N.Y., *Thomas Cole*, cat. by Howard S. Merritt, 1969 (traveling exhibition), no. 35.

Albright-Knox Art Gallery, Buffalo, N.Y., *Heritage and Horizon: American Painting 1776–1976*, 1976 (traveling exhibition), 8.

ASHER B. DURAND
(1796, Maplewood, New Jersey
—1886, Maplewood)

Born in what was then Jefferson Village, Asher Durand learned the engraver's trade in his father's watchmaking and silversmith shop. In 1817 he became partner to the engraver who apprenticed him. For the next fifteen years, working in Newark, New Jersey, and then in New York City, he enjoyed high esteem in his profession, executing such major projects as the engraving of Trumbull's Declaration of Independence in 1820 and Vanderlyn's Ariadne *(cat. no. 19) in 1835. He began painting in the 1830s, turning at the end of the decade from portraits and genre scenes to landscapes, which were substantially influenced by his friend Thomas Cole (q.v.). Durand thus came late to his ultimate vocation; only in 1840 did he make the requisite painter's tour through Europe. But from that time on he was counted among America's major landscape artists.*

Durand's landscapes ranged from shady forest interiors to sunlit pastoral views. Meticulous rendering of a subject was characteristic of his style, and he came to advocate the Ruskinian notion that artists should be sensitive even to nature's smallest detail. An advocate of painting and sketching out-of-doors, Durand was instrumental in leading younger artists toward a straightforward naturalism that marked American landscape painting in the 1850s and 1860s. His "Letters on Landscape Painting" appeared frequently in The Crayon, *a short-lived (1855–61) but influential art journal edited by his son, John. Along with Cole, Durand was a founding member of New York's National Academy of Design and served a lengthy term as its president from 1845 to 1861.*

In 1894 John Durand published an extensive account of his father's career, The Life and Times of A. B. Durand. *More recently, David B. Lawall has written widely on Durand's art. His contributions include* Asher B. Durand: A Documentary Catalogue of the Narrative and Landscape Paintings *(New York, 1978). The Montclair Art Museum, New Jersey, mounted Durand's largest retrospective exhibition,* A. B. Durand, 1796–1886 *(catalogue by Lawall) in 1971.*

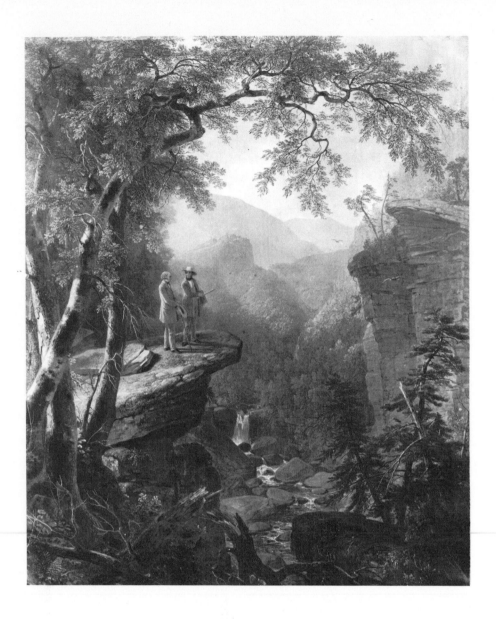

published in 1830 by the New York based art association, the Sketch Club. Bryant frequently championed Cole's work in print, and both men in their own way were nature poets, equally inspired by the American landscape, especially the Hudson Valley.

In this painting, Durand placed Cole and Bryant deep in the type of landscape they loved so much. They stand conversing on a rocky ledge overlooking a mountain gorge, completely engulfed by a wilderness that, although imaginary, resembled areas of the Catskill Mountains.[3] It is the painter, sketchbook and chalk in hand, who appears to introduce the location to the poet. The landscape is rendered in Durand's characteristic style. Its composition is dense with detail, yet is softened by a warm haze in the distance. Cole and Bryant are, to the viewer's eye, almost lost in nature's overgrowth. Yet the two men are completely identified with their surroundings: explicitly, their names are carved into a tree on the left.

By highlighting the sublime and picturesque qualities of this landscape, Durand lets the viewer perceive it as Cole and Bryant might have. The cataracts in the distance, the dark forests and high mountains beyond, and the precipice from which the painter and poet overlook the land had, since the eighteenth century, embodied the sublime in landscape. In addition, the broken branches, ragged leaves, and other natural irregularities visible in the middle ground had been, for an equally long time, part of the picturesque tradition in poetry and painting. But Durand revitalized these old devices by putting them to a new use. Here these features emphasize nature's all-encompassing and ever repeating cycles of rebirth, which had been so much a part of Cole's pantheism.

Thus the meaning of the work has to do with landscape's promise of spiritual sustenance and renewal of life. Even the blasted tree trunk at the lower left, an emblem of the ravages of time used frequently by Cole himself, sprouts new saplings. In the opening and closing passages of his funeral oration, Bryant alluded to the woodland haunts Cole frequented, and lamented how hollow and desolate they would be without him. It seems that Durand's painting soothed Bryant's sense of loss by showing Cole's spirit restored to its adopted home.[4]

D.S.

31

ASHER B. DURAND
Kindred Spirits, 1849
Painted in New York City
Signed and dated on base of precipice:
A. B. Durand / 1849
Oil on canvas, $44\frac{1}{8} \times 36\frac{1}{16}$ in.
(112.1×91.6 cm.)
The New York Public Library, Astor, Lenox and Tilden Foundations

Kindred Spirits was Durand's best-known and most celebrated work from the time it was first exhibited in 1849. He painted it as a memorial to Thomas Cole (q.v.), whose untimely death occurred the previous year. A longtime patron of Durand, Jonathan Sturges, commissioned the picture which he presented to the poet William Cullen Bryant in appreciation for the funeral oration Bryant had delivered for their mutual friend. The painting arrived with this note: "Soon after you delivered your oration on the life and death of our lamented friend Cole, I requested Mr. Durand to paint a picture in which he should associate our departed friend and yourself as kindred spirits."[1]

The members of this circle had long been mutual admirers.[2] Bryant had known Cole since 1829, and they had taken a summer's trip to the Catskills together in 1841. Along with Durand, they collaborated on *The American Landscape,* a collection of vignettes

NOTES

1. Quoted in Parke Godwin, *A Biography of William Cullen Bryant*, 2 vols. (New York, 1883), 2: 37.

2. See Holly Joan Pinto, *William Cullen Bryant and the Hudson River School of Landscape Painting* (Nassau County Museum of Fine Art, Roslyn, N.Y., 1981), pp. 6–7.

3. The steep ledge resembled, for example, a then-popular landmark called "the devil's pulpit."

4. See David B. Lawall, *Asher Brown Durand: His Art and Art Theory in Relation to His Times* (New York, 1977), p. 519.

PROVENANCE

Presented by Jonathan Sturges to William Cullen Bryant, February 1849; in possession of Parke Godwin, Bryant's biographer, New York, 1854; Miss Julia Bryant, daughter of William Cullen Bryant, 1887; to present owner, 1904.

EXHIBITION HISTORY

National Academy of Design, New York, *Annual Exhibition*, 1849, cat.no.180. .

Museum of Modern Art, New York, *Romantic Painting in America*, cat. by James Thrall Soby and Dorothy C. Miller, 1943, no.10.

Tate Gallery, London, *American Painting from the 18th Century to the Present Day*, 1946.

Wadsworth Atheneum, Hartford, Conn., and Whitney Museum of American Art, New York, *Thomas Cole, One Hundred Years Later*, cat. by Esther Seaver, 1948, no.50.

National Academy of Design, New York, *Memorabilia, 1800–1900*, 1954, cat.no.10.

Detroit Institute of Arts, *Painting in America: The Story of 450 Years*, cat. by Edgar P. Richardson, 1957, no.82.

Corcoran Gallery of Art, Washington, D.C., *The American Muse*, 1959.

American Federation of Arts (traveling exhibition), 1961–63.

Minneapolis Institute of Arts, *Four Centuries of American Art*, cat. by Marshall Davidson, 1963.

City Art Museum, St. Louis, *Two Hundred Years of American Painting*, cat. by Merril C. Rueppel, 1964, no. 13.

National Collection of Fine Arts, Smithsonian Institution, Washington, D.C., *American Landscape: A Changing Frontier*, cat. by David W. Scott, 1966, no. 11.

Whitney Museum of American Art, New York, *Art of the United States: 1670–1966*, cat. by Lloyd Goodrich, 1966, no.78.

Musée des Beaux-Arts, Montreal, *The Painter and the New World*, 1967, cat.no.346 (ill.).

Metropolitan Museum of Art, New York, *19th-Century America: Paintings and Sculpture*, 1970, cat. by John K. Howat and Natalie Spassky, no.62.

Montclair Art Museum, N.J., *A. B. Durand, 1796–1886*, cat. by David B. Lawall, 1971, no.56.

New York State Museum, Albany, *New York: The State of Art*, cat. by Courtney Sale et al., 1977, no.28.

FITZ HUGH LANE

(1804, Gloucester, Massachusetts
—1865, Gloucester)

Fitz Hugh Lane is now regarded as the preeminent American marine painter, though in his own day he won only a modest local reputation. Born in the fishing port of Gloucester, Massachusetts, the son of a sailmaker, Lane was crippled early in life and moved only with the aid of crutches. Like John Frederick Kensett and other painters of his generation, he was trained as a printmaker, and he spent the first part of his career making lithographic topographical views, trade cards, sheet music covers, and the like. From 1832–37 he worked in Boston as an apprentice to William S. Pendleton's successful lithography firm, producing in 1835 the first of nearly sixty prints; he later joined the firm of Keith and Moore, and in 1845–47 operated a printmaking partnership with the Boston artist J. W. A. Scott (1815–1907).

Lane began to paint seriously in the early 1840s. Influenced by the work of the talented English-trained marine painter Robert Salmon (1775–c. 1845), who had lived in Boston from 1828 to 1842, he painted a complex ship picture in 1845, Yacht 'Northern Light' in Boston Harbor (Shelburne Museum, Vt.). He exhibited his work at the Boston Athenaeum in 1841, 1845, and regularly thereafter, and in 1848 sold the first of several pictures to the American Art-Union, on this occasion receiving favorable reviews in the New York press. Encouraged by his success, Lane moved back to Gloucester permanently in 1849, in order to concentrate on painting rather than printmaking, and his painting style began to mature.

Lane made the first of many trips to Maine about 1848 and in 1850 went by ship to New York and Baltimore, painting views of both harbors. He sailed regularly along the Eastern coast, painting ship portraits, harbor views, yacht races (including the first America's Cup Race in 1851), landscapes, storms, and empty coastal scenes. His favorite subjects were the harbors of Gloucester and Boston, and the islands and inlets of Penobscot Bay in Maine. By 1860 his painting reached full development with such works as Ships and an Approaching Storm off Owl's Head, Maine (Coll. John D. Rockefeller IV): eliminating the incidental, he concentrated in his last years on works of great clarity, subtle colors, and poetic, empty mood. Though Lane enjoyed a good local reputation and regular patronage, his work never reached the attention of the major collectors and critics of his time. He was quickly forgotten after his death, and interest in the artist revived only in the 1940s.

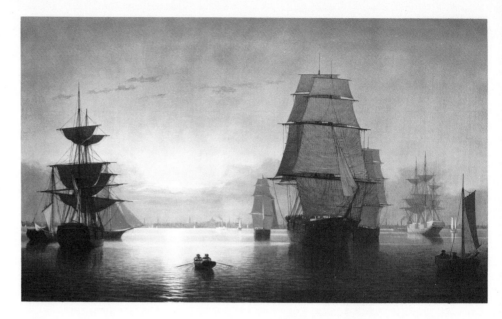

32

FITZ HUGH LANE
Boston Harbor, Sunset, 1850–55
Painted in Boston
Oil on canvas, 24 × 39¼ in. (61 × 99.7 cm.)
Jo Ann and Julian Ganz, Jr.

The earliest treatments of Lane were in the catalogue of the M. and M. Karolik Collection of American Paintings, 1815–1865 (Museum of Fine Arts, Boston, 1949), and in several essays by John I. H. Baur. John Wilmerding wrote a short monograph in 1964, organized the first exhibition of Lane's work in 1966 (De Cordova Museum, Lincoln, Mass.) and prepared a more comprehensive study in 1971. The largest collection of Lane's work is catalogued in Paintings and Drawings by Fitz Hugh Lane at the Cape Ann Historical Association (Gloucester, Mass., 1974).

America's major commercial harbors—Salem, New York, Boston—were a recurrent theme in Lane's painting during the early 1850s. In these works he began to explore paths of expression that set him apart from previous marine painters. Three pictures from this period form a particularly interesting group, since they appear to have been painted in sequence, even though they were not exhibited or sold together.

They show Boston harbor in calm weather at the end of day, from a vantage point deep in the harbor looking toward a distant city skyline on shore. Progressing from the first scene to the third, one can observe nightfall approaching. Dappled golden clouds of the late-afternoon sky in the first harbor scene (Amon Carter Museum, Fort Worth, Tex.) give way to the pink sky of early dusk in a second picture (Museum of Fine Arts, Boston), which in turn yields to a suffusive deep blue characteristic of the final moments of sunset in this, the third view. In the same three scenes, Lane showed the waterway gradually emptying itself of its daily traffic of steamboats, ferries, and small fishing vessels until only the largest ships remain, standing silently at anchor.

Throughout his life, Lane pursued the themes and variations of a limited range of visual material, as these particular views indicate. He was especially interested in the nuances that give character to a scene. The faint change of tint in a clear sky was more important to him than stormy seas or turbulent clouds. Lane also began simplifying his compositions, perhaps in order to render those subtleties visible. Among his three Boston harbor pictures, this final canvas is purest of all; its geometry of vertical ships' masts against an uninterrupted horizon line is almost austere.

In this way Lane arrived at a depiction quite different from those then standard in American marine painting, which portrayed the anecdote and bustle associated with commerce. The bareness and utter stillness of this harbor view make it instead startlingly similar to some earlier European Romantic paintings—which in all likelihood Lane never saw—such as Caspar David Friedrich's *View of a Harbor* (c.1815; Schloss Charlottenhof, Pottsdam).[1] Lane's composition also looks further back, to the crowded, calm harbor scenes by the mid-seventeenth-century Dutch master, Jan van de Cappelle (1624/6–1679).[2]

Finally, Lane's *Boston Harbor* is idyllic, calm, and heroic, with the great sailing ships representing both a picturesque past—the great age of sail—and the prosperous commercial present. The steamboat that cuts across the right background is barely visible, though Lane may have sensed that it represented the future and meant the end of the majestic sailing ships he loved so much.

<div align="right">D.S.</div>

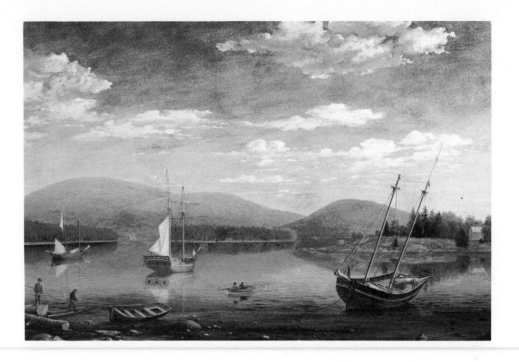

NOTES

1. See Theodore E. Stebbins, Jr. "Luminism in Context: A New View," in *American Light: The Luminist Movement 1850–1875* (National Gallery of Art, Washington, D.C., 1980), p. 221.

2. See Barbara Novak, *Nature and Culture* (New York, 1980), pp. 232–33. In addition, the 1971 exhibition *The Shock of Recognition: The Landscape of English Romanticism and the Dutch Seventeenth-Century School* at the Tate Gallery, London, and the Mauritshuis, The Hague, established that the appreciation of Dutch landscape painting was not merely an eighteenth-century British fashion, as Novak states, but continued to inspire British painters through the 1840s.

PROVENANCE
Mrs. Malcolm E. Smith and Mrs. William Hoffman, Rhinebeck, N.Y.; with Parke Bernet Galleries, Inc., New York, 1962; with Kennedy Galleries, New York; Mr. and Mrs. Bronson Trevor, New York, 1965–1971; with Hirschl and Adler Galleries, New York, 1976; to present owner, 1976.

EXHIBITION HISTORY
Possibly Boston Athenaeum, *Annual Exhibition*, 1858, cat.no.232.
Possibly Boston Athenaeum, *Annual Exhibition*, 1864, cat.no.247.
Metropolitan Museum of Art, New York, *Three Centuries of American Paintings: Collection of Mr. and Mrs. Bronson Trevor*, 1965.
National Gallery of Art, Washington D.C., *An American Perspective: Nineteenth Century Art from the Collection of Jo Ann and Julian Ganz, Jr.*, cat. by John Wilmerding et al., 1982 (traveling exhibition), no.7.

33

FITZ HUGH LANE
Somes Harbor, Maine, c. 1850
Painted in Gloucester, Massachusetts
Oil on canvas, 20⅛ × 30⅛ in. (51.5 × 76.5 cm.)
Erving and Joyce Wolf

During the late 1840s, Lane began a distinctive series of harbor views that grew out of his experience as a printmaker. These views are typically marked by a horizontal foreground beach, on which men work fixing dories, chopping wood, and the like, a calm harbor with boats and men in various positions, and towns or hills in the distance. An early example, *Gloucester Harbor* of 1847 (Cape Ann Historical Association, Gloucester, Mass.), is crammed with detail and reveals Lane's experience as a lithographer. A painting of the same harbor the next year (Virginia Museum of Fine Arts, Richmond) shows a marked advance: though genre elements remain strong, the composition has been clarified, and there is an improved sense of warm light unifying the whole. In *Somes Harbor, Maine* the artist brings this early series to a climax: retaining the use of foreground figures, within an enclosed, topographically detailed harbor, Lane bathes the whole scene with a clear and believable light and creates a tender mood.

During most of the summers between 1848 and 1855, the painter and a group of friends took pleasure cruises from Gloucester "Down East" to Maine, then as now a mecca for sailors. In 1850 the cruise took place in August, and in a drawing Lane records the scene he later painted, calling it *View of Bar Island and Mount Desert Mountains from the Bay in Front of Somes Settlement* (Cape Ann Historical Association, Gloucester, Mass.) and noting the names of his companions, Tildin, Adams, and Joseph L. Stevens, Jr., a close friend with whom Lane sailed frequently, as well as the name of their chartered ship, the *General Gates*, and its pilot, Captain Getchell from Castine,

Maine.[1] In the painting one sees the *General Gates* in the distance to the left of center, under the lee of Bar Island, while just to the right of it on shore is the travelers' tent and campfire. In the foreground are two small lumber schooners, both empty and riding high out of the water, which together with the logs on the beach at the left remind us of Maine's prosperous lumber trade. In the left distance stands Cadillac Mountain, then known as Burnt Mountain, the highest of the peaks on the island.

Joseph Stevens wrote of his and Lane's anticipation at seeing Mt. Desert Island in a newspaper article he completed a few weeks after returning: "this supposed barren and desolate place can boast of scenery so grand and beautiful as to be unsurpassed by any on the whole American coast."[2] He wrote enthusiastically of Somes Sound, "a great gorge seven miles into the heart of the island," the only American fjord, and of the small and protected Somes Harbor which lies at the top of it. He noted also the attraction of the place for artists, commenting that Alvan Fisher, John F. Kensett, and Frederic E. Church were all in the vicinity. In earlier years, Thomas Cole, Thomas Doughty, and other founders of the landscape school had also found their way to Mt. Desert Island.

Lane's painting, like Church's *Mt. Ktaadn* of 1853 (cat. no. 36), represents Maine not simply as powerful wilderness but as a place where the commercial and the pastoral coexist in a perfect state. In *Somes Harbor* fishermen and yachtsmen counterbalance unseen lumbermen and commercial sailors: neither poses a threat to the other in this uniquely bountiful, calm moment.

T.E.S.

NOTES

1. See *Paintings and Drawings by Fitz Hugh Lane at the Cape Ann Historical Association* (Gloucester, Mass., 1974), no. 111.

2. *Gloucester Daily Telegraph*, 11 September 1850, quoted in John Wilmerding, *Fitz Hugh Lane* (New York, 1971), p. 53.

PROVENANCE

The artist to Edward D. Peters, Jr.; his son, William Y. Peters, Boston; his daughter, Amey Peters Amory Ketchum, Brookline, Mass.; Estate of Amey P. A. Ketchum; to present owner, after 1971.

EXHIBITION HISTORY

De Cordova Museum, Lincoln, Mass., and Colby College Art Museum, Waterville, Maine, *Fitz Hugh Lane: The First Major Exhibition*, cat. by John Wilmerding, 1966, no. 24.

William A. Farnsworth Library and Art Museum, Rockland, Maine, *Fitz Hugh Lane, 1804–1865*, 1974, cat. no. 20.

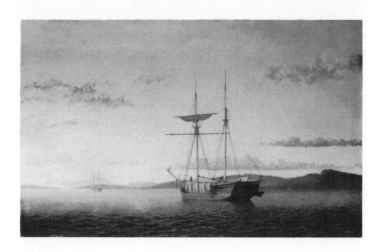

34

FITZ HUGH LANE
Lumber Schooners at Evening on Penobscot Bay, 1860
Probably painted at Castine, Maine
Signed and dated lower right: *F. H. Lane / 1860*
Oil on canvas, $24\frac{5}{8} \times 38\frac{1}{8}$ in. (62.6 × 96.8 cm.)
National Gallery of Art, Washington, D.C., Andrew W. Mellon Fund, and Gift of Mr. and Mrs. Francis W. Hatch, 1980

In the last five years of his life, Lane's compositions became more inventive and less dependent upon earlier pictorial conventions. *Lumber Schooners* suggests the beginning of a new approach in which Lane was less concerned with gathering different objects into his scene than with the asymmetrical balance of a few forms in a delicately colored, starkly empty space. In spite of its title, *Lumber Schooners* is no longer a document of commercial shipping. Lane shifted his interest from man's structures and activities to nature's, and in particular to the fleeting atmospheric effects one can perceive in the painting, such as the high clouds touched with the sunset's glow, and the translucent water and sky suffused with clear blues and pale raspberry reds.

A sensitivity to the intangible qualities in a landscape and a preference for structured, panoramic compositions were characteristic of what has been called the "classic phase" of Luminism that prevailed in the decade after 1855.[1] Lane may have come to appreciate these pictorial qualities as a result of his awareness of the work of Frederic Edwin Church and Martin Johnson Heade (q.v.).[2] The former was a summer visitor to Penobscot Bay, and the latter had exhibited his work along with Lane's at the Boston Athenaeum in 1857 and 1859. It is possible that Lane began to incorporate features of Church's and Heade's styles into his work, just as they may have been affected in turn by Lane's art.

Yet Lane did not try for the meticulous naturalism of his contemporaries. His atmospheric effects did not take on the variety and greater substance characteristic of Church's and Heade's. Instead Lane continued to incline toward purely colored, evenly lit skies (encouraged partly by the recent availability of brighter, cadmium-based paints), and precisely drawn contours. Only the most tentative impasto disturbs the thinly painted surface of *Lumber Schooners*. As a result, there is an insubstantiality to the illusionism of the painting, and a frozen quiet that to late-twentieth-century eyes is peculiarly moving. Indeed, it has been labeled as one of Lane's most poetic and melancholic twilight pictures.[3]

D.S.

NOTES

1. See John Wilmerding, "The Luminist Movement: Some Reflections," in Wilmerding et al., *American Light: The Luminist Movement 1850–1875* (National Gallery of Art, Washington, D.C., 1980), p. 108.

2. See Theodore E. Stebbins, Jr., *The Life and Works of Martin Johnson Heade* (New Haven, Conn., 1975), p. 66.

3. See Wilmerding, *Fitz Hugh Lane* (New York, 1971), p. 76.

PROVENANCE

With Harvey Additon, Boston, until about 1940; Mr. and Mrs. Francis W. Hatch, Sr., c. 1940–1980; to present owner.

EXHIBITION HISTORY

De Cordova Museum, Lincoln, Mass., and Colby College Art Museum, Waterville, Maine, *Fitz Hugh Lane: The First Major Exhibition*, cat. by John Wilmerding, 1966, no. 48.

Cummer Gallery of Art, Jacksonville, Fla., and Norfolk Museum of Arts and Sciences, Va., *American Paintings of Ports and Harbors*, 1969, cat. no. 19.

The William A. Farnsworth Library and Art Museum, Rockland, Maine, *Fitz Hugh Lane, 1804–1865*, 1974, cat. no. 43.

National Gallery of Art, Washington, D.C., *American Light: The Luminist Movement, 1850–1875*, cat. by John Wilmerding et al., 1980, no. 1.

35

FITZ HUGH LANE
Owl's Head, Penobscot Bay, Maine, 1862
Probably painted at Castine, Maine
Signed and dated on back:
 Owl's Head—Penobscot Bay, by
 F. H. Lane, 1862.
Oil on canvas, 16 × 26 in. (40.6 × 66 cm.)
Museum of Fine Arts, Boston,
 M. and M. Karolik Collection

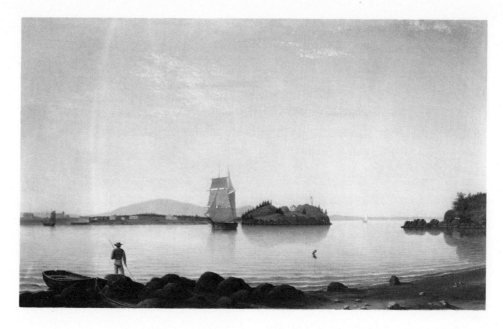

Owl's Head is probably Lane's best-known work and has often been considered the archetypal Luminist picture. It is a painting that presents the culmination of his artistic innovations, but even more, it reveals the traits that make his paintings so distinctive. Those who have written on Luminism in the past two decades have emphasized the limited color range of *Owl's Head*, its barely noticeable brushwork, its extreme horizontality, and its organization into simple bands of sky, water, and land.[1] The result is an evocative simplicity that has caused Lane's work to be described as "spiritual."[2]

Lane found that poetic vision partly in earlier art, and thereby remained tied to the previous artistic generation and its approach to subject matter. He appears to have taken Claude-Joseph Vernet's twilight port scenes, such as *Evening* (1753; Toledo Museum of Art, Ohio) as his point of departure. He borrowed Vernet's crepuscular light, his crescent-shaped strip of foreground, his stylized, almost decorative staffage figures, his faintly rendered backgrounds, and his tendency to cut forms into sharp silhouettes.

Yet Lane greatly simplified his own version of the idyllic harbor view in virtually every detail. The viewer looks out onto a contemporary harbor town with its commercial traffic but sees few props in the foreground and background that would preoccupy one with thoughts of daily affairs. Instead there is a single boatman gazing at a seemingly unpopulated bay. Lane removed the intentional obscurity characteristic of traditional idyllic landscapes—the distinctive profile of Owl's Head, with its tiny lighthouse, is clearly silhouetted against the evening sky—and substituted concise shapes, precise contours, and clear contrasts of tone that bring the picture into sharper focus.

There has been much speculation as to why Lane would have pursued this kind of reduction. It has been suggested that he was inspired to mirror the peculiar cool crispness of Maine's late-summer weather.[3] Another theory proposes that self-taught artists, particularly those who rely upon mechanical drawing tools and conventions, naturally tend to simplify shapes and trace them onto surfaces.[4] According to yet another hypo-thesis, Lane was able to make his observations at once more rational and more ideal by careful measurement and by eliminating the superfluous.[5]

The geometric clarity and simplicity that set Lane's work apart from idyllic landscape of the previous century bound him to the nineteenth-century Romantic view of nature. In *Owl's Head* nature is a presence which envelops and transfixes the solitary boatman, but the picture that presents this vision retains the modest format and a bit of the decorative appeal of an earlier era.

D.S.

NOTES

 1. See e.g., Barbara Novak, *American Painting of the Nineteenth Century* (New York, 1969), p. 121, and Theodore E. Stebbins, Jr., *The Life and Work of Martin Johnson Heade* (New Haven, Conn., 1975), p. 108.
 2. Gene E. McCormick, "Fitz Hugh Lane, Gloucester Artist 1804–1865," *Art Quarterly* 15 (Winter 1952): 295.
 3. John Wilmerding, *Fitz Hugh Lane, American Marine Painter* (Salem, Mass., 1964), p. 15.
 4. Novak, *American Painting of the Nineteenth Century,* p. 110; Lisa Fellows Andrus, *Measure and Design in American Painting* (New York, 1977), pp. 206–85.
 5. Novak, *American Painting of the Nineteenth Century,* p. 117–20.

FREDERIC EDWIN CHURCH

(1826, Hartford, Connecticut
—1900, New York City)

The son of a Hartford businessman, Church received his first artistic training from two local painters, Benjamin H. Coe and Alexander H. Emmons. Aided by Hartford's leading patron of the arts, Daniel Wadsworth, he moved to Catskill, New York, in 1844 to spend two years as the pupil of Thomas Cole. (q.v.). In 1845 Church began to exhibit landscapes and a few historical pictures in New York City, and he took a studio there in 1846. He was elected to the National Academy in 1849, becoming its youngest associate, after the successful debut there of West Rock, New Haven (New Britain Museum of American Art, Conn.) and the following year became a full member. By the early 1850s he was painting native scenery exclusively, rendering sparkling American vistas with what one critic called "daguerrotype accuracy." The comprehensive vision of his first mature landscapes had an objective character in comparison with the full-blown Romanticism of Cole, and their detailed foregrounds reflected the influence of Ruskin's recent theories.

In 1853 Church became the first American artist to paint on location in the Andes Mountains of Colombia and Ecuador. Back in New York, he began a popular series of large paintings of this exotic region based on the sketches he had made there. He continued to paint North American landscapes as well, especially Niagara Falls and scenes in Maine, but he returned to South America for new inspiration in 1857. In 1859 he voyaged to Labrador to prepare for the enormous painting The Icebergs (cat. no. 44). Subsequent sketching tours included Jamaica (1865) and Europe and the Near East (1867–68). The major paintings resulting from these journeys were intended as composites of botanical, geological, and meteorological perceptions of landscape, as well as poetic and spiritual impressions of the places he visited. They were often exhibited alone, in carefully designed settings, and an entrance fee was charged; thus viewing them was not unlike attending a concert or opera. At the height of his career (1855–65), Church was the most successful American artist of the day.

By 1870 Church was preoccupied with the creation of a castlelike estate on a mountaintop overlooking the river near Hudson, New York. An eclectic mixture of Gothic and Persian architectural motifs, well-stocked with bric-a-brac from his travels and a wide range of paintings, the house became a symbol of his worldly success, a place to raise his family, and a retreat for his later years. By 1880 interest in his work was declining in the face of sophisticated new styles, and when he died in 1900 his popularity had waned.

The revival of interest in Church centers on the 1960 dissertation and 1966 monograph of David C. Huntington. His oil sketches have been studied by Theodore E. Stebbins, Jr. Neither a full-fledged biography nor a catalogue raisonné have been written.

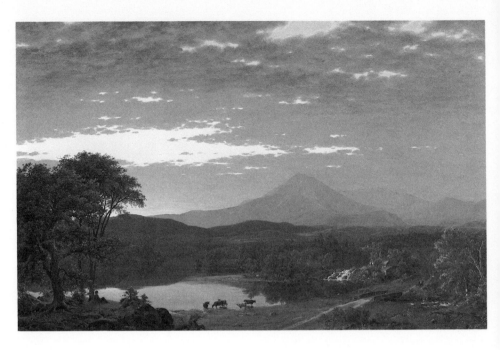

36

FREDERIC EDWIN CHURCH
Mt. Ktaadn, 1853
Painted in New York City
Signed and dated on road: F. E. CHURCH-1853
Oil on canvas, $36\frac{1}{4} \times 55\frac{1}{4}$ in. (92.1 × 140.3 cm.)
Yale University Art Gallery,
New Haven, Connecticut,
Stanley B. Resor, B.A. 1901, Fund

Mt. Ktaadn is one of the most lyrical of Church's early American landscapes, summarizing all that he learned from Cole while anticipating some of the novel luminous and chromatic effects emphasized in his later, more independent works. He based the picture on sketches he made on his annual visits to Maine from 1850 to 1852. It is not a straightforward view, but a composite pastoral and wilderness scene. One can be certain that the topography of the highest mountain, the clouds, and the colors of the twilight were closely observed by the artist. However, this region was then unsettled: the homestead by a waterfall and the generally domesticated landscape of the foreground were imaginative details, added to give the work picturesque charm.[1] Henry David Thoreau had climbed Ktaadn, and in an 1848 essay (later included in The Maine Woods) he portrayed the mountain as primeval and awesome; clearly Church preferred to lead the viewer through a more personal and familiar setting and to give Ktaadn a distant grandeur. Watering cattle like the ones in Mt. Ktaadn were a familiar device in the idyllic meadow and woodland paintings of Asher B. Durand (q.v.), who was at this time the most successful American landscape painter. Other incidental details in Church's picture also add to its popular charm and enhance the overall feeling of harmony and safety: the horse and buggy, the cheery reflections of the sun in the homestead windows, and the youth seated beneath a tree, absorbed in the sunset.

There is a strong relationship between Mt. Ktaadn and Cole's serene late landscapes such as the delicately colored evening scene, River in the Catskills (1843; Museum of Fine Arts, Boston). In that work, Cole evokes a harmony between distant, rugged, unspoiled mountains

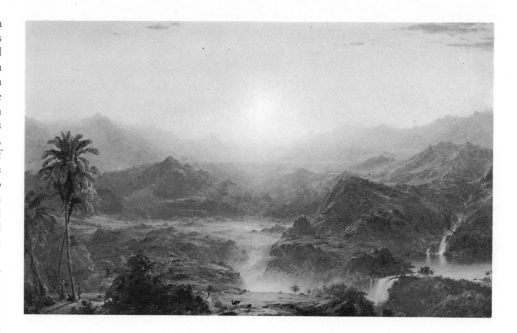

and a fertile river valley with farms and a railroad track. Although he followed Cole's precedent, Church confined all the incidental details to the foreground and developed a wider scenic perspective which allowed a more exhilarating visual experience. The horizon in *Mt. Ktaadn* is deliberately low. As a result, the endless vista of pink-bellied clouds seems to project out of the picture plane, while the lake and lowlands have the sense of nestling into the mountains. The painting is rich in detail, and yet it is carefully crafted to give a strong, simple first impression: an uplifting sense of blissfully hushed natural splendor. This is most strikingly achieved with the extraordinary blue-lilac-pink light that fills the sky and glows across the land.

Church exhibited *Mt. Ktaadn* at the National Academy of Design, New York, in 1853, where it was purchased by New York railroad and steamship financier Marshall Owen Roberts (1814–1880). Church's patrons were usually wealthy urban businessmen and industrialists, with a preference for grand, eye-catching pictures in highly detailed, naturalistic styles. Roberts created an important collection of American art, his most famous acquisition being Emanuel Leutze's *Washington Crossing the Delaware* (1851; Metropolitan Museum of Art, New York). His purchase of *Mt. Ktaadn* was followed by several more of Church's works: *Under Niagara* (1862; unlocated), *Sunrise off the Maine Coast* (cat.no.43) and *Rainy Season in the Tropics* (cat.no.46).

T.J.F.

NOTES

1. See Theodore E. Stebbins, Jr., "American Landscape: Some New Acquisitions at Yale," *Yale University Art Gallery Bulletin* 33 (Autumn 1971): 16.

PROVENANCE

Purchased from the artist by Marshall O. Roberts, New York; Townsend Underhill, New York, purchased from Roberts Estate through American Art Association, New York, 1897; to Underhill's granddaughter, Mrs. John Slade, Oyster Bay, N.Y.; with Vose Galleries, Boston, 1967; Mr. R. Frederick Woolworth, New York; to present owner, 1969.

EXHIBITION HISTORY

National Academy of Design, *Annual Exhibition*, 1853, cat.no.81.
National Collection of Fine Arts, Smithsonian Institution, Washington, D.C., *Frederic Edwin Church*, cat. by David C. Huntington, 1966 (traveling exhibition), no.24 (ill.).

37

FREDERIC EDWIN CHURCH
The Andes of Ecuador, 1855
Painted in New York City
Signed and dated bottom center: *F. E. Church | 1855-*
Oil on canvas, 48 × 75 in. (121.9 × 190.5 cm.)
Reynolda House Museum of American Art, Winston-Salem, North Carolina, Gift of Z. Smith Reynolds Foundation

In the spring of 1853, Church journeyed with his friend and patron Cyrus West Field to Colombia and Ecuador, and produced the sketches that were the basis for the 1855 picture *The Andes of Ecuador*.[1] At the time there was a popular fascination with the remote South American tropics, inspired in part by the German scientist Alexander von Humboldt (1769–1859), who had explored the region in 1799–1804. Humboldt's colorful narratives of these travels achieved great international success, and his experiences in the tropics helped him formulate his major theoretical work, *Cosmos*. He wrote enticingly that in South America snowy mountaintops could be seen beyond palm trees: "This portion of the surface of the globe affords in the smallest space the greatest possible variety of impressions from the contemplation of nature."[2] Humboldt was also aware of the artistic promise of this most heterogeneous locale. Church's great series of tropical landscapes was the most important response to Humboldt's call for an artist who would visit ". . . the humid mountain valleys of the tropical world, to seize, with the genuine freshness of a pure and youthful spirit, on the true image of the varied forms of nature."[3]

The Andes of Ecuador, the largest, most ambitious work inspired by Church's 1853 trip, was first exhibited at the Boston Athenaeum in the summer of 1855, and was purchased later that year by New York railroad financier William H. Osborn. The painting is a Humboldtian vision of the earth's surface, with steaming chasms, sultry jungle, and an immense prospect of mountains, including the frozen summit of Chimborazo(?) at the left. It is all the more remarkable since Church recorded the scene when it was shrouded in thick tropical haze, which made it harder to convey in paint the enormous aerial perspective. Church was influenced by Turner's images of vast light-filled scenes (e.g., his 1812 etching *Chain of Alps from Grenoble to Chamberi*), and he probably knew the etched illustration published by Humboldt of an aerial view of Lake Guatavita with much the same pictorial effect.[4]

Contemporary critics applauded Church's technical mastery and were moved by the emotions *The Andes of Ecuador* aroused:

> [It is] the picture before which perhaps the greatest number of art-critics will congregate.... Wonderful hazy ridges of mountain-peaks, flooded with tropical sunlight. Sharp pinnacles, just tipped with the eternal snow, soaring like white birds to heaven. . . . Grandeur, isolation, serenity! Here there is room to breathe. One feels the muscles grow tense gazing over that great Alpine [sic] panorama.[5]

Church was a devout Christian, and his depiction of the tropics was affected by religious associations. The drama with which he painted the peculiar conjunction of chasms, mountains, and lush vegetation brings to mind the Victorian obsession with the Biblical Age and the world at the Creation. There is also a

spiritual suggestiveness in the way the sun's glow hovers and controls the entire field of vision. Christianity is explicit in the cross in the foreground and the missionary church in the middle distance. The picture suggests both the Edenic innocence of the past and stirring thoughts of a redemptive future.

T.J.F.

NOTES

1. In 1853 Cyrus West Field (1819–1892) was a retired merchant, and later a promoter of the first Atlantic cable. Apparently he traveled to South America in search of a missing brother. For details of his travels with Church, see David C. Huntington, *Frederic Edwin Church, 1826–1900: Painter of the Adamic New World Myth* (Ph.D. diss., Yale University, 1960), pp. 40–49.

2. Alexander von Humboldt, *Cosmos: A Sketch of a Physical Description of the Universe*, trans. E. C. Otté, 2 vols. (New York, 1850), 1:33. His most popular travel book was *Personal Narrative of Travels to Equinoctial Regions of America*, trans. Thomasina Ross (London, 1852).

3. Humboldt, *Cosmos*, 2:93.

4. The etching *Vue du Lac de Guatavita* is plate 67 in Humboldt's *Atlas pittoresque—Vues des Cordillères et monuments des peuples indigènes de l'Amérique* (Paris and Tubingen, 1808–12).

5. "The National Academy Pictures Canvassed," *Harper's Weekly Magazine*, 30 May 1857, p. 339.

PROVENANCE

William Henry Osborn, New York; by descent in the Osborn family; Mr. and Mrs. J. William Middendorf II, New York, 1965; to present owner, 1969.

EXHIBITION HISTORY

Boston Athenaeum, *Annual Exhibition*, 1855, cat. no. 219.
National Academy of Design, New York, *Annual Exhibition*, 1857, cat. no. 23.
New York, *Metropolitan Fair in Aid of the U.S. Sanitary Commission*, 1864, cat. no. 89.
Union League Club, New York, 1877.
Metropolitan Museum of Art, New York, *Paintings by Frederic E. Church, N.A.*, 1900 (ill.).
National Collection of Fine Arts, Smithsonian Institution, Washington, D.C., *Frederic Edwin Church*, cat. by David C. Huntington, 1966 (traveling exhibition), no. 67 (ill.).

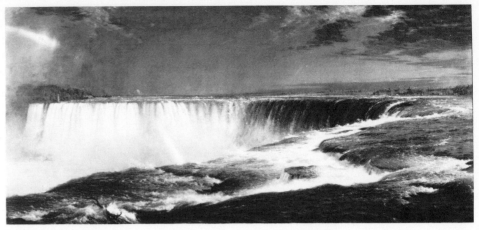

38

FREDERIC EDWIN CHURCH
Niagara Falls, 1857
Painted in New York City
Originally signed and dated bottom right:
　F. E. CHURCH 1857 (remains of inscription visible under magnification)
Oil on canvas, $42\frac{1}{2} \times 90\frac{1}{2}$ in. (108×229.9 cm.)
The Corcoran Gallery of Art,
　Washington, D.C., Gallery Fund Purchase, 1876

Niagara Falls is Church's most original composition, a sweeping panorama on a canvas whose width is more than twice its height. In all respects it is a work of supreme confidence. Rather than send it to a large annual exhibition, Church showed it alone at a commercial gallery in New York (a pattern he continued thereafter with all his major works). The gallery owners, Messrs. Williams, Stevens & Williams, had purchased it with rights for chromolithographic reproduction for $4,500. After the successful New York debut in the spring of 1857, they sent it directly to London to be engraved and exhibited. Astonishing acclaim greeted the picture on both sides of the Atlantic. Indeed, it was a momentous occasion for Church and for the status of American art abroad when *The Times* of London wrote:

> . . . *we note with peculiar pleasure the arrival in this country of a remarkable picture, by an American landscape painter, of an American subject.* . . . *The characteristic merit of the picture is sober truth. It bears throughout unmistakable evidence of the most close and successful study.*[1]

Ten years later the picture won a medal at the Paris Exposition Universelle of 1867.

　Church visited Niagara Falls in the winter and summer of 1856, making enough drawings and oil sketches for this picture and two later ones from different views.[2] A small but detailed study (Coll. Hon. H. John Heinz III)

is even wider in proportion and extends to the left to include a view of the American side of the falls. For the final work, Church brilliantly shifted the field of vision slightly to the right to focus on the curved Horseshoe Falls on the Canadian side. The viewer's eye meets the racing waters in the left foreground, moves diagonally with the line of the falls to the right edge of the canvas, and then returns to the left, all the time progressing deeper into the picture plane. The break in the rainbow that bridges the central chasm and the sky prevents visual interruption of the tiny stratum of land on the horizon and thus reinforces the picture's emphatic horizontality. In contrast to the forcefulness of the image, the palette has surprisingly delicate passages, particularly the violet tints of the mist and the clouds, the pinks in the sky, and their reflections in the dark foreground waves.

　The artist responded symbolically to the water's mighty rush *forward*; he refused the spectator any firm vantage point or safe distance from which to view the impetuous force. At once thrilling, frightening, and inexorable, his image was a perfect conception of the young American nation. In hindsight we can connect this surging spirit with the attitude historians have labeled Manifest Destiny. There are no other contemporary works of American art that equal the uncompromising sense of the nation's indomitable spirit and immensity in Church's *Niagara Falls*; perhaps the best parallel lies in Walt Whitman's *Leaves of Grass*, published two years earlier. One New York art critic described America and her art as "impulsive, erratic, irregular, but yet full of promise and undeveloped power" and called *Niagara Falls* "perhaps the finest picture yet done by an American; at least that which is fullest of feeling."[3] Another wrote, "It marks a point in American landscape-painting, and in the history of the Falls is an event as striking as the suspension bridge."[4] Church, as much scientist as visionary, was surely flattered that his *Niagara Falls* was considered as important as a great engineering feat.

T.J.F.

NOTES

1. Quoted in "Church's Picture of Niagara," *The Crayon* 4 (September 1857): 282.

2. For the oil sketches, see Theodore E. Stebbins, Jr., *Close Observation: Selected Oil Sketches by Frederic E. Church* (Washington, D.C., 1978), pp. 26–29 and cat. nos. 33–36. The later major canvases were *Under Niagara* (1862; unlocated) and *Niagara Falls from the American Side* (1867; National Galleries of Scotland, Edinburgh). See also David C. Huntington, *The Landscapes of Frederic Edwin Church: Vision of an American Era* (New York, 1966), pp. 64–71, and Jeremy E. Adamson, *Frederic Edwin Church's "Niagara": The Sublime as Transcendence* (Ph.D. diss., University of Michigan, 1981).

3. Adam Badeau "American Art," *The Vagabond* (New York, 1859), p. 123.

4. "Church's Niagara," *Harper's Weekly Magazine*, 9 May 1857, p. 290.

PROVENANCE
Sold by artist to Williams, Stevens & Williams, New York, 1857; John Taylor Johnston, New York, by 1861; to present owner from the Johnston sale, Chickering Hall, New York, 1876.

EXHIBITION HISTORY
Williams, Stevens & Williams, New York, 1857.
London and British tour, 1857–58.
Williams, Stevens & Williams, New York, 1859.
Williams and Everett's Gallery, Boston, 1859–60.
Philadelphia 1860.
New York, *"Tiffany" Exhibition*, 1861–62.
New York, *Metropolitan Fair in Aid of the U.S. Sanitary Commission*, 1864, cat. no. 14.
Paris, *Exposition Universelle*, 1867, cat. no. 9.
National Academy of Design, New York, *First Winter Exhibition . . . Including Works from the American Art Department of the Paris Universal Exposition*, 1867–68, cat. no. 646.
Yale College, New Haven, Conn., 1870.
Cincinnati, *Industrial Exhibition*, 1874.
Metropolitan Museum of Art and National Academy of Design, New York, *Centennial Loan Exhibition*, 1876, cat. no. 190.
Metropolitan Museum of Art, New York, *Paintings by Frederic E. Church, N.A.*, 1900 (ill.).
Carnegie Institute, Pittsburgh, *Survey of American Painting*, 1940, cat. no. 97 (ill.).
Corcoran Gallery of Art, Washington, D.C., *De Gustibus: An Exhibition of American Painting Illustrating a Century of Taste and Criticism*, 1949, cat. no. 12 (ill.).
Detroit Institute of Arts, *Painting in America: The Story of 450 Years*, cat. by Edgar P. Richardson, 1957, no. 106.
Wilmington Society of the Fine Arts, Del., *American Painting, 1857–1869*, 1962, cat. no. 13 (ill.).
Albright-Knox Art Gallery, Buffalo, N.Y., *Three Centuries of Niagara Falls*, 1964, cat. no. 23 (ill.).
Metropolitan Museum of Art, New York, *19th-Century America: Paintings and Sculpture*, cat. by John K. Howat and Natalie Spassksy, 1970, no. 105 (ill.).
High Museum of Art, Atlanta, *The Beckoning Land*, cat. by Donelson F. Hoopes, 1971, no. 49 (ill.).

39

FREDERIC EDWIN CHURCH
Twilight in the Wilderness, 1860
Painted in New York City
Signed and dated lower right:
 F. E. CHURCH / -60-
Oil on canvas, 40 × 64 in. (101.6 × 162.6 cm.)
The Cleveland Museum of Art, Purchase,
 Mr. and Mrs. William H. Marlatt Fund
Exhibited in Boston and Washington only

Following the success of *Niagara Falls* (cat. no. 38), Church painted his largest and most overwhelmingly detailed tropical landscape, *The Heart of the Andes* (1859; Metropolitan Museum of Art, New York), which eclipsed his previous works in popularity. Displayed in New York amidst potted palms, the painting was scrutinized by visitors with opera glasses; in London one critic announced that the mantle of Turner had fallen on Church; and in St. Louis, Mark Twain exclaimed that while viewing the piece his brain was "*gasping and straining with futile efforts to take all the wonder in.*"[1]

For his next work, the artist wisely decided against trying to repeat the dazzling complexity of *The Heart of the Andes* so soon. Instead he produced *Twilight in the Wilderness*, a simple composition with an ecstatically concentrated visual effect. Church had painted American twilights regularly since 1845, but this was his crowning statement on the subject. Early examples such as *Twilight, "Short Arbiter Twixt Day and Night"* (1850; Newark Museum, N.J.) and *Mt. Ktaadn* (cat. no. 36) had also shown a concern with a saturation of glowing, colored light; but because they depicted settlers' homes and livestock, they were more like pastoral poems. *Twilight in the Wilderness*, by contrast, was a rapturous ode to an unspecified place in the Northeast untouched by the white man's presence, and glorious in both the natural and godly senses. In short, it was a metaphor for America's promise.

The viewpoint of the picture is from a rocky ledge high above a lake; the subject is the transcendent exhilaration of the celestial pageant taking place above the dark, hushed surface of the earth. The fiery orange-red atmosphere filling the scene is the last act of the sun before night descends. The only

visible creature is the bird perched high at the left, and the only detectable physical force is the storm that has savaged a few of the foreground trees. It was unusual for Church to give his trees an anthropomorphic character, but the ones edging *Twilight in the Wilderness* have various hopeful and anguished postures reminiscent of those regularly used by his teacher Thomas Cole. Church may well have intended them as symbols of healthy Christian triumph and heathen despair.[2] The fully orchestrated spiritual and emotional drama of Church's lake and sky recall passages from Cole's 1836 "Essay on American Scenery"[3]:

> . . . in the unrippled lake, which mirrors all surrounding objects we have the expression of tranquillity and peace. . . . Look at the heavens when the thunder shower has passed, and the sun stoops behind the western mountains—there the low purple clouds hang in festoons around the steeps—in the higher heaven are crimson bands interwoven with feathers of gold, fit for the wings of angels—and still above is spread that interminable field of ether, whose color is too beautiful to have a name.

Just as Cole saw angels' wings in clouds at twilight, so Emerson looked upon the sky's "immense amplitude" as "the daily bread of the eyes," and Thoreau regularly watched sunsets and thought of them as paintings by God "the Great Artist."[4]

Capitalizing on such religious associations, Church created the most tranquil yet violently colorful landscape that had yet been painted in America. His artistic and religious sensibility expressed itself in a statement on the soothing and mystical power of twilight, making possible the fulfillment of the Transcendentalist longing to surrender the soul and become one with Nature. But this spirituality was not achieved with the Turnerian painterliness soon to be favored in America by artists like Inness and critics like Jarves; rather, Church transcribed his vision with a Ruskinian, quasi-scientific attention to minute detail. Clearly he was anxious that his statement have the exactitude and authority promised by photography, as well as convey visually the emotional experience of an inspired soul.

Twilight in the Wilderness represents a high moment in American landscape painting, and certainly is a monument to the search for religious, intellectual, and visual fulfillment in the American sunset. It sparked a series of emulations from Church's competitors and was thus one of the most influential paintings of its time.[5]

T.J.F.

NOTES

1. For more details on contemporary responses to *The Heart of the Andes*, see David C. Huntington, *The Landscapes of Frederic Edwin Church: Vision of an American Era* (New York, 1966), pp. 5–9.

2. See ibid., p. 82: Huntington sees *Twilight in the Wilderness* as a "supreme moment of cosmic time," and the "Natural apocalypse." He discusses the three trees at the right as symbolic characters: the tallest is grand and aspiring; the "beautiful" one at the far right "bows as a Virgin of the Annunciation," and the dead tree "suggests one of the saved on the Day of Judgment rising in ecstasy from the slumber of death."

3. Reprinted in John W. McCoubrey, *American Art, 1700–1960, Sources and Documents* (Englewood Cliffs, N.J., 1965), pp. 98–111.

4. Thoreau and Emerson quoted in "On Divers Themes from Nature, A Selection of Texts," in *The Natural Paradise: Painting in America 1800–1950* (Museum of Modern Art, New York, 1976), pp. 87–89.

5. See Gail Davidson, Phyllis Hattis, and Theodore E. Stebbins, Jr., intro. to *Luminous Landscape: The American Study of Light, 1860–1875* (Fogg Art Museum, Cambridge, Mass., 1966), pp. 6–7, where Bierstadt, Gifford, Heade, Inness, and Whittredge are noted as artists directly influenced by *Twilight in the Wilderness*.

PROVENANCE

Purchased from the artist by William T. Walters, Baltimore, 1860; purchased from Leeds and Miner auction, Düsseldorf Gallery, New York, by John Taylor Johnston, New York, 1866; purchased from sale at Chickering Hall, New York, 1876, by Mr. Garrett; Miss Mary E. Garrett, Baltimore, 1900; Robert W. De Forest; by descent in De Forest family to Taber De Forest, Maine, 1948; to present owner through Robert Weimann (dealer), Ansonia, Conn., 1965.

EXHIBITION HISTORY

Goupil, Vibert & Co., New York, 1860.
Avery's Gallery, New York, 1866.
Yale College, New Haven, Conn., 1870.
Metropolitan Museum of Art and National Academy of Design, New York, *Centennial Loan Exhibition*, 1876, cat. no. 242.
Metropolitan Museum of Art, New York, *Paintings by Frederic E. Church, N.A.*, 1900 (ill.).
Whitney Museum of American Art, New York, *Art of the United States, 1670–1966*, cat. by Lloyd Goodrich, 1966, no. 48.
Corcoran Gallery of Art, Washington, D.C., *Wilderness*, 1971, cat. no. 69.
Albright-Knox Art Gallery, Buffalo, N.Y., *Heritage and Horizon: American Painting 1776–1976*, 1976 (traveling exhibition), cat. no. 10.
National Gallery of Art, Washington, D.C., *American Light: The Luminist Movement, 1850–1875*, cat. by John Wilmerding et al., 1980, no. 204 (ill.).

WORTHINGTON WHITTREDGE

(1820, Springfield, Ohio
—1910, Summit, New Jersey)

Whittredge began his artistic career as a portraitist, supporting himself by making daguerreotypes while studying under the Boston portrait painter Chester Harding and at the Cincinnati Academy of the Fine Arts. By about 1843, he began painting landscapes, a genre in which he had no formal training. His earliest efforts, inspired by the works of Thomas Doughty and Thomas Cole (q.v.), were pleasing to his Cincinnati patrons, who sent him to Europe in 1849.

In Europe Whittredge enrolled at the Düsseldorf Academy, where he met Eastman Johnson, who was to become a lifelong friend and sometime collaborator. After several years in Düsseldorf, he traveled south through the Alps in 1854, finally settling in Rome, where he worked closely with Albert Bierstadt and Sanford Gifford. Soon after his return to America in 1860, he found quarters in New York's Tenth Street Studio Building and gained considerable success as a landscape painter in the Hudson River School tradition. He was elected a member of the Century Association in 1862, the year after he became a full member of the National Academy of Design. He would later serve as the Academy's president (1875–76).

Whittredge's paintings generally embody the poetic sentiment of William Cullen Bryant and the aesthetics of Asher B. Durand (q.v.). Contemporary critics such as Henry Tuckerman often praised the "uncommon intimacy" of Whittredge's forest scenes. These idylls often combined water and trees, dark and light, and living and dead elements. Whittredge also loved the seashore, particularly the region around Newport, Rhode Island, where he frequently summered. He also painted the Far West, having traveled to Colorado and New Mexico with General John Pope in 1866, to Colorado in 1870 with Gifford and John F. Kensett, and again the following year, and to Mexico in 1893 and 1896. After the Centennial, Whittredge's style began to change as he responded to the growing enthusiasm for atmospheric tonality and loose brushwork popularized by George Inness (q.v.) and the French painters of the Barbizon School, particularly Charles-François Daubigny.

Whittredge left an invaluable autobiography that was edited by John I. H. Baur in 1942 and reissued in 1969. Anthony F. Janson's unpublished dissertation (Harvard University, 1966) and several articles are the most important discussions of the artist to date. The first major modern exhibition of his work was organized by Edward Dwight in 1969 at the Munson-Williams-Proctor Institute.

40

WORTHINGTON WHITTREDGE
Twilight on the Shawangunk, 1865
Painted in New York City
Signed and dated lower left: *W. Whittredge
1865*
Oil on canvas, 45 × 68 in. (114.3 × 172.7 cm.)
The Manoogian Collection

The critic Henry Tuckerman found this painting a "memorable landscape" and noted that it was "remarkable for its vivid and true effect of light—the deep yet clear amber gleam of the horizon in contrast with the wild and shadowy hills."[1] Though Whittredge was then a much-admired member of the Hudson River School, he was known generally for smaller quiet and poetic pictures, which typically portray interior forest views with subtle evocations of sunlight shining through the trees. Here the artist turns in another direction, perhaps seeking on this occasion to rival the great wilderness painters of the era, such as Fredric Edwin Church and Albert Bierstadt (q.v.); he enlarges his scale and his vision, and he experiments with strong tonal contrasts and with brilliant colors—especially in the yellows of the sky. The decade of the 1860s saw the peak of dramatic wilderness painting in America. Church had experimented with the genre in the 1850s and reached his own climactic resolution with *Twilight in the Wilderness* (cat.no.39), and Bierstadt, Sanford Gifford (q.v.), Whittredge, and other New York painters, inspired by his vision, made their own wilderness views.

The vantage point Whittredge chose is near Eagle Cliff overlooking the Wallkill Valley in the Shawangunk Mountains, which lie south of the Catskills in New York State. This area had been a popular resort for New Yorkers since the opening of the Delaware and Hudson Canal in 1829 and attracted many artists throughout the century.[2] Like his contemporaries, Whittredge would alter the actual topography in order to heighten his picturesque effects, while appearing simply to record reality. In this picture, he creates a dramatic contrast between a dark, detailed foreground and the vast, distant horizon; the believability of the whole is aided by the hunters at the campfire, who, as Tuckerman noted, establish an "uncommon intimacy" within their vast surroundings.[3]

Here Whittredge represents his conception of the wildness and disorder of the American landscape and forest, in contrast to the tame and manicured woodlands he had seen in Europe.[4] The last rays of yellow sunlight flooding the Wallkill Valley give way to horizontal bands of purple and blue and pull our attention from the foreground into the seemingly unknowable distance. As in Gifford's *Twilight on Hunter's Mountain* of 1866 (Terra Museum of American Art, Evanston, Ill.),[5] Whittredge's rapturous colors calm and soothe, assuring the viewer of the greater goodness of nature. Whittredge has created a complex interaction between the near and far, where the dark, jumbled forest is a safe haven and the far away is beautiful and immeasurable. The distant view is as transitory as the sunset itself: the artist was recording a Northeastern wilderness, not far from New York, which was soon to disappear as civilization spread.

D. D.K.

NOTES
1. Tuckerman, *Book of the Artists: American Artist Life* (New York, 1867): 518. See also the review of the painting in *The Aldine* 9 (1879): 374.
2. See Bradley Simpler, *The Shawangunk Mountains* (New Palz, N.Y., 1981); Roland Van Zandt, *The Catskill Mountain House* (New Brunswick, N.J., 1966), and *Windy Summits, Fertile Valleys* (Cragsmore, N.Y., 1982).
3. Tuckerman, *Book of the Artists*, p. 514.
4. See *The Autobiography of Worthington Whittredge, 1820–1910*, ed. John I. H. Baur (*Brooklyn Museum Journal*, 1942), p. 42.
5. Gifford painted a *Twilight in the Shawangunk Mountains* that was sold to the Artists' Fund Society in 1877.

PROVENANCE
Samuel P. Avery, New York, 1865; W. B. Smith, Philadelphia, by 1867; with Alexander Gallery, New York; to present owner, 1981.

EXHIBITION HISTORY
National Academy of Design, New York, *Annual Exhibition*, 1865, cat.no.205.
Artists' Fund Society, New York, *Annual Exhibition*, 1867, cat.no.47.
Philadelphia, *Centennial Exhibition*, 1876, cat.no.201.

SANFORD R. GIFFORD

(1823, Greenfield, New York
—1880, New York City)

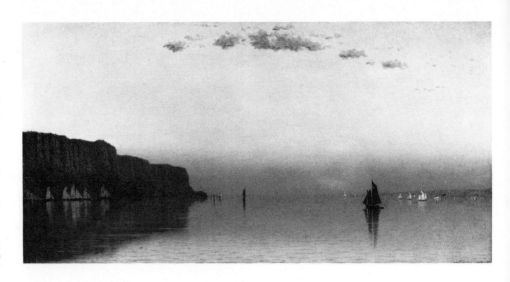

Gifford was raised in Hudson, New York, a small town with a view of the Hudson River and Catskill Mountains, which later provided him with many subjects for his pictures. Unlike most mid-nineteenth-century American painters, he received both a college education (two years at Brown University) and academic training (with John Rubens Smith, a watercolorist and drawing master, and in classes at the National Academy of Design). But like Church, Whittredge, Cropsey, and others, Gifford was more significantly affected by his love of nature and the example of Thomas Cole (q.v.), factors which caused him to turn from figure painting to landscape in 1846. His success was immediate: one of his scenes was chosen the next year for distribution by the American Art-Union; he showed almost annually at the National Academy of Design from 1847 and was elected to membership in 1851. Despite occasional critical objections to his brilliant color and light-dissolved form, he enjoyed the admiration of the public and the affection of his fellow landscape painters throughout his career.

Gifford traveled twice to Europe (1855–57 and 1868–69, the second trip including a visit to the Near East) and twice to the American West (1870 and 1874). These journeys never inspired him to paint large-scale, heroic subjects as they did Church and Bierstadt (q.v.); rather, he was captivated by picturesque views which he recorded on modest-sized canvases and especially in rich, painterly oil sketches which remain among his most-admired works.

After the Memorial Exhibition of the Paintings of Sanford Robinson Gifford (catalogue by John F. Weir) held at the Metropolitan Museum of Art, New York, in 1881, there was no exhibition of Gifford's work until 1970, when Nicolai Cikovsky, Jr., organized a monographic exhibition for the University of Texas (Austin) Art Museum. Ila Weiss's 1968 dissertation for Columbia University, Sanford Robinson Gifford 1823–1880 (New York, 1977), is the most thorough study.

41

SANFORD R. GIFFORD
Sunset on the Hudson, 1879
Painted in New York City
Signed lower right: *S R Gifford*
Oil on canvas, 18⅛ × 34⅛ in. (46 × 86.7 cm.)
Private Collection

In 1877 Gifford reportedly said that "the really important matter is not the natural object itself, but the veil or medium through which we see it."[1] *Sunset on the Hudson* puts that maxim into practice: here the artist's real subject is not the Palisades, rising over the west bank of the Hudson across from New York City, but rather the opalescence of the setting sun. The work of J. M. W. Turner, whose paintings Gifford first admired in 1855, appears to have been an important influence on his style.[2] In *Sunset on the Hudson*, the purple-pink glow of the distant horizon is particularly Turneresque, suggesting a depth in which the skyline can be imagined rather than actually seen. Moving from the dark horizon to the composition's edges, the colors brighten to luminous yellows and blues, the middle ground highlighting the gliding boats with a soft pink hue.

Gifford's work had been tonal and atmospheric since the late 1850s, and in the early seventies he developed these qualities more fully as his former concern with topography and a sense of place disappeared almost entirely in favor of subtleties of color and light, observed chiefly either on the Hudson River or in Venice. These late paintings share with the work of Kensett, Heade, and other so-called Luminists a horizontal format, almost invisible brushwork, and an interest in tonal effects. However, unlike Kensett's pictures filled with clear light or Heade's stormy views, Gifford's images are serene, concentrating on the pervasive orange-yellow haze of late-summer afternoons.

Gifford made several studies for *Sunset on the Hudson*. The largest of these, done in 1876 (Wadsworth Atheneum, Hartford, Conn.), is more traditional in terms of space, and includes boats and clouds absent in the final work. By omitting these details in favor of atmospheric effects, Gifford produced a transcendent scene, almost magical in its iridescence.

D.D.K.

NOTES
1. "How One Landscape-painter Paints," *Art Journal* 3 (1877), quoted in Nicolai Cikovsky, Jr., *Sanford Robinson Gifford, 1823–1880* (University of Texas Art Museum, Austin, 1970), p.16.
2. See Marcia Wallace, "Some Confrontations between American Landscape Painters and Turner's Art" (unpublished, Graduate Center, City University of New York, 1976), pp. 17 and 19–22. Wallace specifically cites Turner's *Old Chain Pier, Brighton* (c.1828; Tate Gallery, London) as a source that Gifford could have seen in the Tate Gallery in 1855 as part of the Turner Bequest.

PROVENANCE
Hudson Academy, Hudson, N.Y., 1879; with Hirschl and Adler Galleries, New York, 1973; to present owner.

EXHIBITION HISTORY
Metropolitan Museum of Art, New York, *Memorial Exhibition*, 1881, cat.no.111.
Hirschl and Adler Galleries, New York, *Faces and Places: Changing Images of 19th-Century America*, 1972, cat.no.28.
The Fine Arts Museums of San Francisco, *American Art: An Exhibition from the Collection of Mr. and Mrs. John D. Rockefeller 3rd*, cat. by Edgar P. Richardson, 1976 (traveling exhibition), cat.no.47.

JOHN FREDERICK KENSETT

(1816, Chester, Connecticut
—1872, New York City)

Kensett was one of the most admired American landscapists of the Civil War era. He trained as an engraver with Alfred Dagett in New Haven, Connecticut, and later worked in Albany and New York City. He was also teaching himself to paint during this time and submitted one of his first efforts, a landscape, to the National Academy of Design in 1838. He soon began associating with other aspiring painters, and in June of 1840 he sailed for Europe with Asher B. Durand, John W. Casilear, and Thomas P. Rossiter. Kensett worked in Paris, making copies of works by Claude Lorrain, in London, and, after a lengthy trip through the Alps, in Rome. Upon his return to New York in 1848, he exhibited several landscapes at the National Academy and the American Art-Union. These works reflected the styles of his friends Thomas Cole and Durand (q.v.), and also showed the influence of John Constable and the British landscapists.

In 1849 Kensett was elected a member of the National Academy and of the Century Association. In 1859 he was appointed to the U.S. Capitol Art Commission, and in 1863 he helped organize the "Sanitary Fair" exhibition in support of the Union troops. He began the Artists' Fund Society in 1865 and was a founding trustee of the Metropolitan Museum of Art in 1870. All this time he continued traveling. He spent summers and autumns visiting Niagara Falls and the popular vacation spots in New England. He returned to Europe at least three times between 1856 and 1870, and also journeyed to the American West, traveling to Colorado and up the Missouri and Mississippi Rivers.

Kensett painted a variety of subjects, from expansive shoreline views to intimate, carefully detailed studies of woodland interiors. Most remarkable is a series of thirty-eight paintings of Long Island Sound produced the year of his death. These works, left to the Metropolitan Museum of Art, are sparkling renderings of light-filled sea and sky. In all his works, Kensett displays a poetic lyricism which, however, always remains firmly grounded in the reality of place. His economical expression of nature's poetic charm led one critic to dub him "the Bryant of our painters."

There are three large collections of letters and journals by Kensett: the James Kellogg Collection (Richmond Hill, New York), the Edwin D. Morgan Collection (New York State Library, Albany), and the journal of his first European trip (Frick Art Reference Library, New York). Also useful are Ellen Johnson's "Kensett Revisited," Art Quarterly 20 (Spring 1957): 71–92, and two exhibition catalogues, John Frederick Kensett, 1816–1872 (American Federation of Arts, New York, 1968, by John K. Howat) and John F. Kensett Drawings (Museum of Art, Pennsylvania State University, University Park, 1978, by John Paul Driscoll).

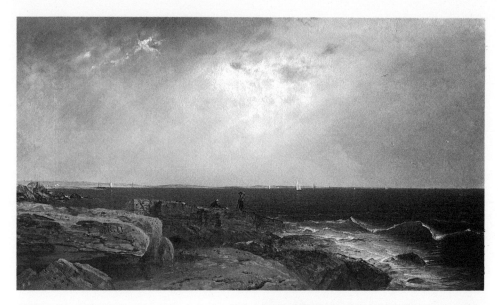

42

JOHN FREDERICK KENSETT
Narragansett Bay, 1861
Painted in New York City
Signed and dated lower left: *J.K. 61*
Oil on canvas, 14 × 24 in. (35.6 × 61 cm.)
Mr. and Mrs. George D. Hart

The viewpoint in this painting is from the rocks just north of Narragansett, Rhode Island, looking east across Rhode Island Sound at Breton Point in Newport, with Beavertail light to the left. Newport had been one of the largest and wealthiest cities in the Northeast prior to the Revolutionary War, only to decline after the British blockade in 1780. With the advent of the railroad at mid-century, Northern families began to frequent the beaches along the Atlantic Ocean and Narragansett Bay. Kensett first visited Newport in 1854, when it was just reviving as a summer resort. In Newport as in the other popular vacation spots Kensett visited, such as Lake George and the White Mountains, the summer residents provided important patronage. For these buyers the artist created idyllic scenes to brighten their urban homes.

Like many of Kensett's works, *Narragansett Bay* is composed of simple elements—horizontal bands of sky above and land and water below, separated by the horizon—and includes a traditional framing device—typically, here, rocks and trees—all within an unusual long and narrow format. The artist's sensitive treatment of atmosphere, value, and color set the standard for "the transfer of atmospheric effects to canvas"[1] which became the hallmark of the Luminists.

Among second-generation Hudson River School painters, Kensett was one of the first to depict the seashore.[2] He was followed by his friends Sanford Gifford and Martin Johnson Heade[3] and later, in the 1870s and '80s, by

Alfred Bricher (1837–1908), Francis A. Silva (1835–1886), and Worthington Whittredge. But unlike these other artists, who tended to deemphasize the physicality of the shore in favor of light and air effects, Kensett called attention to physical details, emphasizing the shoreline's rocks and sand. The effect of this focus in *Narragansett Bay* is to make our experience of the seashore, rather than the people who inhabit it, the central element. The two small figures initially entice the viewer into the painting and establish a human scale, but as the eye is led across the rocks and waves to the distant horizon, the sky assumes greater importance. In contrast to the tangible, crisply detailed land and water, with their clear spatial delineations, the gray sky is cloudless and nearly abstract. As a result, our attention is drawn in measured progression to the deep, luminous atmosphere, the most memorable attribute of the seashore in summer.

D.D.K.

NOTES

1. Henry A. Tuckerman, *Book of the Artists: American Artist Life* (New York, 1867), p. 513.
2. See John Wilmerding, *A History of American Marine Painting* (Boston and Salem, 1968), pp. 73–78.
3. See Theodore E. Stebbins, Jr., "Breaking Waves," *The Life and Works of Martin Johnson Heade* (New Haven, Conn., 1975), pp. 67–82. Stebbins notes that while the breaking wave motif and flat horizon come from Kensett, Heade's seashore paintings have more suspense, often created by an approaching thunderstorm.

PROVENANCE
With Vose Galleries, Boston, 1969; to present owner, 1970.

EXHIBITION HISTORY
National Gallery of Art, Washington, D.C., *American Light: The Luminist Movement, 1850–1875*, cat. by John Wilmerding et al., 1980, plate 12.

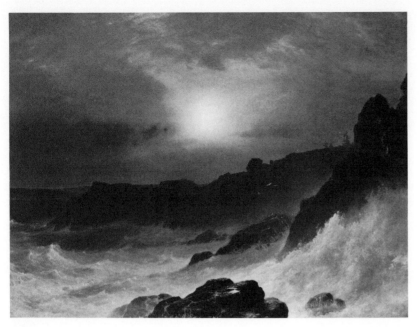

43

FREDERIC EDWIN CHURCH
Sunrise off the Maine Coast, 1863
Painted in New York City
Signed and dated lower right center:
 F. E. CHURCH / 1863
Oil on canvas, 36⅛ × 48 in. (91.8 × 121.9 cm.)
Wadsworth Atheneum,
 Hartford, Connecticut,
 Bequest of Mrs. Clara Hinton Gould

Church began to paint northern coastal scenes early in his career, producing bright, fresh, expansive vistas, often with a fisherman in the foreground (for example, *Grand Manan Island, Bay of Fundy*, 1852; Wadsworth Atheneum, Hartford, Conn.). By the early 1860s he had become famous as the artist of spectacular effects of nature in the wilderness. *Sunrise off the Maine Coast* focuses on the encompassing force of the waves and wind in the rugged terrain, and the odd, fragile colors of the morning sun seen through sea mist and clouds. The format was influenced by Church's teacher Cole, as seen for example in Cole's similarly sized *View across Frenchman's Bay from Mount Desert, After a Squall* of 1845 (Cincinnati Art Museum). However, Church's mature technique was more studied and realistically detailed than Cole's; Church sought to re-create in paint the different appearances of his subjects, from the infinitely complicated foaming waves to the evanescent mist. A contemporary review of the work confirmed Church's success:

> *Here is magnificent force in the sea; we give ourselves up to enthusiasm for it, regarded as pure power; when it dies its final death in mad froth and vapor, tossed quite to the top of the beetling barrier crags on the right foreground, we feel ourselves in an audacious actual presence.*

> *. . . We value the light effects separately, and the fine recklessness of color by itself, among the best instances of Church's power.*[1]

Despite the turbulent weather in *Sunrise off the Maine Coast*, the morning sun has a beautiful and spiritually uplifting effect. Seen through the mist, it is pure white with a pale yellow halo. It colors the lower clouds many different pinks, turns the foreground sea a yellowish green color, and gives a golden glow to the sea spray hitting the rocky coast. Though some critics complained that the polychromatic sky was incompatible in mood with the sea, the artist had in fact attempted to unify the light effects: even the frothing water in the lower right has a multicolored layer of soft blues, grays, and pinks, covered with a white impasto, deftly touched in with a stiff brush, to imitate foaming surf. Much of the composition was provided by an oil sketch Church had made at Mount Desert, Maine (Cooper-Hewitt Museum, New York).[2] This sketch provided the dark-brown silhouettes of the cliffs but did not show the sun or the delicately muted tones of sky and mist. Church gave the finished painting considerably more sky, set all the rocks and cliffs deeper in the picture plane, and introduced the pines on the horizon high at the right. As a result of these subtle adjustments in space and scale, the massive boulder below the sun assumes a more dramatic and menacing presence on the rocky skyline.

The liveliness and grandeur that typify Church's landscapes are obvious when *Sunrise off the Maine Coast* is compared with a contemporary seascape such as Kensett's *Narragansett Bay* (cat. no. 42). This contrast demonstrates the analogy drawn by Barbara Novak, that Church represents a kind of "grand opera" while the quietistic landscapes of Kensett, Heade, and Lane speak with a "still small voice."[3] The drama of *Sunrise off the Maine Coast* addresses the elemental force of the sea and the tremendous solitude of an unspoiled coastline. Twenty years later Winslow Homer began to develop the same subjects; but whereas Homer would use the physical presence of his pigment for aesthetic effect and as a symbol of the rugged Maine coast, Church's handling of paint was more modest and essentially descriptive. As Henry Tuckerman wrote in 1867, ". . . Church advanced from the faithful rendition of details, to a comprehensive realism in general effect."[4]

 T.J.F.

NOTES

 1. Quoted in Henry T. Tuckerman, *Book of the Artists: American Artist Life*, 2d ed. (New York, 1870), p. 372.
 2. See Theodore E. Stebbins, Jr., *Close Observation: Selected Oil Sketches by Frederic E. Church* (Washington, D.C., 1978), p. 21 and cat. no. 23.
 3. The 1971 essay "Grand Opera and the Still Small Voice" is reprinted in Barbara Novak, *Nature and Culture: American Landscape and Painting, 1825–1875* (New York, 1980), pp. 18–33.
 4. Tuckerman, *Book of the Artists*, p. 371.

PROVENANCE
Purchased from the artist by Marshall O. Roberts, New York, 1863; Mrs. Clara Hinton Gould; to present owner, 1948.

EXHIBITION HISTORY
National Academy of Design, New York, *Annual Exhibition*, 1863, cat. no. 74.
Wadsworth Atheneum, Hartford, Conn., *Gould Bequest of American Paintings*, 1948.
Wadsworth Atheneum, Hartford, Conn., *A Second Look: Late 19th Century Taste in Paintings*, 1958, checklist no. 8.
National Collection of Fine Arts, Smithsonian Institution, Washington, D.C., *Frederic Edwin Church*, cat. by David C. Huntington, 1966 (traveling exhibition), no. 46.
Indiana University Art Museum, Bloomington, *The American Scene: 1820–1900*, cat. by Louis Hawes, 1970, no. 4 (ill.).
National Collection of Fine Arts, Smithsonian Institution, Washington, D.C., *National Parks and the American Landscape: An Approach to Nature and the 19th Century*, 1972 (traveling exhibition), cat. no. 2.
Whitney Museum of American Art, New York, *Seascape and the American Imagination*, cat. by Roger B. Stein, 1975, no. 117 (ill.).
Virginia Museum of Fine Arts, Richmond, *Marine Painting in America*, 1976, cat. no. 31 (ill.).
Wadsworth Atheneum, Hartford, Conn., *The Hudson River School: 19th Century American Landscapes in the Wadsworth Atheneum*, cat. by Theodore E. Stebbins, Jr., et al., 1976, no. 24 (ill.).
National Gallery of Art, Washington, D.C., *American Light: The Luminist Movement, 1850–1875*, cat. by John Wilmerding et al., 1980, no. 214 (ill.).

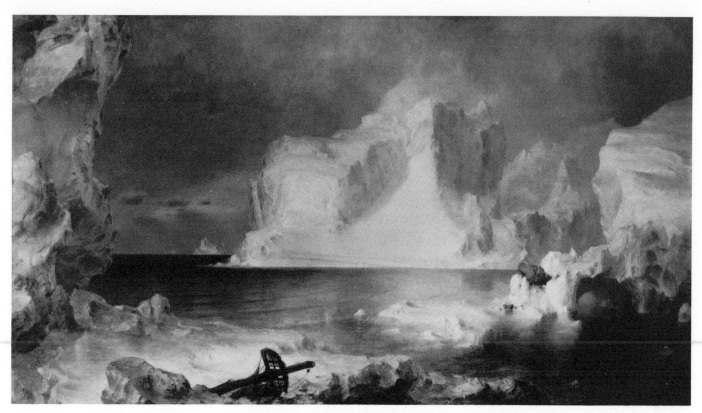

44

FREDERIC EDWIN CHURCH
The Icebergs, 1861
Painted in New York City
Signed and dated lower left: *F. E Church / 1861*
Oil on canvas, 64½ × 112½ in.
 (163.8 × 285.8 cm.)
Dallas Museum of Fine Arts, Anonymous Gift
Exhibited in Paris only

In his quest to experience nature's purest, most spectacular and spiritual manifestations, Church became the first artist to travel to the North Atlantic in preparation for an enormous exhibition picture that would re-create the remote splendor of icebergs for the urban masses. His companion on the journey was the Episcopal minister Reverend Louis L. Noble, a friend and biographer of Thomas Cole, Church's teacher. For about four weeks in June and July of 1859, they observed icebergs from a sixty-five ton schooner chartered by Church in St. John's, Newfoundland. Despite their seasickness, Church sketched in oils and in pencil, while Noble kept a journal from which he would write the book *After Icebergs with a Painter: A Summer Voyage to Labrador and Around Newfoundland* (New York and London, 1861). The publication of Noble's enthusiastic narrative coincided with the debut of Church's painting at Goupil's, New York, in April 1861. In the fervor of the first months of the Civil War, the event was advertised as a benefit for the Patriotic Fund, and the picture was enlisted in the Union cause with the title *The North, Church's picture of Icebergs*. Like *Niagara Falls* before it, *The Icebergs* won a New York critic's accolade as ". . . the most splendid work of art that has yet been produced in this country."[1]

Church's pictorial and scientific interests were closely allied in this work: his intent was to awe and then to educate the viewer with his record of an alien environment. Visitors to the New York and Boston showing received broadsheets which explained the painting's effects. The main masses in the picture are parts of an immense iceberg, afloat at sea after separating from the Greenland glaciers (and still bearing a few boulders from the land-mass). Large segments have broken from the near side, changing the iceberg's center of gravity and causing the entire foreground to rise up out of the waves. The more sharply defined ice surfaces in the foreground were shaped by underwater currents, whereas the rounded and polished forms of the central masses result from atmospheric erosion. The emerald color of the sea in the lower right is caused by the submerged ice, while the pale blue of the left foreground is a pool of fresh water collecting on top of the iceberg. The artist deliberately chose late-afternoon sunlight, when "lights and shadows, hues and tints, shower the scene, and are thrown in all ways, and multiplied by reflection."[2]

The Icebergs differs in handling from the carefully detailed Ruskinian style of Church's earlier exhibition pictures; its loose and apparently rapid execution is reminiscent of the artist's small plein air oil sketches. This unusual style probably results from a combination of factors, including the painting's large size and the fact that it may have been completed in a hurry. Originally there was no splintering mast and rigging in the foreground, although several of the studies for *The Icebergs* show a wrecked hull.[3] The mast was added to the foreground late in 1862 before the picture appeared in London. Church obviously wanted to counter the

work's original sense of almost supernatural beauty with the tragic reminder of the real dangers of icebergs.[4] Like the tree trunk swept up in the foreground torrent of *Niagara Falls* (cat.no.38), the broken mast is also important in establishing the magnitude of the scene presented.

The Icebergs met with great critical acclaim when exhibited in London for three months in 1863. A chromolithograph was made there, and the picture was sold to railroad magnate and Member of Parliament, Edward William Watkin (1819–1901).

<div align="right">

T.J.F.

</div>

NOTES

1. New York *Tribune*, 24 April 1861, quoted in Gerald L. Carr, *Frederic Edwin Church: "The Icebergs"* (Dallas Museum of Fine Arts, 1980), p. 83.

2. Broadsheet presumably written by the artist, *The North. Painted by F. E. Church, from Studies of Icebergs made in the Northern Seas, in the Summer of 1859*, accompanying 1862 exhibition at Boston Athenaeum.

3. The studies are discussed and illustrated in Carr, "*Icebergs*," pp. 68–73. The chromolithograph made in England in 1863 by Charles Risdon shows the foreground wreckage, which is also mentioned in some reviews of the picture's London appearance. David C. Huntington suggests that Church added this grim detail for the British audience, as a salute to the missing arctic explorer Sir John Franklin (*The Landscapes of Frederic Edwin Church: Vision of an American Era* [New York, 1966] p. 86). Carr notes that none of the British reviews refers to Franklin (p. 90).

4. On the 1862 Boston broadsheet (which describes the picture *before* the wreckage was painted in), the following appears under the heading "Expression of the Scene": ". . . an iceberg, in itself alone, is a miracle of beauty and grandeur. . . . Hence the picture presents the beholder with ice only, reposing, under the brightness of the declining sun, in the calm, solitary ocean,—grandeur with repose."

PROVENANCE

Purchased from the artist by Edward William Watkin, M.P., Manchester, England; Sir Alfred Mellor Watkin, Manchester, 1901; William Joseph Parkyn, Northenden, Manchester, 1902; St. Wilfrid's Church, Northenden, Manchester, 1915; Social Services Committee, City of Manchester, 1921; sold at auction, Sotheby Parke Bernet, New York, 1979; private collection, Dallas, 1979; to present owner, 1979.

EXHIBITION HISTORY

Goupil, Vibert & Co., New York, 1861.
Boston Athenaeum, *Annual Exhibition*, 1862.
The German Gallery, London, 1863.
National Gallery of Art, Washington, D.C., *American Light: The Luminist Movement, 1850–1875*, cat. by John Wilmerding et al., 1980, no. 18 (ill.).
Dallas Museum of Fine Arts, *Frederic Edwin Church: "The Icebergs,"* cat. by Gerald L. Carr, 1980.

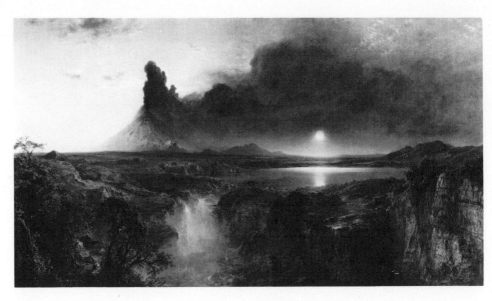

45

FREDERIC EDWIN CHURCH
Cotopaxi, 1862
Painted in New York City
Signed and dated lower right:
 F. E. CHURCH / 1862
Oil on canvas, 48 × 85 in. (121.9 × 216 cm.)
The Detroit Institute of Arts,
 Founders Society Purchase, Robert H.
 Tannahill Foundation Fund,
 Gibbs-Williams Fund, Dexter M. Ferry, Jr.,
 Fund, Merrill Fund, Beatrice W. Rogers
 Fund, and Richard A. Manoogian Fund
Exhibited in Paris only

In the nineteenth century many of Church's landscapes were considered sublime—that is, they aroused powerful emotions ranging from exhilaration and wonderment to fear (as opposed to the tranquil mood associated with paintings of picturesque scenes). Of Church's oeuvre, *Cotopaxi* is the most sublime. The artist first saw the South American volcano in 1853. Its snow-capped cone and extensive foothills loomed in the background of three sunny landscapes painted on his return to New York.[1] When he next saw Cotopaxi, in 1857, an eruption had transformed its silent grandeur, and it now "smoked and spit fire and stones constantly."[2] As Church described in an 1863 broadsheet for *Cotopaxi*'s debut at Goupil's, New York, the smoke was not easily dispersed by the slow tropical breeze: ". . . it hangs heavily over the landscape and along the horizon, so that the newly risen sun flares with a lurid fire through its thick volumes."[3] This atmospheric effect—the rising tropical sun fighting through volcanic smoke—is the picture's most astonishing feature. And paradoxically, the smoke emerges from Cotopaxi in a beautiful dark-brown plume before enveloping the landscape so menacingly.

Cotopaxi was intended to visualize the passionate, teeming spirit that the tropics symbolized for the Victorians. It also had the same hint of repressed sexuality that we now acknowledge in the tropical orchid pictures of Church's friend Martin Johnson Heade (see cat.no.67). Compared with the intellectual order of Church's northern landscapes, *Cotopaxi* revels in the sensuousness of light, color, and motion. It is, as one critic said, ". . . throbbing with fire and tremulous with life."[4]

Apart from the variety of natural spectacles, much of the sublime impact of this picture derives from its immense scope and dizzying aerial vantage point. The viewer of *Cotopaxi* sees the earth's surface as God might see it, and is forced to contemplate the origins and sustaining forces of the protagonists in this embroiled landscape. One New York critic identified the solemnity that the scene gradually aroused:

> *The sense of solitude withering in its splendor, of a torrid fierceness which seems to aim at aridity, but is baffled by unexpected and inextinguishable beauty, the superb disdain which the equator hurls at high civilization and human mastery and progress, are subtly reproduced in this painting, leaving in the spectator's mind a feeling of that profound sadness which the sight or the story of the Tropics always inspires.*[5]

The sorrowful qualities of *Cotopaxi* recall Cole's *Desolation*, a depiction of a mournful sunset from the *Course of Empire* series (1836; New-York Historical Society). In fact, *Desolation* was one of Church's three favorite pictures by Cole; as he said, it had ". . . as much poetic feeling as I ever saw in Landscape Art."[6] Church's painting shares with Cole's a tragic aspect: *Cotopaxi* portrays untamable natural forces that limit human achievements, and *Desolation* acknowledges the inevitable fall of all civilizations; both express the Romantic concept of man's seeming unimportance

within the cosmic life of the earth.

James Lenox, the New York philanthropist and bibliophile, commissioned *Cotopaxi* in 1861, for $5,000. There is a slightly smaller version (c. 1863) at the Reading Public Museum and Art Gallery, Reading, Pennsylvania.

T.J.F.

NOTES

1. The major paintings of the volcano inspired by the artist's first trip to South America are *Cotopaxi* (1855; National Museum of American Art, Smithsonian Institution, Washington, D.C.), *Cotopaxi* (1855; Museum of Fine Arts, Houston), and *View of Cotopaxi* (1857; Art Institute of Chicago).

2. Church to George Warren, Quito, Ecuador, 24 June 1857 (Gratz Collection, Historical Society of Pennsylvania, Philadelphia). The artist joked that the volcano had become "a confirmed old smoker."

3. Quoted in David C. Huntington, *Frederic Edwin Church, 1826–1900: Painter of the Adamic New World Myth* (Ph.D. diss., Yale University, 1960), p. 112.

4. "Church's *Cotopaxi*," *New York Times*, 17 March 1863, p. 4.

5. The Lounger, "Cotopaxi," *Harpers Weekly*, 4 April 1863, p. 211.

6. Church to John D. Champlin, 11 September 1885 (Albert Duveen Collection, Archives of American Art Microfilm Roll DD1, frames 115–16, Smithsonian Institution, Washington, D.C.). A work by Church titled *A Composition*, which quotes from Cole's *Desolation*, is reproduced in *Harper's New Monthly Magazine* 59 (September 1879): 481.

PROVENANCE

James Lenox, New York, 1862; Lenox Collection, New York Public Library; with M. Knoedler & Co., New York, 1945; Mr. John Astor, New York; to present owner, 1976.

EXHIBITION HISTORY

Goupil, Vibert & Co., New York, 1863.
McLean's Gallery, London, 1865.
Museum of Modern Art, New York, *Romantic Painting in America*, cat. by James Thrall Soby and Dorothy C. Miller, 1943–44, no. 49 (ill.).
Brooks Memorial Art Gallery, Memphis, *Loan Exhibition of American Paintings*, 1945, cat. no. 23.
National Collection of Fine Arts, Smithsonian Institution, Washington, D.C., *Frederic Edwin Church*, cat. by David C. Huntington, 1966 (traveling exhibition), no. 82 (ill.).
Metropolitan Museum of Art, New York, *19th-Century America: Paintings and Sculpture*, cat. by John K. Howat and Natalie Spassky, 1970, no. 107 (ill.).

46

FREDERIC EDWIN CHURCH
Rainy Season in the Tropics, 1866
Painted in New York City
Signed and dated lower left:
 F. E. CHURCH / 1866
 and lower right: F. E. CHURCH 1866
Oil on canvas, 56¼ × 84$\frac{3}{16}$ in.
 (142.9 × 213.8 cm.)
The Fine Arts Museums of San Francisco, Museum Purchase, H. K. S. Williams Fund for Mildred Anna Williams Collection

This is Church's last important South American landscape characterized by a high Romantic sense of visionary excitement; later works, such as *Morning in the Tropics* (1877; National Gallery of Art, Washington, D.C.) seem benign, even conventional, after the stirring impact of *Rainy Season in the Tropics*. In 1867 the picture prompted one English critic to remark: "[Church] . . . is a painter of what may be termed phenomenal nature, scenes which awaken a sense of omnipotence, spectacles that transcend the everyday works of Providence."[1]

The symmetrical double rainbow spanning the canvas is a symbol of God's benevolence toward man. The rivers seem to run with renewed force, and the sunshine strikes the vegetation with joyous effect in the wake of the cleansing storm that is moving off to the left. The foreground is especially important: it is a small triangular glimpse of the overgrown mountainside from which the artist views the scene, reminiscent of Cole's *The Oxbow: The Connecticut River Near Northampton* (1863; Metropolitan Museum of Art, New York) in its compositional role as a brink between two worlds. Church gives his

typically minute treatment to the foreground of *Rainy Season in the Tropics*, even detailing the reflections in the puddles on the road as a reminder that a heavy rainfall has just occurred. This section of the picture is the most thickly painted, and the scarlet cape worn by one of the peasants is the most intense color. Beyond the foreground the combined interactions of rain, mist, and sunshine affect the landscape so thoroughly that it seems to be a realm of fantasy, particularly the snowy peak that floats in the clear sky at upper right. The shrouded mountains, plateaus, and lakes proceeding diagonally from that jagged peak and passing beneath the rainbow to the misty gorge in the lower left have the insubstantiality of a vision. The heavenly landscape they compose is joined to the worldly foreground by the graceful form and divine presence of the rainbow. Rainbows were familiar accents of beauty in landscape painting throughout the nineteenth century, but like those in nature, they were smaller fragments and rarely featured with the prominence chosen by Church. To modern viewers the most famous precedent for *Rainy Season in the Tropics* in European Romantic painting is Caspar David Friedrich's *Mountain Landscape with Rainbow* (1810; Museum Folkwang, Essen), but it is not clear if Church knew this work.[2]

Rainy Season in the Tropics was commissioned by the artist's New York patron M. O. Roberts (see cat. no. 36). Church's reasons for making such a bold theistic statement were no doubt complex. There is probably a relationship to his private struggle following the death of his first two children from diphtheria in 1865, but more practical issues, such as the patron's request or the impact this

forceful image would have at an exhibition, should not be discounted.[3] The picture was first exhibited in Paris at the 1867 Exposition Universelle, where it appeared with *Niagara Falls* (cat.no.38); these were the first works Church exhibited in France.

T.J.F.

NOTES

1. "Paris International Exhibition. No. VI— National Schools of Painting," *The Art Journal* 29 (1867): 248.

2. An equally large English picture executed with comparable Ruskinian or Pre-Raphaelite detail is Henry Clarence Whaite's *The Rainbow* (1862; Castle Museum, Nottingham), discussed in the exhibition catalogue *Great Victorian Painters* (Arts Council of Great Britain, 1978), p. 89. For a contemporary description of *Rainy Season in the Tropics* which refers to the rainbow as "the bow of promise," see H. B. H., "A Visit to the Studios of Some American Painters," *The Art-Journal* 27 (1865): 362.

3. Church's private motivations are discussed by David C. Huntington in *The Landscapes of Frederic Edwin Church: Vision of an American Era* (New York, 1966), p. 56. Huntington's suggestion that the landscape combines the artist's South American and Jamaican experiences is somewhat misleading since the peasants in the foreground are clearly not Jamaican.

PROVENANCE

Marshall O. Roberts, New York, 1862; Roberts Estate, 1880; sold through Fifth Avenue Galleries, New York, 1897; to Jonathan Sturges, New York; H. C. Sturges; Sturges Estate; J. William Middendorf II, 1965; to present owner through Hirschl and Adler Galleries, New York, 1970.

EXHIBITION HISTORY

Paris, *Exposition Universelle*, 1867, cat.no.10.
National Academy of Design, New York, *First Winter Exhibition . . . Including Works from The American Art Department of the Paris Universal Exposition*, 1868, cat.no.638.
South Kensington Industrial Museum, London, *Annual International Exhibition*, 1871, cat.no.6.
Metropolitan Museum of Art, New York, *Paintings by Frederic E. Church, N.A.*, 1900 (ill.).
Metropolitan Museum of Art, New York, *Three Centuries of American Painting*, 1965.
National Collection of Fine Arts, Smithsonian Institution, Washington, D.C., *Frederic Edwin Church*, cat. by David C. Huntington, 1966 (traveling exhibition), no.94 (ill.).
Whitney Museum of American Art, New York, *Art of the United States, 1670–1966*, cat. by Lloyd Goodrich, 1966, no. 47.
Musée des Beaux-Arts, Montreal, *The Painter and the New World*, 1967, cat.no.337.
Metropolitan Museum of Art, New York, *American Paintings and Historical Prints from the Middendorf Collection*, cat. by Stuart Feld, 1967 (traveling exhibition), no.31.
M. H. de Young Memorial Museum, San Francisco, *The Rainbow Show*, 1975 (ill.).
Museum of Modern Art, New York, *The Natural Paradise: Painting in America 1800–1950*, cat. by Kynaston McShine et al., 1976, no.31 (ill.).

ALBERT BIERSTADT

(1830, Solingen, Germany
—1902, New York City)

Born near Düsseldorf, Bierstadt was brought to America when he was two years old. Apparently self-taught, by 1850 he was making landscapes and offering lessons in "monochromatic painting" in New Bedford. His mature style developed during a two-year stay in Germany (1853–55): he studied with Worthington Whittredge (q.v.) in Düsseldorf and was influenced by the local school led by Andreas Achenbach (1827–1905). In 1856–57 he toured Italy with Whittredge and met several landscape American artists including Sanford R. Gifford (q.v.). On his return to New Bedford in 1857, he produced a diverse group of paintings from his European sketches; the subjects ranged from German villages to the fish market in Rome, and the pictures were moderately well received at Boston and New York exhibitions.

In 1859 Bierstadt joined Colonel Landers's expedition to the Rocky Mountains, and the oil sketches and photographs from that journey were the basis for the pictures of buffalo herds, wagon trains, prairies, and mountains which won him a reputation as the premier painter of America's West. The success of his 6 × 10 foot Rocky Mountains *(1863; Metropolitan Museum of Art, New York) at the New York Sanitary Fair Art Gallery in 1864 established the artist as a rival of Church in painting Romantic American wilderness scenes (q.v.). In the meantime, Bierstadt had undertaken a more extensive trip west in 1863 which provided materials for paintings of California's Yosemite Valley.*

Like Church, Bierstadt was praised by many English critics in the 1860s for his application of Ruskinian observation and Turnerian grandeur to the virtually unknown scenery of the American West. His patrons were the new industrialist upper middle class who valued the size and conspicuous workmanship of the paintings as much as their tribute to America's seemingly endless natural resources. In 1875 Bierstadt painted two historical landscapes for the United States Capitol in Washington: The Discovery of the Hudson *and* Expedition under Vizcaino Landing at Monterey, 1601.

The American West remained Bierstadt's most important subject. After his success in the early 1860s, there was little development in his style, except the gradual shift to a slightly more atmospheric, less firm mode of execution. He exhibited a very large Rocky Mountains *landscape at the 1867 Exposition Universelle in Paris, and another at the 1869 Salon, after which he received the Legion of Honor. His popular fame persisted throughout his career, but by the 1870s he was increasingly criticized by younger commentators for his blatant theatricality.*

There is one monograph on the artist: Gordon Hendricks's Albert Bierstadt, Painter of the American West *(Amon Carter Museum, Fort Worth, Tex., 1974).*

47

ALBERT BIERSTADT
The Sierra Nevada in California, 1868
Painted in Rome
Signed and dated lower right: *A Bierstadt/68*
Oil on canvas, 72 × 120 in. (182.9 × 304.8 cm.)
National Museum of American Art,
 Smithsonian Institution,
 Washington, D.C.,
 Bequest of Helen Huntington Hull

When Bierstadt traveled west for the first time in 1859, he wrote to the New York art magazine *The Crayon* that the brilliant atmosphere of the mountainous landscape made it "the Italy of America in a primitive condition."[1] He also urged that the doomed Indian cultures be documented. By 1913 President Theodore Roosevelt lamented in his *Autobiography* that the "Wild West" was now as remote as Atlantis. In the intervening years, Bierstadt painted the most stirring and lyrical evocations of the unspoiled, natural West—the plains, the Rockies, the Sierras, and the Yosemite Valley. He celebrated the most sublime and beautiful splendors of the region, much of which was becoming increasingly infiltrated and domesticated by migrants, railroads, and tourists.

The Sierra Nevada in California combines a magically tranquil view of a lake with a sonorous mountain panorama, in which a storm moves off to the left and golden sunlight pours onto the clouds swirling round the snowy peaks. The charged and religiously uplifting transition occurring in the heavens is echoed in the foreground, where deer and ducks return cautiously to the still waters of the lake. The entire scene sparkles with a freshness that makes the viewer feel like the first ever to behold it, and it is imbued with the spirit of a powerful and gracious Creator. The picture is on a scale commensurate with the landscape it depicts. The eye travels from the brown rocks submerged in the crystalline blue water at the bottom left to the awe-inspiring waterfall plunging over the lofty cliff on the opposite shore. This enormous painting illustrates perfectly G. W. Sheldon's 1881 characterization of the artist and his work:

Mr. Bierstadt is a believer in Wagner's principle of the value of mere quantity in a work of art. He has painted more large canvases than any other American artist. His style is demonstrative and infused with emotion; he is the Gustave Doré of landscape-painting. [Bierstadt] doubtless holds that art from beginning to end is nothing more nor less than imitation—imitation inspired (if not controlled) by veracity, refined by taste, and, we may add, assisted by artifice; . . . he likes a subject that is noble in itself, and disdains to illumine common things.[2]

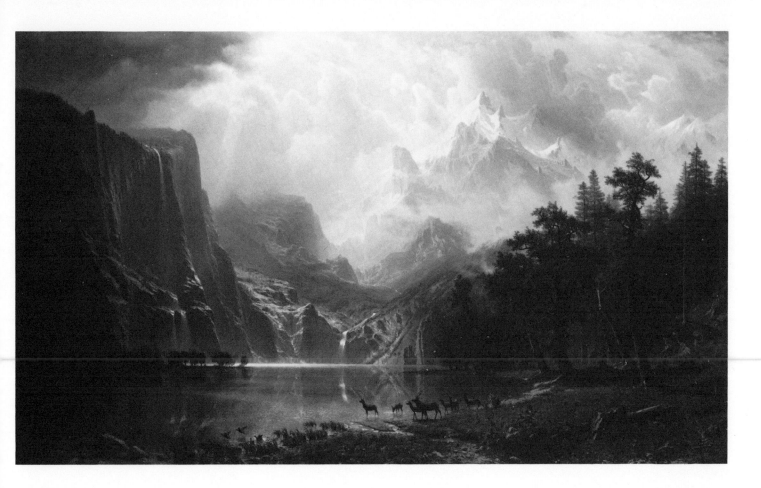

Preliminary work for this and many other paintings was done on Bierstadt's first visit to California in 1863. In 1870 his companion Fitz Hugh Ludlow published a narrative of the tour entitled *The Heart of the Continent* which is suffused with the same ecstatic impulse to aggrandize the scenery. For example, describing the immensity of the sheer precipices seen at the left of Bierstadt's painting, Ludlow writes, "The mighty pines and Douglas firs which grew all along its edge seemed like mere lashes on the granite lid of the Great Valley's upgazing eye."[3]

Surprisingly, Bierstadt painted this work in Rome, during a two-year European sojourn. There are two smaller, contemporary pictures with the same mountains and similar foregrounds but no animals; both may have served as preliminary exercises for *The Sierra Nevada in California*.[4] The large work was an important exhibition piece for Bierstadt while he was in Europe, being shown in Berlin, London (twice), and possibly Paris. It was purchased by the American express mail magnate, Alvin Adams (of Watertown, Mass.), who exhibited it at Childs & Company's gallery in Boston late in 1869.[5]

New York critics had been sharply divided over Bierstadt's major works in the mid-1860s, as had London critics a few years later, and now the same pattern emerged in Boston. A rigorous minority complained bitterly that the execution was hard, insensitive, and unrealistic; the overall character of the landscape bombastic, and exaggerated to the extent of falsehood; the sentiments shallow and sensational. Although this attitude would prevail in the last quarter of the century, in the late 1860s the majority of critics favored Bierstadt's works. They found his treatment of the lake and foreground especially fine in execution and charming in effect; more importantly, they accepted his Romantic desire to interpret the overwhelming mood of the landscape by combining various details (a direct legacy of Thomas Cole). Nor were such critics put out by the fact that eye-catching inventiveness was popular with the large unsophisticated public audience. Thus the writer for the *Boston Post* wrote proudly of this painting: "It is a perfect type of the American idea of what our scenery ought to be, if it is not so in reality. . . . We advise all our readers to inspect the painting. . . . They are sure to have abundant enjoyment and profit as well."[6]

T.J.F.

NOTES

1. *The Crayon* 6 (September 1859): 287.
2. Sheldon, *American Painters* (New York, 1881), p. 149.
3. Ludlow, *The Heart of the Continent: A Record of Travel Across the Plains and in Oregon, with an Examination of the Mormon Principle* (New York, 1870), p. 427.

4. The smaller works are *In the Mountains* (1867; Wadsworth Atheneum, Hartford, Conn.) and *Landscape* (1868; Fogg Art Museum, Cambridge, Mass.). Bierstadt repeats many of the compositional devices of *The Sierra Nevada* in his later work, *Mount Corcoran* (1875–77; Corcoran Gallery of Art, Washington, D.C.).
5. I am grateful to Gerald L. Carr for generously sharing his unpublished research on the picture's exhibition history.
6. "'Among the Sierra Nevada Mountains' by Bierstadt," *The Boston Post*, 11 October 1869, p. 4. Gerald L. Carr provided this Boston review.

PROVENANCE
The artist; Alvin Adams, Watertown, Mass., 1869; William Brown Dinsmore, Duchess County, N.Y., 1873; Madeleine I. Dinsmore; Helen Dinsmore Huntington Hull; to present owner, 1877.

EXHIBITION HISTORY
Berlin, 1868.
Langham Hotel, London, Summer, 1868.
Royal Academy, London, *Annual Exhibition*, 1869, cat. no. 309.
A. A. Childs & Co., Boston, 1869.
Museo del Palacio de Bellas Artes, Mexico City, *La Pintura de los Estados Unidos de Museos de la Ciudad de Washington*, 1980–81, cat. no. 18 (ill.).

MARTIN JOHNSON HEADE

(1819, Lumberville [Bucks County], Pennsylvania—1904, St. Augustine, Florida)

The son of a prosperous farmer, Heade was born in a small village some twenty-five miles north of Philadelphia. After working briefly with the local folk-painter Edward Hicks (1780–1849), in 1838 he traveled abroad to study, spending two years in Rome and visiting England and France. On his return, he continued to paint crude portraits and landscapes. His style became somewhat more sophisticated after a second trip abroad, in 1848, and he added genre painting and neoclassical figurative pictures to his repertoire. At this time he changed the spelling of his name from "Heed" to Heade. He moved about frequently, living in Philadelphia, New York, and Brooklyn during the forties, then in St. Louis, Chicago, Trenton, and Providence during the fifties. In 1859 he moved to New York, where he met Frederic Edwin Church (q.v.), who became a lifelong friend, and other leading painters. Heade's style matured as he began to specialize in marsh and coastal scenes, which won him his first critical notices in 1861. Working in Boston in 1861–63, he turned increasingly to views of the sea, and in 1863 he painted his earliest known still-life, the delicately rendered Vase of Corn Lilies and Heliotrope (St. Louis Art Museum). Later that year he traveled to Brazil where he painted The Gems of Brazil, a series of small pictures devoted to varying species of native hummingbirds. He tried unsuccessfully to have them reproduced in book form in London, and returned to South and Central America in 1866 and again in 1870. There he painted several moderately successful landscapes and, more importantly, began in 1871 a series of tropical orchid and hummingbird pictures that he continued to work on until his death.

From 1866 to 1881 Heade was based in New York City, where he produced his major body of work. He appears to have been fairly successful in terms of patronage, but won only a modest reputation. His specialty became the stormy marsh scene with haystacks, based on marsh studies made in Newbury, Massachusetts, and in Rhode Island and New Jersey. He also painted dramatic, forbidding marine views. Heade's work always varied in quality, but there was a general decline in the late seventies. In 1883 he moved to St. Augustine, Florida, married, and went on to produce several new series of still-lifes of flowers as well as some of the most ambitious landscapes of his career. He was still actively painting when he died in Florida at the age of eighty-five. Heade had been completely forgotten after moving south, and he was rediscovered only in the 1940s.

The first study of the artist was Robert G. McIntyre, Martin Johnson Heade (New York, 1948). The most recent monograph, with catalogue raisonné, is Theodore E. Stebbins, Jr., The Life and Works of Martin Johnson Heade (New Haven, Conn., 1975).

48

MARTIN JOHNSON HEADE
The Stranded Boat, 1863
Painted in Boston or Providence
Signed and dated lower right:
 M. J. Heade / 1863
Oil on canvas, $22\frac{3}{4} \times 36\frac{1}{2}$ in. (57.8 × 92.7 cm.)
Museum of Fine Arts, Boston,
 M. and M. Karolik Collection

Heade's artistic growth was greatly accelerated during 1859–60 in New York, when he worked at the newly opened Tenth Street Studio Building in close proximity to many of the leading American painters. This was followed by a very productive three-year period (1861–63) in Boston, during which he fully matured as a painter. His sunset views of 1861 suggest Church's influence, and in 1862 he painted *Lake George* (Museum of Fine Arts, Boston) in a style even more detailed than that of Church, one that suggests the possible influence of the English Pre-Raphaelites. In the following year, 1863, he turned increasingly to the Rhode Island shore for subject matter, painting coastal shipping scenes or landscapes with water in the distance. *The Stranded Boat* is part of this series, set on Narragansett Bay or the contiguous Mount Hope Bay, a protected deep-water area extending some thirty miles from Newport to Providence, Rhode Island.

Though this picture has frequently been cited as a typical example of Heade's Luminist style, in several respects it is unique in his oeuvre. For one thing, Heade's unusually successful composition balances land and sea equally. The sailing dory on the beach is both the best-drawn boat and the largest in scale in Heade's work. It provides a strong foreground element—also most unusual for him—while its mast leads the eye to the sea, then out to the left. In addition, while Heade often depicts storms, showers, and gray days, only in this work and in one other of the same year, *Hazy Sunrise at Sea* (Shelburne Museum, Vt.) does he paint fog.

In his study of this artist, John Wilmerding reasonably argues that Heade and Fitz Hugh Lane (q.v.) must have come to know each other's work in 1863, as Lane was at Gloucester, Massachusetts, and for a time Heade worked nearby at Lynn and Newbury, and, more importantly, because in this year each man's work shows some influence of the other.[1] *The Stranded Boat* does recall Lane in the dory, the fog, and the composition itself which is so much like Lane's paintings of Brace's Rock.[2] Lane's light, however, is sharp and crystalline, Heade's gray and hazy, and the impact of each is very different. A closer comparison may be made with the German Romantic painter Caspar David Friedrich: in his *Mist* (1807; Kunsthistoriches Museum, Vienna), there is a strong foreground, like Heade's, and a progression of ships barely visible offshore in the fog.[3] Heade's painting, like Friedrich's, may be considered an allegory of loneliness and death. In Heade's picture, the boat's ready oars and sail suggest that the sailor has just stepped away from it; there are two similar craft disappearing into the haze and a tiny figure on land bidding them adieu. A still green branch, recently cut off, lies on the sand awaiting the incoming tide. The

mood is gray and empty, with only the deserted dory still reverberating with life.

This painting is one of the approximately fifty Heades purchased mainly during the 1940s by the artist's modern discoverer, Maxim Karolik of Newport, the bulk of whose important collection of nineteenth-century American paintings was given to the Museum of Fine Arts, Boston, in 1946–47.[4]

<div align="right">T.E.S.</div>

NOTES

1. See John Wilmerding, *Fitz Hugh Lane* (New York, 1971), pp. 84–85. Barbara Novak, *American Painting of the Nineteenth Century: Realism, Idealism, and the American Experience* (New York, 1969), p. 125, argues otherwise.

2. Closest to Heade's composition is Lane's *Brace's Rock* dating from 1864, the year after *The Stranded Boat*. For the other Lanes of this subject, see Wilmerding et al., *American Light: The Luminist Movement, 1850–1875* (National Gallery of Art, Washington, D.C., 1980).

3. See Helmut Börsch-Supan, *Caspar David Friedrich* (New York, 1974), pp. 68–69.

4. See the Museum of Fine Arts, Boston, catalogue, *M. & M. Karolik Collection of American Paintings, 1815 to 1865* (Cambridge, Mass., 1949), with essay by John I. H. Baur.

PROVENANCE

C. R. Smith, Neenah, Wis.; Smith estate sale, 1948; with Victor Spark, New York; Maxim Karolik, Newport, R.I.; to present owner, 1948.

EXHIBITION HISTORY

M. Knoedler & Co., New York, *Paintings by Martin Johnson Heade and Fitz Hugh Lane from the Karolik Collection*, 1954, cat. no. 18.

University of Maryland Art Gallery, College Park, *Martin Johnson Heade*, cat. by Theodore E. Stebbins, Jr., 1969 (traveling exhibition), no. 14 (ill.).

Indiana University Art Museum, Bloomington, *The American Scene*, 1970, cat. no. 9 (ill.).

High Museum of Art, Atlanta, *The Beckoning Land*, cat. by Donelson F. Hoopes, 1971, no. 30 (ill.).

Katonah Gallery, New York, *Luminism in the Nineteenth Century*, 1972.

Museum of Fine Arts, Houston, *Tradition and Innovation: American Painting, 1860–1870*, cat. by Larry Curry, 1974.

Northern Illinois University, De Kalb, *Near Looking*, 1974 (traveling exhibition).

National Gallery of Art, Washington, D.C., *American Light: The Luminist Movement, 1850–1875*, cat. by John Wilmerding et al., 1980, no. 120 (ill.).

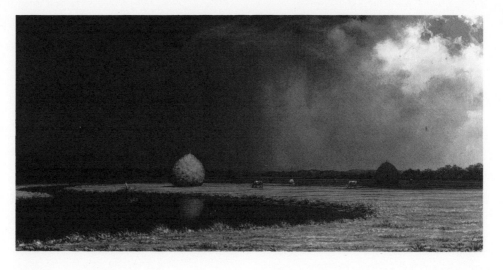

49

MARTIN JOHNSON HEADE
Salt Marsh Hay, c. 1870
Painted in New York City
Signed lower left: *M. J. Heade*
Oil on canvas, 13 × 26 in. (33 × 66 cm.)
The Butler Institute of American Art,
 Youngstown, Ohio

The flat, anonymous salt marshes of the eastern United States were Heade's favorite subject. He frequently painted the marshes in Massachusetts, Rhode Island, and Connecticut, in New Jersey during the 1870s, and in Florida late in his life. These marshes were the very opposite of the typical picturesque Hudson River School subjects, as they lack the topographical distinction of a well-known mountain peak or waterfall. Nonetheless, they must have appealed strongly to Heade, since he made over a hundred paintings of them— "more than of any other class of subjects,"[1] according to contemporary critics. His first marsh scene dates from 1860: here the artist has already discovered the special qualities that attracted him to the subject, the rhythm of the river as it curves one way and then another, the gradual march of the haystacks into the distance, and the broad, quickly changing sky.[2] At these sites, the painter need move only a few steps or wait an hour and a new picture would present itself. For Heade, the subject was inexhaustible: he painted the marshes at dawn and twilight, in harsh storms or soft showers, full of haystacks, animals, and working men, or empty.

Heade's paintings apparently earned him a modest living, though he never won more than a minor reputation. The leading critic of mid-century, Henry Tuckerman, wrote in 1867 that "Heade especially succeeds in representing marshland, with hay-ricks, and the peculiar atmospheric effects thereof," but the more progressive writer James Jackson Jarves found Heade's work repetitious and "wearisome."[3] More recent critics have seen the marsh scenes as "warm, wet, abundant," and ultimately sexual in their symbolism.[4] Others have argued that Heade can be seen as a "proto-Impressionist" and have commented on the obvious but essentially irrelevant relationship to Monet's haystack paintings of the early 1890s.[5]

Salt Marsh Hay probably represents the marshes near Newbury, Massachusetts, which

the artist apparently continued to visit even after settling in New York in 1866. It is executed with the soft, repetitive brush strokes that first appear in his work about this date. However, Heade continued to paint successful, warmly lit marsh scenes at least until 1883.[6] In a group of the most effective examples, all undated and all either 13 × 26 or 15 × 30 inches in size, the artist typically places the foreground and the largest haystack in shadow and shows the sun breaking through clouds in the distance. Here, instead, the foreground and the central haystack are brightly lit, while a passing storm puts the middle ground and distance into shadow. The haystacks themselves—the piles of salt marsh hay which the farmers will use for fodder and other purposes—are very large in size, which is typical of the earlier paintings in the series.

T.E.S.

NOTES

1. Clara E. Clement and Lawrence Hutton, *Artists of the Nineteenth Century and Their Works* (Boston and New York, 1884), p. 340.

2. See Theodore E. Stebbins, Jr., *The Life and Works of Martin Johnson Heade* (New Haven, Conn., 1975), nos. 35, 46, 64, 65, ff.

3. Henry T. Tuckerman, *Book of the Artists: American Artist Life* (1867; New York, 1966), p. 542; James Jackson Jarves, *The Art-Idea* (New York, 1864), p. 193.

4. See Stebbins, *Heade*, p. 55.

5. See Barbara Novak, *American Painting of the Nineteenth Century: Realism, Idealism, and the American Experience* (New York, 1969), pp. 129–31.

6. See *Sunset Marshes* (1883; Private Collection, Philadelphia), reproduced in Stebbins, *Heade*, no. 236.

PROVENANCE

Mr. Hugh Cabot, Boston; with Vose Galleries, Boston, 1954; to present owner, 1955.

EXHIBITION HISTORY

University of Maryland Art Gallery, College Park, *Martin Johnson Heade*, cat. by Theodore E. Stebbins, Jr., 1969 (traveling exhibition), no. 32 (ill.).

Dallas Museum of Fine Arts, *The Romantic Vision in America*, cat. by John Lunsford, 1971, no. 42 (ill.).

Vatican Museum, Rome, *A Mirror of Creation*, cat. by John I. H. Baur, 1980 (traveling exhibition), no. 15 (ill.).

50

MARTIN JOHNSON HEADE
Thunderstorm over Narragansett Bay, 1868
Painted in New York City
Signed and dated lower left: *M.J. Heade/1868.*
Oil on canvas, $32\frac{1}{8}$ × $54\frac{1}{2}$ in. (81.6 × 138.4 cm.)
Amon Carter Museum, Forth Worth, Texas

This painting played the key role in Heade's modern "rediscovery," and it remains the most widely admired of his works. What little reputation the artist gained at the height of his career was completely forgotten in the twentieth century, until *Thunderstorm over Narragansett Bay* was bought in 1942 by two enterprising dealers and was then displayed at the Museum of Modern Art's 1943 exhibition, *Romantic Painting in America*. It then toured in the "Hudson River School" show of 1945 organized by Frederick Sweet, who noted the picture's "eerie quality and sense of impending disaster."[1] Heade's first biographer, Robert McIntyre, wrote in 1948 that this had been the first Heade to come to his attention, and reported his early disappointment when so few other paintings by the artist appeared to have the same qualities.[2]

It is now apparent, however, that this painting is the culmination of a theme which the artist developed for over a decade. In his first fully developed landscape, *The Coming Storm* (1859; Metropolitan Museum of Art, New York), Heade in effect painted a prototype for *Thunderstorm over Narragansett Bay*, for it deals with the same kind of violent summer storm over a bay with sailboats, and similarly reduces color to emphasize sharp black and white contrasts.

Other pictures in the following years carry this further, at times reducing the composition to two horizontal bands, the violent, black sea and the lighter sky.[3] In 1866–67

Heade executed *Approaching Storm: Beach Near Newport* (Museum of Fine Arts, Boston), a disquieting view of breaking waves on a barren, rocky shore, with a single sailboat contrasted with the dark sea and broad, stormy sky. When exhibited at the National Academy of Design in New York, it was greeted with only faint praise, deemed "clever and novel" by the critic Henry Tuckerman.[4] When Heade sent the large *Thunderstorm over Narragansett Bay* to the National Academy in 1868, it received negative reviews. One critic described its "hardness in color and execution" and concluded, "It is to be regretted that so hard and chilling a painting as this should have been allowed to leave his studio."[5] Heade was either discouraged by the reception this work received, or he simply took up new interests, for he turned increasingly to gentler marsh landscapes and to still life, and never again attempted a stormy marine view on a large scale.

Heade was simply not in tune with the prevailing aesthetic of his day. Views of the shore were supposed to be calm and sunlit, recalling the pleasant idylls of summers past. John Frederick Kensett (q.v.), Alfred T. Bricher, and a number of lesser painters were successful specialists in such pictures. Heade's painting, on the other hand, suggests a less beneficent nature, depicting a moment of heightened awareness and frightful calm before the onset of a terrible, uncontrollable storm. Optimistic, detailed depictions of landscape dominated American art at this time, but Heade—always something of an outsider—saw nature differently. Foreshadowing Thomas Eakins, Albert Pinkham Ryder, and other figures later in the century, he painted the complexities of nature (and of man), suggesting the coexistence of violence and calm, of fear and hope, of darkness and light.

T.E.S.

NOTES

1. Sweet, *The Hudson River School* (Art Institute of Chicago, 1945), p. 81.
2. See McIntyre, *Martin Johnson Heade* (New York, 1948), pp. 44–45.
3. For example, *Sunset on the Rocks, Newport* (1861; Private Collection); see Stebbins, *Heade*, no. 42.
4. Tuckerman, *Book of the Artists: American Artists Life* (1867; New York, 1966), p. 543.
5. Review signed "G.T.C.," *National Academy of Design* [New York]. *Exhibition of 1868*, p. 87.

PROVENANCE

Larchmont, N.Y., antique store, 1942; A. Frederick Mondschein (or Mont) and Victor Spark, New York, 1942; Edward Korany, New York, 1943; Ernest Rosenfeld, New York, 1943; with James Maroney, Inc., New York; to present owner, 1978.

EXHIBITION HISTORY

National Academy of Design, New York, *43rd Annual Exhibition*, 1868, cat. no. 375.
Museum of Modern Art, New York, *Romantic Painting in America*, cat. by James Thrall Soby and Dorothy C. Miller, 1943, no. 103 (ill.).
St. Augustine Arts Club, Fla., *Martin Johnson Heade*, 1945.
Art Institute of Chicago, *The Hudson River School and the Early American Landscape Tradition*, cat. by Frederick A. Sweet, 1945 (traveling exhibition), no. 188 (ill.).
Brooklyn Museum, N.Y., *The Coast and the Sea: A Survey of American Marine Painting*, 1948, cat. no. 56.
Whitney Museum of American Art, New York, *Art of the United States, 1670–1966*, cat. by Lloyd Goodrich, 1966, no. 126.
Public Education Association, New York, *The American Vision, Paintings 1825–1875*, 1968, cat. no. 96.
University of Maryland Art Gallery, College Park, *Martin Johnson Heade*, cat. by Theodore E. Stebbins, Jr., 1969 (traveling exhibition), no. 28 (ill.).
Metropolitan Museum of Art, New York, *19th-Century America: Paintings and Sculpture*, cat. by John K. Howat and Natalie Spassky, 1970, no. 139 (ill.).
Whitney Museum of American Art, New York, *Seascape and the American Imagination*, cat. by Roger Stein, 1974 (ill.).
Museum of Modern Art, New York, *The Natural Paradise: Painting in America, 1800–1950*, cat. by Kynaston McShine et al., 1976, no. 74 (ill.).
National Gallery of Art, Washington, D.C., *American Light: The Luminist Movement, 1850–1875*, cat. by John Wilmerding et al., 1980, no. 63 (ill.).

WILLIAM SIDNEY MOUNT

(1807, Setauket, New York—1868, Setauket)

The traditional view of Mount as the consummate provincial painter is belied by his conscientious study of high-style traditions and European pictorial sources, and by his deliberate experimentation with painting methods and materials. In 1825 his brother Henry, a sign painter, took him as an apprentice in his shop in New York City, but Mount's interest in painting soon exceeded the opportunities provided by his brother's trade, and he began studying from engravings after European paintings, British drawing manuals, and copies of Old Masters at the American Academy of the Fine Arts. He was one of the first students to enroll at the newly established National Academy of Design, taking classes there in 1826. Mount's first works were portraits and crudely drawn, flatly colored biblical and historical subjects emulating the neoclassicism of Benjamin West (q.v.). But his native Long Island, to which he returned in 1827, suggested a more accessible subject matter. In 1830, drawing from engravings after the works of the popular Scottish painter David Wilkie and seventeenth-century Dutch and Flemish genre paintings, Mount produced his first depiction of American manners, Rustic Dance after a Sleigh Ride (Museum of Fine Arts, Boston).

In the mid-1830s, Mount reached his artistic maturity. On the strength of Rustic Dance, he was elected an Associate of the National Academy of Design in 1831 (he became a full academician the following year), and already the most influential figures in the New York art world—Luman Reed, James Lenox, Asher B. Durand—had begun to take notice of him. He was sought after as a portrait painter, and although his genre scenes soon progressed beyond the caricature of his early works to a dignified and realistic portrayal of rural America, it was as "the comic painter of American life" that he became best known. Critics such as Henry T. Tuckerman applauded his "happy delineations of the arch, gay, and rustic humors seen among the primitive people of his native place" (Book of the Artists [New York, 1867], p. 421). These images of life on Long Island were reproduced by the American Art Union for mass circulation in the United States, and by the art dealer William Schaus for distribution in Europe.

Mount's diaries and journals are now part of the extensive collection of his work at the museums in Stony Brook. Mount recorded the progress of his artistic self-education: his experiments with pigments and brushes, his studies of lighting and composition, and his construction of a moveable studio. Many American painters including younger contemporaries like Frances Edmonds and Richard Caton Woodville, and later genre painters such as Eastman Johnson, were influenced by his sensitively rendered subjects and clear, meticulous technique.

51

WILLIAM SIDNEY MOUNT
Farmers Nooning, 1836
Painted in Stony Brook, New York
Signed and dated lower left:
Wᵐ. S. MOUNT / 1836.
Oil on canvas, $20\frac{1}{8} \times 24\frac{3}{16}$ in. (51.1×61.4 cm.)
The Museums at Stony Brook, New York,
 Gift of Frederick Sturges, Jr., 1954

The first comprehensive biography of Mount, by Mary Bartlett Cowdrey and Hermann Warner Williams, Jr. (New York, 1944), contains much useful information and catalogue of the artist's work. Alfred Frankenstein organized a major exhibition of Mount's work for the National Gallery of Art, Washington, D.C., in 1969 and published many of his letters and journals in William Sidney Mount *(New York, 1975).*

As a representation of "nature itself, a perfect transcript from life,"[1] *Farmers Nooning* has always been one of Mount's most-admired works. Henry T. Tuckerman, writing in 1867, found it "expressive and well-wrought" and praised it for doing justice "to the humorous and genial phase of the negro character."[2] More than a hundred years later, Mount's scene is still celebrated as the quintessential image of rural American life, presenting a world of optimism and contentment. In addition, the painting has come to be viewed as progressive, embodying trends that would come to fruition only in the next decade—or even the next generation. It has been variously praised for its prescient use of light as a metaphor for tranquility, abundance, and well-being, for inaugurating an era of realism in American art, and, echoing Tuckerman, for its compassionate depiction of the American black.[3]

In *Farmers Nooning*, Mount depicts the midday rest of a group of young farmhands at harvest time. The setting is Mount's beloved Long Island, possibly his own farm, and the artist probably painted the picture in the open air.[4] Mount's colors are bright and pure, as they would remain for the next decade; his brushstrokes are crisp, and the pigment somewhat thinly applied. His figures are familiar types from his earlier genre scenes, though they are no longer caricatures but naturalistic and convincingly drawn.

Unlike the artist's earlier genre pictures,

which pay homage to seventeenth-century Dutch and Flemish tavern scenes, and especially to the genre paintings of his near contemporary David Wilkie, *Farmers Nooning* recalls a classical source. The black man is posed like the Barberini Faun (Glyptothek, Munich), a life-sized marble statue of the second century B.C. which was especially notorious in Mount's time because of the much-publicized international competition for it on the art market.[5] Plaster casts of the Faun were not especially common, although one may have been available at the National Academy of Design, where Mount drew from antique casts in 1826; more likely, he knew the statue from engravings, for his sleeping figure repeats the Faun's pose in reverse.

Variously identified as Pan, Bacchus, a Satyr, and a faun, the Barberini statue was much admired in the late eighteenth and early nineteenth centuries, although its pose, suggesting sleep or a drunken stupor, was considered undignified, indecent, even immoral.[6] These interpretations shed interesting light on Mount's rendition, for by association with the Faun, the black figure in this picture comes to embody indolence and an open sensuality not characteristic of the other farmhands in the scene. This suggests that the picture may not be nearly as sympathetic a portrayal of the black man as has been previously supposed.[7]

Farmers Nooning was commissioned for the handsome price of $270 (plus $30 for the frame) by Jonathan Sturges, one of several prominent New York collectors who avidly sought Mount's work. The correspondence between artist and patron reveals Sturges's great enthusiasm for the picture and his eagerness for more paintings by Mount, who ultimately obliged him with two: *Ringing the Pig* (1842; New York State Historical Association, Cooperstown, N.Y.) and *Who'll Turn the Grindstone?* (1851; Museums at Stony Brook, N.Y.). Sturges's position as president of the New York Gallery of the Fine Arts, frequent host to the exclusive Sketch Club, and member of the Committee of Management of the American Art-Union made him a well-placed adviser; at his suggestion, Mount submitted two paintings to be reproduced and distributed by the AAU. *Farmers Nooning*, the first of these, was engraved in 1843 by Alfred Jones; the popularity of the print assured the success of the AAU and gained for Mount a national reputation. *Farmers Nooning* also appeared as the frontispiece for the July 1845 edition of *Godey's Lady's Book*, engraved by Joseph N. Gimbrede. These prints, with their wide circulation, inspired several artists (most notably James G. Clonney in *Waking Up* [1851; Museum of Fine Arts, Boston]) to appropriate the motif of white boys teasing a sleeping black man. Mount himself returned to the theme of sleeping field hands at least twice in his career, but neither *Boys Caught Napping in a Field* (1848; Brooklyn Museum, N.Y.) nor *The Dawn of Day* (c. 1867; Museums at Stony Brook, N.Y.) is as rich and vivid as *Farmers Nooning*.

C.T.

NOTES

1. W. Alfred Jones, "A Sketch of the Life and Character of William S. Mount," *American Whig Review* 14 (1851): 124, quoted in Mary Bartlett Cowdrey and Hermann Warner Williams, Jr., *William Sidney Mount* (New York, 1944), p. 17.

2. Henry T. Tuckerman, *Book of the Artists: American Artist Life* (1867; New York, 1966), p. 421.

3. See John Wilmerding, "The Luminist Movement: Some Reflections," in *American Light: The Luminist Movement, 1850–1875* (National Gallery of Art, Washington, D.C., 1980), pp. 101, 105; Berry B. Tracy and William H. Gerdts, *Classical America* (Newark Museum, N.J., 1963), p. 191, and Ellwood C. Parry III, *The Image of the Indian and the Black Man in American Art* (New York, 1974), p. 86.

4. Mount, journal entry for 14 November 1852, quoted in Alfred Frankenstein, *William Sidney Mount* (New York, 1975), p. 249. Mount may also be referring to the oil sketch for the picture (Museums at Stony Brook, N.Y.), which shows the figures in a different arrangement and lacks the key character, the sleeping black.

5. See Francis Haskell and Nicholas Penny, *Taste and the Antique* (New Haven, Conn., 1981), p. 202.

6. Ibid., p. 204.

7. See, e.g., Parry, *The Indian and the Black Man*, p. 86: "the teasing is an innocent noon-hour diversion, and the sleeping man is far from a caricature of laziness or sloth."

PROVENANCE

Jonathan Sturges, New York, 1836; his grandson, Frederick Sturges, Jr., Fairfield, Conn., by 1942; to present owner, 1954.

EXHIBITION HISTORY

National Academy of Design, New York, *12th Annual Exhibition*, 1837, cat. no. 268.

Stuyvesant Institute, New York, *Catalogue . . . of the Exhibition of Select Paintings by Modern Artists, Principally American*, 1838, no. 114.

Art-Union Gallery, New York, *Washington Exhibition held in aid of the New York Gallery of Fine Arts*, 1853, cat. no. 77.

Brooklyn Museum, N.Y., *Exhibition of Drawings and Paintings by William Sidney Mount, 1808–68*, cat. by John I. H. Baur, 1942, no. 43.

Metropolitan Museum of Art, New York, *William S. Mount and His Circle*, 1945.

Suffolk Museum at Stony Brook, N.Y., *The Mount Brothers*, cat. by Mary Bartlett Cowdrey, 1947, no. 69 (ill.).

Carnegie Institute, Pittsburgh, *American Classics of the 19th Century*, 1957 (traveling exhibition).

Dallas Museum of Fine Arts, *Famous Families in American Art*, 1960.

Newark Museum, N.J., *Classical America, 1815–1845*, cat. by Berry B. Tracy and William H. Gerdts, 1963, no. 266 (ill.).

Bowdoin College Museum of Art, Brunswick, Maine, *The Portrayal of the Negro in American Painting*, cat. by Sidney Kaplan, 1964, no. 18 (ill.).

Everson Museum of Art, Syracuse, N.Y., *American Painting from 1830*, 1965, cat. no. 58.

Century Association, New York, *William Sidney Mount*, 1967.

Forum Gallery, New York, *The Portrayal of the Negro in American Painting*, 1967.

Hirschl and Adler Galleries, New York, *The American Vision*, 1968.

National Gallery of Art, Washington, D.C., *Painter of Rural America: William Sidney Mount*, cat. by Alfred Frankenstein, 1968 (traveling exhibition), no. 10 (ill.).

Metropolitan Museum of Art, New York, *19th-Century America: Paintings and Sculpture*, cat. by John K. Howat and Natalie Spassky, 1970, no. 52 (ill.).

Art Museum of South Texas, Corpus Christie, *William Sidney Mount*, 1970.

Turman Gallery, Indiana State University, Terre Haute, *American Scene*, 1970.

Museum of Fine Arts, St. Petersburg, Fla., *The Good Life*, 1971 (traveling exhibition), cat. no. 25.

Suffolk Museum and Carriage House, Stony Brook, N.Y., *Mount Exhibition and Festival*, 1972, cat. no. 16.

Finch College Art Museum, New York, *Twice as Natural: 19th Century American Genre*, 1974.

Museums at Stony Brook, N.Y., *Francis William Edmonds, Master of American Genre Painting* (with a corresponding selection of works by William Sidney Mount), 1975.

National Gallery of Art, Washington, D.C., *American Light: The Luminist Movement, 1850–1875*, cat. by John Wilmerding et al., 1980, pp. 101, 105 (ill.).

52

WILLIAM SIDNEY MOUNT
Bargaining for a Horse, 1835
Painted in Stony Brook, New York
Signed and dated lower left:
 W^m. S. MOUNT / 1835.
Oil on canvas, 24 × 30 in. (61 × 76.2 cm.)
The New-York Historical Society

Bargaining for a Horse depicts a cordial negotiation between two farmers, who whittle as they dicker over terms. They are dressed alike, in battered hats, white shirts, vests, neckerchiefs, and patched but clean pants; the similarity of their attire discredits the hypothesis that the picture illustrates the popular legend of the city slicker outsmarted by the clever hayseed.[1] They are most likely haggling over the sleek, handsome saddle horse at the left, although Mount's original title for the painting, *Farmer's Bargaining*, does not specify the object of their discussion.[2] The farm implements strewn about the foreground add visual interest and indicate that this is a working farm, though, as is typical of Mount's rural scenes, no labor is being performed.

The setting for *Bargaining for a Horse* was Mount's own farm in Stony Brook on Long Island; the farmers are posed before the west door of his barn. The composition is as stringently organized as the imposing neoclassical dramas Mount so much admired and creates a comparable sense of measure and order. The space is shallow and carefully circumscribed: the short fence limits recession and confines the action to the foreground plane, while the horse, the two men, and the pitchfork are arranged in a series of gentle diagonals that inject a feeling of naturalness and relieve the rigid planarity of traditional neoclassical compositions. The pure color and cool, clear light augment the harmonious, idyllic mood of the scene. The only disquieting element is the farmer's wife, isolated from the main figures in a distant spatial compartment (a device Mount borrowed from David Wilkie and ultimately from David Teniers); she

stands by the farmhouse, behind the gate at the far left, and shades her eyes with her hand as she strains to follow the progress of the transaction.

In *Bargaining for a Horse*, Mount has replaced the obvious moralizing content of the genre pictures of the previous generation with a more lighthearted picturesqueness. His theme—a colorful rustic ritual with universal fascination and charm—exhibits none of the squalor and chaos that marks many of the genre paintings of Wilkie, with whom Mount has often been compared,[3] nor the pointed satire of Allston's, nor the stark, tragic consequences of Hogarth's ever popular dramas. Rather, his interest is in the exchange between the genial antagonists, whose half-smiles reveal their sly pleasure in the contest.

Mount's sunny, nontheatrical, nondoctrinaire approach appealed to Luman Reed, the pioneer collector of American art, who commissioned this picture in 1835 and recorded his appreciation in an affectionate letter to the artist: "I really feel proud of possessing this picture. . . . The subject 'comick' is a pleasing one and I would rather laugh than cry at any time. . . . you have hit off the character to a charm."[4]

Bargaining for a Horse was first engraved by Joseph Andrews in 1840 for *The Gift*, a Christmas annual published in Philadelphia by Carey and Hart; an engraving after Mount's *The Painter's Triumph* appeared in the same number. A small line engraving was produced by Charles Burt for the American Art-Union in 1851. Three years later, when the publishing concern Goupil, Vibert & Company attempted to buy the plate for the picture from the AAU in order to issue a larger, more marketable engraving, they were stopped by pressure from Mount's dealer, William Schaus, and by protests from Mount himself ("I hope you will not suffer the small plate 'Bargaining for a Horse' to be sold for the purpose of being magnified, and thereby lose the spirit of the painting"),[5] who was constantly vigilant over the quality of the reproductions of his work. Also in 1854, Mount painted a variant of *Bargaining for a Horse* which he called *Coming to the Point* (New-York Historical Society). In that painting, weaker in composition and characterization than the original, Mount documented another phase in the rite of negotiation, as he recorded in his journal the year before: "If I should paint another Farmers Bargaining, I must have one of the figures in the act of cutting towards his body to clinch the bargain."[6]

C.T.

NOTES

1. See Alfred Frankenstein, *William Sidney Mount* (New York, 1975), p. 269.

2. The painting was exhibited under that title at the National Academy of Design in 1836 and is referred to as "The Bargain" by its first owner, Luman Reed, in his 1835–36 correspondence with Mount. The picture first received the title by which it is known today in 1840, when it was reproduced in the Christmas book *The Gift*.

3. See Donald D. Keyes, "The Sources for William Sidney Mount's Earliest Genre Paintings," *Art Quarterly* 32 (Autumn 1969): 258–68, and Catherine Hoover, "The Influence of David Wilkie's Prints on the Genre Paintings of William Sidney Mount," *American Art Journal* 13 (Summer 1981): 4–33. Keyes perceptively suggests a connection between the tone of Mount's genre scenes and the similarly genial, nonsatiric pictures of rural life by his British predecessor George Morland.

4. Reed to Mount, 24 September 1835, quoted in Frankenstein, *Mount*, p. 69.

5. Mount to Jonathan Sturges, 14 March 1854, ibid., pp. 166–67. Sturges was then a member of the Committee of Management of the American Art-Union.

6. Diary entry for 28 February 1853, ibid., p. 266.

PROVENANCE

Luman Reed and his family, New York, to 1844; New York Gallery of Fine Arts, to 1858; to present owner, 1858.

EXHIBITION HISTORY

National Academy of Design, New York, *11th Annual Exhibition*, 1836, cat. no. 155 (as *Farmer's Bargaining*).

New York Gallery of Fine Arts, 1844, cat. no. 62.

American Art-Union Gallery, New York, *Washington Exhibition held in aid of the New York Gallery of Fine Arts*, 1853, cat. no. 118.

Brooklyn Museum, N.Y., *Exhibition of Drawings and Paintings by William Sidney Mount, 1807–68*, cat. by John I. H. Baur, 1942, no. 39.

Suffolk Museum at Stony Brook, N.Y., *The Mount Brothers*, cat. by Mary Bartlett Cowdrey, 1947, no. 65 (ill.).

Metropolitan Museum of Art, New York, *19th-Century America: Paintings and Sculpture*, cat. by John K. Howat and Natalie Spassky, 1970, no. 51 (ill.).

RICHARD CATON WOODVILLE

(1825, Baltimore—1855, London)

Growing up in Baltimore, Woodville apparently learned the rudiments of painting from art books and engravings, although he may well have also studied several Baltimore art collections, notably Robert Gilmor's with its paintings by William Sidney Mount (q.v.) as well as by Dutch and Flemish seventeenth-century artists. He enrolled briefly in medical school at the University of Maryland in 1842, by which time he had already executed several competent portraits. Finally, after exhibiting Scene in a Bar-room *(unlocated) at the National Academy of Design, New York, in 1845, Woodville went to Europe to study painting. For six years he studied under the genre painter Carl Ferdinand Sohn at the Düsseldorf Academy, where precise draftsmanship and high finish were stressed. While in Düsseldorf he produced his best work, painting portraits and sophisticated genre scenes of contemporary American and traditional European themes. In 1851 he left Germany and traveled to Paris and then to London, where he died in 1855 of an overdose of morphine.*

Woodville's output was small, but he nonetheless achieved widespread recognition in America after his death. His popularity stemmed from his ability to reveal the humor in a wide variety of everyday circumstances without resorting to mockery or caricature. Contemporary critics compared him to the popular Scottish painter David Wilkie and praised his clear compositions, meticulous painting technique, and telling insight into middle-class life. Many of Woodville's paintings were engraved, particularly for the American Art-Union. They were bought by some of the most distinguished collectors of the age, including John Taylor Johnston and William T. Walters. The latter's collection of paintings formed the nucleus of the Walters Art Gallery in Baltimore, today the major repository of Woodville's work in America.

The principal work on Woodville is by Francis Grubar, Richard Caton Woodville: An American Artist 1825–1855 *(Ph.D. diss., The Johns Hopkins University, 1966); and his exhibition catalogue for the Corcoran Gallery of Art (1967).*

53

RICHARD CATON WOODVILLE
War News from Mexico, 1848
Painted in Düsseldorf
Oil on canvas, 27 × 25 in. (68.6 × 63.5 cm.)
National Academy of Design, New York

Woodville painted *War News from Mexico* at a time of great patriotic fervor and economic growth in America. In 1848, filled with the doctrine of Manifest Destiny, the nation had expanded its borders into the Southwest and California. Three years earlier Texas had been annexed, resulting in the war with Mexico. In this painting, the front porch of the "American Hotel" is presented as a microcosm of American society, bursting with enthusiasm and self-importance as it eagerly receives news from the front.

One year before *War News* was painted, the American genre painter James G. Clonney executed a similarly titled picture (Munson-Williams-Proctor Institute, Utica, N.Y.). In Clonney's work, two seated men casually chat about the efforts of the American army in Texas. The unaffectedly natural scene is typical of American genre at the time, full of local color and charm. Woodville's more complex picture, by contrast, lacks the regional characteristics of the other work. Crammed with descriptive details and amusing vignettes, *War News* portrays modern American society as composed of well-dressed, urban, white males straining to keep up with the latest news.[1] His characters assume self-conscious postures, as though they were playing to an audience; the stagelike porch, which concentrates, orders, and controls the group's spirit, becomes a kind of vernacular temple, investing the local scene with historical significance.

Although painted in Düsseldorf and strongly influenced by both the figure types and the theatrical lighting of the German genre specialist Johann Peter Hasenclever,[2] *War News from Mexico* was greeted by New York critics as "perfectly American in its character."[3] The American Art-Union commissioned printmaker Alfred Jones to produce two engravings of it for distribution to its members in 1851.[4] The image enjoyed great success, admired not only for its trenchant characterizations of Americans but also for its encapsulation of the nation's contagious energy.

D.D.K.

NOTES

1. See Patricia Hills, *The Painters' America: Rural and Urban Life, 1810–1910* (Whitney Museum of American Art, New York, 1974), esp. pp. 52–57. It is interesting that Woodville portrayed both the blacks and the woman outside the porch itself, that is, on the fringes of American society.

2. See *The Hudson and the Rhine: Die amerikanische Malerkolonie in Düsseldorf im 19. Jahrhundert*

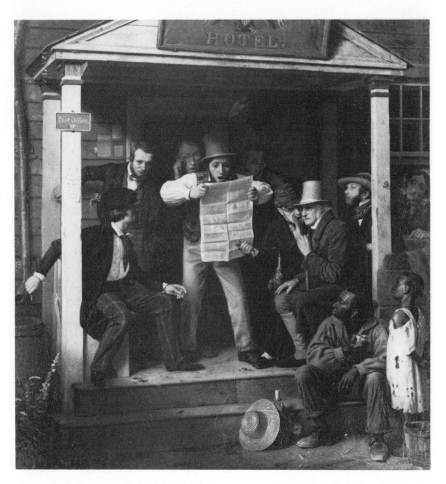

(Kunstmuseum Düsseldorf, 1976), p. 94.

3. *Bulletin* of the American Art-Union, 31 (December 1850), p. 188.

4. See Francis Grubar, *Richard Caton Woodville: An American Artist, 1825–1855* (Ph.D. diss., The Johns Hopkins University, 1966), p. 120, where two copies are cited, one by Garnier (unlocated), and the other in the Maryland Historical Society.

PROVENANCE

American Art-Union; Mr. George W. Austen, 1849; Mr. and Mrs. Marshall O. Roberts, before 1864; Mr. Samuel P. Avery, 1897; Mr. John D. Crimmins; to present owner, before 1915.

EXHIBITION HISTORY

American Art-Union, New York, 1849, cat. no. 707.

Brooklyn Atheneum, N.Y., 1856, cat. no. 53.

Franklin Institute, New York, *Second Annual Exhibition, Delaware Academy of Design*, 1857, cat. no. 98.

New York, *Metropolitan Fair in Aid of the U.S. Sanitary Commission*, 1864, cat. no. 8.

Ortgies & Co. 5th Avenue Galleries, New York, 1897, cat. no. 150.

Metropolitan Museum of Art, New York, 1897.

San Francisco, *Panama-Pacific International Exposition*, 1915, cat. no. 2743.

Whitney Museum of American Art, New York, *American Genre: The Social Scene in Painting and Prints, 1800–1935*, 1935, cat. no. 107.

M. H. de Young Memorial Museum, San Francisco, *Exhibition of American Painting*, 1935, cat. no. 245 (ill.).

Virginia Museum of Fine Arts, Richmond, *Inaugural Exhibition: The Main Currents in the Development of American Painting*, 1936, cat. no. 44 (ill.).

Metropolitan Museum of Art, New York, *Life in America*, 1939, cat. no. 128.

Carnegie Institute, Pittsburgh, *Survey of American Painting*, 1940, cat. no. 33.

National Academy of Design, New York, *Our Heritage*, 1942, cat. no. 195.

Corcoran Gallery of Art, Washington, D.C., *De Gustibus*, 1949, cat. no. 8.

Denver Art Museum, Colo., *Life in America*, 1951.

National Academy of Design, New York, *The American Tradition of Paintings, 1800–1900*, 1951, cat. no. 151.

American Federation of the Arts, New York, *American Painting in the Nineteenth Century*, 1952 (traveling exhibition), cat. no. 38.

The Newark Museum, N.J., *Of Other Days, Scenes of Everyday Life*, cat. by William H. Gerdts, 1957.

Corcoran Gallery of Art, Washington, D.C., *Richard Caton Woodville, An Early American Genre Painter*, cat. by Francis Grubar, 1967, no. 11.

Whitney Museum of American Art, New York, *The Painters' America, Rural and Urban Life 1810–1910*, cat. by Patricia Hills, 1974 (traveling exhibition), no. 64 (ill.).

Whitney Museum of American Art, New York, *The American Art-Union*, 1977.

National Academy of Design, New York, *All Walks of Life*, 1979.

GEORGE CALEB BINGHAM

(1811, Augusta County, Virginia
—1879, Kansas City, Missouri)

Bingham was raised in Franklin, Missouri, where his father was a successful farmer and businessman. During his apprenticeship to a cabinetmaker (c. 1827–33), he determined to become a portraitist, apparently influenced by an unknown itinerant artist. He would continue to paint portraits, mostly of middle-class subjects, throughout his career, from 1834 to the 1870s. Bingham was self-taught, and his earliest style has the provincial qualities of starkness, frank observation, and firm execution. These softened as the artist gradually adopted the conventions of mid-Victorian urban taste.

On a three-month visit from St. Louis to Philadelphia in the spring of 1838, Bingham purchased drawings, engravings, and casts of antique sculpture to aid his efforts at self-improvement back in Missouri. He later worked as a portraitist in Washington, D.C., for three and a half years (1841–44), and painted John Quincy Adams and Daniel Webster.

However, Bingham's fame, in his lifetime as well as in this century, rests not on his portraits but on his genre pictures of two distinct Midwest frontier "societies": the men who lived and worked on the river, and the inhabitants of well-established small towns during election time. He won critical acclaim with the river paintings exhibited in New York from the mid-1840s to early '50s, and in 1847 The Jolly Flatboatmen (1846; Coll. Senator Claiborne Pell, Washington, D.C.) was transmitted across the country as an engraving issued by the American Art-Union to almost ten thousand subscribers. Bingham began his election series a year after he lost his bid to become State Representative for Missouri in 1846. The most important works in this series, such as The County Election (1851–52; St. Louis Art Museum; 1854 engraving by John Sartain) have many more figures than the river pictures and report dryly and humorously the intrigues and corruption as well as the general procedure and festivities of elections. It is evident that he knew the artistic precedent set by William Hogarth. The best river and election pictures—superbly organized, straightforward compositions enhanced by economic modeling and a beautiful response to light—are celebrated for their poetic timelessness. He also painted pastoral landscapes from the 1840s on, but they have never approached the broad success of his genre pieces.

Bingham's popularity in the East had declined when his most important sponsor, the American Art-Union, disbanded in 1852, and he stopped sending pictures to other New York exhibitions. In his mid-forties he visited Paris and worked in Düsseldorf (1857–58), where he completed a life-sized full-length portrait of Thomas Jefferson for the Missouri State Legislature (this and several other state commissioned historical portraits by Bingham were destroyed by fire in 1911). The dramatic grandeur of the monumental history pictures of Emanuel Leutze (whom the artist met in Düsseldorf) is reflected in Bingham's late works of this type such as his Order No. 11 (1865–68; Cincinnati Art Museum). In his later years he maintained his reputation in the West as a portrait painter and held various offices in Missouri local government.

Of the four monographs on Bingham, the most comprehensive study, with a catalogue raisonné, is E. Maurice Bloch, George Caleb Bingham: The Evolution of an Artist, 2 vols. (Berkeley and Los Angeles, 1967); the others are by Fern Helen Rusk (Jefferson City, Mo., 1917), Albert Christ-Janer (New York, 1940), and John Francis McDermott (Norman, Okla., 1959).

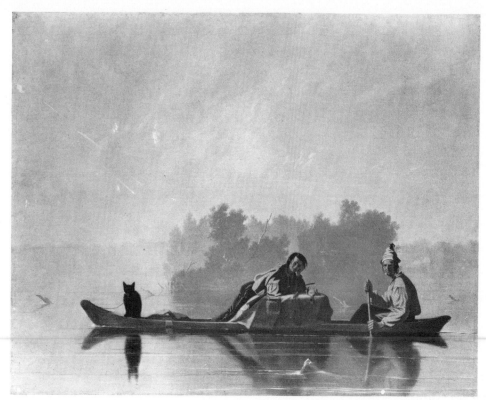

54

George Caleb Bingham
Fur Traders Descending the Missouri, 1845
Painted in St. Louis
Oil on canvas, 29 × 36½ in. (73.7 × 92.7 cm.)
The Metropolitan Museum of Art, New York,
 Morris K. Jesup Fund, 1933

Late in 1845 Bingham sent this picture to the American Art-Union, New York, with the title *French Trader and Half-Breed Son*. The Art-Union purchased it for $75 and exhibited it for a few days as *Fur Traders Descending the Missouri* prior to distribution in their annual lottery.[1] For an Eastern audience, the original title would have suggested the looser family relationships of frontier society; but the new title was more in keeping with the mood of serene romanticism which the picture so brilliantly evokes. A magical setting is established with the mirrorlike river, the silvery, roseate haze, and the delicately touched, layered silhouettes of the trees along the shore. Meeting the direct gazes of the two travelers, the viewer is drawn into their realm and longs to join their slow, peaceful, and seemingly eternal voyage. The vision is poignant since the boat will soon slip through the mist to a modern town downstream. Fleeting moments like this one must have been common scenes in Bingham's youth in Franklin, beside the Missouri; indeed, the work has a strong element of retrospection akin to Mark Twain's later evocation of the lost world of the pre-Civil War period in *Life on the Mississippi* (1883).

The dugout seen in *Fur Traders Descending the Missouri* was the most primitive of the professional craft on the river. Since the 1820s, large freight vessels such as keelboats, flatboats, and side-wheel steamers had predominated. Furthermore, French traders such as the one Bingham painted were among the more exotic and curious figures on the river, representative of a far more rugged, isolated, and independent way of life than that of the large fur companies working in teams from camps. Thus this picture is a nostalgic record of an outmoded way of life that was being gradually displaced by the expanding operations of commercial society in the Midwest.

Bingham responds to the "half civilized, half savage" picturesqueness of his subjects' clothes, heightening their visual impact with the sharp, complimentary blue and pink shirts.[2] However, he preserves the toughness and gypsylike individualism of their life-style. The man is grizzled and mean-looking, and even though his son wears a contented, daydreamy expression, he sprawls protectively across their cargo, nestling over his rifle and the duck he has killed. The black creature tied behind him—probably a bear cub—could be a pet, but it might just as well have been captured for its pelt.[3]

The independent operators in Bingham's picture are taking their furs downriver to the nearest trading post or perhaps to St. Louis, probably at the end of the spring hunting season. The extent of the man's liaison with Indian culture during his long periods in the wilderness is most powerfully symbolized by

his half-breed son.[4] While the artist does not idealize their lives, he places them in a wondrously beautiful setting with tremendous romantic appeal. The luminous colors, rich composition, and sensuous execution make this sky one of the finest in all American painting. An insightful analogy can be made between Bingham's enraptured depiction of the luscious Missouri twilight and Dutch seventeenth-century artists such as Cornelius Poelenburgh and Jan Both when they evoke the golden light of the Italian *campagna*.

Three contemporary pictures by Bingham, covering a wide range of subjects, accompanied *Fur Traders Descending the Missouri* at the American Art-Union in New York in 1845: *Landscape* (unlocated), *Cottage Scenery* (Corcoran Gallery of Art, Washington, D.C.), and *The Concealed Enemy* (Peabody Museum, Cambridge, Mass.). The latter shows an Indian with a rifle spying on an unseen vista from a rocky promontory. Indians threatened travel on the Missouri as late as the 1860s, and *The Concealed Enemy* balanced the peaceful mood of *Fur Traders* by recording one of the dangers of the frontier. There are no known reviews or comments on the four pictures Bingham exhibited in 1845. Until it was purchased by the Metropolitan Museum of Art in 1933, *Fur Traders Descending the Missouri* was essentially unknown; but it was soon incorporated into the history of American art as a work of iconic significance.

T.J.F.

NOTES

1. For an outline of the Art-Union's history, mode of operation, and stimulus to the popularity of genre painting in America from 1839 to 1851, see Maybelle Mann, *The American Art-Union* (Otisville, N.Y., 1977).

2. In his *Astoria* (1836), Washington Irving describes the "half civilized, half savage" dress of the "voyageurs," the plebian French workers in the fur trade, noting the "striped cotton shirt, cloth trousers, or leathern legging moccasins of deer skin, and a belt of variegated worsted, from which are suspended the knife, tobacco pouch, and other implements" (quoted in *19th-Century America: Paintings and Sculpture*, cat. by John K. Howat and Natalie Spassky [Metropolitan Museum of Art, New York, 1970], text to no. 75).

3. The animal has also been identified as a fox and a cat. In the artist's later version of this picture, *Trapper's Return* (1851; Detroit Institute of Arts) the tethered animal is standing and is definitely a bear cub. The two Bingham pencil drawings of the figures in this work are frequently cited as studies and dated 1845, but in fact they are both closer to the *Trapper's Return* and should be dated c. 1851 (both drawings at St. Louis Mercantile Library).

4. This work is discussed in the context of racial intermarriage in Dawn Glanz, *How the West Was Drawn: American Art and the Settling of the Frontier* (Ann Arbor, Mich., 1982), pp. 41–43.

PROVENANCE

Purchased from artist by the American Art-Union, New York, 1845; by lottery to Robert S. Bunker, Mobile, Ala., 1845; his daughter, Caroline, Mrs. Alphonse Du Mont; her daughter, Lena Du Mont, Point Clear, Ala.; with E. Herndon Smith, agent, New York, 1932; with John Wise, New York, 1933; to present owner, 1933.

EXHIBITION HISTORY

American Art-Union, New York, 1845, cat. no. 93.
Detroit Institute of Arts, *Art before the Machine Age*, 1933.
City Art Museum, St. Louis, *George Caleb Bingham, 1811–1879, "The Missouri Artist,"* 1934 (traveling exhibition), cat. no. 3.
Metropolitan Museum of Art, New York, *Life in America*, 1939, cat. no. 132 (ill.).
Museum of Modern Art, New York, *Romantic Painting in America*, cat. by James Thrall Soby and Dorothy C. Miller, 1943, no. 26.
Tate Gallery, London, *American Painting from the 18th Century to the Present Day*, 1946, cat. no. 19.
Brooklyn Museum, N.Y., *Westward Ho*, cat. by Herbert J. Spinden, 1949 (ill.).
City Art Museum, St. Louis, *Mississippi Panorama*, 1949, cat. no. 20.
Pennsylvania Academy of the Fine Arts, Philadelphia, *150th Anniversary Exhibition*, 1955, cat. no. 53 (ill.).
Nelson Gallery–Atkins Museum Kansas City, Mo., *George Caleb Bingham, Sesquicentennial Exhibition, 1811–1961*, 1961 (traveling exhibition), no. 4 (ill.).
Metropolitan Museum of Art, New York, *Masterpieces of Fifty Centuries*, 1970, cat. no. 366.
Museum of Fine Arts, Boston, *Masterpieces of Painting in the Metropolitan Museum of Art*, 1970, cat. no. 106 (ill.).
Tokyo National Museum and Kyoto National Museum, *Treasured Masterpieces of the Metropolitan Museum of Art*, 1972, cat. no. 112.
Pushkin Museum, Moscow, and Hermitage, Leningrad, *100 Kartin iz muzeia Metropolitan [100 Paintings from the Metropolitan Museum]*, 1975, cat. p. 242.
Metropolitan Museum of Art, New York, *A Bicentennial Treasury*, 1976–77.

55

GEORGE CALEB BINGHAM
Boatmen on the Missouri, 1846
Painted in St. Louis
Oil on canvas, $25\frac{1}{8} \times 30\frac{3}{8}$ in. (63.8 × 77.2 cm.)
The Fine Arts Museums of San Francisco, Gift of Mr. and Mrs. John D. Rockefeller 3rd.

Boatmen on the Missouri belongs to a small group of paintings in which Bingham explores deliberately simple and impressive arrangements of three figures with intriguing pictorial and personal relationships. In *Fur Traders Descending the Missouri* (cat. no. 54), the subjects are a Frenchman, his young half-Indian son, and a tethered bear cub; in *The Wood Boat* (1850; St. Louis Art Museum), the three males in the foreground span three generations, with experienced old age and daydreaming boyhood flanking a standing, muscular workman; and in *The Checker Players* (1850; Detroit Institute of Arts), a centrally placed old man watches a wiry, bright-looking fellow play a more oafish individual, and all three are smiling to themselves. *Boatmen on the Missouri* shows a curious group in which only the central figure is working. Selling wood to steamboats was a common job for men such as these who lived rather primitively along the riverbank. The strenuous labor of splitting, heaving, and stacking wood was often followed by long waits for customers. In this painting, the boatmen may have sold the larger part of their load to the steamer heading upriver at the right, and, to judge by the foreground eddies, their boat is about to float downstream.

Although hard work is suggested in the central man's exertions, this character is distanced from the viewer by his place at the back of the picture with his face cast in shadow. The two youths staring out toward the shore are pictorially the most important elements. It is unclear if they are idlers or simply resting after heaving wood. The one on the right looks tough and confident propped against the woodpile with legs and arms crossed and hat set high. His red kerchief, white shirt, and blue suspenders strike a lively patriotic note. In contrast, the figure sitting at the left looks whimsical and easygoing.[1] With his broken black top hat, straggling hair, rolled-up striped pants, and bare feet, he looks like a humorous parody of a respectable townsman gone to seed in the wilderness; yet his big, well-developed hand, forearm, and frame are those of a country laborer.

The coarseness of the subjects of *Boatmen on the Missouri* is belied by the strong, elegant balance of the composition and the sensuous yet smooth application of the paint. The stately, pyramidal grouping of figures is symmetrically placed around the center vertical and gently poised on the V-shaped base created by the sides of the boat and the echoing slant of the oars. Fresh, blond sunlight gives bold definition to the men and the boat, so they project from the riverscape with an immediacy akin to trompe l'oeil. Bingham's delight in graphically simple interplays of light and shadow finds expression in the folds of the shirts and pants. The cleanness of the clothes is unrealistic, but the effect helps the artist maintain a bright, fresh impact.

While Bingham's cheerful depiction of Midwestern life was consistent with the American dream, it was hardly a realistic view. As with most of his genre paintings, the artist has chosen a moment that embodies more leisure than work, allowing two of his three characters to express individuality and intimacy. An exquisitely brushed sky accounts for about half of the canvas as it did in *Fur Traders*, and the river's sheen belies the impression it made on contemporary tourists: for example, "By daylight the broad current is unpoetic and repulsive—a stream of liquid brick-dust or flowing mud, studded with dead tree-trunks, broken by bars and islands of dreary sand, and inclosed by crumbling shores of naked soil."[2] In Bingham's pictures the dangerous snags created by dead trees are always marginal and seemingly harmless.[3] His optimistically biased vision of the life and geography of the Missouri River is consistent with his stylistic preferences for clarity, formal order, and linear definition. With these means, as E. P. Richardson has eloquently written, Bingham was able to interpret "the grand meaning of the commonplace" and to create "a mood of grandeur and solemnity . . . as if he would say to his fellows: This is a heroic age."[4]

T.J.F.

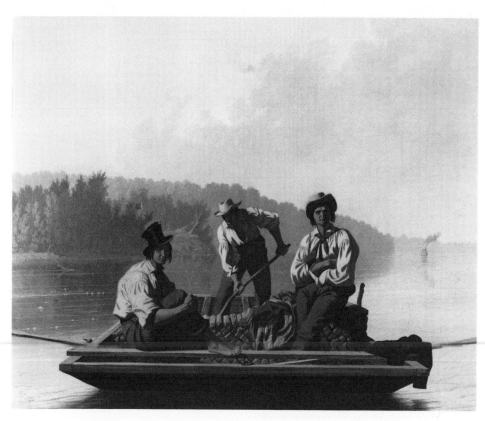

NOTES

1. In the pencil, brush, and ink drawing of this figure (Coll. John S. Kebabian, Scarsdale, N.Y.), presumed to be a study for the painting, the model looks younger, less awkward, and his facial expression is more attentive.

2. Albert D. Richardson, *Beyond the Mississippi: From the Great River to the Ocean* (Hartford, Conn., 1867), p. 19. The beauty which Bingham gives the Missouri recalls the ravishing description of the Mississippi in Twain's *Life on the Mississippi* (1883), quoted at the head of Barbara Novak's chapter on Bingham in her *American Painting of the Nineteenth Century* (New York, 1969).

3. In this work there is a snag at the left, and in cat.no.54 there is one in the foreground and a sequence of four small ones in the background, rhythmically placed between the figures. Behind the trader at the right of cat.no.54 there is a pentimento of a much larger dead tree or snag, which the artist must have found disruptive to the mood he intended.

4. Richardson, *Painting in America from 1502 to the Present* (New York, 1956), p. 176. The author observes that the rivermen were as commonplace in Bingham's day as gas station attendants are today.

PROVENANCE

Purchased from the artist by the American Art-Union, New York, 1846; awarded in Art-Union lottery to J. R. Macmurdo, New Orleans, La., 1846; John H. Clarke, New Orleans; his nephew, Edward Thomas Bergin, Jr., 1905; his wife, Anna Bergin, Los Angeles, 1920; their grandson, George Bergin, La Jolla, Calif., 1960; with Kennedy Galleries, New York, 1966; Mr. and Mrs. John D. Rockefeller 3rd, New York; to present owner, 1979.

EXHIBITION HISTORY

American Art-Union, New York, 1846.
National Collection of Fine Arts, Smithsonian Institution, Washington, D.C., *George Caleb Bingham, 1811–1879*, cat. by E. Maurice Bloch, 1968 (traveling exhibition), no. 14 (ill.).
Fine Arts Museums of San Francisco, *American Art, An Exhibition from the Collection of Mr. and Mrs. John D. Rockefeller 3rd*, cat. by Edgar P. Richardson, 1976, no. 30 (ill.).
National Museum of Western Art, Tokyo, *American Painting, 1730–1930: A Selection from the Collection of Mr. and Mrs. John D. Rockefeller 3rd*, 1982, cat.no. 23 (ill.).

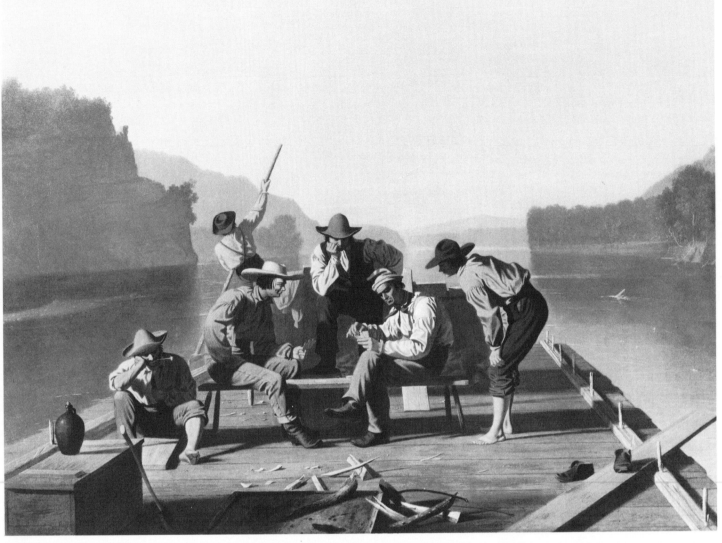

56

GEORGE CALEB BINGHAM
Raftsmen Playing Cards, 1847
Painted in St. Louis
Oil on canvas, 28 × 38 in. (71.1 × 96.5 cm.)
The St. Louis Art Museum, Purchase, Ezra H.
 Linley Fund

Raftsmen Playing Cards was Bingham's follow-up to his first popular success, *The Jolly Flatboatmen* (1846; Coll. Senator Claiborne Pell, Washington, D.C.), which had been selected by the American Art-Union, New York, in 1847 for an engraving distributed across the country to almost ten thousand subscribers.[1] *The Jolly Flatboatmen* was the Art-Union's third important genre print, preceded by the 1843 engraving of William Sidney Mount's *Farmers Nooning* (cat.no.51) and the 1844 reproduction of the rural fireside courtship picture by Francis William Edmonds (1806–1863) called *Sparking* (1839; Sterling and Francine Clark Art Institute, Williamstown, Mass.). All three images treat pleasurable moments in the lives of average Americans and have universal appeal.

Even more so than *The Jolly Flatboatmen*, *Raftsmen Playing Cards* is visually distinct from the works of Mount and Edmonds. Bingham's composition is more monumental and clearly balanced; his subjects lie on a succession of frontally aligned planes; and there is a static uniformity of illumination rather than a range of varying light effects. *Raftsmen Playing Cards* develops the artist's classicism to its finest expression. In the foreground, a large box and slanting plank serve as traditional *repoussoir* devices. The bright transverse light falling on the figures, closely grouped into a central unit, makes them reminiscent of bas-relief antique friezes. The sharp perspective of the raft and the converging shorelines draw the eye unavoidably to the male figures.[2]

Travelers on the Missouri often commented on the delightful singing, dancing, and music of the raftsmen, and noted their fondness for drinking and carousing. Presumably cardplaying was another pastime on the journey downstream. It had been a popular subject with European genre painters since the seventeenth century, and in America Mount and other artists had treated it before Bingham. The burly man in blue jeans and boots on the left has made his play and is shown cockily enjoying his older opponent's indecision and possible defeat.[3] The barefoot youth on the right was imaginatively described by a critic in 1847 as "a mean and

cunning scamp, probably the blacksheep of a good family, and a sort of vagabond idler."[4] Two of the men ignore the game: one maneuvers the raft with his pole, and the other sits dejectedly on a plank at the left, near the liquor flagon and the ashes of the previous night's fire. He is a crucial foil to the cheerier characters behind him and a necessary symbol of the difficult side of life on the river.

In contrast to *Boatmen on the Missouri* (cat. no. 55), this picture does not allow the viewer an intimate exchange with the subjects, even though they exemplify Bingham's talent for characterization; furthermore, the light and the landscape are more schematic. The artist has taken a broader look at the life of the rivermen and telescoped it into a noble, timeless record in the neoclassical mode. Pictorially this work is closer to Benjamin West's history paintings, such as *Agrippina Landing at Brundisium with the Ashes of Germanicus* (1768; Yale University Art Gallery, New Haven, Conn.), than to the contemporary genre scenes of Mount and his followers.[1] When the work was exhibited in St. Louis in 1847, a local critic wrote:

> *Mr. Bingham has struck out for himself an entire new field of historic painting. Among the Western boatmen . . . may be found all the varieties of human character, from the amiable and intelligent to the stern and reckless man. . . . He has not sought out those incidents or occasions which might be supposed to give the best opportunity for display, and a flashy, highly colored picture; but he has taken the simplest, most frequent and common occurences on our rivers . . . which are precisely those in which the full and undisguised character of the boatmen is displayed.*[5]

In the same year a New York critic wrote "Mr. Bingham is the only man in this country who has it in his power to rival Mr. Mount, but he must change the tone of his pictures."[6] This complaint about the strong contrasts and heaviness of Bingham's color is accurate if Mount is used as the absolute standard. Since the 1930s, however, Bingham's reductive aesthetic (in form and design as well as color) has been accepted as a hallmark of his individuality and a key to his great qualities as an American artist.

T.J.F.

NOTES

1. Bingham's earliest recorded river picture is *Western Boatmen Ashore* (unlocated), which was exhibited in New York in 1838 at the Apollo Association (later called the American Art-Union). The next documented examples exhibited in New York date from the mid-1840s: see cat. nos. 54 and 55. *The Jolly Flatboatmen* was the first Western river picture to attract attention in the Eastern press.

2. For differing opinions on the origins and meaning of Bingham's classicism, see E. Maurice Bloch, *George Caleb Bingham: The Evolution of an Artist*, 2 vols. (Berkeley and Los Angeles, 1967), and Barbara Novak, *American Painting of the Nineteenth Century* (New York, 1969).

3. According to an 1847 review in the *Missouri Republican*, the card game is "well known in the West as three-up . . . one has led the *ace*, and the other is extremely puzzled to know what to play upon it" (quoted in John Francis McDermott, *George Caleb Bingham, River Portraitist* [Norman, Okla., 1959], p. 61). "In a Quandary" was the title the artist used for a later, cropped version of this picture (1851; Private Collection).

4. *The New York Express* (1847), quoted in Albert Christ-Janer, *George Caleb Bingham of Missouri* (New York, 1940), p. 42.

5. *The Missouri Republican* (1847), quoted in McDermott, *Bingham*, p. 62.

6. *The New York Express* (1847), quoted in Christ-Janer, *Bingham*, p. 43.

PROVENANCE

Purchased from the artist by the American Art-Union, New York, 1847; awarded in Art-Union lottery to Edwin Croswell, Albany, N.Y., 1847; Berkshire Museum, Pittsfield, Mass.; to present owner, 1934.

EXHIBITION HISTORY

Wool's Picture Store, St. Louis, Mo., 1847.
American Art-Union, New York, 1847, cat. no. 91.
City Art Museum, St. Louis, *George Caleb Bingham, 1811–1879, "The Missouri Artist,"* 1934 (traveling exhibition), cat. no. 6.
Wadsworth Atheneum, Hartford, Conn., *American Painting and Sculpture of the 18th, 19th, and 20th Centuries*, 1935, cat. no. 4.
Palace of the Legion of Honor and the M. H. de Young Memorial Museum, San Francisco, *Seven Centuries of Paintings*, 1939–40, cat. no. L-150 (ill.).
Detroit Institute of Arts, *Five Centuries of Marine Painting: 23d Loan Exhibition of Old Masters*, 1942, cat. no. 109.
Detroit Institute of Arts, *The World of the Romantic Artist: A Survey of American Culture from 1800 to 1875*, cat. by E. P. Richardson, 1944–45.
Tate Gallery, London, *American Painting from the 18th Century to the Present Day*, 1946, cat. no. 20.
Corcoran Gallery of Art, Washington, D.C., *De Gustibus: An Exhibition of American Paintings Illustrating a Century of Taste and Criticism*, 1949, cat. no. 6.
City Art Museum, St. Louis, *Mississippi Panorama*, 1949, cat. no. 15 (ill.).
Isaac Delgado Museum of Art, New Orleans, La., 1950.

Seattle Art Museum, Wash., *Exhibition of Nineteenth-Century American Painting*, 1951.
Wildenstein & Co., New York, *A Loan Exhibition of Great American Paintings: Landmarks in American Art, 1670–1950*, 1953, cat. no. 18.
Pennsylvania Academy of the Fine Arts, Philadelphia, *150th Anniversary Exhibition*, 1955, cat. no. 52.
Cincinnati Art Museum, *Rediscoveries in American Painting*, 1955, cat. no. 5.
Detroit Institute of Art, *Painting in America: The Story of 450 Years*, cat. by E. P. Richardson, 1957, no. 86.
Carnegie Institute, Pittsburgh, *American Classics of the Nineteenth Century*, 1957, cat. no. 19.
Wildenstein & Co., New York, *Fifty Masterworks from the City Art Museum of St. Louis*, 1958, cat. no. 38.
American Federation of Arts, New York, 1959–60 (traveling exhibition).
Nelson Gallery-Atkins Museum, Kansas City, Mo. *George Caleb Bingham: Sesquicentennial Exhibition 1811–1861*, 1961 (traveling exhibition), cat. no. 7.
Lakeview Center for the Arts and Sciences, Peoria, Ill., *Two Hundred Years of American Painting*, 1965, cat. no. 11.
Musée des Beaux-Arts, Montreal, *The Painter and the New World*, 1967, cat. no. 54.
Los Angeles County Museum of Art, *The American West*, cat. by Larry Curry, 1972 (traveling exhibition), no. 37 (ill.).
Whitney Museum of American Art, New York, *The Painters' America: Rural and Urban Life 1810–1910*, cat. by Patricia Hills, 1974–75 (traveling exhibition), no. 57 (ill.).
Missouri State Council on the Arts, Kansas City, *Bingham's Missouri*, 1975–76 (traveling exhibition).
National Collection of Fine Arts, Smithsonian Institution, Washington, D.C., *America as Art*, cat. by Joshua C. Taylor, 1976, no. 75.
St. Louis Art Museum, *Currents of Expansion: Painting in the Midwest, 1820–1940*, cat. by Judith A. Barter and Lynn E. Springer, 1977, no. 31 (ill.).

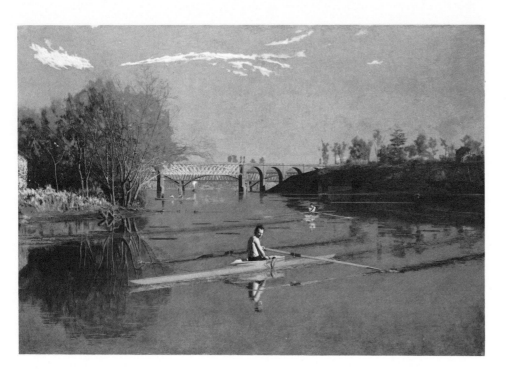

57

Thomas Eakins
Max Schmitt in a Single Scull, 1871
Painted in Philadelphia
Signed and dated on second scull:
EAKINS / 1871
Oil on canvas, $32\frac{1}{4} \times 46\frac{1}{4}$ in. (81.9 × 117.5 cm.)
The Metropolitan Museum of Art, New York,
 Alfred N. Punnett Fund and Gift of
 George D. Pratt

Originally titled *The Champion Single Sculls*, this work was probably painted during the winter of 1870–71, immediately after Eakins's return from Paris. It was first exhibited in April 1871 at Philadelphia's Union League Club (which had begun hosting exhibitions the previous year while the Pennsylvania Academy of the Fine Arts was erecting a new building) and, along with a portrait belonging to M. H. Messchert, a family friend, was the first painting Eakins showed publicly.[1] Oddly, it departs entirely from the kind of historical and exotic subject matter Eakins admired while in Europe, instead illustrating a characteristically American sporting subject, and one derived from Eakins's own experience. Max Schmitt, a high school friend and Eakins's favorite swimming and sculling companion, was the victor in a series of crew races held on the Schuylkill River in Philadelphia in the summer of 1870, and Eakins honors him in this picture. Schmitt was an amateur, rowing for the Pennsylvania Barge Club, to which Eakins also may have belonged. There may have been something of a joke between the two preserved here: the work does not depict the heat of a contest but rather shows a practice session, and Schmitt, the superior athlete, is turned toward the viewer, his oars trailing in the water, while Eakins, having passed his friend, rows vigorously toward the bridge in the distance.

Although he was recording a subject with which he was thoroughly familiar, Eakins did not execute it spontaneously but probably followed his normal practice and first made numerous oil sketches, meticulous perspective drawings, and pencil studies of particular details. Of these, only a sketchbook drawing of a pier of the Girard Avenue bridge survives (c. 1871; Hirshhorn Museum, Smithsonian Institution, Washington, D.C.). This procedure of combining observation with studio sketches, perspective diagrams, and so on was the cornerstone of his academic training in France. The effect of such diligence here is an extraordinarily direct and vivid image, despite occasional inconsistencies in technique: certain forms, such as the rower in the near distance and the bridge along the horizon, are rendered with the sharp outlines and precise finish Eakins learned from Gérôme; others, such as the trees along the bank in the middle distance, are painted in a much looser atmospheric style which may have derived from the warm-toned, intimate Barbizon landscapes just then becoming popular in America.

Max Schmitt in a Single Scull is above all a painting of light, of outdoor tones and luminosity. It shows a remarkable advance over Eakins's student works, and especially over the only other outdoor scene he had completed up to that time, the *Street Scene in Seville* (1870; Estate of Mrs. John Randolph Garrett, Sr., Roanoke, Va.). Here, through intense observation and skillful drawing, Eakins achieves a faithful record of the bends and landmarks of the Schuylkill, as well as a convincing evocation of time and place and of the palpable sensations of an Indian summer's day. Eakins's interest in light as well as his restrained brushwork are in concert with that of Kensett, Gifford (q.v.), and other leading landscapists of the time. Yet unlike them, Eakins insisted on landscape as a setting for human action, and, beginning with *Max Schmitt*, however rich the atmospheric effects Eakins achieves, it is the figures who command our attention.

Just as Eakins's interpretation of the landscape distinguished him from the Luminists, so his treatment of the figure differed both from his master's and from the leading American genre painters of his day. Neither the exoticism and melodrama of Gérôme's own rowing picture, *The Prisoner* (1863; Musée des Beaux-Arts, Nantes), often cited as the inspiration for Eakins's subjects,[2] nor the nostalgic celebration of rural American life that characterized most contemporary genre painting, colored Eakins's portrayal of Max Schmitt, who in his grimy undershirt and slumped posture appears familiar, unheroic, even mundane—yet wholly riveting. For the first painting he showed in public after his return from Europe, Eakins chose a subject and viewpoint that were totally outside his master's range, and never before encountered in America.

C.T.

NOTES

1. See Gordon Hendricks, "The Champion Single Sculls," *Metropolitan Museum of Art Bulletin* n.s. 26 (March 1968): 306.

2. See Gerald M. Ackerman, "Thomas Eakins and His Parisian Masters Gérôme and Bonnat," *Gazette des Beaux-Arts*, series 6, 73 (April 1969): p. 240. According to Ackerman, Eakins brought a photograph of Gérôme's picture with him when he returned to Philadelphia in 1870.

PROVENANCE

Max Schmitt, Philadelphia; his widow, Mrs. Louis S. M. Nache, Philadelphia, to 1930; Mrs. Thomas Eakins, Philadelphia, 1930–33; with Milch Galleries, New York, 1934; to present owner, 1934.

EXHIBITION HISTORY

Union League Club, Philadelphia, *Third Art Reception*, 1871, cat.no.137.

Pennsylvania Museum of Art, *Thomas Eakins 1844–1916*, 1930, cat.no.12.

Babcock Galleries, New York, *Thomas Eakins*, 1930–31, cat.no.2.

Musée du Jeu de Paume, Paris, *Trois Siècles d'art aux États-Unis*, cat. by Alfred H. Barr, Jr., 1938, no. 50 (ill.).

Metropolitan Museum of Art, New York, *Life in America*, 1939, cat.no.229 (ill.).

Carnegie Institute, Pittsburgh, *Survey of American Painting*, 1940, cat.no.182.

Museum of Fine Arts, Boston, *Sport in American Art*, 1944, cat.no.25.

Philadelphia Museum of Art, *Thomas Eakins Centennial Exhibition*, 1944, cat.no.13 (ill.).

Century Association, New York, *Eakins—Homer Exhibition*, 1951, cat.no.3.

Albright Art Gallery, Buffalo, N.Y., *Expressionism in American Painting*, cat. by Bernard Myers, 1952, no. 6 (ill.).

Pennsylvania Academy of the Fine Arts, Philadelphia, *150th Anniversary Exhibition*, 1955, cat.no.76 (ill.).

National Gallery of Art, Washington, D.C., *Thomas Eakins, A Retrospective Exhibition*, cat. by Lloyd Goodrich, 1961 (traveling exhibition), no. 6 (ill.).

Brooklyn Museum, N.Y., *Triumph of Realism*, cat. by Axel von Saldern, 1967 (traveling exhibition), no. 79 (ill.).

Metropolitan Museum of Art, New York, *19th-Century America: Paintings and Sculpture*, cat. by John K. Howat and Natalie Spassky, 1970, no. 154 (ill.).

Museum of Fine Arts, Boston, *Masterpieces of Painting in the Metropolitan Museum of Art*, 1970 (ill.).

National Gallery of Art, Washington, D.C., *Great American Paintings from the Boston and Metropolitan Museums*, cat. by T. N. Maytham, 1970 (traveling exhibition), no. 59 (ill.).

Pushkin Museum, Moscow, *100 Kartin iz Muzeya Metropolitan, Soedinennie Shtati Ameriki* [100 Paintings from the Metropolitan Museum, United States of America], 1975 (traveling exhibition), no. 91 (ill.).

Philadelphia Museum of Art, *Thomas Eakins, Artist of Philadelphia*, cat. by Darrel Sewell, 1982 (traveling exhibition), no. 12 (ill.).

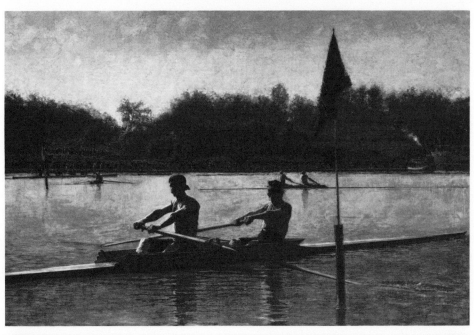

58

THOMAS EAKINS
The Biglin Brothers Turning the Stake, 1873
Painted in Philadelphia
Signed and dated on side of shell at left:
 EAKINS 73.
Oil on canvas, 40¼ × 60¼ in. (102.2 × 153 cm.)
The Cleveland Museum of Art,
 The Hinman B. Hurlbut Collection.
Exhibited in Boston and Washington only.

Competitive rowing became popular in America in the 1830s, when the first independent boat clubs were founded in New York and Philadelphia; by the early 1850s, Harvard, Yale, and other universities had organized crews to compete with one another in meets modeled after the Henley Royal Regatta in England. The development of the single and pair-oared sculls caused a resurgence of popularity in the sport in the years following the Civil War. A number of boat clubs sprang up in several cities, and competitions began to be held for both professional and amateur oarsmen.[1] John and Bernard Biglin, pictured here, were among the best-known professional rowers in Eakins's day. Competing against Henry Couter and Lewis Cavitt of Pittsburgh, the Biglins of New York won one of the first American pair-oared shell races, held on the Schuylkill River in Philadelphia on 20 May 1872.

Historic sporting events had been commemorated in prints issued by Currier & Ives and other publishers since the late 1860s.[2] However, no painting tradition had evolved for rowing, and Eakins was the first to translate such popular subject matter into high art, painting at least twelve rowing pictures in oil and watercolor in the early 1870s (of which seven feature the Biglins), and exhibiting them at the American Society of Painters in Water Colors and the National Academy of Design, as well as through his own dealer in Philadelphia, Charles F. Haseltine. Of these, *The Biglin Brothers*, the only one to depict an actual competition, is the largest and most technically accomplished. In it Eakins provides a narrative account of the race and, as in *Max Schmitt in a Single Scull* (cat.no.57), creates an honorific portrait of the protagonists.

Eakins depicts the Biglins having just completed the complicated maneuver of circling the stake in order to reverse direction. They are already leading the race—according to newspaper accounts, by $3\frac{1}{2}$ lengths at the midpoint of a 5-mile course.[3] Their competitors, wearing red caps, are shown in the middle distance. As he did in many of his works, Eakins includes himself in the picture as a witness to the event: he sits in the stake boat at the far left, signaling with an upraised arm.

Although in its documentary presentation of an American athletic contest Eakins's work seems far removed from the exotic and theatrical canvases of Gérôme, it nonetheless reveals an academic sensibility acquired directly from the French master. *The Biglin Brothers* is a powerful, classical, centrally focused composition. Eakins achieves its understated drama through carefully selected pictorial detail, such as the crowd of spectators along the shore which transforms the river into a sporting arena, and the line of silver light which outlines the rowers' straining muscles and so suggests the effort and tension of the contest. Eakins's friend Earl Shinn, who had been with him in Gérôme's atelier and had since become a critic, recognized the pictorial strategies of their master in these rowing pictures and credited Eakins with applying "the method of Gérôme . . . to subjects the antipodes of those affected by the French realist." Yet Shinn also saw Eakins's rowers as somehow classical, despite their contemporaneity, aspiring to the same sculptural ideal as Gérôme's Roman gladiators, and ultimately embodying "the most Olympian, beautiful, and genuine side of [our] civilization from the plastic point of view."[4]

A perspective drawing establishing the angle of the Biglins's boat and oars and the reflection of their bodies in the water is preserved in the collection of the Hirshhorn Museum, Washington, D.C. A watercolor, presumably made after the oil and shown in the spring 1874 exhibition of the American Society of Painters in Water Colors, has been lost. Despite its size and the popularity of its subject, *The Biglin Brothers* was priced at $250–$300, no higher than most of Eakins's other oils of the 1870s, and little more than the watercolors.[5] The image was made known in a reproduction in wood engraving prepared by Eakins's student Alice Barber, which appeared in *Scribner's Monthly* in 1880 illustrating a story entitled "Spring Hereabouts."[6] Still the painting found no buyer and remained in the Eakins family until it was purchased by the Cleveland Museum in 1927.

C.T.

NOTES

1. In the 1850s and '60s, there were about a dozen regattas a year. By 1869, 65 were recorded, and in 1873, over 150 were held among 289 clubs in 25 states. See Thomas C. Mendenhall, *A Short History of American Rowing* (Boston, 1980), esp. pp. 7, 21.

2. For example, *James Hammill, and Walter Brown, in their Great Five Mile Rowing Match for $4000. & The Championship of America* (published by Currier & Ives, New York, 1867; reproduced in Fred J. Peters, *Sporting Prints by N. Currier and Currier & Ives* [New York, 1930], no. 370), which commemorates a head-to-head single scull race on the Hudson, held 9 Sept. 1867, and which, like Eakins's *Biglin Brothers* shows other shells, steamboats, and spectators on the opposite shore.

3. See Lloyd Goodrich, *Thomas Eakins*, 2 vols. (Cambridge, Mass., 1982), 1:83.

4. Shinn, in *The Nation*, 18 February 1875, p. 120.

5. See Goodrich, *Eakins*, 1:165.

6. The illustration appears, with the caption "On the Harlem" on p. 165 of the *Scribner's* article (June 1880), which describes the pleasures of the season in New York City and also features illustrations by Winslow Homer and Robert Blum, among others.

PROVENANCE

The artist, to 1916; Mrs. Thomas Eakins, Philadelphia, to 1927; to present owner, 1927.

EXHIBITION HISTORY

Metropolitan Museum of Art, New York, *Loan Exhibition of the Works of Thomas Eakins*, 1917, cat. no. 3 (ill.).

Pennsylvania Academy of the Fine Arts, Philadelphia, *Memorial Exhibition of the Works of the Late Thomas Eakins*, 1917, cat. no. 33 (ill.).

Philadelphia, *Paintings, Sculpture and Prints in the Department of Fine Arts, Sesqui-Centennial International Exposition*, 1926, cat. no. 360.

Museum of Modern Art, New York, *Sixth Loan Exhibition: Winslow Homer, Albert P. Ryder, Thomas Eakins*, 1930, cat. no. 94 (ill.).

Museum of History, Science, and Art, Los Angeles, *Art in Relation to Sport*, 1932, cat. no. 753.

Baltimore Museum of Art, *Thomas Eakins 1844–1916, A Retrospective Exhibition of His Paintings*, cat. by Clarence W. Cranmer, 1936, no. 5 (ill.).

National Academy of Design, New York, *Special Exhibition*, 1939, cat. no. 213 (as *Turning Stake Boat*).

California Palace of the Legion of Honor and M. H. de Young Memorial Museum, San Francisco, *Seven Centuries of Painting*, 1939, cat. no. L153.

Philadelphia Museum of Art, *Thomas Eakins Centennial Exhibition*, 1944 (ill.).

Museum of Fine Arts, Boston, *Sport in American Art*, 1944, cat. no. 26.

M. Knoedler & Co., New York, *A Loan Exhibition of the Works of Thomas Eakins 1844–1944*, cat. by W. F. Davidson and Lloyd Goodrich, 1944, no. 6 (ill.).

Carnegie Institute, Pittsburgh, *Thomas Eakins Centennial Exhibition 1844–1944*, 1945, cat. no. 110 (ill.).

Tate Gallery, London, *American Paintings from the 18th Century to the Present Day*, 1946, cat. no. 70 (ill.).

Syracuse Museum of Fine Arts, N.Y., *125 Years of American Art*, 1953, cat. no. 10.

Pennsylvania Academy of the Fine Arts, Philadelphia, *150th Anniversary Exhibition*, 1955, cat. no. 74.

National Gallery of Art, Washington, D.C., *Thomas Eakins: A Retrospective Exhibition*, cat. by Goodrich, 1961 (traveling exhibition), no. 9 (ill.).

Whitney Museum of American Art, New York, *Thomas Eakins Retrospective Exhibition*, cat. by Goodrich, 1970, no. 10 (ill.).

Albright-Knox Art Gallery, Buffalo, N.Y., *Heritage and Horizon: American Painting 1776–1976*, 1976 (traveling exhibition), cat. no. 22 (ill.).

Philadelphia Museum of Art, *Thomas Eakins: Artist of Philadelphia*, cat. by Darrel Sewell, 1982 (traveling exhibition), no. 18 (ill.).

59

THOMAS EAKINS

Will Schuster and Blackman Going Shooting for Rail, 1876
Painted in Philadelphia
Oil on canvas, 22⅛ × 30¼ in. (56.2 × 76.8 cm.)
Yale University Art Gallery,
New Haven, Connecticut,
Bequest of Stephen Carlton Clark, B.A. 1903

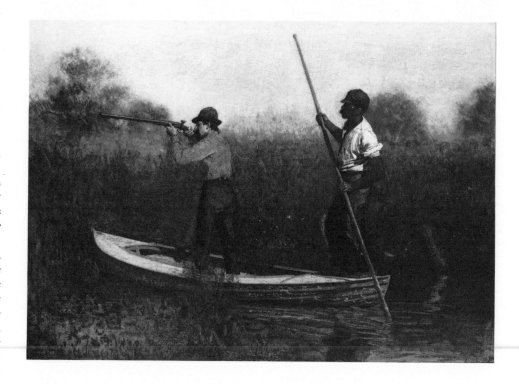

Eakins began a series of hunting scenes in 1874. Like his rowing pictures of the early seventies, these reflect his own experiences, as the title of one of the first in the series—*The Artist and His Father Hunting Reed Birds* (c. 1874; Coll. Mr. and Mrs. Paul Mellon, Upperville, Va.)—attests. But also like the rowing pictures, Eakins's hunting scenes were preceded by a long tradition of popular images. In the case of *Will Schuster*, the influence appears to have been direct: a chromolithograph entitled *Rail Shooting on the Delaware*, only a little smaller than Eakins's image (18 × 22¼ in.) and published by John Smith of Philadelphia in 1866,[1] provided the model for the general composition and poses of the figures, and even for details like the tufts of marsh grass in the foreground and the angles of the pole and gun.

The hunting of water birds was popular in Eakins's time, for the slow-moving rail (as well as reed-birds and plover) abounded in the marshes along the Delaware. The sport was practiced by both gentleman amateurs and skilled hunters. Smith's print caricatured the former, who beginning in September would swarm into the "Neck," the lower-class community in South Philadelphia where the hunting was best, hire their pushers from among the local residents, and set off after their quarry.[2] In his image, by contrast, Eakins minimized the class differences between hunter and pusher and presented a serious representation of the sport. Nothing is known of Will Schuster himself, and the black man's identity remains a mystery, but it is nonetheless clear that Eakins neither satirized nor idealized the hunters but recorded them just as he observed them. Yet behind the documentary accuracy of *Will Schuster* is a poetic vision, for Eakins imbued his direct and unassuming image with all the dignity and measure of a classical procession.

In *Will Schuster*, the expository approach of earlier hunting scenes like *Pushing for Rail* (1874; Metropolitan Museum of Art, New York), in which several pairs of sportsmen are used to illustrate the stages of the hunt, is distilled into a monumental, even iconic representation of two figures who embody the sport's action. At the same time, Eakins skillfully avoids the static quality against which Gérôme counselled him in 1873[3] by inserting anecdotal details, such as the pusher's tilted head as he watches the quarry, and by making subtle adjustments in the two-dimensional design. He uses a grid to structure his composition, but tempers its rigidity with the off-axis placement of the skiff and the rifle and the stronger diagonal of the pusher's pole. Eakins centers his figures in the picture space and silhouettes them, in relief-like fashion, against the textured curtain of damp green marsh grass behind. The startling color of their costumes—the vivid red of Will Schuster's shirt and the intense blue and dazzling white of the black man's—also thrusts them forward. Eakins had used such colors in figures' costumes before, in *Pushing for Rail*, for example, and *Sailboats Racing* (1874; Philadelphia Museum of Art), but always as simple accents and never to give his subjects the aggressive, hieratic presence they take on here. And although Will Schuster and the pusher are still, locked into place by the underlying grid and the background screen, their tensed muscles and frozen poses imply imminent action: a shot will be fired, and the skiff will move off, out of our vision.

This was the last hunt subject Eakins painted. In about 1881, however, he returned to *Will Schuster* and copied it exactly (even including the caustics on the side of the boat) in a wash drawing (Yale University Art Gallery, New Haven, Conn.). That drawing was used for the preparation of a wood engraving entitled *Rail Shooting* which accompanied "A Day in the Ma'sh," an account of the sport published in *Scribner's Monthly* in July 1881.　　*C.T.*

NOTES
1. See Ellwood C. Parry III and Maria Chamberlain-Hellman, "Thomas Eakins as an Illustrator, 1878–1881," *American Art Journal* 5 (May 1973): 41–43.
2. See "A Day in the Ma'sh," *Scribner's Monthly* 22 (July 1881): 352.
3. Gérôme to Eakins, 10 May 1873, quoted in Lloyd Goodrich, *Thomas Eakins*, 2 vols. (Cambridge, Mass., 1982), 1:113–14.

PROVENANCE
The artist, to 1878; George D. McCreary, Philadelphia, to 1915; Stephen C. Clark, New York, after 1933 to 1961; to present owner, 1961.

EXHIBITION HISTORY
Pennsylvania Academy of the Fine Arts, Philadelphia, *49th Annual Exhibition*, 1878, cat.no.186 (as *Rail Bird Shooting*).
Museum of Fine Arts, Boston, *Sport in American Art*, 1944, cat.no.34.
M. Knoedler & Co., New York, *A Loan Exhibition of the Works of Thomas Eakins 1844–1944*, cat. by W. F. Davidson and Lloyd Goodrich, 1944, no. 13 (ill.).
Yale University Art Gallery, New Haven, Conn., *Pictures Collected by Yale Alumni*, 1956, cat.no.65.
Forum Gallery, New York, *The Portrayal of Negroes in American Painting*, 1967.
Whitney Museum of American Art, New York, *The Painters' America: Rural and Urban Life, 1810–1910*, cat. by Patricia Hills, 1974, no. 114 (ill.).

EASTMAN JOHNSON

(1824, Lowell, Maine—1906, New York City)

One of the most cosmopolitan and sought-after painters of his age, Eastman Johnson gained recognition through a series of charming, seemingly spontaneous images of American rural life, executed in a sophisticated, highly controlled manner. Johnson received his first artistic education in Boston at Bufford's Lithographic Shop, which he left in 1844 to establish himself as a portrait draftsman. His natural aptitude in drawing brought him many commissions from prominent citizens in Washington and subsequently in Boston, where Longfellow, Emerson, and Hawthorne were among his sitters. Johnson is not known to have worked in oil until about 1848; his desire for advanced training in that medium, and the popularity of the Düsseldorf Gallery, a collection of modern German pictures recently displayed in New York, prompted him to go abroad in 1849 and enroll in the Düsseldorf Academy. There he developed strong friendships with fellow artists, especially Emanuel Leutze and Worthington Whittredge (q.v.), polished his skills as a draftsman, but found the quality of instruction in the use of color disappointing. As a result, he sought further training in Holland, where he developed a freer handling, warmer palette, and a taste for picturesque subjects, and in Paris, where his study under the popular master Thomas Couture was cut short by news of his mother's death.

Johnson's first success after his return to America in 1855 was Old Kentucky Home—Life in the South *(1859; New-York Historical Society), a sanguine representation of slave quarters in Washington which was admired equally by abolitionists and slaveholders. This painting prompted his election to the National Academy of Design as an Associate in 1859; he became a full Academician the following year. By this time he was established in a studio in New York City and was occupied with a variety of subjects that appealed to the sentimental taste of his age. During the Civil War, he produced numerous melodramatic images of slaves fleeing their masters and of heroic actions by Union soldiers; at the same time, he worked on small, meticulously detailed genre subjects featuring colorful rustic types or attractive young women and children in decorative settings.*

In 1871 Johnson built a summer home on Nantucket Island, off the Massachusetts coast. He soon began painting out-of-doors, and as a result his palette brightened and contrasts between light and shadow became more vivid. Accurately diagnosing his countrymen's nostalgic mood after the Civil War, Johnson embarked on two subjects in which he immortalized the wholesomeness of the rural way of life and the beauty of American scenery as yet unscarred by industrialization. He painted the maple-sugaring camps around Fryeburg, Maine, and the cranberry harvesters on Nantucket in a fresh and lively manner, using figure types and pictorial devices drawn both from American antebellum genre painters and from French peasant painters then at the height of their popularity in Europe and America. At the same time, Johnson's portrait interiors (e.g., The Hatch Family, *1871; Metropolitan Museum of Art, New York) documented the new prosperity of New York's financiers, merchants, and captains of industry. By the 1880s, the last decade in which he painted actively, Johnson had turned almost exclusively to portraiture; the most accomplished of these portraits, such as* The Funding Bill *(1881; Metropolitan Museum of Art, New York), represented men very much like himself: dignified, self-confident, and eminently successful.*

The seminal modern study of Johnson's work is John I. H. Baur's 1940 exhibition catalogue for the Brooklyn Museum. In 1972 the Whitney Museum of American Art, New York, organized a major exhibition, with catalogue by Patricia Hills.

60

EASTMAN JOHNSON
The Cranberry Harvest, Nantucket Island, 1880
Painted in New York City
Signed and dated lower right: *E. Johnson 1880*
Oil on canvas, $27\frac{3}{8} \times 54\frac{5}{8}$ in. (69.5 × 138.8 cm.)
Timken Art Gallery, Putnam Foundation
 Collection, San Diego, California

Johnson's genre scenes of the 1860s and early '70s were conceived in the spirit of antebellum representations of everyday life in rural America. Like William Sidney Mount he was interested in the exchanges between picturesque rustic characters (his *Measurement and Contemplation* [c. 1861; Museum of Fine Arts, Boston] was probably inspired by Mount's *Bargaining for a Horse* [cat.no.52]) and, in more ambitious compositions such as *Sugaring Off* (c. 1861–66; Museum of Art, Rhode Island School of Design, Providence), he, too, represented the convivial, festive side of country life.

Although a contemporary critic saw the same carnival atmosphere in *Cranberry Harvest*,[1] by the time Johnson embarked on the series of sketches and studies which led up to this composition,[2] his style and his approach to his subject were changing. In *Cranberry Harvest*, which followed ambitious treatments of maple-sugaring camps and cornhusking bees, and would be his last monumental genre scene, Johnson's emphasis is clearly on labor; his figures, though naturalistically posed, have become larger than life, and a new sense of epic grandeur prevails.

Johnson's fresh interpretation of rural subject matter was probably influenced by contemporary French peasant painting, which by the 1870s was frequently exhibited and avidly collected in America. Yet his harvesters are not the American equivalent of Millet's laborers, bent and brutalized by their toil, but more closely resemble the graceful, healthy workers depicted by Julien Dupré, Charles Jacque, and especially Jules Breton.[3] Like these artists Johnson expresses the sentimental idealization of agrarian life that accompanied the rapid growth of cities and of industry after mid-century. He chose for his subject a task—the harvesting of cranberries, which grew wild in the Nantucket marshes—and a setting still untouched by mechanization, and painted them as a summer's idyll. In *Cranberry Harvest* he invented for his New York patrons a mythic view of nature in which harvests are always bountiful, the sunshine soft and unceasing, the life close to the soil ennobling, and work on the land a satisfying, even pleasurable activity in which the whole community participates, from the old man who has brought his chair with him to the bogs, to the infant at far right being carried to his mother who

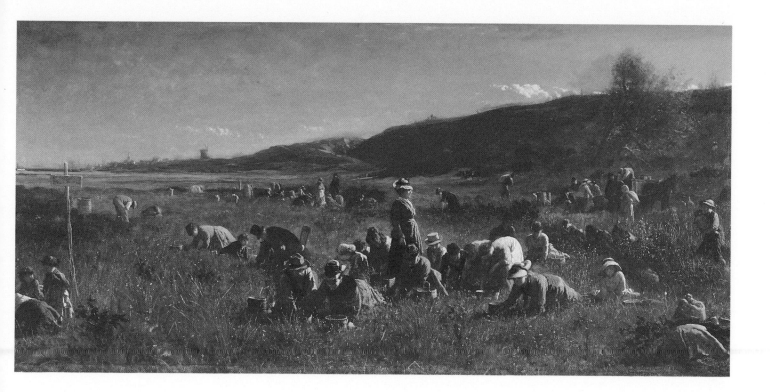

stands at center, awaiting his arrival.

Johnson's lyrical transformation of the Nantucket cranberry bogs—from muck and mire to a lush plain—makes light of work that was actually difficult and wearying. His composition is broad and open; the field recedes without interruption toward the picturesque village on the horizon, while the trees at right seem to flutter and bend from a cooling sea breeze. The brilliant colors of the workers' costumes, untattered and unfaded despite long hours in the sun, also make the scene inviting, as does Johnson's joyous application of paint. With *The Cranberry Harvest*, Johnson has renounced his earlier, finicky manner with its heavy reliance on drawing and has developed a looser, freer style in which inventive brushwork—spatterings of brilliant green and long, dry, scratchy strokes representing spiky grasses—enlivens the meadow and creates a sparkling sunlight effect. The figures' varied poses and their expressive gestures also disguise the tediousness of their work. The more picturesque characters, such as the courting couples, and the bonneted little girls and towheaded boys reminiscent of Winslow Homer's farm children of a few years earlier, are placed in the foreground, and only the stooped postures and synchronized, repetitive gestures of the three figures to the right of the central standing woman give any hint of the grueling, monotonous nature of the harvest.[4] The pivotal figure of the composition, the woman at center awaiting her child, repeats in reverse the statuesque figure in Johnson's earlier *Woman on a Hill* (c. 1875–80; Addison Gallery of American Art, Andover, Mass.);

she also resembles several of Winslow Homer's women of the same period.[5] Standing in the sun, her profile illuminated, her straw hat transformed into a dazzling corona, she becomes even more majestic. Strong, heroic, resolute, she is a monument to the wholesomeness and dignity of rural life.

C.T.

NOTES

1. S. G. W. Benjamin, "A Representative American: Eastman Johnson," *Magazine of Art* 5 (1882): 489: "The business is made the occasion of much mirth and love-making."

2. These are for the most part lively, spontaneous sketches made in the open air near Johnson's summer home on Nantucket. Other related works include the Detroit Institute of Arts' *In the Fields* and *Woman on a Hill*, referred to below, both of which feature the monumental standing woman at the center of this composition, and *Cranberry Pickers* (Yale University Art Gallery, New Haven, Conn.), which is unfinished, is the same size as the present picture and has been proposed as its pendant. See Patricia Hills, *The Genre Painting of Eastman Johnson* (New York, 1977), p. 152.

3. Hills (ibid.) reasonably suggests that Johnson was influenced by Breton's *Les Sarcleuses*, a painting of 1860 of which an 1868 replica (Metropolitan Museum of Art, New York) was owned by a Cincinnati collector in the 1880s.

4. The less noticeable figures in the middle ground seem to be the more diligent laborers; see especially the beautifully painted, Millet-like man bending over his pail at the far left. The kneeling figure in the background to the right of the standing woman is a modern addition and detracts somewhat from the key figure's commanding presence.

5. John Wilmerding (*Winslow Homer* [New York, 1972], p. 87) relates these women to the central figure in Homer's *Long Branch* (1869; Museum of Fine Arts, Boston); see also that artist's *Gloucester Farm* (1874; Philadelphia Museum of Art) and his 1878 watercolor, *Fresh Air* (Brooklyn Museum, N.Y.).

PROVENANCE
Auguste Richard, 1880 to at least 1893; with Bernard Bivall, London, 1969; with Peter Tillou, Inc., Litchfield, Conn. and Vose Galleries, Boston; to present owner, 1972.

EXHIBITION HISTORY
National Academy of Design, New York, *55th Annual Exhibition*, 1880, cat. no. 382.
Metropolitan Museum of Art, New York, *Loan Collection of Paintings and Sculpture in the West Galleries and the Grand Hall*, 1881, cat. no. 10; 1882, cat. no. 174.
Chicago, *World's Columbian Exposition*, 1893, cat. no. 621.
The High Museum of Art, Atlanta, *The Beckoning Land*, 1971, cat. no. 44.
Whitney Museum of American Art, New York, *Eastman Johnson*, cat. by Patricia Hills, 1972, no. 97 (ill.).
National Gallery of Art, Washington, D.C., *American Light: The Luminist Movement 1850–1875*, cat. by John Wilmerding et al., 1980 (ill.).
Terra Museum of American Art, Evanston, Ill., *Life in Nineteenth Century America*, 1981, cat. no. 2.

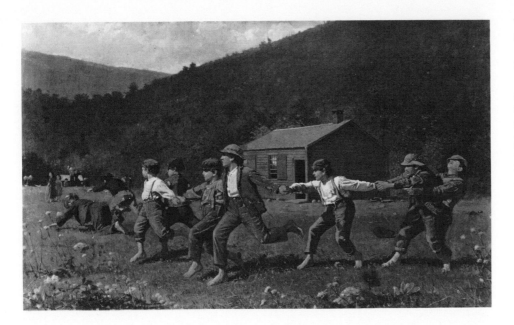

61

WINSLOW HOMER
Snap the Whip, 1872
Painted in New York City
Signed and dated lower right: HOMER 1872
Oil on canvas, 22 × 36 in. (55.9 × 91.4 cm.)
The Butler Institute of American Art,
 Youngstown, Ohio

Following his highly charged years as a battlefield correspondent during the Civil War and his trip to France in 1866–67, Homer turned to less emotionally demanding subject matter and began devoting himself to representations of his countrymen at leisure. He first painted young men and especially women at the new middle-class resorts which were being developed along the New Jersey coast and in the Adirondacks and White Mountains, and then turned to scenes of schoolchildren, occasionally showing them in the classroom but more often picturing their summertime amusements and daydreams or, as here, their favorite recess games. Snap the Whip is a rough, high-spirited game in which children join hands in a line and run in a circle anchored by the biggest of their number (who sometimes grasps a tree or a comrade for support), until their gathering speed snaps the ones on the far end away from the spiral and, caps flying, they tumble to the ground.

Snap the Whip was evidently a picture which meant much to Homer, for he consented to have it represent his achievements at the Centennial in Philadelphia, and again in 1878 at the Exposition Universelle in Paris. Although critics found his entries to these fairs less compelling than the intense *Prisoners from the Front* (1866; Metropolitan Museum of Art, New York), with which he had scored a triumph in the last Paris Exposition eleven

years before, they nonetheless praised them for their expressive rendering of characteristically American scenes.[1] *Snap the Whip* suited well the national mood of nostalgia after the Civil War. It presented an antidote to the clattering machinery and brash implements of progress on display at the 1876 Exposition, providing a vision of America as she preferred to see herself: innocent, sheltered, and rooted in nature and the land.

Homer's spontaneous image of an exuberant childhood game was carefully developed. A small pencil sketch of the six left-hand figures (Cooper-Hewitt Museum, New York), probably made during Homer's travels in the Catskills in the summer of 1872,[2] marks the genesis of the composition. He used this drawing as the basis for a small oil (1872; Metropolitan Museum of Art, New York) and then revised and enlarged the figure group again in another drawing (Butler Institute of Art, Youngstown, Ohio) which served as a study for the present work. As the design evolved, the picture's story became more lively, and the setting took on a more important role. In the final version, a ninth figure has been added at left, establishing a sequence of little boys in pairs. Each pair is defined by parallel movements and gestures, generating a regular rhythm beneath their aggressive play, while the physical tension of the game is concentrated in the outstretched arms of the white-shirted, coatless boy. At the far left, Homer shows adults waving at the boys and little girls with hoops, as though to include the entire village in the carefree, idyllic scene. Homer has also added a series of gently rounded hills in back of the modest red schoolhouse. These hills form a protective screen behind the friezelike line of boys, enclosing the space and sheltering the villagers. Unlike many of Homer's later

works, in which man and nature are depicted as adversaries, nature is benign in *Snap the Whip*, and the emotional connections between figures are natural, if rather boisterous.

Snap the Whip is one of the largest and most ambitious of Homer's series of images of rural childhood. Many of these scenes were subsequently reproduced as wood engravings published in national periodicals, from which Homer derived a good income and widespread recognition. This version of *Snap the Whip* appeared as a two-page illustration in *Harper's Weekly* of 20 September 1873, accompanied by two verses excerpted from Thomas Gray's *Ode on a Distant Prospect of Eton College*, itself a meditation on the passing of childhood innocence. The wood engraving *Snap the Whip* came toward the end of Homer's career as an illustrator—he worked for *Harper's* only two more years. Soon after it appeared in *Harper's*, Homer would turn his attention to new and more original subject matter and, perhaps more important, would begin to explore a new medium, watercolor. C.T.

NOTES

1. See Lucy Hooper, "The Pictures at the Paris Exhibition," *The Art Journal* 4 (1878): 349. The French critic Charles Tardieu wrote that Homer's work was naive, guilty of certain gaucheries, but honest, serious, and strongly imprinted with native character ("La Peinture à l'Exposition Universelle: États-Unis," *l'Art* 4 [1878]: 205).

2. Gordon Hendricks located Homer in the town of Hurley, New York, just west of Kingston: see *The Life and Work of Winslow Homer* (New York, 1979), p. 94.

PROVENANCE
John H. Sherwood; Parke Godwin, by 1879; Richard H. Ewart, New York, by 1911; with William Macbeth, Inc., New York, 1918; to present owner, 1919.

EXHIBITION HISTORY
Philadelphia, *Centennial Exposition*, 1876, cat. no. 177.
Paris, *Exposition Universelle*, 1878, cat. no. 60.
Metropolitan Museum of Art, New York, *Winslow Homer Memorial Exhibition*, 1911, cat. no. 2.
M.H. de Young Memorial Museum, San Francisco, *Exhibition of American Painting*, 1935 (traveling exhibition).
Whitney Museum of American Art, New York, 1935.
Prout's Neck Association, Maine, *Century Loan Exhibition: As a Memorial to Winslow Homer*, 1936.
Kennebunkport Art Association, Maine, *Homer Centennial*, 1936.
Pennsylvania Museum of Art, Philadelphia, *Homer*, 1936, cat. no. 5.
Whitney Museum of American Art, New York, *Winslow Homer Centenary Exhibition*, cat. by Lloyd Goodrich, 1936, no. 6 (ill.).
Carnegie Institute, Pittsburgh, *Winslow Homer Centenary Exhibition*, cat. by Homer Saint-Gaudens, 1937, no. 31.

Cleveland Museum of Art, *American Painting from 1860 to Today*, 1937, cat. no. 87.

Art Association of Newport, R.I., *Fifty Famous Painters*, 1938, cat. no. 34 (ill.).

Metropolitan Museum of Art, New York, *Life in America*, cat. by A. Hyatt Mayor and Josephine L. Allen, 1939, no. 237 (ill.).

Montclair Museum, N.J., *America Yesterday and Today*, 1941.

Macbeth Gallery, New York, *50th Anniversary Exhibit*, 1942.

Worcester Art Museum, Mass., *Winslow Homer*, 1944, cat. no. 8.

Munson-Williams-Proctor Institute, Utica, N.Y., *Exhibition of Paintings by Winslow Homer and Thomas Eakins*, 1946.

Wildenstein & Co., N.Y., *A Loan Exhibition of Winslow Homer*, cat. by Lloyd Goodrich, 1947, no. 13 (ill.).

Saginaw Museum, Mich., *American Painting from Colonial Times until Today*, 1948.

Columbus Gallery of Fine Arts, Ohio, *Romantic America*, 1948.

Toronto, *Canadian National Exhibition*, 1950, cat. no. 13.

Smith College Museum of Art, Northampton, Mass., *Early Work of Winslow Homer*, 1951 (traveling exhibition).

American Federation of Arts, *American Painting of the Nineteenth Century*, 1952 (traveling exhibition).

National Gallery of Art, Washington, D.C., *Winslow Homer, A Retrospective Exhibition*, 1958 (traveling exhibition), cat. no. 20.

Art Gallery of Toronto, *American Painting, 1865–1905*, cat. by Goodrich, 1961 (traveling exhibition).

University of Arizona, Tucson, *Yankee Painter: A Retrospective Exhibition of Oils, Watercolors, and Graphics by Winslow Homer*, cat. by William E. Steadman, Jr., 1963, no. 15 (ill.).

Root Art Center, Hamilton College, Clinton, N.Y., *In Focus: A Look at Realism in Art*, 1964 (traveling exhibition).

Columbus Gallery of Fine Arts, Ohio, *Beaux-Arts: Design and Content*, 1967.

Brooklyn Museum, N.Y., *Triumph of Realism*, cat. by Axel von Saldern, 1967 (traveling exhibition), no. 69 (ill.).

Baltimore Museum of Art, *From El Greco to Pollock*, 1968, no. 69 (ill.).

Whitney Museum of American Art, New York, *Winslow Homer*, cat. by Goodrich, 1973 (traveling exhibition), no. 21 (ill.).

Carnegie Institute, Pittsburgh, *Celebration*, 1974.

Whitney Museum of American Art, New York, *The Painters' America: Rural and Urban Life, 1810–1910*, cat. by Patricia Hills, 1974 (traveling exhibition), no. 92 (ill.).

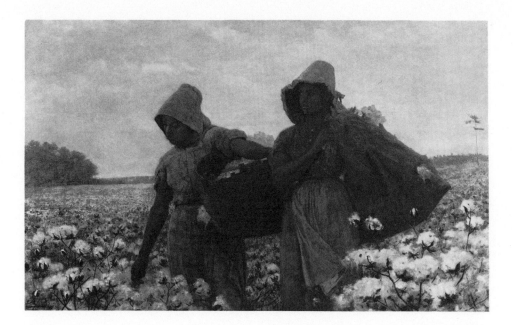

62

WINSLOW HOMER
The Cotton Pickers, 1876
Painted in New York City
Signed and dated lower left:
 WINSLOW HOMER | 1876 (in red)
 under *Winslow Homer N.A./1876*
 (in black)
Oil on canvas, $24\frac{1}{16} \times 38\frac{1}{8}$ in. (61.1×96.8 cm.)
Los Angeles County Museum of Art,
 Acquisition made possible through
 Museum Trustees: Robert O. Anderson,
 R. Stanton Avery, B. Gerald Cantor,
 Edward W. Carter, Justin Dart, Charles
 E. Ducommun, Mrs. F. Daniel Frost,
 Julian Ganz, Jr., Dr. Armand Hammer,
 Harry Lenart, Dr. Franklin D. Murphy,
 Mrs. Joan Palevsky, Richard E. Sherwood,
 Maynard J. Toll, and Hal B. Wallis.

Homer's interest in black Americans began during the Civil War, when he visited the front for *Harper's Weekly*. For the most part, he depicted them in conventional terms, sometimes with elements of caricature, in their roles as auxiliary troops in the Confederate and Union armies. In the middle 1870s, Homer returned to the South, visiting Virginia to paint former slaves in their new role as free men and women. His intentions were not welcomed by white Southerners, however, and his presence and motives were attacked. But the artist was undeterred, and the paintings and watercolors that resulted from his visit depict black Americans in a way that had been rare in our art: as psychologically complex people with full measures of beauty, strength, and dignity.

Homer's figures are probably sharecroppers, fieldhands who worked for a landowner in exchange for a fraction of the profits from the harvest. Although recent studies have demonstrated that black sharecroppers and tenant farmers were generally worked harder and were more impoverished after the Civil War than they were before emancipation, in Homer's day Northerners especially were determined to take an optimistic view of the lives of free blacks in the South. In the many descriptive accounts which Northern periodicals circulated to eager audiences after the war,[1] blacks were idealized as diligent workers, living in respectful harmony with their former owners, as pious, temperate citizens. This was also the attitude of Homer's more picturesque images of black life: *A Happy Family in Virginia* (1875; Private Collection), *A Visit from the Old Mistress* (1876; National Museum of American Art, Smithsonian Institution, Washington, D.C.) and *Sunday Morning in Virginia* (1877; Cincinnati Art Museum).

To some degree, the same message is transmitted by *The Cotton Pickers*. Using pictorial strategies suggested, in part, by the enormously popular rural genre scenes of Jules Breton,[2] Homer transformed ordinary field workers into figures of classical grace and beauty. Standing in the foreground of the picture space, they are central and dominant; their monumentality is accentuated by the low horizon and by the absence of almost all competing detail. Homer emphasized their silhouettes against the nearly monochromatic expanse of field and sky and so intensified their psychological presence. The right-hand figure, pausing in the middle of her task to gaze into the distance, embodies the hope held by many for the New South: by her abstracted expression and majestic bearing, she is shown to possess a deep spiritual reserve, an awareness of a better life ahead despite the endless field of toil surrounding her.[3]

At the same time, Homer's frank observation develops these figures beyond the stereotype of the noble laborer. He uses subtle, carefully chosen details, such as the awkward twist of the shoulder of the woman at left as she balances her large basket, or the momentary catching of a branch on the other woman's apron, to individualize them. Both are far more womanly than is usual in Homer's work of the period, with their clothes clearly outlining their bodies.[4] And rather than shielding their features, as was his usual practice, Homer gives these figures discernible personalities: the woman at left, her lower lip extended, appears petulant, while the taller woman, one of the most directly sensual and beautiful in all of Homer's art, looks straight out at the viewer with an expression that mingles fear and defiance.

The setting itself is idealized, with a silvery gray sky over a white, highly decorative pattern of cotton bolls that the women walk through as if through a sea. The woman at the left skims the bolls as if collecting foam from the ocean. Like Homer's other great image of black people painted at this period, *The Carnival* (1877; Metropolitan Museum of Art, New York), which shows blacks dressing for a celebration with an air of ineffable sadness, *The Cotton Pickers* is simultaneously arresting and vaguely disturbing, a directly real image that somehow carries with it hints of the softness and the sensuality of a dream.

J.C. and *C.T.*

NOTES

1. *The Nation* published John R. Dennett's "The South as It Is" in 1865–66; Jedediah Hotchkins' "New Ways in the Old Dominion" appeared in *Scribner's Monthly* in 1872 and 1873, and was followed by Edward King's *The New South*, also in *Scribner's Monthly* in 1873 and 1874. All were confident views of the potential of the post-emancipation South. In his excellent article on *The Cotton Pickers*, "Homer in Virginia" (*Los Angeles County Museum of Art Bulletin* 24 [1978]: 60–81), Michael Quick proposes that the success of the most popular of these accounts, King's *The New South*, may have prompted Homer once again to seek subject matter among the blacks in Virginia.

2. See, e.g., Breton's *Close of Day* (1865; Walters Art Gallery, Baltimore) which features two statuesque peasant women filling the picture space in a manner quite similar to *The Cotton Pickers*; this painting and nine other rural scenes were displayed at the 1867 Exposition Universelle in Paris, where Homer most likely saw them.

3. See Quick, "Homer in Virginia," p. 76, for a discussion of the pictorial tradition behind Homer's gazing figure.

4. Some hint of the artist's own feeling about these women may well be dimly expressed in an anecdote published several years later about his experiences on his trip to Virginia. When a Southern white woman asked him "Why don't you paint our lovely girls instead of those dreadful creatures?" the artist is said to have replied, "Because they are the purtiest" (see *The Art Amateur* [May 1880]: 112).

PROVENANCE

Private Collection, London, 1877; Dr. Charles D. Guinn, Carthage, Mo., 1911–1945; with Wildenstein & Co., New York, 1947; James Cox Brady II, New York; Mrs. James Cox Brady II, New Jersey; to present owner, 1977.

EXHIBITION HISTORY

The Century Association, New York, 1877, cat. no. 4.
Royal Academy, London, *Annual Exhibition*, 1878, cat. no. 60.
Young's Galleries, Chicago, *Paintings by Eminent American Old Masters and by Some of the Prominent Living American Artists*, 1918, cat. no. 16 (ill.).
Whitney Museum of American Art, New York, *Winslow Homer Centenary Exhibition*, cat. by Lloyd Goodrich, 1936, no. 13.
Whitney Museum of American Art, New York, 1944.
Wildenstein & Co., New York, *A Loan Exhibition of Winslow Homer*, cat. by Goodrich, 1947, no. 19 (ill.).
Los Angeles County Museum of Art, *Winslow Homer and Eastman Johnson*, 1949, cat. no. 5.
Corcoran Gallery of Art, Washington, D.C., *American Processional*, 1950, cat. no. 279 (ill.).
National Gallery of Art, Washington, D.C., *Winslow Homer, A Retrospective Exhibition*, 1959 (traveling exhibition), cat. no. 38 (ill.).
Yale University Art Gallery, New Haven, *American Art from Alumni Collections*, 1968, cat. no. 106 (ill.).

ARTHUR FITZWILLIAM TAIT

(1819, Livesey Hall, England
—1905, Yonkers, New York)

The youngest son of a successful merchant, Tait moved at the age of twelve to Manchester, England, where he found work at Thomas Agnew's print store. It was here that he was first exposed to various methods of draftsmanship, lithography, and watercolor. He left his clerking position to devote more time and energy to mastering fundamental artistic techniques, supporting these creative endeavors by working as a drawing instructor and assistant in an architectural firm. In his twenties, he traveled throughout the English countryside making sketches; in 1845 a series of panoramic railroad views drawn and lithographed by Tait was published in a folio volume.

In 1850 Tait left England for New York, where he was based for the rest of his life. His ability as a figurative painter of outdoor scenes led to immediate commercial success. Tales of the rugged Western frontier that drifted back from explorers and fortune hunters had captured the public imagination; Tait broadened his appeal by studying, and subsequently imitating, images by George Catlin, William Ranney, and Karl Bodmer, artists who had actually traveled in the wilderness. Currier & Ives began to publish inexpensive lithographic reproductions of Tait's work in 1852. He exhibited at the National Academy of Design the same year and was elected to full membership in the Academy six years later.

Tait first visited the Adirondacks in 1852, and later summered there regularly at his camp in the mountains: here he discovered an "outdoorsman's paradise" that became an important source of inspiration for his work. He recorded the mountains, forests, and lakes, as well as the hunters, fishermen, and a wide variety of hunting dogs, gamebirds, and other wildlife that contributed liveliness and drama to his paintings. Henry T. Tuckerman noted in his Book of the Artists *that Tait "has long been a popular animal painter who has had many of his pictures widely distributed through chromolithographs." He also painted a number of frontier scenes, mostly before 1862, though he never traveled west of Chicago. There was little incentive for Tait to alter his style or approach, and after the 1860s his work became repetitive. By the mid-seventies he was turning increasingly to domestic animal subjects—chickens and sheep especially. He remained active through the nineteenth century, and his last paintings are dated 1904, the year before his death.*

Tait kept a register of his work during most of his career; it is preserved at the Adirondack Museum, Blue Mountain Lake, N.Y. The best source on the artist is that museum's 1974 exhibition catalogue, A. F. Tait, Artist in the Adirondacks, with essays by Warder H. Cadbury and Patricia C. F. Mandel.

63

ARTHUR FITZWILLIAM TAIT
A Tight Fix, 1856
Painted in New York City
Signed and dated lower right: *A F Tait/NY 56*
Oil on canvas, 40 × 60 in. (101.6 × 152.4 cm.)
The Manoogian Collection

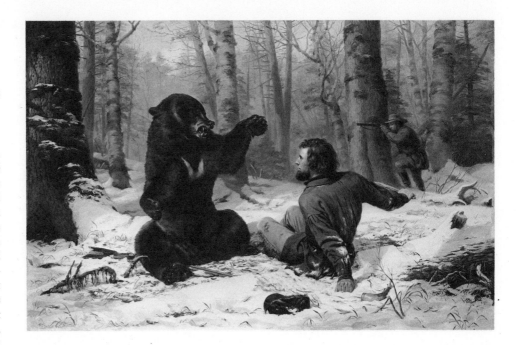

American artists throughout the nineteenth century were fascinated with the hunt and the sporting life. Hudson River School landscapes frequently include figures of fishermen and hunters, and genre painters from William Sidney Mount and J. G. Clonney to Thomas Eakins and Winslow Homer returned again and again to fishing and to the trapping and shooting of birds, deer, and other game. Still-life painters, led by Harnett, made frequent use of the apparatus of the hunt and of its product, the freshly killed prey. This subject had, of course, a long history in England, where hunting was a sport for aristocrats. In this country, it took on increased importance as it came to represent an important part of the American self-image. During the early part of the century, fishermen and hunters were painted as a natural part of idyllic scenery and as evidence of rural and frontier customs. By mid-century, however, the hunters were no longer men from the country, killing for food; rather, they were now city people who hunted and fished on their vacations, as an escape from urban life; shooting had become a "sport," a ritual means of identification with the past.

Tait more than any other artist popularized this new view of the urban sportsman, for he was the most prolific painter of such subjects, and his work was widely known through inexpensive Currier & Ives lithographs. *A Tight Fix* is one of his largest and most ambitious paintings, executed during his first years in New York. A hunter dressed in fringed leather jacket and trousers—a proper hunting apparel, based on Indian costume—has shot and wounded a huge black bear; he has dropped his Kentucky rifle and his powder horn and fights off the angry beast's attack with only a knife. His companion tries to draw a bead on the bear, but he has only one shot, and the outcome is uncertain. The hunter may live or die—surely he is in "a tight fix," as the English-born painter titled his picture, consciously using an apt American colloquialism to describe the predicament.

Tait had only a minor reputation, and his audience throughout his career was a popular rather than a sophisticated one. Tait did strive for election to the National Academy of Design, however, and this picture's poor critical reception must have pained him. Its first buyer apparently returned it, but the artist was able to resell it for $500.[1]

Presumably trying to improve the composition, Tait in 1861 painted a very similar (now unlocated) picture which he called *Life of a Hunter: A Tight Fix*. In this version the bear is no longer seated in such a human pose, but rears up on its hind legs, and the hunter is on his knees wielding his knife. This version was more successful and was reproduced in a popular Currier & Ives print of the same year.

Interest in Tait revived during the 1930s, when he was considered a painter who "stuck to the facts as he saw them."[2] Though today we recognize the degree to which the artist romanticized and dramatized his scenes of outdoor action, he nonetheless appears to have been in some senses more of a realist than more highly regarded contemporaries such as Frederic Edwin Church (q.v.). The latter's wilderness views are idyllically free of human habitation, and represent remembered rather than an actual scenes. Tait, on the other hand, paints not dream but harsh reality as his city-bred hunter, seeking recreation, unexpectedly finds himself too close to nature.

T.E.S.

NOTES

1. Tait recorded the picture in his Register, as No. 3; "Snow Scene in Chateaugay Woods, N.Y. Mar. 25th. Bear Hunt—'Tight Fix' (size 60 × 40). Sold to J. Campell [Campbell], Esq., Pacific Bank. Price $500.00—ret'd by W.S.W. Co. Date when sold Nov. 1856." Information courtesy of William Crowley, the Adirondack Museum.

2. H.E.K., "A. F. Tait in Painting and Lithograph," *Antiques* 24 (July 1933): 24.

PROVENANCE

The artist; J. Campbell, 1856, Esq., Pacific Bank; Redlands Elk Lodge, Calif., c. 1911–1968; with Kennedy Galleries, 1971; Tempel Smith, Illinois, 1974; with Szymanski Gallery, Pasadena, Calif., 1980; to present owner, 1980.

EXHIBITION HISTORY

Philadelphia, 1856.
National Academy of Design, New York, *33d Annual Exhibition*, 1858, cat. no. 182 (as *A Tight Fix. Bear Hunting. Early Winter*).
Adirondack Museum, Blue Mountain Lake, N.Y., *A. F. Tait: Artist in the Adirondacks*, cat. by Warder H. Cadbury and Patricia C. F. Mandel, 1974, no. 10 (ill.).

FREDERIC REMINGTON

(1861, Canton, New York
—1909, Ridgefield, Connecticut)

Remington's ever popular scenes of the American frontier have been widely distributed in reproductions from the artist's day to our own time, and his vivid, light-filled portrayals of life on the plains in oil, bronze, and illustration have become, for many, archetypal images of life in the Old West.

Remington's only formal training consisted of a year and a half of study with John Henry Niemeyer at the Yale School of Fine Arts. His mature style was influenced chiefly by the well-known military compositions of the French painters Alphonse de Neuville, Edouard Detaille, and Jean-Louis-Ernest Meissonier.

Remington made his first trip to the West in 1881 and became determined to record images of the frontier before that rugged way of life disappeared completely. By 1883 he had become a partner in a small ranch in Kansas, but after two years he sold his land and returned East to marry Eva Caten. Remington continued to make sketching trips to the West throughout his career while residing in New Rochelle, New York, where he executed most of his paintings.

In the 1890s Remington's work won both critical and popular acclaim; he was elected an associate of the National Academy of Design, New York, in 1891, and in 1893 and 1895 held two successful sales of his pictures of the American West at the American Art Association. In 1899 he bought an island in the St. Lawrence River and expanded his subject matter to include scenes of the Canadian wilderness. In 1903 Collier's magazine gave him an exclusive contract to reproduce his paintings; this relationship allowed Remington to give up the black-and-white illustrations which had provided him with a steady income since the 1880s. At this time his palette lightened and his brushwork became somewhat looser. Remington died in 1909 at the age of forty-eight, before he could witness the final decline of the Western frontier.

The first comprehensive biography of Remington was Harold McCracken's monograph of 1947. Peter H. Hassrick's catalogue for the Amon Carter Museum's 1973 retrospective exhibition and the accompanying book (New York, 1973) are among the most recent studies of the artist's work.

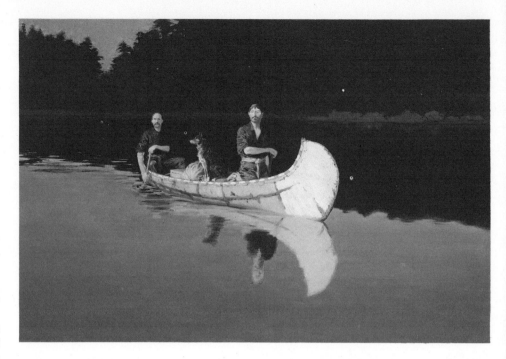

64

FREDERIC REMINGTON
Evening on a Canadian Lake, 1905
Painted in Upper New York State
Signed upper right: *Frederic Remington*
Oil on canvas, 27¼ × 40 in. (69.2 × 101.6 cm.)
The Manoogian Collection

Frederic Remington became one of America's best-known painter/illustrators through the numerous reproductions of his work that appeared in our popular magazines around the turn of the century—*Collier's Weekly, Harper's Monthly*, and *Harper's Weekly*—but his greatest hope was to be respected as a true artist. The style that won him great public acclaim and financial reward was formed by the mid-1880s. *A Dash for the Timber* (1889; Amon Carter Museum, Fort Worth, Tex.) is typical in its colorful portrayal of U.S. Cavalry troops riding away from a band of attacking Indians at breakneck speed, while firing their guns back over their shoulders. Dark figures and horses contrast with the light tones of ground and sky; emphasis is on the action, and brushwork and drawing, though undistinguished, adequately serve the artist's intentions.

Despite having exhibited frequently at the National Academy of Design, however, Remington failed to be elected a full member, and the serious critics agreed with Samuel Isham's assessment of him as "an illustrator rather than a painter" and with Sadakichi Hartmann, who wrote in 1901 that Remington and other illustrators "only represent" and "suggest absolutely nothing."[1] Perhaps in response to such criticism, the painter in the last few years of his life began to experiment with nocturnal scenes, which employ a more tonal palette and stronger compositional schemes, and which show the effect of his plein air landscape studies. In *Evening on a Canadian Lake*, Remington departs from his usual subjects—the cowboy and Indian myths of the West—and portrays time, place, and character. The scenery is that of "Ingleneuk," the small island in Chippewa Bay on the St.

VI. *The Flowering of Still Life*

Lawrence River where he summered regularly beginning in 1898. The figures, a northern trapper or hunter and a younger man who is perhaps half-Indian, are men of the north country, more comfortable in the wilderness than in society. Direct descendants of Bingham's fur traders (see cat. no. 54), they are sweaty, poor, and believable. Their vessel (which was actually Remington's own) is a Rushton canoe, a modern version of the Indian birchbark canoe.

This painting was first reproduced in *Collier's Weekly* in a double-spread in color, on 18 March 1905. During this period *Collier's* was paying the artist $1,000 apiece for exclusive reproduction rights to such works, with the painter retaining ownership of the original. The same firm also made a very popular print of the painting.[2] Here Remington returned momentarily to the American genre tradition, his effective compositions recalling those of George Caleb Bingham, Arthur F. Tait, and Winslow Homer (q.v.).

Attempts have been made to link the artist with Impressionism, but his brushwork always remained conservative and academic, and he brusquely scoffed when he saw French Impressionist pictures, saying "I've got two maiden aunts up-state who can *knit* better pictures than those."[3] Some critics responded favorably to Remington's late efforts, and especially to the night scenes.[4] However, the general critical view remained that "he was preeminently an illustrator and a dramatist on canvas."[5]

T.E.S.

NOTES

1. Isham, *The History of American Painting* (1905; New York, 1927), p. 501; Hartmann, *A History of American Art*, 2 vols. (1902; Boston, 1932), 2: 113.

2. See Harold McCracken, *Frederic Remington: Artist of the Old West* (Philadelphia, 1947), plate 18.

3. Ibid., p. 106.

4. See Royal Cortissoz, "Art Exhibitions," *New York Tribune*, 4 December 1907.

5. Obituary, *American Art News*, December 1909, quoted in Peter Hassrick, *Frederic Remington: The Late Years* (Denver Art Museum, 1981), p. 7.

PROVENANCE
The artist; to private collection; with Kennedy Galleries, New York; to present owner, 1980.

EXHIBITION HISTORY
Noé Galleries, New York, *Special Exhibition of Recent Paintings by Frederic Remington*, 1905, cat. no. 5.

EDWARD ASHTON GOODES

(1832, Wilmington, Delaware
—1910, Philadelphia)

Little is known of the life and art of Goodes, beyond the facts that he was the son of an English tailor who emigrated to America in 1829, and that he married Anna Dobbins of Philadelphia in 1853. According to Philadelphia city directories, he painted portraits (though none is known), and apparently he worked mostly as a sign painter for local fire and beer companies. Fishbowl Fantasy is the only one of about six landscape and floral still-life paintings bearing his signature that is of high artistic merit. Confusion results from the fact that he and his brother Ebenezer, also a painter, both listed themselves as E. A. Goodes (or Goodess) in some of the city directories and exhibition catalogues of the Pennsylvania Academy of the Fine Arts. The earliest directory record appeared in 1850: "Goodess, E.A., sign painter, 460 Poplar." The artist is known to have exhibited six paintings at the Pennsylvania Academy between 1853 and 1865, with surprisingly diverse titles, including Still Life (Music) *in 1853,* Christ Taken to Calvary *in 1855, and* At the Mill; Buoy Boats; Excelsior; *and* A Stranger off the Coast *in 1865. Two surviving sketchbooks (Private Collection) contain pencil and watercolor studies of flowers and landscapes, and preparatory studies for* Christ Taken to Calvary.

There is no detailed study of Goodes. Darrel Sewell's biographical summary based on information gathered by Philadelphia art dealer Anthony A. P. Stuempfig appears in the exhibition catalogue Philadelphia: Three Centuries of American Art *(Philadelphia Museum of Art, 1976), p. 382.*

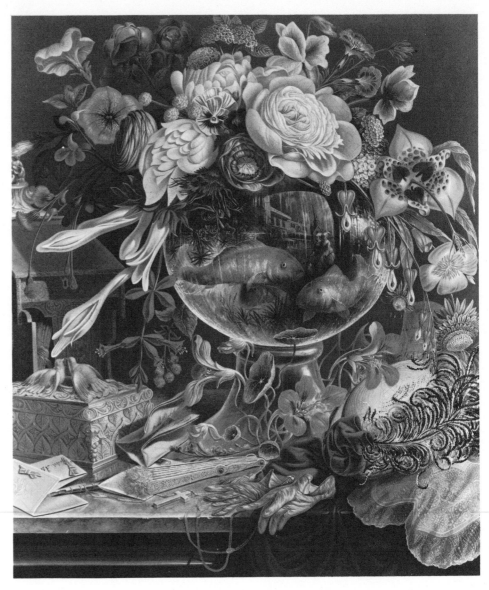

65

EDWARD ASHTON GOODES
Fishbowl Fantasy, 1867
Painted in Philadelphia
Signed and dated lower left:
 E^{D}. A. Goodes. 1867.
Oil on canvas, 30 × 25⅛ in. (76.2 × 63.8 cm.)
Mr. and Mrs. Stuart P. Feld

One's overwhelming first impression of this still life is of a high-keyed profusion of showy summer flowers—symbols of fertility, happiness, and material prosperity. The extravagant crowding of the blossoms and the combination of strong lighting, firm, linear execution, and plain background recall the flower pictures of the well-known and prolific painter Severin Roesen (c. 1815–1871), who worked in Pennsylvania from about 1857. But Goodes's colors are more strident than Roesen's, his drawing less painstaking, and his pictorial imagination more idiosyncratic. Goodes excells in fervently animated

observation—for example, the writhing, snakelike motion of the nasturtiums across the marble surface—and here he contradicts the usual notion of the still life as a calm and relaxing visual experience. The extraordinary feature of this picture is the intriguing mysterious narrative implicit in the objects accompanying the flowers.

It is a shock to find three glum goldfish swimming in the vase where the flower stems should be.[1] Adding to the unusual effect, the glass bowl reflects a small-town street scene with a church, a civic-looking building flying the Stars and Stripes, and a pair of young ladies in fashionable spring walking dress (who hold up their skirts as if to protect them from mud and dirt). The feathered hat in the lower right is the type worn by the ladies in the street; it lies casually with white lace and green cloth accessories, gloves, fan, gold cross and pen on a chain, a letter, an embossed invitation or announcement, an ornamental box decorated with loving doves, and a small writing cabinet containing a bundle of letters

and surmounted with a figurine of a putto or cupid.

The picture hints strongly at the story of a young lady in love. The letter, inscribed "Philadelphia," is written to "Dear Isabel" from "Frank," and the only word that can be read on the invitation is "Isabel." That a young woman is the surrogate subject of the picture may be suggested by the repetition of pink as an identifying color in the gloves, the fluffy plume on the fan, the letter paper, and the ribbon binding the letters in the cabinet.

Another clue comes from the sheet of music largely hidden behind the hat and a pendulous stem of the flower bleeding heart (*Dicentra*). It is a song entitled "Oh! Woo Me Not from My Cottage Home," in which a woman expresses affection for her siblings, her aging parents, and the "cheerful quiet hearth." In the final verse she says:

> Oh! woo me not from my cottage home,
> I cannot be thy bride;
> I cannot sail o'er the sea's white foam,
> Nor leave the old hill's side.
> My heart would often linger back
> With thoughts of fond regret,
> And wander o'er the olden track,
> That love could ne'er forget.[2]

This song is characteristic of the sentimental culture of the Victorian middle classes which also comes across in the painting. The theme of a country girl apprehensive about a marriage that will take her away from home could explicate several motifs in the picture, especially the pathetic captive fish which exist here as fancy ornaments. This story also makes it easier to speculate on the meaning of the many erotic details—the phallic lily buds, the sensuously unfolding roses and ranunculus, and the gaping, mouthlike nasturtiums.

There was an enormous quantity of Victorian literature devoted to the moods and thoughts that different flowers were felt to express. This "language of flowers" was religious, moral, and sentimental, but never explicitly sexual. It is difficult to interpret the collective meaning from the associations attributed to each flower in the Goodes still life. However, the nasturtiums, flowers of patriotism, may relate to the flag reflected on the glass bowl, and one might speculate that "Frank" and "Isabel" were separated by the recent Civil War. Ultimately, the fact that the picture's story cannot be completely deciphered adds to its interest. To our late-twentieth-century eyes it takes on something of the enigma of surrealism. In all respects this is an unconventional extrapolation of the standard Victorian still-life painting.[3]

T.J.F.

NOTES

1. William H. Gerdts and Russell Burke (*American Still-Life Painting* [New York, 1971], p. 243) compare the Goodes with an eighteenth-century Dutch still life by Abraham van Strij at the Dordrechts Museum, which shows a bowl of goldfish, a dog, dead game, fruits, and flowers on a marble ledge. As they point out, the lavish rococo compositions of van Strijs and van Huysums were an important influence on mid-Victorian artists such as Goodes. There are precedents in American art, including Samuel F. B. Morse's domestic genre scene, *The Goldfish Bowl* (1835; National Museum of American Art, Smithsonian Institution, Washington, D.C.).

2. © 1850; published in Philadelphia by T. C. Andrews and G. André. Music by James Cox Beckel, lyrics by Amanda Minnie Douglas. Douglas (1831–1916) was only nineteen when she wrote these lyrics. Her literary career began with numerous stories published in magazines such as *The Lady's Friend*; her first novel *In Trust* (1866) was a popular success, and she published one or more volumes every year from 1866 to 1913. She was a close friend of Louisa May Alcott.

3. It should be noted that the original title of the work is not known, and that the term "fantasy" reflects the mid-twentieth-century attitude to the picture.

PROVENANCE
Mr. Roland Ellis, Philadelphia; Mr. and Mrs. Albert Ten Eyck Gardiner, New York; Mr. and Mrs. Robert Gardiner, Philadelphia, 1967; with Hirschl and Adler Galleries, New York, 1968; to present owner.

EXHIBITION HISTORY
Abby Aldrich Rockefeller Folk Art Collection, Williamsburg, Va., 1960.
Metropolitan Museum of Art, New York, *Three Centuries of American Painting*, 1965.
Hirschl and Adler Galleries, New York, *Twenty-Five American Masterpieces*, cat. intro. by Stuart P. Feld, 1968, no. 10 (ill.).
M. Knoedler & Co., New York, *The American Vision, Paintings, 1825–1875*, cat. by Feld, 1968, no. 40 (ill.).
National Gallery of Art, Washington, D.C., *The Reality of Appearance: The Trompe L'Oeil Tradition in American Painting*, cat. by Alfred Frankenstein, 1970 (traveling exhibition), no. 16 (ill.).
Whitney Museum of American Art, New York, *18th and 19th Century American Paintings from Private Collections*, 1972, cat. no. 25.
Philadelphia Museum of Art, *Philadelphia: Three Centuries of American Art*, 1976, cat. intro. by Darrel Sewell, no. 329 (illus.).

JOHN LA FARGE

(1835, New York City
—1910, Providence, Rhode Island)

The son of emigré French parents, La Farge grew up in a prosperous and highly cultivated Catholic household in New York. As a child he received drawing instruction from his maternal grandfather and around 1850 took some painting lessons from an unidentified French artist in New York. He studied law intermittently in the 1850s, and did not determine to be an artist until 1859. On an 1856 visit to relatives in France (including his cousin Paul de Saint Victor, the journalist and defender of Delacroix), La Farge studied briefly in Thomas Couture's studio, modeled for Puvis de Chavannes, and copied Old Master drawings in the Louvre. In 1857 he saw the "Art Treasures" exhibition in Manchester, which included many works by the English Pre-Raphaelites.

La Farge's work is characteristically rich in allusions to other art, whether old or modern; it is painterly in handling, sophisticated in color, and frequently experimental in its search for new methods. His first paintings—landscapes and flower pictures produced between 1859 and 1862 in Newport, Rhode Island, in the artistic circle of William Morris Hunt—found only limited critical response at American exhibitions in the 1860s (in 1864 one work was rebuked as "a blind muddle of color on a bit of canvas"). An interest in ideal subjects from literature and classical mythology was evident in his engraved illustrations for books and magazines in the 1860s and early '70s. His first important mural and stained glass decorations were featured in buildings by H. H. Richardson (in particular, Trinity Church, Boston, 1876). La Farge's murals reflected Renaissance models primarily, but his stained glass encompassed an innovative mixture of Renaissance, Gothic, and most importantly, Oriental modes. In New York he produced stained glass and designed mantelpieces and embroideries for the residence of millionaire Cornelius Vanderbilt II (1882). He also made murals for two New York churches: the Church of the Incarnation (1885) and the Church of the Ascension (1888). By this time the fine decorative qualities of his easel paintings and his superb floral watercolors were widely recognized, and he became a major figure in the Aesthetic Movement in America.

La Farge's sophistication set him apart from the mainstream of American culture, yet he was one of the most respected figures of his day. His many books and essays include Considerations on Painting *(1895) and* An Artist's Letters from Japan *(1897).*

The basic monograph is by Royal Cortissoz (1911; New York, 1971). There are two recent doctoral dissertations: H. Barbara Weinberg, The Decorative Work of John La Farge *(New York, 1977), and Henry Adams,* John La Farge, 1830–1870: From Amateur to Artist *(Yale University, 1980).*

66

JOHN LA FARGE

Agathon to Erosanthe, A Love Wreath, 1861
Probably painted in Newport, Rhode Island
Signed and dated bottom center:

I. L. F. MDCCCLXI

Oil on canvas, 22 × 12½ in. (55.9 × 31.8 cm.)
Private Collection

The inspiration for this unusual still life was the ancient Greek custom of placing a wreath of flowers outside the home of the person with whom one has fallen in love. The Greek inscription written in red below the wreath says "Beautiful Erosanthe," and, as the title indicates, this woman had won the heart of a man named Agathon. The association of flowers with the blossoming of love and the desire to adorn a lover with their beauty are sentiments expressed in Greek verse. A discussion of the varieties of wreaths and their uses appears in Athenaeus's book *The Deipnosophists*, which La Farge apparently owned.[1] The historicist aspect of this picture is foreign to the still-life tradition that generally prevailed in America: its classical subject recalls neo-Greek painters such as Ingres and Gérôme in France and Lawrence Alma-Tadema and Frederick Leighton in England. In technique, however, it has nothing to do with the minute finish of these classicists: its painterliness derives from the opposing tradition of Delacroix, but perhaps more immediately influenced by Diaz,

Chassériau, Couture, and the young Moreau.

La Farge painted *Agathon to Erosanthe* a year after he married Margaret Mason Perry and may have intended it as a symbol of happy wedlock and fruitful marriage. At that time, La Farge was part of the artistic circle of William Morris Hunt (1824–1879) in Newport. Although he chose not to adopt the figurative emphasis of Hunt's Barbizon idol, Jean-François Millet, La Farge learned Hunt's general dictum to avoid scrutinizing details and achieve "an impression of the *whole thing*." The colors of the flowers in *Agathon to Erosanthe* range widely in tone and intensity. Shadows cast by the strong light complicate the image, but there is no sense that any flower received special attention. In contrast to the tinted glazes that make details of the flowers seem delicate and luminous, the rough surface of the wall is boldly rendered in thickly dragged and caked opaque pigment. This deliberately coarse surface required the same attention as the flowers to achieve its remarkable modulation in tone from sharp white at the top down to soft bluish white. Close examination shows that many pinks, grays, blues, and creams are mixed in with the white to effect this subtle transition. Hunt was dismayed by La Farge's preoccupation with matching colors so precisely. La Farge's determination on this issue was crucial to his art, however: the chromatic sensitivity of *Agathon to Erosanthe* is its surpassing quality, and the uniqueness of the artist's later works in stained glass results in large part from this interest.[2]

The stringently formal design of *Agathon to Erosanthe* was repeated once more in 1866, but most of La Farge's early flower paintings are unpretentious groupings of flowers in rather simple vessels.[3] In all examples the artist's primary concern was to translate the flowers' colors and textures and the precise light conditions into a language of paint that would command the same emotional responses as the flowers themselves. At first there was little appreciation of this developed aesthetic program. Writing on the still lifes La Farge exhibited in New York in 1864, the orthodox Ruskinian critic for the *Tribune* disparaged the flowers as formless, unidentifiable "blots of color."[4] La Farge's most important advocate in the early years was James Jackson Jarves, the American collector of Italian Gothic and Early Renaissance paintings, whose opinions on La Farge were not widely shared by critics until about 1880. In 1870 Jarves wrote:

A flower painted by [La Farge] bears the same relation to the real plant that an angel of Fra Angelico does to the actual man. It is an exhibition of its highest possibilities of being rather than of its present material organization. However beautiful this may seem to the eye, La Farge makes his subject present a still more subtle beauty to the mind, which finds in it a relationship of spirit as well as matter. This phase of art is rare in any school.[5]

T.J.F.

NOTES

1. See Henry Adams, *John La Farge, 1830–1870: From Amateur to Artist* (Ph.D. diss., Yale University, 1980), pp. 264–68.

2. La Farge became well acquainted with Chevreul's writings on color theory early in his artistic career: he admitted their importance in helping him understand the aesthetics of the medieval stained glass he studied in France, and they ". . . more than anything else, determined the direction which my painting took some years afterward, when I began to paint." Quoted in Royal Cortissoz, *La Farge: A Memoir and a Study* (1911; New York, 1971), pp. 87–88.

3. The second floral wreath painting, the same size as this work, is *Greek Love Token* (1866; National Museum of American Art, Smithsonian Institution, Washington, D.C.). The most complete discussion of the flower paintings is Kathleen A. Foster, "The Still-Life Paintings of John La Farge," *American Art Journal* 2 (July 1979): 4–37.

4. Quoted in Foster, ibid., p. 19.

5. Jarves, "Museums of Art, Artists, and Amateurs in America," *Galaxy* 10 (July 1870): 54. Jarves had already written perceptively on La Farge's flower paintings in his 1864 book *The Art Idea*: see Foster, "Still-Life Paintings of La Farge," pp. 16–17.

PROVENANCE

Given by artist to Miss Ellen Sturges Hooper by 1866; Edward W. Hooper, Cambridge, Mass.; Mr. and Mrs. Henry Lee Higginson, Boston, by 1910; Mr. and Mrs. Bancel La Farge, Mount Carmel, Conn., by 1931; Mr. and Mrs. Thomas Sargeant La Farge, Cornwall, Conn., by 1966; to present owner.

EXHIBITION HISTORY

Brooklyn Art Association, N.Y., *Annual Exhibition*, 1864, cat.no.124.

Museum of Fine Arts, Boston, *La Farge Memorial Exhibition*, 1911.

Wildenstein & Co., New York, *Loan Exhibition of Paintings by John La Farge and Descendents*, 1931, cat.no.1.

Metropolitan Museum of Art, New York, *An Exhibition of the Work of John La Farge*, 1936.

Macbeth Gallery, New York, *John La Farge— Loan Exhibition*, 1948, checklist no. 17.

Graham Gallery, New York, *John La Farge*, 1966, cat.no.8 (ill.).

67

MARTIN JOHNSON HEADE
Two Fighting Hummingbirds with Two Orchids,
1875
Painted in New York City
Signed and dated lower left: *M.J. Heade 1875*
Oil on canvas, $17\frac{1}{2} \times 27\frac{3}{4}$ in. (44.5×70.5 cm.)
Whitney Museum of American Art,
 New York, Gift of Henry Schnackenberg
 in memory of Juliana Force, 1967

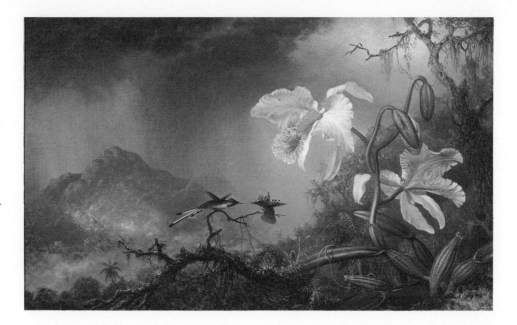

Beginning in about 1871 and continuing over thirty years, Heade painted a series of pictures of orchids and hummingbirds which rank among the most original and most evocative of nineteenth-century American paintings. These unique works have been mistakenly considered the studies of a naturalist, or simple still lifes, and only recently have they been studied with care.

Heade began to paint the hummingbird—which the naturalist Buffon had described as "of all animated beings, the most elegant in form and the most brilliant in color"—during his Brazilian trip of 1863–64. Early in 1864 at Rio de Janiero, he exhibited twelve of a planned series of twenty small paintings (all about 12×10 inches), each of which depicted a male and a female of one of the different Brazilian species of the bird near their nest in the jungle. The painter hoped to turn this series into an illustrated book to be called *The Gems of Brazil*, but this project was never completed.[1]

The painter took a second tropical trip, to Nicaragua, in 1866, which resulted in very little work, and then in 1870 made a third trip, this time going at Frederic Church's urging to Colombia, Panama, and Jamaica. Though he had surely seen orchids frequently before this, Heade was inspired by those he saw in Jamaica, where he sketched the flower. In 1871, back in his New York studio, he combined orchids with hummingbirds for the first time and quickly established his basic composition: the large, light-colored orchid and two small hummingbirds dominating the frontal plane, with a lush, misty jungle extending into the distance behind them.[2]

The early pictures lead up to *Two Fighting Hummingbirds with Two Orchids* of 1875, the largest and most fully developed of the series. Though the paintings have been considered still lifes by most recent critics, in this canvas, at least, the flowers and birds are balanced equally with landscape elements—the luxuriant tropical vegetation with high mountains and a rainstorm in the distance. Drawing on his own earlier experience as a sometime-ornithologist, using living orchids for the first time as a painter's subject, and making use of his experience as a landscapist, Heade in effect created a new genre.

The scenes themselves are imaginary, with the hummingbirds based on the Brazilian studies of 1863–64 and the orchids coming from ones he saw in New York and New Jersey hothouses. His compositions have some parallels in the general movement inspired by John Ruskin toward living, outdoor still lifes.[3] They also suggest the influence of photography in their cropped images and their innovative use of large, clearly focused images in the foreground.

These paintings are the very image of Eden. They evoke, in small scale, the same feelings of awe and excitement as Church's large Jamaican landscape scene *Rainy Season in the Tropics* (cat.no.46). Heade carries the emotive elements further and adds a high sensuality through the close-up orchids—their very name, *orchis*, comes from the Greek "testicle," while the flower's labellum resembles female genitalia. These were flowers which the Victorian mind avoided. They were not depicted in paintings or prints, and they were unmentioned in the many contemporary books on flower symbolism. Through this unique subject, however, Heade speaks to a new world view suggested by the writing of Charles Darwin, who followed his *Origin of the Species* of 1859 with *The Various Contrivances by Which Orchids are Fertilized by Insects* in 1862 and *The Movements and Habits of Climbing Plants* in 1865.[4]

T.E.S.

NOTES

1. In 1982 sixteen of the original paintings in the "Gems of Brazil" were found; they are now in the Manoogian Collection, Detroit. For a fuller discussion of this subject, see Stebbins, *Heade*, pp. 126–37.

2. There are two orchid and hummingbird paintings dated 1871: see Stebbins, *Heade*, nos. 133 and 134.

3. See William H. Gerdts, "The Influence of Ruskin and Pre-Raphaelitism on American Still-Life Painting," *American Art Journal* 2 (Fall 1969): 80–97.

4. See the fine discussion of this subject in Ella M. Foshay, "Charles Darwin and the Development of American Flower Imagery," *Winterthur Portfolio* 15 (Winter 1980): 299–314.

PROVENANCE
With Harry Shaw Newman Gallery, New York; Henry Schnackenberg; to present owner, 1967.

EXHIBITION HISTORY
Whitney Museum of American Art, New York, *Recent Acquisitions*, April 20 1966–May 17, 1967, 1967.
University of Maryland Art Gallery, College Park, *Martin Johnson Heade*, cat. by Theodore E. Stebbins, Jr., 1969 (traveling exhibition), no. 34 (ill.).
Dallas Museum of Fine Arts, *The Romantic Vision in America*, cat. by John Lunsford, 1971, no.41 (ill.).
Society of the Four Arts, Palm Beach, Fla., *Still Life and Flowers*, 1973.
Wildenstein & Co., New York, *Masterpieces in Bloom*, 1973.
Baltimore Museum of Art, *Two Hundred Years of American Art*, cat. by Joshua C. Taylor, 1976 (traveling exhibition), no.25 (ill.).
Bronx Museum of Art, N.Y., *Images of Horror and Fantasy*, cat. by Gert Schiff, 1977.
American Contemporary Art Galleries, New York, *American Flower Painting, 1850–1950*, cat. by Dennis R. Anderson, 1978 (ill.).
Cummer Gallery of Art, Jacksonville, Fla., *Martin Johnson Heade*, cat. by Robert W. Schlageter, 1981 (traveling exhibition), no.4 (ill.).

MARTIN JOHNSON HEADE
Giant Magnolias on a Blue Velvet Cloth, c. 1890
Painted in St. Augustine, Florida
Signed lower right: *M. J. Heade*
Oil on canvas, 15 × 24 in. (38.1 × 61 cm.)
Private Collection

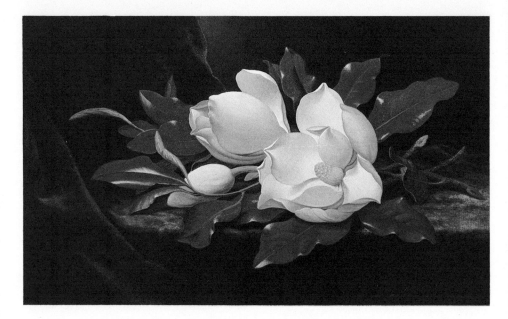

Heade took up still-life painting about 1860, and over a fifteen-year period he made a series of beautiful small pictures of flowers in decorated vases which often stand on silk or satin tablecloths. The flowers vary: they include lilies, heliotrope, hibiscus, nasturtium, and the artist's favorites, apple blossoms and roses, and their mood is sensual and introspective.

In 1870 Heade experimented for the first time with a horizontal format, painting the pink flowers and green leaves of trailing arbutus on a tabletop, with a rich cloth behind.[1] Then, after moving to Florida in 1883, he took up a new group of southern flowers, including orange blossoms, oleanders, and especially cherokee roses and magnolias. The artist experimented with various compositions, at times depicting these flowers in standing vases within vertical formats, but he gradually settled on a horizontal, reclining mode. The pictures of white cherokee roses, often painted on a red velvet cloth, were successful, but by far the most sumptuous of these late still lifes were the magnolia blossoms. There are about a dozen of these paintings, nearly all of the same size, showing the huge white blossoms lying on brown, red, or blue velvet. Just one of them is dated, the fine Ganz Collection example of 1888, and on this basis one can surmise that this final outpouring of Heade's talent occurred roughly in the years 1885 to '90.

Heade had married for the first time in 1883, at the age of sixty-four, and in his new home of St. Augustine, Florida, he found his first generous patron, Henry Morrison Flagler. The still lifes of this late period are no less sensual than the orchids of the previous decade, but there is a major distinction, for the orchids are frenzied and passionate, while the magnolias seem calm and satisfied—possibly reflecting the painter's own state of mind. They also seem inevitably female in form, recalling John I. H. Baur's remark of thirty years ago on their "fleshy whiteness . . . startlingly arrayed on sumptuous red velvet like odalisques on a couch."[2] In the mid-nineteenth century, women were specifically identified with flowers. Nathaniel Hawthorne, in his short story "Rappaccini's Daughter," described a young man who dreamed of a rich flower and beautiful girl: "Flower and maiden were different and yet the same, and fraught with some strange peril

in either shape." And Thomas Moore, a contemporary poet, wrote, "Within the bed fair Isabel / In blushing sweetness lay / Like flowers, half-open'd by the dawn, / And waiting for the day."[3]

These highly original pictures evidently found a ready local market in Florida, but Heade by this time had long since been forgotten by mainstream critics. In 1893, however, possibly on the basis of the magnolias, he was apparently honored with an invitation to show at the World's Columbian Exposition in Chicago, but he declined.[4] *Giant Magnolias on a Blue Velvet Cloth* is one of the most complex, and perhaps the most beautifully executed, of these pictures. Its three flowers in various stages of development suggest that we are watching a single blossom slowly unfold. The two larger blossoms are based directly on an oil sketch, made from nature, at the St. Augustine Historical Society; following his usual practice, Heade used the largest flower unchanged in two other paintings, where it also appears on blue velvet.[5]

T.E.S.

NOTES

1. This painting, *Flowers of Hope*, is unlocated but is known through a chromolithograph by L. Prang & Co., Boston; see Stebbins, *Heade*, p. 120.

2. Baur, *Commemorative Exhibition: Paintings by Martin J. Heade and F. H. Lane from the Karolik Collection in the Museum of Fine Arts, Boston* (M. Knoedler & Co., New York), intro., n.p.

3. Hawthorne, "Rappaccini's Daughter," in *Mosses from an Old Manse*, 2 vols. (New York, 1851), 1:90; Thomas Moore, "The Ring," in *Songs, Ballads, and Sacred Songs* (London, 1849), p. 12. Heade owned a copy of Moore's book; see Stebbins, *Heade*, p. 117.

4. See Stebbins, *Heade*, p. 177.

5. The oil sketch is reproduced in Stebbins, *Heade*, no. 262; the other two paintings with the identical central flower, nos. 329 and 331.

PROVENANCE
With Victor Spark, New York, 1962; to present owner.

EXHIBITION HISTORY
Public Education Association, New York, *The American Vision, Paintings 1825–1875*, 1968, cat. no. 43 (ill.).
University of Maryland Art Gallery, College Park, *Martin Johnson Heade*, cat. by Theodore E. Stebbins, Jr., 1969 (traveling exhibition), no. 52 (ill.).
Museum of Modern Art, New York, *The Natural Paradise: Paintings in America 1800–1950*, cat. by Kynaston McShine et al., 1976, no. 76 (ill.).

JOSEPH DECKER

(1853, Wurtemburg, Germany
—1924, Brooklyn, New York)

Decker and his family emigrated to the United States in 1867. He began his artistic career as a Brooklyn house painter's apprentice and later earned his living as a sign painter, making designs for delivery vans and targets for a sporting club. Professional training came in the late 1870s, when Decker began to take evening classes at the National Academy. In 1879 he returned to his native Germany to study in Munich. He worked for one year with Wilhelm Lindenschmidt (1829–1895), a well-known history painter, and then returned to America, where he lived for most of his life in Brooklyn, while making occasional trips back to Germany. Decker's work attracted the attention of the prominent collector of American art, Thomas B. Clarke. Clarke bought eight of Decker's paintings, and in 1886 he hired the artist to restore and maintain his large collection of Chinese porcelain. Decker soon began to acquire porcelain as well; its influence is apparent in his work.

Decker was a still-life specialist, although he also painted landscapes, portraits, and genre, as well as several pictures of his pet squirrel. His early pictures of the 1880s are sharply focused, close-up depictions of pears, apples, nuts, and the like. Their cropped compositions suggest the influence of photography. In the 1890s, perhaps in reaction to negative reviews, he began to paint in a more tonal, painterly style. His still lifes of this period suggest the influence of Chardin, while his landscapes—including several views of Niagara Falls—are close to the late manner of George Inness (q.v.), whom he admired. Decker received more favorable notice in this decade, exhibiting regularly at the Brooklyn Art Association, the Society of American Artists, and the National Academy of Design. His work weakened after 1900, and the latest known painting is dated 1911. Decker's work was "rediscovered" in the 1960s by the dealers Victor D. Spark and later Robert P. Weimann.

The first modern mention of Decker occurs in Alfred Frankenstein, After the Hunt: William Harnett and Other American Still Life Painters, 1870–1900 (Berkeley and Los Angeles, 1953). A fine, recent study of the painter is Helen A. Cooper, "The Rediscovery of Joseph Decker," The American Art Journal 10 (May 1978): 55–71.

69

JOSEPH DECKER
Pears, c. 1885
Painted in Brooklyn, New York
Oil on canvas, 23½ × 11 9/16 in. (59.7 × 29.4 cm.)
Private Collection

Decker showed three paintings at the Brooklyn Art Association annual exhibition in 1883. Included was a picture simply called *Fruit*, which is apparently the painting now entitled *Pears*, judging from a review by the prominent critic Clarence Cook, who wrote, "J. Decker in his 'Fruit' shows little power to hitch [his] wagon to Beauty's star. Mr. Decker's 'Fruit' is merely so many square feet of pear tree seen through an upright frame."[1] This is Decker's only known still life in vertical format, and so the identification with this review seems clear. Other critics writing of his early paintings agreed with Cook's assessment. Decker's *Russet Apples on a Bough* (c. 1884; Coll. Hon. and Mrs. H. John Heinz III) was criticized in the following year as depicting "unique apples . . . finished to the point of inanity," and for failing to suggest "a loftier reality."[2]

Decker was accused of the same inartistic illusionism as the master of trompe l'oeil, William Harnett (q.v.), and at least one critic connected the two painters:

> *Mr. Harnett's popular success in cheating the untrained eye, following the earlier example of other mechanic painters, has had a bad influence of late; and the greater the handicraft-skill displayed by such disciples as Mr. Decker, the greater the regret we must feel that it could not be directed by better taste. Only children and half-taught people take pleasure in such tricks of the brush.*[3]

Though Decker never practiced pure trompe l'oeil, his art relates to Harnett's in its hard-edged realism, a style that diverged from the painterly, tonalist style that appealed to sophisticated critics and patrons. As with Harnett, Decker's work appealed to a "half-taught" middle-class. Actual influence of Harnett on Decker seems unlikely, as Decker preceded Harnett to Munich, then returned to Brooklyn to develop his own style in 1883–84, at a time when Harnett was still abroad finding his own mature mode. More likely is the influence of Decker himself on other talented fruit painters such as Levi Wells Prentice (1851–1935), who flourished in Brooklyn after 1890.

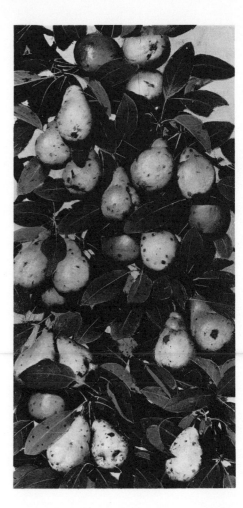

Decker used the same style throughout the eighties, employing firm, visible brushstrokes and yet creating extraordinary images of palpable substance. His inventive technique is far more "painterly" than that of Harnett, Prentice, or Martin Johnson Heade (q.v.); he used it in still lifes as well as superb genre scenes such as *Accused* (1886; Coll. Hon. and Mrs. H. John Heinz III), and outdoor pictures of squirrels and nuts (e.g., *Their Winter Hoard* [1889; Coll. Jo Ann and Julian Ganz, Jr.]). In the 1890s Decker's technique became blurred and tonalist, and his late still lifes, such as *Twelve Plums* (1896; Yale University Art Gallery, New Haven, Conn.), are poetic evocations, with a Whistlerian and Oriental quality.

T.E.S.

NOTES

1. Cook, "Two Picture Exhibitions," *Art Amateur* 10 (January 1884): 28, quoted in Helen A. Cooper, "The Rediscovery of Joseph Decker," *The American Art Journal* 10 (May 1978): 59.

2. "The National Academy of Design," *Art Amateur* 12 (December 1884): 4, quoted in Cooper, *ibid.*, p. 60.

3. "The Society of American Artists, Ninth Exhibition," *The Studio* 2 (June 1887): 216–17, quoted in William H. Gerdts, *Painters of the Humble Truth: Masterpieces of American Still Life, 1801–1939* (Columbia, Mo., 1981), p. 205.

PROVENANCE
With Victor Spark, New York; to present owner,
1965.

EXHIBITION HISTORY
Brooklyn Art Association, N.Y. *Annual Fall
Exhibition*, 1883.
M. Knoedler & Co., New York, *Primitive to
Picasso: St. Paul's School Alumni Collect*, 1968,
cat. no. 73 (ill.).
Fogg Art Museum, Cambridge, Mass., *The
Discerning Eye: Radcliffe Collectors' Exhibition*,
1974, cat. no. 87 (ill.).
Hunt Institute for Botanical Documentation,
Carnegie Mellon University, Pittsburgh,
*American Cornucopia: 19th Century Still Lifes and
Studies*, cat. by John V. Brindle and Sally
Secrist, 1976, no. 54.

WILLIAM MICHAEL HARNETT

(1848, Clonakilty, County Cork, Ireland
—1892, New York City)

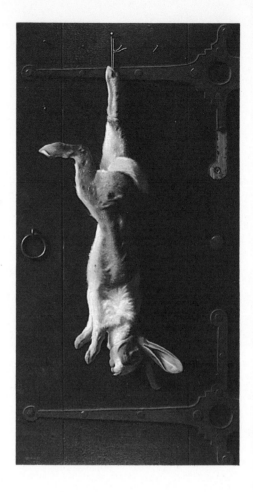

Raised in Philadelphia, a city long associated with
still-life painting, Harnett received his professional
training at the Pennsylvania Academy of the Fine
Arts and subsequently at the National Academy of
Design and the Cooper Union in New York. By the
mid-1870s, he was specializing in small, realistic
tabletop still lifes featuring pipes, books, beer steins,
and other masculine accessories. By the end of the
decade, he had raised enough money from his painting
to finance travel in Europe.

After a few unprofitable months in London,
Harnett moved to Frankfurt to execute several
commissions for a Philadelphia acquaintance living
there, and then settled in Munich early in 1881. At
that time, Munich was, after Paris, the most
attractive center of study for young American artists.
Duveneck, Chase, and many others had preceded
Harnett to Munich; by the time of his arrival, the
bravura style that had so captivated those painters was
rivaled by a finer, more meticulous handling of paint.
Four years in Munich thus led Harnett to refine his
style: he replaced the rough-hewn objects of his early
paintings with luxurious edibles and elegant bric-a-
brac, and his brushwork became so controlled it
resembled a miniaturist's technique. These still lifes
were shown, with moderate success, at the Munich
Art Club and later at the Royal Academy in London.
Also while in Europe, Harnett experimented with a
new compositional type: the hanging game piece. These
efforts culminated in four related pictures entitled
After the Hunt. The last of the series (Fine Arts
Museums of San Francisco) was painted in Paris and
shown, to some acclaim, at the spring Salon of 1885.

When Harnett returned to New York in 1886, he
settled into a different kind of cultural milieu than he
had known in Europe. He participated only rarely in
the major exhibitions of his day and associated little
with the leading figures of the New York art world.
He apparently took no pupils, though his subject
matter and trompe l'oeil style inspired numerous
followers and imitators at the turn of the century.
And although among his patrons were some
distinguished connoisseurs—including Thomas B.
Clarke—most of his clients were indifferent to the
artistic properties of his works, but were fascinated by
their uncanny illusionism. In a New York News
interview conducted a few years before his death in
1892, Harnett revealed his own ambivalence toward
the demands of high art: although he was happy to
profit from his trompe l'oeil successes and gleefully
recounted the story of how his 1879 shinplaster
painting (Philadelphia Museum of Art) nearly led
to his arrest for counterfeiting, he nonetheless was
discouraged by the low esteem in which his specialty
was held and insisted upon the creative component of
his work: "In painting from still life I do not closely
imitate nature. Many points I leave out and many I
add. Some models are only suggestions."

After his death, Harnett's work was neglected by
collectors, scholars, and art dealers until the 1930s,
when Edith Halpert of The Downtown Gallery in
New York found several of his paintings and presented
them in a special exhibition in 1939. Subsequently,
Alfred Frankenstein suggested guidelines for
distinguishing Harnett's work from that of his
follower, John F. Peto; his findings were published in
After the Hunt: William Harnett and Other
American Still Life Painters, 1870–1900
(Berkeley and Los Angeles, 1953; rev. ed., 1969),
the standard monograph on the artist.

70

WILLIAM MICHAEL HARNETT
Trophy of the Hunt, 1885
Painted in Paris
Signed and dated lower left:
 W M HARNETT / 1885. [initials in
 monogram]
Oil on canvas, 42½ × 22 in. (108 × 55.9 cm.)
Museum of Art, Carnegie Institute,
 Pittsburgh, Purchase, 1941

Trophy of the Hunt was completed in 1885, shortly after Harnett's arrival in Paris. An earlier version of the same subject, now lost, drew admiring crowds at the Royal Academy exhibition in Munich in 1883. Presumably Harnett hoped to gain similar praise and profit from this picture, which features in larger scale the stiff, bloody-nosed rabbit that appears in the third and fourth versions of *After the Hunt* (Butler Institute of Art, Youngstown, Ohio, and Fine Arts Museums of San Francisco), the latter also painted in Paris in 1885. Here Harnett renders the coarse fur, rigid limbs, and bulging eye of the rabbit with clinical precision, yet at the same time manipulates his specimen to produce a stringently ordered composition. The iconic starkness of Harnett's design and the meticulousness of his technique create an image of startling brutality that is at once fascinating and repellent.

The aesthetic of the hunting lodge and the barroom dominated popular American culture in the post-Civil War years. Artists like Harnett, Arthur Fitzwilliam Tait (q.v.), William Ranney, and many others specialized in pictures detailing the equipment of sporting expeditions, the hunters, and their quarry. Such images were used to decorate the rustic camps maintained by businessmen who spent their summer holidays fishing and hunting in the White Mountains and the Adirondacks, and were also displayed in the saloons in which these men boasted of their exploits. The grim monumentality of *Trophy of the Hunt* distinguishes it from most other contemporary sporting pictures and game pieces, which are more casually composed and are celebrations of plenty.

The simplicity and severity of *Trophy of the Hunt* was as unusual in Europe as in America. Among the few precedents for this kind of painting are the highly realistic studies of dead game hanging against a wall by the eighteenth-century French master Jean-Baptiste Oudry;[1] these were exhibited occasionally in Germany in the late nineteenth century. Of earlier works, trompe l'oeil images like Jacopo de Barbari's *Still Life with Partridge, Gauntlet, and Crossbow Arrow* (1504; Alte Pinakothek, Munich), featuring a dead bird which seems to project into the viewer's space, would have appealed to Harnett.[2] However, most of the European still lifes of Harnett's day reflect the revival of interest in Chardin that spread throughout Europe after mid-century. They showed the trophies of the hunt against rich landscape backgrounds or in appealing kitchen settings among onions, turnips, and copper pots; and the gruesomeness of the limp and even bloodied prey was masked by the joyful lushness of paint.

Harnett undoubtedly found the compositional pattern used in *Trophy of the Hunt* successful, for after he returned to America in 1886, he painted numerous still lifes in which dark-green, weather-beaten boards with rusted nails and elaborate hinges form the background. Of these, many display a single object—a horseshoe, a pipe, a plucked chicken, a revolver—hung with classical simplicity in the center of the canvas. This formula also appealed to Harnett's followers, and from the 1890s until the First World War, still-life specialists such as George Cope, George W. Platt, and Alexander Pope produced vividly realistic images of dead game hanging against battered doors.[3]

C.T.

NOTES

 1. See, e.g., *Still Life with a Hare and a Leg of Mutton* (1742; Cleveland Museum of Art).
 2. Harnett undoubtedly knew this painting, for it was exhibited in Augsburg from about 1810. See *Italienische Malerei. Alte Pinakothek München, Katalog V* (Munich, 1975), p. 15.
 3. Most indebted to *Trophy of the Hunt* is Richard la Barre Goodwin's *Kitchen Piece* (1890; Stanford University Museum, Palo Alto, Calif.), in which the rigid posture of the dead rabbit is repeated exactly, although in reverse. However, by cluttering the composition with a painted tray, jug, and other bric-a-brac, Goodwin dilutes the impact of Harnett's painting.

PROVENANCE
With The Downtown Gallery, New York, by 1941; to present owner, 1941.

EXHIBITION HISTORY
Downtown Gallery, New York, *Harnett Centennial Exhibition*, 1948, cat.no.11.
Dallas, *Texas State Fair*, 1948.
Ohio University, Athens, 1954.
Cincinnati Art Museum, *Recent Rediscoveries in American Art*, cat. by Edward H. Dwight, 1955, no.49.
Allentown Art Museum, Pa., *Four Centuries of Still-Life Painting*, 1959, cat.no.43 (ill.).
Corcoran Gallery of Art, Washington, D.C., *Past and Present: 250 Years of American Art*, 1966.
National Gallery of Art, Washington, D.C., *The Reality of Appearance: The Trompe L'Oeil Tradition in American Painting*, cat. by Alfred Frankenstein, 1970 (traveling exhibition), no.47 (ill.).

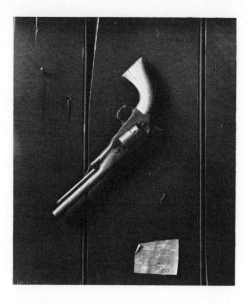

71

WILLIAM MICHAEL HARNETT
The Faithful Colt, 1890
Painted in New York City
Signed and dated lower left:
 W M HARNETT / 1890. [initials in monogram]
Oil on canvas, 22½ × 18½ in. (57.2 × 47 cm.)
Wadsworth Atheneum, Hartford,
 Connecticut, The Ella Gallup Sumner and
 Mary Catlin Sumner Collection

Harnett was a collector of bric-a-brac. Antique china, musical instruments, reliquary objects, swords, and guns were among the items auctioned at the estate sale held in Philadelphia the year after his death, and many of these objects were used as models in his still-life compositions. The revolver depicted here ("a genuine old Gettysburg relic"),[1] was one of several Harnett owned; it is a .44 caliber Model 1860 Army Revolver manufactured in Hartford by Samuel Colt, the renowned gunsmith.

The gun itself was neither particularly valuable nor rare. Over one-hundred thousand were produced and issued to Union Army personnel at a cost of $17.50 each in the early 1860s, and they continued to be manufactured through the end of the century. The 1860 Army Revolver became Colt's most popular model, romanticized as the gun that won the Civil War and later the West, where it was the favorite weapon of the sheriff, the cavalry officer, and the cowboy.[2] Harnett's picture celebrates the romance of the West, for while the image is completely improbable—no cowboy would leave his weapon slung over a nail on a barn door, vulnerable to weather and theft—it nonetheless suggests the frontier hero's reverence for, and dependence on, his gun. The dull glint of the rust-pocked steel barrel and the cracked ivory handle of the Colt bespeak its long and faithful

service; balanced precariously on a projecting nail, it is ever ready for immediate action.

The Faithful Colt was one of the first works by Harnett to enter a public collection. The painting had remained in Harnett's studio at the time of his death in 1892; it was sold the following year to an unnamed buyer for $110. It surfaced again in Philadelphia about 1935 and was sold to Edith Halpert, proprietor of The Downtown Gallery in New York, who admired it, and other works by Harnett which she subsequently located, for its formal sophistication and its anticipation of modern principles of design. In 1935, *The Faithful Colt* was purchased by the Wadsworth Atheneum in Hartford in recognition of the Colt Manufacturing Company's long affiliation with the city. Harnett's work soon came to be sought after by museums and by the kind of sophisticated collector who had scorned his work during his lifetime.

C.T.

NOTES

1. Thomas Birch's Sons, Auctioneers, Philadelphia, *The Wm Michael Harnett Collection: His Own Reserved Paintings, Models and Studio Furnishings*, sale cat. (23–24 Feb. 1893), p.8.
2. See Stephen V. Grancsay, "An Exhibition of Colt Percussion Revolvers," *Bulletin of the Metropolitan Museum of Art* 37 (February 1942): 30–33.

PROVENANCE

Harnett Estate Sale, Thomas Birch's Sons, Philadelphia, 23/24 Feb. 1893, cat.no.33; with The Downtown Gallery, New York, 1935; to present owner, 1935.

EXHIBITION HISTORY

Earle's Galleries, Philadelphia, *Harnett Memorial Exhibition*, 1892, cat.no.33.
Springfield Museum of Fine Arts, Mass., *Thirty Paintings of Early America*, 1935 (traveling exhibition).
Musée du Jeu de Paume, Paris, *Trois Siècles d'Art aux États-Unis*, cat. by Alfred H. Barr, Jr., 1938, no.69.
Downtown Gallery, New York, *Nature-Vivre*, 1939, cat.no.13 (ill.).
Metropolitan Museum of Art, New York, *Loan Exhibition of Percussion Colt Revolvers and Conversions*, 1942 (ill.).
Downtown Gallery, New York, *Harnett Centennial Exhibition*, 1948, cat.no.16.
Lawrence Art Museum, Williams College, Williamstown, Mass., *American Trompe L'Oeil*, 1953.
Pennsylvania Academy of the Fine Arts, Philadelphia, *150th Anniversary Exhibition*, 1955, cat.no.63.
M. Knoedler & Co., New York, *Masterpieces from the Wadsworth Atheneum, Hartford*, 1958.
John and Mable Ringling Museum of Art, Sarasota, Fla., *A. Everett Austin, Jr.: A Director's Taste and Achievement*, 1958 (traveling exhibition), cat.no.43.

La Jolla Museum of Art, Calif., *The Reminiscent Object*, cat. by Alfred Frankenstein, 1965 (traveling exhibition), no.22 (ill.).
National Gallery of Art, Washington, D.C., *The Reality of Appearance: The Trompe L'Oeil Tradition in American Painting*, cat. by Alfred Frankenstein, 1970 (traveling exhibition), no.54 (ill.).
Philbrook Art Center, Tulsa, Okla., *Painters of the Humble Truth: Masterpieces of American Still Life 1801–1939*, cat. by William H. Gerdts, 1981 (traveling exhibition) (ill.).

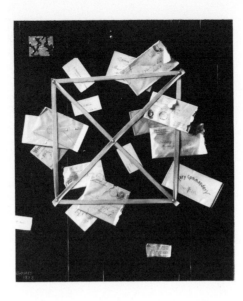

72

WILLIAM MICHAEL HARNETT
Mr. Hulings' Rack Picture, 1888
Painted in New York City
Signed and dated lower left:
 W M HARNETT. / 1888. [initials in monogram]
Oil on canvas, 30 × 25 in. (76.2 × 63.5 cm.)
Mrs. Alice M. Kaplan

Harnett painted this picture for George Hulings (1845–1902), a Philadelphia dry-goods merchant. Hulings was typical of Harnett's patrons during the last years of his career, when he was at the height of his commercial success. These buyers, mostly small-time businessmen, often specialized in acquiring trompe l'oeil paintings. Hulings himself possessed several Harnetts but is not known to have owned any other works of art. He also claimed to have commissioned Harnett's famous *Old Violin* (1886; Coll. William J. Williams, Cincinnati), which the artist mistakenly sold to another patron; the present picture was then painted for Hulings in recompense.[1]

The card rack, formed of tapes or ribbons tacked to a wall to hold correspondence, bills, newspaper clippings, and other papers, was an ideal vehicle for the trompe l'oeil painter since it was composed entirely of flat items. It became a subject for painting in the Netherlands in the seventeenth century as the specialty of a few minor still-life artists such as Samuel van Hoogstraten and Cornelis Gijsbrechtsz. The tradition was carried on in England and France in the eighteenth century, and there are occasional American precedents, but these are mostly either playful sketches or academic exercises rather than serious commissions.[2] Oddly, the theme seems to have engaged Harnett's interest only twice, and it was John F. Peto (q.v.) who more frequently practiced the genre. The two artists painted their first card rack pictures in 1879, Peto's *Office Board for Smith Bros. Coal Co.* (Addison Gallery of American Art, Andover, Mass.) probably preceding Harnett's *Artist's Letter Rack* (Metropolitan Museum of Art, New York) by a few months.[3]

Mr. Hulings' Rack Picture differs markedly from *The Artist's Letter Rack*, in which almost every inch of the picture is filled with visual puns and sly verbal clues, and from Peto's more atmospheric rack pictures, which often contain poignant personal allusions. Here the only oddity is that the card rack is attached to a rough plank, more likely to be found out-of-doors, rather than to an indoor wall where it more logically belonged. Presumably a weathered board was more interesting to paint, and its green-black color, more appropriate for a barn door than a library or office, provided a more stunning contrast with

the brightly colored cards and envelopes. Furthermore, Harnett took only superficial advantage of the biographical opportunities of the card rack genre, recording the names and addresses of Hulings's friends and business associates and identifying him as a member of the militia lodge of St. Mary's Commandery,[4] but otherwise giving little sense of his character. Rather, *Mr. Hulings' Rack Picture* is a straightforward trompe l'oeil, designed to awe rather than to amuse. Meticulous detailing and informal asymmetry give the painting both a stunning realism and a snapshot-like casualness; its startling effect comes from its remarkable austerity and its dramatic, abstract design. Harnett took care, for example, to balance the blue envelopes against the equally richly colored ochre ones, to set off the busy concentration of letters at the top and sides of the rack with empty space at the center and around the edges, and to unify the whole with a hard, chilling light that causes the crumpled and bent corners of the papers to cast shadows almost as deep as the severe black board to which the rack is pinned. *C.T.*

NOTES

1. The legend of Hulings's claim to *The Old Violin* was detailed in an article on Harnett which appeared in *The Philadelphia Item* of 11 June 1895. The article is quoted in full in Alfred Frankenstein, "Mr. Hulings' Rack Picture," *Auction* 2 (February 1969): 6–8.

2. In Europe, Everett Collyer and L. L. Boilly painted several examples of the rack picture; in America, Frederic E. Church and the little-known William M. Davis produced trompe l'oeils with letters and torn envelopes vividly described. For Harnett, the most important precedent was probably Raphaelle Peale's watercolor, *A Deception* (1802; Private Collection), for it remained in the hands of the Peale family in Philadelphia through the end of the century.

3. For the most recent discussion of the development of the card rack theme by Harnett and Peto, see Doreen Bolger Burke, *American Paintings in the Metropolitan Museum of Art*, vol.3 (New York, 1980), p. 52.

4. See Frankenstein, "Mr. Hulings' Rack Picture," p. 9.

PROVENANCE

George Hulings, Philadelphia, by 1895; sale, Parke Bernet Galleries, New York, 19–20 March 1969, lot 62; with Kennedy Galleries, New York, 1970; to present owner, 1970.

EXHIBITION HISTORY

National Gallery of Art, Washington, D.C., *The Reality of Appearance: The Trompe L'Oeil Tradition in American Painting*, cat. by Alfred Frankenstein, 1970 (traveling exhibition), no.51 (ill.).

Philbrook Art Center, Tulsa, Okla., *Painters of the Humble Truth: Masterpieces of American Still Life 1801–1939*, cat. by William H. Gerdts, 1981 (traveling exhibition) (ill.).

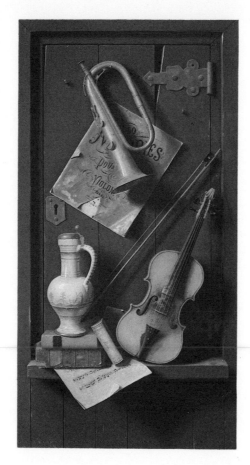

73

WILLIAM MICHAEL HARNETT
Old Models, 1892
Painted in New York City
Signed and dated lower left:
 WM HARNETT./1892. [initials in monogram]
Oil on canvas, 54 × 28 in. (137.2 × 71.1 cm.)
Museum of Fine Arts, Boston,
 Charles Henry Hayden Fund

Six years after the success of *After the Hunt* (1855; Fine Arts Museums of San Francisco) at the Paris Salon, Harnett embarked on another major exhibition picture, this one intended for the Chicago World's Columbian Exposition. He again chose the formula of still-life objects hanging against a wooden door and depicted some of his favorite props. The Dutch jar had been featured in Harnett's work for almost a decade, as had the violin; both were acquired in Europe and add to the painting's air of genteel antiquarianism and sentimentality.[1] The much-dented bugle had appeared less frequently, but the books (here Shakespeare's *Tragedies*, the *Odyssey*, and an unidentified volume of Renaissance literature) and the tattered sheet music ("50 M[elo]dies pour Violon" and, on the ledge, the nostalgic tune "The Last Rose of Summer" from Thomas Moore's "Irish Melodies" of 1807) had been used as props in his pictures since the mid-1870s.[2] The elegant ordering of these familiar objects reveals Harnett's subtle sense of design and contrasts markedly with the cluttered jumble of *The Old Cupboard Door* (1889; Graves Art Gallery, Sheffield, England) painted on order for a Philadelphia patron, with which *Old Models* had occasionally been confused.[3]

Although more softly painted than some of his rigorous trompe l'oeil compositions, *Old Models* nonetheless exhibits several of the illusionistic devices which had become the artist's trademark: the heavy impasto which creates highlights on the bell of the bugle; the folded edges and turned-up corners of the sheet music which seem to extend beyond the picture plane; and above all, the baffling layers of space generated by a cupboard door recessed behind a door frame. That door frame appears to be identical to the picture surface until one notices the ledge, jutting out beyond the frame into space. Such spatial punning, which allowed Harnett to combine a hanging still life with a tabletop arrangement, may have been suggested by John F. Peto's *Poor Man's Store* (1885; Museum of Fine Arts, Boston).

Old Models was never sent to the World's Columbian Exposition for Harnett died shortly after completing it, and it was sold, along with the contents of his studio, at his estate sale in 1893. Had it appeared at the Chicago fair, however, *Old Models* would have

seemed odd, and strangely old-fashioned. Although an enormous variety of styles were represented in the more than a thousand American oil paintings displayed in the Fine Arts building, the majority of the works were, in one way or another, far more cosmopolitan than Harnett's. Pictures of colorful European peasants abounded; the classicizing aesthetic of the Beaux-Arts movement dominated both painting and sculpture sections; and for the first time, Impressionist painting was well represented and well received in America. In contrast, the style of *Old Models*, though it gave birth to a whole school of hard-edged, trompe l'oeil painters which flourished around the turn of the century, was nonetheless rooted in the Brown Decades. The dark, earth-toned masculine palette, the fine, self-effacing brushwork, and especially the nearly obsessive concern with the precise detailing of observed reality (however the forms might be rearranged for pictorial effect) have more in common with landscapes painted by Church and Durand over thirty years before than with the lushly painted still lifes of Harnett's contemporaries William Merritt Chase or Emil Carlsen, or with the ethereal, dreamy views of Tryon, Inness, and Martin. Moreover, Harnett's attitude toward his subject matter is intensely romantic, and his familiar props, through their dents and tears and cracks and stains, bear witness to the effects of time on man's creations. At the same time, he seemed to aspire to a style-less style, one that subordinated any sense of artistic presence to a reverential examination of the things themselves. *Old Models* bears little resemblance to the works of Hassam or Chase, or even of Homer and Eakins; of Harnett's notable contemporaries, only Heade's strange still lifes (see cat. no. 68) demonstrate a comparable distance from the artistic mainstream.

C.T.

NOTES

1. Harnett's skill as a painter far exceeded his perspicacity as a collector. The Dutch jar, with its charming, if crudely painted, designs, is in fact a German vessel called an Enghalskrug (or narrow-necked jug). This type of pitcher, made of tin-glazed earthenware with pewter mounts, was produced in great quantities in ceramic factories in Frankfurt in the late seventeenth and early eighteenth centuries. Harnett's jug, with its coarser proportions and decoration, is probably a nineteenth-century version of the older form. Similarly, the violin (probably the same instrument immortalized in *The Old Violin* [1886; Coll. William J. Williams, Cincinnati]) was acquired by Harnett as a genuine Guarneri, although in fact it is a nineteenth-century replica of the celebrated seventeenth-century instrument. I am grateful to Christina Corsiglia, of the Department of European Decorative Arts, and to Barbara Lambert, Keeper of Musical Instruments

at the Museum of Fine Arts, Boston, for this information.

2. See Carol J. Oja, "The Still-Life Paintings of William Michael Harnett," *The Musical Quarterly* 63 (October 1977): 516–17.

3. *Old Models* was given its present title in the catalogue of Harnett's estate sale ("No. 27. Old Models—This grand production is the last effort of Mr. Harnett; was painted for the Chicago Exposition"). Between 1896 and the Harnett Centennial Exhibition of 1948, it was shown under the name of *The Old Cupboard* or *Old Cupboard Door*, leading to its confusion with the earlier work.

PROVENANCE

Harnett Estate Sale, Thomas Birch's Sons, Philadelphia, 23–24 Feb. 1893; A. Ludwig Collection Sale, Fifth Avenue Galleries, New York, 1–2 Feb. 1898; William J. Hughes, Washington, D.C.; with The Downtown Gallery, New York, 1939; to present owner, 1939.

EXHIBITION HISTORY

Earle's Galleries, Philadelphia, *Paintings of the Late W. M. Harnett*, 1892, cat. no. 20 (as *My Models*).

M. Knoedler & Co., New York, *Harnett*, 1893 (as *The Old Cupboard*).

Saint Louis Exposition and Music Hall Association, *Thirteenth Annual Exhibition*, 1896, cat. no. 221 (as *The Old Cupboard Door*).

Tate Gallery, London, *American Painting from the 18th Century to the Present Day*, 1946, cat. no. 97.

Downtown Gallery, New York, *Harnett Centennial Exhibition*, 1948, cat. no. 20 (ill.).

California Palace of the Legion of Honor, San Francisco, *Illusionism and Trompe l'Oeil*, 1949 (ill.).

Corcoran Gallery of Art, Washington, D.C., *De Gustibus: An Exhibition of American Paintings Illustrating a Century of Taste and Criticism*, 1949, cat. no. 32.

American Federation of Arts, New York, *American Painting in the Nineteenth Century*, 1953 (traveling exhibition), cat. no. 40.

Schloss Charlottenburg, Berlin, *Amerikanische Malerei des 19. Jahrhundert*, 1953.

Cincinnati Art Museum, *Rediscoveries in American Painting*, cat. by Edward H. Dwight, 1955, no. 46 (ill.).

St. Albans School, Washington, D.C., *50th Anniversary Celebration*, 1959, cat. no. 20.

Art Gallery of Toronto, *American Painting from 1865–1905*, cat. by Lloyd Goodrich, 1961 (traveling exhibition), no. 31 (ill.).

Detroit Institute of Arts, *Arts and Crafts in Detroit: The Movement, The Society, The School*, 1976.

JOHN HABERLE

(1856, New Haven, Connecticut —1933, New Haven [?])

Like William M. Harnett and John F. Peto (q.v.), Haberle specialized in the trompe l'oeil subjects popular in the last quarter of the nineteenth century. His work goes beyond theirs, however, in its deliberate attempt to fool the eye: his imagery is wittier than that of his contemporaries, often exhibiting salacious or macabre humor.

Haberle was largely self-trained, although his experience as a preparator for Yale University paleontologist Othniel Charles March (for whom his duties probably included making scientific drawings as well as cleaning fossils and mounting skeletons) surely sharpened his skills at precise, accurate drawing, a prerequisite for successful trompe l'oeil. He first exhibited at the National Academy of Design in 1887, after attending a few classes there. Thereafter he showed only occasionally at major art exhibitions but did exhibit regularly in New Haven, at the Paint and Clay Club. He painted the illusionistic still lifes for which he is now best known between 1887 and 1894, after which trouble with his eyesight forced him to abandon that meticulous style. He subsequently turned his hand to more broadly painted fruit and flower still lifes and sentimental animal pictures.

Although he had a few prominent patrons, such as Thomas B. Clarke, who also collected Harnett's work, most of Haberle's clients were less distinguished. They were for the most part saloon keepers and small-time businessmen who were more enthralled by the trickery than by the aesthetic merit of his work. Similarly, Haberle's influence was more directly felt in popular culture than in fine art. Whereas a few other trompe l'oeil specialists, including F. J. Danton and Victor Dubreuil, perpetuated Haberle's humorous imagery, the real progeny of A Bachelor's Drawer and Changes of Time (Manoogian Collection) are chromolithographic novelties like A Royal Flush (c. 1899; printed by F. J. Tuchfarber, Co., Cincinnati; Cincinnati Art Museum).

As with Harnett, the seminal study of Haberle is Alfred Frankenstein's After the Hunt: William Harnett and Other American Still Life Painters, 1870–1900 (Berkeley and Los Angeles, 1953, rev. ed. 1969). There has been one monographic exhibition of the artist's work, at the New Britain Museum of American Art in 1962, and a recent article by Robert F. Chirico, "John Haberle and Trompe L'Oeil," Marsyas 19 (1977–78): 37–43.

74

JOHN HABERLE
A Bachelor's Drawer, 1890–94
Painted in New Haven, Connecticut
Signed and dated upper left:
·HABERLE·1890–94
Oil on canvas, 20 × 36 in. (50.8 × 91.4 cm.)
The Metropolitan Museum of Art, New York,
 Purchase, Henry R. Luce Gift, 1970

Haberle worked on *A Bachelor's Drawer* from 1890 to 1894. It was his last and most elaborate trompe l'oeil still life. The imagery of the picture is at least in part autobiographical: many of the objects—the corncob pipe, the theater stubs, the girlie pictures, the playing cards—refer to a bachelor's pleasures, while the verse parody of the marriage vows, appended to the drawer at lower right, and the booklet "How To Name the Baby," overlapping the caricature of the dapper bachelor himself, suggest an end to his freedom. Whether this picture coincided with a change in the artist's marital status is not known, but the inclusion of a simulated tintype portrait of the artist next to the large nude photograph invites speculation, as the artist no doubt intended. Also affixed to the drawer are a number of newspaper clippings which serve as wry commentary on Haberle's artistic successes, those occasions when his paintings caused viewers to mistake painted forms for real objects. The juxtaposition of an article headed "It Fooled the Cat" with "A Newspaper Critic Pronounces a Picture a Fraud, but Retracts" was surely meant to suggest that the critic's powers of discernment were no greater than the cat's. Finally, the stack of currency at left—a ten-dollar bill, a foreign note, a Confederate bill, and a bill presumed counterfeit—serves as a treatise on the trompe l'oeil painter's art, confounding the genuine and the fake, the simulated and the real.[1]

The immediate prototypes for Haberle's subject were the card rack pictures produced by Harnett and Peto since 1879. Most of those works are based on a joke, or at least a bit of artistic license. Card racks were used to secure personal items like calling cards, letters, and business papers, and so logically belonged inside the house, in the study or office. Yet Harnett and Peto typically showed the card rack affixed to a coarse and weathered board that was more properly a part of a building's exterior architecture. Haberle's construction is even more improbable, for his mementos are glued to the outside of a dresser drawer or wedged behind a cigar box lid attached to the center of the drawer by hinges. Haberle's collage of simulated photographs, clippings, cards, and currency has another antecedent as well: the elaborate advertisements circulated by printers, lithographers, and other firms at the end of the nineteenth century.[2]

Haberle's subject is ideally suited to fooling the eye. It is composed almost entirely of flat objects affixed to a flat surface, a formula which frees the artist from having to create illusions of receding space or of three-dimensional objects on a two-dimensional picture plane. Unlike Harnett's card rack pictures, which are exercises in formal, abstract design as much as in pictorial deception, *A Bachelor's Drawer* is pure trompe l'oeil, witty and direct. The tawdry clutter randomly displayed brings immediately to life the small-town lothario who accumulated it.

C.T.

NOTES

1. See Doreen Bolger Burke, *American Paintings in the Metropolitan Museum of Art*, vol.3 (New York, 1980), pp. 278–80.
2. See, e.g., Albert Newsam's *Trade Card for P. S. Duval* (1840; lithograph with watercolor, Historical Society of Pennsylvania, Philadelphia), or the advertisement of George S. Harris and Sons, Printers, Engravers, and Lithographers, reproduced in Peter C. Marzio, *The Democratic Art* (Boston, 1979), p. 166, fig. 36.

PROVENANCE
The artist, New Haven, Conn., until 1933; his daughter, Mrs. Vera Haberle Demmer, New Haven, and his granddaughter, Mrs. Gloria Shiner, East Haven, Conn., until 1966; with Robert P. Weimann, Jr., Ansonia, Conn., 1966; J. William Middendorf II, New York, 1966–70; to present owner, 1970.

EXHIBITION HISTORY
Traeger's Hotel, New Haven, Conn., May 1894.
James D. Gill's Stationery and Fine Art Store, Springfield, Mass., June 1894.
Trans-Mississippi and International Exposition, *Official Catalogue of the Fine Arts Exhibit*, Omaha, Neb., 1898, cat.no.263.
Detroit Institute of Arts, *Special Exhibition of Sixty-four Paintings from the Trans-Mississippi Exposition*, 1898–99, cat.no.33.
New Britain Museum of American Art, Conn., *Haberle Retrospective Exhibition*, 1962.
La Jolla Museum of Art, Calif., *The Reminiscent Object*, cat. by Alfred Frankenstein, 1965 (traveling exhibition), no.63 (ill.).
Whitney Museum of American Art, New York, *Art of the United States, 1670–1966*, 1966, cat.no.118.
Metropolitan Museum of Art, New York, *American Paintings and Historical Prints from the Middendorf Collection*, cat. by Stuart Feld, 1967 (traveling exhibition), no. 47.
Metropolitan Museum of Art, New York, *19th-Century America: Paintings and Sculpture*, cat. by John K. Howat and Natalie Spassky, 1970, no. 190 (ill.).
Civic Museum of Turin, *Combattimento per un'Immagine, Fotografi e Pittori*, cat. by D. Palazzoli and L. Carluccio, 1973 (ill.).

JOHN F. PETO

(1854, Philadelphia—1907, New York City)

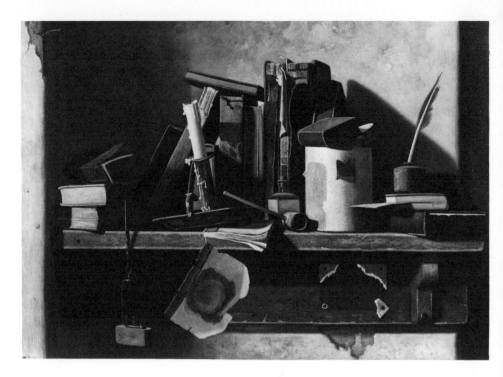

Peto was the son of a Philadelphia picture-frame gilder and dealer. His earliest dated work was made when he was twenty-one, and the only evidence that he received professional training is the record of his enrollment at the Pennsylvania Academy of the Fine Arts in 1877. Between 1879 and 1887 he exhibited six still lifes at the Academy, but received little attention in the local press. He became a friend of the popular still-life painter William Michael Harnett (q.v.), resident in Philadelphia from 1876 to 1880, and many of his compositions from this period reflect Harnett's influence.

After marrying in 1887, Peto built a house with a studio in the small resort town of Island Heights on the New Jersey coast and settled there permanently in 1889. Following this move, he is known to have displayed a few still lifes at the local drugstore, but apparently sent nothing more to formal exhibitions. His patrons were friends, owners of local shops and businesses, and summer visitors to the coast. He never enjoyed even the relative popularity and financial success of his friend Harnett, and yet, ironically, in his last years some of Peto's works were given fake signatures of the better-known artist (who had died in 1892). Peto's last years were burdened by various family problems, including a lawsuit over an inheritance, and by Bright's disease. He died after an operation at the age of fifty-three.

Peto's still lifes of the 1880s repeat subjects popularized by Harnett—close-up, informal tabletop arrangements of "masculine" objects such as pipes, tobacco, matches, and stoneware beer mugs with books or newspapers—but their more thickly painted surfaces distinguish them from Harnett's virtuosic polished finish. One of Peto's most successful subjects was the colorful and humorous trompe l'oeil or illusionistic card rack or office board, in which the patron's name, profession, and other biographical information were hinted at with envelopes and letters, business stationery, and photographs. His late works explored the sad beauty of old, worn objects arranged in dark, unconventional settings or hung on old doors. Their melancholic aspect and relatively painterly finish set them apart from the good humor and sharp detailing associated with the more popular still-life painters of the 1890s, John Haberle (q.v.) and Jefferson David Chalfant (1856–1931).

In the revival of interest in early American still life in the 1930s, Peto remained overshadowed by Harnett. Alfred Frankenstein did much to reestablish Peto's reputation, beginning by reattributing many pictures with fake Harnett signatures. Frankenstein wrote the catalogue and critical biography for the first Peto exhibition (Brooklyn Museum, N.Y., 1950). In 1983 an exhibition was organized at the National Gallery of Art, Washington, D.C.: Important Information Inside: The Art of John F. Peto and the Idea of Still-Life Painting in Nineteenth-Century America, catalogue by John Wilmerding.

75

JOHN F. PETO
Old Companions, 1904
Painted in Island Heights, New Jersey
Signed and dated upper right: *J. Peto / 1904.*
Oil on canvas, 22 × 30 in. (55.9 × 76.2 cm.)
Jo Ann and Julian Ganz, Jr.

Intimately grouped in a tight space, the objects in this wistful, introspective work have the timeless aura of abandonment. By presenting them at eye level in raking overhead light, the artist allows them to assume a beautiful, almost monumental presence. Although the examples in question seem no longer to be in use, the subjects of this still life are associated with the private pursuits of reading, writing, and smoking, done in the evening by the light of a small hanging lamp or a candle. Thus *Old Companions* evokes romantic sadness, since it combines nostalgia and uneasiness in its disarray of things old and forgotten.

Peto painted this particular shelf and this compositional format at least four times, with varying objects. It is one of the many "shelves set high, often in impractical places" in his house in Island Heights.[1] The moods of the shelf pictures vary, depending particularly on the lighting, the number of objects present, and the precariousness of their arrangement. In *Old Companions* the light creates long shadows whose shapes help emphasize the central, pyramidal grouping. The shallowness of the pictorial space is cleverly defined by the projecting corner at the left and the dark receding wall at the right—two bold verticals that flank and visually compress the still-life

arrangement. The torn book cover hanging tenuously in front of the shelf from a single thread is a captivating and nervously dramatic motif which Peto used several times in the 1890s. *Old Companions* is perhaps the most unified and formal of the shelf pieces and a tour de force as a broad selection of props and devices from the artist's earlier work.

Although Peto was probably influenced by Harnett in his frequent use of worn books propped and piled in disarray, he explored the shelf-top setting with originality and unequaled success. He painted the surfaces and textures of his subjects less scrupulously than Harnett; Peto's work is characterized by a quiet mood rather than a startling illusionistic impact, and the softly brushed surfaces give his objects a subtle radiance and lingering fascination. His greatest ability was to transform mute objects into metaphors for a way of life that was modest and perhaps lonely, and relieved by such simple pleasures as tobacco and candy. The original titles of most of his pictures are not known, since only six are recorded in contemporary exhibition catalogues; however, for one work, *The Poor Man's Store*, exhibited in Philadelphia in 1880, a contemporary newspaper review has been found which confirms that the artist sought to depict in his works humble arrangements of commonplace objects: "[The picture] illustrates a familiar phase of our street life. . . . A rough, ill-constructed, board shelf [supports] a half dozen rozy-cheeked apples, some antique gingerbread, a few dozen jars of cheap confectionary . . . and a copy of *The Record* has been spread beneath."[2]

T.J.F.

NOTES

1. Quoted in Alfred Frankenstein, *The Reality of Appearance: The Trompe L'Oeil Tradition in American Painting* (National Gallery of Art, Washington, D.C., 1970), p. 104. Frankenstein illustrates *Old Companions* with two closely related shelf paintings: *Still Life with Lard Oil Lamp* (c. 1900; Newark Museum, N.J.) and *Lamps of Other Days* (c. 1900; Amon Carter Museum, Fort Worth, Tex.) Also related are *Books on a Shelf* (1890s; Museo de Arte de Ponce, Puerto Rico) and *Lights of Other Days* (1906; Art Institute of Chicago).

2. The *Philadelphia Record*, quoted in Frankenstein, *John F. Peto* (Brooklyn Museum, N.Y., 1950), p. 15. On the same page Frankenstein lists the six titles of the works Peto exhibited at the Pennsylvania Academy between 1879 and 1887 (prices ranging from $40 to $200).

PROVENANCE

The artist; his daughter, Mrs. George Smiley, Island Heights, N.J.; The Hon. and Mrs. J. William Middendorf II, New York, through Sally Turner Gallery, Plainfield, N.J.; Sotheby Parke Bernet, New York, sale no. 3348, 1972; to present owner through Meredith Long & Co., Houston, Tex., 1973.

EXHIBITION HISTORY

Brooklyn Museum, N.Y., *John F. Peto*, cat. by Alfred Frankenstein, 1950 (traveling exhibition), no. 44 (as *Books on a Shelf*) (ill.).

Pennsylvania Academy of the Fine Arts, Philadelphia, *150th Anniversary Exhibition*, 1955, cat. no. 176 (ill.); also European tour, no. 64.

Metropolitan Museum of Art, New York, *American Paintings and Historical Prints from the Middendorf Collection*, cat. by Stuart Feld, 1967 (traveling exhibition), no. 45 (ill.).

Everson Museum, Syracuse, N.Y., *Portraiture and Still Life from the Collection of Mr. and Mrs. J. William Middendorf II*, 1969.

National Gallery of Art, Washington, D.C., *The Reality of Appearance: The Trompe L'Oeil Tradition in American Painting*, cat. by Frankenstein, 1970 (traveling exhibition), no. 64 (ill.).

Santa Barbara Museum of Art, Calif., *American Paintings, Watercolors and Drawings from the Collection of Jo Ann and Julian Ganz, Jr.*, 1973, cat. no. 55 (ill.).

Los Angeles County Museum of Art, *American Paintings from Los Angeles Collections*, 1974, checklist.

National Gallery of Art, Washington, D.C., *An American Perspective: Nineteenth-Century Art from the Collection of Jo Ann and Julian Ganz, Jr.*, cat. by John Wilmerding et al., 1981 (traveling exhibition), fig. 98.

WILLIAM RIMMER

(1816, South Milford, Massachusetts
—1879, South Milford)

*The facts of Rimmer's life have frequently been
obscured by romance. Raised in Boston, he was
affected during his childhood by the emotional
disturbances of his father, who, according to legend,
believed himself to be the son of the lost Dauphin and
heir to the throne of France. Because of the spiritual,
even macabre quality of much of his work, Rimmer is
often thought to have shared his father's instability.
Many of his colleagues, however, including the
painter Benjamin Champney, believed his works
aspired to the grandeur of the Old Masters, and
considered him "one of the most original and daring of
American artists" (Sixty Years' Memory of Art
and Artists [Woburn, Mass., 1900], pp. 10–11).*

*Rimmer began his artistic career as a painter but
won little recognition for his early work. In 1847 he
began studying medicine on his own and practiced for
several years before he was licensed as a physician in
1855. By the outbreak of the Civil War he had begun
working as a sculptor, although again without benefit
of formal instruction. His first major commission, for
a statue of Alexander Hamilton to be erected at the
head of Boston's Commonwealth Avenue, was not well
received. He did achieve a significant reputation as a
teacher, however, and between 1866 and 1871 served
as director of the School of Design for Young Women
at the Cooper Union for the Advancement of Science
and Art in New York. He lectured widely on anatomy
and design, and it was for his instructional drawing
books, The Elements of Design (1864) and Art
Anatomy (1877), as much as for his painting and
sculpture, that he was celebrated in his lifetime.*

*Truman H. Bartlett's The Art Life of William
Rimmer (Boston, 1882) is the only contemporary
biography of the artist. The catalogue and essay by
Lincoln Kirstein for an exhibition of Rimmer's work
held at the Whitney Museum in 1946 remains the
principal source of information about the artist. Most
recently, Jeffrey Weidmann has completed a dis-
sertation on Rimmer (Indiana University, 1982),
with a catalogue raisonné.*

76

WILLIAM RIMMER
Flight and Pursuit, 1872
Painted in Boston or Providence
Signed and dated lower right:
 W. Rimmer | 1872
Oil on canvas, 18 × 26¼ in. (45.7 × 66.7 cm.)
Museum of Fine Arts, Boston,
 Bequest of Miss Edith Nichols

A pencil sketch for the central figure of *Flight
and Pursuit* (Yale University Medical Library,
New Haven, Conn.) is the only clue Rimmer
provided for interpreting this enigmatic
image. The inscription on the drawing, "Oh,
for the Horns of the Altar!" connects the
painting with an episode in the story of King
David. As recorded in 1 Kings 1:50 ("And
Adonijah feared because of Solomon, and
arose, and went, and caught hold on the horns
of the altar"), David discovers a plot to usurp
the throne from Solomon, his designated heir,
and sends his henchmen after Adonijah and
Joab, the conspirators. Adonijah and Joab flee
to the holy altar and find sanctuary there.

In recent years numerous allegorical
interpretations have been imposed upon
Flight and Pursuit: it has been described as an
allusion to the pursuit and capture of John
Surratt, one of Lincoln's assassins; as a
reflection of Rimmer's father's delusion that,
as the lost Dauphin, he was persecuted by the
enemies of Louis XVI; and as a reminder of an
1811 massacre of Mamelukes in Cairo, the
brutality of which had made a strong
impression on European and American
minds.[1] None of these interpretations is
wholly convincing, however, for recent
political events play almost no role in
Rimmer's art, while subjects drawn from
classical mythology and the Bible are
numerous.[2] No mention of Lincoln or the
French Revolution or the Cairo massacre is to
be found in contemporary discussions of the
picture; rather, it was seen as a dramatic
adventure story about a figure guilty of some

pernicious crime. The analysis of a reporter
for the *Providence Daily Journal* is typical: "The
scene is the interior of an Oriental sanctuary,
into which a murderer is fleeing for refuge,
while in the distance an avenger is seen
hurrying to intercept him. A shadow
projected into the right hand corner indicates
that other pursuers are behind."[3]

Contemporary critics were more puzzled
by Rimmer's style than by the meaning of his
work. His rendering of the figures in *Flight and
Pursuit* was universally praised, an expected
tribute to a popular lecturer in anatomy. His
use of color, however, caused widespread
concern. The emphasis on outline and the
nearly monochromatic palette led one
reviewer to conclude that *Flight and Pursuit*
"must be regarded as a study rather than a
painting in the ordinary sense, and was evi-
dently meant rather to furnish hints to artists
than to afford pleasure to the public"[4]
Although the pale-toned, thinly painted
forms, the ghostly figures defined by
tremulous outlines, and the stage-set-like
architecture take to an extreme Rimmer's
usual linear style, they no doubt were
calculated to enhance the anxiety of the scene.
At the same time, the virtual absence of color
suggests that Rimmer was working from
prints. Works such as Gérôme's *The Pasha's
Runners* (published as a wood engraving in
1869) may have served as Rimmer's model for
the pair of running figures and suggested the
Moorish setting; versions of the same artist's
Death of Caesar (1867; Walters Art Gallery,
Baltimore) were in American collections by
1870 and may have inspired Rimmer's
infinitely repeating central archway.[5]

Flight and Pursuit reflects the vogue for Near
Eastern subjects that had captivated France
for half a century and had begun to appear in
America in the 1860s in the work of John La
Farge and Elihu Vedder (q.v.). Their paint-
ings, often as mysterious as Rimmer's, were
especially popular in Boston, where Rimmer
was active, and he himself exhibited several

other Near Eastern subjects in the 1870s. Rimmer's practice of dressing biblical figures in Arab garb originated with Delacroix, who used the device both for historic verisimilitude and to enhance the image's exotic appeal. This indicates that Rimmer was aware of artistic fashions abroad and was neither as isolated nor as eccentric an artist as has traditionally been supposed.

C.T.

NOTES

1. See Marcia Goldberg, "William Rimmer's *Flight and Pursuit: An Allegory of Assassination*," *Art Bulletin* 58 (June 1976): 234–40; Charles A. Sarnoff, "The Meaning of William Rimmer's *Flight and Pursuit*," *American Art Journal* 5 (May 1973): 18–19; and Ellwood C. Parry III, "Looking for a French and Egyptian Connection behind William Rimmer's *Flight and Pursuit*," *American Art Journal* 13 (Summer 1981): 51–60.

2. For example, *Hagar and Ishmael* (1857–58; Coll. Lee Anderson, New York); *Massacre of the Innocents* (1857–58; Mead Art Gallery, Amherst College, Mass.); "*And Satan Came Also*" (c. 1878; unlocated); and *Job and His Comforters* (c. 1874; unlocated).

3. Quoted in Jeffrey Weidman, *William Rimmer: Critical Catalogue Raisonné*, 7 vols. (Ph.D. diss., Indiana University, 1982), 2:593.

4. Ibid.

5. See Parry, "Looking for a French and Egyptian Connection," p. 56, and Goldberg, "Rimmer's *Flight and Pursuit*," p. 235.

PROVENANCE

Gift of the artist to Col. Charles B. Nichols, Providence, R.I., 1872; his wife, Mrs. Charles B. Nichols, Providence, 1877; their daughter, Miss Edith Nichols, Providence; to present owner, 1956.

EXHIBITION HISTORY

Williams and Everett's Art Gallery, Boston, 1872.
Mr. Brown's Gallery, Providence, R.I., 1872.
Museum of Fine Arts, Boston, *Exhibition of Sculpture, Oil Paintings and Drawings by Dr. William Rimmer*, 1880, cat. no. 22.
Whitney Museum of American Art, New York, *William Rimmer*, cat. by Lincoln Kirstein, 1946, no. 18 (ill.).
Detroit Institute of Arts, *Painting in America: The Story of 450 Years*, cat. by Edgar P. Richardson, 1957, no. 117.
American Federation of Arts, New York, *A Rationale for Modern Art*, 1959.
Art Gallery of Toronto, *American Paintings, 1865–1905*, cat. by Lloyd Goodrich, 1961 (traveling exhibition), no. 52 (ill.).
Metropolitan Museum of Art, New York, *19th-Century America: Paintings and Sculpture*, cat. by John K. Howat and Natalie Spassky, 1970, no. 117 (ill.).
Los Angeles County Museum of Art, *American Narrative Painting*, cat. by Donelson F. Hoopes, 1974, no. 45 (ill.).
American Federation of Arts, New York, *The Boston Tradition*, cat. by Carol Troyen, 1980 (traveling exhibition), no. 51 (ill.).

JAMES McNEILL WHISTLER

(1834, Lowell, Massachusetts
—1903, Chelsea [London])

Whistler was the most thoroughly Europeanized of the American-born artists who became expatriates during the later nineteenth century. As a child Whistler lived in Russia, where his father was an engineer, and then attended school for some months in England. As a student at the United States Military Academy at West Point in 1851–54, he was taught to draw by Robert Weir. Whistler withdrew from West Point before graduation, then worked briefly at a variety of jobs, the last of which was as a draftsman and etcher of maps for the U.S. Coast Geodetic Survey.

At the age of twenty-two, Whistler decided to become an artist and moved to Paris. He received some academic training in Charles Gleyre's atelier, but the Bohemian life attracted him much more. He met and came to admire Gustav Courbet and subsequently formed close personal and stylistic ties with other avant-garde artists, among them the painters Henri Fantin-Latour and Edouard Manet, the poet Charles Baudelaire, and the critic Théophile Gautier. In 1859 Whistler moved to London but remained in contact with the art world of Paris. When he exhibited Symphony in White, No. 1: The White Girl *(National Gallery of Art, Washington, D.C.), the most controversial of his early works, at the Salon des Refusés of 1863, it created a scandal: critics castigated it for its crude coloring, sloppy brushwork, and incomprehensible meaning. Whistler had firmly established himself as a rebel among painters by the early 1860s.*

Whistler dedicated the decades that followed to freeing his art from the confines of narrative and strict illusionism. He experimented widely with untraditional compositions, incorporating into them the exotic motifs and flat, asymmetrical arrangements of oriental art. His preference for decorative flatness and exoticism gave Whistler an affinity with his English contemporaries of the Aesthetic Movement, which included Dante Gabriel Rossetti and William Morris.

During his lifetime, the man Whistler aroused as much controversy as his work. He lived flamboyantly, frequently verged on bankruptcy, and was openly hostile to most critics. Fame and widespread acceptance came after 1900, when he was increasingly seen as a forerunner of the symbolist and abstract tendencies in modern art.

The chief sources of information about Whistler are his Gentle Art of Making Enemies *(1890; New York, 1967), a collection of letters and anecdotes, and the two-volume* Life of James McNeill Whistler *(Philadelphia and London, 1908) by his admirers Elizabeth and Joseph Pennell. The catalogue of the exhibition held at the Arts Council of Great Britain in 1960 contains an extensive bibliography. More recent is* The Paintings of James McNeill Whistler *(New Haven, Conn., 1980), a catalogue raisonné by Andrew McLaren Young and others.*

JAMES McNEILL WHISTLER
Arrangement in Grey and Black:
Portrait of the Painter's Mother, 1871
Painted in Chelsea [London]
Signed upper left with butterfly monogram
Oil on canvas, 56¾ × 64 in. (144.1 × 162.6 cm.)
Musée du Louvre, Paris

Whistler's portrait of his mother is one of the best-known and widely admired paintings by an American-born artist. He intended the work to be his masterpiece, the embodiment of his most deeply held aesthetic principles; yet virtually every generation of viewers since 1872, the year it was first exhibited, has misunderstood it.

From early in his career Whistler had been intrigued by the novelty of flat shapes and colors, and he came to believe that the purely visual, aesthetic aspects of a picture were more important than the sentimental messages that had become the stock-in-trade of Victorian painting. Like other avant-garde artists of his time, he used the new pictorial means to rebel against academic illusionism. Whistler planned to express his new aesthetic credo in a portrait of his mother that would incorporate extremely spare lines, simple shapes, and restrained colors.

The portrait is essentially a collection of objects arranged about the beautiful gray surface of Whistler's studio wall. The dado, the black curtain, the picture frames, and the striped rug create a monochromatic grid into which he placed his principal object, the sitter, whose profile makes an equally sharp, flat silhouette. Numerous small changes in the pose and placement of the background objects reveal his meticulous concern over the exact relationship of every detail. Indeed, the artist named this work *Arrangement in Grey and Black* to suggest that these formal considerations were paramount. Equally novel was Whistler's painting technique. He worked with thin paint on the rough, unprepared back of a previously used canvas, so that the background color would sink into the canvas and the foreground objects would appear to have no substance. This is especially apparent in the sitter's face, which is virtually translucent.

This work was painted in the summer of 1871 while Anne Matilda McNeill Whistler (1804–1881) was visiting her son in Chelsea. The artist initially intended a standing portrait, but posing proved too tiring for his mother. Whistler presents her in a way that prevents involvement with the viewer; instead she looks off to the left as if posing for another artist seated there. The final effect recalls the seated figures in profile carved on Roman funerary monuments. Although the

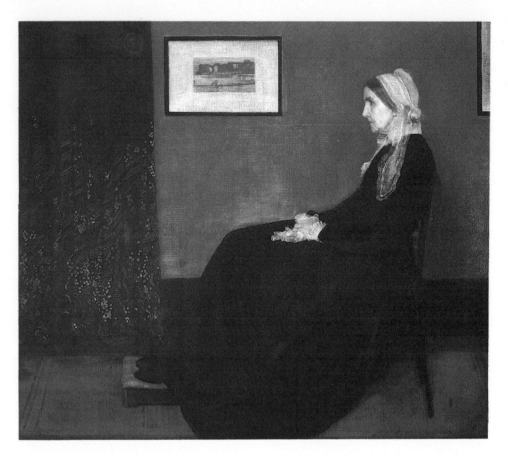

NOTES
1. Quoted in Stanley Weintraub, *Whistler, A Biography* (New York, 1974), p. 148.
2. See E. R. and J. Pennell, *The Life of James McNeill Whistler*, 2 vols. (London and New York, 1909) 1:157–58.
3. For example, Charles H. Caffin in *The Story of American Painting* (New York, 1907), p. 292.

PROVENANCE
The artist, through 1876; to Charles Augustus Howell by 1878; with Graves, London, 1878; the artist, 1879; sold to the French government November, 1891; transferred to Luxembourg Gallery, December, 1891; transferred to Jeu de Paume, 1922; transferred to Musée du Louvre 1929.

EXHIBITION HISTORY
Royal Academy, London, *Annual Exhibition*, 1872, cat.no.941.
Flemish Gallery, London, *Mr. Whistler's Exhibition*, 1874, cat.no.4.
Pennsylvania Academy of the Fine Arts, Philadelphia, *Special Exhibition of Paintings by American Artists at Home and in Europe*, 1882, cat.no.191.
American Art Gallery, New York, *Fifth Annual Exhibition of the Society of American Artists*, 1882, cat.no.124.
Paris, *Salon*, 1883, cat.no.2441.
Sketching Club, Leinster Hall, Dublin, *Annual Exhibition of Sketches, Pictures and Photography*, 1884, cat.no.244.
Königlichen Glaspalast, Munich, *III Internationale Kunst-Austellung*, 1889.
College for Working Men and Women, London, 1889.
Amsterdam, *Tentoonstelling van Kunstwerken van Levende Meesters*, 1889, cat.no.468.
Glasgow Institute of the Fine Arts, *28th Exhibition of Works of Modern Artists*, 1889.
Royal Institute of Painters in Watercolour, Piccadilly, *First Exhibition, Society of Portrait Painters*, 1891, cat.no.224.
Goupil, Vibert & Co., Paris, 1891.
New Gallery, London, *Memorial Exhibition of the Works of the Late J. McNeill Whistler* (organized by the International Society of Sculptors, Painters, and Gravers), 1905, cat.no.23 (ill.).
Palais de l'École des Beaux-Arts, Paris, *Oeuvres de James McNeill Whistler*, 1905, cat.no.23.
Museum of Fine Arts, Boston, *Exhibition of Oils, Water-Colors, Drawings, and Prints by James McNeill Whistler*, 1934, cat.no.1 (ill.).
Musée du Jeu de Paume, Paris, *Trois Siècles d'Art aux Etats-Unis*, cat. by Alfred H. Barr, Jr., 1938, no.176 (ill.).
Glasgow Art Gallery & Museum, *Whistler: Arrangements in Grey and Black*, 1951.
Art Institute of Chicago, *Sargent, Whistler and Mary Cassatt*, cat. by Frederick A. Sweet, 1954 (traveling exhibition), no.104.
Atlanta Art Association, 1964.
City Art Museum, St. Louis, *Arrangement in Grey and Black: Whistler's Mother*, 1965 (traveling exhibition under various titles).

artist deliberately depersonalized his image with both formal and technical devices, the objects in it had, paradoxically, great significance for him. The black fabric hung with deep folds at the left has an oriental design of a type he liked to collect. The black-framed print is Whistler's 1859 *Black Lion Wharf*, one of sixteen etchings that he had just issued in the spring of 1871 as the "Thames Set." And his mother is memorialized wearing her habitual prim black and white clothes in a pose that is classically linear and stoic in impact. Whistler observed: "To me it is interesting as a picture of my mother; but can or ought the public to care about the identity of the portrait? It must stand or fall on its merits as an arrangement."[1]

When the painting was finished, Whistler brought it to Liverpool to show to his patrons, Mr. and Mrs. F. R. Leyland. He was highly satisfied with his effort;[2] however, when the painting was exhibited publicly, first at the London Royal Academy in 1872 and then at the Paris Salon in 1883, it aroused considerable controversy. Most viewers were shocked by its peculiar coloring and composition. Some French critics castigated the portrait, sarcastically calling it a picture of a poor woman trapped in a smoking apartment or a depiction of the artist's mother after her death. A small minority of contemporary critics admired what they saw as the spiritual character of the sitter.[3] But whether they interpreted the artist's mother as pathetic or noble, most art critics insisted upon investing her image with the very sentimental qualities that he intended to rid from his painting. Whistler joked ironically that a Bible and a glass of sherry would have been perfect details to make the picture more popular with the critics.

After the painting's completion, Whistler was quick to build upon his enigmatic and controversial achievement. In 1872 he painted his *Arrangement in Grey and Black No. 2: Portrait of Thomas Carlyle* (Glasgow Art Gallery & Museum), and in 1873 *Miss Cicely Alexander* (Tate Gallery, London). Together the three works establish Whistler as one of the most innovative of nineteenth-century portraitists.

D.S.

78

JAMES McNEILL WHISTLER
Nocturne: Blue and Gold—
 Old Battersea Bridge, 1872–75
Painted in Chelsea [London]
Signed on frame with butterfly monogram
Oil on canvas, 26¼ × 19¾ in. (66.7 × 50.2 cm.)
The Tate Gallery, London
Exhibited in Boston and Paris only.

Whistler's first one-man show, held at London's Grosvenor Galleries in 1877, led to the most notorious episode of the artist's career. Nine paintings were on display: they included this work, *Nocturne in Black and Gold: The Falling Rocket* (Detroit Institute of Arts), *Arrangement in Grey and Black, No. 2: Portrait of Thomas Carlyle* (Glasgow Art Gallery & Museum), and some other portraits. Among those who saw the exhibition was the influential critic John Ruskin. He was outraged by the two-hundred guinea price Whistler placed on *The Falling Rocket*, the only work for sale, and subsequently wrote a review of the show in which he accused Whistler of "flinging a pot of paint in the public face." Whistler sued Ruskin for libel. The works from the exhibition were produced as evidence at the trial, and as such, *Old Battersea Bridge* became one of Whistler's most publicized landscapes.

The court transcript indicated that Whistler was cross-examined at length about this painting; the questions asked of him revealed just how the public saw it. Viewers were not sure that the painting represented a bridge. They could identify neither the yellow specks in the background as fireworks, nor the blotches at the top of the picture as pedestrians crossing the bridge.[1] They complained that the painting showed the same lack of effort and skill that had aroused the ire of Ruskin.

To Whistler, however, *Old Battersea Bridge* represented a culmination of the long and complex development of his ideas about landscape. The scenes of everyday life around London had long been a favorite subject for him. When he first moved to London in 1859 he took up residence in Chelsea, attracted to the unpretentious life at dockside and in neighborhood streets. He made numerous pictures of the wooden bridges crossing the Thames, Old Battersea Bridge among them.

Whistler's etchings and paintings of the 1850s and early 1860s show Old Battersea Bridge for the ordinary, shabby structure it was: a narrow, aging, low-slung bridge that carried much foot traffic. Wooden pilings, built from slats in a lattice pattern, supported it but had fallen into disrepair. Viewing the bridge from the Chelsea shore, one could look across the river and see the barges, warehouses, cargo ships and chimney stacks of industrial London.

In this painting, Whistler greatly exaggerated the height and curve of the bridge and increased the span between its wooden pilings. His intention was obviously to make the landscape look more like a Japanese print. These had become popular in Paris during the 1860s, and Whistler was quickly affected by them.[2] By the 1870s he was painting views of the industrial Thames River in the flat, asymmetrical, monochromatic style of Japanese compositions.[3]

That approach differed significantly from his earlier style. Here the bridge becomes a great flat arc silhouetted against the blue night sky. The composition is empty except for the low horizon line, the flat, sharp diagonal of a barge in the foreground, and a few flecks of gold paint representing fireworks in the distance and lights reflecting in the water. The result is a moody and otherworldly scene.

D.S.

NOTES
1. See Elizabeth and Joseph Pennell, *The Life of James McNeill Whistler*, 2 vols. (Philadelphia, 1908), 1:236–40.
2. It is uncertain exactly which Japanese prints Whistler had seen, but the city views by Ando Hiroshige were the most popular at the time and the most likely to have attracted Whistler's attention.
3. See Gabriel P. Weisberg, "Japonisme: Early Sources and the French Printmaker 1854–1922," in *Japonisme* (Cleveland Museum of Art, 1976), pp. 11–12, 44–45.

PROVENANCE
Sold by the artist to W. Graham, M.P., July 1877; auctioned at Graham Collection Sale, Christie's, London, to Robert H. C. Harrison, Liverpool, 1886; to National Art-Collections Fund, 1905; presented to National Gallery, London, 1905; transferred to Tate Gallery, 1905.

EXHIBITION HISTORY
Corporation of Brighton, England, *Second Annual Exhibition of Modern Pictures*, 1875, cat.no.97.
London, *Twelfth Exhibition of the Society of French Artists*, 1876, cat.no.147.
Grosvenor Galleries, London, *First Summer Exhibition*, 1877, cat.no.6a.
Galerie Durand-Ruel, Paris, 1888, cat.no.46.
Goupil, Vibert & Co., London, *Nocturnes, Marines and Chevalet Pieces*, 1892, cat.no.4.
New Gallery, Regent Street, London, *Memorial Exhibition of the Works of the Late James McNeill Whistler*, 1905, cat.no.12.
Kennedy Galleries, New York, *Paintings, Etchings and Lithographs by Whistler*, 1916, cat.no.8.
Art Institute of Chicago, *Sargent, Whistler and Mary Cassatt*, cat. by Frederick A. Sweet, 1954, no.98.
London Arts Council and M. Knoedler & Co., New York, *James McNeill Whistler*, 1960, cat.no.35.

FRANK DUVENECK

(1848, Covington, Kentucky
—1919, Cincinnati, Ohio)

Duveneck's parents were German immigrants. His father was a shoemaker, and his stepfather a grocer and small-businessman. He worked as a sign painter and then as an assistant to an itinerant German-born church decorator in the Midwest. Duveneck's first academic training was in Munich (1870–73), where he studied at the Royal Academy with its most liberal instructor, Wilhelm von Diez. In 1874 Duveneck taught a free class at the Ohio Mechanics Institute, Cincinnati, and John Henry Twachtman (1853–1902) and Kenyon Cox (1856–1916) were among his first pupils. Although he found little encouragement in Ohio, five male portrait studies were well received at the Boston Art Club in 1875. During his longest European sojourn (1875–88, with a brief American visit in 1881) he formed his own painting class in Munich, which attracted several young Americans, including John White Alexander (q.v.), Otto Bacher (1856–1909), and Joseph DeCamp (1858–1923). This group, the "Duveneck Boys," also studied together in Florence, Venice, and the Bavarian village of Polling. In 1880 Duveneck and Bacher worked closely with Whistler in Venice, where all three artists made etchings. In 1886 Duveneck married his former pupil, Bostonian Elizabeth Boott (1846–1888); they lived in Florence and Paris. When Elizabeth died unexpectedly in 1888, Duveneck settled in Cincinnati, although he continued to visit Europe.

As the recipient of a modern professional training in Europe, Duveneck became a key figure in introducing anti-academic painterly styles to America in the later 1870s. During his first stay in Munich, he was influenced by the dark, realistic portraiture of Wilhelm Leibl, who in turn had been affected by Courbet and Manet in Paris in 1869. Duveneck employed a heavy, painterly style all his life, although his palette became brighter in the 1880s. In his later years in Cincinnati, he was important as a teacher and leader and became less innovative in his art. Beginning in 1890, he taught painting classes at the Cincinnati Art Museum; he was elected first president of the Society of Western Artists in 1897; and in 1900 he joined the faculty of the Art Academy of Cincinnati as a full-time instructor. He contributed to the major international exhibitions of his day, and won a Gold Medal at the 1915 Panama Pacific Exposition in San Francisco.

For an early appreciation by one of his students, see Norbert Heerman's Frank Duveneck *(Boston, 1918); the most recent study is Josephine W. Duveneck's* Frank Duveneck, Painter-Teacher *(San Francisco, 1970). The largest collection of his paintings is at the Cincinnati Art Museum, which was fully catalogued for their exhibition* The Golden Age: Cincinnati Painters of the Nineteenth Century *(1979), pp. 45–65.*

79

FRANK DUVENECK
The Turkish Page, 1876
Painted in Munich
Signed and dated lower left:
 F. Duveneck. Munich. 1876
Oil on canvas, 42 × 56 in. (106.7 × 142.2 cm.)
The Pennsylvania Academy of the Fine Arts,
 Philadelphia, Temple Fund Purchase.

The Turkish Page shows Duveneck at the peak of his powers, effortlessly manipulating thick pigment and evoking textures ranging from the polished hardness of a marble floor to the sensuous plumage of a cockatoo. The picture is an amalgam of the major trends in Munich art of the 1870s: the realistic depiction of peasant types and the seemingly contradictory focus on the picturesqueness of their clothes and way of life; the emulation of various Old Master styles, especially the deep, rich palette of Velázquez and the lively brushwork of Hals and Van Dyck; and, finally, a fascination with still life.

Duveneck's best-known works before *The Turkish Page*—for example, *The Old Professor* (1871; Museum of Fine Arts, Boston) and *Whistling Boy* (1872; Cincinnati Art Museum) —used dark palettes with figures modeled against impenetrable shadow. Seeing these works in 1875, Henry James echoed the opinion of "aesthetic Boston" that an "American Velázquez" had been discovered in twenty-six-year-old Duveneck.[1] Clearly Duveneck had set out in 1876 to broaden his reputation with *The Turkish Page*, his most

elaborate, lively, and colorful work to date. That year he visited the Paris Salon for the first time, and the enormous French vogue for oriental genre and landscape art (exemplified at the Salon, for example, by Gérôme, Bonnat, and the American Frederick Bridgman) may have inspired him to paint this exotic picture.[2] Though the artist had never been to Turkey, he conjured up the flavor of the Near East by employing assorted props. Chase painted this young model at the same time, and even made a sketch showing Duveneck from behind at work on *The Turkish Page*.[3]

Duveneck entered artistic maturity with European training and approval but initially had difficulties in finding patronage in America. In 1877 he sent *The Turkish Page* to the National Academy of Design in New York, where it was prominently displayed and attracted praise for its technical merits. However, the critics complained of the harsh, unharmonious impact of its thickly painted surface. They also objected to the frailness of the boy's body, claiming that the picture did not live up to its anecdotal capacity:

> *It has, properly speaking, no local color, no locality. The boy is quite as much Jewish as Turkish. With the exception of his fez, his costume . . . is not that of a Turkish page. . . . There is something annoying and even exasperating in this uncertainty in which we are left in regard to the meaning of the scene before us, which, added to the boy's painful emaciation and the uninteresting, if not positively disagreeable character of his face, detracts greatly from the pleasure we might otherwise have in the technical qualities of the painting.[4]*

With such shrill criticism punctuating basically enthusiastic reviews, it is perhaps not surprising that this picture did not find a buyer at the $1,500 price Duveneck asked in the National Academy exhibition catalogue. When the doctrine of "art for art's sake" was more prevalent in America, such objections were forgotten, and in 1894 *The Turkish Page* was purchased from the artist by the Pennsylvania Academy of the Fine Arts for $500. It quickly became Duveneck's best-known work and remains so today.

T.J.F.

NOTES

1. James discussed the Duvenecks included in two 1875 Boston exhibitions in two reviews, both reprinted in *The Painter's Eye: Notes and Essays on the Pictorial Arts*, ed. John L. Sweeney (Cambridge, Mass., 1956), pp. 98–99 and 105–6. James found the realism of these early works "brutal, hard, [and] indelicate" and felt that to achieve greatness the artist would need to build on this foundation "a very liberal structure," meaning, presumably, grander subjects that inspired the viewer to more complex and subtle insights.

2. With the notable exception of *Caucasian Soldier* (1870; Museum of Fine Arts, Boston) the subjects of Duveneck's earlier figurative works were either German or American plebeian types, or bohemian artist friends.

3. In Chase's *Turkish Page* (Cincinnati Art Museum), the cockatoo is chained to a hoop-shaped perch, and it is more obvious than in the Duveneck that the boy is encouraging it to eat fruit from the bowl. Chase's *Duveneck Painting "The Turkish Page"* is also owned by the Cincinnati Art Museum. According to Norbert Heerman (*Frank Duveneck* [Boston, 1918], p. 37), *The Turkish Page* was painted in Chase's studio, which might suggest that Chase provided the props from his large bric-a-brac collection.

4. "Art," *The Atlantic Monthly* 39 (May 1877): 641–42. Note the similar sentiment in the review "The Academy Exhibition," *The Art Journal* [New York] 3 (1877): 157: "Assuredly no Art-purpose is served by this portrait of a skeleton lad; nor is it clear that any other purpose is served by it. It is a painting that would have placed the painter on a very high plane had he but consented to believe that harshness is not a necessary element of strength, and that realism may be pushed to a repulsive extreme."

PROVENANCE

The artist; to present owner, 1894.

EXHIBITION HISTORY

National Academy of Design, New York, *Annual Exhibition*, 1877, cat. no. 431.

Cincinnati, *Seventh Industrial Exposition*, 1879, cat. no. 58.

London, *Exhibition of Pictures in the Art Galleries of the American Exhibition*, 1887, cat. no. 1437.

Pennsylvania Academy of the Fine Arts, *Annual Exhibition*, 1893–94, cat. no. 19.

Königliche Akademie der Künste, Berlin, *Austellung Amerikanischer Kunst*, 1910.

San Francisco, *Panama Pacific International Exposition*, 1915, cat. no. 3907.

Cincinnati Art Museum, *Exhibition of the Work of Frank Duveneck*, 1936, cat. no. 19 (ill.).

Whitney Museum of American Art, New York, *Paintings by Frank Duveneck, 1848–1919*, 1938, cat. no. 10.

Woodmere Art Gallery, Philadelphia, *American Art, 1860 to 1914*, 1948.

National Academy of Design, New York, *The American Tradition, 1800–1900*, 1951, cat. no. 44.

Detroit Institute of Arts, *Painting in America: The Story of 450 Years*, cat. by Edgar P. Richardson 1957, no. 120.

University of Arizona Art Gallery, Tucson, and Arkansas Arts Center, Little Rock, *The Bird in Art*, 1964–65, cat. no. 84 (ill.).

Brooklyn Museum, N.Y., *Triumph of Realism*, cat. by Axel von Saldern, 1967–68 (traveling exhibition), no. 42 (ill.).

Metropolitan Museum of Art, New York, *19th-Century America: Painting and Sculpture*, cat. by John K. Howat and Natalie Spassky, 1970, no. 165 (ill.).

Chapellier Gallery, New York, *Frank Duveneck*, cat. by Francis W. Bilodeau, 1972, no. 14 (ill.).

Cincinnati Art Museum, *Masterpieces of American Painting from the Collection of the Pennsylvania Academy of the Fine Arts*, 1974.

Whitney Museum of American Art, New York, *Young America*, 1975–76 (traveling exhibition).

Pennsylvania Academy of the Fine Arts, Philadelphia, *In This Academy*, cat. by Frank H. Goodyear, Jr., 1976, no. 61 (ill.).

THOMAS HOVENDEN

(1840, Dunmanway, County Cork, Ireland —1895, Philadelphia)

As a young man, Hovenden was apprenticed to a carver and gilder in his native County Cork, and also received some artistic training at the Cork School of Design. In 1863 he emigrated to New York, where he enrolled in evening classes at the National Academy of Design while supporting himself as a framemaker. Like increasing numbers of young American artists, he traveled to France for additional training and entered the Parisian atelier of Alexandre Cabanel in 1874. Shortly thereafter he joined Robert Wylie and several other Americans at Pont-Aven, where he worked for several years, painting both historical and genre subjects featuring the Breton peasants. He exhibited regularly at the Salons beginning in 1876 and participated in the Paris Exposition Universelle of 1878, while continuing to send paintings back to America for exhibition at the National Academy of Design, the Brooklyn Art Association, and other institutions. In 1880 he returned to the United States, settling outside Philadelphia. He was elected an Associate of the National Academy of Design in 1881 and a full Academician a year later. Also in the 1880s he became a painting instructor (and for a brief period, the director) at the Pennsylvania Academy of the Fine Arts, where he taught many talented pupils, most notably Robert Henri. Hovenden's large-scale, colorful, and sentimental depictions of Breton peasants and, later, of Americans from the period of the Civil War, won critical and popular acclaim on both sides of the Atlantic. His greatest success occurred in 1893, when his Breaking Home Ties (1890; Philadelphia Museum of Art) was voted the most popular painting at the World's Columbian Exposition in Chicago. Two years later, Hovenden was killed while trying to rescue a child from the path of a train.

There is no modern monograph or exhibition of Hovenden's work. A contemporary account of Hovenden's career may be found in Walter Montgomery, American Art and American Collections, 2 vols. (1889; New York, 1978), 2:930–33.

It has been suggested that the present painting is a smaller replica of Hovenden's Salon entry, which was presumed lost some time after its exhibition at the National Academy of Design in 1881. However, it is unlikely that Hovenden would have painted such a large (and yet not full-scale) replica "for his own future use."[3] Futhermore, the disparity in measurements (150 × 180 cm. for the Salon picture vs. 99 × 137 cm. for Detroit's version) that has been used to suggest the existence of a second version reflects only the fact that the dimensions recorded in the Salon catalogue were for the picture *framed*, as was the custom at the time;[4] today, of course, it is the unframed measurements which are used.

C.T.

NOTES

1. According to Elisabeth Kashey ("Religious Art in Nineteenth-Century France," in *Christian Imagery in French Nineteenth-Century Art* [New York, Shepherd Gallery, 1980, p. 27]) the Catholic/Monarchist alliance held the majority in the National Assembly to about 1875; by the end of the decade, the Republicans had the upper hand.

2. Quoted in Nancy Rivard et al., "American Paintings Acquired During the Last Decade," *Bulletin of the Detroit Institute of Arts* 55 (1977): 103.

3. Rivard, "American Paintings," p. 104.

4. See Kenneth Lindsay, "Millet's Lost Winnower Rediscovered," *Burlington Magazine* 116 (May 1974): 239 and n. 3. I am grateful to Alexandra R. Murphy for bringing this article to my attention.

PROVENANCE

Robert Charles Hall; gift of his daughters to the Peabody Institute, Baltimore, 1924; with Kennedy Galleries, New York, 1964; Mr. and Mrs. Harold O. Love, 1964; to present owner, 1972.

EXHIBITION HISTORY

Paris, *Salon*, 1880, cat. no. 1877 (as *Le Dernier Préparatif*);
National Academy of Design, New York, 1881, cat. no. 300 (as *Hoc Signo Vinces* [La Vendée, 1793]).

80

THOMAS HOVENDEN
In Hoc Signo Vinces, 1880
Painted in Pont-Aven or Paris
Signed and dated lower right: *T Hovenden 1880*
 [initials in monogram]
Oil on canvas, 39 × 54 in. (99.1 × 137.2 cm.)
The Detroit Institute of Arts,
 Gift of Mr. and Mrs. Harold O. Love

In Hoc Signo Vinces (or, as it was originally titled, *Le Dernier Préparatif*) represents an odd choice of subject, even for an adoptive American, to submit to the Salon in the tenth year of the Third Republic. Much of the political controversy of the previous decade in France had stemmed from shifts of power in the National Assembly between the Republicans and the alliance of Catholics and monarchists,[1] and the most sensational painting of the 1880 Salon was a work which, like Hovenden's, challenged the prevailing anticlerical and anti-Royalist sentiment: Jules Bastien-Lepage's *Jeanne d'Arc* (1880; Metropolitan Museum of Art, New York). Hovenden's painting, however, lacked the mystical associations of his colleague's picture, and critics merely remarked that it was "a serious and noble performance."[2] *In Hoc Signo Vinces* ("In This Sign You Shall Conquer") illustrates a poignant scene in a peasant home in the Vendée, the region neighboring Brittany, at the time of the French Revolution. At the height of the Reign of Terror, the local peasantry rebelled against military conscription and conducted a guerrilla campaign against the troops of the republic. Even after the execution of the King in 1793, the

Vendéans remained loyal to Church and Crown; their allegiance was signalled by the "sacred heart," which the young wife fastens to her husband's breast before he departs for battle.

When he painted this picture, Hovenden was working alongside the American expatriates Robert Wylie, Daniel Ridgway Knight, and William Picknell at Pont-Aven in Normandy, and like them had developed an interest in the colorful peasant subjects then fashionable in France. He also shared those artists' rich, high-keyed palette and especially their more informal techniques—thick paint, often dragged over another paint layer to produce a dry, crusty surface, and the juxtaposition of vividly detailed sections with more roughly finished passages—techniques which mark his break with the tight delineation and polished, enamel-like surfaces of the Academic masters with whom he had first trained. Yet from those masters—Cabanel, and especially Gérôme, whose scenes from ancient Roman history and daily life dominated the Salons in the 1870s—came the impulse to treat historical subjects anecdotally, emphasizing their emotional content. Beginning with *In Hoc Signo Vinces*, personal dramas played against a grander historical backdrop became Hovenden's stock-in-trade: a similar tender leave-taking set at the time of the Civil War is the subject of Hovenden's celebrated *Breaking Home Ties* (1890; Philadelphia Museum of Art), and even in paintings featuring historic personages, such as *The Last Moments of John Brown* (c. 1881; Metropolitan Museum of Art, New York), it is the sentimental, rather than the heroic, that is illustrated.

JOHN SINGER SARGENT

(1856, Florence—1925, London)

Sargent was the son of a Philadelphia surgeon who had retired to live in Europe. In the course of his peripatetic youth, Sargent learned several languages and was introduced to the great European museums. He sporadically attended classes at the Accademia delle Belle Arti in Florence (1870–73). In 1874 he sought professional training in Paris: he entered the atelier of Carolus-Duran and attended drawing classes at the École des Beaux-Arts. From 1877 his portraits and subject pictures (picturesque genre scenes of Brittany, Capri, Tangiers, and Seville) were regularly accepted at the Salon. In Spain (1879) he copied works by Velázquez, and in Holland and Belgium a year later copied works by Hals. His reputation at the Salon in the early 1880s culminated with the audacious 1884 portrait of Madame Gautreau (cat.no.82), which scandalized the fashionable world and lost the artist portrait commissions in France.

Sargent had visited and worked in England several times since 1881; he was acquainted with Burne-Jones and Alma-Tadema and was interested in the Aesthetic Movement. When his Paris career foundered, his friend Henry James encouraged him to settle in London, which he did in 1886. After its debut at the Royal Academy in 1887, Carnation, Lily, Lily, Rose (Tate Gallery, London) was purchased for the nation by the Chantrey Bequest. This served to draw attention to Sargent's French style and his recent exploration of Impressionism. (It is not certain when Sargent first met Monet, but he visited and worked with him at Giverny in 1887, and purchased four of his paintings in the next few years.) In England his career developed slowly, and he made two portrait-painting visits to America, working mostly in Boston and New York, in 1887–88 and 1890. He became the world's most celebrated portraitist at the turn of the century.

Sargent's permanent home was London, and the majority of his commissions came from the English upper classes, particularly after his triumphs at the Royal Academy exhibitions in the 1890s. Throughout this period of international success, his commitment to America's cultural development was most apparent in the mural decorations he executed for the Boston Public Library (1890–1919), the Museum of Fine Arts, Boston (1916–25), and Harvard University's Widener Library (1921–22). After the turn of the century, his most novel and exciting works were the watercolors he made during summer excursions. Always unassuming in approach yet technically brilliant, these display the spontaneity and personal observation of his best oil portraits.

The basic biographical monograph on Sargent is by Evan Charteris (New York, 1927), and the best survey of his art is Richard Ormond, John Singer Sargent: Paintings, Drawings, Watercolors *(New York, 1970).*

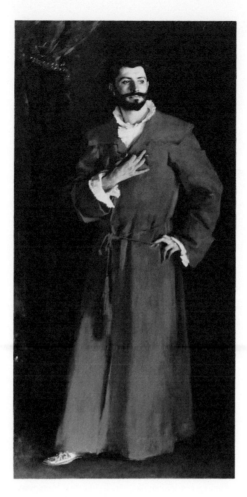

81

JOHN SINGER SARGENT
Dr. Pozzi at Home, 1881
Painted in Paris
Signed and dated upper right:
 John S. Sargent 1881
Oil on canvas, 80½ × 43⅞ in. (204.5 × 111.5 cm.)
The Armand Hammer Collection

In this his first life-sized, full-length male portrait, Sargent re-creates the noble stylishness of Van Dyck. Dr. Pozzi's alert, distinguished bearing and his vibrant scarlet and white clothes readily bring to mind that master's famous *Cardinal Guido Bentivoglio* (1623; Pitti Palace, Florence). His graceful hands and especially the mannered arrangement of the fingers are typical of many of Van Dyck's male portraits. Sargent described Pozzi to Henry James as "a very brilliant creature,"[1] a statement which confirms the artist's visual opinion of Pozzi as prepossessing and acute. Perhaps the most original feature of the portrait is its intoxicating red-on-red color scheme: a scarlet gown and embroidered slipper against a crimson carpet and drape (and even a red signature). This effect might be considered an unabashedly splendiferous response to a recent trend—the Velázquez-inspired figure isolated against a flat, shadowy setting. In the hands of Manet and Whistler, such pictures were executed in the same narrow range of colors, but with very quiet grays, browns, blues, pinks, and black.

Not knowing the subject, one might imagine the picture to represent an actor or opera singer seen backstage with a dressing gown over his costume. In fact, Samuel Jean Pozzi (1846–1918) was an eminent young Parisian surgeon who specialized in gynecology. It has been suggested that he was the lover of the notorious social beauty, Madame Pierre Gautreau, whom Sargent painted soon afterward (cat.no.82).[2] The dramatic pose and palette of *Dr. Pozzi*, the subject's sensuous Mediterranean beauty and charismatic, majestic presence, all suggest that under the guise of a Van Dyck pastiche, this is a study of modern male sexuality, an interpretation which is encouraged by the passionate colors and the velvety, boudoirlike setting. The Honorable Mention Sargent received at the Salon in 1879 for his dashing portrait of his master Carolus-Duran (1879; Sterling and Francine Clark Art Institute, Williamstown, Mass.) brought him to the attention of the entire *beau monde* and must have been one of the factors that prompted the Pozzi commission. Pozzi himself was keenly interested in the arts and amassed a large collection of Egyptian, Greek, and Roman sculpture and coins as well as an eclectic group of more recent objects, including Northern Renaissance fabrics and wood carvings, Oriental carpets and sculpture, Dutch and French faïences, and paintings by Tiepolo and Guardi.[3]

Seeing *Dr. Pozzi* on exhibition in London in 1882, Sargent's friend the writer Violet Paget observed: ". . . poor stuff [at the Royal Academy] for the most part, but John's red picture . . . [was] magnificent, of an insolent kind of magnificence, more or less kicking other people's pictures into bits."[4] *Dr. Pozzi* represented Sargent when he was invited to contribute to the first exhibition of the Belgian avant-garde group, Les XX, in Brussels in 1884. It excited most critical admiration for its execution, several perplexed comments on its noisy palette and air of theatricality, and a few cutting remarks betraying a fear of Sargent's unrestrained bravura (for example, an analogy with a glass of champagne that contains more bubbles than wine because it was poured too quickly).[5] Sargent's request to Isabella Stewart Gardner of Boston to borrow his iconic portrait of her to accompany *Dr. Pozzi* to the 1897 Venice Biennale suggests that the latter was one of his favorite works: "Pozzi sends me his and you would be in good company."[6] T.J.F.

NOTES

1. Sargent to James, Paris, 25 June 1885 (Houghton Library, Harvard University). Sargent indicates that Pozzi was visiting London with one of their mutual friends, "the unique extra-human [Robert de] Montesquiou," whom he also wished James to meet.

2. Apparently Sarah Bernhardt and Robert de Montesquiou were also patients, and Bernhardt was another of his lovers. Pozzi may have been the model for Proust's Dr. Cottard. I am grateful to Richard Ormond for sharing this information from his entry for the Sargent catalogue raisonné currently in preparation.

3. The Pozzi estate was sold by Galerie Georges Petit, Paris, in two sales (paintings and furniture, and ancient art) in June 1919, after the doctor was killed by a madman.

In addition to cat.no.81, Pozzi owned two more works by Sargent: an oil study of Mme Gautreau drinking a toast (c. 1883) and *Incensing the Veil*, a watercolor of an Arab woman (c. 1880; both at the Isabella Stewart Gardner Museum, Boston).

4. *Vernon Lee's Letters*, ed. Irene Cooper Willis (privately printed, 1937), p. 87. "Vernon Lee" was Paget's nom de plume.

5. Emile Verhaeren, "Exposition des Vingtistes à Bruxelles," *La Libre Revue* (February 1884): 233: Le portrait de Sargent . . . vise à étonner, à «épater»; il est théâtrical, il est poseur, il finit par lasser; il renferme, comme un verre à champagne trop précipitamment rempli, plus de mousse que de vin d'or.

6. Sargent to Mrs. Gardner, London, 14 January 1897 (Archives, Isabella Stewart Gardner Museum, Boston). Mrs. Gardner declined the invitation.

PROVENANCE

The sitter; purchased by his son, Jean Pozzi, from the Dr. S. Pozzi Sale, Galerie Georges Petit, Paris, 1919; to present owner from the Jean Pozzi Estate Sale, Palais Galliera, Paris, 1970.

EXHIBITION HISTORY

Royal Academy, London, *Annual Exhibition*, 1882, cat.no.239 (as *A Portrait*).
Palais des Beaux-Arts, Brussels, *Les XX*, 1884, in the Artistes Invités section (as *Portrait*).
Venice, *II Esposizione Internazionale d'Arte della Citta di Venezia*, 1897, cat.no.52.
As part of *The Armand Hammer Collection*, traveling exhibition, worldwide, 1971–83.

JOHN SINGER SARGENT
Madame X (Madame Pierre Gautreau), 1884
Painted in Paris
Signed and dated lower right:
 John S. Sargent 1884
Oil on canvas, $82\frac{1}{8} \times 43\frac{1}{4}$ in. (208.6 × 109.9 cm.)
The Metropolitan Museum of Art, New York, Arthur Hoppock Hearn Fund, 1916

Virginie Avegno Gautreau (1859–1915), the young American-born wife of a wealthy French businessman, was a famous society beauty when Sargent asked to paint her, probably in 1882. She was raised in France and had recently begun to amaze the fashionable world with her unconventional glamour: dressing her hair in a Greek-style chignon, completely baring her shoulders and neck, and avoiding ostentatious jewelry, she affected a classical look which was perfect for her flawless features, long neck, full, round shoulders, and superb figure. Admirers likened her to a classical statue; two famous antique sculptures in the Louvre—*Diane chasseresse* and *Diane de Gabies*—may have inspired her to imitate their coiffures and bare shoulders.

Sargent was fascinated by this fantastic creature, and his preparations for the portrait took over a year. Since most of his studies show her at rest (he complained of her "hopeless laziness"), it is surprising that the picture he showed at the Salon in 1884 is characterized by a strained pose and high-strung atmosphere. Mme Gautreau seems to look away from the viewer deliberately. While appearing to disdain public attention, she displays herself with such unabashed arrogance that she cannot fail to capture it. The image captures the electrifying impression she made on arriving at a social gathering, translating it into a static, cameolike emblem rich in classical allusions. The treatment of her head recalls Renaissance profile portraits; the table is in the neoclassical style; the loose, undulating folds of her dress suggest antique draperies; and the small diamond crescent in her hair is an attribute of Diana, mythical patroness of the hunt. Despite these intelligently handled references to art of the past, the portrait was widely perceived as a grotesquely modern work that dwelled unnecessarily on the outlandish clothes and makeup with which Mme Gautreau indulged her vanity. Some artists, however, appreciated it. As the young painter Marie Bashkirtseff reported:

It is a great success of curiosity; people find it atrocious. For me it is perfect painting, masterly, true. But he has done what he saw. The beautiful Mme.—is horrible in daylight, for she paints herself, despite her twenty-six years. This chalky paint gives to the shoulders the tone of a corpse. Further, she paints her ears rose and her hair mahogany. The eyebrows are traced in dark mahogany color, two thick lines.[1]

Originally there had been one more reason for prudish objection: the diamond shoulder strap at the left was shown in a fallen position, held horizontal by the outstretched arm. To allay public complaint, Sargent asked official permission to retouch this provocative décolletage, but was refused on the grounds that he should learn not to paint such inflammatory portraits of ladies. Soon after the Salon closed, he repainted the strap in an acceptable vertical position.[2]

While the public mocked such a brazen spectacle, conservative art critics protested the flat and unmodeled appearance of the face. Manet's painting and Japanese art were cited as pernicious influences. In all, this portrait was an unexpected failure and embarrassment for Sargent. Only Louis de Fourcaud defended the picture's serious intentions: the exploration of classicizing linear design as a means to fix both the likeness and the psychological hauteur of a particular social type, the fashionable beauty.[3] Indeed, Sargent's portrait does work on two levels: it documents the appearance of a modern woman (in the spirit of Baudelaire) and it imaginatively envisions the woman as classical goddess, a cold idol who enslaved her admirers, a *femme fatale*.

After the picture's poor reception in 1884, Sargent did not exhibit it again until 1905. That year a discriminating French aesthetician, Robert de Montesquiou, pronounced it Sargent's masterpiece, calling it unforgettable, unique, and the early culmination of a career. Recalling the artist's indignant reaction to the commotion it aroused in Paris in 1884, Montesquiou felt that Sargent should have proudly ignored the fuss instead of moving permanently to London, where he never again painted such a powerfully charged and audacious work. When Sargent wrote offering it for sale to the Metropolitan Museum of Art in 1916, he said, "I suppose it is the best thing I have done," and in subsequent years both the critics and the public have come to share this view.

T.J.F.

NOTES

1. *The Last Confessions of Marie Bashkirtseff and Her Correspondence with Guy de Maupassant*, foreword by Jeannette L. Gilder (New York, 1901), p. 87.
2. See Trevor J. Fairbrother, "The Shock of John Singer Sargent's 'Madame Gautreau,'" *Arts Magazine* 55 (January 1981): 90–97.
3. Louis de Fourcaud, "Le Salon de 1884 (Deuxième Article)," *Gazette des Beaux-Arts* 29 (1884): 482–84. André Michel predicted that critics of the future would be freer to comment on the strange and unsettling qualities of the portrait, which would become a document of the high society of 1884, with its preference for the artificiality of the boudoir rather than the wholesome and the natural: see his review "Le Salon de 1884. VII," *L'Art* 37 (1884): 13–14.

PROVENANCE
The artist; to present owner, 1916.

EXHIBITION HISTORY
Paris, *Salon*, 1884, cat.no.2150 (as *Portrait de Mme* ***).
Carfax Gallery, London, [loan exhibition of 3 paintings and 47 watercolors, no known cat.], 1905.
New Gallery, London, *Fair Women* [exhibition organized by the International Society], 1908.
Panama-Pacific International Exposition, San Francisco, 1915, cat.no.3630.
Metropolitan Museum of Art, New York, *Memorial Exhibition of the Work of John Singer Sargent*, cat. by M. G. Van Rensselaer, 1926, no. 10 (ill.).
Art Institute of Chicago, *Sargent, Whistler, and Mary Cassatt*, cat. by Frederick A. Sweet, 1954, no. 49 (ill.).
Brooklyn Museum, N.Y., *Triumph of Realism*, cat. by Axel von Saldern, 1967–68 (traveling exhibition), no. 90 (ill.).
Metropolitan Museum of Art, New York, *19th-Century America: Paintings and Sculpture*, cat. by John K. Howat and Natalie Spassky, 1970, no. 178 (ill.).
Museum of Fine Arts, Boston, *Masterpieces of Paintings in the Metropolitan Museum*, 1970 (ill.).
National Gallery of Art, Washington, D.C., *Great American Paintings from the Boston and Metropolitan Museums*, cat. by Thomas N. Maytham, 1970–71, no. 69 (ill.).
National Portrait Gallery, London, *John Singer Sargent and the Edwardian Age*, cat. by James Lomax and Richard Ormond, 1979 (traveling exhibition), no. 13 (ill.).

ELIHU VEDDER

(1836, New York City—1923, Rome)

A descendent of seventeenth-century Dutch settlers, Vedder grew up in Schenectady, New York, with several extended visits to Cuba, where his dentist-father moved his practice. Around 1853 he entered the studio of the genre and historical painter T. H. Matteson (1813–1884) in Sherburne, New York. On his first visit to Europe (1856–60) he spent eight months in Paris drawing from casts at the Atelier Picot before moving to Florence, where he took lessons in drawing and anatomy from Raffaello Bonaiuti. Influenced by Nino Costa (one of the local impressionistic artists known as the Macchiaioli) Vedder made small, painterly landscapes filled with strong Italian light. On his return to America (1861–65), he settled in New York and, like Walt Whitman, became one of the bohemian habitués of Pfaff's tavern. During the Civil War years, he painted a group of fantastic pictures, several inspired by The Arabian Nights, of which the best-known is Lair of the Sea Serpent *(1864; Museum of Fine Arts, Boston). Such works found success in the literary and artistic circles of Boston, where Vedder was encouraged by two friends who had also formed subtle, chromatically sophisticated styles on the basis of their European experiences: William Morris Hunt (1824–1879) and John La Farge (q.v.). After his second visit to France and Italy (1866–69), Vedder married Caroline Rosekrans in America in 1869, and then settled in Rome. He returned to America several times, but from this point his life and family were based in Italy.*

Vedder achieved international fame with the illustrations he made in 1883–84 for a large deluxe edition of the Rubáiyát of Omar Khayyám: *he created swirling cosmic settings wherein dreamy, loosely clad figures personified Omar's poems on the mysteries of life and death. Vedder's oeuvre represents an artistic withdrawal from the modern Victorian world: beginning in mid-century with Oriental and Tennysonian fantasies, it became an influence on the intellectual aspects of Symbolism and the decorative essence of Art Nouveau (as, for example, in the designs of Aubrey Beardsley).*

In the 1890s Vedder received several commissions through such architects as George Post and the firm of McKim, Mead, and White for classicizing mural decorations in the manner of the Italian High Renaissance. Important examples that remain in situ are at the Walker Art Building at Bowdoin College, Maine, and the Library of Congress, Washington, D.C.

The artist's autobiography, The Digressions of V *(Boston, 1910) remains a major source. There are two recent studies: Regina Soria,* Elihu Vedder: American Visionary Artist in Rome (1836–1923) *(Rutherford, N.J., 1970) and Joshua Taylor et al.,* Perceptions and Evocations: The Art of Elihu Vedder *(Washington, D.C., 1979).*

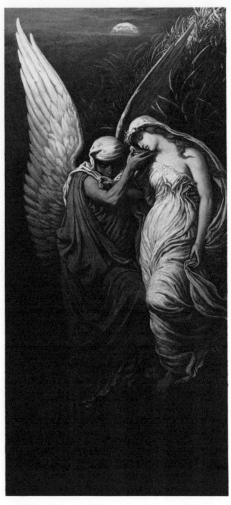

83

Elihu Vedder
The Cup of Death, 1885
Painted in Rome
Signed and dated lower right: *V. | 1885 | copyright 1899 by E. Vedder*
Oil on canvas, $44\frac{3}{8} \times 20\frac{3}{4}$ in. (112.7×52.7 cm.)
Virginia Museum of Fine Arts, Richmond

In 1883–84 Vedder created this design for his illustrated edition of the *Rubáiyát* of Omar Khayyám (a collection of epigrams by the twelfth-century Persian mathematician and astronomer). *The Cup of Death* was the first of two full-length painted versions based on the illustration.[1] The image was inspired by the following quatrain:

> *So when the Angel of the darker Drink*
> *At last shall find you by the river-brink,*
> *And, offering his Cup, invite your Soul*
> *Forth to your Lips to quaff—you shall not shrink.*

In keeping with the rhapsodic yet fatalistic sensuality of Omar's philosophy, the artist visualizes dying as a trancelike nocturnal journey through tall, slender reeds into a slow, dark river. The event transpires silently and without pain; nonetheless, the Angel of Death sheds a tear of grief for his innocent young victim. The translator of the edition used by Vedder[2] appended the following note to this quatrain: "According to one beautiful Oriental legend, Azrael [the Angel of Death] accomplishes his mission by holding to the nostril an Apple from the Tree of Life." Surely Vedder was struck by this idea, for the lethal cup held so close to the woman's face by the angel's large brown hand is the picture's most disquieting detail—a symbol of the irresistible force as well as the inevitability of death. However, as William Howe Downes observed in 1887, Vedder shows the sorrow of death to be "profound but not incurable":

> *Death is portrayed . . . not as a cruel conqueror . . . but as a merciful spirit, whose bowed head, downcast eyes, and protective attitude bespeak a humility approaching pity. It is a figure of Dantesque proportions, full of might and mildness. . . . [The victim's] unseeing eyes and increasing languor show too plainly that life is well-nigh past. But a roseate light from the farther side of the valley touches even Death's wide wings with an unearthly glow. It is the blessed hue of hope.*[3]

Consistent with the reforms of the Aesthetic Movement, the palette of *The Cup of Death* eschews the hard brilliance of contemporary academic art and ranges tastefully from subtle pinks and grays to sombre greens and dark blues and browns. Equally studied and restrained is the graceful rhythmic design constituted by the two figures. In much of his work, Vedder attempted to portray mythological worlds and the realm of the imagination, and his successes depended heavily upon the abstract power of the designs to hold the imagery somewhere between the real and the unreal. In *The Cup of Death* the moods evoked by colors and the expressive beauty of the heavy, clinging draperies are as important as the image in conveying the artist's symbolic vision. Thus the content and form of Vedder's painting have strong affinities with art by George Frederic Watts, Gustave Moreau, Edward Burne-Jones, as well as the book illustrations of Walter Crane.

The aestheticism of *The Cup of Death* marks a rejection of the unrestrained sentimentality that surrounded the theme of death in the mid-Victorian period, and takes formal inspiration from such noble and sensitive neoclassical monuments as Canova's *Monument to Maria Christina* (1799–1805; Augustiner-Kirche, Vienna).[4] As a rather sensuous image of languid descending motion, this work has an interesting relationship with a famous allegorical painting by William Rimmer (q.v.)—*Evening: Fall of Day* (1869; Museum of Fine Arts, Boston)—which Vedder probably saw on his 1882 visit to Boston. An even closer parallel is found in Alfred Gilbert's marble statue *The Kiss of Victory* (1878–81; Minneapolis Institute of Arts): executed in Rome (where Vedder lived), this work shows a naked warrior wounded in battle, receiving a kiss from the winged Genius of Victory, into whose arms he falls dying.[5] Despite its grounding in European Aestheticism, for at least one contemporary critic Vedder's art had American characteristics, most notably a "psychical quality":

> *. . . that charming, pathetic strangeness of idea, too often clad in a turgid phrase or a conventional type, which we meet in the works of Hawthorne and of Poe, no less than in the drawings of Vedder and Lafarge.*"[5]

T.J.F.

NOTES

1. The first edition of the Vedder *Rubáiyát* was published in Boston by Houghton Mifflin and in London by Quaritch in November, 1884. The other version of *The Cup of Death* (National Museum of American Art, Smithsonian Institution, Washington, D.C.) was left unfinished in 1885 because Vedder felt he had made the palette too somber; he completed it in 1911.

2. The first English translation of the *Rubáiyát* was made by Edward Fitzgerald in 1858. Vedder read it for the first time in Perugia in the summer of 1871. The text illustrated by Vedder is Fitzgerald's fourth edition (London, 1879), although the artist changed the sequence of verses 31 to 71. See Jane Dillenberger, "Between Faith and Doubt: Subjects for Meditation," in Joshua Taylor et al., *Perceptions and Evocations: The Art of Elihu Vedder* (Washington, D.C., 1979), pp. 127–49.

3. Downes, "Elihu Vedder's Pictures," *The Atlantic Monthly* 59 (June 1887): 844.

4. If Vedder did not know the Vienna work itself, he would have been familiar with the version that Canova's pupils made as a tribute to their master (1827; Frari, Venice). In both works classically draped mourners move slowly toward the door of the crypt for the spiritual reunion with the deceased.

5. A. Mary F. Robinson, "Elihu Vedder," *The Magazine of Art* 8 (1885): 122. See also Marjorie Reich, "The Imagination of Elihu Vedder—As Revealed in his Book Illustrations," *The American Art Journal* 6 (May 1974): 39–53.

PROVENANCE

The artist; by purchase to Miss Susan Minns through Williams and Everett Galleries, Boston, 1900; Mrs. John G. Booton, Boston; to present owner through Vose Galleries, Boston, 1977.

EXHIBITION HISTORY

Doll and Richards, Boston, *Exhibition of Works by Elihu Vedder*, 1887.

Williams and Everett's Galleries, Boston, *Exhibition of Works by Elihu Vedder*, 1900, cat.no.3.

American Academy of Arts and Letters, New York, *Exhibition of the Works of Elihu Vedder*, 1937, cat.no.113 (ill.).

National Collection of Fine Arts, Smithsonian Institution, Washington, D.C., *Perceptions and Evocations: The Art of Elihu Vedder*, cat. by Joshua Taylor et al., 1978–79 (traveling exhibition), no. 178 (ill.).

Grey Art Gallery and Study Center, New York University, and Helen Foresman Spencer Museum of Art, University of Kansas, Lawrence, *American Imagination and Symbolist Painting*, 1979–80, cat.no.63 (ill.).

John White Alexander

(1856, Allegheny City, Pennsylvania —1915, New York City)

Alexander began his professional career as an illustrator at Harper Brothers, New York, in 1875. In Europe (1877–81) he studied briefly at the Munich Academy, then worked with Frank Duveneck (q.v.) and his circle of American painters in Polling (Bavaria), Florence, and Venice. In New York in the 1880s he became successful as an illustrator and as a fashionable portrait painter. From 1890 to 1901 he lived in Paris and was a close friend of Whistler, Rodin, Mirbeau, Mallarmé, and Henry James; his Parisian portraits and figure pieces show a decorative, tonalist style related to Art Nouveau. He returned to New York in 1901 and was president of the National Academy of Design from 1909 to 1915. He executed mural decorations for the Library of Congress, Washington, D.C. (1895–96) and the Carnegie Institute, Pittsburgh (1905–15).

There is no monograph on Alexander. Two recent exhibitions have been devoted to his works, one at the National Collection of Fine Arts, Smithsonian Institution, Washington, D.C. (1976–77), the other at the Graham Gallery, New York (1980). The catalogues for these shows contain extensive bibliographies.

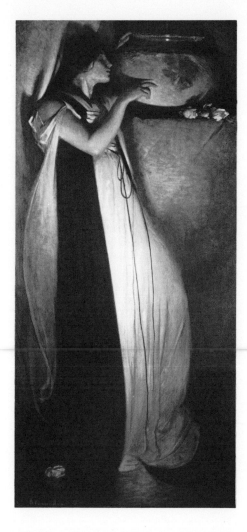

84

John White Alexander
Isabella and the Pot of Basil, 1897
Painted in Paris
Signed and dated lower left: *John Alexander 97*
Oil on canvas, 75½ × 35¾ in. (191.8 × 90.8 cm.)
Museum of Fine Arts, Boston,
 Gift of Ernest Wadsworth Longfellow

This painting was inspired by Keats's poem *Isabella; or The Pot of Basil* (1820), which retells a story from Boccaccio's *Decameron* (c. 1350). Isabella, a beauty from a Florentine merchant family, falls in love with their attractive business manager, Lorenzo; her jealous and ambitious brothers murder Lorenzo, but tell Isabella that he has been called abroad. She suffers a lovesick decline and eventually, in a dream, has a vision of Lorenzo's death. She unearths the corpse in the forest, cuts off the head and washes it with her tears, and secretly places it in a plant pot, wherein she sows sweet basil (a plant associated with lovers).

Alexander focuses on the lethargic, otherworldly state of mind which is the quintessentially Romantic concern of Keats's poem. Keats writes of this gloomy with-

drawal: ". . . simple Isabel is soon to be / Among the dead: She withers, like a palm / Cut by an Indian for its juicy balm." Alexander's *Isabella*, painted at the height of his Parisian career, exemplifies decadent, fin-de-siècle taste. It received its debut at the Salon du Champs-de-Mars in 1897.

The macabre and mysterious *Isabella* is unusual in Alexander's oeuvre, although *Pandora*, painted a year later,[1] employs similar devices: the settings in both pictures are shallow and dimly lit, the voluminous dresses are arranged in broad decorative sweeps, the subjects' shoulders are wantonly bared, and a slightly erotic mood prevails. Twenty years earlier the English Pre-Raphaelite artist William Holman Hunt had painted another life-sized version of Isabella (1867; Laing Art Gallery, Newcastle-upon-Tyne). Hunt's historicist and anecdotal concerns engendered a wide-eyed, entranced Isabella in a rich, colorful scenario with marble floors, exotic furnishings, and a large basil plant. In contrast, Alexander chose a spare setting and a Whistlerian, almost monochrome palette to make a visual metaphor for his bizarre subject—a slow, wasting death brought on by remorse. The laced black bodice merely alludes to Renaissance costume, and the dress serves as a fantastic design motif. Its sinuating, flowing lines display the pre-eminent decorative style of the *belle époque*: Art Nouveau. The picture is broadly and flatly painted on a coarsely woven canvas. A basic palette of blacks, whites, and grays is elaborated with eerie lavender and blue-green hues. The gloomy light gives the flesh a clammy sheen, which underscores the decadent mood of the picture.

When the painting was exhibited in New York in 1898, a reviewer for the *New York Times* criticized the influence of recent graphic art (presumably thinking of Chéret, Mucha, and Toulouse-Lautrec): "[It] . . . has all the artist's grace of line and color sense, but the wind-blown gown and the composition are too suggestive of the now happily waning poster craze."[2] Alexander would emphasize organic, decorative lines in many subsequent society portraits and female figure studies, but these works lack the emotional pitch of *Isabella*. In treating the essential mood of Keats's poem (and not worrying about historical accuracy), Alexander sought to make an image of a psychological state, a theme explored in greater depth by his contemporaries Gustav Klimt and Edvard Munch. In 1900 Gabriel Mourey wrote of Alexander's *Isabella*: "Here he inaugurated the series of his feminine fantasies, wherein he has seized so subtly, so mysteriously, the gestures, the attitudes, and the movements of modern womankind."[3]

T.J.F.

NOTES

1. *Pandora* (unlocated) is reproduced in *Harper's Monthly Magazine* 99 (1899): 698. A pencil study is owned by the Federal Reserve System, Washington, D.C.

2. *New York Times* (*Saturday Review of Books and Art*), 19 March 1898, p. 191.

3. Mourey, "An American Painter in Paris: John W. Alexander," *International Studio* 11 (August 1900): 76.

PROVENANCE

To present owner from Boston artist Ernest Wadsworth Longfellow, 19 March 1898.

EXHIBITION HISTORY

Paris, *Salon du Champ-de-Mars*, 1897, cat.no.13.

Carnegie Institute, Pittsburgh, *Annual Exhibition*, 1897, cat.no.3.

Pennsylvania Academy of the Fine Arts, Philadelphia, *67th Annual Exhibition*, 1898, cat.no.1.

Society of American Artists, New York, *20th Exhibition*, 1898, cat.no.267.

Herron Museum of Art, Indianapolis, *Inaugural Exhibition*, 1906, cat.no.8.

Carnegie Institute, Pittsburgh, *J. W. Alexander Memorial Exhibition*, 1916–17 (traveling exhibition), cat.no.2.

National Academy of Design, New York, *Centennial Exhibition*, 1925–26, cat.no.309.

Metropolitan Museum of Art, New York, *19th-Century America: Paintings and Sculpture*, cat. by John K. Howat and Natalie Spassky, 1970, no.200 (ill.).

American Federation of Arts, New York, *Revealed Masters: 19th Century American Art*, cat. by William H. Gerdts, 1974–75 (traveling exhibition), no.1 (ill.).

GEORGE INNESS

(1825, Newburgh, New York
—1894, Bridge-of-Allan, Scotland)

Inness, a grocer's son, received a modest artistic education in the early 1840s: he studied briefly in Newark, New Jersey, with itinerant American artist John J. Barker, then in New York City with Régis Gignoux (a Frenchman who arrived there around 1840), while he earned a living as an engraver. He began to exhibit landscape paintings at the National Academy of Design in 1844, and at the American Art-Union in 1845; the dominant influence on these early works was Asher B. Durand (q.v.). During his first visit to Europe (1851–52), Inness was deeply affected by the classical landscapes of Gaspard Poussin and Claude Lorrain. His subsequent American pictures suggested the influence of seventeenth-century compositional formulae, and he was quickly admonished by critics for not paying sufficient attention to the specifically American features of the local landscape. Thus he became an outsider to the prevailing aesthetic of objective, literal landscape art which had evolved with Cole and Durand, an art which, in the 1850s, was strictly Ruskinian in its emphasis on "truth to nature." However, Inness was encouraged in his instinctive commitment to painterliness and emotional expressiveness when he saw modern French landscapes by Rousseau, Daubigny, and Corot (now known as the Barbizon School) in Paris in 1853–54, and again later when he worked in England, France, and Italy, and especially Rome (1870–74).

Inness was an epileptic and also had a volatile temperament, and like the stereotypical Romantic artist, he often worked at fever pitch on a group of pictures. He became a Swedenborgian in the mid-1860s and grew increasingly concerned to communicate the spiritual world he intuited in landscape. In the late 1870s he even began to attach poems to the frames of some pictures to enhance their intended messages.

Though well patronized even in the 1850s and '60s and admired by "advanced" critics including James Jackson Jarves, Inness's reputation in no sense came to rival that of Frederic E. Church and Albert Bierstadt (q.v.). However, unlike these contemporaries, he survived the crucial change in taste of the 1870s, instigated in large part by younger artists who had recently learned painterly methods in Europe. In the last decade of his life, Inness was much praised for his expressive and extremely personal use of color: the late landscapes are his most abstractly designed, philosophically harmonious, and transcendent works. He died in 1894, on his fourth visit to Europe.

The most recent monograph on the artist is by Nicolai Cikovsky, Jr. (New York, 1971). There is an illustrated catalogue raisonné by LeRoy Ireland (Austin, Texas, 1965), and an important early book by the artist's son, George Inness, Jr., Life, Art, and Letters of George Inness (New York, 1917).

85

GEORGE INNESS
Lake Albano, c. 1873–75
Probably painted in Italy
Signed and dated lower left: *Geo Inness 1869 [?]*
Oil on canvas, 30⅜ × 45⅜ in. (77.2 × 115.3 cm.)
The Phillips Collection, Washington, D.C.

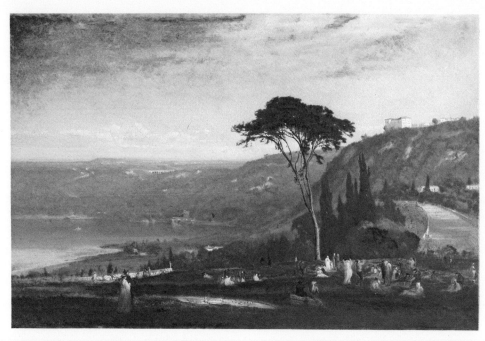

Inness's *Lake Albano* belongs to the tradition of Northern enchantment with the Italian pastoral landscape that began in French, Dutch, and Flemish art of the seventeenth century. In the hundred years preceding Inness's work, the Englishmen Richard Wilson and John Robert Cozens, the German Karl Blechen, and the Americans Thomas Cole (q.v.) and Christopher Pearse Cranch all worked at Lake Albano.[1] Like neighboring Lake Nemi, this lake occupies a volcanic crater high above sea level, about fourteen miles from Rome. In Inness's picture, the white building at the right is probably the Capuchin convent above the town of Albano. The foreground may be the park of the Villa Barberini; the vista beyond the lake includes a sunlit section of an aqueduct or viaduct and a pearly luminosity reflected from the Mediterranean, on the horizon.

The artist's confident articulation of the space and the chromatic subtleties of air and light suggest that *Lake Albano* was painted in Italy rather than in America, around 1873, when Inness produced many landscapes of the Roman Campagna and the Alban Hills.[2] The composition employs Claudian devices, particularly the rhythmic division made by the large solitary stone pine and the careful attempt to render the nebulous beauty of the far distance. Inness had introduced such traditional allusions into his art after his first visit to Italy (1850–52); they are apparent in the early American landscape *The Lackawanna Valley* (1855; National Gallery of Art, Washington, D.C.). However, in *Lake Albano* the artist's mature apprehension of the Claudian vision and his equally perceptive grasp of the Alban terrain are brilliantly combined. The pictorial setting is lively and complex: the downward slope of rambling foreground meadow is countered by the upward rise of the road at the right; the more severe drop to the basin and the lake contrasts with the ethereal view up to the convent and across the horizon. Inness relishes the sensuous diversity of colors—all manner of greens for the different plants, tinted shadows, silvery clear air, and fluffy pink clouds at the horizon—but his draftsmanship takes firm control of the complex topography and thus prevents the picture from being simply a tonal exercise without spatial depth.

Unlike such nativist artists as Asher B. Durand (q.v.), who proposed that American painters focus primarily on the peculiarly local features of the American wilderness, Inness maintained an open mind about his subjects and focused on their humanitarian associations:

> I love [the civilized landscape] and think it more worthy of reproduction than that which is savage and untamed. It is more significant. Every act of man, every thing of labor, effort, suffering, want, anxiety, necessity, love, marks itself wherever it has been. . . . American landscape, perhaps, is not so significant; but still every thing in nature has something to say to us.[3]

Lake Albano exemplifies the civilized landscape Inness preferred. The artist was fully attuned to the gracious beauty of this environment, which had been cherished since the days of ancient Rome. The deliberately sketchy figures picnicking and dancing are archetypal colorful peasants: the occasion they celebrate might be a wedding (observe the one woman in white nearest the big tree) or one of the many holidays when villagers gathered to sing, dance, dine, and enjoy beautiful scenery. With glowing late-afternoon light directly illuminating these characters, the artist seems to suggest that their lives belong to an ancient cultural tradition stretching back to the classical Golden Age. *T.J.F.*

NOTES

1. Most artists worked on the opposite lakeshore, where the view includes the fortress town of Castel Gandolfo with the dome of Bernini's San Tomaso da Villanova. See, e.g., Cranch's *Castel Gandolfo* (1852; Corcoran Gallery of Art, Washington, D.C.) and J. R. Cozens's two drawings *Lake Albano* and *Castel Gandolfo* (c. 1779 and c. 1784; both Paul Mellon Collection, Yale Center for British Art, New Haven, Conn.).

2. The inscribed date on this picture has always been read as 1769, which would make it an American work, predating the 1870–74 European visit. However, stylistically the picture belongs with the landscapes painted in Italy in the early 1870s (many of them dated 1872 and 1873). It might have been painted soon after the artist's return to America in 1875, but the date of 1769 is unacceptable (and may have been added after the artist's death).

3. Quoted in George Inness, "A Painter on Painting," *Harper's New Monthly Magazine* 56 (February 1878): 46.

PROVENANCE
Nickerson Collection; with C. W. Kraushaar Galleries, New York; to present owner, 1920.

EXHIBITION HISTORY
Museum of Modern Art, New York, *American Painting and Sculpture, 1862–1932*, 1932–33, cat. no. 55.
Wadsworth Atheneum, Hartford, Conn., *American Painting, American Sculpture, Three Centuries*, 1935, cat. no. 25.
Century Club, New York, 1938.
Corcoran Gallery of Art, Washington, D.C., *De Gustibus: An Exhibition of American Paintings Illustrating a Century of Taste and Criticism*, 1949, cat. no. 19.
Colorado Springs Fine Arts Center, 1942–44.
George Walter Vincent Smith Art Museum, Springfield, Mass., *George Inness: An American Landscape Painter*, 1946 (traveling exhibition), cat. no. 20.
University of Texas, Austin, *Retrospective Exhibition: Paintings by George Inness*, cat. no. 29 (ill.).
University of Kansas Museum of Art, Lawrence, *The Arcadian Landscape: Nineteenth-Century American Painters in Italy*, cat. by Charles C. Eldredge, 1972, no. 25 (ill.).
Phillips Collection, Washington, D.C., *Master Paintings from the Phillips Collection*, cat. by Eleanor Green and Robert Cafritz, 1981–83 (traveling exhibition) (ill.).

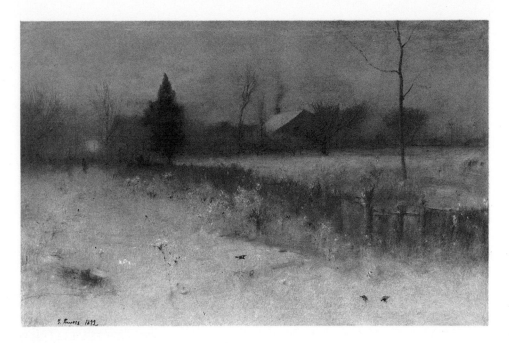

86

GEORGE INNESS
Home at Montclair, 1892
Painted in Montclair, New Jersey
Signed and dated lower left: *G. Inness 1892*
Oil on canvas, 30⅛ × 45 in. (76.5 × 114.3 cm.)
Sterling and Francine Clark Art Institute,
 Williamstown, Massachusetts

Inness did not begin to achieve broad-based critical acclaim until the late 1870s, when he was in his fifties. In 1884 a retrospective exhibition in New York revealed his long commitment to experimental landscape paintings, outside the Hudson River School mainstream. The 1884 exhibition also demonstrated the aesthetic affinities between Inness and the controversial younger generation of painterly Impressionist artists; in fact, he had exhibited with them at the Society of American Artists several times since their first exhibition in 1878. During this fruitful late period, Inness's landscapes attained a new level of imaginative abstraction, as seen in the wintery elegy of 1892, *Home at Montclair*. It is just as emotionally expressive as the earlier *Lake Albano* (cat.no.85), but its register is one of delicacy and sensitive refinement. It has the softness of certain charcoal drawings by Rousseau and the magic etherealness of a late Corot twilight.

The rural township of Montclair, New Jersey, became Inness's home in 1878. The scene in *Home at Montclair* is that behind the artist's house: two fields separated by a hedge and fence that lead to the neighboring farmstead with its screening trees. In the last decade of his life, Inness painted many lush spring and summer pictures in these meadows, but few winterscapes.[1] Furthermore, he depicted the leaden atmosphere of a misty evening rather than the brilliant effects of sun or snow which usually attracts artists. Thus the tall pine on the horizon makes a somber black-green accent, and the setting sun is dull orange-pink. Inness seems to stress the absence of the green life-giving forces in nature's winter dormancy. The snow blanket and strange orange sky create an unearthly state of quietude; nonetheless, it is a godly landscape, addressing spiritual withdrawal rather than desperate isolation. The small bundled figure before the sun will surely find warmth and comfort at the farm with the smoking chimney, and the birds fluttering in the foreground will soon nest.

The artist's technique in *Home at Montclair* is diverse: the background paint is lightly and thinly applied, leaving a sense of the weave of the canvas; the boughs of the trees are painted over this in soft, hesitant lines that recall charcoal drawings in their effect; the large foreground area of snow is rendered with freely worked white impasto on a gray ground and further elaborated with touches of grays, fawns, and blues. The painterliness of the foreground and the forceful articulation of the otherwise flattened scheme by the diagonal, sharply receding fence were the kinds of features for which Inness was compared to the French Impressionists around 1870. However, the artist considered the style a fad and was outraged by this facile categorization of his work; indeed he resisted the Impressionist label as strongly as that of the Hudson River School. Inness maintained an independent stance; he deplored the systematized quasi-scientific orthodoxy of both these opposing styles in favor of landscape art that was tolerably objective or realistic, but essentially inspiring, thought-provoking, and directly expressive of his own emotional experience:

While pre-Raphaelitism is, like a measure-worm, trying to compass the infinite circumference, impressionism is the sloth enwrapped in its own eternal dullness. Angularity, rotundity involving solidity, air and light involving transparency, space and color involving distance, these constitute the appearances which the creative mind produces to the individualized eye, and which the organized mind endorses as reality.[2]
 T.J.F.

NOTES
 1. A roughly contemporary example is *Winter Evening* (1887; Private Collection), no. 1259 in LeRoy Ireland's catalogue raisonné. A fine snow scene in Inness's earlier, more vividly colored style is *Winter, Close of Day* (1866; Cleveland Museum of Art).
 2. Inness, quoted in J. R. W. Hitchcock's introduction to the catalogue *Special Exhibition of Oil Paintings, Works by Mr. George Inness, N.A.* (The American Art Galleries, New York, 1884), p. 13. Inness then jokingly refers to his determination to maintain his artistic independence: ". . . as I do not care about being a cake I shall remain dough, subject to any impression which I am satisfied comes from the region of truth."

PROVENANCE
The artist; James W. Ellworth, New York; Bernon S. Prentice, New York; with M. Knoedler & Co., New York, 1952; to present owner, 1955.

EXHIBITION HISTORY
M. Knoedler & Co., New York, *A Half-Century of Landscape Paintings by George Inness*, 1953 cat. no. 24.
M. H. de Young Memorial Museum, San Francisco, *American Tonalism, 1880–1910*, cat. by Wanda Corn, 1972, no. 20 (ill.).

ALBERT PINKHAM RYDER

(1847, New Bedford, Massachusetts
—1917, Elmhurst, New York)

Ryder was born and raised in the busy whaling center of New Bedford, Massachusetts. At the age of twenty, he moved with his family to New York City, where he lived most of the rest of his life. Just as Ryder's formal education ended with grammar school, his artistic education was not much more extensive, and he was mainly self-taught. He began painting in New Bedford with the guidance of only a local amateur. In New York, rejected upon his first application to the school of the National Academy of Design, he received guidance from a minor artist, William Edgar Marshall (1837–1906), a portraitist and painter of religious scenes. When finally admitted to the National Academy of Design, Ryder remained there for four seasons—not a lengthy period of training—studying primarily drawing. Although Ryder traveled to Europe four times, in 1877, 1882, 1887, and 1896, he remained surprisingly disinterested in both its academies and avant-garde art.

Ryder's work consists primarily of small, imaginary genre and landscape scenes painted on panel or canvas. Many are interpretations of the literary themes that passionately interested him: he took subjects from Chaucer, Shakespeare, the Bible, Byron, Tennyson, and Poe. He exhibited his work in New York's galleries and artists' associations, where they attracted little attention until the last years of his life. At that time he was reported to be a reclusive eccentric. It is true that Ryder shunned the amenities of life to become completely absorbed in his art. Correspondingly, in his artistic practice he rejected the conventions of illusionistic representation and the standard use of materials. He was not, however, isolated from his fellow artists. In New York he knew Julian Alden Weir and other painters who respected his artistic ideas. He supported the cause of independent painters by becoming, in 1877, one of the twenty-two founders of the Society of American Artists.

Ryder has been labeled one of the most visionary of nineteenth-century American painters. His art was relatively neglected in his own time, but after his death he gained international recognition as a forerunner of modernism, and his work began to be admired for what was perceived as its primitive originality and symbolic abstract forms.

Ryder left one brief account of his life and work, "Paragraphs from the Studio of a Recluse," printed in Broadway Magazine *in September 1905. John Robinson reported more of Ryder's reminiscences in* Art in America *(June 1925). The principal monographs on Ryder were written by Frederic Fairchild Sherman in 1920 and Lloyd Goodrich in 1959. The most extensive exhibitions of Ryder's work were those mounted by the Metropolitan Museum of Art in the year after his death, and by the Whitney Museum of American Art in 1947 on the occasion of the centenary of the artist's birth.*

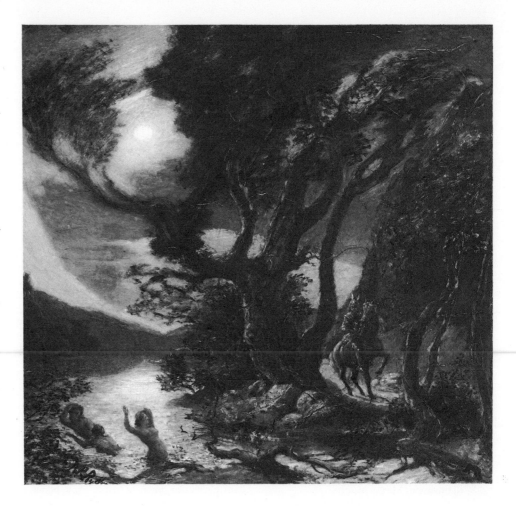

87

ALBERT PINKHAM RYDER
Siegfried and the Rhine Maidens, 1888–91
Painted in New York City
Signed lower left: *A. P. Ryder*
Oil on canvas, $19\frac{7}{8} \times 20\frac{1}{2}$ in. (50.5 × 52.1 cm.)
National Gallery of Art, Washington, D.C.,
 Andrew W. Mellon Collection, 1946

Of all Ryder's paintings, *Siegfried and the Rhine Maidens* best reveals his attitudes toward subject and its representation. Ryder was especially attracted to myths and legends that told of great drama and supernatural events occurring in an indeterminate past; yet he always interpreted those legends in a highly personal way, depicting equivalents of objects rather than convincing illusions of them.

The viewer of this painting is struck first, not by the figures who act out the story, but by the dark, luminous, and heavily glazed masses of curves and swirls that create the unearthly beauty in this nocturnal landscape. To a modern observer, these shapes and colors make the painting interesting; but art critics of the 1880s disparaged what they perceived as Ryder's inattention to drawing and anatomy and the darkness and murky vagueness of the painting.

Ryder reported that he was inspired to paint *Siegfried and the Rhine Maidens* by Wagner's *Götterdämmerung:* "I had been to hear the opera and went home about 12 o'clock and began this picture. I worked for 48 hours without sleep or food, and this picture was the result."[1] Wagner's opera was performed in New York on two occasions, on 25 January 1888—its United States premiere—and 4–11 March 1889, as part of the *Ring des Nibelungen*. Ryder exhibited the painting in 1891, but probably continued working on it after that, as the build-up of the paint surface suggests. Ryder portrayed a scene from the final act of the opera: Siegfried, the hero of the *Ring* cycle, is hunting on the banks of the Rhine and comes upon the three Rhine Maidens who ask him to surrender his ring, made from the magic, power-bestowing Rhinegold, which he had taken from them. The scene itself is uneventful, but it does present two symbolic forms central to Wagner's opera: the Rhine Maidens are an emblem of fate, and Siegfried is the embodiment of heroic struggle against fate's inevitable force.

Ryder's artistic choices in this work are characteristic of his untraditional practices in depicting myths and legends. First, he chose a Germanic legend of great loftiness, yet

rendered it on a diminutive scale. Second, though he chose a specific theme from a dramatic opera, he did not focus on the story itself. The landscape is the major actor here: the tree, clouds, and night sky make the grand gestures in the painting and convey emotion and agony; Siegfried and the Rhine Maidens are limp and doll-like. This emphasis upon supernatural ambience rather than the action of individuals appears in many of Ryder's paintings. Such transference of human identity to natural forces characterized earlier nineteenth-century European Romanticism, and reveals Ryder as an inheritor of that tradition.

Siegfried and the Rhine Maidens was one of two paintings by Ryder directly inspired by Wagner's music. The other was *The Flying Dutchman* (National Museum of American Art, Smithsonian Institution, Washington, D.C.), which the artist had exhibited in 1887. These two works are the most rhythmically complex of his compositions. In each the landscape elements twist and turn in a sinuous fashion suggestive of the fluid tones of music. It was not unusual in Ryder's generation for music to be an inspiring element in the visual arts, if Thomas Wilmer Dewing, James McNeill Whistler, and Ralph Blakelock can be cited as examples. Ryder was probably less concerned with the fashionable currency of musical themes in art than with music's ability to stimulate the painter's creative sensibilities.

D.S.

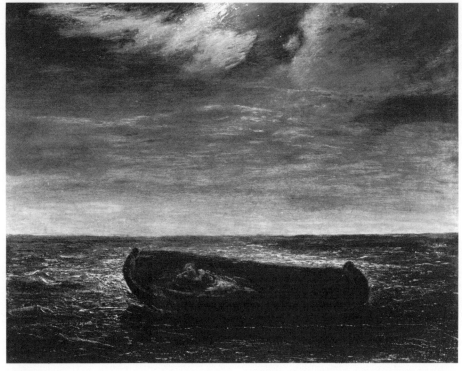

88

Albert Pinkham Ryder
Constance, 1896
Painted in New York City
Oil on canvas, $28\frac{1}{4} \times 36$ in. (71.7×91.4 cm.)
Museum of Fine Arts, Boston,
 Abraham Shuman Fund

NOTES

1. Quoted in Elliott Daingerfield, "Albert Pinkham Ryder, Artist and Dreamer," *Scribner's Magazine* 63 (March 1918): 380.

PROVENANCE
Richard Haines Halsted, New York, c. 1891; Sir William Cornelius Van Horne, Montreal (?), to 1945; Parke Bernet Galleries, 1946; Andrew W. Mellon Collection; to present owner, 1946.

EXHIBITION HISTORY
Society of American Artists, New York, 1902.
Metropolitan Museum of Art, New York, *Albert P. Ryder Memorial Exhibition*, 1918.
Whitney Museum of American Art, New York, *Albert P. Ryder Centenary Exhibition*, cat. by Lloyd Goodrich, 1947, no. 38.
Carnegie Institute, Pittsburgh, *American Classics of the 19th Century*, 1957 (traveling exhibition), cat.no.81.

Ryder usually limited his work to extremely small panels and canvases, often one foot square or smaller. However, between 1885 and 1896 he began five paintings of about 29×36 inches, a relatively monumental size for him. The paintings were *Jonah* (c. 1885; National Museum of American Art, Smithsonian Institution, Washington, D.C.), *The Tempest* (1892; Detroit Institute of Arts), *Macbeth and the Witches* (1890–1908; Phillips Collection, Washington, D.C.), *The Race Track; or, Death on a Pale Horse* (1895–1910; Cleveland Museum of Art), and *Constance*. The artist intended the five works to be his major artistic statements.

These works can be considered as a series. All relate stories of human daring and frailty at moments when supernatural forces take control over life and death. The subject for *Constance* comes from Chaucer's *The Man of Law's Tale*. Constance, daughter of the Emperor of Rome, and her infant son were treacherously abandoned at sea in a boat without rudder or sail. They miraculously were kept alive for five years until their boat drifted back to Rome. Ryder may have considered the tale a counterpart to the Old Testament story of Jonah and the whale, a painting of which he had completed before he began *Constance*. The tale from Chaucer may also have served as a literary link between his biblical and Shakespearian subjects.

At first glance, Ryder's *Constance* appears somewhat static and empty, conveying little of the emotional impact of Chaucer's story. However, on closer examination the composition is indeed complex. The entire picture is arranged to focus the viewer's attention on

two specific passages: Constance's expression of despair as she lies in the boat clutching her child, and the subtle aureole of benevolent light that surrounds the boat, outside Constance's range of vision. Early photographs of this painting reveal that both these details were once much more evident than they appear now, victim to the accelerated deterioration that has plagued most of Ryder's paintings.

Ryder's unconventional painting technique is evident here. The paint is elaborately layered onto the canvas, particularly in the area of the water, where the surface is thick with minute strokes of pigment mixed with varnish. Ryder was attempting to duplicate the luminous glazing technique used by Washington Allston (q.v.) and other early Romantic painters. The desired effect was a scene full of translucent shadows that would reveal flickers of different colors beneath. This laborious working method reflects Ryder's devotion to the act of painting. For him, a painterly style provided creative freedom that could not be found in other mediums.

The image of a boat upon a moonlit sea was one that Ryder used repeatedly in his mature work. The special significance that this imagery had for him usually has been explained by referring to the artist's New Bedford childhood. Yet Ryder's vessels are those of myth, not his own memory. They carry a faint suggestion of the well-known moonlit seascapes of artists like Claude and Vernet. These images, as well as his painting technique, suggest that Ryder may have been striving to revive, in his own way, something of the great art of the past.

D.S.

PROVENANCE
Sir William Van Horne, Montreal, before 1905; Lady Van Horne, Montreal, by 1918; Art Association of Montreal, 1918–45; to present owner, 1945.

EXHIBITION HISTORY
Worcester Art Museum, Mass., *15th Annual Exhibition of Art*, 1912, cat.no.43.
Metropolitan Museum of Art, New York, *Loan Exhibition of the Works of Albert P. Ryder*, 1918, cat.no.43.
Whitney Museum of American Art, New York, *Albert P. Ryder Centenary Exhibition*, cat. by Lloyd Goodrich 1947, no.5.
Museum of Fine Arts, Boston, *American Marine Paintings*, cat. by Richard McLanathan 1955, no.21.
Corcoran Gallery of Art, Washington D.C., *The American Muse*, 1959, cat.no.65.
Swain School of Design, New Bedford, Mass., *Ryder-Bierstadt*, 1960 (traveling exhibition), cat.no.4.
Corcoran Gallery of Art, Washington D.C., *Ryder Retrospective*, cat. by Goodrich 1961, no.56.

CHILDE HASSAM

(1859, Dorchester, Massachusetts
—1935, East Hampton, New York)

The son of a Boston hardware merchant, Hassam was apprenticed to a Boston wood engraver in 1876 and soon worked locally as a free-lance illustrator. At the same time, he attended evening art classes sponsored by the Boston Art Club and took private lessons from local artists, including the aged William Rimmer (q.v.) and recent German immigrant Ignaz M. Gaugengigl (1855–1932). Following an extensive tour of Europe in 1883, Hassam won critical acclaim in Boston with the watercolors he brought home. Thereafter he produced his first important Boston oil paintings, urban landscapes with charming figurative details. During a three-year stay in Paris (1886–89), he studied at the Académie Julian and exhibited a few street scenes at the Salon. Returning to America, he settled in New York, where he became a leading exponent of Impressionism, producing landscapes, city views, and interior genre pictures in pastels, watercolors, and oils. From the early 1890s on, he remained a successful, influential, and prolific artist. He was a founding member of the independent group of "The Ten American Painters," who in 1897 seceded from the Society of American Artists in order to show their largely Impressionist works in the small, nonjuried exhibitions they held annually from 1898 to 1918. In 1913 Hassam showed twelve works at the Armory Show. His subjects and style remained essentially the same after 1890, excepting the famous series of patriotic paintings of flags in Manhattan (1917–18). Having produced several fine book illustrations in the 1890s, he made many etchings and lithographs in the 1910s and '20s.

There are two monographs on Hassam, one by Adeline Adams (New York, 1938) and another by Donelson Hoopes (New York, 1979), and a good summary of his career in William H. Gerdts, American Impressionism *(Henry Art Gallery, University of Washington, Seattle, 1980), pp. 57–61.*

89

CHILDE HASSAM
Rainy Day in Boston, 1885
Painted in Boston
Signed and dated lower right:
 Childe Hassam / *1885* [crescent motif]
Oil on canvas, 26⅛ × 48 in. (66.4 × 121.9 cm.)
The Toledo Museum of Art, Ohio,
 Gift of Florence Scott Libbey

Before Hassam's trip to Europe in 1883, his subjects had tended to be picturesque rural and coastal scenes, and his preferred medium was watercolor. *Rainy Day in Boston* is his first major oil painting and an ambitious treatment of the urban landscape, a novel work by Boston standards. It shows the conjunction of Columbus Avenue (at the left) and Appleton Street, the neighborhood in the South End where Hassam and his wife lived. At the end of the vista down Columbus Avenue lies the Public Garden and the center of town, and the streetcars that traveled this major access route are visible in the middle distance. Most of the houses reflect the French Second Empire style practiced in Boston in the 1860s and '70s. Boston's newest architectural mode and urban plan echoed, in smaller scale, the new face which Baron Haussmann created when redeveloping key areas of Paris for Napoleon III.

The composition celebrates the convenience and spaciousness of the modern Boston cityscape: its wide angle of vision, sharp, deep perspective, and big empty foreground conjure up an environment at once clean and elegant. Hassam was attracted to the pictorial effects produced by the rain: the streets were relatively empty and the perspectives of buildings therefore more apparent; the wetness gave the roads and pavements shiny reflections and the damp red bricks a richer color; and the mist and

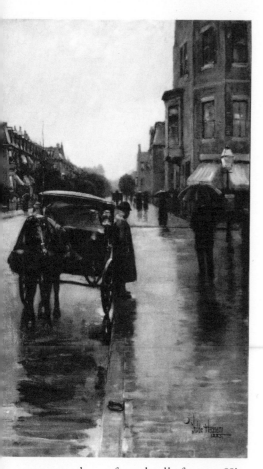

overcast sky softened all forms. His inspiration came from the popular painters of modern Paris, most notably Giuseppe de Nittis (1846–1884) who managed to capture the excitement of the big new spaces in bold compositions, then populated them with anecdotal figural groups that had far more conventional appeal than the more progressive cityscapes of the French Impressionists.[1] Furthermore, Hassam's handling cannot yet be labeled Impressionist: it recalls that of his late Boston friend and kinsman, William Morris Hunt (1824–1879), who had championed the Barbizon painters. Thus Hassam avoids elaborate detail and applies paint smoothly and generously but without bravura. Like Hunt he enjoys the subtleties of a limited palette (in this case dull pinks, reds, grays, and blacks) and strives for an overriding simplicity of effect.

Rainy Day in Boston was Hassam's first work shown with the Society of American Artists in New York in 1886. One critic offered the backhanded compliment, ". . . Hassam's 'Rainy Day' in the Boston Back Bay district is properly gloomy and dispiriting. . . ."[2] Surely the critic was wrong in disparaging the picture as gloomy, for the scene is pervaded with a soft rosy tone and the light rain does not seem to discourage the pedestrians.[3] This writer was even more off the mark in mistaking Hassam's location as the Back Bay instead of the South End, for the former was

the newest and most fashionable residential neighborhood in town. Despite the stylishness of Hassam's picture, the South End was not a place where the upper class lived. Such fine points were touched upon in two famous novels about Boston, which had been serialized in *The Century Magazine* early in 1885: Henry James' *The Bostonians* and William Dean Howell's *The Rise of Silas Lapham*. Although these novels have a critical dimension lacking in Hassam's picture, the painter's choice of subject was most timely. Indeed his next major canvas was another local scene with a glimpse of street cars and modern buildings, *Boston Common at Twilight* (1885–86; Museum of Fine Arts, Boston). This work is similar to *Rainy Day in Boston* in its tonalism and bold organization, but it is a snow scene. At the height of his career in New York in the 1890s, the grand architecture of the modern avenues and city parks became the setting for many of Hassam's Impressionist pictures, which are more brilliantly lit and more vigorously painted than his atmospheric Boston work.[4]

T.J.F.

NOTES

1. For a discussion of the connection with de Nittis, see Jennifer A. Martin Bienenstock, "Childe Hassam's Early Boston Cityscapes," *Arts Magazine* 55 (November 1980), pp. 168–171. The most striking parallel with *Rainy Day in Boston* in French Impressionist art is Gustave Caillebotte's *Rue de Paris: Temps de pluie* (1877; Art Institute of Chicago), but it seems more likely that Hassam's city painting was inspired by the more conservative artists associated with the Salon.

2. "The American Artists' Exhibition," *The Art Amateur* 15 (June 1886): 25.

3. The woman and child sharing the umbrella in the left foreground seem to be smiling; these two figures are exactly repeated as the subject of Hassam's painting *A Wet Day in the City*, dated 1886, and reproduced in the catalogue of the Boston Art Club's January 1886 *Exhibition of Oil Paintings* (no.45). The same exhibition included Hassam's *Columbus Avenue in the Rain* (no.61; unidentified).

4. For Hassam's comments on his cityscapes, see A. E. Ives, "Mr. Childe Hassam on Painting Street Scenes," *The Art Amateur* 27 (October 1892): 116–17.

PROVENANCE

The artist; Mary Woodard, Boston; with Hirschl and Adler Galleries, New York, 1955; to present owner, 1956.

EXHIBITION HISTORY

Society of American Artists, New York, *Eighth Exhibition*, 1886, cat.no.58 (as *A Rainy Day*).
Hirschl and Adler Galleries, New York, *Childe Hassam, 1859–1935*, 1964, cat.no.11.
Corcoran Gallery of Art, Washington, D.C., *Childe Hassam, A Retrospective Exhibition*, 1965 (traveling exhibition), cat.no.1.

90

JOHN SINGER SARGENT
Venetian Interior, c. 1882
Probably painted in Venice (possibly Paris)
Signed lower left: *John S. Sargent*
Oil on canvas, 27 × 34 in. (68.6 × 86.4 cm.)
Museum of Art, Carnegie Institute,
 Pittsburgh, Purchase, 1920

Sargent made extended visits to Venice in the fall and winter of 1880 and the summer of 1882, painting interior genre scenes such as this, similarly organized outdoor figure pieces, and at least one Whistlerian misty cityscape. *Venetian Interior* represents a long hall (probably on the *piano nobile* of a palazzo) with six women and a child: in the shadows at the left the seated figure may be stringing beads; the central pair stroll slowly; and at the end of the room two women mind the infant, while another leans over the balustrade in full sunlight. The picture captures the unique Venetian characteristic of confined dark areas that open dramatically onto luminous space, while evoking the easy pace of Venetian life. Sargent candidly observes the mood, colors, and social texture of a specific aspect of Venice and refuses to show the local women as childlike, playful, or decorative (in contrast to such popular genre painters as the Englishmen Henry Woods and Luke Fildes, and the American Robert Blum). Exercising one of his habits as a portraitist, he involves the foremost woman with the viewer by posing her in an engaging gesture of surprise; in this respect, Sargent breaks a basic convention in genre painting, that the subjects should be innocent of the spectator.[1]

This picture shows the artist applying much that he had learned from his 1879 study of the paintings by Velázquez at the Prado, where he copied several examples, most significantly *Las Meninas* and *The Spinners*. The organization of both these images—in which the foreground figures are played against those in a brightly lit background but are separated from them by a shadowy, yet clearly articulated, space—is reflected in several of Sargent's Venetian works of the early 1880s. Equally important influences on the composition of *Venetian Interior* were Whistler's 1880 Venetian etchings (particularly *The Beggars*). The picture's sober, almost monochromatic dark palette reflects Sargent's study of Velázquez and Hals: apart from the minor touches of pink and pale orange, the image is elaborated in black and white against large areas of khaki and parchmentlike colors, reminiscent of the portraits of these Old Masters.[2]

Venetian Interior is smaller and less showy than Sargent's contemporary Salon pieces, and yet more experimental in concept and

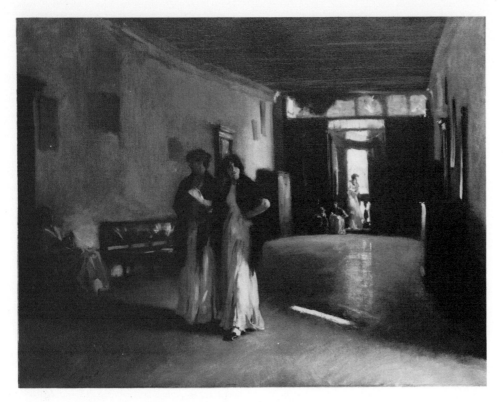

NOTES

1. *Venetian Interior* anticipates Sargent's unconventional portrait sketch, *Robert Lewis Stevenson and His Wife* (1885; Private Collection), which employs a walking pose, a quizzical glance to the viewer, a curiously draped woman, and a view into a dark hallway.

2. One major product of the formal experimentation of Sargent's Venetian work is his large, square, group portrait, *The Daughters of Edward D. Boit* (1882; Museum of Fine Arts, Boston), as observed by James Lomax and Richard Ormond in *John Singer Sargent and the Edwardian Age* (Leeds Art Galleries, 1979), p. 29.

3. Brimmer to Sarah Wyman Whitman, Venice, 26 October 1882 (Martin Brimmer Papers, Archives of American Art, Smithsonian Institution, Washington, D.C., microfilm roll D 32, frame 182). Brimmer notes that Sargent was staying with the expatriate Boston family of Daniel Sargent Curtis in their Venice home, Palazzo Barbaro. The hall depicted in *Venetian Interior* has not been conclusively identified.

4. See Arthur Bagnières, "Première Exposition de la Société Internationale des Peintres et Sculpteurs," *Gazette des Beaux Arts* 27 (February 1883): 187.

5. James, "John S. Sargent," *Harper's New Monthly Magazine* 75 (October 1887): 689. James here describes the Venetian interior Sargent had exhibited at the Grosvenor Gallery, London, in May 1882.

PROVENANCE

Henry Lerolle, Paris; to present owner, 1920.

EXHIBITION HISTORY

Carnegie Institute, Pittsburgh, *19th Annual International Exhibition*, 1920, cat. no. 297 (ill.).

Grand Central Art Galleries, New York, *Retrospective Exhibition of Important Works by John Singer Sargent*, 1924, cat. no. 44.

Museum of Fine Arts, Boston, *Memorial Exhibition of the Works of the Late John Singer Sargent*, 1925, cat. no. 23.

Fine Arts Gallery, San Diego, Calif., 1926.

California Palace of the Legion of Honor, San Francisco, *American Exhibition*, 1926–1927.

Art Gallery of Toronto, *Loan Exhibition of Great Paintings in Aid of Allied Merchant Seamen*, 1944.

Columbus Gallery of Fine Arts, Ohio, 1952.

Munson-Williams-Proctor Institute, Utica, N.Y., *Expatriates: Whistler, Cassatt, Sargent*, 1953, cat. no. 29.

Carnegie Institute, Pittsburgh, *American Classics of the 19th Century*, 1957 (traveling exhibition), cat. no. 109.

technique. Such passages as the single stroke of thick paint denoting the bar of sunlight in the right foreground exemplify the resolute painterliness that made his work interesting to avant-garde artists such as Monet. Furthermore, Sargent's Venice, especially the street scenes, looked shabby, unhealthy, and threatening to most people. For example, the enlightened Boston collector Martin Brimmer wrote in 1882:

> Sargent had . . . some half-finished pictures of Venice. They are clever, but a good deal inspired by the desire of finding what no one else has sought here—unpicturesque subjects, absence of color, absence of sunlight. It seems hardly worthwhile to travel so far for these. But he has some qualities to an unusual degree—a sense of values and a faculty for making his personages move.[3]

When Sargent showed at least three Venetian works (probably including this one) at the Galerie Georges Petit, Paris, in December 1882, the French critics, like Brimmer, found them dismal.[4] Sargent often gave the early Venetian pictures as gifts to friends in the arts who appreciated their subtle painterliness. And his friend Henry James was the first to write perceptively of their beauty and originality:

> [One interior represents] a small group of Venetian girls of the lower class . . . in the big, dim hall of a shabby old palazzo. . . . The whole place is bathed in a kind of transparent shade; the tone of the picture is dark and cool. . . . The figures are extraordinarily natural and vivid; wonderfully light and fine is the touch by which the painter evokes all the small familiar Venetian realities . . . and keeps the whole thing free from that element of humbug which has ever attended most attempts to reproduce the Italian picturesque.[5]

T. J. F.

WILLIAM MERRITT CHASE

(1849, Williamsburg [now Ninevah],
Indiana—1916, New York City)

*From humble and untutored beginnings, Chase became
one of the most visible artists of his age, as famous for
his fashionable lifestyle as for his bravura portraits
and sparkling plein air landscapes. He was first trained
locally in Indiana and then at the National Academy
of Design in New York. In 1871, he enrolled at
Munich's Royal Academy, where he was deeply
affected by the naturalism of Wilhelm Leibl and by
the prevailing enthusiasm for Dutch and Spanish art.
Chase returned to New York in 1878. There he rented
rooms in the famous Tenth Street Studio Building,
sent a painting to the inaugural exhibition of the
Society of American Artists, began teaching at the
Art Students' League, and soon became known as one
of the most progressive young artists in New York.*

*By the 1880s, the pattern of Chase's career was
established: winters in New York, painting and
teaching, and summers touring Europe with artist-
friends and later his students. In Europe, Chase took on
the role of tastemaker, buying works of art and exotic
bric-a-brac for his celebrated studio and promoting
the work of artists he admired. On his recom-
mendation, Julian Alden Weir secured Manet's*
Woman with a Parrot *and* Boy with a Sword *for
his client Erwin Davis, making them the first
paintings by Manet to enter an American collection.
And under Chase's direction, the Pedestal Loan
Exhibition of 1883 brought to New York many Im-
pressionist works, constituting the public's first broad
exposure to that style.*

*By the time of the Pedestal Loan show, Chase
dominated the New York art world. His eclectic style
was universally admired, and he found eager buyers
both for his portraits, executed in a dark, painterly
Munich manner, and for his landscapes, painted in an
Impressionist style. He was an inspiring teacher and
was sought after by pupils at the Art Students'
League and the Pennsylvania Academy of the Fine
Arts (where he taught from 1896–1907) and at his
own school at Shinnecock on Long Island, founded in
1891. Among his students were not only many who
imitated his style, but also a number who would
emerge in the early twentieth century as the leaders of
American modernism, among them Charles Sheeler,
Charles Demuth, Georgia O'Keeffe, and Alfred
Maurer. From the 1880s until his death, Chase was a
leading figure in New York's major artistic insti-
tutions. He was a charter member of the Society of
American Artists, and served as its president for ten
years beginning in 1885; he founded the Society of
Painters in Pastel (1882); and he joined the
progressive Ten American Painters in 1902.*

*Chase's student and admirer Katherine Roof wrote the
only contemporary biography,* The Life and Art of
William Merritt Chase *(New York, 1917). A
recent study of the artist is by Ronald Pisano,*
William Merritt Chase *(New York, 1979).*

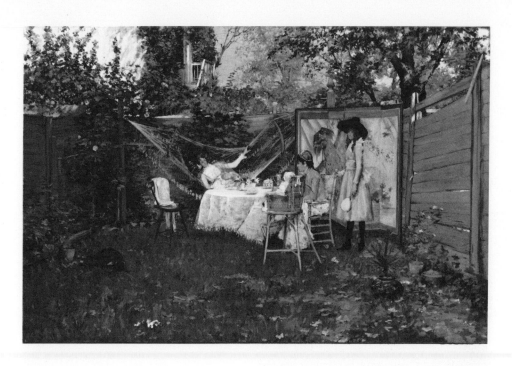

91

WILLIAM MERRITT CHASE
The Open Air Breakfast, c. 1888
Painted in Brooklyn, New York
Signed lower left: *W^m M. Chase.*
Oil on canvas, $37\frac{7}{16} \times 56\frac{3}{4}$ in. (95.1 × 144.1 cm.)
The Toledo Museum of Art, Ohio,
 Gift of Florence Scott Libbey

In 1886 Chase moved with his young bride to
the fashionable Park Slope section of Brooklyn
and began a series of small, high-keyed
paintings of his surroundings, especially of the
newly landscaped Prospect Park. *The Open Air
Breakfast*, the largest of those landscapes
produced by Chase in his Brooklyn years, is
set in his own backyard. Chase littered this
intimate and circumscribed space with the
kind of exotic accessories—a Japanese screen,
Oriental porcelains, a seventeenth-century
Dutchman's hat, a cashmere shawl—that
filled the interior of his celebrated Tenth
Street Studio. The figures in the picture, all
members of Chase's family, are not rendered
with portraitlike distinctness, nor are they
actors in an autobiographical genre scene.
Stylishly dressed and surrounded by the
trappings of fashion, they are part of the
decorative milieu, an artificial ensemble of
unrelated, beautiful objects which the artist
has arranged to create a pleasing effect. In *The
Open Air Breakfast*, Chase has returned to his
studio picture of the early 1880s and set it out-
of-doors.

While exploring new subject matter during
this decade, Chase was also formulating his
artistic principles. He dedicated himself
increasingly to technical virtuosity rather
than to any particular style, and maintained
that art should emphasize formal beauty
rather than a narrative message. In a similar
subject painted five years before this work, *A
Summer Afternoon in Holland* (1884; Joslyn Art
Museum, Omaha), Chase was clearly engaged
in storytelling: the interaction of his two
figures—the man smoking nervously and
toying with his teacup, and the woman gazing
in a bored manner over the edge of her
hammock—suggests a courtship progressing

awkwardly. But in *The Open Air Breakfast*, all obvious anecdote and psychological interchange have been eliminated. Instead, we are admitted into a magical secret garden in which the picturesque furnishings, the geraniums and roses, the sparkling harmonies of color and texture, and the decoratively posed figures are all part of a poetic, make-believe world. Chase's wife, daughter, sister, and sister-in-law, all dressed in white and so stunningly set apart from the surrounding landscape, form the centerpiece of the artist's domestic paradise. They are secluded from the outside world by a high fence whose walls recede protectively according to an old-fashioned system of one-point perspective. The women are pushed to the back of the space; the empty foreground before them suggests a threshhold to be crossed, a threshhold guarded, however unmenacingly, by the large wolfhound at left and the spiky-leafed plant at right. Chase's garden presents a world of languid elegance and self-satisfaction, the more perfect for being sheltered and secure. It is a commonplace situation transformed into a scene of delightful fantasy, a private summer idyll to which the viewer has been privileged to enter.

In painting his own backyard, Chase turned to a theme that had been popular with his French colleagues, especially Manet, who in the 1870s had painted several artist friends in their gardens. Probably most interesting to Chase, however, were Manet's intimate, unpopulated and poignantly personal views of the garden adjacent to the villa at Versailles where he spent his last years. Those pictures are painted with the same rich salmon pinks, reds, and ochres with which Chase enlivens *The Open Air Breakfast*.[1]

The garden subject was not the exclusive property of the avant-garde, however; in fact, it was a mainstay of fashionable painters like Alfred Stevens, Giuseppi de Nittis, James-Jacques-Joseph Tissot, and others who were themselves indebted to Manet. The highly stylized splendor of *The Open Air Breakfast* is also found in the paintings by Tissot that document the artist's private world of garden and family.[2] And like Tissot, Chase maintained a respectful distance from the technique of the more advanced painters: he uses small brushstrokes and relatively dry pigment throughout, yielding an opaque, chalky texture especially noticeable in the whites of the table and the dress. His retention of firm outlines and centralized motif (rather than employing the more casual composition of the Impressionists) reflect his fidelity to his academic training. And although his picture may well have been painted out-of-doors, Chase seems relatively unconcerned with recording the effects of light, or with using light in an Impressionist fashion to bind the figures to the landscape. Rather, his protective adoration of his family required that they remain pure and distinct: they cast no shadows, and a tighter technique detaches them from the more lushly painted natural surroundings of the garden.

Chase kept this complex and highly artificial composition for the rest of his life, perhaps recognizing that it represented his highest achievement. Never again would he so perfectly express his dedication to formal values on the one hand, and his solicitude toward his family on the other.

C.T.

NOTES

1. See *Monet's Family in the Garden* (1874; Private Collection, New York), *The Croquet Party in Paris* (1873; Stadelisches Kunstinstitut, Frankfurt), and esp. *The Artist's Garden in Versailles* (1881; Coll. Mrs. John Barry Ryan, New York), all reproduced in Denis Rouart and Daniel Wildenstein, *Edouard Manet. Catalogue raisonné*, 2 vols. (Lausanne and Paris, 1975).

2. See esp. *En Plein Soleil* (c. 1881; art market, London) and *A Quiet Afternoon* (1879; unlocated) which, like Chase's picture, features a woman reclining in a hammock.

PROVENANCE
The artist, to 1916; Mrs. William Merritt Chase; Chase sale, American Art Galleries, New York, 14–17 May 1917, lot 375 (as *The Backyard: Breakfast Out-of-Doors*); Gabriel Weiss, New York, 1917–at least 1949; J. A. Hoffman, Charleston, S.C.; with Victor Spark, New York, by 1953; to present owner, 1953.

EXHIBITION HISTORY
Art Institute of Chicago, *28th Annual Exhibition of American Oil Paintings and Sculpture*, 1915, cat. no. 73 (ill.).
Metropolitan Museum of Art, New York, *Loan Exhibition of Paintings by William M. Chase*, 1917, cat. no. 15 (as *The Backyard, Breakfast Out-of-Doors*).
Pennsylvania Academy of the Fine Arts, Philadelphia, *150th Anniversary Exhibition*, 1955, cat. no. 56 (ill.).
Carnegie Institute, Pittsburgh, *American Classics of the 19th Century*, 1957 (traveling exhibition), cat. no. 93.
Metropolitan Museum of Art, New York, *19th-Century America: Paintings and Sculpture*, cat. by John K. Howat and Natalie Spassky, 1970, no. 173 (ill.).
National Gallery of Art, Washington, D.C., *American Impressionist Painting*, cat. by Moussa Domit, 1973, no. 17 (ill.).
Whitney Museum of American Art, New York, *The Painters' America: Rural and Urban Life, 1810–1910*, cat. by Patricia Hills, 1974, no. 24 (ill.).

92

WILLIAM MERRITT CHASE
The Fairy Tale, 1892
Painted in Shinnecock, New York
Signed lower right: *W^m M. Chase*
Oil on canvas, $16\frac{1}{2} \times 24\frac{1}{2}$ in. (41.9×62.2 cm.)
Mr. and Mrs. Raymond J. Horowitz

Chase's sparkling *Fairy Tale* is one of a number of moderate-sized landscapes painted in the 1890s at Shinnecock, on the eastern tip of Long Island. Chase and his family spent their summers there, in a large clapboard house designed by Stanford White, and in 1891 he established an art school at Shinnecock, one of the first in America in which students were counseled to paint out-of-doors. Members of Chase's large family frequently appear in the Shinnecock pictures; here his wife and second daughter, Koto Robertine (b. 1888) are seated among the dunes in the foreground of the picture.

The emphasis Chase has placed on the figures in *The Fairy Tale* makes it one of the most affectionate and personal of the Shinnecock pictures. Usually just a "red note" or splash of bright color amid the sand and bayberry bushes, here the figures dominate: they are large-scale, centrally located, and posed in the immediate foreground of the picture. Although Mrs. Chase's back is to the viewer and her daughter's features are indistinct, the painting is unmistakably about *them*, and here more than in any other Shinnecock picture, the landscape is viewed as the setting for human activity. The painting's title, probably supplied by the artist, suggests that Mrs. Chase is amusing her daughter with a story. It equally well describes the idyllic, enchanted quality of the summer's day.

Chase's attraction to the plein air landscape, first seen in the mid-eighties in his pictures of Prospect Park, was heightened by the move to Shinnecock, where the sandy, sun-bleached terrain and panoramic stretches of coastline offered a new challenge to his bravura technique. Although a quiet picture, *The Fairy Tale* is full of passages demonstrating Chase's delight in the manipulation of paint. He effortlessly combines a variety of strokes, from long, chalky marks in the foreground denoting the scrubby shoreline foliage and short, commalike strokes in the bayberry trees, to the nearly imperceptible brushwork in the sky. Most novel is the use of vertical scratches, made by dragging the end of the brush through wet pigment, to describe the spiky grasses in the foreground. The bright palette of *The Fairy Tale* and Chase's general interest in informal, outdoor subjects were also affected by Impressionist painting, which he had been studying and collecting since the early 1880s. Chase was drawn equally to the most radical of the French artists and to those more fashionable painters who were on the fringes of the Impressionist movement. Here his blond palette and sketchy, dry-brush technique owe less to the fragmented, light-evoking manner of Monet or Renoir than to the sprightly, dashing, but fundamentally more concrete brushwork of artists such as Jean-Charles Cazin, Giovanni Boldini, or, as

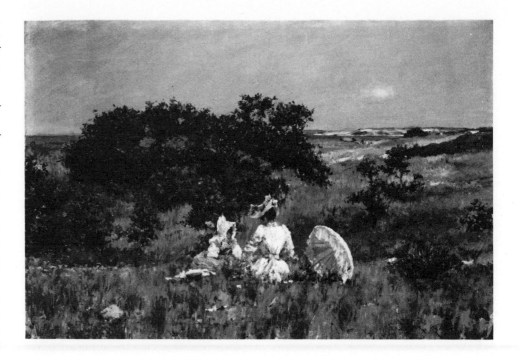

one scholar has recently suggested, Giuseppe de Nittis.[1]

Chase's style, an eclectic blend of avant-garde and academic techniques, was far more accomplished and self-assured than that of most American painters who aspired to an Impressionist manner. Chase's freedom from imitation and cliché was admired by his fellow artists (said Arthur B. Frost, "I like Chase both personally and artistically; his last summer's landscapes . . . are beautiful. No 'purple fad' business, but full of air and out of doors"[2]) and by most critics, even those like William Howe Downes who resisted Impressionism. Of the Shinnecock pictures Downes wrote, "The landscape work . . . has a character of precise, candid objectivity, and a cheerfulness that is infectious. The scenes . . . pretend to nothing more complicated than free and happy descriptive pages which give forth an aroma of summer holidays in a most paintable region of dunes, breezes, wild flowers and blue seas."[3]

C.T.

NOTES

1. Dianne H. Pilgrim ("The Revival of Pastels in Nineteenth-Century America: The Society of Painters in Pastel," *American Art Journal* 10 [November 1978]: 43) convincingly compares Chase's *Fairy Tale* with *Nei Campi Intorno a Londra*, a pastel of 1874 by de Nittis, an Italian-born artist whose works Chase owned and who showed with the Impressionists in their inaugural exhibition of 1874.

2. Frost to Augustus Daggy, quoted in Ronald Pisano, *Students of William Merritt Chase* (Heckscher Museum, Huntington, N.Y., 1973), p. 7.

3. Downes, "William Merritt Chase, A Typical American Artist," *International Studio* 39 (December 1909): 32.

PROVENANCE
With Macbeth Gallery, New York; William T. Evans, New York, 1898; with American Art Galleries, New York (William T. Evans Collection Sale, no. 182), 1900; W. R. Beal, 1900; with Coe Kerr Gallery, New York, 1969; to present owner, 1969.

EXHIBITION HISTORY
Gill's Art Galleries, Springfield, Mass., *16th Annual Exhibition of American Paintings*, 1893, cat. no. 41 (ill.) (as *A Sunny Day*).
Society of American Artists, New York, *15th Exhibition*, 1893, cat. no. 60.
Metropolitan Museum of Art, New York, *American Impressionist and Realist Paintings and Drawings from the Collection of Mr. and Mrs. Raymond J. Horowitz*, cat. by Dianne H. Pilgrim, 1973, no. 6 (ill.).
M. Knoedler & Co., New York, *William Merritt Chase* (benefit exhibition for the Parrish Art Museum), 1976.

MARY CASSATT

(1844, Allegheny City [Pittsburgh]
—1926, Château Beaufresne, Oise, France)

Although born and partially trained in the United States, Cassatt owes little of her style or development to American art. Apart from her infancy, a few years during her late adolescence (during which time— 1861 to 1865—she studied at the Pennsylvania Academy of the Fine Arts in Philadelphia), and some eighteen months during the Franco-Prussian War, Cassatt lived her whole life in Europe. Her childhood was spent in Paris, Heidelberg, and Darmstadt; her artistic training, after Philadelphia, took place in the Paris atelier of the orthodox master Charles Chaplin. She began exhibiting at the Salon in 1872. However, when her Young Bride *(Montclair Art Museum, N.J.), which had been rejected from the Salon in 1874, was accepted the following year after she had darkened the background in accordance with academic convention, she broke with the French artistic establishment. With the encouragement of Degas (who would become her mentor, chief artistic influence, and close friend), she joined the radical Impressionist painters: "I had already recognized who were my true masters. I admired Monet, Courbet, and Degas. I hated conventional art. I had begun to live." Cassatt showed with the Impressionists from 1877 to 1881, and again in 1886, to increasing critical acclaim.*

Cassatt's work also began to be seen in America, where it was moderately well received. Her first two Salon pictures were shown at the National Academy of Design in 1874, and her Head of a Woman *was included in the American section of the 1878 Exposition Universelle (although the more daring* Little Girl in a Blue Armchair *[Coll. Mr. and Mrs. Paul Mellon, Upperville, Va.] was rejected). Her controversial mural* Modern Woman *(now lost), commissioned for the Woman's Building at the World's Columbian Exposition held in Chicago in 1893, made her name known in America. However, her paintings had less impact on the American art world than did her relationship with prominent collectors, whom she encouraged to buy modern French paintings. These collectors, including James Stillman of New York, her brother Alexander Cassatt of Philadelphia, and Mrs. Potter Palmer of Chicago, became great benefactors of the museums in their cities. Chief among them were Louisine and Horace Havemeyer, whose collection is now at the Metropolitan Museum of Art, New York.*

By the turn of the century, Cassatt had abandoned the domestic genre scenes and family portraits of her earlier years and devoted herself almost exclusively to her best-known subject, sentimental images of mothers and children. At the same time, her technique started to decline. About 1910, her eyesight began to fail, and by 1914 progressive blindness forced her to stop painting. She died at Château Beaufresne, her summer home since 1893, in 1926.

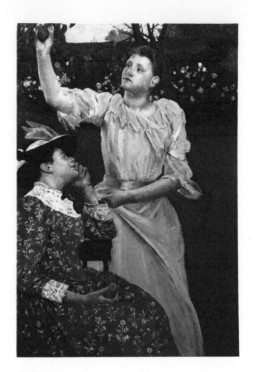

93

MARY CASSATT
Young Women Picking Fruit, 1891
Painted at Château Bachivillers on the Oise, France
Signed lower right: *Mary Cassatt*
Oil on canvas, $51\frac{3}{8} \times 35\frac{3}{4}$ in. (130.5 × 90.8 cm.)
Museum of Art, Carnegie Institute, Pittsburgh, Patrons Art Fund, 1922

Frederick Sweet's biography, Miss Mary Cassatt, Impressionist from Pennsylvania, *contains good illustrations of her work and many excerpts from her letters. Adelyn D. Breeskin published a useful catalogue raisonné of Cassatt's oils, pastels, watercolors, and drawings in 1970.*

The subject of women picking fruit had attracted many of Cassatt's Impressionist colleagues during the 1880s. Degas treated the theme in a bronze relief (1881; Metropolitan Museum of Art, New York); Pissarro painted several variants on the theme of apple pickers beginning in 1881, the best known being the monumental *La Cueillette des pommes* (1886; Ohara Museum of Art, Kuranshiki, Japan); Renoir painted his arcadian *Grape Pickers at Lunch* (Coll. Armand Hammer, Los Angeles) in about 1881, and under his guidance Morisot produced at least three versions of the subject in 1891 (unlocated). Pissarro's conceptions seem to have been the most influential, but Cassatt's version most closely resembles that of Morisot in the transformation of Pissarro's peasants into middle-class women, fashionably dressed, engaged in genteel conversation rather than absorbed by serious labor. Whereas Morisot had used her daughter and niece as models, Cassatt hired young peasant women from Bachivillers, where she had rented a summer villa, and dressed them in couturier gowns. Both the models and the gowns recur in other paintings by Cassatt.

A more important inspiration for *Young Women Picking Fruit*, however, was probably the work of Puvis de Chavannes, whose mural *Inter Artes et Naturam* (Musée des Beaux-Arts, Rouen; reduced replica, Metropolitan Museum of Art, New York) was shown in the inaugural exhibition of the Société Nationale des Beaux-Arts (Salon du Champs-de-Mars) in Paris in 1890. Like her close colleague Degas, Cassatt had already been moving toward simpler, more decorative compositions and a relief-like conception of form. She had consistently placed monumental figures in the foreground of her compositions, but by the late eighties she had minimized illusions of recession into space, however eccentric, in favor of advancing figures against a flat, ornamental background. Cassatt would have found reinforcement for the use of these devices in the increasingly popular works of Puvis. Moreover, the central figure in Puvis's mural—a pink-gowned young woman languidly picking an apple from a branch above her head—probably inspired the pose of the standing figure in *Young Women Picking Fruit*, and would be repeated even more literally in *Baby Reaching for an Apple* (1893; Coll. Mrs. Blaine Durham, Hume, Va.).

When it appeared in 1890, Puvis's *Inter Artes et Naturam* was praised for its expression of a classical spirit while featuring figures in contemporary dress,[1] and Cassatt seems to have taken the same approach in her work. In their stylish gowns, Cassatt's young women call to mind none of the traditional associations of her theme—Eve in the Garden of Eden, the golden apples of the Hesperides, and so on—yet their assertive sculptural

presence, the decorative S-curve their arms describe on the picture surface, and their Amazon-like robustness suggest a meaning more allegorical than anecdotal.

Cassatt would continue to pay homage to the spirit of Puvis in her most ambitious composition, the mural *Modern Woman* painted for the Woman's Building of the 1893 World's Columbian Exposition in Chicago, which was commissioned while Cassatt was working on *Young Women Picking Fruit*; the theme and arrangement of the figures here were modified for the mural's center panel, "Young Women Plucking the Fruits of Knowledge and Science." The same decorative simplicity and classical gravity of the present picture existed in the mural, and it, too, had an allegorical theme without specific literary or mythological associations.[2]

Neither *Young Women Picking Fruit* (which remained unsold until 1922 despite frequent exhibitions in New York) nor *Modern Woman* was particularly well received in America. Cassatt's new style was admired in France, however, and the mural, seen in progress, elicited a warm response: "It behooves us to ascend even to Puvis de Chavannes to find so grand a decorative scene, an intent so majestic. In all sincerity one must declare that, with the exception of Whistler, Miss Cassatt is perhaps the only artist America possesses who exercises a talent, high, personal and distinguished."[3]

C.T.

NOTES

1. See Richard J. Wattenmaker, *Puvis de Chavannes and the Modern Tradition* (Art Gallery of Toronto, 1975), p. 79.

2. The other two sections of the mural were titled "Young Girls Pursuing Fame" and "Music and Dance."

3. André Mellerio, trans. Eleanor B. Caldwell, quoted in "Exposition Mary Cassatt. Gallery Durand-Ruel, Paris. November-December MDCCCXCIII," *Modern Art* 3 (Winter 1895): 5.

PROVENANCE
The artist, to 1893; with Durand-Ruel, Paris, 1893; with Durand-Ruel, New York, 1895; to present owner, 1922.

EXHIBITION HISTORY
Galeries Durand-Ruel, Paris, *Exposition de tableaux, pastels et gravures de Mary Cassatt*, 1893, cat.no.9.
St. Botolph Club, Boston, *An Exhibition of Paintings, Pastels and Etchings by Miss Mary Cassatt*, 1898, cat.no.16.
Carnegie Institute, Pittsburgh, *4th Annual Exhibition*, 1899, cat.no.33 (ill.).
Durand-Ruel Galleries, New York, *Exhibition of Paintings and Pastels by Mary Cassatt*, 1903, cat.no.3; 1917, cat.no.17; 1920, cat.no.18.
Carnegie Institute, Pittsburgh, *Art and Science in Gardens*, 1922, cat.no.26.
California Palace of the Legion of Honor, San Francisco, *First Exhibition of Selected Paintings by American Artists*, 1926, cat.no.27 (ill.).
Carnegie Institute, Pittsburgh, *A Memorial Exhibition of the Work of Mary Cassatt*, 1928, cat.no.48.
Durand-Ruel Galleries, New York, *Exhibition of Paintings and Pastels by Mary Cassatt*, 1935.
Cleveland Museum of Art, *20th Anniversary Exhibition*, 1936, cat.no.350 (ill.).
Carnegie Institute, Pittsburgh, *The Patrons Art Fund Paintings*, 1940, cat.no.7 (ill.).
M. H. de Young Memorial Museum, San Francisco, *Golden Gate International Exposition*, 1946.
Dayton Art Institute, Ohio, *America and Impressionism*, 1951 (traveling exhibition).
Munson-Williams-Proctor Institute, Utica, N.Y., *Expatriates: Whistler, Cassatt, Sargent*, 1953, cat.no.20.
Art Institute of Chicago, *Sargent, Whistler, and Mary Cassatt*, cat. by Frederick A. Sweet, 1954 (traveling exhibition), no. 18.
Pennsylvania Academy of the Fine Arts, Philadelphia, *150th Anniversary Exhibition*, 1955, cat.no.120 (ill.).
Detroit Institute of Arts, *Painting in America: The Story of 450 Years*, cat. by E. P. Richardson, 1957, no.121.
Munson-Williams-Proctor Institute, Utica, N.Y. *American Classics of the 19th Century*, 1958 (traveling exhibition), cat.no.75.
Society of the Four Arts, Palm Beach, Fla., *Paintings by John Singer Sargent and Mary Cassatt*, 1959, cat.no.42.
Columbia Museum of Art, South Carolina, *Impressionism*, 1960, cat.no.6.
Art Gallery of Toronto, *American Paintings, 1865–1905*, cat. by Lloyd Goodrich, 1961 (traveling exhibition), no. 8 (ill.).
Minneapolis Institute of Art, *Four Centuries of American Art*, 1964.
Whitney Museum of American Art, New York, *Art of the United States: 1670–1966*, 1966, cat.no.41 (ill.).
National Gallery of Art, Washington, D.C., *Mary Cassatt, 1844–1926*, cat. by Adelyn D. Breeskin, 1970, no. 48 (ill.).
Whitney Museum of American Art, New York, *Turn-of-the-Century America: Paintings, Graphics, Photographs, 1890–1910*, cat. by Patricia Hills, 1977 (traveling exhibition) (ill.).
Portland Museum of Art, Maine, *Miss Mary Cassatt: Impressionist from Pennsylvania*, 1979.
National Gallery of Art, Washington, D.C., *Post-Impressionism: Cross-Currents in European and American Painting*, 1980, cat.no.259 (ill.).
Isetan Art Gallery, Tokyo, *The Art of Mary Cassatt (1844–1926)*, cat. by Breeskin, 1981 (traveling exhibition, sponsored by the American Federation of Arts, New York), no. 26 (ill.).

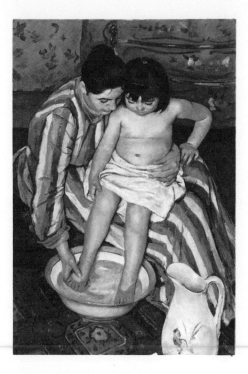

94

MARY CASSATT
The Bath, 1891–92
Painted in Paris, or at Château Bachivillers on the Oise, France
Signed lower left: *Mary Cassatt*
Oil on canvas, 39½ × 26 in. (100.3 × 66 cm.)
The Art Institute of Chicago,
 The Robert A. Waller Fund

The 1890s were the years of Cassatt's greatest accomplishments and successes. In this decade, she began participating in international exhibitions and achieved critical recognition independent of the Impressionists, with whom she had been associated since 1877. *The Bath* was the centerpiece of her first major solo show, held at the Galeries Durand-Ruel in Paris in 1893. That show was hailed as "particulièrement remarquable. On s'y trouve effectivement en présence d'oeuvres rares qui révèlent chez l'artiste un très vif sentiment personnel, un goût exquis et beaucoup de talent."[1] *The Bath* has since come to be regarded as Cassatt's masterpiece.

Although she had painted the type of tender, domestic subject represented in *The Bath* for over ten years, it is not until this point that Cassatt achieved a mature and independent style. Here she moves away from the free brushwork, soft contours, and high-keyed palette of the Impressionists and adopts a more thoughtfully orchestrated color scheme, crisper outlines, and more solidly rendered form. The impetus for these developments came from her colleagues, especially Degas, and from the Neo-Impressionists, whose work she outwardly disdained but whose adventur-

ous experiments with color seem to have inspired her to restructure her palette. Here she employs a carefully balanced triad of secondary colors—lavender, green, and orange-red—while retaining a classical rendering of form. But for *The Bath* and subsequent works, the most important stimulus was her renewed exposure to Japanese prints.

Japanese prints had been admired by the French avant-garde for several decades; enthusiasm for them was rekindled by the landmark exhibition *La Gravure Japonaise*, held in 1890 at the École des Beaux-Arts. Cassatt had until then remained unmoved by the new compositional ideas offered by Japanese prints (except as absorbed secondhand through the work of Degas) and by the passion for Japonisme which caused Manet, Whistler, and many others to sprinkle their paintings with Oriental bric-a-brac. With this show, Cassatt was suddenly and dramatically impressed: she is known to have visited it at least twice, and began to purchase Japanese prints, eventually owning over fifty, of which as many as a dozen were by the eighteenth-century master Kitagawa Utamaro. Utamaro's intimate and sympathetic treatment of maternal love and other domestic subjects was especially congenial to Cassatt, and she seems to have borrowed both motifs and compositional devices from him for her remarkable series of ten colored aquatints executed in 1891.[2] *The Bath*, probably begun the same year, also reflects Cassatt's interest in Utamaro's prints.

Utamaro's colored woodcut *Woman Bathing a Baby in a Tub*[3] inspired Cassatt's first tentative efforts at Japanese-style design in her print *The Tub*, but the aesthetic is more fully realized in *The Bath*. Here, the simple, emphatic outlines, the juxtaposition of multicolored patterns, the compressed and flattened composition, and the unusually high horizon line indicate Cassatt's full absorption of the Ukiyo-e style. More specifically indebted to Utamaro's print, however, is the tender yet playful rapport between mother and child, and an unusually economical approach to design, in which a very few furnishings, in a severely limited, vertical slice of space, evoke the entire interior.

Degas's images of women at their toilettes were another source of inspiration for this picture, and Cassatt arranged this composition as Degas characteristically did, with hired models posing among the artist's own belongings intermingled with studio props (the green painted chest in this picture is an elaborated version of one that remained in Cassatt's family for many years after her death, while the striped robe was worn by models in several of her compositions). Works like Degas's pastel *Women Bathing* (1884; Coll. Mr. and Mrs. Joseph H. Hazen, New York)[4] no doubt inspired Cassatt's use of an elevated perspective and the device of anchoring the composition with a pitcher in the lower right corner. Yet whereas Degas's models are observed from a voyeur's keyhole perspective, Cassatt's suggest a wholesome domesticity and are seen from the vantage point of a member of the family.

C.T.

NOTES

1. "Here we find works of rare quality which reveal an artist of lively sentiment, exquisite taste, and great talent." A. de Lostalot, "Exposition des oeuvres de Miss Mary Cassatt," *La Chronique des arts* 2 (9 December 1893): 299.

2. See Colta Feller Ives, *The Great Wave: The Influence of Japanese Woodcuts in French Prints* (Metropolitan Museum of Art, New York, 1974), p. 46. Cassatt's prints were first exhibited in 1891 at her first solo show, held at Durand-Ruel's gallery. They were shown again at Durand-Ruel's in 1893, in an exhibition which also included *The Bath*.

3. Reproduced in Ives, *The Great Wave*, p. 47.

4. Reproduced in John Rewald, *The History of Impressionism*, 4th rev. ed. (New York, 1973), p. 527.

PROVENANCE

The artist, to November 1893; with Durand-Ruel, Paris, November–December 1893; with Durand-Ruel, New York, December 1893–1910; to present owner, 1910.

EXHIBITION HISTORY

Galeries Durand-Ruel, Paris, *Exposition de tableaux, pastels et gravures de Mary Cassatt*, 1893, cat. no. 1.

Durand-Ruel Galleries, New York, *Exposition of Paintings, Pastels and Etchings by Miss Mary Cassatt*, 1895, cat. no. 21; 1903, cat. no. 6.

Pennsylvania Academy of the Fine Arts, Philadelphia, *67th Annual Exhibition*, 1898, cat. no. 62 (ill.).

Cincinnati Museum Association, *Seventh Annual Exhibition of American Art in the Art Museum*, 1900, cat. no. 13 (ill.).

Minneapolis Institute of Arts, *Inaugural Exhibition*, 1915, cat. no. 151.

Art Institute of Chicago, *Memorial Collection of the Works of Mary Cassatt*, 1926, cat. no. 29 (ill.).

Carnegie Institute, Pittsburgh, *A Memorial Exhibition of the Work of Mary Cassatt*, 1928, cat. no. 38 or no. 39.

Art Institute of Chicago, *A Century of Progress, Exhibition of Paintings and Sculpture*, 1933, cat. no. 439.

Art Institute of Chicago, *A Century of Progress, Exhibition of Paintings and Sculpture*, 1934, cat. no. 440.

Cleveland Museum of Art, *Exhibition of American Painting from 1860 until Today*, 1937, cat. no. 27 (ill.).

Brooklyn Museum, N.Y., *Leaders of American Impressionism: Mary Cassatt, Childe Hassam, John H. Twachtman, J. Alden Weir*, cat. by John I. H. Baur, 1937, no. 22.

Museum of Modern Art, New York, *Art in Our Time*, 1939, cat. no. 48 (ill.).

Santa Barbara Museum of Art, Calif., *Painting Today and Yesterday in the United States*, 1941, cat. no. 23 (ill.).

Baltimore Museum of Art, *Mary Cassatt*, 1941, cat. no. 25 (ill.).

Wildenstein & Co., New York, *A Loan Exhibition of Mary Cassatt for the Benefit of the Goddard Neighborhood Center*, 1947, cat. no. 25 (ill.).

Des Moines Art Center, Iowa, *19th and 20th Century European and American Art*, 1948, cat. no. 16.

Museum of Fine Arts, Springfield, Mass., *Fifteen Fine Paintings*, 1948, (ill.).

Wildenstein & Co., New York, *Landmarks in American Art, 1670–1950*, 1953, cat. no. 38 (ill.).

Art Institute of Chicago, *Sargent, Whistler, and Mary Cassatt*, cat. by Frederick A. Sweet, 1954 (traveling exhibition), no. 19 (ill.).

Pennsylvania Academy of the Fine Arts, Philadelphia, *150th Anniversary Exhibition*, 1955, cat. no. 119 (ill.).

Brooks Memorial Union, Marquette University, Milwaukee, *75th Anniversary Exhibition*, 1956.

Detroit Institute of Arts, *Painting in America: The Story of 450 Years*, cat. by E. P. Richardson, 1957, no. 122, (ill.).

M. Knoedler & Co., New York, *The Paintings of Mary Cassatt*, 1966, cat. no. 21 (ill.).

Whitney Museum of American Art, New York, *Art of the United States: 1670–1966*, 1966, cat. no. 39 (ill.).

Joslyn Art Museum, Omaha, Neb., *Mary Cassatt among the Impressionists*, 1969, cat. no. 4 (ill.).

Metropolitan Museum of Art, New York, *19th-Century America: Paintings and Sculpture*, cat. by John K. Howat and Natalie Spassky, 1970, no. 169.

National Gallery of Art, Washington, D.C., *Mary Cassatt, 1844–1926*, cat. by Adelyn D. Breeskin, 1970, no. 49 (ill.).

Newport Harbor Art Museum, Newport Beach, Calif., *Mary Cassatt 1844–1926*, 1974, cat. no. 7 (ill.).

Museum of Fine Arts, Boston, *Mary Cassatt at Home*, cat. by Barbara Shapiro, 1978, no. 19 (ill.).

Exhibition history courtesy of the Art Institute of Chicago

THEODORE ROBINSON

(1852, Irasburg, Vermont
—1896, New York City)

Born in Vermont, Robinson was raised in the Midwest. In 1869 or 1870 he went to Chicago to study, but his artistic training there was interrupted by severe attacks of asthma, a chronic illness which would debilitate him for much of his life. In 1874 he enrolled at the National Academy of Design in New York, but by 1876 he was in France, studying with Carolus-Duran. The next year he transferred to the École des Beaux-Arts and the studio of Gérôme, and had his first painting accepted at the Salon. For the next fifteen years Robinson would travel back and forth between Paris (and the Normandy countryside, where there were several large summer colonies of American artists) and New York, with occasional trips to Wisconsin to see his family and recuperate from bouts of illness. Robinson experimented with a succession of styles—academic realism, the intimate naturalism of the Barbizon School, and, finally, Impressionism—continually striving for his own manner and, especially toward the end of his life, for a way to apply his Impressionist technique to recognizably American scenery.

In 1888 Robinson met Claude Monet at Giverny, where the French painter had been a summer resident since 1883. Although Monet remained aloof from most of the American artists working there, he developed a warm friendship with Robinson. Working alongside Monet, Robinson abandoned the dark tonality of his earlier pictures in favor of a brighter palette and looser brushwork. He never wholly adopted the Impressionist style, however, for the contours of his forms would always remain distinct, his objects solid.

In 1892 Robinson and Theodore Wendel, another of Monet's followers, showed their paintings in Boston. This exhibition, which coincided with a large show of the works of Monet in the same city, did much to advance the cause of Impressionist painting in America. Robinson spent the last four years of his life painting and teaching in New York, in Cos Cob, Connecticut, and other American art centers. He died, a victim of asthma, in 1896, at the age of forty-four, just as he was arriving at a mature realization of his Impressionist style.

The standard source on Robinson is John I. H. Baur, Theodore Robinson, 1852–1896 *(Brooklyn Museum, N.Y., 1946): it remains the most complete listing of Robinson's work and quotes extensively from his unpublished diaries. Helpful discussions of his work with additional bibliography are found in Doreen Bolger Burke,* American Paintings in the Metropolitan Museum of Art, *vol. 3 (New York, 1980), pp. 125–29, and in William H. Gerdts,* American Impressionism *(Henry Art Gallery, University of Washington, Seattle, 1980), pp. 51–56.*

95

THEODORE ROBINSON
World's Columbian Exposition, 1894
Painted in New York City
Signed lower right: *Th. Robinson*
Oil on canvas, 25 × 30 in. (63.5 × 76.2 cm.)
The Manoogian Collection

After the close of the Chicago World's Columbian Exposition in October 1893, Francis D. Millet, Director of Decorations for the fair, commissioned a number of his friends to paint views of the White City, which he intended to reproduce as colored lithographs and publish in a commemorative album. Robinson was asked to produce two illustrations. This picture may well be the second of them, described in his diary as "a big world's fair canvas, for colored plate 25 × 30".[1] The album, by Millet and Daniel H. Burnham (the Director of Works for the exposition), appeared serially in 1894 and documented the entire history of the fair.[2] It included illustrations after paintings by Millet, Childe Hassam (q.v.), Thomas Moran, and several others, but Robinson's designs were not among them. *World's Columbian Exposition* apparently remained with Robinson until his death. It was subsequently bought by William H. Perkins, who presented it to the Spalding Memorial Library in Athens, Pennsylvania (where his parents were residing) with the hope that it would form the

nucleus of an important art collection. The painting hung in the Library until 1977.

Robinson was never happy with the project: his diary records the commission as "a fearful grind"; when he turned this picture over to Millet, he admitted that it "looked beastly."[3] His distress may well have reflected the fact that he was not producing an original design but rather was working from a photograph, made by Charles Dudley Arnold, the head of the Bureau of Photography for the exposition.[4] Although Robinson had used photographs as aide-mémoire since the early 1880s, he had always made them himself, and so they reflected his own compositional ideas. That Arnold's photograph had more documentary than artistic merit can only have increased Robinson's frustration with the assignment.

Arnold's image shows a panoramic view southward, along the east bank of the Lagoon, which formed the central axis of the fairgrounds. Robinson transcribed all of the features of the photograph in precise detail: not only the main architectural monuments—the Western Fisheries Building at left, with the U.S. Government Building looming up behind it, and the Manufacturer's and Liberal Arts Building leading the viewer toward the Colonnade and Obelisk in the far distance—but also the more mundane details, such as the position of the lamp posts, the pleasure boats on the lagoon, and every visitor, along with his shadow, on the footpaths. Robinson's only

additions were the fair-weather clouds in the sky and, of course, the color. Robinson's choice of brilliant blues and greens, and the terracotta red of the roof of the Fisheries Building and the iron bridge, were undoubtedly dictated by the actual appearance of the scene, but the intensity of the hues, far brighter than his usual subdued palette, set off to perfection the fair's gleaming, fairy-tale architecture. Because his picture was destined for reproduction, Robinson rendered the architecture fastidiously, with fine, precise strokes producing clear contours and legible detail. But for the foliage, the rippling water of the lagoon, and the sky, Robinson reverted to his looser and more richly textured Impressionist technique, thereby animating the scene by the suggestion of a summer's breeze.

C.T.

NOTES

I am grateful to Jeffrey R. Brown, Erica E. Hirshler, and Joseph B. Zywicki for the information they supplied for this entry.

1. "Diaries" (Frick Art Reference Library, New York), 12 March 1894, quoted in John I. H. Baur, *Theodore Robinson 1852–1896* (Brooklyn Museum, N.Y., 1946), p. 94. Robinson's other view of the fair, *North Lagoon, World's Columbian Exposition*, was bought by James W. Ellsworth, a member of the executive committee for the exposition. That painting is now owned by the Chicago Historical Society.

2. *World's Columbian Exposition: The Book of the Builders; being the Chronicle of the Origin and Plan of the World's Fair* (Springfield, Ohio, 1894). This encompasses the first six numbers of *The Columbian Serial*, originally issued biweekly. No more issues were published.

3. "Diaries," quoted in Baur, *Robinson*, p. 94.

4. Avery Architectural and Fine Arts Library, Columbia University, New York, reproduced in Stanley Applebaum, *The Chicago World's Fair of 1893, A Photographic Record* (New York, 1980), p. 72.

PROVENANCE

William H. Perkins, New York, 1899; Spalding Memorial Library, Athens, Pa., 1899–1977; with Jeffrey R. Brown, Amherst, Mass., 1976–78; with Hirschl and Adler Galleries, New York, 1978; to present owner, 1978.

EXHIBITION HISTORY

Whitney Museum of American Art, New York, *Turn-of-the-Century America: Paintings, Graphics, Photographs, 1890–1910*, cat. by Patricia Hills, 1977–78 (traveling exhibition) (ill.).

GEORGE HITCHCOCK

(1850, Providence, Rhode Island —1913, Marken, Holland)

Hitchcock began his artistic career late, graduating from Harvard Law School in 1874 and practicing law for several years before pursuing his interest in watercolor. Enrolling first at Heatherly's School of Fine Arts in London in 1879, he soon grew dissatisfied with the instruction there and moved to Paris and the Académie Julian. Thereafter his studies were desultory: he spent several summers in the atelier of Hendrik Mesdag in The Hague and a winter at the Düsseldorf Academy, before a tour of Holland with painter Gari Melchers persuaded him that that country suited him best. He settled in Egmond (near Amsterdam) and maintained a studio there for the rest of his life.

International success came to Hitchcock in 1885, when his paintings were accepted at both the National Academy of Design in New York and the Paris Salon; Gérôme called his Salon entry, La Culture des tulips, *the best American picture of the year. He was awarded an Honorable Mention at the Salon of 1887, and at the 1889 Exposition Universelle won a Gold Medal and the enthusiastic approbation of discerning American critic Theodore Child. By this time Hitchcock had come to specialize in Dutch costume pictures, many of which were in fact religious subjects in the guise of contemporary genre scenes. By the turn of the century, his application of a decorative Impressionist style to Dutch subjects, now predominantly secular, inspired critic Christian Brinton to call him "the painter of sunlight."*

Hitchcock made a triumphal return to the United States in 1905, exhibiting in New York, Providence, and Detroit. In 1909, he was made an Associate of the National Academy of Design and an officer of the Franz Joseph Order of Austria. He won several other international honors before he died in 1913. Hitchcock was all but forgotten until recently, when a revival of interest in American Impressionist and expatriate painters again brought his work to public attention.

Hitchcock's series of articles on "The Picturesque Quality of Holland" in Scribner's Monthly (August 1887, February 1889, and November 1891) defends his choice of subject and explains his affection for Holland when most of his colleagues were residing in France. The best contemporary discussion of Hitchcock is in Michael Quick's American Expatriate Painters of the Late Nineteenth Century (Dayton Art Institute, Ohio, 1976), which also contains an extensive bibliography.

96

GEORGE HITCHCOCK
The Bride, c. 1900
Probably painted in Marken, Holland
Signed lower left: G HITCHCOCK
Oil on canvas, 30 × 24 in. (76.2 × 61 cm.)
Private Collection, Courtesy of Jordan-Volpe Gallery, New York

Hitchcock probably painted this picture around the turn of the century, when his interest in anecdotal and religious subject matter gave way to more decorative concerns. In earlier works, figures were located more deeply within the picture's space, and trees, houses, and animals dotted the landscape. Here, however, the half-length figure fills the canvas, her gaily printed cloak billows past the edges of the picture, and behind her the tulip fields and budding trees of early spring appear as a tapestry woven in horizontal bands of brilliant color. Whereas in earlier works Hitchcock would have made the religious meaning explicit with a biblical title or a halo painted over the figure's head, here he relies on formal elements—the iconic presence of the figure, her bowed head, and nature's cloth of honor behind her—to imbue his secular subject with pious sentiment.

The precedent for Hitchcock's subjects is found not in the silver-toned landscapes of the contemporary Hague School, as one would expect, but rather in the work of Jules Breton, Jules Bastien-Lepage, and other French painters of rural subjects. Sentimental peasant subjects were at the height of their popularity in the 1880s, when Hitchcock was in Paris, and were avidly collected in France and America. Breton in particular had made his reputation with simple compositions in which single monumental figures symbolize the spiritual feeling of the rural community, and Hitchcock's works of the eighties and early nineties echo the mood and treatment of these. His later peasant pictures show the impact of stylistic developments at the end of the century. Although he retains academic drawing and modeling in this picture, his heightened palette and interest in decorative pattern parallel several different advanced styles, especially the ornamental divisionism of the Post-Impressionists and the dense and intimate images of artists such as Vuillard. And at the same time, the sculptural presentation of the figure and the brocadelike background, as well as the implied religious content of the subject, reflect the aesthetic and thematic concerns of the Beaux-Arts movement in America.[1]

The cloak and headgear shown here also appear in another of Hitchcock's paintings of the late 1890s, *Vespers* (Metropolitan Museum of Art, New York). The costume in that picture has been identified with the native dress of Zeeland, which Hitchcock himself notes was "always worn at work or play."[2] It is distinct from the bridal headdress that Hitchcock represents in other pictures of Dutch peasant women,[3] suggesting that the painting's present title may be a misnomer.

C.T.

NOTES
1. Several pointillist painters anticipated Hitchcock's patterning of landscape elements into horizontal bands, among them Signac (e.g., *Sunset at Merblay*, 1889–90; Glasgow Art Gallery and Museum); Cross (*La Pointe de la galère*, 1891–92; Private Collection); and the Dutchman Jan Toorop (*The Shell Gatherer*, 1891; Rijksmuseum Kröller-Müller, Otterlo). The ethereal sentimentality of Hitchcock's work is also characteristic of paintings of women by American artists like Abbott Thayer (*Caritas*, 1894–95; Museum of Fine Arts, Boston); Albert Herter (*Woman with Red Hair*, 1894; National Museum of American Art, Washington, D.C.); and Thomas Dewing (*Hymen* [with Maria Dewing], 1886; Cincinnati Art Museum).
2. Hitchcock, "The Picturesque Quality of Holland. Figures and Costumes" (*Scribner's Monthly Magazine* 10 [November 1891]: 624), quoted in Doreen Bolger Burke, *American Paintings in the Metropolitan Museum of Art*, vol. 3. (New York, 1980), p. 114.
3. Hitchcock sent a painting entitled *Dutch Bride*, in which the figure wears an elaborate, bejeweled headdress, to the Third Annual Exhibition of the Carnegie Institute, Pittsburgh (1902). A three-quarter-length version of that painting was recently exhibited and reproduced in the catalogue for *American Expatriate Painters of the Late Nineteenth Century* by Michael Quick (Dayton Art Institute, Ohio, 1976, no. 22) under the title of *In Brabant*.

PROVENANCE
With R. Gordon Barton, The Sporting Gallery, Middleburg, Va., by 1974; with Jordan-Volpe Gallery, New York; to present owner.

An exhibition history for cat.no.96 has not been established

97

CHILDE HASSAM
The Room of Flowers, 1894
Painted on Appledore Island, New Hampshire
Signed and dated lower center:
 Childe Hassam. 1894.
Oil on canvas, 34 × 34 in. (86.5 × 86.5 cm.)
Mr. and Mrs. Arthur G. Altschul

This painting is an homage to the woman who created the beautiful room it depicts: the writer Celia Laighton Thaxter (1835–1894), whose many poems and prose pieces often appeared in the *Atlantic Magazine*. The Thaxters were well traveled and made many friends in international artistic, literary, and musical circles, including the poet Robert Browning. However, Celia Thaxter's spiritual home was the isolation of Appledore Island in the Isles of Shoals off New Hampshire, where she cultivated a profuse garden around the cottage in which she held an informal summer salon for her friends.

It is not clear when she met Hassam, but he had been working on illustrations since 1892 for Mrs. Thaxter's book, *An Island Garden* (Boston, 1895). In that text, Thaxter observed: "Ever since I could remember anything, flowers have been like dear friends to me, comforters, inspirers, powers to uplift and to cheer." The "large, light, airy room" featured in Hassam's painting opened onto a long piazza overlooking the flower beds:

> *This room is made first for music; on the polished floor is no carpet to muffle sound, only a few rugs. . . . There are no heavy draperies to muffle the windows. . . . The piano stands midway at one side; there are couches, sofas with pillows of many shades of dull, rich color, but mostly of warm shades of green. There are low bookcases round the walls, the books screened by short curtains of pleasant olive-green; the high walls to the ceiling are covered with pictures, and flowers are everywhere.*[1]

The Room of Flowers shows Hassam at the height of his power and inventiveness as an Impressionist, a style he assimilated during his second and longest sojourn in France (1886–89). In this remarkable work, the artist embellished his typically uniform surface of shimmering brushstrokes with several prominent areas of impasto, including the thickly worked white tablecloth in the bottom right. He must have worked from a low seat, for the foreground table and its vase of lilies stand out boldly at eye level, while beyond them the interior perspective rises sharply in an overwhelming bounty of flowers, furniture, and works of art. At first the viewer does not see in the corner of this light-filled composition the young lady in a fine white and pink

dress who is reclining on the sofa and reading a book.

In addition to recording a classic turn-of-the-century artistic summer house, *The Room of Flowers* visually captures the quasi-religious sentiments behind Thaxter's love for flowers and music. The yellow lilies in the foreground strike an infectiously joyous note, and the entire picture radiates the loveliness of a fresh bouquet, predominately yellow and green, but scattered with reds, pinks, and whites. Thaxter believed that by sharing such heightened moments of tranquil beauty and happiness with her guests, she enriched their lives; and the annual cycle of her flower garden reminded her always of those who had enjoyed Appledore Island on previous occasions. *The Room of Flowers* is the culminating work from the summers Hassam spent on Appledore preparing the illustrations for *An Island Garden*; it turned out to be a memorial, for Mrs. Thaxter died unexpectedly very soon after the picture was finished. Hassam continued to make summer visits to Appledore Island until 1914, painting scenes of the rocky coast looking out to sea, for example *Bathing Pool, Appledore* (1907; Museum of Fine Arts, Boston), in his typical Impressionist style.[2] *T.J.F.*

NOTES

1. Thaxter, *An Island Garden*, pp. v, 94. For photographs of the room, see Rosamund Thaxter, *Sandpiper: The Life and Letters of Celia Thaxter* (Francestown, N.H., 1963), facing p. 161; and Susan Faxon et al., *A Stern and Lovely Scene: A Visual History of the Isles of Shoals* (University of New Hampshire Art Galleries, Durham, 1978), p. 117. Celia Thaxter, in her 1886 poem "Schumann's Sonata in A Minor," describes the hushed, flower-filled room on a summer night and then evokes her emotional responses to "the sacred power of music."

2. According to Adeline Adams (*Childe Hassam* [New York, 1938], p. 83), *The Room of Flowers* won the artist an award at the Salon du Champs-de-Mars, but this claim cannot be documented. I am grateful to Stuart P. Feld for his help with the exhibition history.

PROVENANCE
The artist; bequeathed to the American Academy of Arts and Letters, 1935; with Milch Galleries, New York; John Fox, Boston; to present owners, 1960.

EXHIBITION HISTORY
Pennsylvania Academy of the Fine Arts, Philadelphia, *Annual Exhibition*, 1895–96, cat.no.154.
Society of American Artists, New York, *Annual Exhibition*, 1896, cat.no.39.
Pennsylvania Academy of the Fine Arts, Philadelphia, *Exhibition of Paintings by Ten American Painters*, 1908, cat.no.46.
Montross Gallery, New York, *Exhibition of Pictures by Childe Hassam*, 1912, cat.no.2.
Carnegie Institute, Pittsburgh, *Annual Exhibition*, 1912, cat.no.137.
City Art Museum, St. Louis, *Annual Exhibition*, 1912, cat.no.54.
Museum of Fine Arts, Boston, extended loan 1919–21.
American Academy of Arts and Letters, New York, *Exhibition of the Works of Childe Hassam*, 1921, cat.no.26.
Durand-Ruel Galleries, New York, *Exhibition of Paintings by Childe Hassam*, 1926, cat.no.5.
Corcoran Gallery of Art, Washington, D.C. *Childe Hassam: A Retrospective Exhibition*, cat. intro. by Charles E. Buckley, 1965, no.19 (ill.).
Whitney Museum of American Art, New York, *Art of the United States: 1670–1966*, cat. by Lloyd Goodrich, 1966, no.124.
Metropolitan Museum of Art, New York, *New York Collects*, 1968, cat.no.73.
University of Arizona, Tuscon, and Santa Barbara Museum of Art, Calif., *Childe Hassam*, 1972, cat.no.39 (ill.).
Whitney Museum of American Art, New York, *18th and 19th Century American Art from Private Collections*, 1972, cat.no.34.
Coe Kerr Galleries, New York, *Masters of American Impressionism*, 1976, cat.no.11 (ill.).
Metropolitan Museum of Art, New York, *Childe Hassam as Printmaker*, 1977, cat.no.19.
University of New Hampshire Art Galleries, Durham, *A Stern and Lovely Scene: A Visual History of the Isles of Shoals*, cat. by Susan Faxon et al., 1978 (ill.).
National Gallery of Art, Washington, D.C., *Post-Impressionism: Cross-Currents in European and American Painting, 1880–1906*, 1980, cat.no.271 (ill.).

THOMAS EAKINS

(1844, Philadelphia—1916, Philadelphia)

Eakins's career was marked by controversy and paradox. He was castigated in his own time, yet no other artist ever gathered around him a more fiercely loyal group of supporters; and in periods when realist painting has been popular in America, including the present day, he has been hailed by many as America's greatest artist. Eakins was renowned as a teacher, yet he had few students or followers of significant achievement. After receiving rigorous and progressive training in drawing at Central High School in Philadelphia, Eakins studied in Paris (1866–70) under Gérôme, Bonnat, and the sculptor Dumont, his choice of mentors inspired by the enthusiasm for French academic art in Philadelphia. Yet when he returned and attempted to adapt his French training to characteristically American subject matter, his efforts met with puzzlement and, later, disdain.

Eakins pursued subjects sequentially, as though enrolled in a lifelong self-education program. In the 1870s his outdoor sporting scenes were balanced by interior genre subjects. At the end of the decade, after completing the monumental Gross Clinic *(cat. no. 98), he turned his attention to a series of old-fashioned themes inspired by the Philadelphia Centennial. He was less prolific in the 1880s: his work in that decade incorporated the experimental practices and research in photography and anatomy he conducted as part of his teaching at the Pennsylvania Academy of the Fine Arts (1879–86) and later at the Art Students' League in New York. Forced to resign from the directorship at the Academy in 1886, Eakins became deeply depressed and painted little for the next several years, until a trip to the Dakota badlands in 1892 restored his health and spirits. For the rest of his career, Eakins devoted himself almost exclusively to portraiture. He won few commissions, since his unidealizing, penetrating style was still unacceptable to most patrons, but instead painted many highly sympathetic and emotional images of family and close friends. Eakins was belatedly elected to the National Academy of Design in 1902 at age fifty-eight—most artists of his generation were elected in their thirties. He died in Philadelphia in 1916.*

The first and still definitive biography of Eakins was written in 1933 by Lloyd Goodrich; a revised and much-enlarged edition was published in 1982. More idiosyncratic studies are by Fairfield Porter (New York, 1959), Sylvan Schendler (Boston, 1967), and Gordon Hendricks (New York, 1974). The major Eakins collections at the Hirshhorn Museum was published in 1977, and that of the Philadelphia Museum in 1978. Recent exhibitions of Eakins's work include a 1970 retrospective at the Whitney Museum, with catalogue by Goodrich, and one in 1982, organized by Darrel Sewell for the Philadelphia Museum of Art.

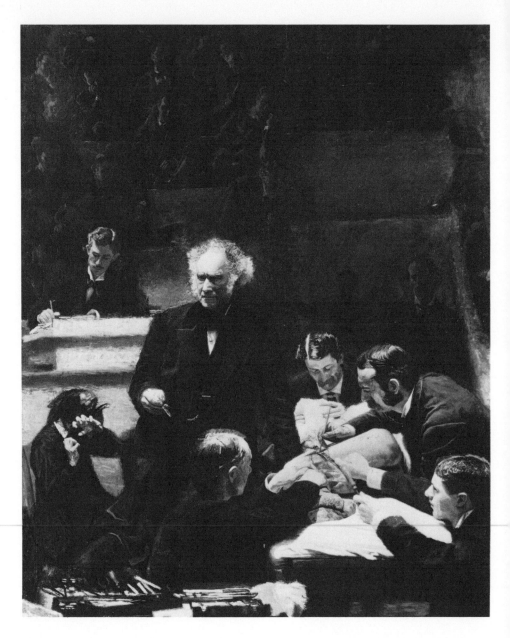

98

THOMAS EAKINS
The Gross Clinic, 1875
Painted in Philadelphia
Signed and dated lower right: *Eakins 1875*
Oil on canvas, 96 × 78½ in. (243.8 × 199.4 cm.)
Jefferson Medical College,
 Thomas Jefferson University, Philadelphia

Eakins was thirty-one at the time of the Centennial Exposition in Philadelphia. He had already received a few commissions and exhibited works to mostly favorable reviews in his native city; his paintings were also known in New York through the American Watercolor Society, with whom he had shown since 1874. By 1875 he was ready to enter a larger arena, and although Eakins never announced that he planned *The Gross Clinic* specifically for the Centennial, the size and complexity of the image suggest that it was designed for such a purpose.

Eakins's experience at the crowded, densely hung French Salons had taught him what was required for a painting to win notice in such a setting. It had to be grand, dramatic, daring, and even violent—like his master Gérôme's graphic *Death of Caesar* (1867; Walters Art Gallery, Baltimore) which had been greatly acclaimed at the 1867 Exposition

Universelle. The Philadelphia Centennial, modeled after such European fairs as the Exposition Universelle and London's 1851 Crystal Palace Exposition, was to be an international celebration of arts and industry. The arts display, intended to complement the machinery displayed elsewhere, was like the Salons in its emphasis on recent works of living artists, with native artists given preference. There was to be a "Saloon of Honor" for American masterworks, with additional paintings and sculpture, as well as foreign works, to be shown in the smaller side galleries. In fact, so many entries were submitted that an annex had to be built.

For his entry, Eakins chose a subject that reflected his own values and personal experiences, while illustrating the ideals of scientific progress that the Centennial celebrated. Samuel David Gross (1805–1884) was a professor at Jefferson Medical College in Philadelphia, where Eakins had attended lectures in anatomy in 1864–65 and again in 1873. Gross was the author of well-known treatises in anatomy, surgery, and orthopedics and had developed innovative surgical procedures for the treatment of bladder stones and of osteomyelitis, the latter being demonstrated here.[1] Gross embodied for Eakins both craftsmanship and intellectual achievement. Rather than honoring him with a conventional portrait, the artist chose to present him, as he had other figures he admired, in his own milieu, in this case the surgical amphitheater at Jefferson Medical College. The portrait of Dr. Gross thus became a vivid testimonial to the achievement of a modern man of science.

The composition of *The Gross Clinic* repeats almost exactly that of an oil sketch Eakins is believed to have made on the spot (Philadelphia Museum of Art),[2] and as he would do so often, the painter included himself in the picture, at the far right. But while *The Gross Clinic* is based on actual experience and events drawn from everyday life, Eakins transformed his observations into a dramatic history painting. The canvas was the largest on which he had ever worked. He employed a baroque pyramidal composition, with the leonine head of Dr. Gross at its apex. The brilliant light enhances the focus on Gross and on the patient whose body is dramatically foreshortened. The tiers of students recede dimly into shadowy space, contrasting with Gross's vivid sculptural presence. Finally, Eakins deviates from his austere color scheme only with accents calculated to shock: the pink of the towel on the instrument table in the foreground, the blue of the patient's socks, and the blood oozing from the incision and dripping from Gross's hands.

Despite the distinguished precedents for Eakins's subject—Rembrandt's *Anatomy Lesson of Dr. Tulp* (1632; Mauritshuis, The Hague), and in his own time Auguste Feyen-Perrin's *Anatomy Lesson of Doctor Velpeau* (1864; Musée des Beaux-Arts, Tours), which had been shown both in the 1864 Salon and at the Philadelphia Centennial—the painting was not accepted for display in Memorial Hall.[3] Apparently its unconventional subject matter and graphic treatment caused the Centennial's selection committee to reject it. Through the intervention of Dr. Gross, it was finally displayed in the U.S. Army Post Hospital pavilion, where it accompanied displays of modern medical equipment and techniques. The committee's squeamishness was echoed in a review describing a subsequent exhibition of the picture at the Society of American Artists in 1879. The critic for the *New York Times* grudgingly acknowledged the artist's skills, but condemned the work as a "morbid exhibition," offensive to people "with nerves and stomachs," and lacking any lesson on moral purpose.[4]

Eakins clearly miscalculated the effect of his painting and its suitability for the Centennial. Despite the Exposition's dedication to American progress in science and technology—which Eakins's portrait of a hero of scientific advancement clearly illustrates—most of the works of art on display did not respond to the realities of the urban industrial age but rather looked to the past.[5] Pride of place at the Centennial was given to paintings like Bierstadt's *Yosemite Valley*, a panoramic view of magnificent Western scenery that perpetuated the myth of the American frontier; also featured were works like Winslow Homer's *Snap the Whip* (cat. no. 61), a nostalgic tribute to the innocence of rural childhood, and William Sidney Mount's *Husking Corn* (1833; Museums at Stony Brook, N.Y.), which celebrated the kind of outmoded manual labor the machinery exhibited at the fair had long since displaced. In contrast, Eakins viewed the modern world without idealization or sentiment in an image designed to shock, to awe, but not to disgust. Unfortunately, his bid for recognition resulted only in notoriety: the reputation Eakins gained as a great talent led astray by a taste for inappropriate, even objectionable subject matter would haunt him ever after.

C.T.

NOTES

1. See *Dictionary of American Biography*, s.v. "Gross, Samuel David."
2. See Theodor Siegl, *The Thomas Eakins Collection, Philadelphia Museum of Art* (Philadelphia, 1978), p. 64.
3. The five works by Eakins which were accepted for exhibition at the Centennial were all more modest in scale and more conventional in subject matter. He showed three oils (*Elizabeth at the Piano*, *Dr. Benjamin Rand*, and *The Chess Players*) and two watercolors (*Negro Whistling Plover* and *Baseball Players Practicing*).
4. *New York Times*, 22 March 1879, quoted in Gordon Hendricks, "Thomas Eakins's *Gross Clinic*," *Art Bulletin* 51 (March 1969): 62–63.
5. This fact was not missed by the press. A writer for the *New York Daily Tribune* commented in a review of 1 June 1876 that most artists had submitted "not the best they can do today, but the best they could do five, ten, twenty years ago" (quoted in Hendricks, "*Gross Clinic*," p. 62).

PROVENANCE
To present owner, 1878.

EXHIBITION HISTORY
Haseltine Galleries, Philadelphia, April 1876.
Philadelphia, *Centennial Exhibition*, 1876 (in U.S. Army Post Hospital Building).
Haseltine Galleries, Philadelphia, November 1876.
Society of American Artists, New York, *Second Annual Exhibition*, 1879, cat. no. 7.
Pennsylvania Academy of the Fine Arts, Philadelphia, *Fiftieth Annual Exhibition*, 1879, cat. no. 465.
St. Louis, *Universal Exposition*, 1904, cat. no. 222.
Metropolitan Museum of Art, New York, *Loan Exhibition of the Works of Thomas Eakins*, 1917, cat. no. 9 (ill.).
Pennsylvania Academy of the Fine Arts, Philadelphia, *Memorial Exhibition of the Works of the Late Thomas Eakins*, 1917, cat. no. 122 (ill.).
Pennsylvania Museum, Philadelphia, *Exhibition of Thomas Eakins's Work*, 1930, cat. no. 40 (ill.).
Philadelphia Museum of Art, *Thomas Eakins Centennial Exhibition*, 1944, cat. no. 26 (ill.).
Philadelphia Museum of Art, *Diamond Jubilee Exhibition*, 1951, cat. no. 64 (ill.).
Pennsylvania Academy of the Fine Arts, Philadelphia, *150th Anniversary Exhibition*, 1955, cat. no. 90 (ill.).
National Gallery of Art, Washington, D.C., *Thomas Eakins: A Retrospective Exhibition*, cat. by Lloyd Goodrich, 1961 (traveling exhibition), no. 19 (ill.).
Philadelphia Museum of Art, *The Art of Philadelphia Medicine*, 1965, cat. no. 59 (ill.).
Whitney Museum of American Art, New York, *Thomas Eakins Retrospective Exhibition*, cat. by Goodrich, 1970, no. 21 (ill.).
Metropolitan Museum of Art, New York, *19th-Century America: Paintings and Sculpture*, cat. by John K. Howat and Natalie Spassky, 1970, no. 155 (ill.).
Museum of Art, Birmingham, Ala., *The Art of Healing—Medicine and Science in American Art*, cat. by William H. Gerdts, 1981 (ill.).
Philadelphia Museum of Art, *Thomas Eakins, Artist of Philadelphia*, cat. by Darrel Sewell, 1982 (traveling exhibition), no. 33 (ill.).

99

THOMAS EAKINS
The Pathetic Song, 1881
Painted in Philadelphia
Signed and dated lower left: *Eakins. / 1881*
Oil on canvas, 45 × 32½ in. (114.3 × 82.6 cm.)
The Corcoran Gallery of Art, Washington,
 D.C., Gallery Fund Purchase, 1919

Upon returning to Philadelphia from France in 1870, Eakins embarked on a series of interior genre scenes featuring his sisters and the young women of the Crowell family who lived next door. At mid-decade, inspired by the Centennial Exposition's celebration of life in America during the colonial period, he posed some of the same young women in early period attire and painted them performing household tasks of their grandmother's era. In *The Pathetic Song*, his last and most ambitious domestic genre subject, Eakins abandoned the old-fashioned costume pieces and returned to depicting life around him. Again his models were close friends: the singer is Margaret Alexina Harrison, sister of the painters Alexander and Birge Harrison, and a pupil of Eakins's at the Pennsylvania Academy; the pianist, Susan Hannah Macdowell (whom Eakins would marry in 1884), was also his pupil; the cellist was a Mr. Stolte who performed with the Philadelphia Symphonic Society (later the Philadelphia Orchestra).

Eakins's return to scenes of contemporary life met with the approval of critic Mariana Griswold Van Rensselaer who, in discussing *The Pathetic Song* in her review of the 1881 Society of American Artists' exhibition, extolled Eakins's devotion to "actual life around him" against those artists who sought out picturesque subjects and "pretty effects":

"All possible renderings of Italian peasants and colonial damsels and pretty models cannot equal in importance to our growing art one such strong and real artistic work as this one I have noted."[1]

Eakins's subject, the home musicale, was popular among both British and American painters of the Victorian era. During this period, most middle-class women had some musical training, and these pictures paid homage to the performer's charms and to her comfortably appointed surroundings; or, as in the case of J. G. Brown's *The Music Lesson* (1870; Metropolitan Museum of Art, New York), where the lesson of the title disguises a gentle flirtation, they tell a sweet and sentimental story. Eakins, however, neither flattered the subjects nor glorified their surroundings, and his picture suggests a certain determination, even strain, on the part of the performers. Even in his own time, this awkwardness was recognized as part of Eakins's interpretation of the subject. The painting's title can be read in two ways: it refers to the lyric ballad (which frequently treated "pathetic" themes of unrequited love, sacrifice, and untimely death), a mainstay of these home entertainments; but it applies as well to the setting and the subjects themselves. In her review Van Rensselaer credited Eakins with making "delightful pictures" out of "three homely figures with ugly clothes in an 'undecorative' interior."[2]

Here color and the skillful manipulation of light isolate the main figure. Her lavender-gray gown is the brightest tone in a composition built of muted secondary colors; strong, focused light coming from the side not only accentuates the satiny sheen of her gown but also separates her from the accompanists, who seem to fade into the dull-green patterned wallpaper behind. The light and the figure's static pose give her a sculptural presence. Eakins introduces in this picture a theme far more subtle and perceptive than any found in the "home musicale" subjects of his contemporaries: the isolation and loneliness of the solo performer.

The Pathetic Song clearly had strong emotional associations for Eakins. According to Lloyd Goodrich, a photograph of the work in progress shows another (unidentified) figure at the piano; Eakins later substituted the woman who would become his wife.[3] He gave his friend David Wilson Jordan the oil sketch for the picture (Hirshhorn Museum, Smithsonian Institution, Washington, D.C.) and gave Margaret Harrison a watercolor replica (Metropolitan Museum of Art, New York) in gratitude for her patience in posing. *The Pathetic Song* was one of several works Eakins showed at the Society of American Artists in the early 1880s and the only one to find a buyer. In 1885, Edward Hornor Coates,

a Philadelphia industrialist (and the conservative successor to Eakins's supporter Fairman Rogers as chairman of the committee on instruction at the Pennsylvania Academy) took the picture for $800, reduced from the $1200 Eakins was asking. C.T.

NOTES
 1. Van Rensselaer, "The New York Art Season," *Atlantic Monthly* 48 (August 1881): 198–99.
 2. Ibid.
 3. See Lloyd Goodrich, *Thomas Eakins*, 2 vols. (Cambridge, Mass., 1982), 1:222.

PROVENANCE
Edward Hornor Coates, Philadelphia, 1885–1919; to present owner, 1919.

EXHIBITION HISTORY
Society of American Artists, New York, *Fourth Annual Exhibition*, 1881, cat.no.21.
Pennsylvania Academy of the Fine Arts, Philadelphia, *Memorial Exhibition of the Works of the Late Thomas Eakins*, 1917, cat.no.119 (ill.).
Museum of Modern Art, New York, *American Paintings and Sculpture 1862–1932*, 1932 cat.no.30 (ill.).
Whitney Museum of American Art, New York, *American Genre: The Social Scene in Paintings and Prints*, cat. by Lloyd Goodrich, 1935, no.29.
Carnegie Institute, Pittsburgh, *Exhibition of American Genre Paintings*, 1936, cat.no.33.
Minneapolis Institute of Arts, *Great Portraits of Famous Painters*, 1952, cat.no.43.
Pennsylvania Academy of the Fine Arts, Philadelphia, *150th Anniversary Exhibition*, 1955, cat.no.90.
The Detroit Institute of Arts, *Painting in America: The Story of 450 Years*, cat. by E. P. Richardson, 1957, no.138 (ill.).
The American Academy of Arts and Letters, *Thomas Eakins, 1844–1916*, 1958.
Art Gallery of Toronto, *American Paintings 1865–1905*, cat. by Goodrich, 1961 (traveling exhibition), no.20 (ill.).
National Gallery of Art, Washington, D.C., *Thomas Eakins, A Retrospective Exhibition*, cat. by Goodrich, 1961 (traveling exhibition), no.40 (ill.).
Brooklyn Museum, N.Y., *The Triumph of Realism*, cat. by Axel von Saldern, 1967 (traveling exhibition), no.82 (ill.).
Metropolitan Museum of Art, New York, *19th-Century America: Paintings and Sculpture*, cat. by John K. Howat and Natalie Spassky, 1970, no.156 (ill.).
Whitney Museum of American Art, New York, *Thomas Eakins Retrospective Exhibition*, cat. by Goodrich, 1970, no.37 (ill.).
Whitney Museum of American Art, New York, *The Painters' America: Rural and Urban Life, 1810–1910*, cat. by Patricia Hills, 1974 (traveling exhibition), no.109 (ill.).
Corcoran Gallery of Art, Washington, D.C., *Of Time and Place: American Figurative Art from the Corcoran Gallery of Art*, cat. by Edward Nygren, 1981 (traveling exhibition), no.21 (ill.).

100

THOMAS EAKINS
Home Ranch, 1892
Painted in Philadelphia
Signed on table, center right : *EAKINS*
Oil on canvas, 24 × 20⅛ in. (61 × 50.8 cm.)
Philadelphia Museum of Art,
 Gift of Mrs. Thomas Eakins
 and Miss Mary Adeline Williams

In July 1887 Eakins traveled alone to the Dakota badlands, where he stayed for about two months at the B-T Ranch as the guest of his friend Dr. Horatio Wood, professor of nervous diseases at the University of Pennsylvania. Wood may have suggested the trip, for Eakins was exhausted and depressed from his struggles over curriculum with the trustees of the Pennsylvania Academy of the Fine Arts, which had culminated in his forced resignation as director of the Academy the year before. Although work on the ranch was hard and living conditions primitive, Eakins seems to have enjoyed the company of the cowboys and their exotic life, and the trip had its desired restorative effect.

Upon returning to Philadelphia, Eakins began a series of pictures reflecting his experiences in the badlands and drawing upon the oil sketches and photographs he made there. The last of these is a group of four interior scenes, for which Eakins's pupil, the bohemian painter, poet, and musician Franklin Schenck, posed. For three of the pictures (*Cowboy Singing*, c. 1892, watercolor, Metropolitan Museum of Art, New York; *Cowboy Singing*, c. 1892, oil, Philadelphia Museum of Art; and *Home Ranch*) Schenck wears the same costume, sits in the same chair, and assumes the same pose, but is shown from a different angle and in different light in each scene. *Home Ranch* is the most complete of these : the addition of a spectator in the background (Eakins's favorite pupil, Samuel Murray) and a black cat at the singer's feet, gives the composition a narrative quality not found in the other versions.

A painting by Eakins's Parisian master Gérôme, *Bashi-Bazouk Singing* (1859; Walters Art Gallery, Baltimore) may be the source for the cowboy's pose in *Home Ranch*. Eakins is known to have brought back from Paris a photograph of Gérôme's painting;[1] it was also reproduced in Eakins's friend Earl Shinn's honorific album of paintings by Gérôme, published in 1881–83. Such direct borrowing of pose and composition appears in few of Eakins's earlier works.[2]

Eakins responded to the American West much as his master had to Egypt. His trip seems to have sparked an interest in ethnography : like Gérôme, he took photographs of the "natives," bought their costumes and paraphernalia, and after returning to the studio, dressed models in the costumes and used the photographs as guides for re-creating the characteristic attitudes of his subjects. Yet unlike Gérôme's paintings, which emphasize the exotic, *Home Ranch* remains familiar and comfortable, despite the rude furniture, the gun and bullet-studded holster, and the black cat with upraised tail and searing yellow eyes. Eakins's subject recalls the many other "home musicales" he painted during his career (e.g., *Professionals at a Rehearsal*, 1883 ; Philadelphia Museum of Art); and the wildness of the West is tempered by the image's nostalgic picturesqueness. Eakins's cowboy sings with relative abandon, and while his expression is not entirely free of melancholy, he nonetheless appears far less self-conscious and inhibited than most of the other figures Eakins painted. The cowboy's personality may well have been suggested by the unconventional Schenck's own character; one could also speculate that it mirrors Eakins's own feelings of release.

Home Ranch was exhibited, along with nine other works by Eakins, at the 1893 World's Columbian Exposition in Chicago. Eakins won a medal at that fair—his first honor since 1878—and, with Homer and Inness, was one of the best-represented American artists. The painting was also included in Eakins's only one-man show in his lifetime, at Earles's Galleries in Philadelphia in 1896. It was priced at $800 and did not sell. It remained with the family and became part of Mrs. Eakins's gift to the Philadelphia Museum of Art in 1929.[3]

C.T.

NOTES

1. See Gerald M. Ackerman, "Thomas Eakins and His Parisian Masters, Gérôme and Bonnat," *Gazette des Beaux-Arts* 73 (April 1969): 243–44.

2. This renewed interest in Gérôme was apparently long lasting; the boxing pictures which Eakins painted at the end of the decade seem to be translations into a modern American idiom of the French artist's popular gladiator paintings. See Ackerman, "Eakins and His Parisian Masters," p. 244.

3. See Lloyd Goodrich, *Thomas Eakins*, 2 vols. (Cambridge, Mass., 1982), 2 :163, 166.

PROVENANCE
The artist, Philadelphia, to 1916; Susan MacDowell Eakins and Mary Adeline Willams, to 1929; to present owner, 1929.

EXHIBITION HISTORY
Detroit Museum of Art, *First Annual Exhibition of Paintings by American Artists*, 1906, cat.no.22.
Metropolitan Museum of Art, New York, *Loan Exhibition of the Works of Thomas Eakins*, 1917, cat. no. 3 (ill.).
Pennsylvania Academy of the Fine Arts, Philadelphia, *Memorial Exhibition of the Works of the Late Thomas Eakins*, 1917, cat.no.95 (ill.).
Joseph Brummer Galleries, New York, *Exhibition of Paintings and Water Colors by Thomas Eakins*, 1923, cat.no.6.
Joseph Brummer Galleries, New York, *Exhibition of Paintings and Drawings by Thomas Eakins*, 1925, cat.no.13.
Buffalo Fine Arts Academy, N.Y., *Catalogue of a Collection of Paintings and Drawings by Thomas Eakins (1844–1916)*, 1926, cat.no.12.
Philadelphia, *Paintings, Sculpture, and Prints in the Department of Fine Arts, Sesqui-Centennial International Exposition*, 1926, cat.no.359.
Philadelphia Museum of Art, *Thomas Eakins Centennial Exhibition*, 1944, cat.no.64.
Carnegie Institute, Pittsburgh, *Thomas Eakins Centennial Exhibition 1844–1944*, 1945, cat.no.81.
Philadelphia Museum of Art, *Thomas Eakins: Artist of Philadelphia*, cat. by Darrel Sewell, 1982 (traveling exhibition), no. 107 (ill.).

IOI

THOMAS EAKINS
Amelia C. van Buren, c. 1890
Painted in Philadelphia
Oil on canvas, 45 × 32 in. (114.3 × 81.3 cm.)
The Phillips Collection, Washington, D.C.

Although Amelia van Buren studied with Eakins for only a few months at the Pennsylvania Academy, she became a close family friend and traveled frequently from her home in Detroit to visit with them in Philadelphia during the late 1880s and '90s. It was Eakins who kindled her interest in photography, and she would later enjoy moderate success as a photographer, exhibiting in the Photographic Salons held in Philadelphia in 1898, 1899, and 1900, and with Eakins and Susan Macdowell Eakins in the 1899 Camera Club Exhibition in New York.[1] She was also one of Eakins's favorite and most frequently used models outside his family, and his images of her are extraordinarily sensitive and sympathetic.

Eakins began *Amelia C. van Buren* a few years after he was forced to resign as director of the Pennsylvania Academy, and at a time when, except for occasional lectures in anatomy, he had stopped teaching at other institutions as well. During his tenure at the Academy, he had experimented with a wide variety of techniques, genres, and mediums; by the nineties, he put much of the experimentation behind him and devoted himself to portraiture, a genre which would be his almost exclusive concern for the rest of his career. Few of the portraits painted after about 1890 were commissions; most were of close friends like Amelia van Buren whose personal histories were well known to Eakins and deeply felt.

Eakins's approach to portraiture—straightforward, unflattering, and unadorned—had been molded in Paris under the tutelage of Léon Bonnat. Bonnat's *Portrait of a Woman* (1868; Séligmann Antiquités, Paris),[2] completed just before Eakins entered his atelier, provided the prototype for Amelia van Buren's pose, and particularly for the graceful gestures of her left hand supporting her head while her right, resting in her lap, holds a folded fan. From Bonnat's portrait style Eakins adopted the strong lighting and subdued, neutral background so effective in focusing attention on the sitter's features and personality. But whereas Bonnat's subject sits upright, filling the picture plane and confronting the viewer squarely, Amelia van Buren is slumped to one side, her head turned, her eyes averted, her expression abstract and brooding. The chair in which she sits was one of Eakins's favorite studio props, an ornate Renaissance Revival armchair probably dating from the 1850s. The chair was old-fashioned by this time, and had bulky, masculine proportions, yet Eakins used it repeatedly for portraits of women, and it almost always dwarfed the sitter and underscored the frailty of both her person and her psyche.[3]

Eakins's handling in *Amelia C. van Buren* is more sensuous than usual, his stroke richer, his attention to the multicolored flowers on his sitter's gown worthy of Copley. Yet the youthfulness and gaiety of her dress seem to have been deliberately chosen by Eakins to contrast with his sitter's melancholy expression: she wears the clothes of a young woman and holds a fan, a coquettish accessory; yet her hair, the lines around her mouth and at her brow, and her tense, bony hands describe a woman of middle age, a spinster whose charms have passed unnoticed.

That this was Eakins's own view of Amelia van Buren, and not her actual appearance, is borne out by the over half-dozen photographs which Eakins made of her at about the same time. These photographs were not used to develop the pose or gestures of the oil, nor were they taken, after Bonnat's practice, to free the subject from prolonged and tedious sittings. Rather, they were a separate means by which Eakins explored the character of his sitter. Interestingly, the photographs of Amelia van Buren reveal a much younger woman, energetic, with expressive eyes, and with only a hint of the painting's evocation of a "personality in tension with its world."[4] Eakins frequently depicted his sitters as older than they were and, in the portraits of those to whom he felt a special closeness, used their features to mirror his own thoughts and feelings. It may well be that the weariness and resignation we see in Amelia van Buren's face were in fact Eakins's own. *C.T.*

NOTES
1. See Lloyd Goodrich, *Thomas Eakins*, 2 vols. (Cambridge, Mass., 1982), 1:259.
2. Reproduced in Gabriel P. Weisberg, *The Realist Tradition: French Painting and Drawing 1830–1900* (Cleveland, 1980), p. 177.
3. Goodrich mentions a dozen paintings in which the armchair appears, beginning with *Kathrin* (1872; Yale University Art Gallery, New Haven, Conn.), and ending with *The Old-Fashioned Dress* (1908; Philadelphia Museum of Art), one of his last portraits. See *Eakins*, vol. 2, pp. 64 and 323 n. 64.
4. Sylvan Schendler, *Eakins* (Boston, 1967), p. 124.

PROVENANCE
Amelia van Buren, Tryon, N.C.; to present owner, 1927.

EXHIBITION HISTORY
Chicago, *World's Columbian Exposition*, 1893, cat. no. 383 (as *Portrait of a Lady*).
Museum of Modern Art, New York, *Sixth Loan Exhibition: Winslow Homer, Albert P. Ryder, Thomas Eakins*, cat. by Lloyd Goodrich et al., 1930, no. 102 (ill.).
The Century Association, New York, *Exhibition of Portraits*, 1931.
Metropolitan Museum of Art, New York, *The Taste of Today in Masterpieces of Painting before 1900*, 1932.

Museum of Modern Art, New York, *Art in Our Time*, cat. by Alfred H. Barr, Jr., 1939, no. 33 (ill.).

Carnegie Institute, Pittsburgh, *Thomas Eakins Centennial Exhibition, 1844–1944*, 1945, cat. no. 90 (ill.).

Tate Gallery, London, *American Painting from the 18th Century to the Present Day*, 1946, cat.no. 71.

Pennsylvania Academy of the Fine Arts, Philadelphia, *150th Anniversary Exhibition*, 1955, cat.no.89.

Brooklyn Museum, N.Y., *Face of America: The History of Portraiture in the United States*, 1957, cat.no.62 (ill.).

Corcoran Gallery of Art, Washington, D.C., *The American Muse: Parallel Trends in Literature and Art*, cat. by Henri Dorra, 1959, no. 5 (ill.).

National Gallery of Art, Washington, D.C., *Thomas Eakins: A Retrospective Exhibition*, cat. by Lloyd Goodrich, 1961 (traveling exhibition), no. 58 (ill.).

Whitney Museum of American Art, New York, *Art of the United States: 1670–1966*, cat. by Goodrich, 1966, no. 83 (ill.).

Metropolitan Museum of Art, New York, *19th-Century America: Paintings and Sculpture*, cat. by John K. Howat and Natalie Spassky, 1970, no. 158 (ill.).

Whitney Museum of American Art, New York, *Thomas Eakins Retrospective Exhibition*, cat. by Goodrich, 1970, no. 56 (ill.).

Bell Gallery, Brown University, Providence, R.I., *The Classical Spirit in American Portraiture*, 1976, cat.no.47 (ill.).

Brandywine River Museum, Chadds Ford, Pa., *Eakins at Avondale; and Thomas Eakins: A Personal Collection*, cat. by James H. Duff et al., 1980, no. 1.

National Gallery of Art, Washington, D.C., *Post-Impressionism: Cross-Currents in European and American Painting 1880–1906*, 1980, no. 260 (ill.).

Museo del Palacio de Bellas Artes, Mexico City, *La Pintura de los Estados Unidos de Museos de la Ciudad de Washington*, 1980, p. 88 (ill.).

Fine Arts Museums of San Francisco, *Master Paintings from The Phillips Collection*, 1981 (traveling exhibition), cat.no.19 (ill.).

102

THOMAS EAKINS
The Thinker: Portrait of Louis N. Kenton, 1900
Painted in Philadelphia
Signed and dated lower right: *Eakins/1900.*; inscribed on stretcher, probably by Susan Macdowell Eakins: *"Thinker" T. Eakins*
Oil on canvas, 82 × 42 in. (208.3 × 106.7 cm.)
The Metropolitan Museum of Art, New York, Kennedy Fund, 1917

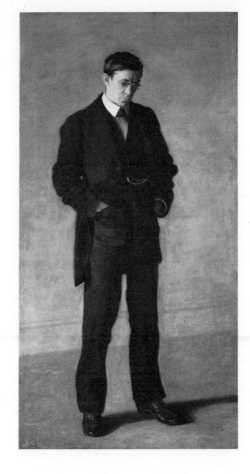

One of Eakins's most familiar portraits depicts a man about whom little is known. Louis N. Kenton (1869–1947) was Eakins's brother-in-law, having married Susan Macdowell Eakins's sister Elizabeth (1858–1953) probably about the time this portrait was painted. Elizabeth Macdowell Kenton, also an artist, was an independent and strong-willed person; her marriage to Kenton was short and stormy, "barely outlasting the honeymoon."[1] Mrs. Kenton kept the portrait after it was completed. As though to underscore the subject's estrangement from the family, Susan Eakins rechristened the painting the "Thinker" (so inscribing it on the stretcher) when it entered the collection of the Metropolitan Museum of Art, New York, in 1917. It has been known by that name ever since and today seems less a portrait of an individual than an image of a type—the introspective man.

Eakins must have thought highly of this portrait, for he exhibited it at least thirteen times between 1900 and 1916.[2] These exhibitions marked a turning point in his critical reception: for the first time, his penetrating realism was understood and admired. The critic M. E. Wright, reviewing the work when it was shown at the seventieth annual exhibition (1901) of the Pennsylvania Academy of the Fine Arts, found it superior in its "simplicity and vigor" to a Sargent portrait (of General Ian Hamilton, 1898; Tate Gallery, London) in the same show, and called it "a masterpiece of correct portraiture, devoid of all flattery, but instinct with the strong individuality of the subject. . . . It is a pictorial expression of character which could only result from the closest communion between painter and subject." The comments of Charles H. Caffin also indicate that the vogue for idealized, bravura painting was waning in America in favor of a more direct and expressive style. He singled out Eakins's portrait in his review of the Pan-American Exposition in Buffalo in 1901: "We may find it ungainly in composition, certainly without any superficial qualities of beauty; but its intense realism and the grasp which it suggests of the subject's personality render the picture one of notable fascination."[3] Perhaps encouraged by this praise, Eakins

embarked on another full-length male portrait which in size and spirit is a companion to *The Thinker*: the *Portrait of Leslie Miller* (1901; Philadelphia Museum of Art), whose energetic subject is shown addressing the viewer, depicts the man of action as *The Thinker* shows the contemplative man. *Leslie Miller* was also widely exhibited, and won several prizes.[4]

Eakins's *Thinker* reflects the international revival of enthusiasm for the portraits of Velázquez evidenced by painters as diverse as Manet, Whistler, and Chase. Beginning about 1860, each of these artists painted full-length portraits of men dramatically silhouetted against a simple light background. In 1869, Eakins's master Léon Bonnat sent him to Spain and encouraged him to study Velázquez, and the influence of the Spanish master proved to be deep and long lasting. The connection between Velázquez's court paintings such as *Pablo de Valladolid* (1630s; Museo del Prado, Madrid) and this portrait of Kenton has been noted by critics since 1918.[5] But whereas artists like Whistler admired the decorative qualities of Velázquez's work and the brilliance of his surface design, it was the sculptural aspect of the Spanish master's style, as well as his strong lighting and austere color scheme, that attracted Eakins. The previous year, Eakins had experimented with the Whistlerian manner in a portrait of his

good friend David Wilson Jordan (1899; Coll. Anthony Mitchell). That portrait shows Jordan from behind, his aristocratic profile silhouetted against a scumbled ground, his figure elongated, his right hand holding a pair of elegant leather gloves. For his portrait of Kenton, Eakins returned to his more characteristically straightforward approach, choosing as his subject a self-absorbed and thoughtful man of undistinguished appearance. He wears rumpled clothes and his head is lowered, his eyes cast down and his mouth drawn. In many of his earlier portraits, Eakins had made the hands as compelling as the face; here they are no less expressive for being thrust unselfconsciously in Kenton's pockets, as though to prove Duranty's dictum, "Hands held in pockets can also be eloquent."[6]

<div align="right">C.T.</div>

NOTES

1. Quoted in David Sellin, *Thomas Eakins, Susan Macdowell Eakins, Elizabeth Macdowell Kenton* (Slack Hall, North Cross School, Roanoke, Va., 1977), pp. 29–30. For information about Kenton, and especially for the excerpts from early reviews of *The Thinker* quoted above, I am greatly indebted to Natalie Spassky.

2. See Lloyd Goodrich, *Thomas Eakins*, 2 vols. (Cambridge, Mass., 1982), 2:182.

3. Wright, "Philadelphia Art Exhibition," *Brush and Pencil* 7 (February 1901): 264; Caffin, "The Picture Exhibition at the Pan-American Exposition," *International Studio* 14 (October 1901): xxxii.

4. At the annual exhibition of the National Academy of Design in 1905, *Leslie Miller* was awarded the Thomas R. Proctor prize ($200) for the best portrait in the show. Two years later, it won a Second Class Medal at the Carnegie exhibition in Pittsburgh. See Theodor Siegl, *The Thomas Eakins Collection* (Philadelphia Museum of Art, 1978), p. 156.

5. See B[ryson] B[urroughs], "Recent Accessions," *Metropolitan Museum of Art Bulletin* 13 (January 1918): 25.

6. Edmond Duranty's essay *La Nouvelle Peinture* (Paris, 1876) was a major treatise on realism and describes subjects and compositional devices that can be used to enhance a picture's fidelity to actual experience.

PROVENANCE

Mrs. Louis N. Kenton, Philadelphia, 1900–17; to present owner, 1917.

EXHIBITION HISTORY

Carnegie Institute, Pittsburgh, *Fifth Annual Exhibition*, 1900, cat.no.70.
Pennsylvania Academy of the Fine Arts, Philadelphia, *Seventieth Annual Exhibition*, 1901, cat.no.11.
Buffalo, N.Y., *Pan-American Exposition*, 1901, cat.no.310.
National Academy of Design, New York, *77th Annual Exhibition*, 1902, cat.no.309.
Copley Hall, Boston, *The Copley Society Second Annual Exhibition of Contemporary Art*, 1902, checklist, p. 9.
St. Louis, *Universal Exposition*, 1904, cat.no.220.
Detroit Museum of Art, *First Annual Exhibition of Paintings by American Artists*, 1906, cat.no.21.
Metropolitan Museum of Art, New York, *Loan Exhibition of the Works of Thomas Eakins*, 1917, cat.no.48 (ill.).
Pennsylvania Academy of the Fine Arts, Philadelphia, *Memorial Exhibition of the Works of the Late Thomas Eakins*, 1917, cat.no.68 (ill.).
National Academy of Design, New York, *Commemorative Exhibition by Members of the National Academy of Design*, 1925, cat.no.315.
Baltimore Museum of Art, *Thomas Eakins, 1844–1916: A Retrospective Exhibition of His Paintings*, cat. by Clarence W. Cranmer, 1936, no. 32.
Metropolitan Museum of Art, New York, *Life in America*, 1939, no. 263.
Philadelphia Museum of Art, *Thomas Eakins Centennial Exhibition*, 1944, cat.no.90.
Century Association, New York, *Eakins-Homer Exhibition*, 1951, cat.no.5.
Pennsylvania Academy of the Fine Arts, Philadelphia, *150th Anniversary Exhibition*, 1955, cat.no.88.
Metropolitan Museum of Art, New York, *Fourteen American Masters*, 1958.
National Gallery of Art, Washington, D.C., *Thomas Eakins: A Retrospective Exhibition*, cat. by Lloyd Goodrich, 1961 (traveling exhibition), no. 77 (ill.).
Metropolitan Museum of Art, New York, *Three Centuries of American Painting*, 1965.
Metropolitan Museum of Art, New York, *19th-Century America: Paintings and Sculpture*, cat. by John K. Howat and Natalie Spassky, 1970.
Whitney Museum of American Art, New York, *Thomas Eakins Retrospective Exhibition*, cat. by Goodrich, 1970, no. 76 (ill.).
M. Knoedler & Co., New York, *What is American in American Art?* cat. by Goodrich and Mary Black, 1971, no. 87 (ill.).

103

THOMAS EAKINS
Mrs. Edith Mahon, 1904
Painted in Philadelphia
Inscribed on reverse: *To my friend Edith Mahon / Thomas Eakins 1904*
Oil on canvas, 20 × 16 in. (50.8 × 40.6 cm.)
Smith College Museum of Art, Northampton, Massachusetts, Purchase, 1931

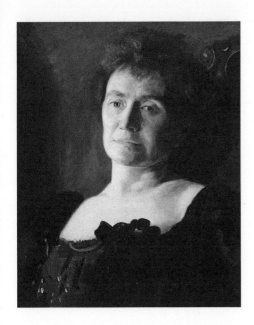

Edith Mahon was an English-born pianist and professional accompanist. She came to the United States around the turn of the century and shortly thereafter became acquainted with the Eakinses, frequently entertaining them at the piano in their Mount Vernon Street home in Philadelphia. Like Eakins, she achieved little recognition or popular success. On one occasion she did serve as accompanist to the celebrated Mme Ernestine Schumann-Heink when the contralto gave one of her many concerts with the Philadelphia Orchestra; but according to Susan Eakins, Mrs. Mahon was engaged at the last minute and had not been able to rehearse the program. Nevertheless, "so accurate and sympathetic was her playing, Madame Heink [sic] was delighted and declared she now knew where to find a perfect accompanist."[1]

Eakins painted many amateur and professional musicians during his career. At the time Mrs. Mahon sat for him, he painted several associated with the newly formed Philadelphia Orchestra. These performers—depicted in *The Oboe Player* (Dr. Benjamin Sharp, 1903; Philadelphia Museum of Art), *The Violinist* (Hedda van der Beemt, 1904; Hirshhorn Museum, Smithsonian Institution, Washington, D.C.), and *Music* (van der Beemt and pianist Samuel Myers, 1904; Albright-Knox Art Gallery, Buffalo, N.Y.)—were also friends of Eakins's and performed at musicales which the artist attended. Unlike Mrs. Mahon, they are all shown with their instruments practicing their art; yet despite the intensity and concentration their portraits convey, none displays the depth of feeling of the portrait of Edith Mahon.

Mrs. Mahon, clothed in an elegant black gown she might have worn on stage, sits in Eakins's familiar Renaissance Revival chair, her head pulled back, her shoulders slumped,

her face wearing an expression of fatigue one might expect following a performance. Yet there is no elation, no sense of satisfaction or triumph in her expression; rather, her red-rimmed eyes speak of deep sadness, the firm set of her lips, of stoicism, determination, and endurance. In his portraits of women, Eakins frequently used the brilliance of his sitter's gown as a foil for her sober, contemplative expression, but nowhere does he do so more poignantly than here, where even his technique is modified to underscore the disparity. Mrs. Mahon's fashionable gown is rendered with a rich shorthand of bright daubs and lush, thick strokes, a sophisticated, bravura handling unique in Eakins's work. But for her features he returns to his more characteristic self-effacing style: soft fine strokes create shuddering contours and deep shadows, describe wisps of hair and tiny veins, and etch lines and creases into her flesh.

The resignation and sorrow Eakins finds in Mrs. Mahon were surely the result of a great personal disappointment, yet her tragedy remains as obscure as the rest of her biography. Reflecting on the portrait's tragic expression, Susan Eakins commented, "I can only repeat what I heard outside, never from her, that she had suffered from great unkindness."[2]

C.T.

NOTES

1. Susan Macdowell Eakins to Alfred Vance Churchill, 27 April 1931 (Curatorial files, Smith College Museum of Art, Northampton, Mass.).
2. Ibid.

PROVENANCE
Edith Mahon, Philadelphia (?), 1904; with Pancoast Galleries, Wellesley, Mass.; to present owner, 1931.

EXHIBITION HISTORY
M. Knoedler & Co., New York, *A Loan Exhibition of the Works of Thomas Eakins 1844–1944*, cat. by W. F. Davidson and Lloyd Goodrich, 1944, no. 74 (ill.).
Munson-Williams-Proctor Institute, Utica, N.Y., *Exhibition of Paintings by Winslow Homer and Thomas Eakins*, 1946, cat.no.23.
Williams College Museum of Art, Williamstown, Mass., *Sixteen Portraits 1600–1900*, 1950.
Wildenstein & Co., New York, *Seventy Twentieth-Century American Painters*, 1952, cat.no.62.
Museum of Art, Rhode Island School of Design, Providence, *Sculpture by Painters*, 1952.
M. Knoedler & Co., New York, *Paintings and Drawings from the Smith College Collection*, 1953, cat.no.35.
Los Angeles County Fair Association, *Painting in the USA, 1721–1953*, 1953.
William Hayes Ackland Memorial Art Center, University of North Carolina, Chapel Hill, *Paintings, Drawings, Prints and Sculpture from American College and University Collections*, 1958, cat.no.109 (ill.).
Arts Club of Chicago, *Smith College Loan Exhibition*, 1961, cat.no.10.
National Gallery of Art, Washington, D.C., *Thomas Eakins: A Retrospective Exhibition*, cat. by Lloyd Goodrich, 1961 (traveling exhibition), no. 93 (ill.).
Smith College Museum of Art, Northampton, Mass., *Portraits from the Collection of the Smith College Museum of Art*, 1962, cat.no.19 (ill.).
Smith College Museum of Art, Northampton, Mass., *An Exhibition of American Painting for a Professor of American Art*, 1964, cat.no.17 (ill.).
Baltimore Museum of Art, *From El Greco to Pollock*, 1968, cat.no.64 (ill.).
Colby College Art Museum, Waterville, Maine, *19th and 20th Century Paintings from the Collection of the Smith College Museum of Art*, cat. by Charles Chetham, Mira M. Fabian, and Michael Wentworth, 1969 (traveling exhibition), no. 20 (ill.).
Philadelphia Museum of Art, *Thomas Eakins: Artist of Philadelphia*, cat. by Darrel Sewell, 1982 (traveling exhibition), no. 141 (ill.).

WINSLOW HOMER

(1836, Boston—1910, Prout's Neck, Maine)

Throughout his career, Homer was deliberately reticent about his life and his art. He refused to cooperate with even the most sympathetic of his biographers, he was rarely candid with interviewers, and he declined to comment about his paintings. Although he had been an active participant in organizations such as the American Watercolor Society, the Tile Club, and the prestigious Century Association during his middle years in New York, he effectively withdrew from the art world in his midforties and for the rest of his life remained aloof from his colleagues. Homer's silence has caused scholars to link him with Eakins and Ryder as heroic recluses who produced direct and original American styles, and to seek autobiographical and psychologically revealing information in his work.

Homer's early life was unremarkable, and followed a pattern common to many self-educated American artists. After a brief period at Bufford's Lithography Shop in Boston, he moved to New York in 1859 and was hired by Harper's Weekly for which he would produce designs until 1875. He covered the Civil War for Harper's, making several trips to the front, but on his return to New York after the war he concentrated on oil paintings. His masterpiece of that period, Prisoners from the Front (1866; Metropolitan Museum of Art, New York) was much admired by both French and American critics at the Exposition Universelle of 1867. Homer went to Paris himself in 1866–67, but little is known of his experiences there.

On his return to the States, Homer again settled in New York, his home for the next thirteen years. He spent his summers in resort towns and in the country, producing idyllic images of Americans at leisure: handsome couples playing croquet, and barefoot, healthy children frolicking in the fields and at the seashore. On a visit to Gloucester, Massachusetts, in 1873, he made his first watercolors, a medium in which he would become America's undisputed master. Homer traveled to England in 1881, but instead of working in London he chose to settle in the tiny North Sea fishing village of Cullercoats, near Tynemouth—a decision that anticipated his solitude of the next thirty years. His first works produced there were narrative and picturesque. They soon became more iconic, and with the stirring watercolor Inside the Bar (1883; Metropolitan Museum of Art, New York) he arrived at the subject which would concern him for the rest of his life: man's struggle with his environment.

Homer returned to America in November 1882. Shortly thereafter, he settled in the isolated community of Prout's Neck, Maine, where he would remain for the rest of his life. His paintings of the eighties, honoring the fishermen at Prout's Neck and their constant battle with the sea, were the first to win national acclaim and command high prices. During these years, he continued to travel to the Adirondacks to hunt and fish; he also visited Florida and the

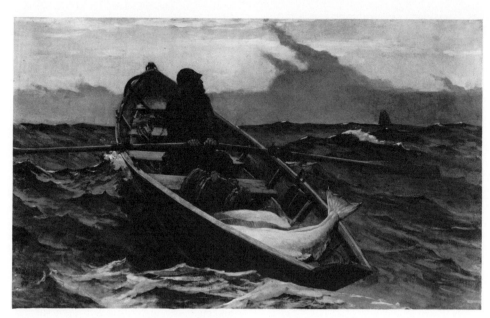

Bahamas, trips which resulted in memorable watercolors and a few oils, some, like Huntsman and Dogs (1891; Philadelphia Museum of Art) and The Gulf Stream (1899; Metropolitan Museum of Art, New York), containing a grim and sinister message. It was at Prout's Neck in the 1890s that Homer painted the heroic seascapes which are acclaimed as his greatest works. Beginning in 1906, a series of illnesses prevented him from painting. Nonetheless, in the year before his death, Homer produced Driftwood (1909; Private Collection), his last majestic seascape, and completed Right and Left (cat.no.110), his final, chilling statement on the inevitable violence between man and nature.

William Howe Downes, Homer's most supportive and sympathetic critic, respected his wishes and did not publish his biography (The Life and Works of Winslow Homer) until the year after the artist's death. The still-definitive modern study is Lloyd Goodrich's Winslow Homer (New York, 1944). The most recent exhibition of Homer's work, with catalogue by Goodrich, was held in 1973 at the Whitney Museum of American Art in New York.

104

WINSLOW HOMER
The Fog Warning, 1885
Painted in Prout's Neck, Maine
Signed and dated lower left: *Winslow Homer 1885*
Oil on canvas, 30 × 48 in. (76.2 × 121.9 cm.)
Museum of Fine Arts, Boston,
　Otis Norcross Fund

Following his return from England in 1882, Homer resumed his practice of submitting works to the annual exhibition of the National Academy of Design in New York. His entry for 1884, *The Life Line* (Philadelphia Museum of Art), won immediate acclaim and was Homer's first major commercial success. The painting, a thrilling representation of a rescue at sea, based on a lifesaving demonstration Homer had witnessed at Atlantic City, New Jersey, was pronounced the greatest figure painting of the exhibition. Within a few days of the opening, it was bought for $2500 by tobacco heiress Catherine Lorillard Wolfe. The first American work to enter her renowned collection, otherwise consisting of fashionable French academic paintings, it lent new prestige to American art and afforded Homer a measure of artistic celebrity.[1] Homer's response to this triumph was not to attempt to surpass *The Life Line* with another stirring melodrama, but rather to return to Prout's Neck, where he had settled in the summer of 1883, and resume work on the series of paintings begun at the same time as *The Life Line* which honored a quieter kind of heroism, the routine bravery of the fishermen who made their living in the North Atlantic. *The Fog Warning*, the first and most graphically powerful of these, was painted at Prout's Neck in the fall of 1885.

Like *The Life Line*, *The Fog Warning* was

based on Homer's own experiences. He is believed to have made a trip with a fishing fleet to the Grand Banks off Nova Scotia sometime in 1884, and recorded his observations in a series of sketches, some of which were later used for his oils. For *The Fog Warning*, he hired a local fisherman to pose in a dory beached on a sand dune near his studio; this model enabled him to reproduce accurately the angle of the boat buoyed up by the swelling waves. Homer originally called this painting *Halibut Fishing*, presumably conceiving it as a pendant to *The Herring Net* (1885; Art Institute of Chicago): both works are naturalistic representations of the arduous work of the fishermen and the chilling majesty of the sea. But before exhibiting it in 1885, Homer changed the title to draw attention to the impending danger represented by the oncoming fog.

Homer had painted fishermen since about 1880, first at Tynemouth in England and then at Prout's Neck. *Coming Away of the Gale* (1883/1893; Worcester Art Museum, Mass.),[2] which tells the story of a young woman valiantly defying the hurricane sweeping through her tiny village, is typical of these earlier works, for in it Homer tempered his monumental theme of the struggle between man and nature with anecdote and picturesque detail. But in *The Fog Warning*, he eliminated all landmarks, all extraneous detail—even showing the fisherman with head averted and facial features generalized—and instead used a powerful, centrally focused composition to create an image of greater breadth and universal meaning. Using simple congruent shapes, Homer evokes the anxious bond between man and his environment. The sturdy boat is the material counterpart of the insubstantial fog bank; its ragged streamers mimic the fisherman's profile. The fisherman, rowing steadily, parallels the horizon with his extended oars; the dory, rocking forward with the swell of the waves, reveals the fisherman's catch while emphasizing the critical distance between the fisherman and the safety of his ship on the horizon. Yet the sea is relatively placid; there is little indication of turmoil, and the occasional whitecap signals nothing more ominous than a fresh breeze. Here nature's treachery is not violent, but subtle and insidious; like loneliness and fatigue, it is the fisherman's constant adversary.

Unlike *The Life Line*, *The Fog Warning* did not win immediate acclaim. Although it was exhibited in Boston shortly after it was painted, it did not find a buyer until 1893, when Grenville Norcross, a Boston cousin of Homer's, bought it and subsequently presented it to the Museum of Fine Arts. It was the first painting by the artist to enter a public collection, and has since become one of his best-known works. *C.T.*

NOTES

1. Lloyd Goodrich (*Winslow Homer* [New York, 1944], p. 87) quotes the writer for the New York *Herald* of 7 April 1884: "This purchase shows that the tide is turning, and our richer collectors are beginning to patronize American as well as foreign art. . . . The Homer is well fitted to rank with the foreign paintings in Miss Wolfe's superb collection, and she deserves the thanks of all friends of American art for this spontaneous recognition of the great talents of one of the strongest and most thoroughly American of the figure painters."

2. This painting was severely criticized when it appeared at the National Academy of Design's exhibition of 1883. Homer withdrew it from the market and repainted the sea, covering over the group of men preparing to launch a lifeboat at left. He sold it to Thomas Clarke in 1893 and, under the title of *The Great Gale*, it was well received at the World's Columbian Exposition in Chicago that year.

PROVENANCE

With Doll and Richards, Boston, 1886; Laura Norcross and Grenville H. Norcross, Boston, 1893–94; to present owner, 1894.

EXHIBITION HISTORY

Doll and Richards, Boston, 1886.
Chicago, *World's Columbian Exposition*, 1893, cat.no.576.
Carnegie Institute, Pittsburgh, *Twelfth Annual Exhibition*, 1908, cat.no.156.
Museum of Fine Arts, Boston, *Winslow Homer Memorial Exhibition*, 1911.
Pennsylvania Museum of Art, Philadelphia, *Homer*, 1936, cat.no.15.
Carnegie Institute, Pittsburgh, *Survey of American Painting*, 1940, cat.no.172 (ill.).
Worcester Art Museum, Mass., *Winslow Homer*, 1944, cat.no.71.
Denver Art Museum, *American Heritage*, cat.no.44.
National Gallery of Art, Washington, D.C., *Winslow Homer; A Retrospective Exhibition*, 1959 (traveling exhibition), cat.no.51.
Museum of Fine Arts, Dallas, *Directions in 20th Century American Painting*, 1961, cat.no.1 (ill.).
Museum of Fine Arts, Boston, *The Boston Tradition*, cat. by Carol Troyen, 1980 (traveling exhibition), no.58 (ill.).

105

WINSLOW HOMER
Eight Bells, 1886
Painted in Prout's Neck, Maine
Signed and dated bottom center: *Winslow Homer 1886*
Oil on canvas, $25\frac{3}{16} \times 30\frac{1}{8}$ in. (64×76.5 cm.)
Addison Gallery of American Art, Phillips Academy, Andover, Massachusetts

Although in the summer months Prout's Neck, Maine, was a popular resort—Homer's family had vacationed there since 1875—for the rest of the year, the tiny town was a chilling, desolate place where fishermen and their families were Homer's only neighbors. Most likely, Homer settled there because its remote location enabled him to paint undisturbed; its rugged, forbidding coastline and vigorous, picturesque types inspired him to develop in more epic fashion the subjects he had begun to explore while in England. Among the first paintings Homer produced at Prout's Neck were a series of scenes representing fishermen at work. *Eight Bells* is the smallest of these, yet the most compelling.[1]

Unlike most of the other works in the series, which show moments of great dramatic force and emotional tension, *Eight Bells* depicts an everyday occurrence. The sounding of eight bells (rung six times a day, at four, eight, and twelve o'clock) here signals that it is noon, and two sailors, presumably the ship's officers (although their oilskins hide any indications of their rank) emerge on the foredeck of the large fishing schooner to take the noon sighting. The left-hand figure holds a sextant and adjusts it as the sun moves directly overhead; the other man reads his instrument to calculate the ship's longitude. Their task, fixing the ship's location, is made more difficult by the passing storm, for the heavy clouds prevent a clear sighting. Homer presents his sailors as strong, dedicated men, and draws their sextants with accuracy and precision. But unlike his contemporary Thomas Eakins, Homer was fascinated by neither the men's personalities nor the intricate machinery with which they work. Rather, he was absorbed by the sea and by the changing light as the storm passed. Overhead, the murky gray-brown clouds are giving way to bright aquamarine as the sun breaks through the clouds. Homer used the same icy blue-green tones, capped with strokes of frothy, buttery white, for the mighty ocean swells, and, in a remarkably bold bravura touch, he dragged over the canvas a thick line of pure white paint to suggest the first strong ray of sunlight dancing off the gunwale of the boat. Although Homer hired two of his Prout's Neck neighbors to pose for the fishermen, he did not identify them as individuals, but

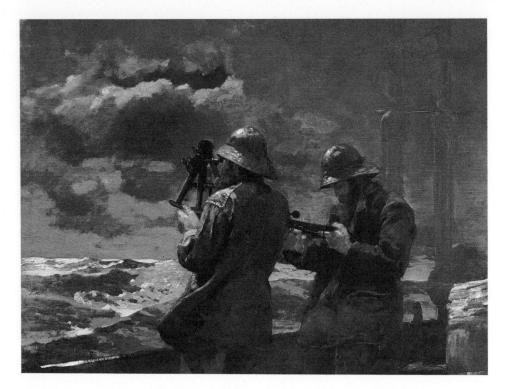

rather, as had become his practice, he turned their faces away from the viewer and simplified their features in order to present them as universal types. He placed them in the immediate foreground of the composition, and described them as monumental, statuesque forms silhouetted against sea and sky. Performing their mundane, if critical, task with dignity and composure, they become, in Lloyd Goodrich's words, "symbols of man's courage and skill matched against nature."[2]

Counting on the popularity of his subject, Homer reproduced *Eight Bells* as an etching, a medium with which he'd lately begun to experiment. For the large plate, nearly two-thirds the size of the original canvas, Homer enlarged and darkened the figures and cropped the right side of the picture, distilling into simple graphic terms the tension between the men and the sea. The etching was offered at $20, but did not sell particularly well in Homer's lifetime, perhaps because connoisseurs preferred the more delicate, aesthetic effects of etchings by James McNeill Whistler and others, while more general audiences may have favored more sentimental subjects.[3] The oil, however, increased in popularity. Soon after Homer completed it, it was bought by the famous collector Thomas B. Clarke, who would eventually own fifteen oils and sixteen watercolors by the artist; it became well known through its appearance at the World's Columbian Exposition in 1893 and at an 1898 show of works by Homer and George Inness from Clarke's collection, held at the Union League Club in New York. The painting gained even greater celebrity at the 1899 auction of Clarke's collection, where it

sold for $4,700—only the ever popular Inness and Homer Martin brought higher prices. Since then, the work has been owned by a succession of sophisticated collectors, has been widely exhibited, and has been praised frequently by critics. More than Homer's more overtly dramatic seascapes of this period, *Eight Bells* seems always to have prompted romantic associations in the imaginations of its audience, filling "the remotest corners of the mind with an overwhelming impression of the power and infinitude of the open sea."[4]

C.T.

NOTES

1. The series includes: *Coming Away of the Gale* (1883, repainted 1893; Worcester Art Museum, Mass.); *The Fog Warning* (1885; cat.no. 104); *The Herring Net* (1885; Art Institute of Chicago); and *Lost on the Grand Banks* (1885–86; Coll. Mr. and Mrs. John Broome, Oxnard, Calif.). Also related are *The Life Line* (1884; Philadelphia Museum of Art) and *Undertow* (1886; Sterling and Francine Clark Art Institute, Williamstown, Mass.).
2. Goodrich, *Winslow Homer* (New York, 1944), p. 94.
3. See ibid., p. 100.
4. William Howe Downes, *The Life and Works of Winslow Homer* (Boston, 1911), pp. 146–47.

PROVENANCE
Thomas B. Clarke, New York, 1887; Clarke Collection Sale, Chickering Hall, N.Y., 1899, lot 370; with William Schaus, New York, 1899; E. T. Stotesbury, Philadelphia, after 1899; with John Levy Galleries, New York; E. L. Lueder, New York; Thomas Cochran, 1930; to present owner, 1930.

EXHIBITION HISTORY
National Academy of Design, New York, *63d Annual Exhibition*, 1888, cat.no. 370.
Art Institute of Chicago, *First Annual American Exhibition*, 1888, cat.no. 144.
Union League Club, New York, *A Group of Paintings by American Artists Accepted for the Columbian Exposition*, 1893, cat.no. 1.
Chicago, *World's Columbian Exposition*, 1893, cat.no. 569.
Pennsylvania Academy of the Fine Arts, Philadelphia, *73d Annual Exhibition*, 1904, cat.no. 17 (ill.).
Metropolitan Museum of Art, New York, *Winslow Homer Memorial Exhibition*, 1911, cat.no. 8.
National Academy of Design, New York, *Centennial Exhibition*, 1925 (traveling exhibition), cat.no. 311 (ill.).
Museum of Modern Art, New York, *Sixth Loan Exhibition: Winslow Homer, Albert P. Ryder, Thomas Eakins*, 1932, cat.no. 11 (ill.).
Pennsylvania Museum of Art, Philadelphia, *Homer*, 1936, no. 17.
Carnegie Institute, Pittsburgh, *Winslow Homer Centenary Exhibition*, cat. by Homer Saint-Gaudens, 1937, no. 16.
Musée du Jeu de Paume, Paris, *Trois siècles d'art aux Etats-Unis*, cat. by Alfred H. Barr, Jr., 1938, no. 82 (ill.).
Museum of Modern Art, New York, *Art In Our Time*, 1939, cat.no. 37 (ill.).
Art Institute of Chicago, *Half a Century of American Art*, 1939, cat.no. 78 (ill.).
Worcester Art Museum, Mass., *Winslow Homer*, 1944, no. 72.
Tate Gallery, London, *American Painting from the 18th Century to the Present Day*, 1946.
Wildenstein & Co., New York, *A Loan Exhibition of Winslow Homer*, cat. by Lloyd Goodrich, 1947, no. 24 (ill.).
Seattle Art Museum, 1951.
Denver Art Museum, 1952.
Wildenstein & Co., New York, *The American Vision: Paintings of Three Centuries*, 1957.
Dallas Museum of Fine Arts, *Famous Paintings and Famous Painters*, 1958, cat.no. 3 (ill.).
National Gallery of Art, Washington, D.C., *Winslow Homer, A Retrospective Exhibition*, 1959 (traveling exhibition), cat.no. 50.
Virginia Museum of Fine Arts, Richmond, *Treasures in America*, 1961 (ill.).
Seattle, *Seattle World's Fair: Masterpieces of Art*, 1962, cat.no. 11 (ill.).
University of Arizona Art Gallery, Tucson, *Yankee Painter: A Retrospective Exhibition of Oils, Watercolors, and Graphics by Winslow Homer*, cat. by William E. Steadman, Jr., 1963, no. 1 (ill.).
Everson Museum of Art, Syracuse, N.Y., *American Painting from 1830*, 1965, cat.no. 51 (ill.).
Bowdoin College Museum of Art, Brunswick, Maine, *Winslow Homer at Prout's Neck*, cat. by Philip C. Beam, 1966, no. 10 (ill.).
Brooklyn Museum, N.Y., *Triumph of Realism*, cat. by Axel von Saldern, 1967 (traveling exhibition), no. 74 (ill.).
Whitney Museum of American Art, New York, *Winslow Homer*, cat. by Goodrich, 1973 (traveling exhibition), no. 49.
Currier Gallery of Art, Manchester, N.H., *Masterworks by Artists of New England*, 1982.

106

WINSLOW HOMER
A Summer Night, 1890
Painted in Prout's Neck, Maine
Signed and dated lower left: *HOMER 1890*
Oil on canvas, $30\frac{3}{16} \times 40\frac{1}{8}$ in.
 (76.7 × 101.9 cm.)
Musée du Louvre, Paris

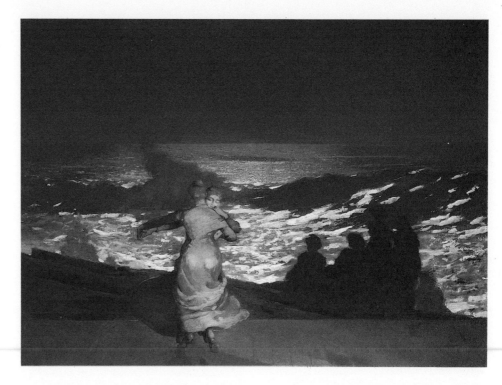

Between 1883 and 1887, Homer painted the epic of man and the sea (see cat.nos. 104 and 105), and then for two years he concentrated on watercolors and made no oils at all. In 1890 he executed four paintings including *A Summer Night* and *Sunlight on the Coast* (cat.no. 107).[1] A contemporary critic immediately recognized their quality and proclaimed them "in their way, the four most powerful pictures that any man of our generation and people has painted."[2] *A Summer Night* is the most idiosyncratic of the four, the least typical of Homer, and of all his works the one in which he comes closest to the European mainstream. Unlike the others, it found no immediate buyer, and the artist still owned it in 1900 when it was exhibited at the Exposition Universelle in Paris. Here the artist gained his first real international recognition, winning a Gold Medal and, more significantly, being honored by the French purchase of the painting for the Luxembourg Museum.

A Summer Night is one of Homer's most emotional works.[3] The subject is complex, as the critic Alfred Trumbull explains:

Across the foreground goes the platform of a seaside hotel, perched on a rocky bluff above the surf. On the platform two girls dance as partners, their figures lighted by the lamplight from the house. Below the platform, figures make a dim group on the rocks, watching the breakers. On the rollers an unseen moon makes a great, scintillating pathway to the horizon, and the figures of the dancers are modelled against it.[4]

Most extraordinary for Homer is the pair of women in the foreground, who dance intimately and lovingly on a magical summer night, unnoticed by the group to the right and unaware of them. Their joy is self-contained, and they dance to music known only to themselves.[5] They seem figures in a dream, whose private, swaying rhythm echoes the powerful, steady rhythm of nature herself, as seen in the never-ending swells of the sea.

Homer painted women by the sea in many works, beginning with early paintings such as *Waiting for Dad* (Coll. Mr. and Mrs. Paul Mellon, Upperville, Va.), in which a woman stands with her children, apparently wondering if her husband has been lost at sea, to the Tynemouth watercolors of 1881–82, to late paintings such as *A Light on the Sea* (1897;

Corcoran Gallery of Art, Washington, D.C.), in which the robust female seems to mock the sea, turning her back on it, while she also seems part of it. In *A Summer Night,* Homer approaches the introspective, fin-de-siècle mood that one finds in Scandinavian painting of the same period, especially in the work of Edvard Munch.[6] Unlike Munch, however, Homer could never have painted a man and woman dancing: normal communication between the sexes, either verbal or physical, seemed impossible for Homer the painter, as it probably was for Homer the man, and in his paintings children and women are allowed to touch each other, but male and female adults are not. In this painting, Homer identifies women with the sea, as Edgar Allan Poe does in his poem "Annabel Lee," and as Ibsen does in *Lady from the Sea* (1888). Many of Homer's pictures deal with shyness and love, with the question of touching and the problems of communication. *A Summer Night* goes further than he ever would again in making his interests explicit, and it reveals him as a profoundly romantic artist.

T.E.S.

NOTES
 1. The other two were the narrative picture *The Signal of Distress* (Thyssen Collection, Lugano) and *Winter Coast* (Philadelphia Museum of Art), a richly painted view of snow-covered rocks and breaking waves.
 2. Alfred Trumble, in *The Collector,* 1 Feb 1891, quoted in William H. Downes, *The Life and Works of Winslow Homer* (Boston, 1911), p. 156.
 3. Lloyd Goodrich (*Winslow Homer* [New York, 1944], p. 119) inexplicably called this work "an unemotional kind of painting."

 4. Trumble, quoted in Downes, *Homer,* p. 157
 5. The historian Gordon Hendricks, in *The Life and Work of Winslow Homer* (New York, 1979), writes that Homer originally "called this painting *Buffalo Gals* after the song: 'Buffalo Gal won't you come out tonight and dance by the light of the moon?'" (p. 199). He cites no source for this. More convincingly, Hendricks points out the relationship of the picture to Homer's watercolor *A Summer Night* (Wadsworth Atheneum, Hartford, Conn.), a very similar moonlit view of the shore and the group of figures in the dark, without the dancing women (p. 206).
 6. See P. S. Kroyer's *Summer Evening on the South Beach at Skagen* (1893; Skagens Museum) and Munch's *Dance of Life* (1899–1900; National Gallery of Art, Oslo).

PROVENANCE
With the artist to 1900; Musée du Luxembourg, 1900; transferred to the Louvre, 1970.

EXHIBITION HISTORY
Reichard & Co., New York, 1890–91.
Cumberland Club, Portland, Maine.
Carnegie Institute, Pittsburgh, *Fourth Annual Exhibition,* 1899, cat.no.121.
Paris, *Exposition Universelle,* 1900, cat.no.155.
Musée National du Luxembourg, Paris, *Exposition d'artistes de l'école Américaine,* 1919, cat.no.22.
Musée du Jeu de Paume, Paris, *Trois siècles d'art aux Etats-Unis,* cat. by Alfred H. Barr, Jr., 1938, no.83.
Museum of Modern Art, New York, *Art in Our Time,* 1939, cat.no.38 (ill.).
National Gallery of Art, Washington, D.C., *Winslow Homer, A Retrospective Exhibition,* 1959 (traveling exhibition), cat.no.56 (ill.).
Bowdoin College Museum of Art, Brunswick, Maine, *Winslow Homer at Prout's Neck,* cat. by Philip C. Beam, 1966, no.22 (ill.).

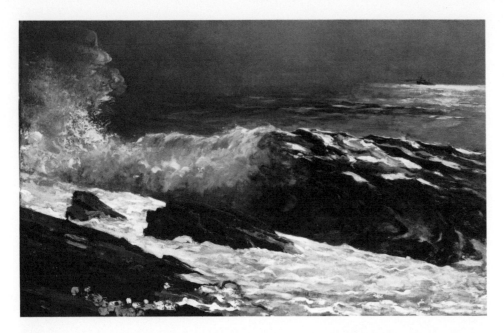

Homer the sea was changeable, death-dealing, life-giving, and, above all, eternal. In painting the sea again and again, he sought the true relationship of man and nature. As one critic noted during his lifetime, "Strangely enough, though withdrawn from the world of men and living the life of a recluse, Mr. Homer has been most concerned by the human problem."[4]

T.E.S.

NOTES

1. Mechlin, "Winslow Homer," *The International Studio* 34 (June 1908): 125.
2. See Lloyd Goodrich, *Winslow Homer* (New York, 1944), p. 119.
3. Ibid, pp. 119–20.
4. Mechlin, "Homer," p. 129.

PROVENANCE
With Reichard & Co., New York, 1891; John G. Johnson, Philadelphia, 1891–1911; with Henry Reinhardt, New York, 1911; Mr. and Mrs. Edward Drummond Libbey, Toledo, Ohio, 1911–12; to present owner, 1912.

EXHIBITION HISTORY
Reichard & Co., New York, 1891.
Chicago, *World's Columbian Exposition*, 1893, cat. no. 579.
Metropolitan Museum of Art, New York, *Winslow Homer Memorial Exhibition*, 1911, cat. no. 10.
Toledo Museum of Art, Ohio, *Inaugural Exhibition*, 1912, cat. no. 44 (ill.).
Carnegie Institute, Pittsburgh, *Winslow Homer Centenary Exhibition*, cat. by Homer Saint-Gaudens, 1937, no. 34.
National Gallery of Art, Washington, D.C., *Winslow Homer, A Retrospective Exhibition*, 1959 (traveling exhibition), cat. no. 57 (ill.).
Whitney Museum of American Art, New York, *Winslow Homer*, cat. by Lloyd Goodrich, 1973 (traveling exhibition), no. 51.
National Gallery of Art, Washington, D.C., *Post-Impressionism*, 1980, cat. no. 256 (ill.).

107

WINSLOW HOMER
Sunlight on the Coast, 1890
Painted in Prout's Neck, Maine
Signed and dated lower left: *Winslow Homer 1890*
Oil on canvas, 30¼ × 48½ in. (76.8 × 123.2 cm.)
The Toledo Museum of Art, Ohio, Gift of
 Mr. and Mrs. Edward Drummond Libbey

Sunlight on the Coast, one of Homer's four much-praised paintings of 1890 (see cat. no. 106), was exhibited at a New York dealer's in 1891 and was immediately bought by the prominent Philadelphia collector John G. Johnson. Two years later it was included as one of fifteen works by the artist at the World's Columbian Exposition in Chicago; here Homer won a Gold Medal, and finally also won national acclaim. From this time until his death, he was generally considered one of the nation's leading artists. Nonetheless, criticism of his technique—which had haunted him from the start of his career—was still widespread. Even as late as 1908 the admiring critic Leila Mechlin wrote: "There is none who, from the technical standpoint, commonly paints more hatefully than he, and yet at the same time none who, as a rule, produces greater pictures."[1] His pictures were praised for their strength, their Americanness, and especially their "virility," which must have pleased the artist very much, but his rough manner of execution—which seems so bold and fresh to our eyes today—often led critics to qualify their praise.

Homer had painted the sea nearly from the beginning, since he first worked at the fishing port of Gloucester in the early seventies, then at Tynemouth in England, and now at Prout's Neck; but until *Sunlight on the Coast*, he had always included figures, and only at this time did he begin the series of pure and elemental paintings of the sea alone which became his best-known work.[2] As Lloyd Goodrich describes this scene, "A big wave is gathering itself to break on rocks. Cold white sunlight is reflected on its crest and on the sea, but a gray fogbank is creeping in, obscuring sky and horizon and throwing the sunlit green wave into dramatic relief—a peculiar weather effect accurately observed."[3] The fog makes the view a dark one; it obscures the horizon and gives the sea itself a cold, ominous color. Sunlight shines only on the crest of the huge, rolling wave, which appears suddenly and inexorably from the void behind. The series continues through the nineties, with such pictures as *Northeaster* (1895; Metropolitan Museum of Art, New York)—its frothy green waves quite different in mood, though painted from nearly the same rocky ledge—into the twentieth century, with the tender, less involved vision of *West Point, Prout's Neck* (cat. no. 109), and right up to *Driftwood* of 1909 (Private Collection), executed the year before the painter's death.

Breaking waves had been a basic subject for American Romantic painters since Washington Allston. Thomas Doughty, Thomas Cole, Frederic Edwin Church, and Albert Bierstadt all painted them; at mid-century the subject became a specialty for John F. Kensett (see cat. no. 42) and Martin J. Heade, and in Homer's time the theme became even more popular and was taken up by such specialists as William Trost Richards and Alexander and Birge Harrison. Homer's pictures have an emotional and painterly quality, and his contemporaries' work seems artificial and unfeeling in comparison. He painted the wave as elemental, with bulk and power, representing all of nature's force. For

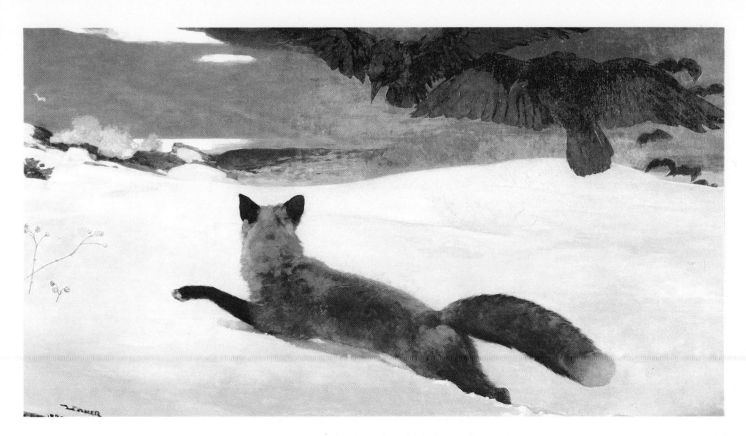

108

WINSLOW HOMER
The Fox Hunt, 1893
Painted in Prout's Neck, Maine
Signed and dated lower left: HOMER/1893
Oil on canvas, 38 × 68½ in. (96.5 × 174 cm.)
The Pennsylvania Academy of the Fine Arts,
 Philadelphia, Temple Fund Purchase

In this, the largest of his paintings, Homer at the age of fifty-seven contemplates his own death. Themes of loneliness, isolation, and mortality had occupied him from the beginning,[1] and by the time he reached artistic maturity in the 1880s, "his paintings invariably form narrative cycles which repeat obsessively the progression from life to death,"[2] as Henry Adams points out.

This painting, which had also been called *Fox and Crows*, pleased the artist, as he wrote to his New York dealer on its completion: "It is quite an unusual *and very beautiful* picture." It was sent to his Boston gallery, where it was praised by the critic William H. Downes but still failed to sell. In the following year it was shown at the Pennsylvania Academy of the Fine Arts, which purchased it at a reduced price of $1200—the painter's first major sale to a museum.[3]

In his biography of the painter, Downes takes care to defend the scene as natural and believable: "In the depths of winter it has been observed that a flock of half-starved crows will occasionally have the temerity to attack a fox, relying on the advantage of their numbers, the weakened condition of the fox, and the deep snow, which makes it peculiarly difficult for the victim either to defend himself or to escape."[4] Nonetheless, Homer has surely painted an extraordinary scene. The fox, normally the hunter, here is attacked, and from an unexpected quarter—the black crows streaming in from the sea, the source of mystery and death. Red berries in the snow to the left foretell the drops of blood that will soon be shed. The first two crows are just beginning the attack: their wings spread, they will alight on the fox and go for its eyes. The composition is one of the artist's most original, the fox stretched across the foreground, the birds above it, on top of a cropped composition whose Japanese quality was noted in Homer's lifetime.[5]

Nineteenth-century painters dealt frequently with violence and death in the animal world, and animals are seen attacking other animals in the work of Stubbs, Delacroix, and Courbet. The latter's *Hind Forced Down in the Snow* of 1856–57 (Private Collection)[6] resembles the Homer in its composition, the victim lying in the foreground while hounds streak across the snow toward it. American artists were particularly concerned with such subjects: Audubon often portrayed freshly killed rabbits in the grasp of hawks, Catlin pictured buffalo trapped in deep snow, and Arthur F. Tait painted sheep and deer dying in the snow—on one occasion, at least, depicting a black crow attacking a dying fawn in winter.[7]

Homer's painting, however, conveys a special power and urgency. Even its title, *The Fox Hunt*, is ironic, for Homer knew as well as anyone that fox hunts in art are usually "civilized" affairs, with many men and dogs pursuing their quarry. Two decades ago, a critic identified the hunted animal with the artist ("Homer is the fox, as Flaubert was Madame Bovary"),[8] and a more recent writer,

Thomas Hess, took an extreme position, finding the fox a self-portrait, "where the nightmare black birds (the nightmare of the flying black penis) swoop down on a dainty fox encumbered in drifts of white snow."[9] Hess argues—not wholly successfully—that the painting speaks of Homer's sexual repression; however, there is much other evidence that the artist was indeed repressed. And just as surely, the painter was a lonely and often angry man, who frequently must have felt as wantonly attacked and isolated as the fox in his painting.

<div align="right">T.E.S.</div>

NOTES

1. For example, loneliness and displacement are studied in *Veteran in a New Field* (1865; Metropolitan Museum of Art, New York); estrangement from society in *The Morning Bell* (c. 1866; Yale University Art Gallery, New Haven, Conn.); facing death in *Waiting for Dad* (1873; Coll. Mr. and Mrs. Paul Mellon, Upperville, Va.).

2. This theme has been suggested by Helen Cooper of Yale University and was developed further in a superb article by Henry Adams, "Mortal Themes: Winslow Homer," *Art in America* (Feb. 1983): 112–26.

3. See Lloyd Goodrich, *Winslow Homer* (New York, 1944), pp. 133–34.

4. Downes, *The Life and Works of Winslow Homer* (Boston, 1911), p. 168.

5. See Leila Mechlin, "Winslow Homer," *The International Studio* 34 (June 1908): 126.

6. Illustrated in Kenneth Clark, *Animals and Men* (New York, 1977), fig. 198.

7. See Tait's *Maternal Solicitude* (1873; Cleveland Museum of Art), inscribed on the reverse, "The Dying Fawn."

8. Leslie Katz, "The Modernity of Winslow Homer" *Arts* 33 (February 1959): 27.

9. Hess, "Come Back to the Raft Ag'in, Winslow Homer Honey," *New York Magazine*, 11 June 1973, p. 75.

PROVENANCE
To present owner from the artist, 1894.

EXHIBITION HISTORY
Century Association, New York, 1893.
Doll and Richards, Boston, 1893.
Paris, *Exposition Universelle*, 1900, cat. no. 152.
Carnegie Institute, Pittsburgh, *Twelfth Annual Exhibition*, 1908, cat. no. 145.
Metropolitan Museum of Art, New York, *Winslow Homer Memorial Exhibition*, 1911, cat. no. 13.
Art Institute of Chicago, *A Century of Progress*, 1934, cat. no. 396 (ill.).
Pennsylvania Museum of Art, Philadelphia, *Homer*, 1936, no. 22.
Whitney Museum of American Art, New York, *Winslow Homer Centenary Exhibition*, cat. by Lloyd Goodrich, 1936, no. 25 (ill.).
Virginia Museum of Fine Arts, Richmond, *Inaugural Exhibition: Main Currents in the Development of American Painting*, 1936, cat. no. 56 (ill.).
Carnegie Institute, Pittsburgh, *Winslow Homer Centenary Exhibition*, cat. by Homer Saint-Gaudens, 1937, no. 14.
Detroit Institute of Arts, *Eakins and Homer*, 1937.
Museum of Modern Art, New York, *Modern Masters*, 1940, cat. no. 3 (ill.).
Carnegie Institute, Pittsburgh, *Survey of American Painting*, 1940, cat. no. 170.
Museum of Modern Art, New York, *Art in Progress*, 1944 (ill.).
The Century Association, New York, *Centennial Exhibition*, 1946.
Wildenstein & Co., New York, *A Loan Exhibition of Winslow Homer*, cat. by Lloyd Goodrich, 1947, no. 31 (ill.).
Corcoran Gallery of Art, Washington, D.C., *De Gustibus: An Exhibition of American Paintings Illustrating a Century of Taste and Criticism*, 1949, cat. no. 33 (ill.).
Philadelphia Museum of Art, *Diamond Jubilee Exhibition*, 1950, cat. no. 63 (ill.).
Wildenstein & Co., New York, *Landmarks in American Art, 1670–1950*, 1952, cat. no. 36 (ill.).
Fort Worth Art Center, Texas, *Inaugural Exhibition*, 1954, cat. no. 41.
National Gallery of Art, Washington, D.C., *Winslow Homer, A Retrospective Exhibition*, 1959 (traveling exhibition), cat. no. 61 (ill.).
Bowdoin College Museum of Art, Brunswick, Maine, *Winslow Homer at Prout's Neck*, cat. by Philip C. Beam, 1966, no. 26 (ill.).
Whitney Museum of American Art, New York, *Art of the United States, 1670–1966*, cat. by Goodrich, 1966, no. 136 (ill.).
Whitney Museum of American Art, New York, *Winslow Homer*, cat. by Goodrich, 1973 (traveling exhibition), no. 54 (ill.).
United States Embassy, London, *Young America*, 1975 (traveling exhibition).

109

WINSLOW HOMER
West Point, Prout's Neck, 1900
Painted in Prout's Neck, Maine
Signed and dated lower right: HOMER 1900.
Oil on canvas, $30\frac{1}{16} \times 48\frac{1}{8}$ in. (76.4 × 122.2 cm.)
Sterling and Francine Clark Art Institute, Williamstown, Massachusetts
Exhibited in Boston and Paris only

Homer considered *West Point* to be a masterpiece. Writing to his dealer, M. Knoedler in New York, he said, "I send you to-day a Picture that is no ordinary affair. . . . I consider it the best that I have ever painted."[1] Few critics who saw the work at the Spring 1901 exhibition of the Society of American Artists agreed with his assessment. Although they admired *West Point*'s pendant, *Eastern Point, Prout's Neck* (1900; Sterling and Francine Clark Art Institute, Williamstown, Mass.), they found this painting "hard in its lines, without air, disagreeable and cheap in color, and altogether mournful." Even Charles Caffin, generally a supporter of Homer's, noted that it "smacked a little of the spectacular."[2] Nonetheless, the painting proved to be marketable. It was bought by the New York collector Hugh Harrison for $3,000 shortly after it was displayed—the largest sum Homer had realized from a sale since *The Life Line* (1884; Philadelphia Museum of Art). The very features to which the critics objected—its graphic clarity and intense color—are those which most appeal to the modern eye, and *West Point* has become one of Homer's best-liked oils.

The most acclaimed pictures exhibited at the Society of American Artists in 1901 were more cosmopolitan than *West Point* and reflected international influences. There were sophisticated Beaux-Arts figure pieces by George de Forest Brush and Kenyon Cox, wistful tonalist landscapes by C. H. Woodbury and Alexander Harrison, and bright, Impressionist-inspired works by Edward Potthast and William Paxton. Homer's *West Point* has frequently been discussed as an Impressionist picture, not because of its technique, but because of the artist's concern for the precise recording of light effects:

> *The picture is painted* fifteen minutes *after sunset—not one minute before—as up to that minute the clouds over the sun would have their edges lighted with a brilliant glow of color, but now* (in this picture) *the sun has got beyond their immediate range and* they are in shadow.[3]

Yet this quasi-scientific scrutiny of atmospheric effects had a different purpose than the similar practice of the Impressionists; it was

part of the meticulousness that was the cornerstone of Homer's working method and provided the naturalistic underpinning to his most inventive, abstract designs.

Homer's bold, masculine style in *West Point*, and his subject—a dramatic sunset observed from the west point of Prout's Neck looking across Saco Bay toward Old Orchard Beach—had few counterparts in contemporary art. Not since mid-century had natural effects been rendered with such ecstatic reverence. Homer's sunset is the heir of the powerful landscapes of Frederic E. Church especially *Twilight in the Wilderness* (cat.no.39), which had been featured in the memorial exhibition of that artist's work held at the Metropolitan Museum in New York the summer before Homer began *West Point*. The two works share a spectacular palette of fiery reds and deep, resonant dark tones and a magical transformation of light into tactile substances: Church's lake is as smooth and rich as a polished mahogany table, while Homer's sea is a milky-blond tundra, dense and frozen. But whereas Church's image is one of almost spiritual tranquility, a scene on which man gazes from the safe distance of a hill high above the lake, the stillness of *West Point* is interrupted by a moment of passion and violent energy into which the viewer is ruthlessly plunged. In a preliminary sketch of this dramatic view (1900; Cooper-Hewitt Museum of Decorative Arts and Design, Smithsonian Institution, New York), Homer imagined the viewer high above the scene and showed several figures watching the waves from a stretch of rocky beach. But in the final version, he lowered the viewpoint drastically. All footholds are eliminated, and the viewer is confronted directly by the treacherously slippery rocks, the churning surf, and the exploding wave.

Several other of Homer's Prout's Neck landscapes have compositions built around a billowing wave in the left half of the picture, including his earlier masterpiece *Northeaster* (1895; Metropolitan Museum of Art, New York) and *On a Lee Shore* (1900; Museum of Art, Rhode Island School of Design, Providence), painted at the same time as *West Point*. But the most startling precursor of the design of *West Point* is *Light on the Sea* (1897; Corcoran Gallery of Art, Washington, D.C.),[4] a painting of a robust young woman with a fishing net draped over her shoulder, standing on a rocky ledge at the edge of the sea. Homer had used natural forms as the counterparts of human figures before (see *The Fog Warning*, cat.no.104), but never so poetically as here. For the solid, statuesque figure of the woman, Homer here substitutes the shimmering, transparent cloud of spray, its sinuous contours echoing her curves, but appearing as ephemeral as she seems substantial. If the

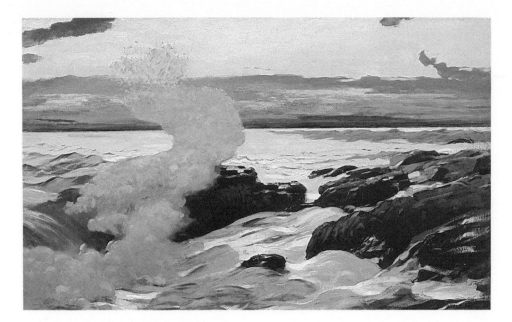

wave in *Prout's Neck* is indeed a stand-in for humanity, then the image Homer has created, with its majestic but fleeting light effects and dissolving anthropomorphic shape, becomes a metaphor for mortality set against the spectacular rhythms of nature. The *Brooklyn Daily Eagle*'s description of this picture as "altogether mournful" is perhaps not unfitting.

C.T.

NOTES

1. Quoted in Gordon Hendricks, *The Life and Work of Winslow Homer* (New York, 1979), p. 246.
2. *Brooklyn Daily Eagle*, 31 March 1901; Caffin, in *The Artist* (May 1901), quoted in Lloyd Goodrich, *Winslow Homer* (New York, 1944), p. 166.
3. Quoted in Goodrich, *Homer*, p. 165.
4. This connection was first suggested in a discussion of this picture with Theodore Stebbins and John Caldwell.

PROVENANCE

Randal Morgan, Chestnut Hill, Pa.; with M. Knoedler & Co., New York, 1951; to present owner, 1951.

EXHIBITION HISTORY

M. Knoedler & Co., New York, 1909.
Pennsylvania Academy of the Fine Arts, Philadelphia, *105th Annual Exhibition*, 1910, no.461 (ill.).
Metropolitan Museum of Art, New York, *Winslow Homer Memorial Exhibition*, 1911, cat.no.22.
Pennsylvania Museum of Art, Philadelphia, *Homer*, 1936, cat.no.30 (ill.).
Whitney Museum of American Art, New York, *Winslow Homer Centenary Exhibition*, cat. by Lloyd Goodrich, 1936, no. 34 (ill.).
Carnegie Institute, Pittsburgh, *Winslow Homer Centenary Exhibition*, cat. by Homer Saint-Gaudens, 1937, no.25.
Museum of Modern Art, New York, *Art in Our Time*, 1939, cat.no.41 (ill.).
Museum of Fine Arts, Boston, *Sport in American Art*, 1944, cat.no.66.
Wildenstein & Co., New York, *A Loan Exhibition of Winslow Homer*, cat. by Goodrich, 1947, no.39 (ill.).
Philadelphia Museum of Art, *Masterpieces of Private Collections*, 1947, cat.no.6.
Brooklyn Museum, N.Y., *The Coast and the Sea: A Survey of American Marine Painting*, 1948, cat.no.63.
National Gallery of Art, Washington, D.C., *Winslow Homer, A Retrospective Exhibition*, 1959 (traveling exhibition), cat. no.78 (ill.).
Colby College Art Museum, Waterville, Maine, *Art in Maine*, 1963.
Virginia Museum of Fine Arts, Richmond, *Homer and the Sea*, cat. by Goodrich, 1964, no.53.
Portland Art Museum, Oregon, *75 Masterworks, 75th Anniversary Exhibition*, 1967, cat.no.66 (ill.).
William A. Farnsworth Library and Art Museum, Rockland, Maine, *Winslow Homer, 1836–1910*, 1970.
Whitney Museum of American Art, New York, *Winslow Homer*, cat. by Goodrich, 1973 (traveling exhibition), no.72 (ill.).

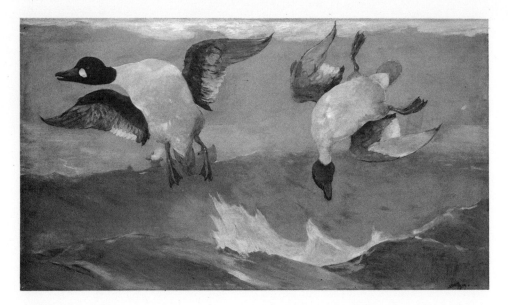

110

WINSLOW HOMER
Right and Left, 1909
Painted in Prout's Neck, Maine
Signed and dated lower right: *HOMER/1909.*
Oil on canvas, 28¼ × 48⅜ in. (71.8 × 123 cm.)
National Gallery of Art, Washington, D.C.,
 Gift of the Avalon Foundation, 1951.

Homer painted *Right and Left* in three months, from November 1908 to January 1909. He himself gave the painting no title, but a visitor to his dealer's art gallery in New York dubbed it *Right and Left*, referring to the double-barreled blasts of the shotgun used to bring the birds down: the duck on the right, with its dull eyes and slack feet, seems to have been killed by the first shot, and the other is rising into the air in an attempt to escape from the second shot, graphically presented in the painting as a flash of fire and smoke. Perhaps sensing that *Right and Left* was to be his last major work, Homer requested that the picture be sold only to a museum, but relented when Randal Morgan, brother of his good friend Charles E. Morgan, expressed interest in it.

In a letter to his brother, Homer termed *Right and Left* "a most surprising picture,"[1] most likely referring to the unusual point of view. The observer is placed over the water on eye-level with the wounded ducks and becomes, by analogy, the target of the hunter's fire. In *The Fox Hunt* (cat. no. 108), the fox, with which the viewer also identifies, faces inevitable but not immediate death as he struggles to flee from his attackers. Here death is violently present, and inescapable.

Many of Homer's greatest works have death as their primary subject, but in none of them is the approach so direct or the experience so powerful. In his superb watercolor

of 1891, *Mink Pond* (Fogg Art Museum, Cambridge, Mass.), there is a similar scene of great natural beauty and incipient violence, as a frog and a fish leap to devour two butterflies. In *A Good Shot* (1892; National Gallery of Art, Washington, D.C.), a deer has just been hit, and in the next work of the series, *The Fallen Deer* (1892; Museum of Fine Arts, Boston) the animal is seen at the moment just after death. In both these watercolors, however, the viewer shares the perspective of the hunter, and he remains well out of the line of fire. In several watercolors of fishing, for example *Ouananiche Fishing, Lake St. John, Province of Quebec* (1897; Museum of Fine Arts, Boston), Homer anticipates the radical viewpoint of *Right and Left* by suspending the observer in an unlikely position over water. In these, the fish has just been hooked but is pushed back from the picture plane, leaving the onlooker unthreatened.

Right and Left incorporates the theme of *A Good Shot* and the compositional structure of the fishing watercolors, but because its meaning depends on the reaction of the viewer, it is also related to several of Homer's paintings. In *Undertow* (1886; Sterling and Francine Clark Art Institute, Williamstown, Mass.), we are expected to conclude that one of the women being pulled to shore by lifeguards has perished in an effort to rescue the other. In *The Gulf Stream* (1899; Metropolitan Museum of Art, New York), we are alerted by the presence of sharks in the water to the fate of other members of the crew of the disabled boat and to the probable end of the remaining sailor. In both pictures the grim conclusion is only implied, but not so in *Right and Left*. As the viewer deciphers the subject, spotting the distant boat and the flash of the hunter's gun, and recognizes that the two ducks are dead or at the moment of dying, he is reminded of his own mortality. Whereas in

The Fox Hunt, Undertow, and *The Gulf Stream,* the viewer's horror is tempered by the implication of a heroic and poignant struggle against death, in *Right and Left* death is sudden, unromantic, and without meaning.

In this painting as in many of his late works, Homer combined artistic interests of his own day with ideas and models drawn from the past. The motif of a bird suspended from the top of the picture may have been suggested by Japanese prints,[2] but the painting most clearly derives from John James Audubon's prints of golden-eyed ducks for his *Birds of America,* published from 1827 to 1838. Using a similar, almost featureless background, Homer reversed the positions of the two birds and turned their poses slightly so that their vulnerable white breasts would be visible. Homer's choice here of an extremely limited palette of gray, green, and white and the nearly flat gray of the background may also be a distant reflection of the style of James McNeill Whistler and the American Tonalist artists whom he influenced.

J.C.

NOTES
1. Quoted in John Wilmerding, "Winslow Homer's *Right and Left,*" *Studies in the History of Art,* vol. 9, (National Gallery of Art, Washington, D.C., 1980), p. 62. This article is a comprehensive survey of information on the picture and its visual sources, as well as an excellent discussion of its meaning.

2. The author of the most serious study of this subject is generally skeptical of the depth and persistence of the influence of Japanese art on Homer. See John J. Walsh, Jr., "Winslow Homer: Early Work and the Japanese Print" (M.A. thesis, Columbia University, 1965).

PROVENANCE
With M. Knoedler & Co., New York, 1901; Hugh H. Harrison, New York, 1901; George W. Young (National Bank and Trust Co., New Rochelle, N.Y.); with I. A. Rose, New York; Dr. George G. Heye, c. 1902; with Babcock Gallery and M. Knoedler & Co., New York; R. S. Clark, 1942; to present owner.

EXHIBITION HISTORY
Union League Club, N.Y., *Loan Exhibition of American Paintings,* 1901, cat. no. 3.
Society of American Artists, N.Y., *23d Annual Exhibition,* 1901, cat. no. 263.
Whitney Museum of American Art, N.Y., *Oils and Watercolors by Winslow Homer,* 1944.
Whitney Museum of American Art, N.Y., *Art of the United States, 1670–1966,* cat. by Lloyd Goodrich, 1966, no. 140 (ill.).
Baltimore Museum of Art, *From El Greco to Pollock,* 1968, no. 70 (ill.).
Whitney Museum of American Art, N.Y., *Winslow Homer,* cat. by Goodrich, 1973 (traveling exhibition), no. 67 (ill.).
Currier Gallery of Art, Manchester, N.H., *Masterworks by Artists of New England,* 1982.

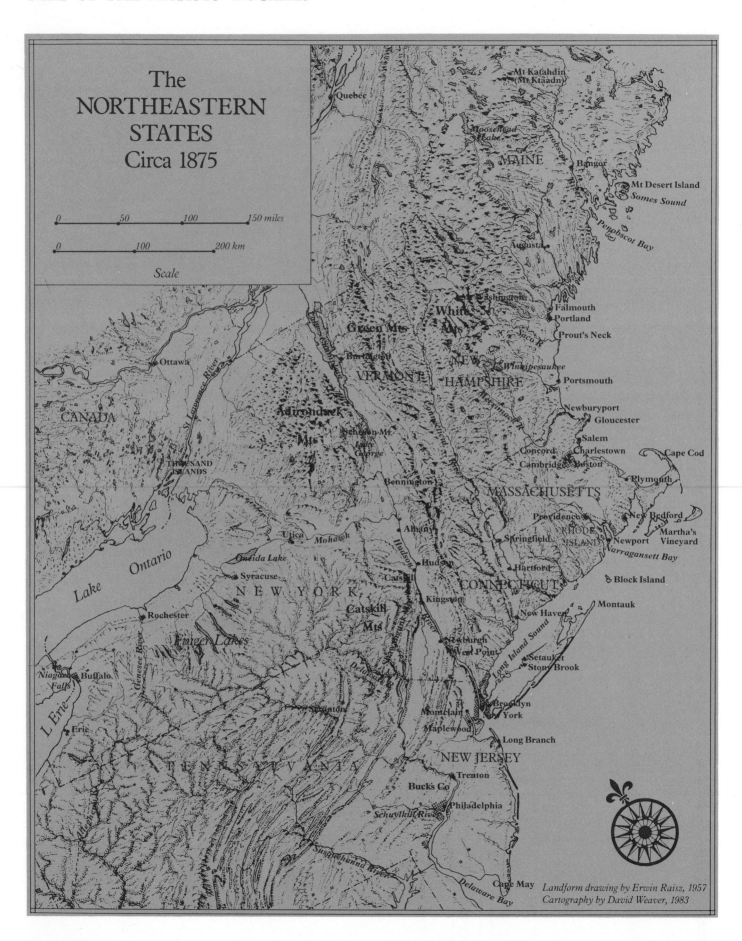

The
NORTHEASTERN
STATES
Circa 1875

0 50 100 150 miles

0 100 200 km

Scale

Quebec

Mt Katahdin
(Mt Ktaadn)

Moosehead
Lake

MAINE Bangor

Mt Desert Island
Somes Sound

Penobscot Bay

Augusta

Ottawa

Mt Washington
White Mts

Green Mts

Falmouth
Portland
Prout's Neck

Saco R

Burlington

NEW
HAMPSHIRE

Winnipesaukee

Portsmouth

VERMONT

CANADA

Adirondack
Mts

Newburyport
Gloucester

Schroon Mt

Salem

Lake George

THOUSAND
ISLANDS

Concord Charlestown
Cambridge Boston

Cape Cod

Bennington

MASSACHUSETTS

Plymouth

Albany

Providence

New Bedford

Utica

Mohawk

Springfield

RHODE
ISLAND

Martha's
Vineyard

Oneida Lake

Lake Ontario

Hudson

Newport

Narragansett Bay

Syracuse

Hartford

Block Island

NEW YORK

Catskill

CONNECTICUT

Kingston

Montauk

Rochester

Catskill
Mts

New Haven

Finger Lakes

Long Island Sound

Genesee River

Newburgh
West Point

Setauket
Stony Brook

Niagara
Falls

Buffalo

Delaware

L Erie

Erie

Scranton

Brooklyn
York

Montclair

PENNSYLVANIA

Maplewood

Long Branch

NEW JERSEY

Trenton

Bucks Co

Philadelphia

Schuylkill River

Allegheny

Susquehanna River

Cape May

Delaware Bay

Landform drawing by Erwin Raisz, 1957
Cartography by David Weaver, 1983

SELECTED BIBLIOGRAPHY: GENERAL WORKS

Adams, Henry. *The Education of Henry Adams.* Boston, 1927.

American Academy of the Fine Arts and American Art-Union, 1816–1852. Ed. Mary Bartlett Cowdrey. 2 vols. New York, 1953.

Barker, Virgil. *American Painting: History and Interpretation.* New York, 1950.

Baur, John I. H. *American Painting in the Nineteenth Century: Main Trends and Movements.* New York, 1953.

Belknap, Waldron Phoenix, Jr. *American Colonial Painting.* Cambridge, Mass., 1959.

Benjamin, S. G. W. *Art in America: A Critical and Historical Sketch.* New York, 1880.

——— . *Contemporary Art in America.* New York, 1877.

Bermingham, Peter. *American Art in the Barbizon Mood.* National Collection of Fine Arts, Smithsonian Institution, Washington, D.C., 1975.

Black, Mary, and Jean Lipman. *American Folk Painting.* New York, 1966.

Blashfield, Edwin Howland. *Mural Painting in America.* New York, 1913.

Boston Athenaeum Art Exhibition Index, 1827–1874. Ed. Robert F. Perkins, Jr., and William J. Gavin III. Boston, 1980.

Boyle, Richard J. *American Impressionism.* Greenwich, Conn., 1974.

Brimo, René. *L'Évolution du goût aux États-Unis d'après l'histoire des collectiones.* Paris, 1938.

The Britannica Encyclopedia of American Art. Chicago, 1973.

Brooklyn Art Association. *A History of the Brooklyn Art Association with an Index of Exhibitions.* New York, 1970.

Brooks, Van Wyck. *The Dream of Arcadia: American Writers and Artists in Italy, 1760–1915.* New York, 1958.

Brown, Milton W. *American Art to 1900.* New York, 1977.

Brown University Department of Art. *The Classical Spirit in American Portraiture.* Providence, R.I., 1976.

Burke, Doreen Bolger. *American Paintings in the Metropolitan Museum of Art,* vol. 3. New York, 1980.

Burroughs, Alan. *Limners and Likenesses: Three Centuries of American Painting.* Cambridge, Mass., 1936.

Caffin, Charles. *The Story of American Painting: The Evolution of Painting in America from Colonial Times to the Present.* 1907; rpt. New York, 1970.

Cahill, Holger, and Alfred H. Barr, Jr., eds. *Art in America: A Complete Survey.* New York, 1935.

Callow, James T. *Kindred Spirits: Knickerbocker Writers and American Artists, 1807–1855.* Chapel Hill, N.C., 1967.

Carnegie Institute Museum of Art. *Catalogue of Painting Collection.* Pittsburgh, 1973.

Carter, Denny, et al. *The Golden Age: Cincinnati Painters of the Nineteenth Century Represented in the Cincinnati Art Museum.* Cincinnati, 1979.

Champney, Benjamin. *Sixty Years' Memories of Art and Artists.* Woburn, Mass., 1900.

Clement, Clara, and Laurence Hutton. *Artists of the Nineteenth Century and Their Works.* Boston, 1879, 1884; St. Louis, 1969.

Constable, William G. *Art Collecting in the United States of America: An Outline of a History.* London and New York, 1964.

Cook, Clarence. *Art and Artists of Our Time.* New York, 1888.

Corcoran Gallery of Art. *A Catalogue of the Collection of American Paintings in the Corcoran Gallery of Art.* 2 vols. Washington, D.C., 1966; 1973.

Corn, Wanda H. *The Color of Mood, American Tonalism, 1880–1910.* California Palace of the Legion of Honor, San Francisco, 1972.

Craven, Wayne. "Luman Reed, Patron: His Collection and Gallery." *American Art Journal* 12 (Spring 1980): 40–59.

Curry, Larry. *The American West: Painters from Catlin to Russell.* New York, 1972.

Dickson, Harold E. *Arts of the Young Republic: The Age of William Dunlap.* Chapel Hill, N.C., 1968.

Domit, Moussa M. *American Impressionist Painting.* National Gallery of Art, Washington, D.C., 1973.

Downes, William Howe. "Boston Painters and Paintings." *Atlantic Monthly* 62 (July–December 1888).

Dresser, Louisa. *Seventeenth-Century Painting in New England.* Worcester Art Museum, Mass., 1935.

Dunlap, William. *A History of the Rise and Progress of the Arts of Design in the United States.* 3 vols. 1834; rpt. New York, 1965.

Durand, Asher B. "Letters on Landscape Painting." *The Crayon* 1 (1855).

Eldredge, Charles. *The Arcadian Landscape: Nineteenth-Century American Painters in Italy.* University of Kansas Museum of Art, Lawrence, 1972.

Ewers, John C. *Artists of the Old West.* New York, 1965.

Fielding, Mantle. *Dictionary of American Painters, Sculptors, and Engravers.* Philadelphia, 1926; with addendum by James F. Carr, New York, 1965.

Fink, Lois. *Academy: The Academic Tradition in American Art.* National Collection of Fine Arts, Smithsonian Institution, Washington, D.C., 1975.

———. "American Artists in France, 1850–1870." *American Art Journal* 5 (November 1973): 32–49.

Flexner, James T. *That Wilder Image: The Painting of America's Native School from Thomas Cole to Winslow Homer.* Boston, 1962.

Foshay, Ella. "Charles Darwin and the Development of American Floral Imagery." *Winterthur Portfolio* 15 (Winter 1980): 299–314.

Frankenstein, Alfred. *The Reality of Appearance: The Trompe L'Oeil Tradition in American Painting.* National Gallery of Art, Washington D.C., 1970.

French, H. W. *Art and Artists in Connecticut.* Boston and New York, 1879.

Gardner, Albert Ten Eyck, and Stuart P. Feld. *American Paintings in the Collection of the Metropolitan Museum of Art,* vol. 1. New York, 1965.

Gerdts, William H. *American Impressionism.* Henry Art Gallery, University of Washington, Seattle, 1980.

———. "The Influence of Ruskin and Pre-Raphaelitism on American Still-Life Painting," *American Art Journal* 1 (Fall 1969): 80–97.

———. *Painters of the Humble Truth: Masterpieces of American Still Life, 1801–1939.* Columbia, Mo., 1981.

———, and Russell Burke. *American Still-Life Painting.* New York, 1971.

Goodrich, Lloyd. "Realism and Romanticism in Homer, Eakins, and Ryder." *Art Quarterly* 12 (Winter 1949): 17–29.

Goodyear, Frank H., et al. *In This Academy.* Pennsylvania Academy of the Fine Arts, Philadelphia, 1976.

Groce, George, and David Wallace. *The New-York Historical Society's Dictionary of Artists in America, 1564–1860.* New Haven, Conn., 1957.

Hagen, Oskar. *The Birth of the American Tradition in Art.* New York, 1940.

Harris, Neil. *The Artist in American Society: The Formative Years, 1790–1860.* New York, 1966.

Hartmann, Sadakichi. *A History of American Art.* 2 vols. 1902; rev. ed., Boston, 1932.

Hills, Patricia. *The Painters' America: Rural and Urban Life, 1810–1910.* Whitney Museum of American Art, New York, 1974.

———. *Turn-of-the-Century America.* Whitney Museum of American Art, New York, 1977.

Hoopes, Donelson F. *The American Impressionists.* New York, 1972.

———, and Wend von Kalnein. *The Düsseldorf Academy and the Americans.* High Museum of Art, Atlanta, 1972.

———, and Nancy Wall Moure. *American Narrative Painting.* Los Angeles County Museum of Art, 1974.

Howat, John K., and Dianne H. Pilgrim. *American Impressionist and Realist Paintings and Drawings from the Collection of Mr. and Mrs. Raymond J. Horowitz.* Metropolitan Museum of Art, New York, 1973.

———, and Natalie Spassky. *19th-Century America: Paintings and Sculpture.* Metropolitan Museum of Art, New York, 1970.

Isham, Samuel. *The History of American Painting.* 1905; rev. ed. with supplemental chapters by Royal Cortissoz, New York, 1927.

James, Henry. *The Painter's Eye.* Ed. J. L. Sweeney. London, 1956.

Jarves, James Jackson. *Art Hints, Architecture, Sculpture, and Painting.* New York, 1855.

———. *The Art Idea.* 1864; rpt. Cambridge, Mass., 1960.

Koke, Richard J., et al. *American Landscape and Genre Painting in the New-York Historical Society.* 3 vols. Boston, 1982.

La Farge, John. *Considerations on Painting.* New York, 1895.

———. *The Higher Life in Art.* New York, 1908.

Landgren, Marchal E. *American Pupils of Thomas Couture.* University of Maryland Art Gallery, College Park, 1970.

Larkin, Oliver W. *Art and Life in America.* 1949; rev. ed., New York, 1960.

M. and M. Karolik Collection of American Paintings, 1815–1865, Museum of Fine Arts, Boston. Cambridge, Mass., 1949.

Maass, John. *The Glorious Enterprise: The Centennial Exhibition of 1876.* Watkins Glen, N.Y., 1973.

McCoubrey, John. *American Tradition in Painting.* New York, 1963.

———, ed. *American Art, 1700–1960: Sources and Documents.* Englewood Cliffs, N.J., 1965.

McShine, Kynaston, et al., *The Natural Paradise: Painting in America, 1800–1950.* Museum of Modern Art, New York, 1976.

Mandel, Patricia C., et al. *Selection VII: American Paintings from the Museum's Collection, c. 1800–1930.* Museum of Art, Rhode Island School of Design, Providence, 1977.

Marx, Leo. *The Machine in the Garden: Technology and the Pastoral Ideal in America.* New York, 1964.

Marzio, Peter C. *The Democratic Art.* Boston, 1979.

Mather, Frank Jewett, Jr. *Estimates in Art.* Series 2. New York, 1931.

Matthiessen, F. O. *American Renaissance: Art and Expression in the Age of Emerson and Whitman.* London, 1941.

Mendelowitz, Daniel M. *A History of American Art.* 2d ed., New York, 1970.

Miller, Lillian. *Patrons and Patriotism: The Encouragement of the Fine Arts in the United States, 1790–1860.* Chicago, 1966.

Montgomery, Walter, ed. *American Art and American Art Collections.* 2 vols. Boston, 1889.

Mooz, R. P. *American Painting to 1776: A Reappraisal.* Ed. Ian M. G. Quimby. Charlottesville, Va., 1971.

Morgan, John Hill. *Early American Paintings.* New York, 1921.

Mumford, Lewis. *The Brown Decades: A Study of the Arts in America, 1865–1895.* New York, 1931.

Museum of Fine Arts, Boston. *American Paintings in the Museum of Fine Arts, Boston.* 2 vols. Boston, 1969.

National Academy of Design Exhibition Record, 1826–1860. 2 vols. New York, 1943.

National Academy of Design Exhibition Record, 1861–1900. Ed. Maria Naylon. 2 vols. New York, 1973.

Neuhaus, Eugen. *The History and Ideals of American Art.* Palo Alto, Calif., 1931.

Novak, Barbara. *American Painting of the Nineteenth Century: Realism, Idealism, and the American Experience.* New York, 1969.

———. *Nature and Culture: American Landscape and Painting, 1825–1875.* New York, 1980.

The Pennsylvania Academy of the Fine Arts, 1807–1870; The Society of Artists, 1800–1814; The Artists' Fund Society, 1835–1845. Cumulative Record of Exhibition Catalogues. Ed. Anna Wells Rutledge. Philadelphia, 1955.

Pleasants, J. Hall. "Four Late Eighteenth Century Anglo-American Landscape Painters." *Proceedings of the American Antiquarian Society* 52 (1943): 187–324.

Prown, Jules D., and Barbara Rose. *American Painting.* 2 vols. Cleveland, 1969.

Quick, Michael. *American Expatriate Painters of the Late Nineteenth Century.* Dayton Art Institute, Ohio, 1976.

———, et al. *American Portraiture in the Grand Manner, 1720–1920.* Los Angeles County Museum of Art, 1981.

———, et al. *Munich and American Realism in the Nineteenth Century.* E. B. Crocker Art Gallery, Sacramento, Calif., 1978.

Richardson, Edgar P. *American Art: An Exhibition from the Collection of Mr. and Mrs. John D. Rockefeller 3rd.* Fine Arts Museums of San Francisco, 1976.

———. *American Romantic Painting.* New York, 1944.

———. *Painting in America: The Story of 450 Years.* New York, 1956.

———, and Otto Wittman, Jr. *Travelers in Arcadia: American Artists in Italy.* Detroit Institute of Arts, 1951.

Saarinen, Aline. *The Proud Possessors: The Lives, Times, and Tastes of Some Adventurous American Art Collectors.* New York, 1958.

Sadik, Marvin S. *Colonial and Federal Portraits at Bowdoin College.* Bowdoin College Museum of Art, Brunswick, Maine, 1966.

Sellin, David. *Americans in Brittany and Normandy 1860–1910.* Phoenix Art Museum, Ariz., 1982.

Sewell, Darrel, et al. *Philadelphia: Three Centuries of American Art.* Philadelphia Museum of Art, 1976.

Shadwell, Wendy J., and Robert Strunsky. *Catalogue of American Portraits in the New-York Historical Society.* New Haven, Conn., 1974.

Sheldon, George W. *American Painters.* New York, 1879.

———. *Hours with Art and Artists.* New York, 1882.

———. *Recent Ideals of American Art.* 3 vols. New York, 1888.

Shinn, Earl [Strahan, Edward], ed. *The Art Treasures of America.* 3 vols. Philadelphia, 1880.

Simoni, John Peter. "Art Critics and Criticism in Nineteenth-Century America." Ph.D. diss., Ohio State University, 1952.

Soby, James Thrall, and Dorothy C. Miller. *Romantic Painting in America.* Museum of Modern Art, New York, 1943.

Stebbins, Theodore E., Jr. *American Master Drawings and Watercolors.* New York, 1976.

———, et al. *The Hudson River School: 19th Century American Landscapes in the Wadsworth Atheneum.* Hartford, Conn., 1976.

Stein, Roger B. *John Ruskin and Aesthetic Thought in America, 1840–1900.* Cambridge, Mass., 1967.

———. *Seascape and the American Imagination.* New York, 1975.

Strickler, Susan E., and William Hutton, eds. *The Toledo Museum of Art: American Paintings.* Toledo, Ohio, 1979.

Sweet, Frederick A. *Sargent, Whistler, and Mary Cassatt.* Art Institute of Chicago, 1954.

Taft, Robert. *Artists and Illustrators of the Old West, 1850–1900.* New York, 1953.

Taylor, Joshua C. *America as Art.* National Collection of Fine Arts, Smithsonian Institution, Washington, D.C., 1976.

———. *The Fine Arts in America.* Chicago, 1979.

Tracy, Berry B., and William H. Gerdts. *Classical America.* Newark Museum, N.J., 1963.

Troyen, Carol. *The Boston Tradition: American Paintings from the Museum of Fine Arts, Boston.* American Federation of Arts. New York, 1980.

Truettner, William H. "William T. Evans, Collector of American Paintings." *The American Art Journal* 3 (Fall 1971): 50–79.

Tuckerman, Henry T. *Book of the Artists: American Artist Life.* 1867; rpt. New York, 1966.

Van Dyck, John C. *American Painting and Its Tradition, as Represented by Inness, Wyant, Martin, Homer, La Farge, Whistler, Chase, Alexander, Sargent.* New York, 1919.

Weinberg, H. Barbara. "Thomas B. Clarke: Foremost Patron of American Art from 1872–1899." *The American Art Journal* 8 (May 1976): 52–83.

Williams, Hermann Warner, Jr. *Mirror of the American Past: A Survey of American Genre Painting: 1750–1900.* Greenwich, Conn., 1973.

Wilmerding, John. *A History of American Marine Painting.* Boston and Salem, 1968.

———, et al. *American Light: The Luminist Movement, 1850–1875.* National Gallery of Art, Washington, D.C., 1980.

———, Linda Ayres; and Earl A. Powell. *An American Perspective: Nineteenth-Century Art from the Collection of Jo Ann and Julian Ganz, Jr.* National Gallery of Art, Washington, D.C., 1981.

Wilson, Richard Guy; Dianne H. Pilgrim; and Richard N. Murray. *The American Renaissance, 1876–1917.* Brooklyn Museum, N.Y., 1979.

Selected Bibliography: Artists

ABBEY, EDWIN AUSTIN
Foster, Kathleen A., and Michael Quick.
 Edwin Austin Abbey. Yale University Art
 Gallery, New Haven, Conn., 1973.
ALEXANDER, JOHN WHITE
Goley, Mary Anne. *John White Alexander*.
 National Collection of Fine Arts,
 Smithsonian Institution,
 Washington, D.C., 1976.
Leff, Sandra. *John White Alexander*. Graham
 Gallery, New York, 1980.
ALLSTON, WASHINGTON
Flagg, Jared B. *The Life and Letters of
 Washington Allston*. 1892;
 rpt. New York, 1969.
Gerdts, William H., and Theodore E.
 Stebbins, Jr. *"A Man of Genius": The Art of
 Washington Allston (1779–1843)*. Museum
 of Fine Arts, Boston, 1979.
Richardson, Edgar P. *Washington Allston: A
 Study of the Romantic Artist in America*.
 Chicago, 1948.
AUDUBON, JOHN JAMES
Audubon, Maria, ed. *Audubon and His
 Journals*. 2 vols. New York, 1960.
Ford, Alice. *John James Audubon*. Norman,
 Okla., 1964.
Reynolds, Gary A. *John James Audubon and
 His Sons*. Grey Art Gallery and Study
 Center, New York University,
 New York, 1982.

BIERSTADT, ALBERT
Hendricks, Gordon. *Albert Bierstadt, Painter of
 the American West*. Amon Carter Museum,
 Fort Worth, Tex., 1974.
Trump, Richard Shafer. *The Life and Works of
 Albert Bierstadt*. Ph.D. diss., Ohio State
 University, 1963.
BINGHAM, GEORGE CALEB
Bloch, E. Maurice. *George Caleb Bingham: The
 Evolution of an Artist*. 2 vols. Berkeley and
 Los Angeles, 1967.
Christ-Janer, Albert. *George Caleb Bingham of
 Missouri: The Story of an Artist*.
 New York, 1940.
McDermott, John Francis. *George Caleb
 Bingham, River Portraitist*. Norman, Okla.,
 1959.
BIRCH, THOMAS
Gerdts, William H. *Thomas Birch, 1779–1851:
 Paintings and Drawings*. Philadelphia
 Maritime Museum, 1966.
BLACKBURN, JOSEPH
Morgan, John Hill, and Henry Wilder Foote.
 *An Extension of Lawrence Park's Descriptive
 List of the Work of Joseph Blackburn*.
 American Antiquarian Society, Worcester,
 Mass., 1937.
Park, Lawrence. *Joseph Blackburn, A Colonial
 Portrait Painter*. Worcester, Mass., 1923.
BLAKELOCK, RALPH ALBERT
Geske, Norman A. *Ralph Albert Blakelock,
 1847–1919*. Lincoln, Neb., 1974.

BLYTHE, DAVID GILMOUR
Chambers, Bruce W. *The World of David Gilmour Blythe*. National Collection of Fine Arts, Smithsonian Institution, Washington, D.C., 1980.
Miller, Dorothy. *The Life and Work of David G. Blythe*. Pittsburgh, 1950.

BRICHER, ALFRED THOMPSON
Brown, Jeffrey. *Alfred Thompson Bricher, 1837–1908*. Indianapolis Museum of Art, Ind., 1973.

CASSATT, MARY
Breeskin, Adelyn D. *Mary Cassatt: A Catalogue Raisonné of the Oils, Pastels, Watercolors, and Drawings*. Washington, D.C., 1970.
Bullard, E. John. *Mary Cassatt: Oils and Pastels*. New York, 1972.
Sweet, Frederick A. *Miss Mary Cassatt, Impressionist from Philadelphia*. Norman, Okla., 1966.

CATLIN, GEORGE
Haberly, Lloyd. *Pursuit of the Horizon: A Life of George Catlin, Painter and Recorder of the American Indian*. New York, 1948.
McCracken, Harold. *George Catlin and the Old Frontier*. New York, 1959.

CHASE, WILLIAM MERRITT
Pisano, Ronald C. *William Merritt Chase*. New York, 1979.
Roof, Katherine Metcalf. *The Life and Art of William Merritt Chase*. 1917; rpt. New York, 1975.

CHURCH, FREDERIC EDWIN
Huntington, David C. *The Landscapes of Frederic Edwin Church: Vision of an American Era*. New York, 1966.
Stebbins, Theodore E., Jr. *Close Observation: Selected Oil Sketches by Frederic E. Church*. Washington, D.C., 1978.

COLE, THOMAS
Merritt, Howard S. *Thomas Cole*. Memorial Art Gallery of the University of Rochester, N.Y., 1969.
Noble, Louis Legrand. *The Life and Works of Thomas Cole*. Ed. Elliott S. Vessell. 1853; rpt. Cambridge, Mass., 1964.

COPLEY, JOHN SINGLETON
Amory, Martha Babcock. *The Domestic and Artistic Life of John Singleton Copley, R.A.* Boston, 1882.
Fairbrother, Trevor J. "John Singleton Copley's Use of British Mezzotints: A Reappraisal Prompted by New Discoveries." *Arts Magazine* 55 (March 1981): 122–30.
Jones, Guernsey. *Letters and Papers of John Singleton Copley and Henry Pelham, 1739–1776*. Massachusetts Historical Society Collections 71. Boston, 1914.
Parker, Barbara Neville, and Anne Bolling Wheeler. *John Singleton Copley: American Portraits*. Boston, 1938.

Prown, Jules D. *John Singleton Copley*. Cambridge, Mass., 1966.

CROPSEY, JASPER F.
Maddox, Kenneth W. *An Unprejudiced Eye: The Drawings of Jasper F. Cropsey*. Hudson River Museum, Yonkers, N.Y., 1979.
Talbot, William S. *Jasper F. Cropsey, 1823–1900*. National Collection of Fine Arts, Smithsonian Institution, Washington, D.C., 1970.

DECKER, JOSEPH
Cooper, Helen A. "The Rediscovery of Joseph Decker." *American Art Journal* 10 (May 1978): 55–71.

DEWING, THOMAS WILMER
Ely, Catherine Beach. "Thomas W. Dewing." *Art in America* 10 (August 1922): 224–29.
Hobbs, Susan. "Thomas Wilmer Dewing: The Early Years, 1851–1885." *American Art Journal* 13 (Spring 1981): 4–35.

DOUGHTY, THOMAS
Goodyear, Frank H. *Thomas Doughty*. Pennsylvania Academy of the Fine Arts, Philadelphia, 1973.

DURAND, ASHER B.
Durand, John. *The Life and Times of A. B. Durand*. New York, 1894.
Lawall, David B. *A. B. Durand, 1796–1886*. Montclair Art Museum, N.J., 1971.
———. *Asher B. Durand: A Documentary Catalogue of the Narrative and Landscape Paintings*. New York, 1978.

DURRIE, GEORGE HENRY
Hutson, Martha Young. *George Henry Durrie, 1820–1863: Connecticut Painter of American Life*. Wadsworth Atheneum, Hartford, Conn., 1947.

DUVENECK, FRANK
Duveneck, Josephine W. *Frank Duveneck, Painter-Teacher*. San Francisco, 1970.
Exhibition of the Work of Frank Duveneck. Cincinnati Art Museum, 1936.
Heerman, Norbert. *Frank Duveneck*. Boston, 1918.

EAKINS, THOMAS
Ackerman, Gerald M. "Thomas Eakins and His Parisian Masters Gérôme and Bonnat." *Gazette des Beaux-Arts* 73 (April 1969): 235–36.
Goodrich, Lloyd. *Thomas Eakins*. 2 vols. Cambridge, Mass., 1982.
Rosenzweig, Phyllis D. *The Thomas Eakins Collection*. Hirshhorn Museum, Washington, D.C., 1977.
Schendler, Sylvan. *Eakins*. Boston, 1967.
Sewell, Darrel. *Thomas Eakins, Artist of Philadelphia*. Philadelphia Museum of Art, 1982.
Siegl, Theodor. *The Thomas Eakins Collection, Philadelphia Museum of Art*. Philadelphia, 1978.

FULLER, GEORGE
Millet, Josiah B., ed. *George Fuller, His Life and Works*. Boston, 1886.

GIFFORD, SANFORD ROBINSON
Cikovsky, Nicolai, Jr. *Sanford Robinson Gifford, 1823–1880*. The University of Texas Art Museum, Austin, 1970.
Weiss, Ila. *Sanford Robinson Gifford, 1823–1880*. New York, 1977.

HABERLE, JOHN
Chirico, Robert F. "John Haberle and Trompe l'Oeil." *Marsyas* 19 (1977–78): 37–43.
Haberle Retrospective Exhibition. New Britain Museum of Art, Conn., 1962.

HARNETT, WILLIAM MICHAEL
Frankenstein, Alfred. *After the Hunt: William Harnett and Other American Still Life Painters 1870–1900*. Berkeley and Los Angeles, 1953, rev. ed., 1969.

HASSAM, CHILDE
Childe Hassam, 1859–1935. University of Arizona Museum of Art, Tucson, 1972.
Childe Hassam: A Retrospective Exhibition. Corcoran Gallery of Art, Washington, D.C., 1965.
Hoopes, Donelson F. *Childe Hassam*. New York, 1979.

HEADE, MARTIN JOHNSON
McIntyre, Robert G. *Martin Johnson Heade*. New York, 1948.
Stebbins, Theodore E., Jr. *The Life and Works of Martin Johnson Heade*. New Haven, Conn., 1975.

HOMER, WINSLOW
Downes, William Howe. *The Life and Works of Winslow Homer*. Boston, 1911.
Gardner, Albert Ten Eyck. *Winslow Homer, American Artist: His World and His Work*. New York, 1961.
Goodrich, Lloyd. *Winslow Homer*. New York, 1944.
———. *Winslow Homer*. Whitney Museum of American Art, New York, 1973.
Wilmerding, John. *Winslow Homer*. New York, 1972.

HOVENDEN, THOMAS
Livesy, Helen Corson. *The Life and Works of Thomas Hovenden, N.A.* Archives of American Art, Smithsonian Institution, Washington, D.C.

HUNT, WILLIAM MORRIS
Hoppin, Martha J., and Henry Adams. *William Morris Hunt: A Memorial Exhibition*. Museum of Fine Arts, Boston, 1979.
Knowlton, Helen M. *Art-Life of William Morris Hunt*. 1899; rpt. New York, 1971.
Landgren, Michael E., and Sharman Wallace McGurn. *The Late Landscapes of William Morris Hunt*. University of Maryland Department of Art, College Park, 1976.

INNESS, GEORGE

Cikovsky, Nicolai, Jr. *George Inness.*
New York, 1971.

Inness, George, Jr. *Life, Art, and Letters of George Inness.* Intro. by Elliott Daingerfield. New York, 1917.

Ireland, LeRoy. *The Works of George Inness: An Illustrated Catalogue Raisonné.* Austin, Tex., 1965.

JOHNSON, EASTMAN

Baur, John I. H. *Eastman Johnson, 1824–1906: An American Genre Painter.* Brooklyn Museum, N.Y., 1940; rpt. 1969.

Hills, Patricia. *Eastman Johnson.* Whitney Museum of American Art, New York, 1972.

KENSETT, JOHN FREDERICK

Driscoll, John Paul. *John F. Kensett Drawings.* Museum of Art, Pennsylvania State University, University Park, 1978.

Howat, John K. *John Frederick Kensett, 1816–1872.* American Federation of Arts, New York, 1968.

Johnson, Ellen. "Kensett Revisited." *Art Quarterly* 20 (Spring 1957): 71–92.

LA FARGE, JOHN

Cortissoz, Royal. *La Farge: A Memoir and a Study.* Boston, 1911.

Foster, Kathleen A. "The Still-Life Paintings of John La Farge." *The American Art Journal* 11 (July 1979): 4–37.

Weinberg, H. Barbara. *The Decorative Work of John La Farge.* New York, 1977.

LANE, FITZ HUGH

Paintings and Drawings by Fitz Hugh Lane at the Cape Ann Historical Association. Gloucester, Mass., 1974.

Wilmerding, John. *Fitz Hugh Lane.* New York, 1971.

LEUTZE, EMANUEL

Groseclose, Barbara S. *Emanuel Leutze, 1816–1868: Freedom Is the Only King.* National Collection of Fine Arts, Smithsonian Institution, Washington, D.C., 1975.

MARTIN, HOMER DODGE

Mandel, Patricia C. F. "Homer D. Martin: American Landscape Painter (1836–1897)." Ph.D. diss., New York University, 1973.

Martin, Elizabeth G. *Homer Martin: A Reminiscence.* New York, 1904.

MORAN, THOMAS

Clark, Carol. *Thomas Moran: Watercolors of the American West.* Amon Carter Museum, Fort Worth, Tex., 1980.

Wilkins, Thurman. *Thomas Moran, Artist of the Mountains.* Norman, Okla., 1966.

MORSE, SAMUEL F. B.

Mabee, Carleton. *The American Leonardo: A Life of Samuel F. B. Morse.* 1943; rpt. New York, 1969.

Morse, Edward Lind, ed. *Samuel F. B. Morse: His Letters and Journals.* New York, 1970.

Staiti, Paul J., and Gary A. Reynolds. *Samuel F. B. Morse.* Grey Art Gallery and Study Center, New York University, New York, 1982.

MOUNT, WILLIAM SIDNEY

Cowdrey, Mary Bartlett, and Hermann Warner Williams, Jr. *William Sidney Mount, 1807–1868: An American Painter.* New York, 1944.

Frankenstein, Alfred. *William Sidney Mount.* New York, 1975.

Keyes, Donald D. "The Sources for William Sidney Mount's Earliest Genre Painting." *Art Quarterly* 32 (Autumn 1969): 258–68.

NEAGLE, JOHN

Fielding, Mantle. *Catalogue of an Exhibition of Portraits by John Neagle.* Pennsylvania Academy of the Fine Arts, Philadelphia, 1925.

Lynch, Marguerite. "John Neagle's Diary." *Art in America* 37 (April 1949): 79–99.

NEWMAN, ROBERT LOFTIN

Landgren, Michael E. *Robert Loftin Newman, 1827–1912.* National Collection of Fine Arts, Smithsonian Institution, Washington, D.C., 1974.

PEALE FAMILY

Hindle, Brooke; Lillian B. Miller; and Edgar P. Richardson. *Charles Willson Peale and His World.* New York, 1982.

The Peale Family: Three Generations of American Artists. Detroit Institute of Arts, 1967.

Sellers, Charles Coleman. *Charles Willson Peale.* New York, 1969.

———. *Raphaelle Peale.* Milwaukee Art Center, 1959.

PETO, JOHN F.

Wilmerding, John. *Important Information Inside: The Art of John F. Peto and the Idea of Still-Life Painting in Nineteenth-Century America.* National Gallery of Art, Washington, D.C., 1983.

QUIDOR, JOHN

Baur, John I. H. *John Quidor.* Munson-Williams-Proctor Institute, Utica, N.Y., 1965.

Sokol, David M. *John Quidor, Painter of American Legend.* Wichita Art Museum, Kan., 1973.

REMINGTON, FREDERIC

Hassrick, Peter H. *Frederic Remington.* Amon Carter Museum, Fort Worth, Tex., 1973.

McCracken, Harold. *Frederic Remington: Artist of the Old West.* Philadelphia, 1947.

RICHARDS, WILLIAM TROST

Ferber, Linda S. *William Trost Richards: American Landscape and Marine Painter, 1833–1905.* Brooklyn Museum, N.Y., 1973.

RIMMER, WILLIAM

Bartlett, Truman H. *The Art Life of William Rimmer.* Boston, 1882.

Kirstein, Lincoln. *William Rimmer.* Whitney Museum of American Art, New York, 1946.

ROBINSON, THEODORE

Baur, John I. H. *Theodore Robinson, 1852–1896.* Brooklyn Museum, N.Y., 1946.

RYDER, ALBERT PINKHAM

Goodrich, Lloyd. *Albert Pinkham Ryder.* New York, 1959.

Sherman, Frederic Fairchild. *Albert Pinkham Ryder.* New York, 1920.

SALMON, ROBERT

Wilmerding, John. *Robert Salmon, Painter of Ship and Shore.* Boston, 1971.

SARGENT, HENRY

Nylander, Jane C. "Henry Sargent's 'Dinner Party' and 'Tea Party.'" *Antiques* 121 (May 1982): 1172–83.

SARGENT, JOHN SINGER

Charteris, Evan. *John Sargent.* New York, 1927.

Lomax, James, and Richard Ormond. *John Singer Sargent and the Edwardian Age.* Leeds Art Galleries, 1979.

Ormond, Richard. *John Singer Sargent: Paintings, Drawings, Watercolors.* New York, 1970.

Ratcliff, Carter. *John Singer Sargent.* New York, 1982.

SMIBERT, JOHN

Evans, Sir David; John Kerslake; and Andrew Oliver. *The Notebook of John Smibert.* Boston, 1969.

Foote, Henry Wilder. *John Smibert, Painter.* Cambridge, Mass., 1950.

Saunders, Richard H., III. "John Smibert (1688–1751): Anglo-American Portrait Painter." Ph.D. diss., Yale University, 1979.

STUART, GILBERT

Mount, Charles Merrill. *Gilbert Stuart: A Biography.* New York, 1964.

Park, Lawrence. *Gilbert Stuart: An Illustrated Descriptive List of His Works.* 4 vols. New York, 1926.

Richardson, Edgar P. *Gilbert Stuart, Portraitist of the Young Republic.* Museum of Art, Rhode Island School of Design, Providence, 1967.

SULLY, THOMAS

Biddle, Edward, and Mantle Fielding. *The Life and Works of Thomas Sully (1783–1872).* Philadelphia, 1921; Charleston, S.C., 1969.

Sully, Thomas. *Hints to Young Painters and the Process of Portrait Painting.* Philadelphia, 1873.

TAIT, ARTHUR FITZWILLIAM

Cadbury, Warder H., and Patricia C. F. Mandel. *A. F. Tait, Artist in the Adirondacks*. The Adirondack Museum, Blue Mountain Lake, N.Y., 1974.

THAYER, ABBOTT HANDERSON

Anderson, Ross. *Abbott Handerson Thayer*. Everson Museum, Syracuse, N.Y., 1982.

TRUMBULL, JOHN

Cooper, Helen A. *John Trumbull: The Hand and Spirit of a Painter*. Yale University Art Gallery, New Haven, Conn., 1982.

Jaffe, Irma. *John Trumbull, Patriot-Artist of the American Revolution*. Boston, 1975.

Sizer, Theodore. *The Works of Colonel John Trumbull*. New Haven, Conn., 1967.

——— . ed. *The Autobiography of Colonel John Trumbull*. New Haven, Conn., 1953.

TWACHTMAN, JOHN HENRY

Boyle, Richard J. *A Retrospective Exhibition: John Henry Twachtman*. Cincinnati Art Museum, 1966.

VANDERLYN, JOHN

Averill, Louise Hunt. "John Vanderlyn, American Painter." Ph.D. diss., Yale University, 1949.

Lindsay, Kenneth C. *The Works of John Vanderlyn: From Tammany to the Capitol*. University Art Gallery, State University of New York at Binghamton, 1970.

Schoonmaker, Marius. *John Vanderlyn, Artist, 1775–1852*. Kingston, N.Y., 1950.

VEDDER, ELIHU

Soria, Regina. *Elihu Vedder: American Visionary Artist in Rome (1836–1923)*. Rutherford, N.J., 1970.

Taylor, Joshua, et al. *Perceptions and Evocations: The Art of Elihu Vedder*. National Collection of Fine Arts, Smithsonian Institution, Washington, D.C., 1979.

Vedder, Elihu. *The Digressions of V*. Boston, 1910.

WEIR, JULIAN ALDEN

Millet, J. B., ed. *Julian Alden Weir: An Appreciation of His Life and Works*. New York, 1921.

Young, Dorothy Weir. *The Life and Letters of J. Alden Weir*. Ed. Lawrence W. Chisolm. New Haven, Conn., 1960.

WEST, BENJAMIN

Dillenberger, John. *Benjamin West: The Context of His Life's Work with Particular Attention to Paintings with Religious Subject Matter*. San Antonio, Tex., 1977.

Evans, Dorinda. *Benjamin West and His American Students*. National Portrait Gallery, Smithsonian Institution, Washington, D.C., 1981.

Evans, Grose. *Benjamin West and the Taste of His Times*. Carbondale, Ill., 1959.

WHISTLER, JAMES MCNEILL

Pennell, Elizabeth, and Joseph Pennell. *The Life of James McNeill Whistler*. 2 vols. Philadelphia and London, 1908.

Staley, Allen, Theodore Reff, et al. *From Realism to Symbolism: Whistler and His World*. Department of Art History and Archeology of Columbia University, New York, 1971.

Whistler, James McNeill. *The Gentle Art of Making Enemies*. 1890; rpt. New York, 1967.

Young, Andrew McLaren; Margaret MacDonald; and Robin Spencer. *The Paintings of James McNeill Whistler*. 2 vols. New Haven, Conn., 1980.

WHITTREDGE, WORTHINGTON

Baur, John I. H., ed. *The Autobiography of Worthington Whittredge*. 1942; rpt. New York, 1969.

Janson, Anthony F., "Worthington Whittredge: The Development of a Hudson River Painter," *American Art Journal* 11 (April 1979): 71–84.

Worthington Whittredge: A Retrospective Exhibition of an American Artist. Munson-Williams-Proctor Institute, Utica, N.Y., 1969.

WOODVILLE, RICHARD CATON

Grubar, Francis. *Richard Caton Woodville, An Early American Genre Painter*. Corcoran Gallery of Art, Washington, D.C., 1967.

INDEX OF ARTISTS & TITLES